THE
TREASURES
OF VENICE

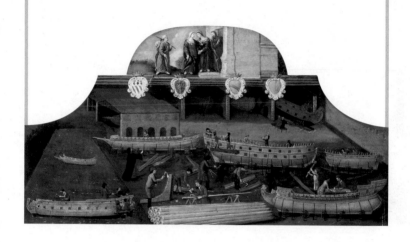

THE *RIZZOLI* ART GUIDES
NEW YORK

text by
ANTONIO MANNO

photographs by
**PIERO CODATO AND
MASSIMO VENCHIERUTTI**

CONTENTS

editorial project
VALERIA MANFERTO
DE FABIANIS
LAURA ACCOMAZZO

graphic layout
PAOLA PIACCO
CLARA ZANOTTI

graphic design
CLARA ZANOTTI

editing
ENRICO LAVAGNO

translation
RICHARD PIERCE

First published in the
United States of America in 2004 by
Rizzoli International Publications, Inc.
300 Park Avenue South,
New York, NY 10010
http://www.rizzoliusa.com

© 2004 White Star S.r.l.
Via Candido Sassone 22/24
13100 Vercelli, Italy

This edition published by arrangement with
White Star S.r.l., Vercelli, Italy

ISBN 0-8478-2630-9
Library of Congress Control Number: 2003116888

Printed in Italy
Color separation by Fotomec, Turin, Italy

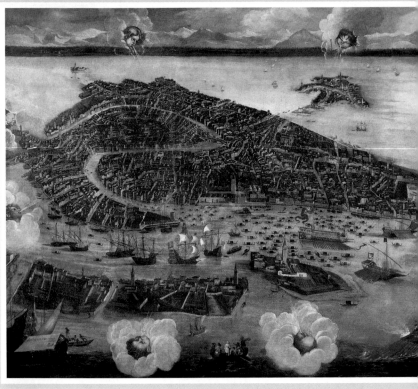

 ## THE REASONS OF A MYTH

According to traditional sacred Venetian geography, the Lagoon was the center of the world, set in direct communication with Heaven. Its circuit, similar to a circumference, marked the border between order and chaos, life and death. That site, situated between the ports of Aquileia and Ravenna, was a refuge during storms. Popular legend has it that among the most illustrious navigators who moored there was St. Mark (San Marco), the patron saint of Venice. The adjacent islands afforded

protection for the populations that fled from the barbarians. The mythical foundation of Venice, the prefiguration of the Promised Land, dates back to A.D. 421, before the devastation wrought by Attila the Hun, the "scourge of God." This early period was fraught with hardship. The inhabitants, who were boatmen and fishermen, had to become engineers and architects in order to reclaim the marshy area and build upon it. A point in favor of the Venice Lagoon was its felicitous position between East and West and the protection

provided by a powerful ally whose main cities, Ravenna and Byzantium, remained the model for Venice for over seven centuries. Proof of this is the basilican cathedral on the island of Torcello, which during the Middle Ages enhanced its magnificence with the addition of the grandiose *Last Judgment* mosaic. In the meantime, Venice, which in the 8th century had become a ducal seat, was experimenting with a combination of Byzantine and Roman culture, the latter embodied in nearby Altino and Aquileia. With its rapid population growth, the

THE REASONS ● **4** ● OF A MYTH

1 Ship-carpenters'
sign, Museo
Correr.

4-5 Josef Heintz
the Younger,
Plan in Perspective
of Venice, Museo
Correr.

of the Doge's Chapel and St. Mark's Mausoleum – cubes and spheres, circles and squares – evoke the perfection of the City of God, while the elegant decoration represents a fascinating utopia, combining in a sort of universal reliquary Early Christian, Byzantine, Eastern, Romanesque, and Gothic artistic culture.

The new city, governed by an elected doge, had already embarked on a policy of economic and territorial expansion toward the Adriatic Sea and the eastern Mediterranean. The temporary conquest of Constantinople during the Fourth Crusade, the minting of gold coins, the swift galley ships built in the Arsenal to transport precious cargo were some of the main catalysts for this adventurous enterprise. The churches and monasteries dotting the Lagoon became the nerve centers of civilization, around which vast reclamation and construction works were begun, creating zones filled with rented houses, workshops, and production sites populated by the new classes of workmen and artisans. By the same token, the canals and squares were now lined

young state of Venice became a leading international city, centered on three areas: San Marco was the hub of the city-state's politics, justice and religion; the Rialto, with its bridge, was the center of trade and business; and the Arsenal (Arsenale) manufactured weapons and ships. In the vicinity were numerous merchants' warehouses (fondaci), boat construction yards (squeri), houses, and churches. In the 12th century, St. Mark's Square (Piazza San Marco) and the adjacent Piazzetta became a worthy setting for the Basilica, which was rebuilt and consecrated in 1094. The design elements employed in the construction

with mansions and dwellings standing side by side, just as the altars, tombs, and paintings in the churches were commissioned by people from different classes. Although the artworks in the churches revealed a deep-seated pride of background or profession, they were still the expression of a harmony among the social classes. Though still involved in wars of conquest, Venice was setting itself up as the cradle of peace and civil harmony, which was expressed allegorically by polyphonic religious music and by that noble musical instrument, the organ. Mercantile culture was so strong in the city that sacred images sometimes took on a propagandistic, "promotional" nature. Indeed, the saints and episodes from the Bible not only spoke of the Christian faith, but also exalted the fundamental components of the city – virtuous individuals, aristocratic families, trade guilds, religious and foreign communities, confraternities, the clergy, and of course, the Venetian state. All, in their own ways, were involved in charitable works to help the hungry and the ill, orphans and pilgrims, the elderly and

prostitutes, at a time when there was a huge difference in the living conditions. The extreme poverty of the masses was in striking contrast with the luxurious life of the clergy and patricians. Thanks to the continuous demand for products made by local artisans and to the trade with the eastern Mediterranean and northern European countries, Venice became the capital of art and culture, of jewelry- and furniture-making, fashion and textiles, and spices. Above all, the city produced salt (indispensable for food preservation), and thanks to the salt tax it was possible to finance many public works. The influx of wealth went hand in hand with vigorous urban growth marked by the Gothic style, which was adapted to local needs and was receptive to influences from central Italy. The new Doge's Palace, the boldest expression of the city's new status as a signory, was completed in the 15th century, when the second phase of Venetian history began. With mainland conquests from Udine to Bergamo, Venice developed from a maritime city-state into a regional power. Public finances enjoyed a sizeable income and private individuals prospered

through new sources of profit and commercial opportunities. Territorial expansion led to the drafting of land maps and the construction of fortresses. The contemporary allegories of Justice and Knowledge personified the important changes made in the state administrative apparatus. For example, the myth of good government mirrored the political custom based on collective decisions that were distinguished by foresight and prudence. The end of the 15th century marked the slow and inexorable decline of Venice caused by the rise of the Ottoman Empire and the opening of new trade routes to the Indies. This fertile atmosphere was the setting for the rebirth of art and humanist culture that led to a profound change in mentality. The Serenissima was ennobled by the art of the Lombardos, Mauro Codussi, Giovanni Bellini, Palma Vecchio, Lorenzo Lotto, and Giorgione. The transition from tempera on wood panel to oil on canvas made painting a means of communication enjoyed by everyone. Painting became the rage in Venice, and the local style was marked by the magical and dramatic use of color, accompanied by innovative research that was at once naturalistic,

theatrical, dynamic, and psychological. Titian and Veronese produced their greatest paintings, while the works of Jacopo Tintoretto and Palma Giovane embodied the most popular messages, which also revealed the first traces of a nascent crisis in identity. Having abandoned its medieval traditions, Venice now embraced classical rationality, but in its own special way. The Rialto, San Marco, and Arsenal areas were altered. Among the main figures in the new architecture were Scarpagnino, Jacopo Sansovino, and Antonio da Ponte; Palladio, the author of a pure classical style, was commissioned to design many churches. The stylistic reach of these architects was expanded and varied by Alessandro Vittoria, Vincenzo Scamozzi, Giuseppe Sardi, and Giorgio Massari, who in the construction of churches attempted to reconcile the religious autonomy of Venice with the new principles adopted by the Council of Trent (1545–63). However, the most original by buildings were designed Baldassare Longhena. In the Salute basilica he established the reach of Venetian Baroque architecture and, in the period when the Republic lost Crete to the

Turks, anticipated the character of certain palazzi (palaces) built for the new members of the patrician class. The virtuoso sculptural skill of Juste Le Court and Heinrich Meyring was followed by the splendid colors and bold perspective of artists such as Piazzetta, the Ricci, the Tiepolos, and the view painters. After the fall of the Venetian Republic to Napoleon in 1797 the city became provincial, and over the next century its social and urban configuration was systematically eliminated. First of all, many churches, monasteries, guilds, and confraternities were suppressed. The establishment (for hygienic reasons) of a central cemetery deprived the clergy of an important source of income and put an end to the construction of new monumental tombs. Later on, historic buildings were demolished, canals were filled in, and new bridges were built in order to limit the city's traditional maritime life and connect it more closely to life on the mainland. With the construction of the rail bridge, the magnificent water access to St. Mark's was replaced by nondescript arrival in Venice at the S. Lucia railway station. For the sake of modernity, the huge Piazzale Roma parking area was constructed, and now there is talk of building an underwater subway in Venice. The dual imperatives of reducing traveling time and increasing the number of access points clash with the maritime nature and very essence of Venice. After the tragic 1966 flood, the exodus of inhabitants became a sort of background to the changes in the city's social and economic life. The most evident signs include the increase in the elderly population and the great decrease in young and middle-class people. Abandoned houses and shops are now being used for new activities such as the service sector and tourism. These developments have recently gathered momentum; however, they have been offset somewhat by the qualified and difficult conservation efforts made by the authorities in charge of Venice's artistic heritage. Their initiatives and those of other public and private groups and associations are also to be credited with having improved local museums, exhibition areas, and churches with their art treasures. The future of Venice's historic center will be conditioned by two factors: how the Lagoon will be conserved and protected against floods, and how the massive flow of tourists can be controlled. Now it is up to the local and national government agencies and the major private and public cultural bodies to enact a policy for the common good, so that the myth of Venice can continue to live and inspire humanity.

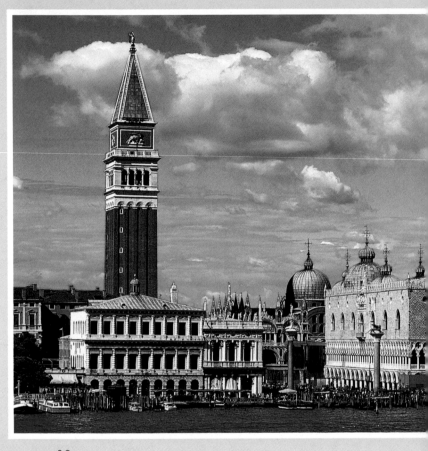

8-9
PLATEA MARCIANA.

NOTE TO THE READER

THIS GUIDE CONTAINS 15 ITINERARIES ARRANGED IN KEEPING WITH DIFFERENT CRITERIA:

THEMATIC
(for example, Itinerary 1. Grand Canal, Venice's Highway; Itinerary 2. St. Mark's, the Heart of the City, etc.)

TOPOGRAPHICAL
(3. The Central Areas of San Marco; 5. The Arsenale and Its Surroundings, etc.)

HISTORIC-CULTURAL
(7. Dominican Religiosity; 11. Franciscan Religiosity, etc.)

■ Each itinerary has a detailed map with the route highlighted in green and the starting and arrival points in yellow.
❑ On the maps the interesting sights are marked with the reference numbers in the legend and are separated by category, as follows:
❑ churches and religious complexes (in pink);
❑ palazzi (in red);
❑ other buildings (schools,

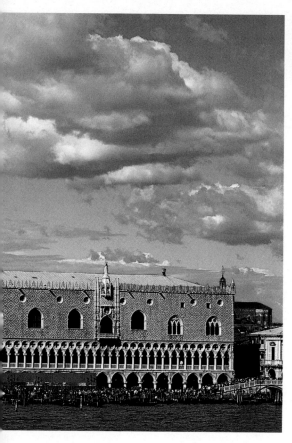

when otherwise indicated. The date of a work of art is in parentheses after the title. The dates of birth and death of an artist are given right after his/her name, usually when the date of the artwork itself is lacking.

■ The date given after the name of a person, preceded by "d.," refers to his/her death (e.g., d. 1949).

■ The two dates after the name of a doge indicate the beginning and end of his government, which almost always ended with his death.

■ The names or numbers of the rooms in museums correspond to those used in the institutions themselves or those used in the latest guidebooks of these museums.

■ "Attributed to" means that a work of art has been attributed to a certain artist on the basis of stylistic analysis and without any documentary evidence.

■ The names in **boldface** refer to sites or monuments shown on maps or in legends.

■ Words printed in *italics* refer to foreign words or terms in Venetian dialect, as well as to works of art or important buildings and architectural elements.

■ The names of artists are in SMALL CAPITALS.

hospices, etc.) and monuments (in green);
❑ museums (in purple).

■ The legend at the beginning of each chapter contains (with a few exceptions, such as chapters 1 and 15) the following:

■ the name of the *sestiere* or *sestieri* the itinerary concerns;

■ the sights, grouped together according to type
❑ churches and religious complexes;
❑ palazzi;
❑ other buildings and monuments;

❑ museums;
❑ the reference number of each sight.

■ For some of the most important religious or civic buildings there is a plan, accompanied by a legend with numbers referring to the text proper.

INFORMATION CONCERNING THE TEXT INCLUDES THE FOLLOWING:

■ The descriptions of the interiors of churches go from from right to left, counter-clockwise, except

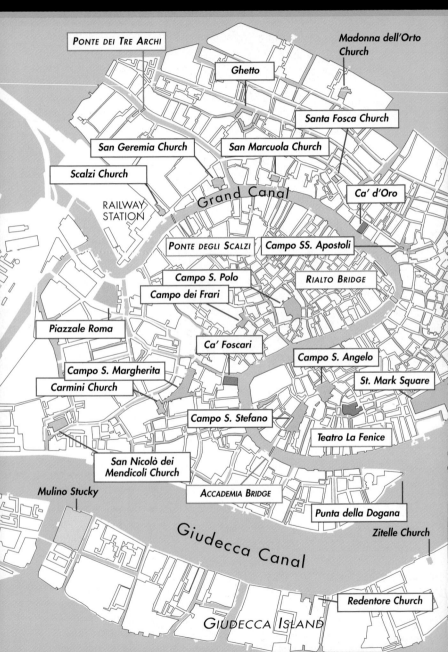

PONTE DEI TRE ARCHI

Madonna dell'Orto Church

Ghetto

Santa Fosca Church

San Geremia Church

San Marcuola Church

Scalzi Church

Ca' d'Oro

RAILWAY STATION

Grand Canal

PONTE DEGLI SCALZI

Campo SS. Apostoli

Campo S. Polo

RIALTO BRIDGE

Campo dei Frari

Piazzale Roma

Ca' Foscari

Campo S. Angelo

Campo S. Margherita

St. Mark Square

Carmini Church

Campo S. Stefano

Teatro La Fenice

San Nicolò dei Mendicoli Church

Mulino Stucky

ACCADEMIA BRIDGE

Punta della Dogana

Zitelle Church

Giudecca Canal

Redentore Church

GIUDECCA ISLAND

ISOLA DI
SAN MICHELE

LAGOON

Campo SS. Giovanni e Paolo

Campo S. Maria Formosa

ARSENALE

San Pietro
di Castello Church

Doge's Palace

Campo S. Zaccaria

Entrance to the Arsenale

S. Francesco Di Paola
Church

ISOLA DI
SAN GIORGIO
MAGGIORE

Biennale
Internazionale
d'Arte

Sant'Elena Church

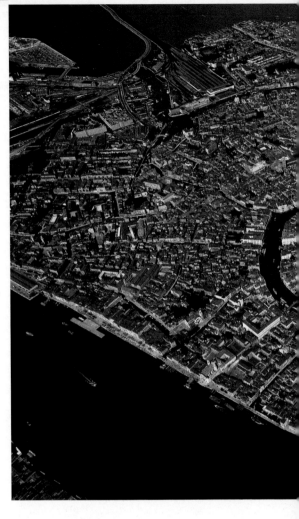

From ancient times, decisive factors led to the urbanization of the Grand Canal. They included its fluvial origin, its closeness to connections with land routes to Padua and to Germany, its central position among the canals in the Venice Lagoon, its depth, and the fact that it connected directly with the sea. From the outset, this artery took on a residential and commercial character. The first surviving residence – warehouses – mostly dating from the 12th and 13th century – are the most precious and dazzling examples and will help to explain the evolution of the Venetian palazzo with its two entrances. One was a land entrance connected to a *calle* (street, alley) or *campo* (public square), and the other was a water entrance. Although rebuilt in the 19th century, the Fontego dei Turchi epitomizes the most ancient type of Venetian palazzo. This was recognizable by its façade with two side towers (*torreselle*), the long portico at water level that allowed for the unloading and loading of goods kept in the storehouses on the ground floor, and the multiple windows of the drawing room, used as a state room

for receptions. In the early 1300s, which saw the rise of Gothic architecture and the spread of narrow, elongated plots of land, a new type of palazzo began to predominate. The porch on the canal was shortened, the two side towers were incorporated into the façade, which took on its typical tripartite plan.

Besides the warehouses, the ground floor also housed a mezzanine used for offices. The drawing rooms multiple windows – also shortened in breadth – were flanked by those of the side rooms.
The new top story – a sort of attic – was used by other members of the family, the servants, and the workers

VENICE'S HIGHWAY

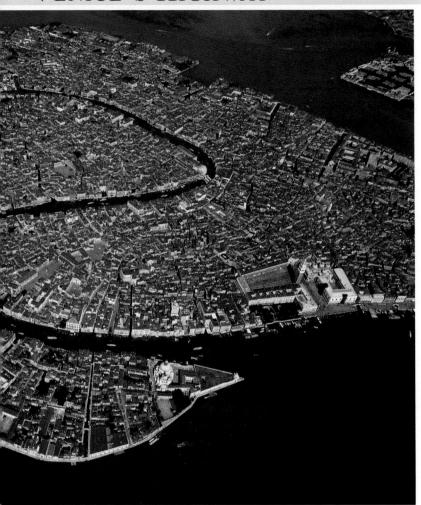

for the owner's business. The wealthier families later added a second *piano nobile*. Viewed from above, we can see that this type of residence was articulated around a wide, long entrance hall, the *portego*, whose shape was repeated on the upper floors by the drawing room that had to be crossed to reach the other rooms.

12 TOP GONDOLA, DETAIL.

12-13 AERIAL VIEW OF VENICE.

13 BOTTOM LEFT THE BASILICA DELLA SALUTE.

13 BOTTOM CENTER RIALTO BRIDGE.

13 BOTTOM RIGHT PALAZZO DONÀ, DETAIL.

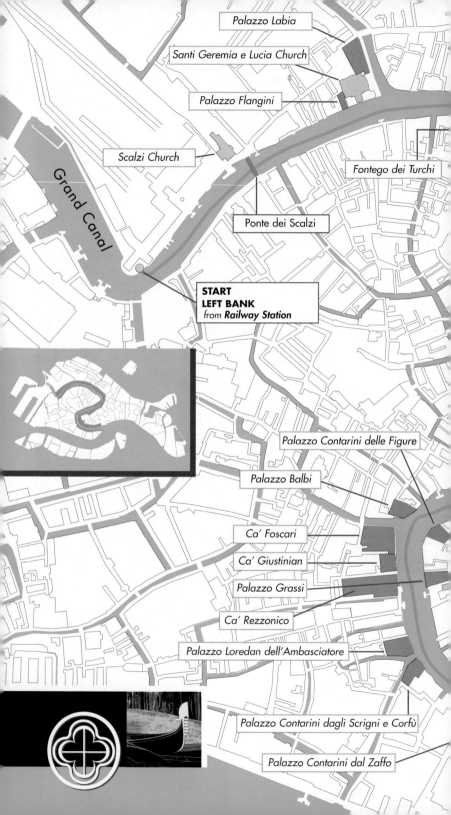

Palazzo Labia

Santi Geremia e Lucia Church

Palazzo Flangini

Scalzi Church

Fontego dei Turchi

Grand Canal

Ponte dei Scalzi

**START
LEFT BANK**
from Railway Station

Palazzo Contarini delle Figure

Palazzo Balbi

Ca' Foscari

Ca' Giustinian

Palazzo Grassi

Ca' Rezzonico

Palazzo Loredan dell'Ambasciatore

Palazzo Contarini dagli Scrigni e Corfù

Palazzo Contarini dal Zaffo

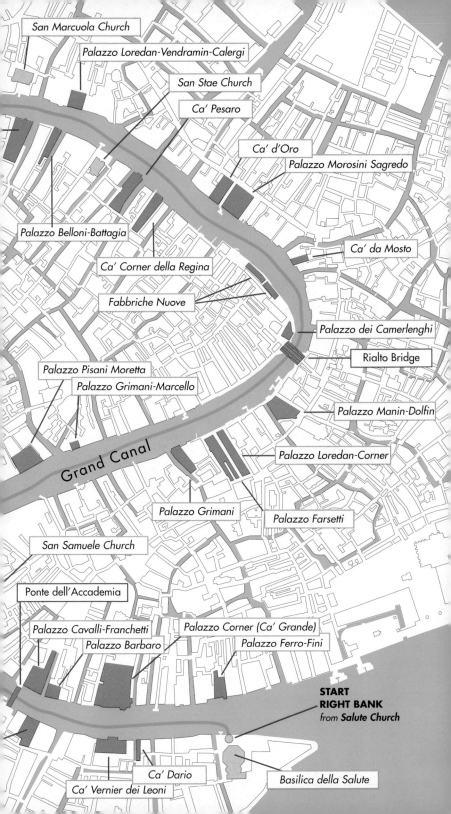

San Marcuola Church

Palazzo Loredan-Vendramin-Calergi

San Stae Church

Ca' Pesaro

Ca' d'Oro

Palazzo Morosini Sagredo

Ca' da Mosto

Palazzo Belloni-Battagia

Ca' Corner della Regina

Fabbriche Nuove

Palazzo dei Camerlenghi

Rialto Bridge

Palazzo Pisani Moretta

Palazzo Grimani-Marcello

Palazzo Manin-Dolfin

Grand Canal

Palazzo Loredan-Corner

Palazzo Grimani

Palazzo Farsetti

San Samuele Church

Ponte dell'Accademia

Palazzo Cavalli-Franchetti

Palazzo Corner (Ca' Grande)

Palazzo Barbaro

Palazzo Ferro-Fini

**START
RIGHT BANK**
*from **Salute Church***

Ca' Dario

Ca' Vernier dei Leoni

Basilica della Salute

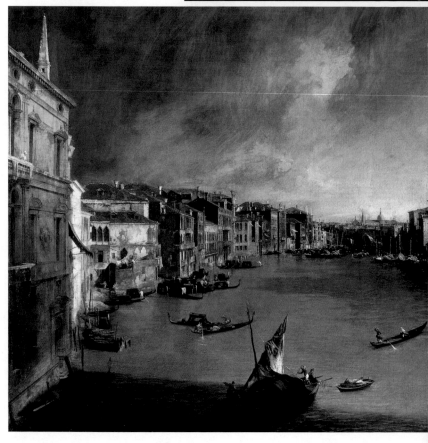

The only important variation was the plan of the courtyard. In the Ca' d'Oro, for example, this area, with a wellhead and external access staircase, is situated in a lateral position, thus creating a "C"-shaped residence. The invaluable commercial function of the Grand Canal and the resulting high prices of the land alongside it were the reasons for the limited number of public buildings erected on its banks. The uninterrupted series of residences lined up along the winding course of the canal offers one of the most amazing "cross-sections" of the history of Venice, which make it possible to reconstruct the cultural, artistic, and building evolution of its most prestigious families. In this context, the palazzi façades become a mirror reflecting both the transitions of decorative-architectural styles and the changes in mentality and fashion over the centuries. The changes that occurred between the Middle Ages and Renaissance are particularly striking. A useful indication in this regard is the shape of the multi-lancet windows. The multiple windows crowned by quatrefoils on the heads – thanks to which the prestige of a residence approached that of the Doges' Palace – were gradually transformed into simple or paired classical

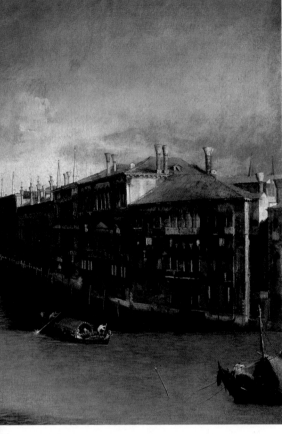

exceptions, the rigor of the architectural composition is overwhelmed by the colors and chiaroscuro effects, made even more vibrant by the reflections of the water and by the unique, variable Venetian light. As the main artery of the city, the Grand Canal was, and still is, the favorite backdrop for public spectacles, processions, and boat races. Nor did it fail to attract the attention of painters such as VITTORE CARPACCIO, CANALETTO, and MONET, who immortalized its life, beauty, light, and reflections. And although the works of these masters may have been for the privileged few, the engravings of other artists who were able to reach a larger public made this unique canal famous and the 1700s and onward. ANTONIO QUADRI and DIONISO MORETTI, on the other hand, are to be credited with the first complete and faithful reproduction of the canal, which was published in 1828 as *Prospetto del Canal Grande di Venezia.*

half-columns, quite foreign to Venetian tradition. The Veneto-Byzantine façades, so rich in reliefs with symbolic or religious subjects, became façades with secular frescoes or sculptures that aimed at glorifying the culture or fame of the patron and his dynasty. Analogous celebratory aims can be seen in the exceptional size of some of these palazzi, such as Ca' Foscari, or – two centuries later – the

17th-century Ca' Pesaro, the conception of which is so audacious that it actually extends over the bank of the Grand Canal. One of the rare constant factors in this evolution was the decorative and aesthetic autonomy of the façade compared to the inner structure. Along the Grand Canal's banks, which wind for 2.5 miles (4 km), is an extraordinary sequence of spectacular buildings. In these buildings, with rare

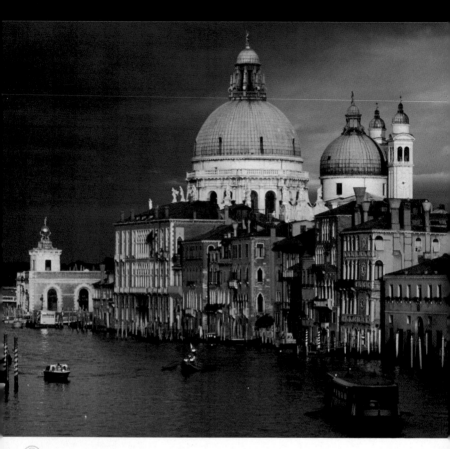

■ DORSODURO DISTRICT
At the point where the Giudecca Canal, the Grand Canal, and the St. Mark Basin converge – one of the most thrilling panoramic spots in Venice – the Republic erected a series of buildings used as maritime customs houses. Starting off from the left, the turret with a loggia is the **Dogana da Mar** (designed by GIUSEPPE BENONI in 1677), recognizable for the Palla d'Oro, or golden globe, by

BERNARDO FALCONE. This is followed by the austere **Magazzini al Sal**, the salt warehouses rebuilt in 1838 by GIOVANNI ALVISE PIGAZZI. This customs area lies next to another one with important religious buildings: the **Palazzo del Seminario**, designed by BALDASSARE LONGHENA in 1671, home of the Pinacoteca Manfrediniana and the spectacular **Basilica di Santa Maria della Salute**, also designed by BALDASSARE

LONGHENA (1631-74), with its two cupolas.

■ SALUTE *VAPORETTO* LANDING STAGE

■ RIO DE LA SALUTE
This canal runs along the 15th-century apse of the deconsecrated **San Gregorio Church** and, toward the Grand Canal, the former **San Gregorio Abbey**, whose low brick façade is dignified by the Gothic portal on the canal flanked by two trefoil

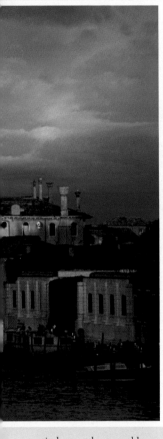

18-19 Dogana da Mar and Basilica della Salute.

19 left Bernardo Falcone, Palla d'Oro, Dogana da Mar.

19 right Water entrance, former San Gregorio Abbey.

▶ WARNING
To assist with identification of the monuments, the names of the sestieri or districts, the canals, the landing stages of the vaporetti (waterbuses), and the three bridges on the Grand Canal are listed here for easy reference.

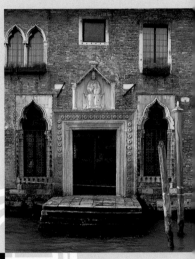

windows and crowned by a relief of *The Benedictory St. Gregory on His Throne* (ca. 1342). When the monastery's second cloister was demolished, it was replaced by Palazzo Genovese, a pretentious Neo-Gothic building erected in 1892 by the architect Tricomi Mattei. Further along the canal is the **Casa Salviati** (1924-26), designed by the engineer G. Dall'Olivo and recognizable by the mosaics on the façade.

▶ MAIN SIGHTS

● *SESTIERI (Districts):* Dorsoduro, S. Polo, S. Croce.

● *CHURCHES*: Basilica della Salute; San Stae.

● *PALAZZI:* Ca' Dario; Ca' Venier dei Leoni; Contarini dal Zaffo; Contarini dagli Scrigni e Corfù; Loredan dell'ambasciatore; Ca' Rezzonico; Ca' Giustinian; Ca' Foscari; Palazzo Balbi; Pisani-Moretta; Grimani-Marcello; Camerlenghi; Fabbriche Nuove; Ca' Corner della Regina; Ca' Pesaro; Belloni-Battagia; Fontego dei Turchi.

20 TOP AND 21 BOTTOM DETAILS OF THE MOSAICS DESIGNED BY GIULIO CARLINI.

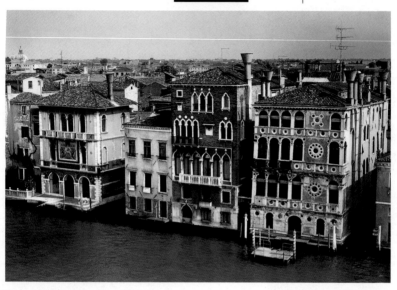

RIO DE LA FORNACE
The narrow building dressed in precious marble is **Ca' Dario**. The façade, begun around 1487 and attributed to PIETRO LOMBARDO or his workshop, was built onto the earlier Gothic building for/by Giovanni Dario after his return from Constantinople, where the Venetian Republic sent him in 1479 as its ambassador to negotiate a peace treaty with the Turks. Because of its precious material, the Ca' Dario's façade was considered second only to that of the Ca' d'Oro, and at the time was one of the most brazen displays of personal wealth and success in the city, as can be seen by the inscription on the ground floor: "Urbis Genio Ioannes Darius." Built almost at the same time as Santa Maria dei Miracoli Church, the façade is a departure from the Gothic style and presents classicizing elements combined with round polychrome composition, in keeping with the rising Neo-Byzantine style practiced by painters such as VITTORE CARPACCIO and CIMA DA CONEGLIANO. From 1838 to 1842, Rawdon Brown, a historian of Venice and friend of John Ruskin, lived in this palazzo.

RIO DE LE TORRESELE
The long, unfinished building is **Ca' Venier dei Leoni** (no. 708), designed by LORENZO BOSCHETTI in 1749, home of the Peggy Guggenheim Collection. The Venetian painter ROSALBA CARRIERA (1675-1757), known throughout Europe for her delicate, elegant pastel portraits, lived and worked in the **Casa Biondetti** nearby. **Palazzo da Mula** has a double water entrance and rises up with three Gothic four-lancet windows with 14th-century style capitals. Its interior is decorated with 18th-century stuccowork, frescoes, and furnishings.

20 BOTTOM
CASA SALVIATI, PALAZZO
BARBARO, AND CA' DARIO.

(CENTER), HOME OF THE PEGGY
GUGGENHEIM
COLLECTION.

21 TOP
PALAZZO VENIER DEI LEONI.

21 CENTER
PALAZZO BARBARIGO.

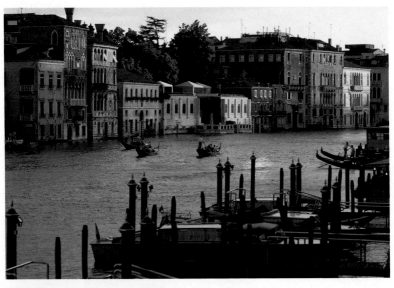

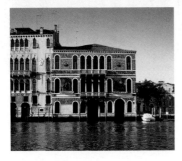

The façade of **Palazzo Barbarigo** is cased with mosaics, the cartoons of which were done by GIULIO CARLINI (d. 1887). The first scene at left shows *Michelangelo Conversing with Titian* in front of the mosaic above the inner entrance of St. Mark's Basilica. At the end of

Campo San Vio you can catch a glimpse of the ex-Oratory of **Santi Vito e San Modesto**, a Neo-Gothic construction erected by the master mason GASPARE BIONDETTI to a design by the painter GIOVANNI PIVIDOR and inaugurated in 1865. The façades of this building have 11th-13th century "itinerant sculptures" that may come from the demolished houses that belonged to Bajamonte Tiepolo, the head of the ill-fated

conspiracy of 1310. Next to the oratory, now the **St. George Anglican Church** (designed by MARANGONI in 1926), there was the Santi Vito e Modesto Church, founded in the 10th century and demolished shortly after 1813.

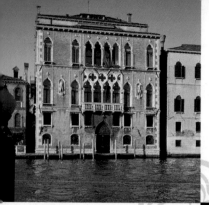

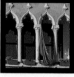

22 TOP AND CENTER PALAZZO LOREDAN DELL'AMBASCIATORE.

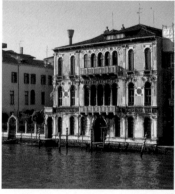

 RIO DE SAN VIO

Palazzo Molin-Bali-Valier della Trezza (17th century) incorporates elements from the medieval building that stood on this site; it has a three-opening *portego* flanked by two smooth rusticated concave wings with a balustrade (18th century). Beyond the building's garden is the elegant **Palazzo Contarini dal Zaffo** (end of the 15th century), attributed to PIETRO LOMBARDO or MAURO CODUSSI, with decorative elements by GIOVANNI ANTONIO BUORA, whose workshop was situated at San Vidal, on the other side of the Grand Canal. The Corinthian façade, like the one on the nearby Ca' Dario, is Neo-Byzantine, but it has more classicizing elements deriving from Florentine models.

■ PONTE AND PONTILE OF THE ACCADEMIA

The square at the Accademia landing stage is lined with the Gothic side of the former church of

Santa Maria della Carità, designed by BARTOLOMEO BON and his workshop (1441-52), the 14th-century façade affording access to the cloister, and the façade of the **Scuola Grande della Carità**, now the home of the **Accademia Galleries**. Farther on are the two flanking edifices of **Palazzo Contarini dagli Scrigni e Corfù**. The Contarini dagli Scrigni family commissioned the architect VINCENZO SCAMOZZI to modernize the

complex and merge it into one building, while maintaining the Gothic façade at the right, which is characterized by its fresh 15th-century four-lancet window crowned by quatrefoils. SCAMOZZI designed the edifice at left, constructed in 1608. The façade, lacking excessive sculptural decoration and modeled after the works of the Bolognese SEBASTIANO SERLIO (c. 1475–1554), was a prototype for the architects of the first half of

22 BOTTOM
PALAZZO CONTARINI
DEL ZAFFO.

22-23 THE TWO
FACADES OF PALAZZO
CONTARINI DAGLI
SCRIGNI E CORFÙ.

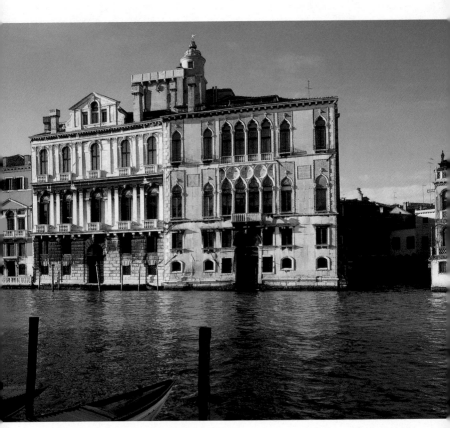

the 17th century. The ground floor with mezzanine is distinguished by its elegant rustication, while the two upper floors have coupled Ionic and Corinthian pilasters. The residence, the interior of which was rebuilt by the Palladian-inspired FRANCESCO SMERALDI (IL FRACÀ), once housed a collection of art that was later put in the Accademia Galleries and the Museo del Settecento Veneziano in Ca' Rezzonico.

■ RIO DE SAN TROVASO The Neo-Gothic **Casa Mainella**, designed in 1858 by LODOVICO CADORIN and rebuilt in the interior by CARLO SCARPA in 1964 for the Balboni family, is followed by the symmetrical façade of **Palazzo Loredan dell'Ambasciatore**. The late Gothic elements of the central four-lancet window (c. 1465-70) drew inspiration from the nearby Ca' Foscari, while the two Renaissance niches with

statues of *Shield-bearing Warriors* (c. 1480–85) are attributed to PIETRO LOMBARDO and his school. The building was used as a residence by the Holy Roman Empire's ambassadors and later on by Marshal Matthia Johann von Schulenburg, a military strategist and expert in fortifications,who defended Corfù in 1716. Nearby is the rigorous **Palazzo Moro** (early 16th century), with Lombard school decorations.

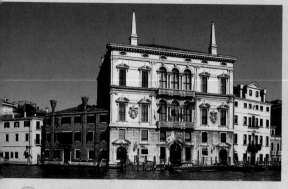

24 TOP PALAZZO BALBI.

24-25 THE GRAND CANAL SEEN FROM THE ACCADEMIA BRIDGE LOOKING TOWARD CA' REZZONICO.

■ RIO DEL MALPAGA
Palazzo Stern, built at the beginning of the 20th century by the architect GIUSEPPE BERTI, is an example of the success of Neo-Gothic architecture. In this case, it even goes so far as to introduce Veneto-Byzantine elements, crests, paterae, and reliefs dating back to the 9th-15th century to make it look like the original model.

■ PONTILE OF CA' REZZONICO

■ RIO DE S. BARNABA
The Istrian stone façade of **Ca' Rezzonico**, designed by BALDASSARE LONGHENA and others (1667 and later) and now the home of the Museo del Settecento Veneziano, stands out both for its size and for the chiaroscuro effects created by its decorative elements. A little further on is the long, majestic brick façade of **Ca' Giustinian**. This building,

construction of which may have begun soon after 1451, consists of two symmetrical palazzi characterized by a beautiful six-lancet Gothic window crowned with quatrefoils and by a larger multiple window with quatrefoil tracery, attributed to BARTOLOMEO BON. This is followed by **Ca' Foscari**, which rises up like a stage wing at the point called Volta de Canal, the sharp bend of the Grand Canal that offers a splendid panoramic view ranging from the St. Mark Basin to the Rialto Bridge. This building was purchased in 1452 by Doge Francesco Foscari, who promoted the expansion of Venetian territory into the mainland and who was later sent into exile, where he died in 1457. The façade has two superposed eight-lancet multiple windows. The quatrefoil of the upper ones emulate those in the Doge's

Palace, while the tracery patterns on the third floor are modeled after those on the Ca' d'Oro façade. These two last-mentioned elements are separated by a frieze with *putti (cupids)* bearing the family coats of arms (late 15th century). Among the illustrious guests in this palazzo – the venue for memorable parties and banquets – were Henry III, King of Poland and France, who stayed here in 1574. The section overlooking the courtyard in the back (no. 3246) was rebuilt in the late 17th to early 18th centuries and the entire building was restored in 1847.

■ RIO DE CA' FOSCARI
At the beginning of the right-hand side of this canal is the **Casa Masieri**, a symbol of the difficult relationship between Venetian conservatism and contemporary architecture. In 1953 the American

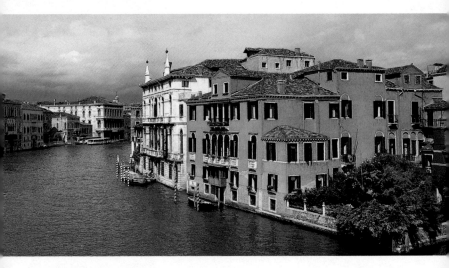

architect FRANK LLOYD WRIGHT (1869–1959) was asked by the Masieri Foundation to design the Masieri Memorial in honor of one of his followers, Angelo Masieri. The great architect's design, based on a new façade, was refused by the local authorities. In 1973 a project to restructure the interior conceived by CARLO SCARPA was approved; after the architect's death, his ideas were carried out only to a minimum degree owing to a lack of funds. Like nearby Ca' Foscari, **Palazzo Balbi** (1582-90) is situated on the main bend of the Grand Canal. This building, attributed to the Trentino sculptor ALESSANDRO VITTORIA and commissioned by Nicolò Balbi, has an eclectic Ionic façade. The decoration and broken pediments show the influence of Mannerist architecture and painting, but with a fine sense of proportion, and served as

models for many other Venetian palazzi. Note the three-lancet windows supported by paired Ionic columns. This residence, a favorite subject with the Venetian view painters, was purchased in 1887 by Michelangelo Guggenheim, a passionate supporter of handicrafts and promoter of the Higher School of Art Applied to Industry (1872). The luxurious interior, renovated in 1737, contains the pair of maps of the earth (1579 and 1580) drawn up by the cosmographer GASPARO BALBI, precious furniture, paintings, and stuccowork, as well as the *Triumph with Allegories* frescoed by JACOPO GUARANA (1720-1808) on the ceiling of a hall now used as the office of the president of the Veneto Region.

■ RIO DE LA FRESCADA

■ SAN POLO DISTRICT
Palazzo Civran-Grimani,

rebuilt in 1741 and attributed to GIORGIO MASSARI, has a façade modeled after the compositional scheme of Palazzo Contarini dagli Scrigni, introducing some variations that make the architecture even more simple and refined.

■ PONTILE OF SAN TOMÀ
The 17th-century **Palazzo Marcello dei Leoni**, which stands on the Fondamenta del Tragheto, was the home of Pompeo Molmenti (1852-1928), known for his *History of the Private Life of Venice, from the Origin to the Fall of the Republic*. This is one of the first popularizing books on the history of the city and is rich in erudition and anecdotes; it deals with politics, legislation, economy, commerce, the fine arts, festivities, education, and episodes concerning the public and private customs and habits of the Venetians.

■ RIO DE SAN TOMÀ
Past the 16th-century **Palazzo Tiepolo**, on the façade of which are poorly preserved traces of the frescoes painted by ANDREA MELDOLLA, known as LO SCHIAVONE (1505-63) from the island of Zadar, is the splendid **Palazzo Pisani-Moretta**, built in ca. 1470-75 by the Bembo family. The innovative element in the façade is the six-lancet multiple window on the second floor, which is taller than one below it. The plan of this latter was modeled after the Doges' Palace, while the former – derived from the upper tracery on

the Ca' d'Oro – consists of a series of round arches with small trefoil tracery topped by quatrefoils. The predominating Gothic taste is timidly challenged by some Renaissance elements such as the rigorous string course cornices and the balconies with small, slender columns from the same period. During the 18th century the Pisani family modernized the interior. The monumental double staircase (1739-42) is based on a design by ANDREA TIRALI (ca. 1660-1737). In addition to precious furniture, lavish stuccowork, fine paintings, and a collection of Venetian porcelain, there is sumptuous decoration on the first-floor drawing-room ceiling, created to a design by the Frenchman ANTOINE RIGOTIE and with stuccowork by GIUSEPPE FERRARI and PIETRO

CASTELLI that frames the frescoes by JACOPO GUARANA. These represent *Light Defeating Darkness* and *Apollo with the Hours of the Morning* (1772). On the ceiling of an adjacent hall is *Venus and Mars,* a fresco painted by Giambattista Tiepolo in 1742). The palace also once housed some masterpieces, now kept in other collections, of artists such as PAOLO VERONESE, GIAMBATTISTA PIAZZETTA and ANTONIO CANOVA. Even more famous for its prestigious collection of art

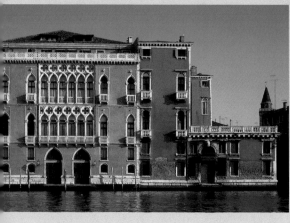

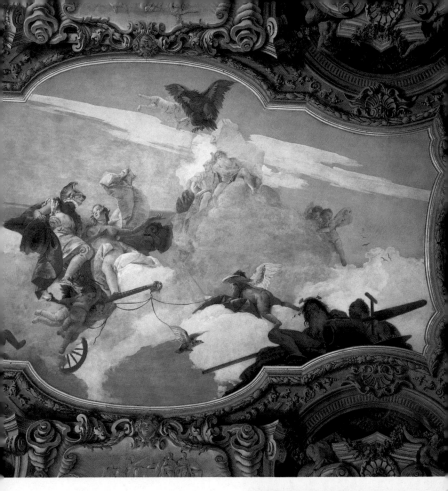

works was the neighboring **Palazzo Barbarigo della Terrazza**, attributed to BERNARDINO DI FRANCESCO CONTIN (d. 1597), brother-in-law of ANTONIO DA PONTE, who designed the Rialto Bridge. This palazzo, now the headquarters of the German Center of Venetian Studies, housed works by artists such as GIOVANNI BELLINI, TITIAN, PALMA VECCHIO, GIULIO ROMANO, FRANCESCO and JACOPO BASSANO, JACOPO TINTORETTO, RUBENS and GUIDO RENI.

26 TOP PALAZZO PISANI-MORETTA AND PALAZZO BARBARIGO DELLA TERRAZZA.

26 BOTTOM AND 26-27 GIAMBATTISTA TIEPOLO, *VENUS AND MARS* AND DETAIL OF SAME, PALAZZO PISANI-MORETTA.

27 BOTTOM SALON OF PALAZZO PISANI-MORETTA.

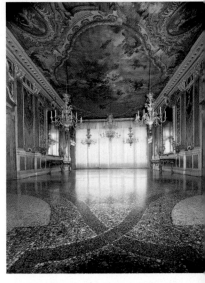

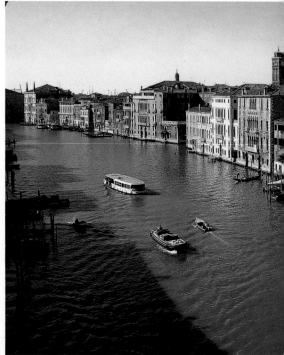

■ RIO DE S. POLO
Palazzo Grimani-Marcello
was built for the Vendramin
family early in the 16th
century. Although of
uncertain attribution, its
façade has features
characteristic of a well-
balanced and fruitful
collaboration among
Lombard artists whose style
was similar to that of
Mauro Codussi (d. 1504)
and Giovanni Buora. The
brilliant stone composition
of the façade – framed by

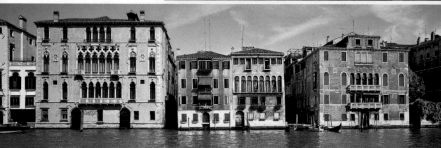

pilasters – is heightened by
paterae arranged in an
extremely orderly fashion.
The meeting place of
Venetian exponents of the
Enlightenment, the Neo-
Classic interior was
reorganized in the second
half of the 18th century. A
short distance away is
Palazzo Bernardo (ca.
1460), whose late Gothic
façade is enhanced on the
second floor by a six-lancet

multiple window with
quatrefoiled piercings and
small side balconies, and
windows made precious by
five-lobed arch tracery.

■ RIO DE LA MADONETA
The *piano nobile* of Ca'
Donà de la Madoneta (no.
1429) is occupied by a
Veneto-Byzantine eight-
lancet multiple window
with elevated arches, the
only remaining element of

a typical Venetian merchant's
residence with a warehouse.
The cross in relief and the
paterae representing animals
date back to the 11th-13th
century. Even more precious
is the 13th-century upper
cinquefoil on nearby **Ca'
Donà** (no. 1426) crowned by
four panels dating from the
first half of the 13th century,
with symbolic animal scenes.
This palazzo is followed by
Palazzo Coccina-Tiepolo-

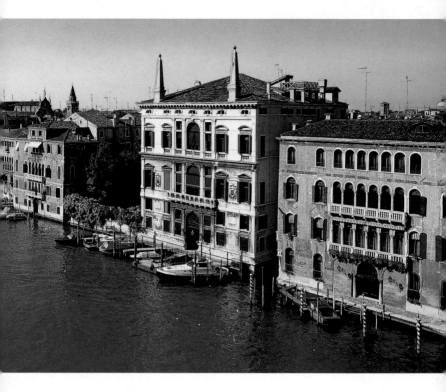

Papadopoli, flanked by a garden. It was finished in 1560 and is attributed to GIAN GIACOMO DE' GRIGI, son of the Bergamasque architect GUGLIELMO DEI GRIGI. The classicizing façade is articulated on three superposed Serlianas of the Doric, Ionic and Corinthian orders and is topped by a trabeation along which are the oval windows (perhaps installed at a later date) of the attic. The canvases by PAOLO VERONESE, commissioned by the Coccina family, are now kept in the Gemäldegalerie, Dresden.

■ RIO DEI MELONI (which marks the border of the Rialto island). Despite the alterations, **Palazzo Barzizza**

(ca. 1225) has preserved its elegant Veneto-Byzantine water entrance (late 12th century) and has panels dating from the 11th-13th century. Along the façade of the adjacent **Palazzo Chiurlotto** are the remains of columns and arches with Byzantinesque features (12th century) that once belonged to a *fondaco*. On the archivolts are sculpted peacocks, flowers and fruit.

28 TOP PALAZZO CHIURLOTTO, DETAIL.

28-29 FROM RIGHT PALAZZO BUSINELLO, PALAZZO COCCINA-TIEPOLO-PAPADOPOLI.

28 BOTTOM PALAZZI BERNARDO, SICHER, DONÀ DELLA MADONNETTA AND DONÀ.

29 BOTTOM PALAZZI BUSINELLO, LANFRANCHI, BARZIZZA AND CHIURLOTTO.

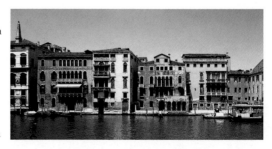

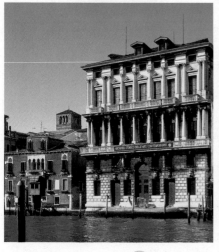

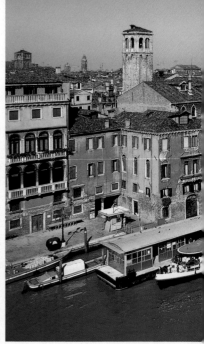

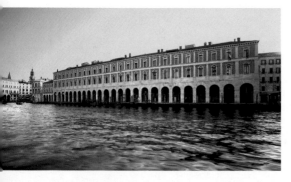

30 TOP AND 31 BOTTOM
EPISODES FROM THE LIFE OF
QUEEN CORNARO AND
DETAIL.

30 CENTER CASA
FAVRETTO AND, CENTER,
CA' CORNER DELLA REGINA

30 BOTTOM FABBRICHE
NUOVE.

30-31 RIVA DEL VIN AND
RIALTO BRIDGE.

■ PONTILE OF SAN
SILVESTRO
After the Sotoportego del
Tragheto is a 17th-century
palazzo on the Riva del
Vin, on the foundation of
which stood the residence
of the patriarchs of Grado.
The residence is depicted
by VITTORE CARPACCIO in
his *Miracle of the Relic of
the Cross at Rialto Bridge*,
now kept in the Accademia
Galleries. From a proper

distance, behind the palazzo
you can see the church of
San Silvestro and the statue
of St. Sylvester (15th
century) in bishop's attire
holding the patriarch's cross.
On the opposite side of the
bank is **Palazzo dei Dieci
Savi alle Decime** (no. 19),
designed by ANTONIO
ABBONDI, known as LO
SCARPAGNINO, in 1521.

■ RIALTO BRIDGE
(ANTONIO DA PONTE, 1588-
91).
Palazzo dei Camerlenghi.
The **Erberie** (by ANTONIO
ABBONDI, 1521). **Fabbriche
Nuove** (by JACOPO TATTI,
known as SANSOVINO 1555-
56). In Campo de la
Pescaria is the **Loggia della
Pescaria**, a Neo-Gothic
construction built in 1907
by DOMENICO RUPOLO and
CESARE LAURENTI.

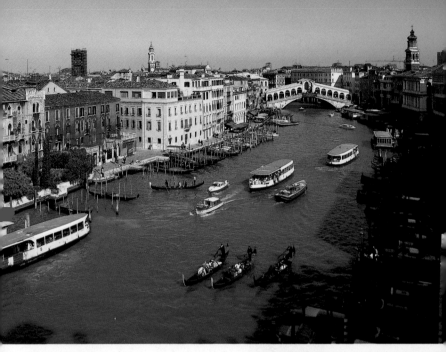

■ RIO DE LE BECARIE (which marks the border of the Rialto island). At the end of Riva de l'Ogio is the wide **Palazzo Morosini-Brandolin**, built in the mid-15th century. The third floor was demolished in the 19th century.

■ RIO DE SAN CASSAN SANTA CROCE DISTRICT **Casa Favretto** was the home of the Venetian painter GIACOMO FAVRETTO (1849-87). **Ca' Corner della Regina** was named after Caterina Cornaro, the queen of Cyprus (*regina*=queen), who was born in the original Gothic residence (which no longer exists). The building, now home of the Historical Archive of the Biennale, was begun in 1724 to a design by DOMENICO ROSSI, who planned a

rational and classicizing façade (1726) similar to the one on nearby Ca' Pesaro. But unlike this latter, the ground floor is dressed with smooth rustication enlivened by masks-*cum*-protomes, while the upper trabeation is discordantly interrupted by the windows of the attic floor. In the mid-18th century, the lower section of the palazzo was enlarged by FRANCESCO BOGNOLO. The ceiling and walls of the long drawing room were frescoed in 1773-83 by COSTANTINO CEDINI (1741-1811), assisted by the *trompe l'oeil* artist DOMENICO FOSSATI and

completed, with other celebratory subjects, by the frescoes of the Emilian GIUSEPPE MONTANARI (signed and dated 1793), and by the stuccowork of VINCENZO COLOMBA.

■ RIO DE LE DO TORRE **Ca' Pesaro**, home of the **Galleria d'Arte Moderna**, by BALDASSARE LONGHENA and ANTONIO GASPARI (1628-1710).

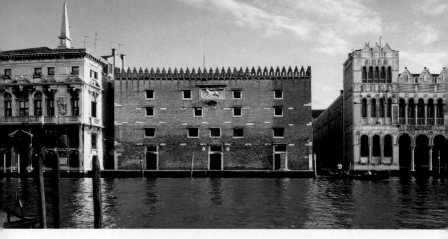

32 TOP
MAGAZZINI DEL
MEGIO.

32 CENTER
PALAZZI DUODO,
TRON AND
BELLONI-BATTAGIA.

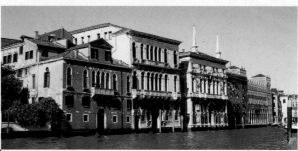

32 BOTTOM AND 33 TOP RIGHT
GIOVANNI SCALFAROTTO, SAN
SIMEON PICOLO CHURCH.

33 TOP LEFT SAN STAE
CHURCH AND PALAZZO
PRIULI-BON.

■ RIO DE LA PERGOLA
■ RIO DE SAN STAE
On Campo San Stae is the former **Scuola dei Batti e Tiraoro** (GIACOMO GASPARI, 1711) and the church of **San Stae** (GIOVANNI GRASSI, DOMENICO ROSSI, 1683-1745).

■ PONTILE OF SAN STAE
Palazzo Priuli-Bon has the 13th-century remains of the canal porch with elevated arches and a cinquefoil with an arch inflected in the Arab manner that may have been redone in the 15th century. **Palazzo Tron**, once the home of a painting gallery

now dispersed, was rebuilt in the second half of the 16th century and enlarged in 1710-20, perhaps to a design by ANTONIO GASPARI.

■ RIO CA' TRON
Palazzo Belloni-Battagia was commissioned by Bortolo Belloni in 1648, a year after his family became part of the Venetian patrician class. The building, finished in 1663, is attributed to BALDASSARE LONGHENA. On the ground floor of the façade are lion protomes at water level and broad recessed stone

panels, a multiple window on the *piano nobile* with broken pediments, and an attic ending in trabeation on the frieze of which are stars and crescents, motifs repeated in the noble crests below them. Next come the **Magazzini del Megio** (the millet warehouses), with a brick façade and crenellation. Millet was used to make bread when famine struck the city, or it was sent to the inhabitants and the troops stationed in the territory ruled by the Republic or in the East. The three coats of arms on

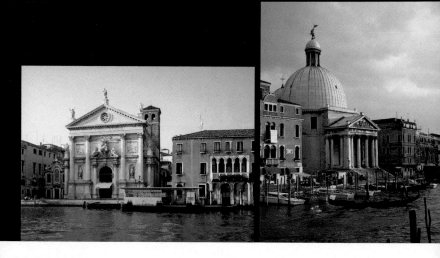

the first floor date from the 14th century, while the relief above them, *Lion of St. Mark Walking*, is by CARLO LORENZETTI (1858-1945) and replaced an older relief that was still there in 1900.

■ RIO DEL MEGIO
Nearby is the **Fontego dei Turchi**, now home of the Museo di Storia Naturale, rebuilt by FEDERICO BERCHET in 1864-69.

■ RIO DE S. ZAN DEGOLÀ
In the garden along the canal there stood **Ca' Bembo**, once characterized by a Veneto-Byzantine water entrance porch designed by ANTONIO QUADRI in 1828.

■ PONTILE RIVA DI BIASIO
In the middle of the Riva di Biasio is the unadorned **Palazzo Donà-Balbi** (no. 1299/A), built in the 17th century and characterized by off-centered entrance and quatrefoil windows. Beyond Campo di San Simeon Grando you can see

the campanile (1778) of the church of the same name.

■ RIO MARIN
■ **PONTE DEI SCALZI**
(EUGENIO MIOZZI, 1933)
At the beginning of Fondamenta San Simeon Piccolo, in the two **Palazzetti Foscari-Contarini** tradition recognizes the bithplace of the doge Francesco Foscari. The first (no. 715; early 14th century) has three one-lancet windows on the façade delimited by balconies with columns and, toward the courtyard, a four-arched loggia. The second (early 16th century), elegant and austere, is embellished, on the *piano nobile*, by a Doric cinquefoil window with round arches and ends in a multiple window with architrave. The adjacent **Casa Adoldo-Spera** (no. 712) has, on the first floor, two allegorical reliefs and plaques dated 1520. On the third floor, on the architrave of the central

trefoil window, an inscription reads *Bonum est in Deo Sperare*. Above the lunette, a statue of an eagle standing on the Earth dates from the same period. This residence is followed by the **Church of San Simeon Picolo**, (GIOVANNI SCALFAROTTO, 1720-38) and the former **Scuola dei Tessitori di Pannilani** (1559). At no. 561, **Palazzo Diedo-Emo** (end of 16th century) has a three-lancet Corinthian window crowned by a pediment.

■ RIO DE LA CROCE
Beyond the Ponte de la Croce, at left on Fondamenta del Monastero, a column with an Early Christian capital in Greek marble of uncertain provenance is similar to the "pillars of Acre" in St. Mark's Square. In this area, partly occupied by the **Giardini Papadopoli**, there once stood the church and monastery of Santa Croce, founded in the 8th-9th century and demolished around 1813.

34 TOP AND
BOTTOM SCALZI
CHURCH AND
DETAIL.

34 CENTER
PALAZZO SORANZO-
CALBO-CROTTA.

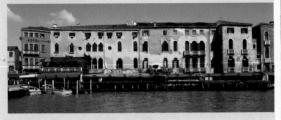

▶ MAIN SIGHTS

● **SESTIERI (Districts):** Cannaregio, S. Marco.

● **CHURCHES:** Scalzi; Santi Geremia e Lucia; San Marcuola;
San Samuele.

● **PALAZZI:** Flangini; Labia; Loredan-Vendramin-Calergi;
Ca' d'Oro; Morosini-Sagredo; Ca' da Mosto; Manin-Dolfin;
Loredan-Corner; Farsetti; Grimani; Contarini delle Figure;
Grassi; Cavalli-Franchetti; Barbaro; Corner, known as the
Ca' Grande; Ferro-Fini.

LEFT BANK		From the Railway Station to Piazza San Marco

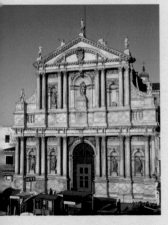

34-35 PALAZZO
FLANGINI AND, AT
RIGHT, CAPPELLA DI
SANTA VENERANDA
AND SANTI GEREMIA E
LUCIA CHURCH.

■ CANNAREGIO

Lining the Fondamenta Santa Lucia are the **Uffici del Dipartimento Ferroviario** (second half of the 19th century). The *Monument to Veneto Railway Workers Who Died for Their Country* (first half of the 20th century), to the right of the façade, is a bronze high relief by the sculptor MISTROZZI. To the right of the building is an 1846 plaque commemorating the inauguration of the railway bridge over the lagoon. Next to the offices is the **Stazione Ferroviaria Santa Lucia**, by PAOLO PERILLI (1954), and

the **Scalzi Church** (BALDASSARE LONGHENA, GIUSEPPE POZZO and GIUSEPPE SARDI, 1654-94).

■ PONTILE OF RAILWAY STATION
■ PONTE DEI SCALZI
(by EUGENIO MIOZZI, 1933) The long façade of **Palazzo Soranzo-Calbo-Crotta** still has a small Gothic three-lancet window. The building, restructured in the 18th century, has a rich art collection. GIAMBATTISTA TIEPOLO painted *The Patron Saints of the Crotta Family* (1754-55) for this palace, which is now kept in the

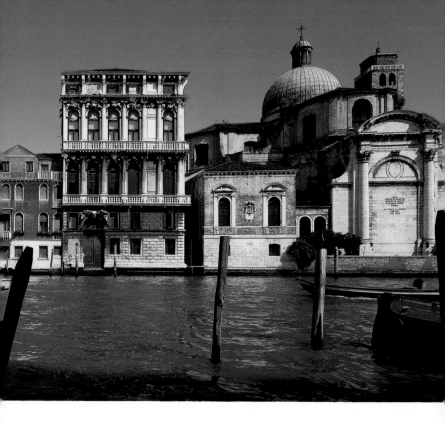

Städelsches Kunstinstitut, Frankfurt. At the end of Rio Terà dei Sabioni is **Palazzo Manin-Sceriman** (18th century). Nearby, on the Grand Canal, **Casa Testa** was damaged by an Austrian bomb in 1848. The shell, as in many other cases, is exposed on the façade. Nearby, the tall, narrow **Palazzo Flangini**, made of Istrian stone, is unfinished on the left side. The construction of this building, attributed to Giuseppe Sardi, began around 1664, on the occasion of Girolamo Flangini's (whose family came from Corfù) admission into the Venetian patrician class, and was interrupted in 1682. The

residence was modeled after Longhena's Ca' Pesaro and has a ground floor and mezzanine in smooth rustication and without capitals, with a tall portal embellished with a mask and two recumbent male figures in high relief. The two main floors with elegant Ionic and Corinthian columns have busts of warriors, weapons and objects related to war on a level with the pendentives of the multiple windows. Bernardo Falcone, who assisted Sardi in the construction of buildings such as the nearby Scalzi Church, is thought to be the author of this sculptural decoration. The interior still has its

17th-century stuccowork. The next four buildings are the former headquarters of the Scuola della Beata Vergine del Suffragio dei Morti, associated with the archconfraternity of the Madonna del Suffragio in Rome in 1624 and now the **Santa Veneranda Chapel** (no; 252/B); **Santi Geremia e Lucia Church**, built by Carlo Corbellini and Giuseppe Brunello in 1754-1829; the **Casa del Pievano** (1662); and the short side of **Palazzo Labia**, behind which you can catch a glimpse of the church bell-tower. There is also the statue by Giovanni Marchiori of *St. John of Nepomuk* (1764), the patron saint of boatmen who is also invoked to protect the city from floods.

36-37 PALAZZO
GRITTI AND PALAZZO
MEMMO-
MARTINENGO AT
SAN MARCUOLA.

36 BOTTOM AND
37 TOP PALAZZO
LOREDAN-
VENDRAMIN-CALERGI
AND DETAIL.

37 BOTTOM
PALAZZO ERIZZO,
PALAZZO SORANZO-
PIOVENE.

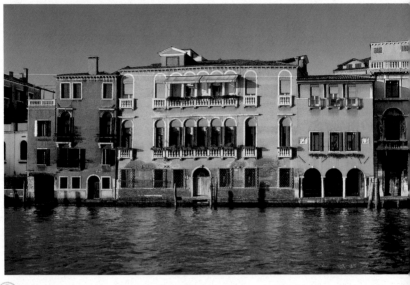

■ CANAL DE
CANNAREGIO
Behind the **Ponte delle
Guglie** (1777) you can see
some tall buildings in the
Ghetto Vecchio. Much
farther on, along the Grand
Canal, is the 17th-century
Palazzo Gritti. The
residence next to it, which
can be recognized by its

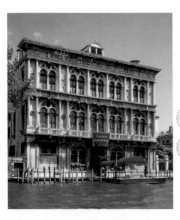

porch with three arches, has
two 15th-century reliefs on
the first floor of a Gritti
family coat of arms and a
seated dog with a collar.
**Palazzo Memmo-
Martinengo** (17th-18th
century) has an off-center
entrance crowned by a
window flanked by recessed
panels with relief panoplies.
This is followed
by **San Marcuola
Church**, which
faces the square,
built by GIORGIO
MASSARI in 1728-
35.

■ PONTILE OF
SAN MARCUOLA
■ RIO DE SAN
MARCUOLA
The patrician
Andrea Loredan
was responsible

for the construction of the
sumptuous **Palazzo
Loredan-Vendramin-
Calergi**, attributed to
MAURO DOCUSSI and built in
1502-09. The façade is the
most accomplished and
elegant example of the
felicitous marriage of
Venetian building tradition,
classical rationality and a
sensibility for color that
derived from Neo-Byzantine
taste, which had already
been in fashion for decades.
The innovations introduced
in this façade – which mark
the definitive break with
Gothic architecture – are
the use of columns solely
for decorative purposes and
the separation of the stories
by means of trabeation. The
skillful arrangement of the
double-lancet windows with
simple roundels and

already adopted a similar expedient for their palazzo along the Rio de Palazzo. The allegorical high reliefs on the façade of Palazzo Loredan-Vendramin-Calergi substantiate the devotional aims of the construction.

The frescoes attributed to GIORGIONE that adorned the atrium were covered with a layer of white paint in 1766. Among the works in the interior, there are the elegant entrance arch of the staircase and the 17th- and

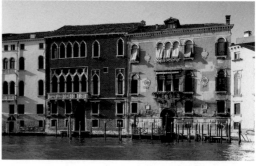

Corinthian columns marks a step forward compared to the earlier experimentation made on Palazzo Corner-Spinelli. Ca' Loredan was also named *Non nobis*, from the inscription engraved along the ground floor: *Non nobis Domine, non nobis*. This Latin expression was taken from Psalm 112 of the *Biblia Sacra Vulgata*, now in Psalm 115, "Not unto us, O Lord, not unto us, but unto thy name give glory." Aware of the extreme ostentation and vanity rampant in Venice, Andrea Loredan (who financed the building of the Camaldolite church presbytery of San Michele in Isola, where he is buried) justified his own luxurious residence as a way of glorifying the name of God. The Trevisan family had

On the second floor, the motifs of the lion protome and severed head of Medusa seem to allude to the victory of Virtue over Vice. Along the majestic crown, the facing eagles – the symbol of nobility, glory and ascension – pay homage to the Loredan family crest, while in the middle the unicorns – animals with miracle-working properties and the conventional symbol of Mary's virginity – are looking at the pelican feeding its young with its own blood, a reference to Christ's sacrifice.

The palazzo contained numerous works of art that Andrea Loredan, in his will drawn up in 1513, justified as "ornaments of the house, or rather, of the nation."

18th-century stuccowork and inlay, as well as the fine fireplaces, one of which is by ALESSANDRO VITTORIA (ca. 1524-1608), two large canvases by the Venetian NICOLÒ BAMBINI (1651-1736) and, in the Yellow Hall of the so-called White Wing, the ceiling frescoed by GIOVANNI BATTISTA CROSATO (ca. 1685-1758). Richard Wagner (1813-83) stayed in this palazzo and also died there.

In nearby **Palazzo Marcello** the Venetian composer Benedetto Marcello was born (1686-1739). This is followed by **Palazzo Erizzo**, with a five-lancet multiple window (half of the 15th century), and **Palazzo Soranzo-Piovene**, with a Renaissance façade built in the first decades of the 16th century.

38 TOP COLUMN OF
PORTICO, PALAZZO
CONTARINI-PISANI.

38-39 FROM LEFT PALAZZO
FONTANA-REZZONICO,
PALAZZO COLETTI-DUODO,
CA' D'ORO.

38 BOTTOM PALAZZI
MICHIEL DALLE COLONNE
AND MANGILLI-VALMARANA.

39 BOTTOM PALAZZI
GIUSTINIAN-PESARO, AND
MOROSINI-SAGREDO.

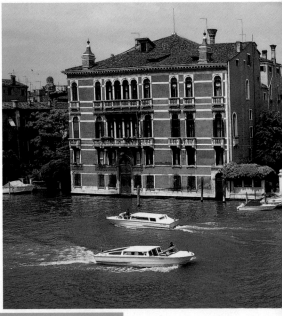

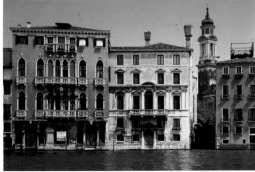

■ RIO DE LA MADALENA
Above the double lancet window of the *piano nobile* of **Palazzetto Barbarigo** is a relief of the Madonna of Mercy (late 15th century) under whose mantle are the kneeling figures of the members of the Scuola Grande della Carità. On the façade of the adjacent **Palazzo Barbarigo** are some fragments of late 16th-century allegorical figures by CAMILLO BELLINI, a follower of PALMA GIOVANE,

and some examples of frescowork still on the exterior, a rarity in Venice. Further along is **Palazzo Gussoni-Grimani della Vida** (1548-56), attributed to MICHELE SANMICHELI. Up to the mid-18th century, the frescoes of JACOPO TINTORETTO on the façade and in the interior were still in good condition.

■ RIO DE NOAL
Along the water entrance of the 16th-century **Palazzetto**

Contarini-Pisani is an interesting column, whose octagonal abacus capital with scroll molding seems to anticipate the more evolved ones in the portico of the Doges' Palace.

■ RIO DI SAN FELICE
After the 16th-century **Palazzo Fontana-Rezzonico**, where Pope Clement XIII (Carlo Rezzonico, 1693-1769) was born, is **Palazzo Coletti-Duodo**, designed by ANTONIO VISENTINI (1688-1782). The façade, dated 1766 in an inscription, has a singular ground floor with a false Doric portico and dotted with niches with allegorical statues. Restructured in the mid-19th century, the building was purchased after 1916 to serve as an extension of the adjacent Galleria

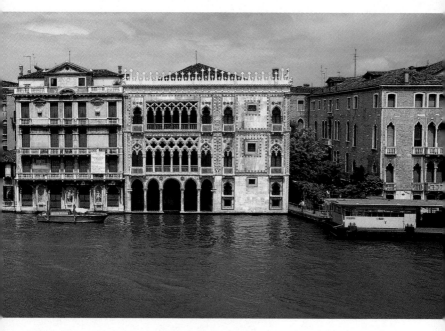

Giorgio Franchetti, the gallery in the splendid **Ca' d'Oro**, by MATTEO RAVERTI, and GIOVANNI and BARTOLOMEO BON (1420-334).

■ PONTILE OF CA' D'ORO

The nearby **Palazzo Morosini-Sagredo** distinguishes itself for the long façade with an elegant Veneto-Byzantine six-lancet multiple window with small cusped arches (late 13th century). Among the Gothic windows on the *piano nobile* – used as a model by the stone-cutters of the Ca' d'Oro – there is the singular frieze with quatrefoil roundels aligned with those of the four-lancet window below (late 14th century). The interior has 18th-century frescoes by GIROLAMO BRUSAFERRO and NICOLÒ BAMBINI, as well as stuccowork by CARPOFORO MAZZETTI and ABBONDIO STAZIO, signed and dated 1718 in the attic. A short distance from Campo Santa Sofia is **Palazzo Michiel dalle Colonne**, the Byzantine façade of which has a tall portico as a water entrance and was rebuilt by ANTONIO GASPARI in the last decade of the 17th century. Further on is the classicizing **Palazzo Mangilli-Valmarana**, commissioned by Joseph Smith and completed in 1751 to a design by the Venetian painter and engraver ANTONIO VISENTINI. Smith, the British consul and merchant, was an enthusiastic patron of the Venetian artists of the time, such as CANALETTO. The building, purchased by Count Mangilli in 1784, was modified in the upper stories by the architect GIANNANTONIO SELVA.

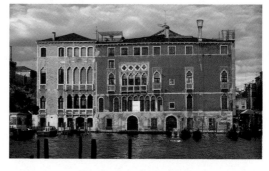

40 TOP CA' DA MOSTO, DETAIL.

40-41 PALAZZO MANGILLI-VALMARANA, CASA ZAGO, CA' DA MOSTO (CENTER) AND MANIN-DOLFIN.

40 BOTTOM PALAZZO MANIN-DOLFIN, PALAZZO BEMBO.

41 BOTTOM FONTEGO DEI TEDESCHI.

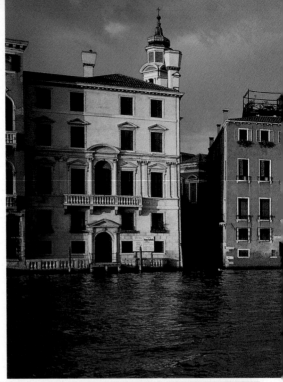

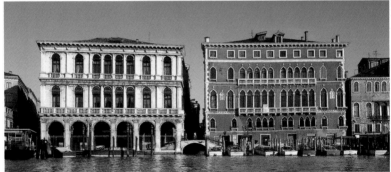

■ RIO DEI SS. APOSTOLI
The fascinating **Ca' da Mosto**, a favorite subject with 19th-century painters, has one of the oldest façades in Venice, and the first two stories can be dated back to the mid-13th century. The water entrance has three elevated arches. On the *piano nobile*, the six-lancet window originally had seven light. On the sides, the two isolated

windows are flanked by a bas-relief with small twinned blind windows. The arches of the multiple windows, which are slightly inflected in the Oriental manner, derive from those in St. Mark's Basilica. The overlying row of elegant paterae and panels with monsters and animals, dates from the same period. The one in the middle depicts an enthroned Christ.

■ RIO DE SAN GIOVANNI GRISOSTOMO
■ RIO DEL FONTEGO DEI TEDESCHI
SAN MARCO DISTRICT
Fontego dei Tedeschi (1505-08)
■ **RIALTO BRIDGE** (by ANTONIO DA PONTE, 1588-91)
Riva del Ferro

■ **PONTILE OF RIALTO** After Calle Larga Mazzini,

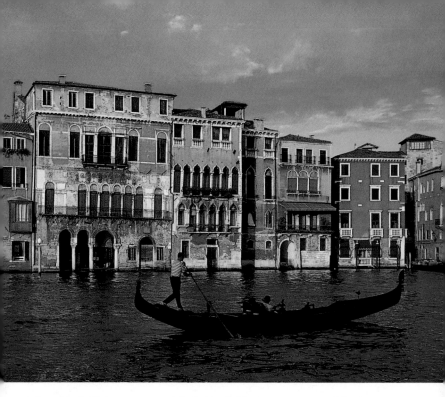

enlarged in 1884, is
Palazzo Manin-Dolfin (no.
4796-97), designed by
JACOPO SANSOVINO for the
procurator of St. Mark's,
Giovanni Dolfin. The first
phase of the construction
was in 1536-40; work was
resumed in 1545 and
lasted, after Sansovino's
death, until 1575. The
unadorned façade, which
has no polychrome marble,
stands out for its rational
simplicity, in keeping with
Vitruvius' principles of
composition and
proportions. The ground
floor portico extending
over the public quayside is
a type similar to that of the
traditional Venetian
residences with
warehouses. There are
Doric pilasters on the piers
of the six arches. The Ionic

and Corinthian half-
columns above have a
purely decorative function.
The corners, which were
conceived in conformity
with the compositional
principles of Leone Battista
Alberti, have rather crude
architectural details.
Between 1787 and 1801 the
interior was modernized in
Neo-Classic style by
ANTONIO SELVA for Ludovico
Manin, the last doge of
Venice.

■ RIO DE SAN SALVADOR

The beginning of
Riva del Carbon
is dominated by
Palazzo Bembo
(no. 4793), with
tiny Gothic
windows on the
first floor and

two sets of five-lancet
windows on the second and
third stories (ca. 1460). On
the corners of the ground
floor of the house after
Calle Bembo are two 11th-
century bas-reliefs in
Aurisina stone. One (no.
4643) has a cross and the
other (no. 4640) a blind
two-lancet window
crowned by a frieze with
animals, including two
facing griffins.

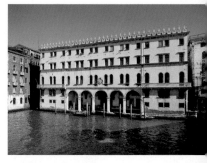

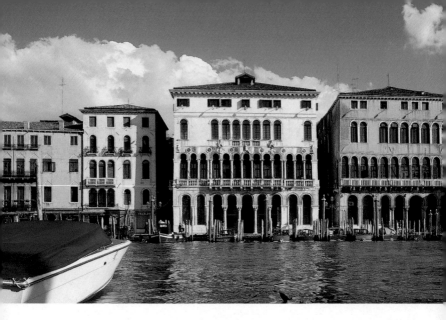

After Ramo del Carbon is **Palazzetto Dandolo** (no. 4168); on its narrow mid-14th-century Gothic façade, made of stone fill material, there are coats of arms and paterae dating from the 13-15th century. This was the home of the author Pietro Aretino (1492-1556), a great friend of Titian.

The adjacent **Palazzo Dandolo** may have been inhabited by Doge Enrico Dandolo (plaque at no. 4170), who led the troops of the Fourth Crusade. Since the French noblemen did not have enough money to finance the expedition, the Venetians were compensated with the reconquest of Zadar and the conquest of Constantinople in 1204. This doge remained in the capital of the Eastern Empire, died there a year later, and was buried in the church of Santa Sophia.

At the beginning of Calle del Carbon, at right, a plaque commemorates Elena Lucrezia Cornaro Piscopia – related to Caterina Cornaro, the queen of Cyprus – who was the first woman in the world to earn a university degree. In 1678, this noblewoman, who spoke many languages, discussed a dissertation on philosophy at the Studio (university) in Padua and was acclaimed by the audience that witnessed this event.

The adjacent **Palazzo Loredan-Corner** (no. 4137), dating from the first decades of the 13th century, is the most important example of the Venetian merchant's residence with warehouse. The porticoed water entrance has five elevated, round arches. Two double lancet windows were opened at the point where the original side towers once stood, and two three-lancet windows were

opened on the upper floor. In 1363, Federico Corner hosted Peter of Lusignan, King of Cyprus, Jersusalem and Armenia, in this residence. In return for a generous loan from Corner, the king granted the Corner family the district of Piscopia in Cyprus and allowed them to grow and refine sugar cane there. To celebrate his success, Federico – probably around 1366 – had an elaborate stone frieze put on the palazzo. In the middle, above the long multiple window, there is a sallet, which may be the insignia of the fief of Piscopia, flanked by four coats of arms – one of the Lusignan and three of the Corner families. These alternate with green marble roundels, two high reliefs with a baldachin representing Justice and Strength and, on the ends, David and Goliath sculpted in panels. On the

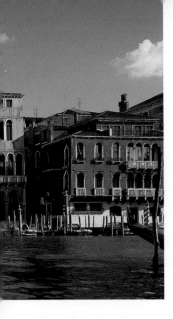

42-43 Palazzo
Loredan-Corner,
Palazzo Dandolo-
Farsetti.

43 left Palazzo
Dandolo.

43 right
Palazzo Loredan-
Corner, detail.

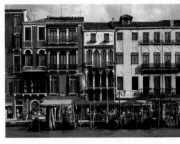

walls of the portico are plaques commemorating the martyrdom of Nazario Sauro (1954) who was hanged by the Austrians at Pola in 1916; the exploits of the Italian troops in World War One (1918); and Giovanni Battista Gianquinto, the first mayor of Venice after 1945 (1990). The interior, restored several times over the centuries, is now the Venice City Hall. In the state room on the *piano nobile*, beside the two 18th-century canvases of children over the door attributed to Gregorio Lazzarini (1655-1730), there are paintings by Bonifacio De' Pitati, including *The Birth of the Virgin Mary* (1554), in the background of which one can see Campo San Giacomo de Rialto. The same Virgin theme is in a large canvas on the same wall, opposite the entrance staircase; it is by Benedetto Caliari (1538-98), brother

and assistant of Veronese. This interesting work – brought here from the Scuola di San Cristoforo (or dei Mercanti) at the Madonna dell'Orto Church (Cannaregio district – shows, at left, Mary being nursed by some servants, while at right Anne is being revived after the difficult birth.

Palazzo Dandolo-Farsetti (no. 4136), despite the drastic restoration work of 1874, has preserved its basic structure as a typical residence with warehouse, (first decades of the 13th century). Among its owners was the abbot Filippo Vincenzo Farsetti, a friend of the sculptor Antonio Canova and also the owner of a collection of his terracotta pieces, some of which are now in the Giorgio Franchetti Gallery in the Ca' d'Oro. In the palazzo, which was bought by the municipality of

Venice in 1826, there is a fine 18th-century double staircase (perhaps by Andrea Tirali) and, in the state room, 18th-century stuccowork and paintings by Antonio Zanchi, Felice Boscarati, Vincenzo Guarana and Bartolomeo Tarsia. The works by Antonio Molinari, Johann Carl Loth and Francesco Fontebasso are accompanied by paintings from San Michele in Isola Church: *The Massacre of the Innocents* by Bartolomeo Tarsia (early 18th century), and *St. Romuald and the Emperor Otto* by Vincenzo Guarana (ca. 1753-1815). In the mayor's salon are *Esther and Ahasuerus* by Johann Carl Loth, *Angelo Correr, Podestà* by Alessanddro Maganza, *Anthony and Cleopatra* by Antonio Molinari and, on the ceiling, *Allegory of Day and Night*, attributed to Francesco Fontebasso.

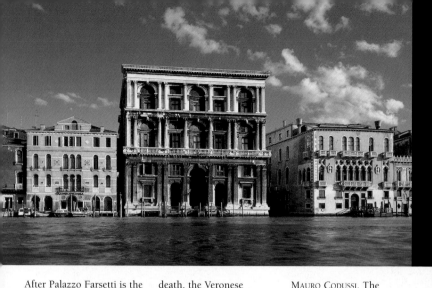

After Palazzo Farsetti is the imposing, superb Istrian stone façade of **Palazzo Grimani**, designed in 1556 by MICHELE SANMICHELI (1484-1559) for the senator Girolamo Grimani. Built after Palazzo Manin-Dolfin, this Corinthian-order building has three major features: the monumental triumphal arch entrance, the correct architectural elements on the corners of the upper floors, and the originality of the plan that encompasses an irregular plot of land. The Serliana motif had already been used by SANMICHELI in Palazzo Corner-Mocenigo, in the San Polo district. After his death, the Veronese architect was replaced by the *proto* GIAN GIACOMO DE' GRIGI, who designed a mediocre second floor that is too squat and has no balconies. Construction was finished in 1575 by GIAN ANTONIO RUSCONI.

■ RIO DE SAN LUCA
Palazzo Corner-Contarini dei Cavalli still has its six-lancet window on the *piano nobile*, modeled after the loggia in the Doges' Palace, and its late Gothic single-lancet window, alternated with two elegant high-relief family crests. Neighboring **Palazzetto Tron-Memmo**, built after 1828, is an affected and eclectic example of Neo-Gothic architecture.

■ RIO DE CA' CORNER
Palazzo Lando-Corner-Spinelli, built by the Lando family around 1490, is attributed to

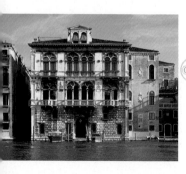

MAURO CODUSSI. The building has a ground floor with a rusticated wall marked off – as in the San Michele in Isola Church – by two Ionic pillars. The modular motif of the double lancet windows on the upper floors, which may be a variation of the five-lancet window on Palazzo Cavalli-Franchetti, was later introduced again in Palazzo Loredan-Vendramin-Calergi. Note, on the side windows of the first story, the sophisticated trilobate balcony, created by overturning the profile of the roundels and the two small arches that crown the window. Giovanni Corner, who bought this palazzo in 1542, commissioned GIORGIO VASARI in the same year to paint nine canvases, and asked MICHELE SANMICHELI to restore the interior. This latter architect probably designed the Tuscan-order atrium. In the interior, the drawing room has a splendid coffered

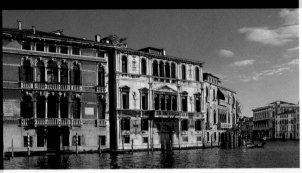

44 TOP PALAZZO
GRIMANI (CENTER).

44 BOTTOM AND
45 TOP PALAZZO
LANDO-CORNER-
SPINELLI AND DETAIL.

45 CENTER PALAZZO
MOCENIGO "CASA
VECCHIA." PALAZZO
CONTARINI DELLE
FIGURE.

45 BOTTOM
PALAZZO MOCENIGO
"CASA NUOVA".

ceiling executed in 1547 and a small fireplace attributed to JACOPO SANSOVINO, surmounted by the bust of a doge (Giovanni II Corner?) (first half of the 18th century).

■ PONTILE OF SANT'ANGELO
■ RIO DE CA' GARZONI

Palazzo Garzoni, whose Gothic façade, perhaps dating from the first half of the 15th century, has been drastically altered, is followed by **Palazzo Mocenigo "Casa Nuova,"** built around 1579 and attributed – because of alleged affinities with Palazzo Balbi – to ALESSANDRO VITTORIA, but really more in tune with Palazzo Coccina-Tiepolo-Papadopoli. The drawing room has a marvelous 16th-century wooden ceiling as well as a precious glass collection. The adjacent and contemporaneous **Palazzo Mocenigo** hosted the great and adventure-loving

English poet, Lord George Gordon Byron (1788-1824), in 1818 and 1819. Next to this building is **Palazzo Mocenigo "Casa Vecchia,"** whose façade (1623-25) was rebuilt by FRANCESCO CONTIN. Immediately after this edifice, where the inner bend of the Grand Canal begins, **Palazzo Contarini delle Figure**, of uncertain attribution, was built in the first half of the 16th century. The architect seems to have imitated and updated the structure of the preceding Gothic façade, adopting the vocabulary of CODUSSI and Lombardesque architecture in an eclectic and pragmatic fashion. Although it is rather original, especially the four-lancet window with a pediment and the gradual decrease in the proportions of the Corinthian pilasters, this building betrays a certain naïveté, for example in the use of the long and slender pilaster strips on the second floor. Among those who

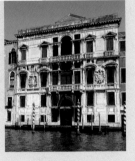

lived in this palazzo was Jacopo Contarini, the illustrious art collector and patron of Andrea Palladio. A short distance away is **Palazzo Moro-Lin** (ca. 1670), with a compact series of superposed arches that alternate with Doric and Ionic pilaster strips. The third, Corinthian-order story was added shortly before 1703. This palazzo belonged to the painter PIETRO LIBERI and was probably designed by the Florentine SEBASTIANO MAZZONI (1611-78), who ignored the Baroque innovations of LONGHENA and SARDI and seems to prefigure a return to a revived classicism.

46 TOP AND CENTER
MICHELANGELO
MORLAITER, *FIGURES OF
VENETIAN NOBLES
DURING A RECEPTION*
AND DETAILS, PALAZZO
GRASSI.

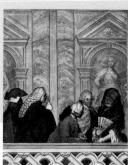

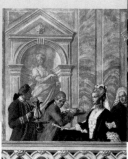

46 BOTTOM PALAZZO GRASSI,
STAIRCASE.

46-47 PALAZZO GRASSI AND
SAN SAMUELE CHURCH.

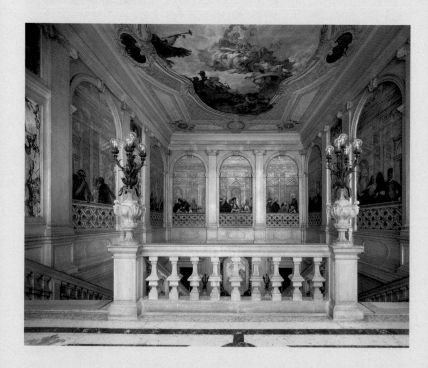

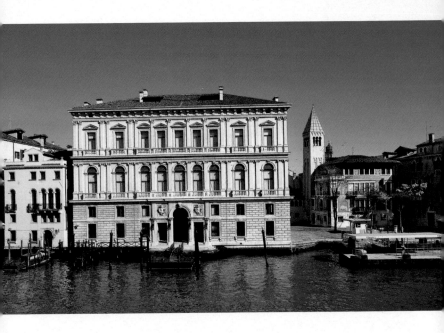

On the other hand, the architect GIORGIO MASSARI adopted more monumental solutions that better respect Venetian tradition in the nearby **Palazzo Grassi**, begun in 1748 for Angelo Grassi (d. 1758), whose family of Bolognese origin from Chioggia was admitted into the Venetian patrician class in 1718. The preponderance of smooth surfaces creates a mirror-like façade whose light makes the individual architectural elements even more rarified. The Serliana on the ground floor, with the two windows closed off by the family coat of arms, evokes the solutions proposed by SANMICHELI, while at the same time rendering the supporting elements lighter with repeated molding. The idea of the paired Ionic and Corinthian pilasters on the upper floor seems to have derived from VINCENZO SCAMOZZI's palazzo Contarini dagli Scrigni. MASSARI's measured and erudite eclecticism is seen in the plan as well. The atrium, long hall and courtyard – which are aligned – merge and change in a measured fashion with elements taken from SANMICHELI and SANSOVINO and are made more theatrical by means of a Tuscan portico and an ending staircase built in 1766-72, after the death of the architect. The monumental two-story hall is decorated with a high relief by GIAN MARIA MORLAITER, *The Allegory of Concord* (1760-63), the *Figures of Venetian Nobles during a Reception* (ca. 1770) frescoed on the walls by MICHELANGELO MORLAITER, and, on the ceiling, *The Triumph of Justice* (ca. 1780), a fresco placed onto canvas by GIAMBATTISTA CANAL. The other rooms have paintings by GASPARE DIZIANI and CHRISTIAN GRIEPENKERL (1874) and stuccowork (1920) by VITTORIO TRENTIN. Around 1870 the central, two-story salon was reduced in size. After 1984, when the Palazzo Grassi firm, part of the FIAT company, bought the palace, GAE AULENTI and ANTONIO FOSCARI supervised the restoration of the interior, which since then has been used for exhibitions of ancient and contemporary art and civilization. The lighting system was designed by PIETRO CASTIGLIONI.

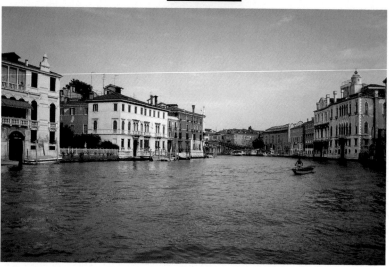

PONTILE OF SAN SAMUELE

San Samuele Church, which dates back to the 11th century, still has its original outer porch, which was changed over the centuries and restored in 1952. The lovely campanile with pilaster strips and whose belfry has Veneto-Byzantine three-lancet windows, dates from the 12th century. The nave with two aisles, ending in a 15th-century Gothic apse, was rebuilt after 1683. After the church are the 17th-century **Palazzo Malipiero-Cappello** and the **Ca' del Duca**. This latter still has a tall foundation part of the original façade with diamond-pointed rustication built – perhaps to a design by ANTONIO AVERULINO, known as FILARETE – soon after 1461 for Francesco Sforza, Duke of Milan.

RIO DEL DUCA

The charming, romantic **Palazzo Falier-Canossa** is of Gothic origin and is characterized by two rare *liagò*, or upper floor loggias. In the interior is a singular 18th-century dining room whose walls are covered with mirrors. Next is **Palazzo Giustinian-Lolin** (1623 and following years), an early work by BALDASSARE LONGHENA characterized, on the *piani*

48 center View of the Grand Canal looking toward Accademia Bridge.

48 bottom left Palazzo Falier-Canossa.

48 bottom right Ca' del Duca.

49 top Palazzo Malipiero-Cappello.

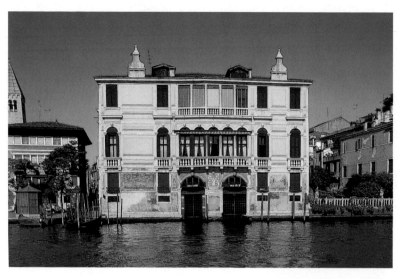

nobili, by the Serlianas with Ionic and Corinthian pilasters. The building (no. 2893) is now the home of the Fondazione Ugo e Olga Levi, a center of higher musical culture founded in 1962 and boasting a rich musicological library that contains the archive of the Fenice Theater.

RIO DE SAN VIDAL
At the end of Campo San Vidal is the campanile of **San Vidal Church**, designed by Antonio Gaspari and Andrea Tirali (17th and 18th century).

ACCADEMIA BRIDGE
The almost square façade of the Gothic **Palazzo Cavalli-Franchetti** (seventh decade of the 15th century)

is embellished by two five-lancet multiple windows. The first one has the felicitous creation of quatrefoil roundels supported by interwoven arches which, unlike those in the upper six-lancet window on Palazzo Pisani-Moretta, are aligned with the columns below them. The second imitates the upper six-lancet window on the Ca' d'Oro, while varying its proportions. Around 1860, Giambattista Meduna restored the building and created the garden at its left. In 1878, Baron Raimondo Franchetti – who created the art gallery named after him in the Ca' d'Oro – had the side facing the garden restored by Gerolamo Manetti. In

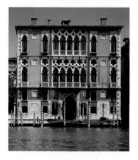

the back of the building, near San Vidal Church, is the modern Neo-Gothic wing designed by Camillo Boito. In the interior, the kaleidoscopic staircase, finished in 1886, has stuccowork by A. Bortoluzzi, painted decoration by Carlo Matscheg and bronze and stone sculpture pieces by Emilio Marsili, E. Chiaradia and A. Felici.

■ RIO DE L'ORSO

Palazzo Barbaro consists of two adjacent buildings. On the façade of the first one, the Gothic style of the multiple windows (1425) – attributed to GIOVANNI BON, who worked on the Ca' d'Oro as well, and his workshop – merges with the Lombardesque imitation niches and the polychrome paterae (15th century). Note, on the ground floor,

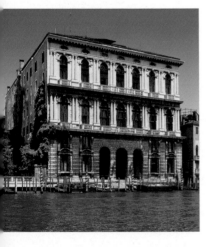

the side entrance with an inflected Gothic arch and the central Renaissance entrance whose architrave has dentils. The second building, which is taller and crowned by a small pediment, was built in 1694 by ANTONIO GASPARI. Besides the elaborate furnishings, the interior has precious Venetian-style floors and allegorical figures in stucco, as well as a Baroque ballroom with stucco decoration and canvases by SEBASTIANO RICCI and GIOVAN BATTISTA PIAZZETTA and an elegant library. Thanks to the Curtis family of Boston, which purchased the palazzo in 1885, the great author Henry James and the artists John

Singer Sargent and Claude Monet lived there.

■ RIO DEL SANTISSIMO

Palazzo Corner, known as the **Ca' Grande** (no. 2662), was built by Giovanni Corner, the rich grandson of Caterina Cornaro, queen of Cyprus, after a fire had destroyed the earlier Gothic building in 1532. The commission was given to JACOPO SANSOVINO who began the construction a few years later. The building marked a turning point in Venetian architecture, serving as a model for other, later private residences. The classicizing façade rises up like a huge canvas with its striking chiaroscuro effects. The smooth rustication of the ground floor is interrupted in the middle by three arches of equal height that transforms the typical portico of a merchant's residence with a warehouse into an obvious reference to

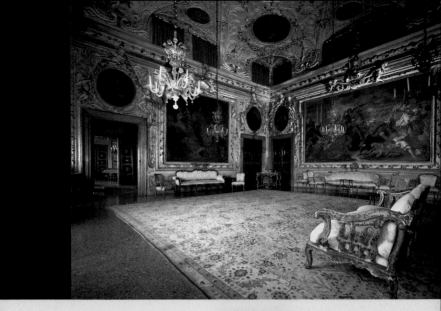

ancient Roman architecture. The side pilaster strips – which barely emerge from the surface and have no capitals – alternate with singular Michelangelesque multiple windows. Because of the windows with Doric trabeation and a pediment with geometric forms, the ground floor no longer looks like the traditional warehouse, but rather like a floor fit for habitation. Above this, the windows of the mezzanine are flanked by tall modillions. The rhythm of the two *piani nobili* – Ionic and Corinthian – is similar to the one in Palazzo Loredan-Vendramin-Calergi, but it is more compact because the paired half-columns are closer together. Not having architectural elements on the corners, the building is like a handmade product that opens out ideally onto the urban fabric of the city. The atrium, *portego* (long

50 TOP PALAZZO BARBARO.

50 BOTTOM PALAZZO CORNER (CA' GRANDE).

51 TOP SALON, PALAZZO BARBARO.

51 CENTER FAMILY COAT OF ARMS, PALAZZO BARBARO.

51 BOTTOM STUCCOWORK WITH 18TH-CENTURY PORTRAIT, PALAZZO BARBARO.

hall going down the length of the building) and courtyard are aligned. The lower section of the sides of the courtyard repeat the tripartition and rustication of the water entrance, but here the Doric pilasters stand out more. The well head is crowned by a statue of Apollo by FRANCESCO PENSO, known as CABIANCA. The interior once boasted a prestigious picture gallery, and the staircase was

rebuilt after the 1817 fire. At present, the halls – now the headquarters of the Prefecture and the Province of Venice – have 18th-century furnishings, a painting cycle concerning Phaeton by GIOVANNI SEGALA of Murano (1663-1720), and many other paintings, including *The Glories of Venice*, executed by VITTORIO BRESSANIN for the Veneto pavilion during the Rome Exposition (1911).

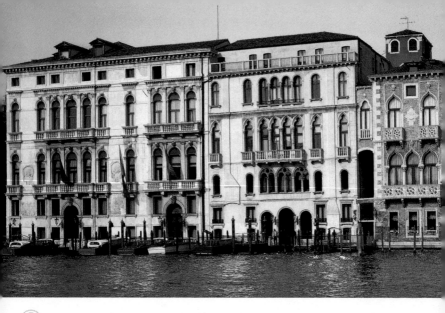

RIO DE SAN MAURIZIO
RIO DI SANTA MARIA ZOBENIGO
PONTILE OF SANTA MARIA

The church of the same name was built by GIUSEPPE BENONI and GIUSEPPE SARDI in ca. 1680-1683.

RIO DE L'ALBORO
Originally, **Palazzo Ferro-Fini** was made up of two Gothic edifices purchased sometime between 1638 and 1640 by Tommaso Flangini, a lawyer and patron of the Greek community in Venice. In 1628, that is, well before Flangini's purchase, the city master builder PIETRO BETTINELLI supervised the restoration of the buildings until 1642. The two properties were then bought in 1661 by Girolamo Fini, of Cypriot origin, who, to celebrate his family's admission into the Venetian patrician class in

1649, restored the palazzo and commissioned the erection of the façade of the nearby church of San Moisè, entrusting both works to ALESSANDRO TREMIGNON. On that occasion, with the aim of merging the two edifices, the Paduan architect must have designed the present façade, which was built in 1686-1703. Despite later spoliation, the interior of the palazzo (now the home of the Veneto Region Council) still has thirteen canvases with mythological subjects, eleven of which were painted – perhaps for Girolamo Fini – by PIETRO LIBERI (1614-87). Among these is the *Apotheosis of Hercules* on the ceiling of the regional president's office. This subject matter may have some connection with the façade, since, among the busts of noble ladies and knights, there is one of the Greek hero with

the skin of the Nemean lion as a family crest.
The adjacent **Palazzo Manolesso-Ferro**, which was also bought by the Veneto Region, was merged with the Palazzo Ferro-Fini around 1860-74, when the Ivancich family turned the complex into an elegant hotel. On the façade are Gothic and Renaissance architectural elements; particularly noteworthy is the lower three-lancet window, modeled after CODUSSI's on Palazzo Lando-Corner-Spinelli. Next door is the **Palazzetto Contarini-Fasan**, the legendary home of Othello's wife, Desdemona. This residence, dating back to around the mid-15th century, is characterized by its magnificent balconies with tracery work.

RIO DE SAN MOISE
The **Bauer-Grünewald Hotel** was built in 1901 in false Gothic style by

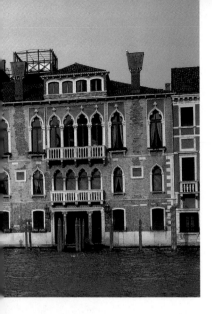

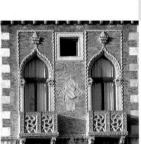
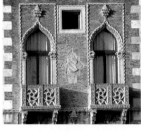

52 PALAZZI CONTARINI-FLANGINI-FINI, MANOLESSO-FERRO, CONTARINI-FASAN AND CONTARINI.

53 PALAZZETTO CONTARINI-FASAN, CONSIDERED DESDEMONA'S HOUSE, DETAIL.

GIOVANNI SARDI, who used some stone material dating from the early 1400s for part of the construction. Next door is the imposing **Palazzo Giustinian-Morosini** (1474), by PAOLO DI GIACOMO. The building, in which the present left wing was incorporated, was turned into a hotel in 1820. Giuseppe Verdi and Marcel Proust were two illustrious guests here.

■ PONTILE OF SAN MARCO-VALLARESSO
Since the foundation, in 1931, by the Bostonian Harry Pickering and the Venetian Giuseppe Cipriani, **Harry's Bar** (no. 1323) has been a favorite haunt of artists, writers, movie stars and aristocrats. Among its most famous regulars were Ernest Hemingway, who had a table always reserved for himself, Arturo Toscanini, Charlie Chaplin, Truman Capote, Orson Welles, Peggy

Guggenheim, Aristotle Onassis, the Aga Khan and Woody Allen. The nearby **Fonteghetto della Farina**, an unadorned, functional structure built in 1492 to store and sell flour, was restored in 1717 (plaque) and in 1756 became the home of the Accademia di Pittura, Scultura e Architettura, directed by none other than GIAMBATTISTA TIEPOLO.

■ RIO DEI GIARDINETTI
In the singular **Coffeehouse** (ca. 1838), LORENZO SANTI combined the Neo-Classic rigor of the Doric order ground floor with the excessive decoration of a large frieze and sculptural elements that surmount it. Further on are the **Giardini Reali**, the gardens opened in 1807 on the site of the demolished public wheat warehouses, known as Granai di Terra Nova, built in 1341.

Past the bridge that crosses the canal, in front of St. Mark Basin and in the St. Mark's Basilica area, you will see the **Zecca**, designed by JACOPO SANSOVINO (1536-66); the smaller façade of the **Biblioteca Marciana**, the historic library designed by VINCENZO SCAMOZZI (1583-90); the **Columns of St. Mark and St. Theodore**, behind which are **St. Mark's Campanile** and its **Loggetta**, rebuilt in 1903-12; the **Procuratorie Vecchie** (1517-38); the **Clock Tower** designed by MAURO CODUSSI and PIETRO LOMBARDO (1495-1506); **St. Mark's Basilica**; and, along the St. Mark's Quay, the **Doges' Palace**, **Ponte della Paglia** (14th century) and, behind this, the **Bridge of Sighs** designed by ANTONIO CONTIN (1600-01) and the façade of the **Palazzo delle Prigioni** (ANTONIO DA PONTE, 1581-1610).

▶ MAIN SIGHTS

● *SESTIERI (Districts)*: S. Marco.
● *CHURCHES*: [1] St. Mark's Basilica;
[2] San Basso; [3] San Zulian.
● *PALAZZI*: [4] Doges' Palace; [5] Procuratie Nuove;
[6] Ala Napoleonica; [7] Procuratie Vecchie;
[8] P. Patriarcale.
● *OTHER MONUMENTS*: [9] Campanile;
[10] Loggetta; [11] Libreria sansoviana; [12] Zecca; [13]
Columns of St. Mark and St. Theodore; [14] Ponte de la
Paglia; [15] Ponte dei Sospiri (Bridge of Sighs);
[16] Prigioni Nuove; [17] Bacino Orseolo;
[18] Clock Tower; [19] Piazzetta dei Leoni; [20] Marzaria.
● *MUSEUMS*: [21] Civico Correr.

THE HEART OF THE CITY

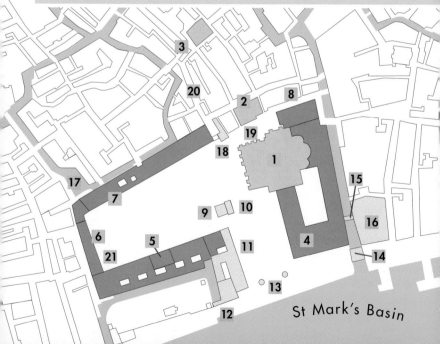

St Mark's Basin

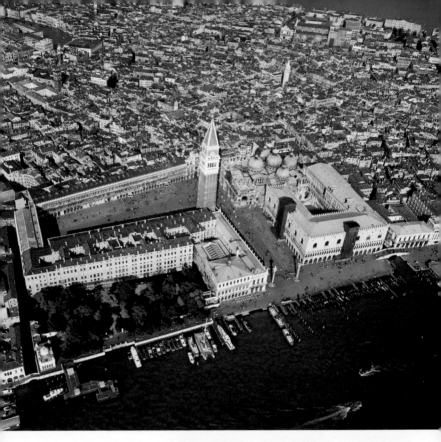

P iazza San Marco: undeniably the heart and symbol of the history of Venice, the mirror of the city's political and religious mentality, and a grandiose stage for processions, festivities and public ceremonies and gatherings where art was used as an educational and propagandistic tool. The square and the adjacent areas situated toward the Lagoon began their long and spectacular transformation in the year 810. During the centuries Piazza San Marco was broadened and fitted out

to take in new magistracies and to become the area of public and state ceremonies, the showcase, as it were – one of the oldest in Italy – of the new institution of the city. In a later period the most important building activities concerned the enlargement of the Doges' Palace, the construction of the Torre dell'Orologio (Clock Tower) and the renovation of the Procuratie Vecchie. The last major intervention was the

replacement of the old pavement – consisting of bricks in a herringbone pattern dating from 1266 – by the present one, with the two geometric band patterns in white marble conceived by ANDREA TIRALI in 1723. Along the area between these bands and the arcades, called the Liston, there was the procession of masked figures on the feast day of St. Stephen, when the Carnival festivities were officially inaugurated.

■ An expression of the city's desire to gain autonomy, a showcase and stage of incredible wealth: St. Mark's Basilica was all this and more, the city's most representative building.

HISTORY: The political birth of the city coincided with the arrival of St. Mark's remains in the Lagoon, on January 31st of the year 829, under the doge Giovanni Partecipazio.

To house the precious relic – the possession of which sanctioned Venice's superiority over the patriarchal sees of Grado and Aquileia – a new chapel was erected, which was restored during the 10th century and rebuilt, on a Byzantine pattern, under the doges Domenico Contarini and Domenico Selva. After the consecration, in 1094, was annexed to this five domed building an atrium, which was completed in the first half of 13th century.

After the defeat and the consequent domination over Costantinople, St. Mark's city became rich in treasures, works of art and precious marbles. The Venetians displayed the booty of their victory in St. Mark's Basilica with great pride. The four bronze horses, placed over the main entrance of St. Mark's

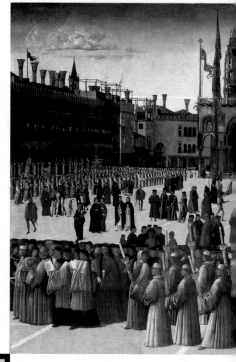

Basilica – the symbol of strength and triumph – were without a doubt the most eloquent emblem of the city's new imperial ideology. Since its origins, the Basilica was placed under the authority of the state. The doge entrusted his own chaplain, known as the *primicerio*, who in turn – without depending upon the authority of the bishop of San Pietro di Castello or on the patriarch of Grado – exercised wide-ranging prerogatives in the vicarial churches. Once the external

cupolas were built at the end of the 13th century, the architecture of the Basilica and its main decoration were virtually finished and definitive. What strikes one most about this complex and singular monument is the fusion of artistic styles, the deliberate synthesis of various artistic languages. At St. Mark's, Early Christian, Byzantine and Arab-Oriental influences mingled with Romanesque and Gothic, giving rise to an extraordinarily unique structure resulting from Venice's desire to proclaim itself the heir of Rome, Ravenna and

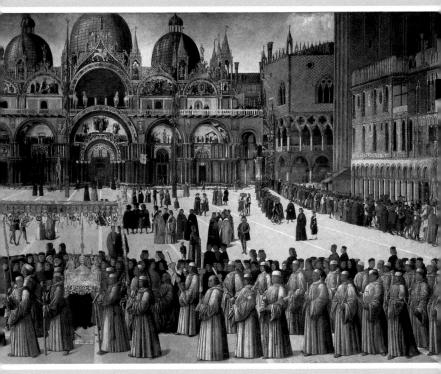

Constantinople – as well as the link between East and West. Without a doubt, this choice was made even more striking by the independent contribution of the skilled workmen and artisans from Venice or abroad who, once engaged in the construction work, were induced to use ancient works already in the Basilica or from the eastern Mediterranean as their models. During the first half of the 14th century the present Baptistery was built, and around the middle of the same century the St. Isidore Chapel was built with masonry from the church of St. Theodore. In 1384 work on the Gothic crown of the façade was begun. The last important undertakings in the artistic history of the Basilica were the reorganization of the Mascoli Chapel (1430-50) and the reconstruction of the sacristy (1486-1523).

In the meantime, thanks to its increasing diplomatic influence, Venice obtained, with the papal decree of 1451, the fusion of the bishop's see of San Pietro di Castello and the patriarchate of Grado. From the 16th to the 18th century, the Basilica was subject to numerous alterations, in which the stone material of the pavement and walls was replaced. The same was true of many mosaics. But the most unfortunate and damaging period was the 19th century, in particular from 1836 to 1877, when the architect GIOVANNI BATTISTA MEDUNA finished massive and reckless restoration work.

In that period, thanks to a Napoleonic decree in 1807, the Basilica, which, as we have seen, was the doges' chapel, became the seat of the patriarchate as well as the Cathedral, which had been located in San Pietro di Castello Church.

■ **FAÇADES**: The west façade lines the Piazza; its sculptural decoration and mosaics exalt the figure of Christ, the glorification of St. Mark (Christ's imitator and apostle, and patron saint of the Republic), and the celebration of the power of Venice.

The **central portal** has bronze doors (*opus*

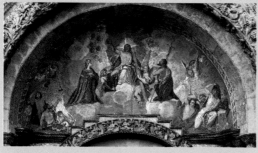

clatratum) brought from Constantinople. The lions' heads were added later and the wooden core of the door itself has been dated at around 964-978. The small sculpture piece in the niche above the architrave depicts *St. Joseph's Dream* (12th century); it came from the storerooms of the Basilica and was placed here in 1890. The reliefs on the **first arch** date from the first half of the 13th century. The reliefs on the

archivolt have scenes of hunting and children doing bad deeds. On the intrados of the **second arch** is a splendid sculpted calendar in which the allegories of the months – embodied by figures of the rural and urban world – are flanked by their respective signs of the Zodiac. The series begins at left, with *January*

engrossed in transporting firewood and ends at right, with *December* killing a pig. *March* is a Roman soldier, the image of the planet Mars and of the military strength of Venice: on his shield is the Lion of St. Mark, which was painted later, in 1493. On high, in a tondo, is *Christ Emmanuel* being adored by the Sun and Moon and flanked by the constellations of Cancer and Leo. His presence here,

as in the cupola of the presbytery, means that He is the first-born who comes before every other creature and that His presence extends for all time.

In the archivolt are the *Virtues* and *Beatitudes*, dating back to the 1240s, which are to be interpreted as examples of how to achieve salvation.

In the lunette above this arch is the large mosaic of the *Last Judgment* (1836-38) by LIBORIO SALANDRI, based on a cartoon by LATTANZIO QUERENA.

The **third arch**, dating from the 1250s and 1260s, in this context revolves around the theme of human salvation and work as a means of redemption. On the intrados, besides the so-called *Proto* or

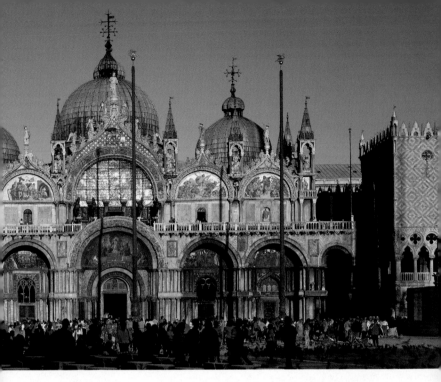

master builder (an old man seated and with crutches, at left), there are the representations of fifteen trades in homage to the city's main categories of artisans. However, this is also an admonition to engage in a profession based on justice and honesty, in view of the Last Judgment. As confirmation of this, in the keystone of this arch is the *Agnus Dei* in a roundel supported by two angels. On the archivolt, the *Sibyl*, the *prophets* and *Christ Emmanuel* announce the beginning of that fulfillment, made possible by the Word of God being incarnated in the Virgin Mary.

Terrace: The **four bronze horses**, the originals of which are now in the Basilica Museum, are the most prestigious "trophies" from Constantinople after the 1204 conquest and looting of the city. The horses came from the Hippodrome, an area for chariot and horse races. After being kept in the Arsenal for 50 years, the quadriga was placed over the main portal of the basilica to highlight its central role and also to suggest its function as a triumphal arch. The presence of the horses in St. Mark's underscores, first and foremost, the military power of Venice and the doge's new title as "Lord of a quarter and half a quarter of the Roman Empire."

Behind the quadriga is the large window and the **fourth central arch**, the reliefs of which, perhaps executed after 1419, are attributed to GIOVANNI DI MARTINO DA FIESOLE and PIETRO LAMBERTI. The reliefs depict *patriarchs and evangelists* in a niche and, in the archivolt, scenes from the Old Testament alternating with figures of prophets.

60 top *Christ's
Descent into Limbo,
terrace lunette.*

60-61 *The Body of St.
Mark Is Taken to the
First Basilica, Where It
Will Be Laid, St. Alipius
Portal.*

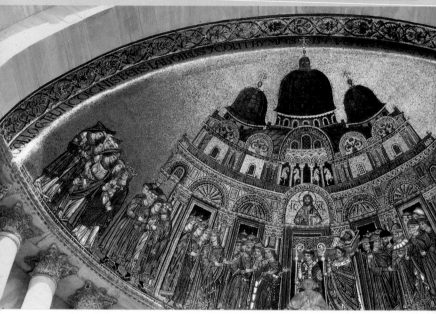

The gilded *Walking Lion* (1826) above this is a reconstruction sculpted by Gaetano Ferrari. Behind this animal, the symbol of St. Mark and of Venice, is a star-studded sky (redone in 1821-22). On the top of the arch is the 15th-century statue of St. Mark Evangelist – attributed to Nicolò Di Pietro Lamberti – which, from the heavens, blesses his city. Viewed as a whole, the main façade of the basilica, like the two side ones, also had the function of a public reliquary. Over and above their value as trophies,

the columns made of marble, the capitals, marble slabs, friezes and high reliefs were placed there to help protect the city. This was the meaning of the relief figures on the marble slabs inserted in the spandrels of the first register of the façade. Those at the ends are *Hercules with the Erymanthian Boar* and, at the right end, *Hercules with the Hind of Cyrene and the Hydra of Lerna*, both of uncertain date. Hercules – like Samson – was viewed as a prefiguration of Christ. The mosaics above the

portals should be viewed from right to left. In the **first arch**, after the *pietra del Bando* in red porphyry – placed here in 1256 – the story begins with *The Theft of the Body of St. Mark from the Alexandrine Tomb*, with which Rustico of Torcello and Bono of Malamocco were credited; *The Body of St. Mark Is Lowered by Rope* and, in the lunette, *The Saracen Customs Officers, Terrified by the Sight of Pork, Refuse to Inspect the Basket* (where the body of the saint was hidden). These scenes were finished in 1674

and the preparatory cartoons (1660-63), now in Sant'Alvise Church, in Cannaregio, were executed by PIETRO MUTTONI, known as DELLA VECCHIA. In the vault of the **second arch**, the 17th-century mosaics illustrate *The Body of St. Mark on the Boat Being Wrapped in*

LEOPOLDO DAL POZZO were finished in 1729 and the preparatory cartoons (1727-28), kept in the Liagò of the Doges' Palace, are by SEBASTIANO RICCI. The doors of the portal beneath date from 1300 and were signed by the Veneto artist BERTUCCIO. In the lunette of the **fifth arch** (the last one), which stands on the St. Alipius portal, is the only surviving scene of the original church mosaics; it dates back to 1270-75 and depicts *The Body of St. Mark Is Taken to the First Basilica,*

61 TOP LEFT AEDICULE AND LARGE LUNETTE ON THE TERRACE.

61 TOP RIGHT THE LION OF ST. MARK AND ST. MARK, CENTRAL CROWN.

61 BOTTOM THE SARACEN CUSTOMS OFFICERS, LUNETTE OF FIRST ARCH.

the Cloth of the Sails, while *The Alexandrians Gather along the Beach.* In the lunette is *The Body of St. Mark Arrives in Venice and Is Welcomed by Bishop Orso and the Clergy* and, on the other side of the arch, *The Body of St. Mark, Accompanied by the Clergy, Is Taken to the Doges' Palace.* Skipping the main portal, we come to the **fourth arch**, with *The Venetians and a Man Holding the Doge's Faldstool, The Doge Receives the Body of St. Mark and Pays Tribute to Him,* and some *Muslims.* These mosaics by the Roman

Where It Will Be Laid. The façade with the lead-cased cupolas is not the original one, but the one belonging to the basilica built in the second half of the 13th century, and the doge at right is Lorenzo Tiepolo (1268-75). The story-line of the mosaics on the **terrace** begin at left (north side) with the large lunette of the *Deposition* (1617-18) by ALVISE GAETANO, to a cartoon by MAFFEO VERONA. The same artists did the adjacent *Christ's Descent into Limbo* and, after the central arch,

the *Resurrection* (dated 1617) and the *Ascension.*
The Gothic crown of the main façade, begun in 1384 and finished around 1430, was executed by many artists. The statues on the tops of the arches – beside the central one of St. Mark already mentioned – portray four *Warrior Saints* (1618) by GIOVANNI BATTISTA ALBANESE. The 15th-century statues in the baldachins portray, from left to right, the *Annunciatory Archangel Gabriel,* the *Four Evangelists* and the *Virgin Annunciate.*

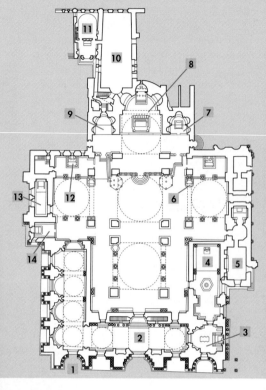

ST. MARK

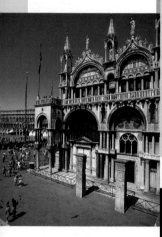

62 LEFT SOUTH
FAÇADE AND THE
PILLARS OF ACRE.

62 RIGHT DETAIL OF
THE *TETRARCHS*.

63 TOP STATUES
ON THE CROWN.

◼ The architectural structure of the **south façade**, which faces the Piazzetta, was totally redone in 1865-75. Starting from left, there are the small portico with stilted round arches, the atrium doorway or *porta da mar* or door facing the sea (walled up when the Cappella Zen was built), with late 13th-century reliefs on the arch, and the so-called pillars of Acre (6th century) in red porphyry in front of the side entrance to the Baptistery – placed here in 1258-60 after being brought from St. Polyeuktos in Constantinople. Near the pillars are the Gothic double-lancet window and the corner of the Basilica Treasury, on which are the *Tetrarchs* (4th century?), also made of red porphyry; they were brought from Constantinople and placed here in the first half of the 13th century. Before the Porta della Carta of the Doges' Palace there are the 11th- and 12th-century Byzantine plutei on the wall, as well as the frieze of the Istrian stone bench with dragons and *putti* supporting a cartouche with an ancient inscription in Venetian dialect. The 15th-century statues on top of the Gothic crown of the south façade represent

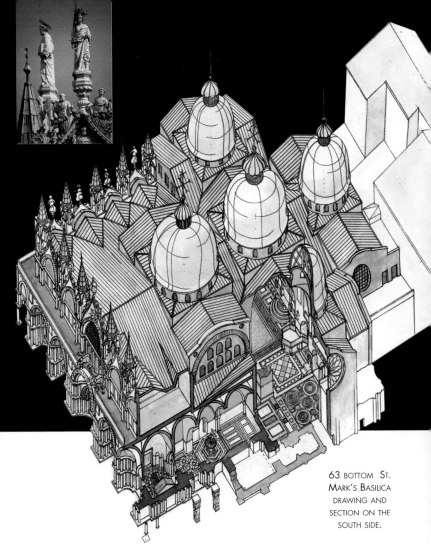

Justice and Fortitude, while those in the baldachin are St. Anthony Abbot and St. Paul the Hermit.

Toward the Piazzetta dei Leoni, the numerous fragments of reliefs on the **north façade** underscore its role as a sort of artistic reliquary or stone museum. Worthy of mention among these pieces, in the lunette of the first arch, at right, is

the throne of God or *Etimasia*, which has the empty throne before the Last Judgment, flanked by two trees of Paradise and twelve lambs, and – in the spandrel above left – *The Flight of Alexander the Great* (date uncertain), in which the Macedonian emperor flies into heaven in a chariot drawn by two griffins. At left on the ground floor is the Porta dei Fiori, in the

tympanum of which is a 12th-century relief of the *Nativity*. On the outer end of the transept is the tomb of Daniele Manin (ca. 1868). The four 15th-century statues on the top of the Gothic crown portray Charity, Faith, Temperance and Prudence, and those in the baldachin represent the four saints and doctors of the Western Church: Gregory, Ambrose, Augustine and Jerome.

64 SCENES FROM
*THE LIFE OF ST.
MARK* AND DETAIL.

65 TOP SCENES
FROM *THE LIFE OF
ST. MARK.*

65 BOTTOM THE
CAPPELLA ZEN.

INTERIOR: Once you are past the central portal facing the piazza, you will find yourself in the atrium or narthex, built after the 1117 earthquake; it communicates, at right, with the **Cappella Zen**. The interior of this latter, which is not open to the public, can be seen from the atrium through the bronze doors of the inner portal, which were brought from Constantinople and may date from the 6th century. Originally, the space where the chapel now stands was used as a vestibule and communicated with the Piazzetta by means of the so-called Porta da Mar. Access was reserved for those coming from the quay. It was walled up around 1504 so as to house the altar (dated 1515), the composite-order ciborium, the statue group *Enthroned Madonna and Child between St. Peter and St. John the Baptist,* and the monument to Cardinal Giovanni Battista Zen (d.

1501), which were cast in bronze by PIETRO CAMPANATO to a design by ANTONIO LOMBARDO and PAOLO SAVIN. The two Romanesque pink marble column-bearing lions at either side of the altar may originally have stood outside the Porta da Mar. On the right wall you can see a marble slab representing the *Nativity* and the *Flight into Egypt;* its date is uncertain. The lunette above the inner portal, not visible from the atrium, dates from the 12th century and has a mosaic of *The Odighitria Madonna with the Archangels Michael and Gabriel* (reconstruction, 1887-88). In the niches underneath, the central mosaic figure is Christ Emmanuel, flanked by eight prophets, four of which are statues (13th century), while the remaining ones are mosaic figures (late 13th-early 14th century). The mosaic cycle on the barrel vault, which dates back to 1270-80, illustrates *The Life of St. Mark,* in particular his writing his Gospel in Rome, the apostolic mission to Aquileia and Alexandria, Egypt, and his martyrdom. These scenes are the

prologue to the mosaics in the portals of the south façade, which, as we have seen, depict the transport of the body of St. Mark from Alexandria to Venice. In the Cappella Zen, a scene that was a special favorite of the doges and the populace was *St. Mark's Dream.* It can be seen in the lower register of the east section of the vault (at left, for those looking from the atrium). The saint and St. Hermagorus – the first legendary bishop of Aquileia – are sleeping on a boat. They were heading for Rome with a third person, and, according to the official legend, took refuge in the Venice Lagoon to avoid a storm in the open sea. It was here that the Evangelist had a dream in which an angel revealed that, once dead, his body would lie at rest precisely in that place. This prophecy was created deliberately by the Venetians, therefore justifying the purloining of their patron saint's relics from Alexandria and projecting the city's history into a divine dimension.

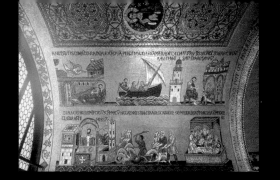

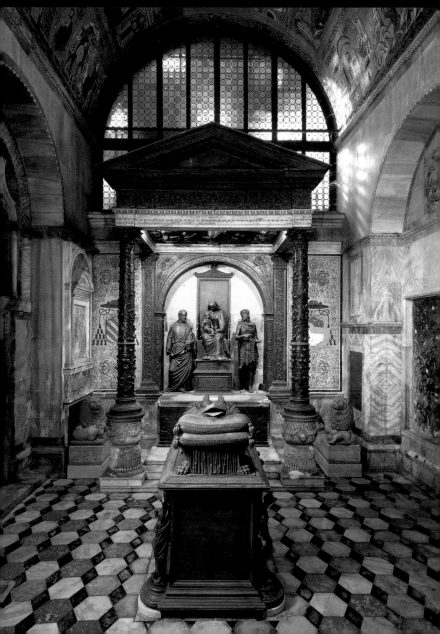

66 TOP LEFT *THE LEGEND OF NOAH*, DETAIL OF THE MOSAICS, ATRIUM VAULT.

66 BOTTOM *THE DELUGE*.

67 TOP THE ATRIUM SEEN FROM THE SOUTH.

67 BOTTOM *GENESIS*, FIRST DOME.

The **Atrium** or narthex of the basilica consists of two wide corridors crowned by arches and small domes. The first corridor was built after the 1117 earthquake, while the second one, which communicates with the north transept, was built in the first half of the 13th century. The original mosaics, realized from 1215 to 1280, were restored or redone several times over the centuries. The numerous, splendid scenes drawn from *Genesis* and *Exodus* show the faithful the path to salvation.

For those entering the atrium, the cycle begins with the **Dome of *Genesis*** or **Dome of the *Creation of the World*** (1215-25). The first scene, recognizable by the dove of the Holy Ghost with a halo, depicts *The Spirit of God Hovering over the Water*, and the last one, on the outer register, is *The Expulsion from the Garden of Eden*, with Adam and Eve leaving from a door. Along the second register, a particularly interesting scene is *The Creation of Man*, in which God, without a beard and in the guise of Emmanuel, is modeling a clay statue. On the spandrels

are four cherubs and, in the lunettes, some episodes from the *Life of Abel and Cain*. This is followed by the **Vault of *The Deluge*** (third and fourth decade of the 13th century), a prototype of the sacrament of baptism. Noah, a descendant of Adam and Eve, saves his offspring from destruction.

The visit continues with the central chamber of the atrium that, because of its characteristic shape (which already existed in 1419), is called the **Pozzo** ("well"). Its mosaics, dated 1549, are signed by the brothers FRANCESCO and VALERIO ZUCCATO and were executed to cartoons attributed to GIOVANNI ANTONIO DE SACCHIS, known as IL PORDENONE, or to FRANCESCO SALVIATI.

Central apsidal entrance: In the half-dome is the isolated figure of *St. Mark* in priestly garb against a solid gold background,

probably celebrating Easter Mass before being captured by the Saracens. This work, dated 1545, was executed by the ZUCCATO brothers to a cartoon by TITIAN. In the underlying register are the mosaics of the *Odighitria Virgin* (Indicator of the Way), the *Eight Apostles* and the *Four Evangelists*. These mosaics, by Greek artists, are among the oldest in the church and have been dated from the end of the 11th century to the early 12th century. The doors of the portal are Byzantine and made of orichalc, an alloy much like brass, like that used for the nearby door of San Clemente. The damascened panels, which are in poor condition, represent *angels*, *prophets* and *apostles*. In one of these is *St. Mark*, with the donor, the procurator Leo da Milin (who lived in 1112) at his feet. **Vault with the *Legend of Noah*** (third and fourth decade of the 13th century): On the second register are *The Building of the Tower of Babel* and *God Confounds the Language of the Earth* by scattering men throughout the world.

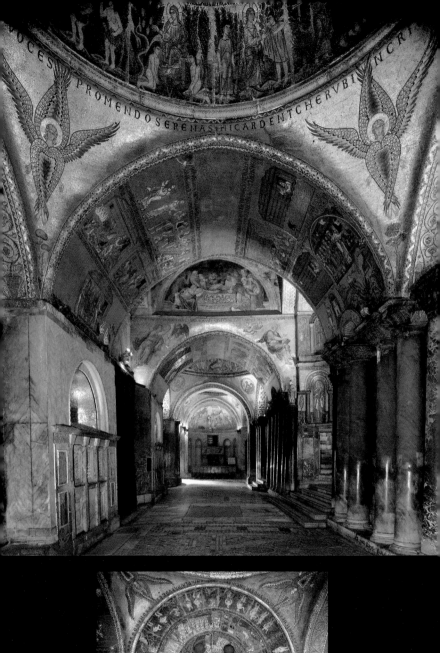

68 TOP *THE LEGEND OF JOSEPH* (THIRD PART), FIFTH DOME.

68 CENTER AND 68 BOTTOM RIGHT *THE LEGEND OF JOSEPH* (SECOND PART), FOURTH DOME.

68 BOTTOM LEFT *THE LEGEND OF MOSES* AND DETAIL, SIXTH DOME.

69 LEFT *THE LEGEND OF ABRAHAM*, SECOND DOME.

69 RIGHT *THE LEGEND OF JOSEPH* (FIRST PART), THIRD DOME.

The adjacent **Dome of Abraham** (third and fourth decade of the 13th century) has only one register. The story begins with *The Lord Orders Abraham to Leave for Canaan* and ends, after *The Birth of Ishmael*, with *Abraham Circumcising Ishmael and the Men of His House*. The prophets in the spandrels are Isaiah, Ezekiel, Jeremiah and Daniel. The story of Abraham continues in the lunette above the Porta di San Pietro with *Abraham Paying Homage to the Three Angels* and *The Three Angels Prophesy the Birth of a Son* (with Sarah listening behind a curtain), a prototype of the Annunciation. In the opposite lunette are *The Birth of Isaac* and *The Circumcision of Isaac*, followed, in the soffit, by the figure of Justice in a roundel, flanked by two stylite saints, Simeon and Alipius. The mosaics omit some famous episodes in *Genesis*: the punishment of Sodom, the birth and sacrifice of Isaac, as do the

two cycles of Isaac and Jacob. Next is the **First Dome of Joseph** (fourth decade of the 13th century), the son of Jacob and Rachel. The register begins with *Joseph's Dream*. Among the following scenes, the one that stands out is *Joseph Being Lowered into the Well* by his brothers – a prototype of the Deposition of Christ – and, next to the first episode, *Abraham in Despair upon Seeing Joseph's Bloody Coat*.

Along the north atrium is the **Second Dome of Joseph** (ca. 1260), with *Joseph Being Sold to Potiphar*; this latter figure is recognizable by his blue mantle and by the soldier behind him with a star-shaped shield. In one of the scenes with the wife of Potiphar tempting Joseph, she is seizing his mantle. In the pendentives, which for the first time are used for the main story, there are other scenes: *The*

Pharaoh Takes the Cupbearer Back into His Service, The Baker Hanging from a Tree, The Pharaoh Sleeping and *The Pharaoh's Dream*. Past the soffit with Hope (ca. 1260) in the middle and, on the north side, the lovely figure of St. Geminiano executed in 1535 by FRANCESCO ZUCCATO to a cartoon attributed to LORENZO LOTTO, is the **Third Dome of Joseph** (1260-70). Here, in addition to the scenes of famine in Egypt, are the episodes of Joseph meeting his brothers, which continue in the lunette that ends with *Joseph Welcoming Benjamin*. Lastly, on level with the Porta dei Fiori is the **Dome of Moses** (1270-80) which begins, toward the transept, with *Moses Abandoned and Found Again* and ends, at the same point, with the scene of *Moses Taking off His Shoes before the Burning Bush*. In the lunette is *The*

Passage of the Red Sea (16th century), after a cartoon by PIETRO MUTTONI (PIETRO DELLA VECCHIA), while the conch opposite, at left, has *The Miracles of the Manna and Quails* and, at right, *Moses Striking the Rock*. In the conch above the transept entrance, GIOVANNI MORO reproduced – fortunately respecting the original iconographic program – *Enthroned Madonna and Child with St. John the Evangelist and St. Mark* (1839-40). This subject is closely connected to the main figures portrayed in the domes. In fact, Adam, Noah, Abraham, Joseph and Moses are all read as prefigurations of Christ. It is with Him that the Christian community begins a new Creation, a new Exodus, and a new Covenant. in this way, Christians synthesized The Old Testament with The New Testament.

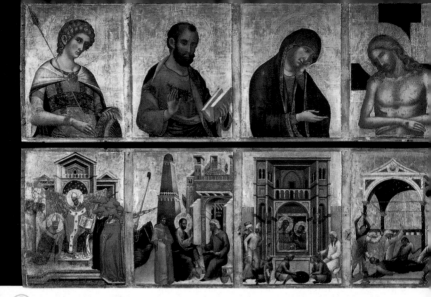

■ The atrium past the doorway into the central section of the nave gives access to the **MUSEO DI SAN MARCO** – inaugurated in 1927 and enlarged in 2003 – and the **Loggia dei Cavalli**. The mosaics in *Room 2*, known as the "Pozzo" ("well"), represent the *Book of Revelation*. The story, based on the Second Coming of Christ, begins in the east vault above the central section of the nave. The large barrel vault known as the **Vault of Paradise** (late 16th-early 17th century, with drastic reconstruction work done after 1870), has along the central band the *Etimasia* (preparation of the God's throne) surmounted by the *Deesis* or intercession. These two themes, the emblems of the realization of the kingdom of God, are the conclusion of the escatological and didactic program illustrated in the three main domes of the church. Past the large window one can go onto the basilica terrace. Back in the museum, you should visit *Room 5*, from which you can admire the Gothic rose window, the galleries with screens and plutei (6th-11th century), and the inlaid pavements. The mosaics on the arch above this illustrate *The Miracles of Jesus* (first half of the 12th century, restored in the 18th and 19th century), while on the wall and in the large north lunette there is *The Stump of Jesse* (1542-52) by VINCENZO BIANCHINI and assistants, after a cartoon by GIUSEPPE PORTA known as SALVIATI. *Room 7* – once part of the Palazzo Patriarcale – features some splendid watercolors representing St. Mark's Basilica (19th century). *Room 8*, which was once part of the Doges 'Palace, was designed by BAROLOMEO MONOPOLA in the 17th century to house the banquets for foreign ambassadors. The 18th-century frescoes on the ceiling by JACOPO GUARANA have ornamentation by FRANCESCO ZANCHI and stuccowork by BERNARDINO MACCARUZZI. Once past the "corridor" where fine liturgical paraments and fragments of tapestries are exposed (second half of the 15th century), you come to the monumental *Madonna del Latte* (Venetian-Byzantine school, first half of the 15th century), a figure of charity and salvation. The four tapestries on the walls (perhaps of Venetian origins) illustrate ten episodes from the *Life of Christ*. The cartoons are attributed to *Nicolò di Pietro*. Following is the *Pala Feriale* (weekday altarpiece), dated 1345 and signed by PAOLO VENEZIANO

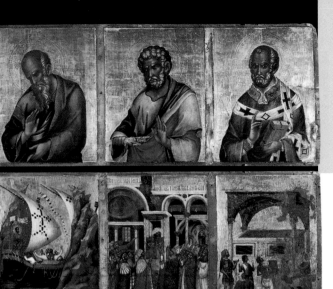

and his sons LUCA and GIOVANNI. The most interesting scene is the second from the right, representing the *Apparition of the Ark with the Body of St. Mark*. The legend relates that, during the construction of the third version of the Basilica, the Venetians had forgotten the location of the secret room where their patron saint had been placed. After much imploring, the saint revealed the site by breaking the marble slab that covered it. The clergy and the Signoria of Venice witnessed the miracle, which occurred along the right transept, in the pillar set against the altar of St. James. Having retraced your steps, you come to *Room 9*, where, beside fragments from plutei (5th-6th

century), are hosted the four **gilded bronze horses**, which originally stood on the terrace and have been replaced with copies. These works, each weighing 1,980 lbs (897 kg), were taken from the Hippodrome in Constantinople after 1204. Their date is uncertain; they may have been executed by a Greek or Roman workshop in the 2nd or 3rd century A.D.

And they are the only quadriga that has come down to us from antiquity: in fact, the harness shows that the horses were yoked to a chariot. These animals are divided into two pairs distinguished by their heads being bent toward one another and their raised hoofs: a play of symmetry that combines harmony and equilibrium with the vivid realism of their features.

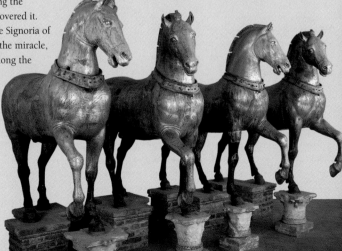

72 top and 72-73
THE PENTECOST
DOME VIEWED FROM
THE LEFT AISLE, AND
DETAIL.

72 bottom THE
MOSAICS ON THE
FIVE DOMES.

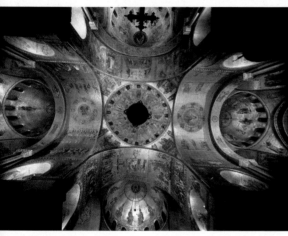

■ Returning to the main entrance of the atrium, we can now go into the **Interior** of the church. Along the median or main axes there are five segmental, slightly elliptical cupolas. Besides the drums, they are supported by tower-like elements connected by wide vaults that touch the base of each dome. Each tower or tetrapylon consists of four pillars merged by two rows of arches. This spatial organization is clearly evident in the case of the central dome, known as the "*cuba* (cupola) of St. Mark" and imitated for centuries in numerous Venetian churches. Taking into consideration only the five domes, St. Mark's has a Greek cross plan. However, if we bear in mind the smaller size of the domes at the ends of the transept and the greater length of the central section of the nave, we will see that the church also has a longitudinal, basilican plan. Furthermore, there are two "churches" mentioned by historic chronicles. The larger one was reserved for the city and marked off by the extension of the transept, while the smaller one was for the clergy and doge, delimited by the iconostasis and marked off transversely by the space connecting the two choirs on either side of the high altar. Therefore, three types of plan merge in the Basilica: the Greek-cross plan, derived from Byzantine models; the nave with two aisles plan that harks back to Early Christian churches; and the double cross plan,

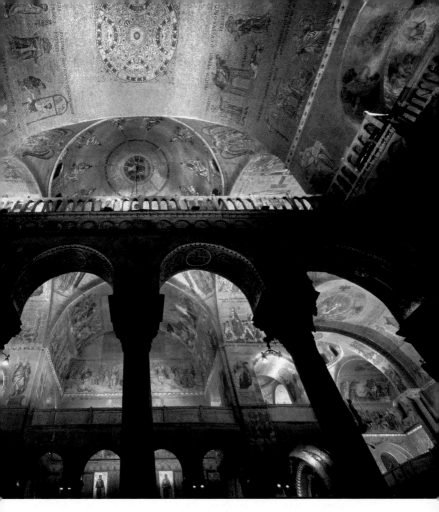

whose shape suggests the patriarchal cross – the symbol of the dignity of St. Mark and the independence of Venice. The vast and complex mosaic decoration of the interior was begun in the second half of the 12th century, covering an area of about 86,080: sq. feet (8,000 sq. m.). As was the case with the atrium, over the centuries the mosaics and their inscriptions were restored, altered or even redone. A centuries-old tradition based on rather feeble evidence and yet still alive, considers the Calabrian abbot and iconographer GIOACCHINO DA FIORE the inspirer, and perhaps even the creator, of the iconographic program of the mosaic decoration. The starting point for a reading of the mosaics should begin with the domes, followed by the vaults and walls. As was the case with the atrium, the mosaics had a didactic function. The main theme is God's design for the salvation of humanity, which takes place on two closely connected levels: the good tidings of the Kingdom of God and the time of the Church as the road to the end of the world. The linchpin of this theological discourse is the figure of Christ, understood as the advocate of humanity with God the Father. Other intercessors are the Virgin Mary, the apostles and the saints, who are depicted in different areas; they are emblems of the militant Church and the expression of the liturgical calendar that sanctifies human time, or the cycle of the year.

74 TOP DETAIL OF
THE PAVEMENT.

74 BOTTOM
PRAYING VIRGIN,
RIGHT AISLE.

75 TOP THE
INTERIOR LOOKING
TOWARD THE HIGH
ALTAR.

75 BOTTOM
AGONY IN THE
GARDEN, RIGHT
AISLE.

The splendor of the mosaics is matched, in the lower part of the church, by the dazzling marble casing on the walls and pavements, for the most part installed in the second half of the 13th century. An expression of richness and elegance, their colors or geometric shapes had particular symbolic meanings that have not yet been totally clarified. The old red porphyry, much like purple, stood for the majesty and the kingdom of Christ. The green Thessalian marble evoked hope for a better existence in the next world. Since in describing St. Mark's Basilica we must strike a compromise between the official itineraries and the counter-clockwise one used in this guide, we will begin our visit at the right aisle and then resume it in the central section of the nave. In fact, there are two official itineraries that converge in the right transept: one, on holidays and the day before holidays, begins from the right aisle; the other, on weekdays, goes along the central section of the nave.

Right aisle: this is covered with a vault whose mosaic decoration (late 12th-early 13th century; mostly restored in the 19th century) narrates the martyrdom of four saints, James the Less, Philip, Bartholomew and Matthew. The Church, depicted in the nearby west Pentecost Dome, is called upon – through its apostles – to testify to the blood shed by Christ to save mankind, a prefiguration of the suffering of the faithful. On the wall below this vault is the martyrdom of two of Jesus' disciples, Simon the Zealot and Jude, followed in the lower part by the

splendid, majestic *Agony in the Garden* (ca. 1214-20), created by three different mosaicists. After the Last Supper, during which the good tidings of the Kingdom of God are announced, Jesus goes to pray on the Mount of Olives, which became the theater of a dramatic conflict between the Son of Man, terrified by his imminent death, and the Son of God, conscious of the importance of his mission to implement the plan of divine salvation. So we have a connection with the testimony and necessity of martyrdom – understood as total abnegation – illustrated in the vault. Jesus is portrayed six times. Three times we see him praying, and another three he is rebuking Peter and the other disciples for falling asleep and for lacking in steadfastness and determination. On the wall below these scenes are five framed mosaic illustrations (1230-35): in the middle is the praying Virgin, flanked by four prophets announcing the coming of Christ.

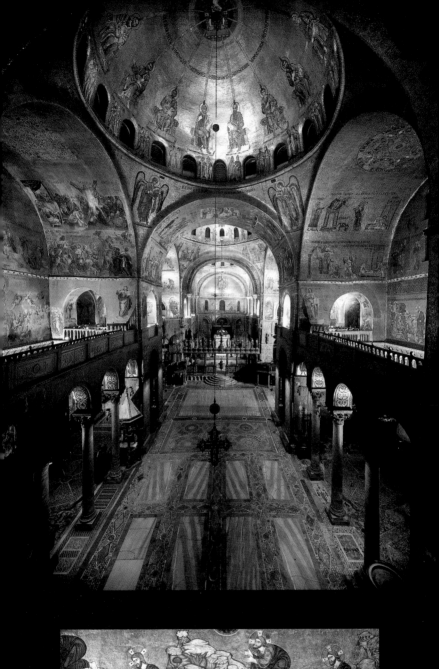

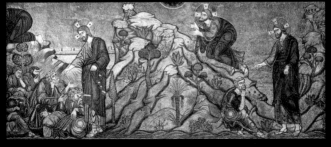

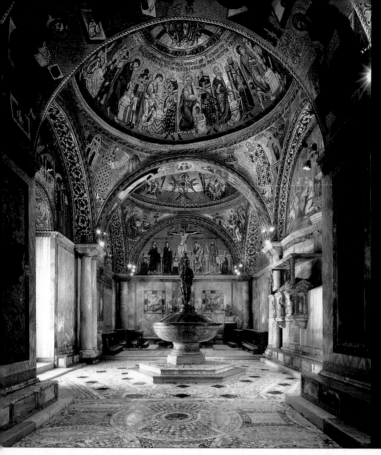

Along the wall is the entrance to the **Baptistery**, which is not open to the public. This room – once called Chiesa dei Putti, or Children's Church – was reorganized in the first half of the 14th century, perhaps thanks to the good offices of Doge Giovanni Soranzo (1312-28), whose tomb is in the ante-baptistery, the small room that communicates with the Cappella Zen. The theme of baptism is closely connected to that of the Pentecost, illustrated in the west dome of the church. For this reason, besides the prophets, there are interconnected scenes of the lives of St. John the Baptist – he who proclaims baptism by water and spirit – and Jesus. In the central band of the barrel vault of the ante-baptistery is the *Bust of God the Father*, flanked by eight prophets whose cartouches announce the kingdom and greatness of God. The side bands represent *The Magi Meeting Herod*, *Adoration of the Magi*, *Flight into Egypt* and *Massacre of the Innocents*. Among the other scenes is *The Baptism of Christ* above the sarcophagus of Doge Soranzo.

Past the soffit with the *Four Evangelists* is the **Dome of the Baptism**. In the middle, Christ, who has already risen to Heaven, reminds us, thanks to the Latin inscription in the cartouche, of the words he uttered to his disciples after his Resurrection: "Go ye into all the world, and preach the gospel to every creature. He that believeth, and is baptized." The sentence is interrupted at this point, but since it is well-known and, by no accident, is from the Gospel according to St. Mark, every Venetian of good faith knew the rest of it by heart: "shall be saved; but he that believeth not,

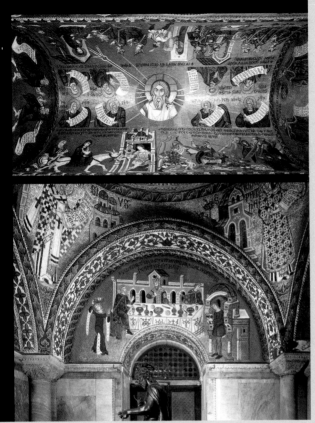

76 The Baptistery.

77 top God the Father and Prophets, ante-baptistery.

77 center left Herod's Banquet and Salomé.

77 center right Dome of the Baptism, detail of the mosaics.

77 bottom Dome of the Parousia.

shall be damned."
The outer band of the Dome of the Baptism shows the Apostles who, obeying Christ's divine instructions, baptize the people of the Earth and proclaim the universality of salvation. Baptism with water inaugurates the time of the Universal Church, that is, the people who enjoy salvation in Christ. This is the explanation of the figures of the Four Doctors of the Eastern Church inserted in the four spandrels below the dome, which are to be related to the figures of the four Doctors of the Western

Church represented in the adjacent dome. Among the other mosaics, mention should be made of the sensual and extremely elegant figure of Salome – in the lunette above the entrance to the church – who is walking and holding aloft the plate with the severed head of St. John the Baptist. The font under the dome has a bronze cover with the figures of the four Evangelists and scenes from the life of St.

John the Baptist (ca. 1545), the work of Tiziano Minio and Desiderio da Firenze, pupils of Jacopo Sansovino. The bronze statuette of St. John the Baptist (1565) on the cover is by Francesco Segala.

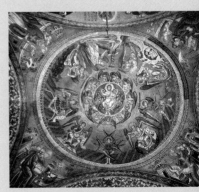

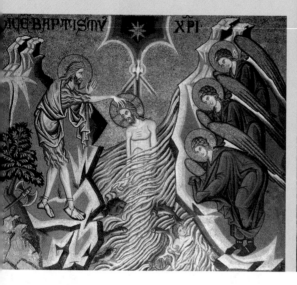

On the right wall is the sarcophagus of Andrea Dandolo (d. 1354), the last doge to be buried in St. Mark's, who commissioned the mosaics in the Baptistery, the original parts of which are thought to have been executed during his time as doge, which began in 1343. In the middle of this sarcophagus is the statuette of the Madonna and Child, flanked by reliefs depicting the martyrdom of St. John Evangelist and St.

Andrew (who has the same name as the deceased doge). At the ends, in niches, is the Annunciation, with the statues of the Madonna and the Archangel Gabriel, while on the upper sides are St. Leonard and St. Isidore. The other bay of the Baptistery is dominated by the **Dome of the Parousia (Dome of the Angelic Hierarchies)**, which has a singular iconographic program illustrating a pivotal aspect of the Last Judgment. In the middle, the Lord appears in his Second (and last) Coming. Around the tondo are nine red angels, manifestations of the immaterial celestial beings

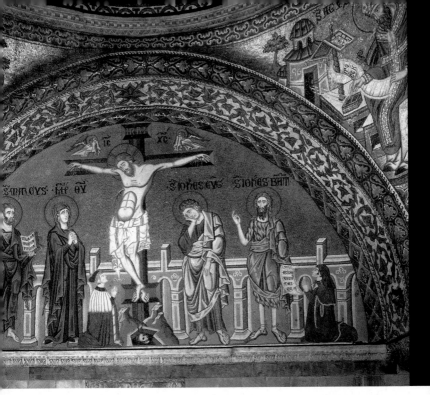

that imitate the purity of God by making themselves similar to fire. The reference to the baptism of fire, as the fulfillment of baptism of water, is evident. In the outer band of the dome, the nine angelic hierarchies take on various appearances and perform, for Christ the Lord, the apocalyptic acts that announce his Coming and the fulfillment of his reign. This message is for those who are baptized, those who seek salvation. The path is marked out by the cherub with eight wings, in whose blue disc are the words "Sience Plentitudo," that is, "the plenitude of science" or plenitude of knowledge to achieve salvation. For those who know how to interpret symbols, the solution is implicit in the image of the angelic creature, or better, in the cruciform arrangement of its wings. For those who cannot interpret symbols, the meaning becomes clear in the underlying lunette, in which the Crucifixion is represented. At the foot of the cross, the Doge Andrea Dandolo is praying, well aware of the salvific nature of the death and resurrection of Jesus. Next to him, the skull of Adam – placed at the foot of the sacred wood – is being baptized by the Lord, an eloquent sign of the good tidings. The theme of baptism is repeated in the wall below, where there are three fine reliefs by different sculptors. These reliefs date from the early 14th century: in the middle is the baptism of Christ, with two statuettes of angels holding candelabras, while the figures on either side are of St. George and St. Theodore. This room, which also houses the tomb of the architect and sculptor JACOPO SANSOVINO (1486-1570), still has, in the 11th-century structure, the original font and the block of granite above it.

80 AND 81 TOP
CHRIST ENTHRONED
WITH THE VIRGIN
MARY AND ST.
MARK, NAVE,
COUNTERFACADE.

81 BOTTOM THE
DOME OF THE
ASCENSION.

As has already been explained above, once the right aisle has been visited, our tour of the church will not continue along the transept, but moves on from the beginning of the **central nave**. Here we have the **Dome of the Pentecost** (second half of the 12th century, with many later renovations), the description of which should begin after that of the other two domes in the central section of the nave, and then proceed with the nearby vaults of the Apocalypse and of Paradise. In the middle of the dome is the throne of God, or *Etimasia* – the prefiguration of the Second Coming of Christ – on which is the dove of the Holy Spirit of God. From the throne are rays of light descending like jets of pure water in the form of tongues of fire that alight on the head of each Apostle. In keeping with Byzantine tradition, among them is St. Mark. With this baptism of the Holy Ghost, mentioned in *The Acts of the Apostles*, the new Covenant is inaugurated according to what Jesus said after his Resurrection. The Apostles receive the gift of other tongues in order to be able to spread the good news of the Kingdom of God throughout the world. And in fact the nations of the world, which will be converted by the apostles' message, appear between the small windows. The Holy Ghost of the Pentecost is the agent of the sanctification of Christians, who must aspire to Christ. This is the meaning of the words, abbreviated in Latin, on the cartouches held up by the four angels in the spandrels: "Holy, Holy, Holy is the Lord." On the inner façade, the lunette above the entrance contains *Christ Enthroned with the Virgin Mary and St. Mark* (mid-13th century). The Latin inscription carved on the stone band above clarifies its salvific meaning and connects it to the themes illustrated: "I am the way; whosoever enters through me will be saved and will find nourishment." Proceeding toward the high altar, you will note, at the sides, the two series of three columns with gilded Byzantine capitals. Before heading to the right, as does the official itinerary, it is worthwhile stopping to admire the famous dome and the works of art below it. Above is the **Dome of the Ascension** (late 12th century), dominated by the figure of Christ being lifted to Heaven by four angels.

This scene, mentioned in *The Acts of the Apostles*, is set on the Mount of Olives. Among the trees appear Jesus' disciples and, aligned with the Lord, is the Madonna praying. At his side are two men "in white apparel," here depicted as angels, who said: "Why stand ye gazing up into heaven? This same Jesus, which is taken up from you into heaven, shall so come in like manner as ye have seen him go into heaven." The Ascension (or Sensa, one of the most popular religious feasts) is therefore the prelude to the Parousia illustrated in the vault of Paradise and in those of the central portal. Between the windows are Seven Virtues and Nine Beatitudes that set an example for those who seek salvation. In the spandrels, the Four Evangelists remind us that the teachings of the Virtues are explained in the Gospel. Under their figures are the images of four men with an amphora from which water is spouting. These are the allegories of the rivers of Paradise, which were repeated in a later period in the gargoyles of the west façade. Their water, the symbol of the Gospel and of the holiness of God's word, is the promise of a new life.

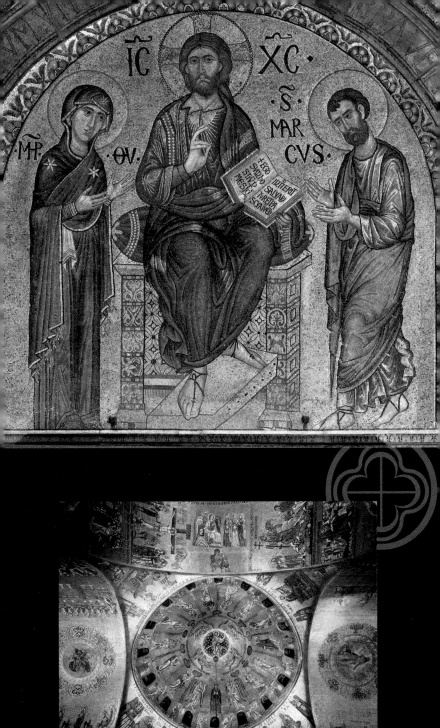

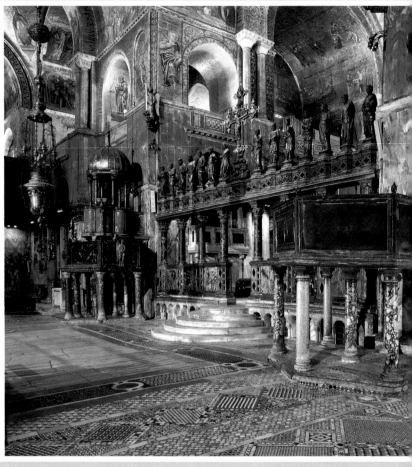

82-83 THE TWO
AMBOS AND THE
ICONOSTASIS ALONG
THE TRANSEPT.

82 BOTTOM *THE
DESCENT INTO
LIMBO*, CENTRAL
DOME, WEST VAULT.

83 TOP DETAIL OF
THE MOSAICS,
APSIDAL CONCH,
CHAPEL OF ST.
PETER.

In the four vaults that
support the dome are the
main episodes of the life of
Christ as narrated in the
Gospels. Their function is
to explain to the
congregation that the
Kingdom of God is here and
now, and that salvation can
be gained by anyone who
converts to Christ's
teachings. The oldest scenes
are in the south vault – *The
Temptations of Christ*, *The
Entry into Jerusalem*, *The
Last Supper* and *Christ
Washing the Disciples' Feet*:
(first half of the 12th

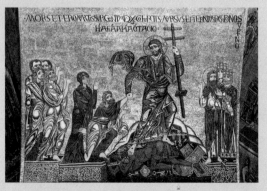

equivalent to the Resurrection (*Anastasis*); in the middle, *The Marys at the Tomb*; at right, *Judas' Kiss* and *Pilate's Sentence*, which are surmounted by the moving, crowded scene of the Crucifixion. Between the two splendid marble ambos is the majestic **Iconostasis**. The small windows at the sides of the stairway communicate with the crypt. This rood screen is divided into three parts. The central one, which separates the chancel from the central nave, has on the

83 CENTER *THE ENTRY INTO JERUSALEM*, CENTRAL DOME, SOUTH VAULT.

83 BOTTOM LEFT *JUDAS' KISS* AND *PILATE'S SENTENCE*, CENTRAL DOME, WEST VAULT.

83 BOTTOM RIGHT *CRUCIFIXION*, CENTRAL DOME, WEST VAULT.

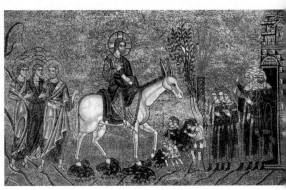

century) – and in the west vault (last decades of the 12th century): at left, *The Incredulity of St. Thomas* and *Noli me tangere*, which are surmounted by *The Descent into Limbo*, which in Byzantine iconography is

middle of the trabeation a silver crucifix dated 1394 and signed by MARCO BENATO; on the sides are the statues of Our Lady of Sorrows, St. John Evangelist and the Apostles, also dated 1394 and sculpted by

JACOBELLO DALLE MASEGNE. The other two sections, realized by PIERPAOLO DALLE MASEGNE, are in front of the chapels of St. Peter and St. Clement and both have a Madonna and Child flanked by four saints (1394-97).

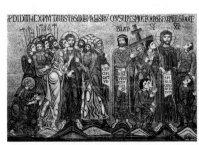

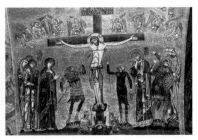

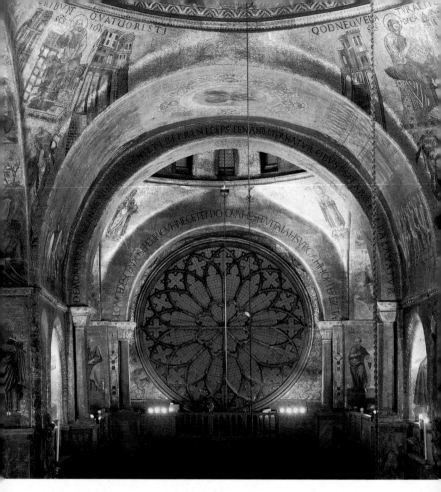

Continuing along the official itinerary, we now enter the **right transept**, dominated by the **Dome of St. Leonard** (mid-12th century) and the large Gothic rose window (late 14th-early 15th century). Compared to the others, this dome is rather austere, and the saints represented there (Saints Leonard, Nicholas, Clement, and Blaise) are perhaps to be understood as figures particularly dear to the doges. On the other hand, the female saints in the spandrels (Saints Dorothea, Euphemia, Erasma and Thecla) refer to the city and patriarchate of Grado. The vaults, large lunettes and walls that support this dome have scenes concerning the life of Christ, the Virgin Mary and some saints that highlight their miracles. This choice was by no means casual; it is related to the escatological subject matter illustrated along the central section of the nave. The preaching and miracles are in fact signs of the presence of the Kingdom of God that demonstrate the end of Satan's reign.

The famous mosaic situated in the west wall of the transept and depicting *The Apparition of the Body of St. Mark in the Basilica* (mid-13th century) is the first known representation of this episode, called the *Inventio*, which according to tradition occurred in 1094, the year when the third version of the basilica was completed and consecrated. As was mentioned above, it seems that the Venetians had forgotten where they had placed the body of St. Mark and therefore began a

84-85 THE ROSE WINDOW IN THE RIGHT-HAND TRANSEPT.

85 *THE APPARITION OF THE BODY OF ST. MARK IN THE BASILICA* AND DETAIL, RIGHT TRANSEPT, WEST WALL.

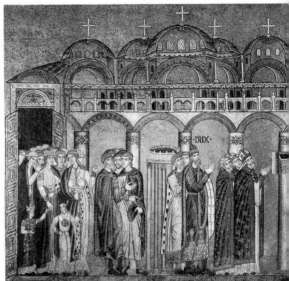

three-day fast. On the fourth day – as can be seen in the first part of the mosaic, at left – they gathered in the Basilica to pray for divine aid in their search for the saint's body. Suddenly a column in the church opened up, revealing the precious hiding place. In the right-hand part of the mosaic, the saint's body cannot be seen, since this episode depicts the final thanksgiving ceremony. However, we can see the place where the body was cached, which is also shown in the painting of the *Pala Feriale*, the cover of the Pala d'Oro kept in the Basilica Museum. This mosaic is particularly interesting in that it also shows us a view of the inside of St. Mark's. Note the two domes, still lacking the outer casing; also, we can see the two ambos and the baldachin of the high altar.

In the right transept, the **St. Leonard (or Holy Sacrament) Altar** stands against the east wall. The column at the left is the one of the famous miraculous apparition of the body of St. Mark described above. The small Altar of St. James (ca. 1469), situated at its feet, financed by Doge Cristoforo Moro (1462-71) and built by ANTONIO RIZZO, is the only (and quite significant) example of early Renaissance sculpture in the Basilica, together with the twin Altar of St. Paul in the left transept.

The central portal, situated at the head of the transept, communicates with the Foscari Corridor in the Doges' Palace, while the door at right leads to the **Treasury**.

86 FRONTAL WITH SCENES FROM THE LIFE OF ST. MARK, BASILICA TREASURY.

87 TOP BUST OF THE ARCHANGEL MICHAEL, ICON, BASILICA TREASURY.

87 BOTTOM THE ARCHANGEL MICHAEL STANDING, ICON, BASILICA TREASURY.

■ In the nearby room of the **TREASURY** are housed, for precautionary measure, the most precious relics and works of art on display here, which mostly came from Constantinople. Some were sent by Doge Enrico Dandolo in 1205, while others arrived during the Latin occupation of the city, which lasted until 1261. Some other objects were placed in the Treasury in the following centuries, either sent from other cities, donated by private citizens or pawned in exchange for huge loans from the Republic. Unfortunately, Napoleon's victorious army demanded a large sum of money from the city, and in 1797 the city was obliged to melt down and sell many gold and silver objects in the Treasury.

The immense value of this collection does not lie only in the precious materials used to make the various objects, but also in the relics, especially those concerning the Passion of Christ and his imitators, the saints. These were considered tangible proof of

the Kingdom of God, a concrete exemplification of the subjects illustrated in the mosaics. Since they were considered fragments of the splendor of Paradise, they were priceless. They were not only a demonstration of the power and prestige of those who owned them, but also attested to their role and hierarchical position in the Christian community.

The precious collection include the jewels that once decorated the Madonna *Nicopeia* icons situated on the altar of the same name. On the next wall, one frontal – which dates from ca. 1300-1336 and was restored in 1885 and 1888 – is made of gilded silver on a wooden base. In its lower register are fourteen scenes from the *life of St. Mark*. Here you can also admire candelabra, a small marble ciborium, rock-crystal plates, a splendid turquoise glass bowl, mother-of-pearl ships, onyx chalices, a ruby glass ship, a sardonyx ampulla,

the inner side of a Gospel cover (no. 142; 1230-40) made of embossed silver leaf on wood, attributed to the so-called Artist of Tournai. Among the precious works in the glass cases in the middle of the room are: a 4th-century *situla* (no. 13) with hunting scenes made of blown glass enclosed in a *diatretum*, a finely wrought network of pierced glass; the extremely elegant icon with the *bust of the Archangel Michael* (no.17) from Constantinople (late 10th-early 11th century) made of gilded silver, gold cloisonné and precious stones; on the lower shelf, the splendid icon of the *Archangel Michael standing* (no. 16; from Constantinople, late 11th-early 12th century); the Byzantine *Reliquary of the True Cross* (no. 24; late 10th-early 11th century). In the room opposite, the **Sanctuary**, are the relics – the pride and joy of Venice and the Signoria – put on display and carried in procession during religious ceremonies or processions.

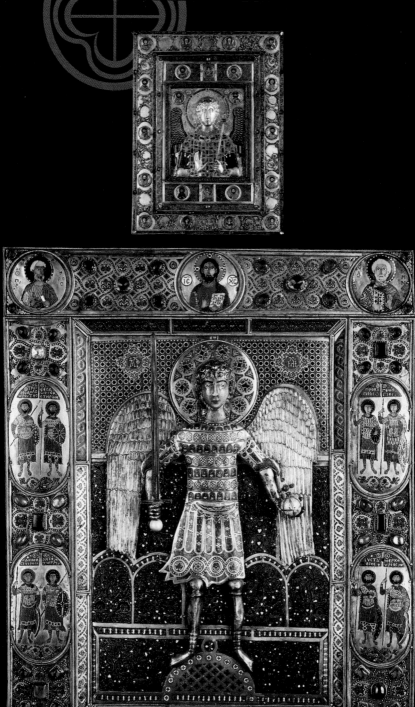

88 TOP ALTAR OF THE CHAPEL OF ST. CLEMENT.

88 BOTTOM THE CRYPT.

89 TOP LEFT EAST DOME OF EMMANUEL.

89 TOP RIGHT AND BOTTOM CHANCEL WITH CIBORIUM AND DETAIL OF THE APSE CONCH.

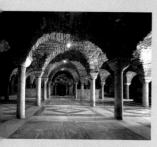

■ Go back to the right transept and proceed to the Cappella di San Clemente. Next to the access stairway of this chapel is another one that leads down to the **CRYPT**, which is not open to the public. It has three apses and is supported by 56 small columns, and it was here that the body of St. Mark was laid. The oldest masonry dates back to the construction of the first basilica. Once past the short iconostasis, you are in the **CHAPEL OF ST. CLEMENT**. Right, in the lunette with the mosaics of *Cain and Abel*, there is a window that communicates

with the Chapel of St. Nicholas, in the Doges' Palace, where the doge sat and followed the weekday masses. The door below, which communicates with the palace, is connected to the Cortile dei Senatori. Above, past the women's galleries, you can see the vault of the **south choir**. This area, together with its counterpart on the opposite side, makes up the transverse arm of the so-called minor cross of the basilica. The fourteen mosaic scenes on the vault and lunette represent episodes of the *theft and translation of the body of St. Mark from Alexandria to Venice* (first half of the 12th century). Under the women's galleries is the conch with the mosaic of *St. Clement* (first half of the 12th century, restored in 1892-95). The marble altarpiece in relief placed above the altar comes from

the nearby Chapel of St. Nicholas; among the figures is the Doge Andrea Gritti (ca. 1524). Turning left, note the soffit with the *Enthroned Christ* (12th century, restored in the 15th century), crowned by a Latin inscription inviting the faithful to meditate on the meaning of the holy images: "In fact, God is that which the image shows, but it is not God. You see the image, but with your soul you venerate that which you recognize in it." The lavish Gothic tabernacle underneath (1388), with side pillars, is attributed to JACOBELLO and PIERPAOLO DALLE MASEGNE and workshop, who also probably executed the tabernacle on the opposite side.

The **Chancel**, the liturgical and iconographic heart of St. Mark's, is dominated by the **Dome of Emmanuel** (early 12th century and 1170). In

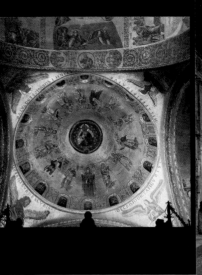

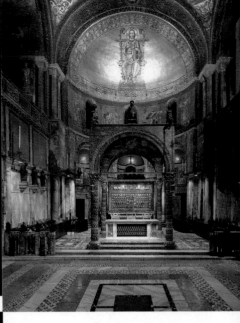

the middle is the figure of *Emmanuel* (15th-century reconstruction), he who remains forever and whose kingdom is everlasting. The figure, depicted much like a young beardless Apollo, also appears in the mosaics in the atrium. In this latter context, which refers to the Old Testament, Emmanuel expresses the presence of God as the guide of the chosen people. But on the dome he is the prefiguration of Christ: below him is the Virgin Mary praying, she who – according to the prophet Isaiah, at her left – "shall conceive, and bear a son, and shall call his name Emmanuel." (The name *Emmanuel* means "God is with us.") It is in this dome above the altar with the body of St. Mark that the theological and pedagogical discourse on all the mosaics in the basilica begins. The

ongoing parallel between Christ and St. Mark declares and demonstrates the faith of the Venetian government and the central role it plays in Christendom.

On the spandrels of the dome are the symbols of the *Four Evangelists*, while the apse conch contains the imposing figure of Christ on a throne, dated 1506 and signed by a mosaicist named PIETRO. In the register underneath this are *St. Nicholas*, *St. Peter*, *St. Mark* and *St. Hermagorus* (late 11th-early 12th century). Hermagorus was the legendary first bishop of Aquileia. In the lower part of the chancel, next to the two ends of the rood screen, are the two small choirs on the parapet of which are eight bronze panels by JACOPO SANSOVINO

illustrating *St. Mark the Miracle-worker, His Martyrdom and Posthumous Miracles* (1537-44). The same artist executed the four bronze statues of the Evangelists (1550-52), placed above the balustrades.

The **high altar**, probably dating from around 1209, was a worthy frame for the Pala d'Oro. The *verde antico* marble ciborium is held up by four alabaster columns of uncertain date and provenance (probably the 11th-12th century). On the shafts are sculpted, like three-dimensional miniatures filled with details and explanatory inscriptions, the *Life of the Virgin*, *Childhood of Christ*, *Episodes from the Life of Christ* and the *Passion and Resurrection of Christ*. These subjects were drawn from written sources dating from the 6th-9th century.

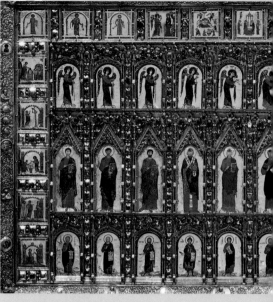

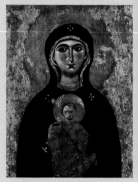

In the apse is the **Pala d'Oro**, the dazzling, amazing image of the plenitude of the Kingdom of God and of Venice's faith, an admirable example of the combination of Byzantine and Venetian Gothic goldsmithery. This work is divided into two main parts, both highlighted by a frame, which probably have no connection with the original *pala* (altarpiece) commisioned by Doge Pietro Orseolo I (976-978). The oldest section is the lower one, finished in 1105, as is stated in the 14h-century inscription below it. It is divided into two laminae between which are the *praying Virgin*, *Doge Ordelaffo Falier* (1102-08), who commissioned the work, and the *Empress Irene*. These three figures are surmounted by a *Christ Pantocrator* (early 12th

century) flanked, at the corners, by the *Four Evangelists*, an allegory of the Lord's chariot and hence an expression of the Church, in keeping with the visions described in *Revelation* and *Ezekiel*. In the small upper enamel we can recognize the *Etimasia* with the dove of the Holy Ghost. The same subject, referring to the Pentecost, was taken up again in the central part of the Pentecost (west) Dome. The horizontal series of enameled panels depicts fourteen episodes from the *life of Christ and three saints*. Proceeding downward, the horizontal series illustrate the *archangels*, *Apostles* and *prophets*. The two vertical series at the ends describe ten episodes from the *life, martyrdom and translation of St. Mark*; they form the oldest figurative cycle

concerning Venice's patron saint.

The upper part of the Pala d'Oro was added in 1209 (as an inscription tells us). Its magnificent enamels came from Byzantium and represent six episodes in the life of Jesus and Mary: *The Entry into Jerusalem*, *Crucifixion*, *Descent into Limbo*, *The Ascension*, *The Dormition of the Virgin* and the *Pentecost*. These scenes are interrupted in the middle by the enamel piece with the *Archangel Michael*. The frame of the Pala was entirely redone under Doge Andrea Dandolo, thanks to the work of BONESEGNA and another goldsmith (1342-45). Before leaving the apse, take a look at the *sacristy door* (mid-16th century), a work in bronze designed by JACOPO SANSOVINO with scenes of *Christ's deposition and resurrection*.

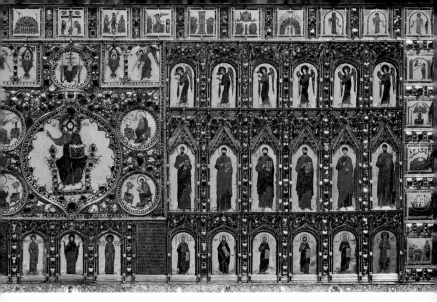

Now in the left transept, note the *small Altar of St. Paul* (ca. 1469), financed by Doge Cristoforo Moro (1462-71) and executed by ANTONIO RIZZO.

Further along is the **CHAPEL OF ST. PETER**, not open to the public and originally reserved for the clergy of St. Mark's. On high, past the women's gallery, you can see the vault and lunette of the **north choir**, with the mosaic cycle concerning *St. Mark at Rome, Aquileia and Alexandria* (first half of the 12th century, mostly redone in 1867-80). In the conch of this chapel is *St. Peter with the keys to the kingdom* (first half of the 12th century). The altar was rebuilt around 1885. The gilded relief altarpiece has *St. Peter and Two Kneeling Donors* (early 14th century). The door behind the altar leads to the **SACRISTY** (1486-1493), by master builder GIORGIO SPAVENTO. The mosaics on the ceiling were executed in 1524 by FRANCESCO ZUCCATO, MARCO LUCIANO RICCIO and ALBERTO ZIO based on cartoons by TITIAN and other artists.

The marquetry (1498-1500 and subsequent restorations) on the wardrobes or credenzas were signed by or attributed to the Mantuan brothers ANTONIO and PAOLO MOLA. Eight of these views contain episodes from the *life of St. Mark*. The marquetry of the underlying doors were begun by the same wood-carvers and finished in 1523 by the Olivetan friar VINCENZO DA VERONA and by the Jesuit PIETRO DA PADOVA. At left is the entrance to the **Chapel of St. Theodore**, built together with the reconstruction of the sacristy. On the two side walls are four canvases by GENTILE BELLINI that once decorated the shutters of the organ situated in the right (south) choir of the basilica and are portraits of *St. Mark, St. Theodore, St. Jerome and St. Francis* (1464-86).

The **LEFT TRANSEPT** is reserved for those who wish to pray, but visitors can view it, although at a distance. The area is crowned by the **Dome of St. John** (first half of the 12th century). For the most part, the mosaics on the vaults below, on the large lunettes and on the walls concern the Virgin Mary and Jesus 12th century; with additions in 1611-14 and restoration works in 18th and 19th century). The west vault and lunette illustrate the *life of the Madonna* (mid-12th century) according to the apocryphal gospels, with the emphasis on her

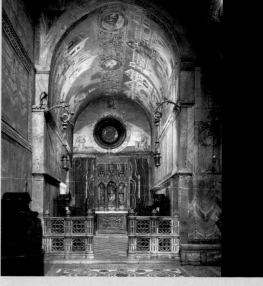

marriage with St. Joseph, the *Annunciation* (represented here as Mary is on her way to the well), the flight to Egypt and return to Palestine, and *Jesus among the Doctors*. The north wall and lunette are entirely taken up with the *genealogical tree of the Virgin*, the so-called *Tree of Jesse*, realized by VINCENZO BIANCHINI and assistants in 1542-52, on a cartoon by GIUSEPPE PORTA, known as IL SALVIATI.

The left transept is divided into three areas. The east one has the **altar** originally named after **St. John** and, since 1618, when it was partially renovated at the behest of the doge Giovanni Bembo, has been known as the **Altar of the Madonna Nicopeia** because of its famous icon. This holy image was yet another part of the spoils brought from Constantinople after the sack of 1204. The *Nicopeia*, or Madonna Victorious, was considered the patron saint of the Byzantine Empire and, at Venice, where she is still quite popular, the people

would pray to her during wars and calamities – as in 1630, when, pleading for the plague to end, the Signoria made a vow to build a church (the Salute basilica). This Byzantine painting was executed sometime before the 10th century. After the infamous theft of 1967, the jewels that adorned it are now kept in the Basilica Treasury. The frame, which dates from 1617-18, was made by a certain ANTONIO, a goldsmith "at the Cavaletto" who used precious stones and sixteen 11th-century enameled plaquettes to make it. In the central area of the left transept are many fascinating geometric motifs on the sectile pavement. Some scholars maintain that these motifs – in this case, the large cross and the eleven circumferences – contain symbolic references whose meaning coincides with

those on the domes or the vaults above them.

At the head of the left transept is the entrance to the **CHAPEL OF ST. ISIDORE**, which was begun in 1350 under Doge Andrea Dandolo (1343-54) and completed under Doge Giovanni Gradenigo (1355-56). The remains of St. Isidore were brought to Venice from the island of Chios in Greece in 1125 and set in the lovely sarcophagus (ca. 1355) situated above the altar and executed by two sculptors. The mosaics on the vault are divided into two registers. The southern one, to the right of the altar, has episodes from the *Life of St. Isidore* (mid-14th century). The scenes of *St. Isidore Being Dragged by a Horse* and *The Decapitation of St. Isidore* also appear on the sarcophagus. The north register narrates the story of the translation of the body of the saint from

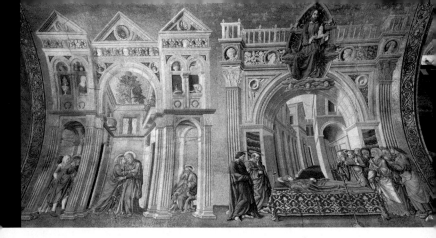

Chios to Venice on the part of Doge Domenico Michiel (1118; abdicated in 1129). In the lunette toward the entrance there is the *Enthroned Madonna and Child with St. John the Baptist and St. Nicholas*, and in the one over the altar, *Enthroned Christ with St. Mark and St. Isidore*. In the west area of the transept there is the **CHAPEL OF THE MADONNA DEI MASCOLI**. This was rebuilt in 1430 (as the plaque tells us) by Doge Francesco Foscari, probably to fulfill a vow made after he survived an assassination attempt, and dedicated to the Virgin Mary. The name "Mascoli" dates back to 1618, when the chapel was granted to the confraternity of the same name, founded in 1221. The origin of the name is uncertain. It may have been used because the confraternity members were all males (*mascoli*), or because they prayed to the Virgin Mary to have male children. The mosaics on the vault, signed by the mosaicist MICHELE ZAMBONO (or GIAMBONO) and dating from around 1449-50, narrate some episodes from the life of Mary. ANDREA DEL CASTAGNO is considered one of the possible authors of the cartoons.

The niches in the frame of the altarpiece, an example of flamboyant Gothic, has the statues of the Madonna and Child, St. Mark, and St. John Evangelist (ca. 1424), probably executed by an assistant of LORENZO GHIBERTI.

Once in the **LEFT AISLE**, you will see the small hexagonal altar with a ciborium, which has the miraculous *Crucifix* on display. The main mosaics, like those in the right aisle, illustrate the martyrdom of the Apostles. The scenes on the vault were executed by LUIGI and GIROLAMO GAETANO on cartoons by ANTONIO VASSILACCHI, known as L'ALIENSE (1607-20), ALESSANDRO VAROTARI, known as IL PADOVANINO (1621), and TIZIANELLO (1622-23); those on the large lunette, dedicated to *St. Peter and St. Paul*, are the work of the mosaicists LUIGI GAETANO, LORENZO CECCATO and GIACOMO PASTERINI, on cartoons by PALMA GIOVANE (1619-20 and 1624). The large mosaic on the wall below represents *Paradise*, by LUIGI GAETANO and GIACOMO PASTERINI, with cartoons by GIROLAMO PILOTTI (1628-31). Under this mosaic are five framed mosaic illustrations with Christ Emmanuel in the center flanked by four prophets (1225-30).

■ Once outside St. Mark's, in front of the main façade you will see the three **flagpole bases** (1505), round bronze pedestals by ALESSANDRO LEOPARDI.

■ In 1902, the **Campanile**, already in poor condition, collapsed and an exact reproduction was made in 1903-12 by LUCA BELTRAMI and GAETANO MORETTI. In front of the campanile entrance is the **Loggetta**, designed and built by JACOPO SANSOVINO in 1537-49, and reconstructed after the collapse. This construction housed the Loggia dei Nobili and, from 1569 on, the Arsenal workers' guard corps. In 1749, GIORGIO MASSARI added the access terrace. A year later, ANTONIO GARO (or GAI) did the *bronze gate* and the two side reliefs with *putti* in the attic. The original figurative programme was conceived by the procurator Vettor Grimani. The allegorical statues, signed by SANSOVINO, celebrate the virtues of the aristocracy. The high reliefs are the work of DANESE CATTANEO, GIROLAMO LOMBARDO AND TIZIANO MINIO. The one at the center represents *Venice in the Form of Justice*. To the

left is *Zeus and the labyrinth at Knossos* – an allegory of the island of Crete ruled by the Venetians – while to the right, the figure of *Venus* evokes Cyprus.

■ To the left of the Loggetta is the **Libreria Vecchia** or **Sansoviniana**.
HISTORY: This edifice, contructed with the purpose of housing a public library, was built by SANSOVINO – starting 1536 – until the 16th arcade toward the quayside, while the task of completing the works (1583-90) was given to VINCENZO SCAMOZZI.
FAÇADE: The double portico on columns in the Doges' Palace is matched here by a double series of superposed arches on pillars, modeled after BRAMANTE and the Theater of Marcellus in Rome. The portico – doric in order and in an axis with the nearby campanile – inaugurated the ambitious plan of giving the entire St. Mark's area the appearance of a Roman *Forum*, which was to be completed in the

subsequent decades. The first arch toward the campanile is dated at 1538. A particular object of study and planning was the angle bracket of this arch – which was damaged when the campanile collapsed in 1902 – and its corner metope. At a 90° angle so as to avoid any interruption of the frieze, this little panel reveals the architect's intention to make the façade of the square a stylistic continuum. The portico is surmounted by Ionic arches in which there are elegant windows. This is a narrow Serliana whose slender, paired, cabled Ionic columns were rotated inwardly and aligned with the deep side antae. Note the tall frieze, modeled after Roman prototypes and placed there to conceal an attic, which is embellished by high reliefs of putti holding festoons overflowing with fruit. It is surmounted by a balustrade with statues of pagan gods (1586-91) sculpted by CAMILLO MARIANI, AGOSTINO

94 St. Marks' Square.

95 LEFT Loggetta of St. Mark's Campanile, detail.

95 RIGHT The Piazzetta, Libreria Vecchia and Loggetta.

and Virgilio Rubini, Girolamo Campagna, Tiziano Aspetti and others. This frieze is an unusual invention that emphatically ends a plastic-sculptural crescendo that begins in the lower part of the building. In fact, with its accentuated chiaroscuro the façade marks the abandonment of late Gothic and Neo-Byzantine polychromatic architecture. The sculpture work on the exterior, attributed to Alessandro Vittoria, Bartolomeo Ammannati, Danese Cattaneo and Pietro da Salò, is a prelude to the decorative cycles in the interior based on the themes of the wisdom, erudition and virtues of an aristocrat. The exaltation of the ancient origins and power of the Venetian Republic – evoked by the lions' heads on the keystones and by the metopes with lions of St.

Mark – intermingles with an erudite exposition of classical mythology taken from authors such as Hesiod and Ovid. We do not know who inspired this encylopedic iconographic program, but contributions may very well have been made by Pietro Bembo, Vettor Grimani – the procurator who followed the construction work on the Loggetta and the Libreria – and the Florentine canon Girolamo de' Bardi, who was called upon to suggest the subjects of the statues along the balustrade.

The recumbent figures in the spandrels on the ground floor represent the Rivers, a probable allegory of the Venetian mainland territory and its gifts and, on the piano nobile, the Winged Victories. The soffits behind the lions' heads on the

arcade have grotesques in relief, while the human heads of pagan divinities (from right to left, Saturn, Jove, Juno, Mars, Venus, Minerva, Diana, Apollo and Pan) are accompanied, again in the soffits, by three scenes concerning the respective god. In the soffit of Jove, the fourth, the central panel representing Seated Jove with the Eagle and Thunderbolt is flanked by The Fall of the Giants and The Fall of Phaeton, obvious allusions to Arrogance and Conceit. Behind the arcade, on a level with the arch of Juno, is the old entrance to the Museo Nazionale Archeologico (no. 17), the present entrance of which is in the Ala Napoleonica. Going back outside, in the soffit of Venus the two side reliefs depict Venus and Adonis and Venus and Mars Snared with a Net by Vulcan.

INTERIOR: the entrance to the Old Library of St. Mark is in the arcade, but visitors must enter at the Ala Napoleonica. The portal is recognizable by the two *Caryatids* on the side (1553), which Vasari called "Junoesque women of stone." The one at right bears the initials of ALESSANDRO VITTORIA along her girdle, but both works were really sculpted by his two assistants, LORENZO and GIACOMO RUBINI. These sensual figures, which are the ideal counterpoint to the two terrifying Giants situated in the vestibule of the nearby Zecca, introduce us to the Neo-Platonic themes of Love and the

Virtues as prime movers of the universe, which are illustrated in the decoration inside. Following is the monumental STAIRCASE modeled after the Scala d'Oro in the Doges' Palace. The stuccoed vaults (1556-59) are by ALESSANDRO VITTORIA, while the frescoes were executed by GIAMBATTISTA FRANCO and BATTISTA D'ANGELO, known as BATTISTA DEL MORO. Taken from mythological

and astrological sources, these subjects – the Liberal Arts, the Seasons, the Virtues – illustrate the ascending steps toward universal knowledge. In the vestibule to the right (left for those coming from the Museo Archeologico) of the upper landing, inside a showcase protected by a curtain, is the extraordinary mid-15th century *projection world map* drawn by the Camaldolite cartographer FRA' MAURO. The lovely Ionic portal affords access into the vestibule or ANTECHAMBER. The ceiling has *trompe l'oeil* architectural painting (1559-60) by the Brescians CRISTOFORO ROSA and his brother STEFANO, in the octagonal panel of which is the *Allegory of Wisdom* (1560) by TITIAN. This

young woman, the thematic linchpin of the entire library, is seated on the clouds much like an evangelist, holding a long cartouche and wearing a crown of laurel.

Originally, this chamber housed the humanistic Scuola dei Nobili, where the Venetian patricians learned Latin and Greek. Later it was transformed into the Museo Grimano or Pubblico Statuario (Public Statuary Museum), opened in 1596, after Cardinal Domenico Grimani, his nephew Giovanni, Patriarch of Aquileia, and Federico Contari donated their prestigious collections to the Libreria. On this occasion, since it was necessary to house the sculpture collection, VINCENZO SCAMOZZI replaced the stuccowork and paintings on the walls with Corinthian pilaster strips alternating with Ionic aedicules with niches. The Pubblico Statuario, originally made up of over 200 marble pieces, was later transferred to the Doges' Palace, and then to the Museo Archeologico. Now it is again in its original home and the exhibition partly revives the original 1736 layout, which can be seen in the drawings by ANTON MARIA ZANETTI IL GIOVANE. The antechamber leads into the SALONE or Great Hall. The gilded wood ceiling here has grotesque decoration by GIAMBATTISTA FRANCO and 21 medallions divided into seven sets of three (1555-59). The subjects had the instructive aim of extolling the virtues, disciplines and occupations of a nobleman; they were executed by young artists chosen by SANSOVINO and TITIAN: GIOVANNI DEMIO (IL FRATINA), GIUSEPPE PORTA (IL SALVIATI), GIAMBATTISTA FRANCO, GIULIO LICINIO, GIAMBATTISTA ZELOTTI, and ANDREA MELDOLLA (LO SCHIAVONE). This team of talented draftsmen, who introduced the innovations of Tuscan-Roman Mannerism into Venice, also included PAOLO VERONESE, who painted the penultimate set at the end of the room housing drawings (the second set for those coming from the Museo Archeologico). Thanks to one of the three roundels, representing *Music* (1556-57) with two women playing a viola da gamba and a lute, VERONESE won a gold chain that the Senate had decided to award for the best painting. In 1635, two paintings were replaced with works by BERNARDO STROZZI and ALESSANDRO VAROTTARI, (IL PADOVANINO). The figures in niches along the walls represent the *Pagan Philosophers* (1562-72) by JACOPO TINTORETTO, PAOLO VERONESE (the two paintings at either side of the portal), ANDREA SCHIAVONE, BENEDETTO CALIARI, GIUSEPPE SALVIATI, GIAMBATTISTA FRANCO and LAMBERT SUSTRIS.

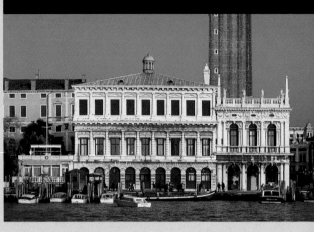

■ Back in the Piazzetta, we will continue our visit by going toward the Molo or quay, where, next to the Libreria, is the **Zecca**: (the Mint). The decision to rebuild and enlarge the site for the coinage of the Republic's money and for private and public deposits was made in 1535. A year later JACOPO SANSOVINO's project was approved. The rusticated façade gives the impression of a solid, impenetrable treasure chest. The ground floor arches on pillars support the *piano nobile* in which the Doric order is somewhat simplified and varied, in keeping with the utilitarian functions of the building.

Construction of the Zecca was finished in 1548, and ten years latter the Consiglio dei Dieci decided to add another story to the building. In 1566 the Ionic-order addition was already finished. In this case attribution is uncertain, and the work may have been assigned to another architect. In the vestibule, the statues of two Giants, signed by TIZIANO ASPETTI (left) and GIROLAMO CAMPAGNA (right), both frighten and amaze visitors. To the right of the Zecca façade are the two **Columns of St. Mark and St. Theodore** (known as **Todaro**). The granite monoliths may have come from Greece and were erected under Doge Sebastiani Ziani (1172-78) thanks to the apparatus provided by the Lombard engineer NICOLÒ DE' BARETTERI.

The two columns, placed at the end of the St. Mark's area and facing St. Mark's Basin, are like an ideal city gate opening out to the sea and lend strong political connotations to the site. The two statues on the monoliths, which represent the patron saints of Venice, were placed there in a later period. The old bronze *Lion of St. Mark*, of uncertain provenance and date, was originally a chimera and the wings and book were added later. This work was removed by the French in 1797 and brought back in 1815 and restored by BARTOLOMEO FERRARI. The statue of *St. Theodore*, the first patron saint of the city, is a copy made around 1940. The original, now kept in the Doges' Palace, was put on top of the column in 1329. The space between the columns was also occupied by a scaffold for capital punishment, after which the body of the condemned person was put on display as a warning to citizens.

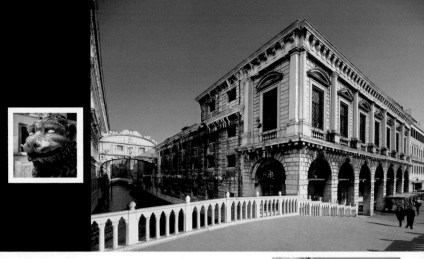

■ Once past the Doges' Palace on the quayside, you come to the **Ponte de la Paglia**. On the side of the bridge facing the quay is a shrine with various 15th-century elements used in other structures and a high relief of the *Madonna of the Gondoliers*. This work, which belonged to the Barcaioli del Traghetto della Paglia (ferrymen) confraternity, dates from 1583. This bridge crosses over the Rio de Palazzo and therefore offers a fine view of the **Bridge of Sighs** (Ponte dei Sospiri), designed and begun by ANTONIO CONTIN in 1600 and finished the following year by BORTOLO DI ALESSANDRO DI VENEZIA. The name, which became common in the 1800s, refers to the sighs and moans the prisoners supposedly made after being tried in the Doges' Palace and while being taken, via the bridge, to the **Prigioni Nuove (New Prisons)**, which can be seen at right.

HISTORY: After the original design by GIAN ANTONIO RUSCONI, was partly executed around 1566, the prisons were enlarged in 1574 and reorganized and altered in 1581 in keeping with a plan by ZAMARIA DE' PIOMBI and ANTONIO DA PONTE. This work was finished in 1610. With its architectural and functional originality, this block-shaped complex is one of the first European prisons of its kind. Although life was particularly hard for the prisoners, there was an innovative system of regulations and aid. Privileges could be had either by paying through official channels or by bribing the guards. Well-to-do prisoners had to pay for the expenses of their imprisonment, while the poor ones had the right to be assisted by an attorney appointed by the court who, besides defending them in court, was called upon to make a monthly check of the living conditions in prison. Torture and capital punishment were applied in various forms, depending on the crime. The section of the

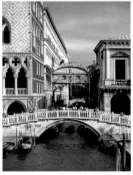

prison facing the Riva degli Schiavoni is taller than the cells behind it and is attributed to ANTONIO DA PONTE. The FAÇADE has a tall, austere arcade with seven arches. The beautiful lions' heads on the keystones are a reference to the Lion of St. Mark and have a menacing appearance befitting a prison.

INTERIOR: After going through the main doorway (no. 4209), take the stairway at left to the upper rooms reserved for the Signori di Notte al Criminal (members of the police court), their archive and the courtroom that communicated with a torture chamber.

101 FRANCESCO BASSANO, POPE ALEXANDER III CONSIGNS THE SWORD TO DOGE

SEBASTIANO ZIANI AND DETAIL, DOGE'S PALACE, SALA DEL MAGGIOR CONSIGLIO.

■ To visit the Prison cells you must go the **Doges' Palace**. HISTORY: In 810, after the Venetian duchy had moved from Malamocco to the Rivo Alto (or Reatine) islands, the wealthy Partecipazio family turned its residence into the doges' apartments and the seat of local government with political, juridical and prison functions. The ancient residence, which may have risen up on an outpost or on a Byzantine stonework wall, was a fortified palace with a courtyard and corner towers. The history of the construction of the Doges' Palace from the 9th century to the first decades of the 13th century – marked by a fire that broke out in 976 during a popular revolt that led to the assassination of Doge Pietro IV Candiano – is uncertain. In this period the entire area was laid out in three fundamental buildings: the doge's residence, the palace of justice and the "city hall," located south, toward the quay and used to house the Maggior Consiglio (the nobles' assembly) and other magistracies. In 1301, as a consequence of the increasing number of patricians, a first extension was needed. A new project was approved at the end of 1340, when Bartolomeo Gradenigo was doge. Already in mid-1341 construction was in full swing and the

following year further expansion of the hall was decided upon. At the beginning of 1343 a new doge was elected: Andrea Dandolo. Since Dandolo lived until 1354, he was able to witness first-hand the erection of the new south wing and main hall of the palace, the frescoed decoration of which was done in 1355-65. The only information we have concerning those in charge of construction refers to PIETRO BASEGGIO (d. before 1354) and a master stonecutter named ENRICO, while the main sculpted decorations of the south side of the palace would have been the work of FILIPPO CALENDARIO (1355). The expenses for the new palace wing were so high that during the doge's subsequent investiture ceremonies it was established that any new construction work would have to have the approval of the responsible governing bodies, and that the doge would be obliged to pay a personal tax of 1,000 ducats. This enormous sum was in fact paid by Doge Tommaso Mocenigo, and the section of the palace that had still not been built – the extension from the eighth column of the portico on the Piazzetta in the direction of St. Mark's Basilica – was completed in 1422 and 1435-42. The last

touch was the construction of the sumptuous Porta della Carta, which is the external "border" between the Basilica and the Doges' Palace. Work on this gateway was contracted in 1438 and finished around 1450. In 1483, after the renovation of two sides of the building had been completed, a fire broke out and destroyed the old east wing along the canal that had included the doge's apartments and the magistrates' chambers. The reconstruction is attributed to ANTONIO RIZZO, who supervised the works up to the end of 1497, when he was replaced a few months later by PIETRO LOMBARDO (d. 1515). The Scala dei Giganti and the nearby Chapel of St. Nicholas were built in the same period. The staircase was designed by ANTONIO RIZZO and was completed in 1485, while the latter, designed by GIORGIO SPAVENTO, was under construction in 1505. Later on, renovation work along the east wing of the palace was resumed and the Scala d'Oro was completed in 1559. When the new organization of the palace was finalized, there were two other fires. The first one, in 1574, again broke out in the new east end, consuming the halls of the Quattro Porte, the Anticollegio, the Collegio and the Senate. The second

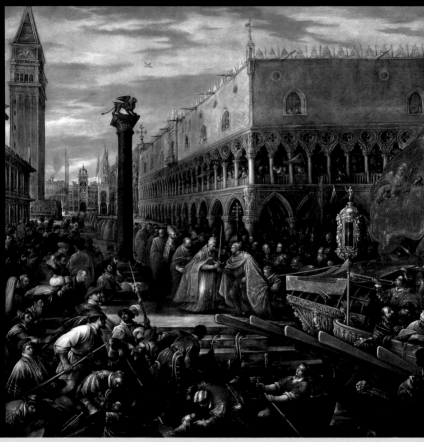

fire (1577) was even more devastating, as it destroyed the Sala del Maggior Consiglio and the Sala dello Scrutinio and also weakened the surviving outer walls facing the Basin and the Piazzetta. Reconstruction of the sections destroyed in 1574 was entrusted to the master builder ANTONIO DA PONTE, who was advised by ANDREA PALLADIO and GIOVANNI ANTONIO RUSCONI. For the restoration and reconstruction work after the second fire, at least fifteen architects and engineers were approached. Among them was ANDREA PALLADIO, who suggested reconstructing the south façade overlooking the Basin in Classical style. Fortunately, this idea was turned down and the Senate decided to follow the advice of GIOVANNI ANTONIO RUSCONI and preserve the Gothic façades while renovating the interior. The structural parts of the two wings were finished around 1580. After this episode two other major architectural projects were undertaken that gave the palace its definitive form. The first was the construction of the Prigioni Nuove on the other side of the canal. The second involved the ground floor of the courtyard, where the builder BARTOLOMEO MANOPOLA opened a new arcade in 1605-09.

102 TOP CAPITAL IN THE SOUTH PORTICO.

102 CENTER DRUNKENNESS OF NOAH, DETAIL, SOUTHEAST CORNER.

102 BOTTOM LEFT DETAIL OF THE ORIGINAL SIN, WEST ARCADE.

102 BOTTOM RIGHT ARCHANGEL MICHAEL, SOUTHWEST CORNER.

102-103 SOUTH FACADE OF THE DOGES' PALACE.

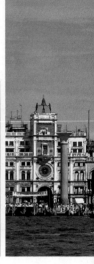

FAÇADES: the **south façade**, which faces St. Mark's Basin, is the oldest one (1340-55). It is distinguished by its bold construction, since the enormous Sala del Maggior Consiglio, the largest hall in Venice, instead of being on the ground or first floor, was placed on the second story, at a considerable height, by means of the support of two superposed rows of columns. The continuous double row of superposed arches was modeled after the structure of the typical merchant's residence with a warehouse, the *casa-fondaco*, but with substantial differences resulting from a new architectural style and from problems of statics. Then there is the huge second floor wall with large Gothic windows that is dressed with pink and white stone in a lozenge pattern, crowned by characteristic acroteria whose shapes look like the profile of a royal crown. The palace's most singular feature is the decoration of its corners and capitals; these have hundreds of sculpted figures, much like a huge medieval encyclopedia open to the public – one whose fundamental message is based on the theme of wisdom as an instrument of ethics and a means of individual salvation. The key to interpreting the entire iconographic program is the **southwest (left) corner**. The octagonal capital (a copy: the original is in the palace Museo dell'Opera) bears the twelve signs of the Zodiac associated with the seven planets – one for each side – that are diurnal and nocturnal dwellings. According to astrology, which was then

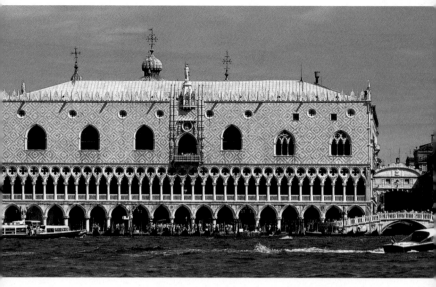

considered a science and a worthy companion of astronomy and mathematics, these combinations indicated the maximum influence these celestial bodies had on the earth. The eighth side of the capital has *The Creation of Adam* who, owing to the particular influence of the stars at his birth, can be considered the perfect or ideal human being, or, in biblical terms, man created in God's image. The inscriptions carved along the abacus corroborate and clarify the sculpted images with erudite references taken from classical sources, astrological and alchemical treatises, and on the eighth side, placed precisely on the corner of the palace, mention is also made of the creation of Eve. Above the capital with the *Creation of Adam* is the *Original Sin* sculpture

group. Adam and Eve are separated by the tree of knowledge of good and evil, which here is a fig tree, around which is coiled a serpent with a woman's head representing Satan. The gestures of the couple manifest their dialogue with God before being driven out of the Garden of Eden. And in fact, above them on a level with the loggia, is the statue of the *Archangel Michael*, whose cartouche states in Latin: "With my sword I protect the good and punish the crimes of the evil." Because of the sin of pride, humanity loses eternal life and knowledge of all heavenly things. The path to individual salvation is suspended between wickedness and goodness, vice and virtue. Note that precisely above the statue of the Archangel Michael,

the guardian of Paradise, is the Sala del Maggior Consiglio, the great assembly hall where all the male members of the noble class over 25 years old met. Here GUARIENTO frescoed *Paradise* to show the Venetian ruling class the place reserved for those who, with virtue, devoted their efforts to the art of good government. The Doges' Palace was therefore viewed as a central place for the salvation of the soul. Further confirmation of this is the corner capital of the arcade, under the statue of Michael, which represents, on its four sides, the *Cardinal Winds, the Course of the Sun and the Polar Star*. In medieval symbology, these allegories attested to the centrality of a place as an *axis mundi*, that is, the shortest path the soul had to take to return to Heaven.

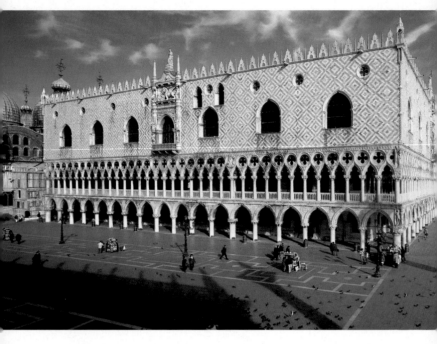

On the opposite corner of the façade, right over the Ponte de la Paglia, are two other sculpture groups with themes related to filial piety and charity. Below is *The Drunkenness of Noah*, who is being mocked by his son Ham, while his other two sons cover his nudity; above them is the Archangel Raphael. In the middle of the façade is the Gothic balcony made in 1404 by PIERPAOLO DALLE MASEGNE and assistants. This work, which looks like a reliquary or liturgical object of the period, was conceived as a grandiose triumphal arch bordered by two coupled pilasters with statues of saints and virtues in niches. In the blind roundel is the allegory of Charity (16th century). The panel above this, now empty, once contained the sculpture group of *Doge Michele Steno Kneeling before the Lion of St. Mark*. The three crown niches have statues of St. Peter, St. Mark and St. Paul surmounted by the allegory of Venice (1579) in the guise of Justice, by ALESSANDRO VITTORIA. The **west façade**, which overlooks the Piazzetta, was interrupted in the 14th century at the eighth column. Among the most interesting 14th-century capitals, the fifth from the right represents *The Influence of the Planets on the Duration of Life*, while the seventh, known as the capital of love, has *Love Life and Married Life*. Along the eight sides of this latter are the salient moments in the life of a hapless noble couple. The courting period is followed by marriage; lovemaking is followed by the birth of a son, and the education of the son is followed by his premature death. In the upper loggia a roundel is surrounded by the elegant bas-relief of *Personified Venice on the Throne* (1341-55), an allegory of good government supported by the virtues of Fortitude and Justice. In the middle of the façade is the balcony with the statue of *Doge Andrea Gritti Kneeling before the Lion of St. Mark* (ca. 1536). The four statues of divinities, set on the side piers, are the work of PIETRO DA

105 TOP THE CAPITAL WITH LOVE LIFE AND MARRIED LIFE, WEST ARCADE, DETAIL.

105 CENTER THE ARCHANGEL GABRIEL, NORTHWEST CORNER.

105 BOTTOM PERSONIFIED VENICE ON THE THRONE, WEST FACADE.

SALÒ and DANESE CATTANEO, while *Justice* on the crown is signed by ALESSANDRO VITTORIA. The rest of this wing of the palace was built in the same Gothic style between 1422 and 1435-42. Nicolò Barbarigo, the procurator of San Marco, probably supervised the construction work. Along the arcade are two pink Verona marble columns, where the doge appeared on special occasions. In the **northwest corner**, at left, is another magnificent sequence of sculpture that completes the complex theme of the relationship between history, religion, politics and ethics initiated on the 14th-century façade. The octagonal capital –

restored by PIETRO LORANDINI in 1854-58, represents *Justice, Wise Men and Legislators*, among whom are Aristotle, Moses, Solon, Scipio, Numa Pompilius and Trajan. Above this is the sculpture group *The Judgment of Solomon* (ca. 1435), attributed to BARTOLOMEO BON (d. 1464-67), who also did sculptures in the Ca d'Oro. The figure of Solomon, the wise king, was considered a prototype of Christ, and it is this relationship that justifies the statue of the Archangel Gabriel making the Annunciation, in the loggia above. This latter figure faces the Basilica and can thus be interpreted as a symbolic image of the Virgin Mary.

According to the Fathers of the Church, Mary, having conceived Jesus, was the temple of God and the seat of divine wisdom. And in St. Mark's, besides the body of Christ in the form of the Eucharist, there is also the body of St. Mark, the patron saint of Venice.

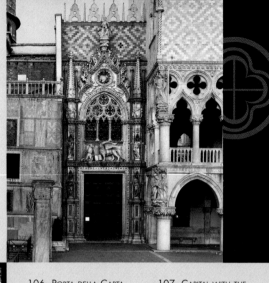

The nearby **Porta della Carta** marks the boundary between St. Mark's Basilica and the Doges' Palace. The name – Gateway of the Paper – probably derives from the archive of paper documents in the adjacent chamber. Construction of the gateway, contracted in 1438, dates from 1442-57 and was the work of BARTOLOMEO BON (the contribution of his assistants and his father

106 PORTA DELLA CARTA AND DETAIL.

107 CAPITAL WITH THE CREATION OF ADAM AND DETAIL, MUSEO DELL'OPERA.

GIOVANNI is yet to be verified). The opulent flamboyant Gothic decoration underscores its function as an official entranceway, and the statues celebrate the figure of the donor, set above the architrave, *Doge Francesco Foscari Kneeling before the Lion of St. Mark*. This type of portrait, quite common in the Doges' Palace, is a synthesis and manifestation of one of the bases of the Venetian concept of the state. After 1032, the doge was elected and his post was no longer hereditary. His power was by no means absolute and the decisions he made had to conform to the mandate he agreed to during his investiture and had to be approved by the other organs of the government. Thus, the doge had to respect the supreme authority of the

Venetian state and its laws. The doge kneeling in front of the Lion of St. Mark is an allegory of Venice and its divine origin, and therefore meant submitting to the collective interests of the Republic and its traditions. The sculpture group at the Porta della Carta is by LUIGI FERRARI and was redone in 1885. The original head of the old doge Foscari is now kept in the Museo dell'Opera of the Doges' Palace. The four statues in the niches of the side piers represent *Temperance* and *Fortitude*, attributed to ANTONIO BREGNO, and *Prudence* and *Charity*. On the crown with geometric motifs is the bust of *St. Mark* and, above this, *Benevolent Justice* (ca. 1441) by BARTOLOMEO BON. The **east façade** along the Rio di Palazzo canal was destroyed by fire in 1483. Its

reconstruction, the design of which is attributed to ANTONIO RIZZO, began with the doge's apartment, whose windows are near Ponte de la Canonica. The work was interrupted for a long period and resumed in 1544-45 under the supervision of the *proto* or master builder, ANTONIO ABBONDI, known as LO SCARPAGNINO. Construction proceeded in the direction of the 13th-century wing with the building of a new hall of justice, the prison known as I Piombi (made famous when Giacomo Casanova escaped in 1756), and the Camera del Tormento or torture chamber. ■ MUSEUM: the Doges' Palace is the property of the Italian state and since 1924 has been run by the municipality of Venice. The ENTRANCE is at the Porta del Frumento (no. 2),

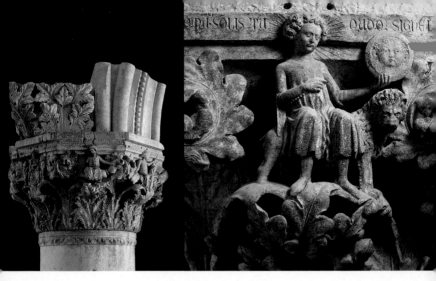

situated in the south arcade. This gateway owes its name (*frumento*=wheat) to the proximity to the offices or storerooms of the Magistratura delle Biade, which was responsible for the distribution of food, especially grain.

GROUND FLOOR: the walls of the Porta del Frumento vestibule have some plaques that publicly expose the officials who were banished for stealing money from the state coffers. Once past the ticket office, you can either enter directly into the courtyard or turn left and visit the **Museo dell'Opera**, which has the original columns, capitals and arches that were removed from the two main façades of the Doges' Palace. As soon as you enter the *first room* you will see, in a showcase, the *wooden model of the scaffolding* (1875-76) that was used during the restoration of the southwest corner of the palace, which took place in three phases

(1876-87) and was supervised by the engineer ANTONIO FORCELLINI. The two façades were completely disassembled and reassembled with copies of those elements in poor condition. The original pieces were stored for decades; some of them were put on display for a brief period in 1962 and were then placed in storerooms again until 1996, when they became part of a permanent exhibition open to the public. Among the six capitals note *The Kings and Emperor* (1340-55) and *Solomon and the Seven Sages*, who personify the Liberal Arts. The figure of Pythagoras, an allegory of mathematics, is personified by a cashier or moneychanger who is counting coins. On the tablet is the number 1344 carved upside down, which is believed to be one of the construction dates of the south façade. In the *third room* there are three other

capitals. The largest one (no. 11) is a corner capital already mentioned in the description of the south façade. Another superbly wrought piece is the *Capital Vices* (no. 12), in which Pride is personified by a soldier with horns on his helmet and Gluttony is in the guise of a woman holding a glass and sinking her teeth into a piece of meat. Passing the *fourth room* through an old stone wall, we come to the *fifth room*, which boasts a fragment of the loggia with two quatrefoil roundels and the composite capital of the loggia situated under the outer bas-relief of *Venice Personified*. In the *sixth room* there are 26 square capitals from the loggia with traces of gilding that give you an idea of the splendor of the palace decoration. This room also has two important fragments from the Porta della Carta: in the middle of the right wall, the *Head of Doge Francesco Foscari*, attributed to BARTOLOMEO BON, and on the back wall, an architrave signed by the same sculptor.

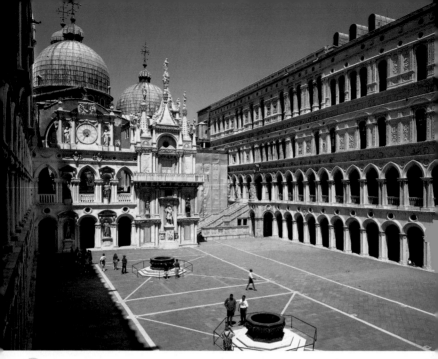

■ From this room you go directly into the COURTYARD. The arcade, together with the west one, was built in 1605-09 by the *proto* (master builder) BARTOLOMEO MANOPOLA. Further on, the first of the two octagonal wells is dated 1556 and signed by NICOLÒ DE CONTI. The second well, cast by the famous ALBERGHETTI workshop, has only mythological scenes. Along the north part of the courtyard, BARTOLOMEO MANOPOLA tore down the Foscara staircase, built another section of the arcade, placed a *clock* (1615) over the loggia and, at right, may have inserted the Doric shrine with the *Monument to Francesco Maria I della Rovere* (1587), Duke of Urbino, an expert in fortifications, and captain of the Venetian Republic's army.

The statue of the duke, who died in 1538, was sculpted by GIOVANNI BANDINI, known as GIOVANNI DELL'OPERA, and donated by his grandson in 1625. The bronze statue in the upper niche at right is a 19th-century copy of the *Warrior with a Shield*, the original of which, attributed to ANTONIO RIZZO, is on the first floor Liagò, or upper floor loggia. The east wing, used as the doges' apartment and offices for the various magistrates, burned down in the 1483 fire. Its reconstruction, attributed to ANTONIO RIZZO, went on for over 60 years in at least two distinct phases, by PIETRO LOMBARDO and by the *proti* ANTONIO SCARPAGNINO and ANTONIO ROSSO. The loggia, with pointed arches, harks back and lends continuity to those built in the preceding centuries. The pilaster strips,

trabeation and numerous lavish reliefs on the upper stories make up an "old-fashioned" façade, but without order, symmetry and proportions, because, as often happens in Venice, the irregular arrangement of the earlier windows was maintained. Inside the arcade is the double Riva Barbarigo portico. At the beginning of the right wall, note the massive Istrian stone door of a passageway that communicates with the Pozzi prison. Proceeding to your right, you will come to the Riva Donà portico and, immediately afterward, the *Scala dei Censori* (last half of the 16th century), which leads to the **Piano delle Logge**. At this point, one can go in two directions. At left is the 14th-century loggia. If you have the time, it is well worth paying at

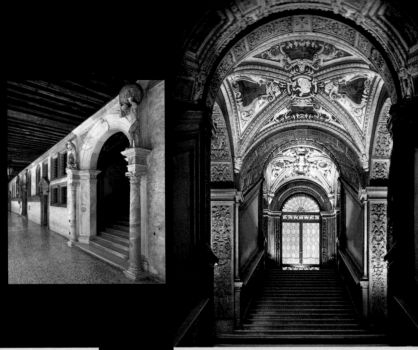

108 COURTYARD OF THE DOGES' PALACE.

109 LEFT ENTRANCE ARCH OF THE SCALA D'ORO AND DETAIL.

109 RIGHT THE SCALA D'ORO.

least a short visit, during which you can see the capitals from up close as well as the *Loggia Foscara*, which communicates with the loggia toward the Piazzetta, and also enjoy an enchanting view of St. Mark's Basin. At right, on the other hand, is the official itinerary of the interior of the Doges' Palace. Along the loggia wall, after the first door, there is a beautiful *inscription* in Gothic letters and in Venetian dialect with the text of an indulgence granted by Pope Urban V in 1362. This spot was the site of the old Chapel of St. Nicholas enlarged by Doge Pietro Ziani (1205-29) and renovated in 1332. Further on is the *Bocca della Verità* (late 16th century) in relief, next to which citizens could make anonymous reports of crimes, especially against tax evaders. This is followed by the luxurious **Scala d'Oro**, the staircase which marks the end of the ceremonial course that begins at the Porta della Carta. The entrance arch of the staircase was built under Doge Andrea Gritti (1523-38) and is dominated by the statues of *Hercules Slaying the Hydra* – probably an allegory of Venice defeating the Turks – and *Atlas Holding up the Sky* (late 16th century), signed by TIZIANO ASPETTI. Construction of the structural parts of the staircase, headed by the chief architect PIETRO PICCOLO to a design by JACOPO SANSOVINO, began in 1556 and completed three years later. In 1561 the gilding of the staircase was still in progress. The lavishness of the reliefs along the wall, the profusion of stucco decoration on the vaults by ALESSANDRO VITTORIA, and the sumptuous frescoes by BATTISTA FRANCO, all introduced the international Mannerist style into the Doges' Palace. The statues of Charity and Plenty in the side niches of the last landing are by the Paduan FRANCESCO SEGALA and may date after 1573.

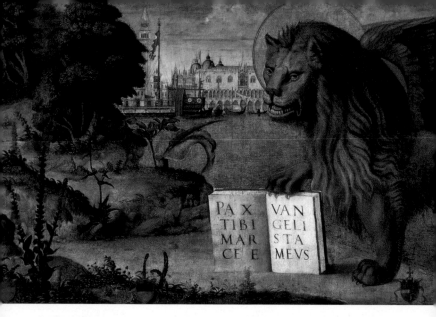

After the first flight, turn right and follow the signs of the official tour; on the first floor is the **DOGES' APARTMENT**, rebuilt after 1483. The first room is the *Sala degli Scarlatti*, or hall of scarlet fabric. The curved wooden ceiling may be older than its painted cornice installed under Doge Andrea Gritti (1523-38). Above the entrance is a bas-relief of *Doge Leonardo Loredan and Three Saints Adoring the Enthroned Madonna and Child* (1501-21), which may be by PIETRO LOMBARDO. This is followed by the *Sala dello Scudo* (or *Sala delle Mappe*), whose name derives from the custom of displaying the shield (*scudo*) or coat of arms of the doge in office. In the middle of the right wall

there is still the crest of Ludovico Manin, the last doge of Venice, who was deposed in 1797. This hall, also used for banquets, has a T-shaped plan. The splendid maps (hence the other name of the hall), which were already here in the 16th century, were redone in 1762 by FRANCESCO GRISELLINI, who added the representation of the journeys made and lands discovered by famous Venetian explorers and navigators. The figures of the various populations are by FRANCESCO FONTEBASSO. Works of the same period are the well-worn globes depicting the celestial and terrestrial spheres.

In the **Sala Grimani**, the wooden ceiling (ca. 1506) is attributed to the woodcarvers BIAGIO and

PIETRO DA FAENZA. Past the late 15th-century Lombardesque fireplace are some canvases, including, on the right wall, the *Lion of St. Mark* (1516) by VITTORE CARPACCIO. The aggressive animal, the symbol of the strength of the Republic, is placing its paws on the earth and water, the two spheres of Venetian dominion. Note the lovely view of the Piazzetta in the background.

The **Sala Erizzo** has an adjoining terrace or hanging garden on its left. The wooden ceiling (ca. 1506) is also attributed to the woodcarvers BIAGIO and PIETRO DA FAENZA. In the frieze below the ceiling, which may have been executed by the Veronese

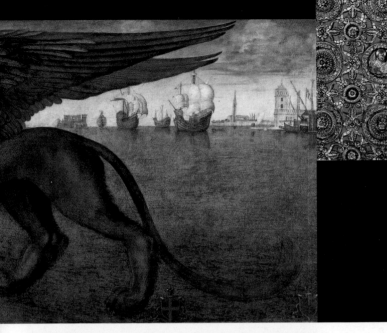

painter GIOVAN BATTISTA
LORENZETTI, are *Scenes of
Putti and Other Figures of
Warriors* commemorating
the war of Gradisca
(1616-17). The elegant
late 15th-century fireplace
bears the crest of Doge
Francesco Erizzo (1631-
46), whose tomb lies in
the church of San

Martino, near the
Arsenale.
In the **Sala degli Stucchi**
(or **Sala Priuli**; early 17th
century), in frames made
under Doge Pietro
Grimani in 1743, are
paintings donated by the
nobleman Bertuccio
Contarini, most of which
have a religious subject.

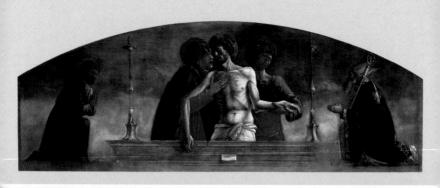

To the right is the long **Sala dei Filosofi**. The second door communicates with a small stairway on the inside wall of which TITIAN frescoed the massive and impressive figure of *St. Christopher* (1523-24). Why Doge Andrea Gritti commissioned this work has not yet been clarified. The image was undoubtedly chosen as an object of personal devotion, since the stairs were used only by the doge to go up to the Doges' Chapel, the Senate and the Collegio. St. Christoper, who had dedicated his life to serving potentates, is captured in the act of his conversion to Christianity when the Infant Jesus indicates the existence of God Almighty with his lifted forefinger. The allusion to Venice and its greatness is also obvious, since the saint has his feet in St. Mark's Basin and the barely sketched city can be seen in the background. Therefore, one might very well view the figure of the saint as a veiled reference to Gritti himself, the doge at the service of the mightiest nation.

Along the left wall of the Sala dei Filosofi is the entrance to the **Sala dei Leoni**, **Sala Corner** and **Sala dei Ritratti**. This last hall has a very moving *Pietà* that was formerly in the offices of the Ministry of Justice, the Avogaria di Comun. This canvas, once dated to 1472, is signed by GIOVANNI BELLINI. Going through the Sala dello Scudo you enter the *Sala degli Scudieri*, reserved for the doge's servants and private guards. To the right, the long canvas attributed to DOMENICO TINTORETTO

112 TOP AND 113 TOP GIOVANNI BELLINI, *MOURNING OF CHRIST AND SAINTS* AND DETAIL, SALA DEI RITRATTI.

112-113 *DOGE MARINO GRIMANI RECEIVES THE MEMBERS OF THE SHOEMAKERS' GUILD*, SALA DEGLI SCUDIERI.

113 BOTTOM TITIAN, *ST. CHRISTOPHER*, STAIRWAY OF THE SALA DEI FILOSOFI.

depicts *Doge Marino Grimani Receiving the Members of the Shoemakers' Guild* (ca. 1597) on occasion of the coronation of his wife Morosina Morosini as dogaressa (this latter episode is also documented in two canvases in the Museo Correr). The two wooden wings of the portal that communicates with the Scala d'Oro are attributed to ALESSANDRO VITTORIA and are surmounted by the crest of the Doge Lorenzo Priuli (1559-67).

Having finished your visit to the doges' apartment, go up the last flight of the Scala d'Oro.

At either side of the last landing are the statues mentioned above, by FRANCESCO SEGALA. Once at the top of the staircase, note the sculptural decoration on the side pilaster strips, with trophies of ancient weapons surmounted by a medallion representing the Lion of St. Mark, the symbol of the Republic. The sculpture at left is dated 1559, the year when the staircase was finished.

114 top JACOPO TINTORETTO, *DOGE GEROLAMO PRIULI, JUSTICE AND VENICE IN THE GUISE OF PEACE*, ATRIO QUADRATO.

114 bottom GIAMBATTISTA TIEPOLO, *VENICE RECEIVING THE GIFTS OF THE SEA FROM NEPTUNE*, SALA DELLE QUATTRO PORTE.

114-115 AND 115 BOTTOM TITIAN, *DOGE ANTONIO GRIMANI KNEELING BEFORE FAITH*, SALA DELLE QUATTRO PORTE.

■The next room, on the SECOND FLOOR, is the **Atrio Quadrato** or square atrium. The mid-16th century wooden ceiling has an octagonal cornice with a painting by JACOPO TINTORETTO, *Doge Gerolamo Priuli, Justice and Venice in the Guise of Peace* (1561-67). The female figure at left is Venice, who is wearing a crown and an olive branch, symbols of regality and peace. She is walking barefoot on the stones of a stream, and in order to avoid falling, has one hand on the shoulders of her companion, Justice. The allusion is quite clear: Peace proceeds on tricky terrain and is sustained by her respect for the law. In the meantime,

the easy-going, affable doge Priuli is about to receive from Justice the attributes of the scale and sword and is accompanied by the splendid figure of his personal patron saint, St. Jerome (Gerolamo, in Italian). The next hall, the **Sala delle Quattro Porte**, was used as an antechamber and communicating room, as its name (four doors) implies. It was rebuilt by the chief architect or *proto* ANTONIO DA PONTE to a design by ANDREA PALLADIO and ANTONIO RUSCONI after a fire damaged it in 1574. The stuccowork on the ceiling (1576-77), depicting *gods, genii, tritons* and *mermaids*, was done by GIOVANNI BATTISTA CAMBI

(known as IL BOMBARDA). The frescoes with mythological subjects – Jove, in the center, flanked in the two tondos by *Juno and Venice* – were painted by JACOPO TINTORETTO, who began them in 1577 to an iconographic program drawn up by JACOPO SANSOVINO. The canvas of *Doge Antonio Grimani Kneeling before Faith* was placed in the middle of the hall's entrance wall sometime after 1595. TITIAN had been given the commission for this work in 1555, but he never finished, so it was completed in 1589 by ORAZIO VECELLIO, who added the two figures at the ends. In addition to the paintings by GIOVANNI

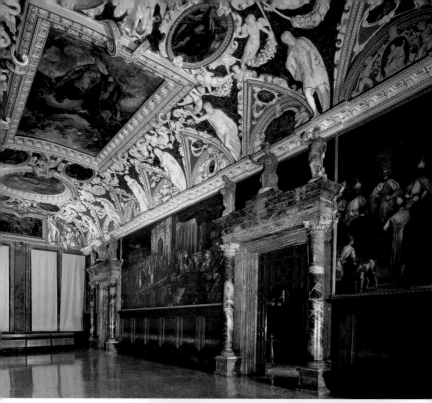

CONTARINI and CARLETTO and GABRIELE CALIARI, note, opposite Titian's large canvas, *Henry III Meeting with Doge Mocenigo* (ca. 1593) by ANDREA MICHIELI (known as IL VICENTINO), which depicts the solemn welcome Venice paid to the future king of France in 1574, here painted in black attire, during his arrival at the Lido. On the four doors of this hall, which are decorated with precious Oriental marble and composite capitals designed by ANDREA PALLADIO, are twelve statues. They were sculpted in 1589 by GIULIO DEL MORO, FRANCESCO CASTELLI, ALESSANDRO VITTORIA and GEROLAMO CAMPAGNA and depict

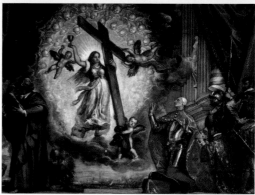

allegories chosen in relation to the room onto which each of the doors opens. At right, at the end of the hall and on an easel, is an oil canvas by GIAMBATTISTA TIEPOLO of *Venice Receiving the Gifts of the Sea from Neptune* (1748-50). Despite the fact that the Republic – here portrayed in the guise

of a dogaressa – and its economy were in decline, this work, with its extraordinary painterly qualities and lifelike delicacy, depicts an impossible return to the city's former splendor, deriving from Venice's belief that she could sustain her wealth through maritime trade.

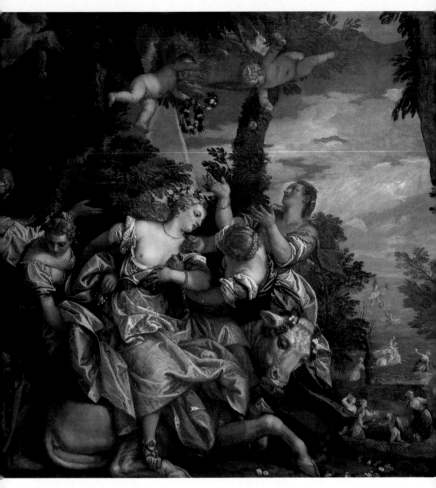

The **Sala dell'Anticollegio** was reserved for ambassadors and representatives of the cities ruled by Venice. Its design is attributed to ANDREA PALLADIO, who was replaced by VINCENZO SCAMOZZI. The latter is also credited with the design of the large, lavish Carrara marble fireplace (1580) at left, between the two windows. The two side telamones, once ascribed to TIZIANO ASPETTI, are now attributed to GIROLAMO CAMPAGNA

(1586). However, ASPETTI did execute the relief scene on the hood of *Vulcan's Forge*. The other divinities and allegories are attributed for the most part to FRANCESCO MONTEMEZZANO. The stuccowork on the vault was executed in 1576 by MARCO ANGOLO DEL MORO, while the hexagonal fresco (quite deteriorated and touched up) is attributed to PAOLO VERONESE. It depicts *Venice Bestowing Ecclesiastic Posts and Privileges*, a

controversial subject indeed, which takes a polemic stance against the papacy and patriarchate, which claimed total jurisdiction over the Venetian churches. The four canvases on the walls come from the nearby Atrio Quadrato and are by JACOPO TINTORETTO, who painted them in 1578. Some scholars have related the subjects of these works, which are of a political-mythological nature, to the seasons. On

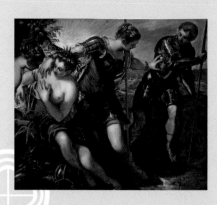

the entrance wall are
Vulcan's Forge (fire, winter)
and *Mercury and the Three
Graces* (flowers, spring),
while on the opposite wall
are *Adriane, Venus and
Bacchus* (grapes, autumn)
and *Minerva Dismissing
Mars* (grain, summer).
This last-mentioned
allegory is an obvious
allusion to one of the
cornerstones of Venetian
political ideology in the
16th century: Minerva, the
image of Venice and the
wisdom of its senators,
dismisses Mars, the god of
war, to protect Peace and
Plenty. On the right-hand
wall, after JACOPO BASSANO's
*Abraham Departs for
Canaan* (1575-80), there is
the magnificent *Rape of
Europa* (1580) by PAOLO
VERONESE, which was
painted for Jacopo
Contarini, a supporter of
PALLADIO and leading figure
in Venetian culture of the
time. It was brought to the
Doges' Palace in the 18th
century. The scene
narrated by Ovid in the
second book of his
Metamorphosis, shows
Europa on the back of a
meek bull while being
dressed by her
handmaidens. The animal,
which is really Jove in
disguise, is going toward
the beach to dive into the
sea and swim to Crete, the
island where the girl will
be raped. Above the door,
note the three statues by
ALESSANDRO VITTORIA. The
one in the middle is an
allegory of *Venus Seated on
the Lion.*

The **Sala del Collegio** was used to deliberate on matters of state. On the back wall is the wooden "tribune" (1575) with the seats for the doge and his six counselors. The canvas above this is a votive painting of *Doge Sebastiano Venier Thanking Christ for the Naval Victory of Lepanto* (ca. 1582), a masterpiece of the mature PAOLO VERONESE. The magnificent wooden ceiling, begun in 1576 by the woodcarvers ANDREA DA FAENZA and FRANCESCO SA SAN MOISÈ (known as IL BELLO), has a series of famous canvases that PAOLO VERONESE painted between 1575 and 1578. This cycle is considered one of the artist's greatest masterpieces and celebrates the greatness, knowledge, virtues and faith of Venice by utilizing a classical figurative repertory that is made even more lofty by the rich and elegant costumes and fabrics of that period. Starting from the entrance, the three central panels represent *The Lion of St. Mark between Mars and Neptune* (indicated, in Latin, as the "Strength of the Empire"), *The Triumph of Faith* ("Foundation of the Republic") and *Justice and Peace Paying Homage to Venice* ("Custodians of Freedom"). In the side panels there are the following eight allegories: *Fortune* or *Recompense* (dice), *Dialectic* or *Industry* (spider's web), *Vigilance* (crane), *Prosperity* or *Plenty* (horn of plenty), *Fidelity* (dog), *Meekness* (lamb), *Purity* or *Chastity* (ermine), and *Moderation* (eagle). Most of the other canvases on the walls were executed by JACOPO and DOMENICO TINTORETTO in ca. 1581-1612 and represent votive scenes in which the doges Andrea Gritti, Francesco Donà, Nicolò da Ponte and Alvise I Mocenigo appear. The nearby **Sala del Senato** (or **Consiglio dei Pregadi**) was reserved for one of the most prestigious

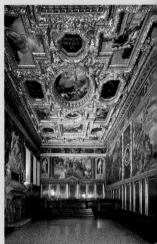

118-119 Sala del Senato.

119 top Jacopo Tintoretto, *The Triumph of Venice Receiving the Tribute of the Sea*, detail, Sala del Senato.

119 bottom Sala del Collegio.

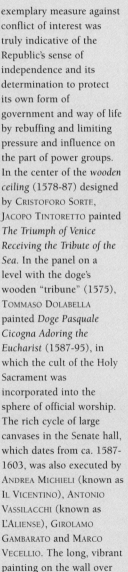

constitutional organs of the Venetian Republic, which may have been founded in 1229. The council was the legislative body that governed the city and the state, including its land and sea possessions, devoting itself to political, administrative, legislative, economic and financial questions. The Senate deliberated foreign policy, coordinating the activities of the diplomatic centers. During the discussions and deliberations concerning relations with the Holy See, all the members related to prelates or in any way had personal interests in the subject were required to leave the hall. This

exemplary measure against conflict of interest was truly indicative of the Republic's sense of independence and its determination to protect its own form of government and way of life by rebuffing and limiting pressure and influence on the part of power groups. In the center of the *wooden ceiling* (1578-87) designed by CRISTOFORO SORTE, JACOPO TINTORETTO painted *The Triumph of Venice Receiving the Tribute of the Sea*. In the panel on a level with the doge's wooden "tribune" (1575), TOMMASO DOLABELLA painted *Doge Pasquale Cicogna Adoring the Eucharist* (1587-95), in which the cult of the Holy Sacrament was incorporated into the sphere of official worship. The rich cycle of large canvases in the Senate hall, which dates from ca. 1587-1603, was also executed by ANDREA MICHIELI (known as IL VICENTINO), ANTONIO VASSILACCHI (known as L'ALIENSE), GIROLAMO GAMBARATO and MARCO VECELLIO. The long, vibrant painting on the wall over the doge's "tribune," *The Doges Pietro Lando and*

Marcantonio Trevisan Kneeling before the Pietà with Angels (1582-84), is by JACOPO TINTORETTO and his son DOMENICO. Among the other paintings in the hall is *Doge Pietro Loredan Contemplating the Madonna in Glory* (1582-84), again by JACOPO and DOMENICO TINTORETTO, recognizable for the view of St. Mark's and the Clock Tower. Of the four votive paintings by PALMA GIOVANE, mention should be made of *Doge Pasquale Cicogna and the Risen Christ* (1585-95). The two doors at the sides of the doge's "tribune" lead to the **Cappella Ducale**, the doge's chapel, which is not open to the public.

120 TOP LEFT PAOLO VERONESE, *AGE AND YOUTH*, DETAIL, SALA DEL CONSIGLIO DEI DIECI.

120 TOP RIGHT PAOLO VERONESE, *JUNO OFFERING THE DUCAL CROWN TO VENICE.*

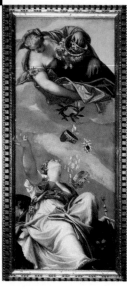

After passing through the Sala delle Quattro Porte and a small L-shaped hall, you enter the **Sala del Consiglio dei Dieci** (or **Sala dell'Udienza**). The Council of Ten was established in 1310; its power ranged from the security of the state to controlling the patricians, monasteries, devotional schools and guilds. The Council consisted of the ten titled members, the doge and the doge's six counselors.

The canvases on the ceiling were painted in 1553-54 by GIAMBATTISTA PONCHINO (*Mercury and Peace*), GIAMBATTISTA ZELOTTI (*Venice with Mars and Neptune*) and PAOLO VERONESE. In the middle of the ceiling is a moralizing scene, *Jove Casting Out the Vices*, in which the iconography refers to the fall of the Giants. This canvas is a copy by JACOPO DI ANDREA, which in the 19th century replaced the original by VERONESE, now in the Louvre. The late 16th-century paintings on the walls represent *The Adoration of the Magi* by ANTONIO VASSILACCHI (known as L'ALIENSE) along the semi-circle; at right, *Pope Alexander II Welcomes Doge Ziani* by FRANCESCO and LEANDRO BASSANO; and at left, *The Peace Treaty of Bologna* by MARCO VECELLIO.

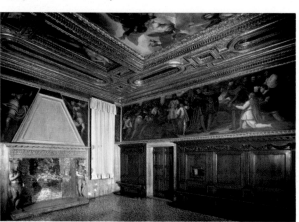

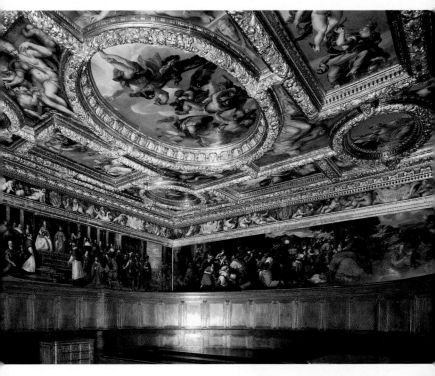

The next hall, the **Sala della Bussola**, was the antechamber for those who were summoned by the three chief magistrates of the Council of Ten and by the Inquisitors. The passageway into the rooms reserved for these magistrates is screened by a large wooden wardrobe in the right-hand corner and surmounted by the figure of *Justice*. On the ceiling, the central panel with *St. Mark in Glory Crowns the Theological Virtues* is a 19th-century copy by GIULIO CARLINI of the original by PAOLO VERONESE, which is now in the Louvre. The design of the *fireplace* (1553-54) between the windows is attributed to JACOPO SANSOVINO. Follow

120 BOTTOM SALA DELLA BUSSOLA.

120-121 SALA DEL CONSIGLIO DEI DIECI.

121 BOTTOM ARMERIA, FOURTH ROOM.

the sign of the official tour and enter the **Sala d'Armi** or **Armeria**, the Armory with weapons from different countries and areas dating from the 15th to the 17th century. Among the objects in the *second room*, there is the *armor of Henry IV* of France; in the *fourth room* is the monument the Senate built in honor of *Francesco Morosini*; the bronze *bust*

(1687-88) by the Genovese FILIPPO PARODI. Close to the exit, is a splendid *culverin* (1569) signed by SIGISMONDO ALBERGHETTI. Going down the short stairway, on the entrance door you will see the bust of Sebastiano Venier (before 1608), the admiral and person responsible for the victory at Lepanto against the Turks, sculpted by ALESSANDRO VITTORIA.

■ Go down the stairs to the FIRST FLOOR and turn left into the **Liagò (Andito del Maggior Consiglio)**, the L-shaped upper loggia hall reserved for the nobles taking a break from the meetings. Along the right-hand wall is a long canvas signed by PALMA GIOVANE and dated 1615: *Doge Marcantonio Memmo Kneeling before the Madonna and Child*. The first door at left leads to the **Sala delle Quarantia Civil Vecchia**. Besides the paintings by PIETRO MALOMBRA and GIOVAN BATTISTA LORENZETTI, there are two large canvases by ANDREA CELESTI (1637-1712). The first one, at right, represents *Moses Destroying the Golden Calf*. Next is the **Sala dell'Armamento**, which has the remains of the great fresco that GUARIENTO DI ARPO painted for the Sala del Maggior Consiglio that was destroyed in the fire of 1577. This work depicted *The Coronation of the Virgin*

(1365-68). In the middle you can still make out the double Gothic throne on which Jesus and Mary are seated, flanked by hosts of angels and saints. Below them, in two rows of stalls, are angels playing music and the Evangelists. Going back into the Liagò, you will see, in a glass case, the statues of *Adam and Eve* (1462-71) by ANTONIO RIZZO, which were originally in the Arco Foscari. These statues strike one for the great change in religious sentiment in just one century. The two 1300s figures situated on the main outside corner of the palace were based on the dialogue with God and the theme of guilt for the sin committed, while these stand out for their anatomical realism that betrays an obvious sensual enjoyment of the beauty of the human body, imperfect though it may be. Of the two figures, only Adam is absorbed in justifying his acts with God. Yet his Herculean physique

manifests strength and the desire for self-sufficiency. On the contrary, Eve is already completely removed from her sense of guilt, and instead of making excuses with her Creator, she exudes self-confidence. The gesture of covering her pubes is not one of shame, but of modesty, so much so that it reminds us of the classical figures of Venus. The *Warrior Holding a Shield*, attributed to ANTONIO RIZZO, was also originally in the Arco Foscari. This figure was called *malocchio* "evil eye" because of the severed head of Medusa on his shield, which is considered a later addition to the work. Retracing your steps, on the right-hand wall of the Liagò are the three large canvases (1728) by SEBASTIANO RICCI used as preparatory models for the mosaics of the fourth doorway of St. Mark's Basilica and representing, in the middle, *The Doge Receives the Body of St. Mark in His Palace and Pays Tribute to Him* (1729).

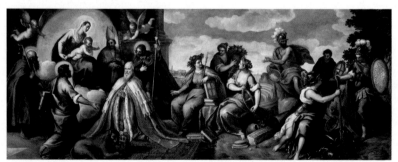

122 AND 123 CENTER LEFT PALMA GIOVANE, *DOGE MARCANTONIO MEMMO KNEELING BEFORE THE*

MADONNA AND CHILD AND DETAIL.

123 TOP THE LIAGÒ.

123 BOTTOM ANDREA CELESTI, *MOSES DESTROYS THE GOLDEN CALF*, SALA DELLA QUARANTIA CIVIL VECCHIA.

123 BOTTOM RIGHT ANTONIO RIZZO, *ADAM*.

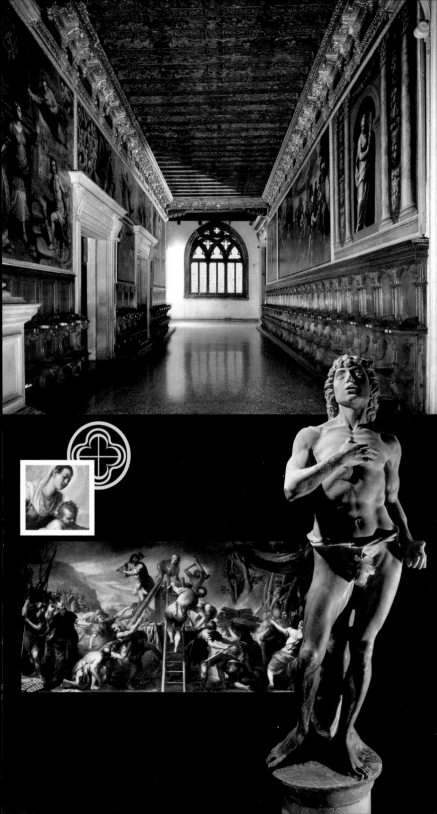

124 TOP LEFT PAOLO
VERONESE, *TRIUMPH OF
VENICE*, SALA DEL
MAGGIOR CONSIGLIO.

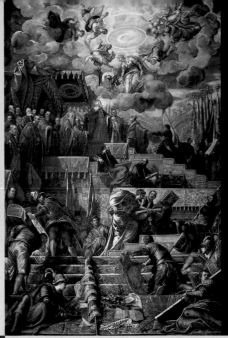

124 TOP RIGHT
J. TINTORETTO
AND HELPERS, *THE
TRIUMPH OF DOGE
DA PONTE.*

124 BOTTOM
*VICTORY AT
CHIOGGIA.*

125 SALA DEL
MAGGIOR
CONSIGLIO.

This is followed by the **Sala del Maggior Consiglio**, where all the patricians over twenty-five years of age met. The assembly of the Council, founded toward the end of the 12th century and consisting of 1,200 to 2,000 members, was considered the sovereign body of the aristocracy, which, besides its wide-ranging legislative powers, also elected the members of the Senate and also the doge. This large hall, destroyed during the 1577 fire, was rebuilt and decorated between 1578 and about 1605. The painting cycles, together with the Sala dello Scrutinio, were elaborated by the Florentine canon Girolamo de' Bardi and by the patricians Jacopo Marcello and Jacopo Contarini. The walls of the hall illustrate three fundamental episodes in the history of Venice. First is its role as mediator between Pope Alexander III and Holy Roman Emperor Barbarossa, which culminated in the peace of 1177. Second is the Fourth Crusade (1204), with the conquest of Zadar and Constantinople, which marked Venetian dominion in the Adriatic and eastern Mediterranean. And third is the victorious War of Chioggia against the Genovese, which ended with the peace of 1381 that sanctioned the Republic's maritime and commercial supremacy and paved the way for further expansion on the Italian mainland. On the upper part of the walls is a frieze with the *portraits of 76 doges.* Most of these canvases were painted by DOMENICO TINTORETTO and members of his workshop. The side panels on the ceiling narrate the three main military victories in the 15th and early 16th century, which established Venetian dominion of the mainland and sparked the

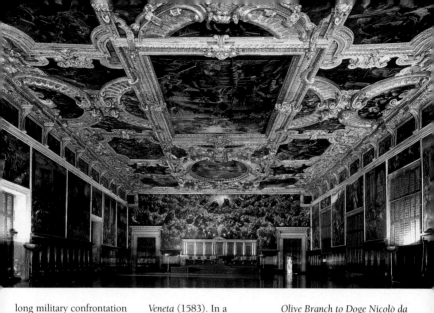

long military confrontation with the Ottoman Empire. The three central panels on the ceiling celebrate the triumph of Venice, whose female image – in the three-fold role of dogaressa, Virgin, and queen – is aloft in the heavens. This literary and theatrical display is matched, on the main wall, by the theme of *Paradise*. The apotheosis of the city is therefore the counterpoint of the celestial court. The history of Venice is reflected and interwoven in that of Christianity, of which it is the bulwark against infidels. The triumphal *wooden cornice* on the ceiling, designed by CRISTOFORO SORTE, was finished in 1582. Beginning on a level of the "tribune" with the doge's seat, the first of the three main ceiling panels, painted by PAOLO VERONESE, represents *The Apotheosis of Venice* or the *Pax Veneta* (1583). In a spectacular setting framed by two tortile, composite-order columns, all the peoples and social classes subject to the dominion of the Venetian Republic face one another. A reminder of this is also the golden lion that stands out between two horses. Of the same golden hue, against a blue background, is the crest on the balustrade, belonging to Doge Nicolò da Ponte (1578-85). Venice is truly in glory. Above her head fly Fame and a Winged Victory, while at her side are seated, much like ladies-in-waiting, the allegories of six virtues. The one at left, dressed like an ancient warrior, is Honor. Traditionally her features have been likened to those of Henry III of France. In the central panel, JACOPO TINTORETTO and his helpers immortalized Doge Nicolò da Ponte in *Venice Giving an Olive Branch to Doge Nicolò da Ponte* (or *The Triumph of Doge da Ponte*; 1579-84). The dizzying staircase populated by exotic figures and austere senators, seems like a version of the Scala dei Giganti in the palace courtyard. However, the scene is set outdoors, in front of the Basilica, which is in the background. The last large panel is by PALMA GIOVANE, *Venice Crowned by Victory*, surrounded by the subject cities (1578-79). The scenes of the side panels, depicting battles and examples of heroism, are the work of the following artists and their workshops: JACOPO TINTORETTO, PAOLO VERONESE, FRANCESCO BASSANO, PALMA GIOVANE, and, in the smaller panels, ANTONIO VASSILACCHI (known as L'ALIENSE), LEONARDO CORONA, FRANCESCO MONTEMEZZANO and ANDREA MICHIELI (known as IL VICENTINO).

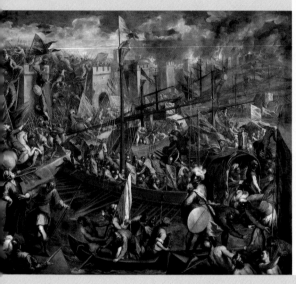

126 TOP LEFT AND 127 BOTTOM JEAN LE CLERC, *DOGE ENRICO DANDOLO AND THE CRUSADERS IN ST. MARK'S BASILICA* AND DETAIL.

The main wall, on the stalls of which sat the doge and his six counselors, is dominated by the large canvas depicting *Paradise* (1588-92), conceived by JACOPO TINTORETTO and painted for the most part by his son DOMENICO and helpers. This work replaced GUARIENTO's *The Coronation of the Virgin*, mentioned above. In the center of the upper section of the painting are the figure of Christ and the Virgin Mary. But here, instead of being crowned, Mary is interceding with her Son and therefore alludes to the Last Judgment. Farther down are the Four Evangelists. At right are the saints of the Church, among whom St. Jerome stands out

with his red cloak. Next to the door is the titanic figure of St. Christopher, who, instead of bearing the Infant Jesus on his shoulders, is holding the transparent sphere of the Universe, much like Atlas. Behind him are the innocents massacred at Bethlehem. At left, besides the many saints, there are also prophets and other persons from the Old Testament. Among them we can recognize St. Lawrence, with the ever-present gridiron, and Moses with the Tables of the Law and recognizable by the rays of divine light issuing from his head.

Along the north wall, which faces the palace courtyard, is the cycle of twelve large

canvases devoted to Pope Alexander III and Frederick Barbarossa, painted by CARLO and GABRIELE CALIARI, LEANDRO BASSANO, JACOPO TINTORETTO and his workshop, PAOLO FIAMMINGO, DOMENICO TINTORETTO, ANDREA MICHIELI (IL VICENTINO), PALMA GIOVANE, FEDERICO ZUCCARI, GIROLAMO GAMBARATO and GIULIO AGNOLO DEL MORO. Note, in particular, the scene between the two windows, *Pope Alexander III Consigns the Sword to Doge Sebastiano Ziani*, who is on his way to combat Barbarossa's fleet. This mediocre painting is by FRANCESCO BASSANO, who painted the Piazzetta and, in the foreground, genre scenes

with boats and the charming episode of the man and his dog who have fallen into the water. Along the south wall, which faces the Molo or quay, is the cycle of eight large canvases concerning the Fourth Crusade (ca. 1580-1605), which also continues on the west wall. Beginning with the huge *Paradise* canvas behind you, the first painting is *Doge Enrico Dandolo and the Crusaders in St. Mark's Basilica* by JEAN LE CLERC, which is surprising for the unspeakable confusion that reigns inside the church. This is followed by *The Conquest of Zadar* by ANDREA MICHIELI (IL VICENTINO); *Consigning the Keys of Zadar* by DOMENICO TINTORETTO; *Alexius IV*

Meeting the Crusaders at Zadar by IL VICENTINO; *The Siege of Constantinople* by PALMA GIOVANE; *The Conquest of Constantinople* by DOMENICO TINTORETTO; *Baldwin Being Elected Emperor of the East* by IL VICENTINO; and *The Coronation of Baldwin* by ANTONIO VASSILACCHI (L'ALIENSE). Then there is a ninth canvas, *The Victory of Chioggia against the Genovese* by CARLO and GABRIELE CALIARI, which is not part of the cycle.

126 BOTTOM PALMA GIOVANE, *THE SIEGE OF CONSTANTINOPLE*.

126-127 JACOPO TINTORETTO AND ASSISTANTS, *PARADISE*.

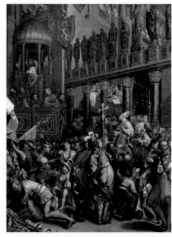

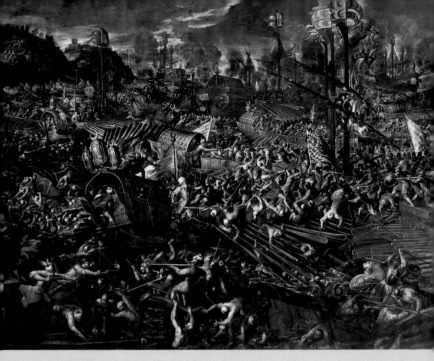

128-129 ANDREA
VICENTINO, THE
BATTLE OF LEPANTO,
SALA DELLO
SCRUTINIO.

128 BOTTOM
JACOPO
TINTORETTO, THE
BATTLE OF ZADAR.

The adjoining door leads to the **Sala della Quarantia Civil Nuova**, which has paintings by ANTONIO FOLER, GIOVANNI BATTISTA LORENZETTI and FILIPPO ZANIBERTI. The next, large hall is the **Sala dello Scrutinio**, in which elections were held, including that of the doge. The procedure for the election of the highest office in the Venetian Republic was quite complex, involving no less than nine ballotings in order to prevent fraud on the part of the most powerful families. This hall was rebuilt in between 1582- ca. 1599. The pictorial program in this hall was worked out together with that in the Sala del Maggior Consiglio, but was then changed and completed in the 17th century. The design of the wooden ceiling

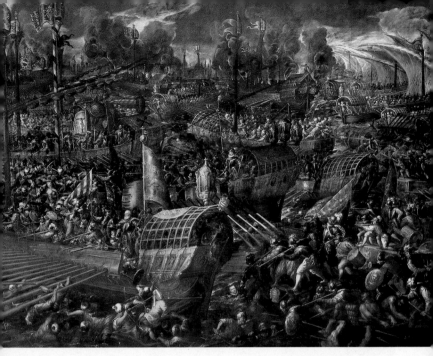

(late 16th century) is by CRISTOFORO SORTE. In the panels, ANDREA VICENTINO, FRANCESCO MONTEMEZZANO, NICOLÒ BAMBINI, ANTONIO VASSILACCI (L'ALIENSE), CAMILLO BALLINI and GIULIO DEL MORO painted *Venice's War against the Maritime Republics* from the 11th to the 13th century. In the oval near the entrance wall, FRANCESCO BASSANO executed a splendid nocturnal canvas that narrates the only mainland episode in this cycle, *The Capture of Padua*, which took place in 1405. The main wall of the Sala dello Scrutinio is decorated with *The Last Judgment* (1594-95) by PALMA GIOVANE. In the center, Christ is being held up by a group of angels. On either side, the Virgin Mary and St. John the Baptist intercede for humanity. The

scenes on the other walls depict naval and land battles won by the Venetians from the 9th to the 17th century. These canvases are by ANDREA VICENTINO, SANTE PERANDA, ANTONIO VASSILACCHI (L'ALIENSE), MARCO VECELLIO and PIETRO LIBERI. The allegorical scenes and the other war episodes, situated above the windows, are by SEBASTIANO RICCI, ANTONIO VASSILACCHI, MARCO VECELLIO and PIETRO BELLOTTO. Especially noteworthy is the enormous canvas between the two windows overlooking the courtyard. This is the theatrical *Battle of Lepanto* (which took place in 1571), in which ANDREA VICENTINO (ca. 1539- ca.1617) describes in great detail the violent encounter between the galley of the Turkish admiral, Ali Pasha, and, at

right, that of the Venetian admiral, Sebastiano Venier. On the same wall, at right, JACOPO TINTORETTO immortalized the spectacular *Battle of Zadar* (1584-87), which depicts the battle between the Venetian and Hungarian armies that took place in 1346. Above left, note the crests of the *provveditori* of the Venetian army, together with the Lion of St. Mark. On the back wall, which communicates with the entrance stairway, is the *Triumphal Arch*, attributed to ANDREA TIRALI, which the Senate commissioned in 1694, as can be seen in the commemorative plaque in honor of Francesco Morosini, commonly known as the Peloponnesian. The allegorical paintings concerning the conquest of the Peloponnesus are by GREGORIO LAZZARINI.

■ You now go back along the north wall of the Sala del Maggior Consiglio, toward the courtyard, and past the small door in the left-hand corner. From there, follow the signs of the official tour and you will pass through the **Sala della Quarantia Criminal** and arrive at the first **Sala del Magistrato alle Leggi**, which was an archive. In the Sala del Magistrato alle Leggi there are fine oil paintings on wood panels by Flemish artists. This hall has the only works by HIERONYMUS BOSCH in Italy. The group of four panels (1500-04) comes from the collection of Cardinal Domenico Grimani. The first two panels depict *Paradise*, with the chosen in the nude and the fountain of eternal life, followed by *The Ascent*

into the Empyrean, in which the souls, aided by the guardian angels, go up into the Empyrean through the passageway above the North Star. In the other two panels the artist paints a horrible *Hell*, where the sulfurous air and utter darkness are invaded by perennial fires and satanic creatures who vomit flames much like those of an arquebus. On the adjoining wall, the *Retable of St. Jerome* (1505), signed by Bosch, shows St. Jerome in the desert and, on the wings, St. Anthony Abbot and St. Giles. The three scenes, which drew inspiration from traditional hagiographic sources, are set in a fantastic, visionary world filled with mystical, hermetic and alchemical references, medieval symbols and surreal

creatures. This work is followed by the triptych, signed by the artist, with the *Retable of St. Julia* (1500-04) in the center. The young saint was crucified by her father because she had asked God to let her grow a beard so she could remain a virgin. Following the official itinerary, pass through the first corridor of the Ponte dei Sospiri or Bridge of Sighs and into the Prigioni Nuove. In case of flooding or other special circumstances, this tour – in which you can visit the prisoners' cells and see an exhibit of the archeological digs from St. Mark's Square – will be limited.

■ The second corridor in the Bridge of Sighs leads back to the loggia story of the palace and then to the **Sala dei Censori**, which was reserved

for the magistracy established in 1517 that was charged with preventing election frauds and had jurisdiction over gambling. Among the paintings, the first one at right, *The Annunciation and Three Censors*, is by DOMENICO TINTORETTO and is dated 1605. This hall is followed by the **Sala dell'Avogaria di Comun**, the magistracy established in the second half of the 12th century. This was prompted by the aim of defending the public interest in fiscal and state property matters and also ensuring the proper application of the law and observance of the statutes. Among the paintings, the most interesting one, above the entrance door, is DOMENICO TINTORETTO'S *The*

Risen Christ with the Magistrates Michele Bon, Francesco Pisani and Ottaviano Valier (ca. 1571). The nearby **Sala dello Scrigno**, divided into two rooms, was where the magistrates housed the *Libri d'Oro delle Nascite* (1506), and the *Libri d'Oro dei Matrimoni* (1526), the "golden books" or registers of births and marriages that were necessary to certify the legitimacy of titles of nobility. After this hall there are the **Sala della Milizia da Mar**, the magistracy instituted in 1545 to recruit crews for the war fleet, the **Sala della Bolla** (not open to the public), and the **Sala della Cancelleria Inferiore**, after which, once out of the Loggia, you proceed to your right. On the wall is the

commemorative plaque in honor of Henry III of France (1574-75) whose elaborate Mannerist style frame was sculpted and signed by ALESSANDRO VITTORIA. After going down the *Scala dei Senatori*, you are on the ground floor. At left are two rooms used for temporary exhibitions, including the one given over to the restoration of the mechanisms of the Tower Clock. Opposite this, in the short arcade, is the statue of the first patron saint of Venice, *St. Theodore* (or Todaro, as the Venetians call him), which comes from one of the two huge columns on the quayside (Molo). In the adjacent **Cortile dei Senatori** is the **Chapel of St. Nicholas**, rebuilt in 1505 and attributed to GIORGIO SPAVENTO.

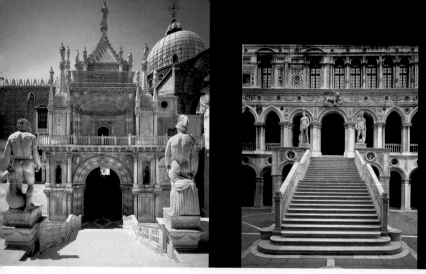

On the side facing the chapel, the courtyard is closed off by the **Scala dei Giganti**, designed by Antonio Rizzo and completed in 1485. The top of the staircase was used for the coronation ceremony of the doge. On particular ceremonial occasions, the doge would wait here "on high" for the arrival of the ambassadors. The decorative motifs were executed around 1491 by at least two workshops of Lombard artisans. On the top of the staircase, three pointed arches on the arcade were replaced by round arches decorated with lions' heads. The statues of *Mars* and *Neptune* – allegories of the military and maritime power of Venice executed in 1565 – are signed by Jacopo Sansovino but in reality are the work of seven assistants. The decoration of the **Arco Foscari** is attributed to Bartolomeo Bon and serves as the counterbalance of the Porta della Carta outside. The bronze statues of Adam and

Eve are copies of the original stone sculptures by Antonio Rizzo, which are now in the Liagò of the Doges' Palace. The crown is dominated by the statue of *St. Mark*, under which are the figures of the *Liberal Arts*, the *Virtues* and *Adoring Angels* (1462-76), done by various sculptors. *Prudence*, recognizable by her round mirror, was sculpted by Antonio Corradini shortly after 1727. The arch opens on to the **Andito Focari**, built in 1438-45. This broad corridor consists of six bays by Stefano Bon. Besides the official itinerary of the Doges' Palace, there is another one:

■ **Itinerari segreti (secret itineraries)**, which can be done by reservation only. This tour begins from the door at left in the *Atrio Quadrato*. Then you go up to the *Ufficio della Cancelleria Grande* and the adjacent *Ufficio del Segretario alle Voci*, the Chancellery and Registrar's Office where the elected members of the

various magistracies were registered. On the top floor is the archive of the *Cancelleria Superiore* (or Secreta), the Chancellery archive. The upper doors of the credenzas are painted with the blazons of the 34 registrars. After the rooms of the *Reggente e Vice Reggente della Cancelleria Ducale* (deputy and vice deputy of the Chancellery), you enter the **Camera del Tormento** or torture chamber, designed by Antonio Da Ponte, who put in a tall skylight. This place was feared by every Venetian and it was also called "tribunale del luogo della Corda," or the "rope court," because of the long rope with which the accused were hung by the hands, with their arms behind their backs. The tour continues with the cells of the old prison, known as the *Piombi* because it lay under the palace roof, which was lined with lead (*piombo*). On the top floor, past the lovely *Armeria del Consiglio dei Dieci*, a gallery leads to the

The *Allegories of Virtue* in the side panels are by the school of TINTORETTO. Behind the desk is the 15th-century *Madonna and Child*, an oil-on-wood panel by BOCCACCIO BOCCACCINO. The tour proceeds through the *Archivi segreti della Inquisizione* (Secret Archives of the Inquisition), which communicate with the Sala della Bussola and then returns to the starting point of the tour, in the Atrio Quadrato.

attic section of the Sala del Maggior Consiglio. Besides the long trussing – designed by ANTONIO DA PONTE and built by the Arsenal artisans. The next stop, down on the second floor, is the **Sala dei Tre Capi del Consiglio dei Dieci** (Hall of the Three Heads of the Council of Ten). In the octagonal panel of the ceiling GIAMBATTISTA ZELOTTI painted *Virtue Defeating Vice*. The other panels are by GIAMBATTISTA PONCHINO (*The Triumph of Faith over Heresy*) and PAOLO VERONESE (*The Triumph of Virtue over Evil* and *The Triumph of Nemesis over Sin*). The fine *fireplace* (1553-54) has two caryatids. The one at right is signed by

PIETRO GRAZIOLI DA SALÒ, the other caryatid was attributed by G. VASARI to DANTE CATTANEO. On the wall, the *Pietà with Three Angels* (before 1497) by ANTONELLO DA SALIBA is a copy of the work by his uncle, ANTONELLO DA MESSINA, now in the Museo Correr. A small stairway leads to the **Sala degli Inquisitori di Stato**, the hall of the state inquisitors, the magistrature connected to the Council of Ten and founded in 1539, responsible for security and also the supreme political court. On the ceiling, framed by an octagonal profile, J.TINTORETTO painted *The Prodigal Son* (1565-66).

132 LEFT ARCO FOSCARI SEEN FROM THE COURTYARD.

132 RIGHT THE SCALA DEI GIGANTI.

133 TOP AND BOTTOM RIGHT BOCCACCIO BOCCACCINO, MADONNA AND CHILD: AND DETAIL, SALA DEGLI INQUISITORI DI STATO.

133 CENTER CAMERA DEL TORMENTO (TORTURE CHAMBER).

133 BOTTOM LEFT CANCELLERIA SUPERIORE.

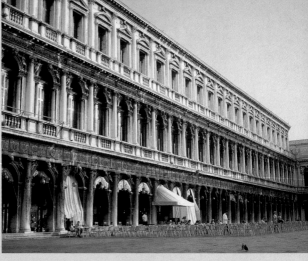

134 LEFT AND 135
EXTERIOR AND
INTERIOR OF THE
CAFFÈ FLORIAN.

134 RIGHT
PROCURATIE
NUOVE.

■Exiting from the Porta della Carta, you now go around the right side of SANSOVINO's Loggetta. The long building that bounds one side of St. Mark's Square to the left was the home of the **Procuratie Nuove** (new offices of the Procurators of S. Marco) and was built as a continuation of the Libreria by VINCENZO SCAMOZZI. The architect continued the design and decoration of SANSOVINO's façade of the Libreria, lowered and simplified the Ionic frieze and added another, Corinthian-order story without a frieze and with traditional windows that were embellished above the crown by statues of recumbent figures.

Work on the foundations began around 1583, and the architect supervised construction up to the tenth arch. When he died in 1616, he was replaced by the chief architects of the Procuratia, SIMONE SORELLA, FRANCESCO DE BERNARDIN, MARCO DELLA CARITÀ and, from 1640 on, by BALDASSARE LONGHENA, who completed the Procuratie Nuove around 1650. LONGHENA left his mark on the end of the edifice, which can be seen from the Calle Larga de l'Ascension. In 1807, a Napoleonic decree established that the Procuratie Nuove would become the royal palace. Although it was no longer independent, Venice was, together with Milan, the capital of the Lombardy-Veneto area and continued to hope for a revival of its maritime economy. Prince Eugène Beauharnais, viceroy of Italy, named a new superintendent of the Procuratie Nuove, GIOVANNI ANTONIO ANTOLINI, who had designed the Foro Bonaparte in Milan. This architect altered the layout and decoration of the interior, adapting it to the new Neo-Classical taste and summoning artists such as CARLO BEVILACQUA and GIUSEPPE BORSATO to do the painting decoration. The building is now the home of the Museo Civico Correr and the Museo Archeologico Nazionale. In the arcade of the Procuratie Nuove you can take a pleasant stroll and go see the famous **Caffè Florian** (no. 57), which was opened in 1720 by the Venetian Floriano Francesconi. The present décor dates back to 1858 and was designed by LODOVICO CADORIN, who utilized several local artisans and artists, such as the painters CESARE ROTA and GIACOMO CASA, who executed the *Four Seasons* and *Oriental Beauty* respectively. The room at left of the entrance, since 1820 called the Sala del Senato, was a favorite haunt of the Venetians in that period. From the outset the café was frequented by well-known artists, writers, patriots and politicians and now

sometimes hosts small exhibitions of internationally known artists. Continuing your walk, at the end of the arcade, toward the Ala Napoleonica, you will see, at left, the **Opera Bevilacqua La Masa** exhibition center (no. 71D). The foundation of the same name was inaugurated in 1905 thanks to the bequest that the Duchess Felicita Bevilacqua La Masa left to the city of Venice. The foundation also has offices at San Barnaba that are used for art shows, and studios for young artists in Palazzo Carminati. Among the recent shows, there have been group exhibitions of young artists, and one-man shows by JEAN-MICHEL BASQUIAT, JOSEPH BEUYS, SHIRIN NESHAT, LOUISE BOURGEOIS and FRIDA KHALO. The side of the square opposite the basilica is occupied by the **Ala Napoleonica**, or Napoleonic Wing. After the above-mentioned decree that the

Procuratie Nuove be transformed into a royal palace, Prince Eugène, the Viceroy of Italy, decided to build halls for balls and festivities and a monumental access way worthy of Napoleon's court in this area. The original project by GIOVANNI ANTONIO ANTOLINI was discarded, and construction was entrusted in 1810 to GIUSEPPE MARIA SOLI from Modena, who demolished SANSOVINO's Church of San Geminiano and a part of the Procuratie Vecchie, and in about four years built a new façade that is in the same style as the Procuratie Nuove. The only innovation was the replacement of the second floor with an attic decorated with fourteen statues of Roman emperors in a martial pose by ANTONIO BOSA and DOMENICO BANTI and a central relief with a mythological subject. The back side of the building,

which is more austere, bears the influence of LORENZO SANTI, who also designed the interior, the *piano nobile* of which is made up of a large staircase, an antechamber, a ballroom and a long inner loggia facing St. Mark's Square. The painting decoration, typical of Venetian Neo-Classical taste, was executed by GIUSEPPE BORSATO, SEBASTIANO SANTI and ODORICO POLITI. When Venice was ceded to Austria in 1814 the building became the residence of the Austrian governor of the Venetian Provinces. In 1848 and 1849, it briefly housed the government of the revolutionary and democratic republic headed by Daniele Manin. When Austria regained control of the city, the building hosted the Emperor Franz Joseph and his wife Elizabeth of Bavaria, known as Sissi. It is now the home of the Museo Civico Correr.

■ Once in the middle of the arcade, go into the wide corridor, the Sotoportego San Geminian. At right is the entrance to the **Musei di Piazza San Marco**, which groups together the Museo Civico Correr, the Museo Archeologico Nazionale di Venezia and the Sale Monumentali della Biblioteca Nazionale Marciana (the library). After going up the majestic

monumental staircase crowned by the ceiling fresco by SEBASTIANO SANTI depicting *The Apotheosis of Neptune* (1837-38), you are in the Antisala on the FIRST FLOOR, where the ticket office is located. Past the entrance, to the left, are the rooms of the **Museo Civico Correr**, which are in both the Ala Napoleonica and the Procuratie Nuove. Opened in 1836 thanks to a generous bequest on the part of Teodoro Correr (1750-1830), an art collector who was also a passionate collector of objects and memorabilia concerning Venice, this museum was originally housed in Correr's residence. Later on, it was housed in the Fontego dei Turchi, now the home of the Civic Natural History Museum. Numerous donations increased the number of art works, and the museum was

transferred to Piazza San Marco in 1922. The permanent exhibition space, flanked by a library of Venetian art and history and by a well-stocked engravings and drawings section (Gabinetto di Stampe e Disegni), is divided into eight main sections. On the first floor is the Canova gallery, in the Neo-Classical rooms (*rooms 3-5*); the history of Venetian civilization section (*rooms 6-14, 45-47, 52-53*); the Correr and Morosini armories (*rooms 15-18*); and the collection of small 15th-17th century bronze sculpture (*rooms 20-22*). On the second floor there is the picture gallery (*rooms 25-31, 33-39, 41*) and the medieval and Renaissance art section (*rooms 23, 32, 40, 43*), which includes majolica (*room 42*). Again on the first floor are the handicrafts and trades sector (*room 48-51*) and the one given over to public and private games and entertainment in Venice (*rooms 52 and 53*). The

design of the museum exhibits, done in two phases (1952-53 and 1960), is by CARLO SCARPA. The museum organizes small and fine documentary exhibits with material from the library and storerooms. In other rooms on the second floor not covered in this itinerary, interesting temporary exhibits of modern and contemporary art are held. The museum entrance leads into the **Canova Gallery** (*room 3.1-6*) or Napoleonic Loggia. The first room (*3.1*) has two plaster bas-reliefs by ANTONIO CANOVA (1757-1822). The first is the moving *Death of Priam* (1787-90), the king of Troy killed by Achilles' son Neoptolemus. At left is the *Sala delle Belle Arti* (*3.3*). The figured decoration, flanked by GIUSEPPE BORSATO's ornamentation, is attributed to PIETRO MORO, who also executed *Virtue Triumphs over Envy* in the tondo on the ceiling. The plaster statue of a *Young Girl Weeping* is by ANTONIO CANOVA, other

136 TOP ALA
NAPOLEONICA.

136 BOTTOM
ANTONIO
CANOVA, *DEATH
OF PRIAM*.

137
MONUMENTAL
STAIRCASE, ALA
NAPOLEONICA,
MUSEO CORRER.

plaster works of whom are in the loggia. *Room 3.5* has other works by ANTONIO CANOVA. At right, the terracotta and wood model for the elegant and moving *Monument to Titian* (1795), executed for the Frari Church and used instead to build the *Funerary Monument of Canova* in the same church. There is also a small wax and wood model for the refined and erudite *Funerary Monument to Francesco Pesaro* (dated 1799), the procurator of S. Marco and last librarian of the Republic. At the end of the room is the life-size plaster statue of *Paris* (1807). The numerous small points or studs in the figure of Paris served as marks for the sculptor's helpers to measure the coordinates when they rough-hewed the block of marble that was to be sculpted. The room continues via the corridor beyond the statue of Paria, up the stairway that leads to the rooms used for temporary shows. In this small area there are other plaster casts

by CANOVA. On the back wall is the large *Bust of Pope Clement XIII* (1784-86), the Venetian Carlo Rezzonico (1693-1769), executed for his tomb in St. Peter's Basilica, Rome. The right-hand wall has bas-reliefs inspired by Plato's *Phaedo*: *Socrates Taking Leave of His Family*, *Socrates Drinking the Hemlock* and *Crito Closes Socrates' Eyes*. On the wall opposite are *Charity* and *Hope* (1798-99). Returning to the beginning of *Room 3.6* and turning left, you enter the *Salone da ballo*, the splendid and vast Imperial style ballroom made ornate with Corinthian columns with gilded capitals. The loggias were once used by the orchestra. The decoration is by GIUSEPPE BORSATO (1822-43). In the middle of the ceiling, ODORICO POLITI frescoed *Peace Surrounded by Virtue and the Genii of Olympus* (ca. 1834). The sculpture group in Vicenza stone by ANTONIO CANOVA, *Orpheus and Eurydice* (1773-76), was commissioned by

Senator Giovanni Falier. The scene, taken from Virgil's *Georgics* and Ovid's *Metamorphoses*, illustrates the moment when the poet and musician Orpheus, attempting to take his wife from the Underworld, makes the fatal mistake of disobeying Hades' order not to look back at her. In that instant, the hand of a Fury emerges from the miasma of the Underworld and drags the desperate Eurydice back. Note that this work is sometimes placed in other rooms. Returning to the Canova Gallery, you enter *Room 4* or the Sala del Trono (Throne Room), with lovely Neo-Classical decoration dating from the first two decades of the 19th century (some of which was brought from the rooms of the Procuratie Nuove when it was transformed into a royal palace in 1807) by GIUSEPPE BORSATO, GIAMBATTISTA CANAL and FRANCESCO HAYEZ. On the ceiling, GIOVANNI CARLO BEVILACQUA painted *Victory Guides Faith to Crown Europe* (1814).

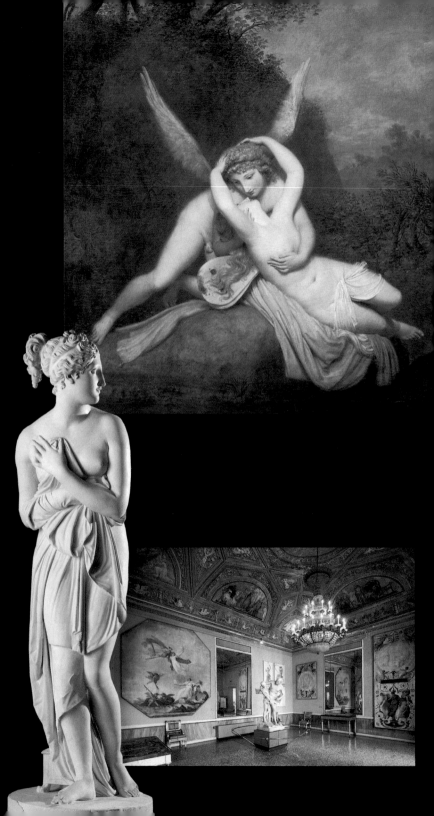

138 TOP
ANTONIO CANOVA,
CUPID AND PSYCHE.

138 BOTTOM RIGHT
THRONE ROOM.

138 BOTTOM LEFT
ANTONIO CANOVA,
VENUS ITALICA.

139 ANTONIO
CANOVA, *DAEDALUS
AND ICARUS* AND
DETAIL.

Among the sculptures by CANOVA, in addition to the plaster cast of the *Winged Cupid* (ca. 1797), there is the splendid *Daedalus and Icarus*, sculpted in marble in 1778-89 for the palazzo on the Grand Canal of the procurator Pietro Vettor Pisani. This subject, taken from Book VIII of Ovid's *Metamorphoses*, depicts Daedalus carefully placing artificial wings on his son so that he can escape from the labyrinth at Knossos, where he was imprisoned by Minos, the king of Crete. The father's intense concentration contrasts with the light-hearted insouciance of his young son, who is oblivious to the danger and pays no heed to his father's instructions on how to fly. CANOVA was twenty-two at the time, and although still under the influence of late Baroque sculpture, he already distinguishes himself in this work for his subtle approach to human emotions, which he renders with great poise. Other noteworthy features are the masterful counterpoint in the pose of the figures and the original use of iron, such as the wire held by Daedalus and the long feathers (painted white) folded behind one of Icarus'

shoulders. At the base of this group are a mallet and chisel, which could be interpreted as an allegory of sculpture but are really appropriate to the character of Daedalus, who was a master inventor and skillful sculptor.

Room 5 or the Dining Room: on the ceiling is a fresco of Olympus by GIOVANNI CARLO BEVILACQUA. In the roundels are *The Stories of Cupid and Psyche* by PIETRO MORO, while the roundels on the walls have the *Months*, the *Signs of the Zodiac*, and *Views of the Cities of the Lombard-Veneto Region*. Above the doors are couples of putti (1824-25) by SEBASTIANO SANTI. The plaster statue of *Venus Italica* between the windows, by ANTONIO CANOVA, describes the goddess drying herself and being distracted by someone. The marble original (1804-12) is in the Galleria Palatina, Florence. Behind this work are two oil paintings on an easel, again by CANOVA. The first is *Cupid and Psyche* (1789-94), in the same recumbent position as the famous statue group in the Louvre, Paris; and Psyche's dragonfly wings were copied from GIAMBATTISTA TIEPOLO. The

second painting is a portrait of the antiquarian Amedeo Svajer (1790), which was done before the sculptor moved to Rome and was left unfinished. Among the terracotta working models by CANOVA in the glass cases, the one titled *Cupid and Psyche* (1787) is really a young man wriggling in the arms of a girl. This work, executed rapidly and with great skill, owes its vibrant expression to the parallel marks made by the graver. The precious 19th-century circular table made in France rests upon three winged sphinxes in bronze. In the middle of the table is *The Judgment of Paris* surrounded by other mythological scenes in white Sèvres porcelain with a light blue ground.

Room 6 (Sala dei Dossali, with dogal clothing): at right, on an easel, is LAZZARO BASTIANI's *portrait of Doge Francesco Foscari* (1450-57). The canvases on the walls represent *The Arrival in Venice of Caterina Cornaro after Her Abdication as Queen of Cyprus* by ANTONIO VASSILACCHI (known as L'ALIENSE). Above the showcases, the two shutters of the organ made by the Brescians GIOVANNI and BERNARDINO D'ASOLA come from the church of San Michele in Isola; they depict *St. Benedict and Two Monks* and *Doge Pietro Orseolo before St. Romualdo* (1526). *Festivities for the Coronation of the Dogaressa Morosina Morosini Grimani* (ca. 1595) by ANDREA MICHIELI (IL VICENTINO) is on the nearby wall. The dogaressa is disembarking on the Molo quayside in front of the Doges' Palace. The

140-141 ANDREA MICHIELI (IL VICENTINO), *FESTIVITIES FOR THE CORONATIONE OF THE DOGARESSA MOROSINA MOROSINI GRIMANI*.

temporary triumphal arch was erected by the butchers' guild. *Room 7*, formerly given over to an exhibit concerning the *election of the doge and the dogal festivities*, and *Room 8* – which houses the Pisani Library from the San Vidal palazzo, with elegant fluted composite-order half-columns – are now used for temporary exhibitions. *Room 11*

(numismatics) boasts rare and important Venetian coins such as the *denaro scodellato* or *piccolo* – coined under Doge Sebastiano Ziani (1172-78) – the *grosso* or *ducato amatapan*, the gold ducat, the *zecchino* and the *oselle* (medals that the doge gave to the nobles on New Year's Day). On the wall at right, above the showcases, is *St. Justina and the Camerlenghi* by JACOPO TINTORETTO, brought here from the Accademia Galleries. Two models of the 18th-century *galera grossa* or large galley ship (19th and 20th century) are in the showcase in the middle of the room.
Room 13 (the Arsenale): at right, a watercolor by

ANTONIO DI NATALE, *Plan and View of the Arsenal* (17th century), in which one can see both the land and water entrances and, in the New Arsenal, a ship on its side being repaired and caulked. On the wall near the exit is the insignia of the ship carpenters (1517, restored in 1753), in which the main ship-building phases are illustrated. *Room 14* (maps and views of Venice): at right, *Plan of Venice* (1729), a copper engraving designed by LODOVICO UGHI. This is followed by the *Plan in Perspective of Venice*, signed by GIUSEPPE HEINTZ IL GIOVANE, with the Bucintoro ceremonial ship followed by a procession of gondolas. In the middle of the room are globes by VINCENZO CORONELLI (1693). After *Rooms 15 and 16*, which house the precious Correr Armory, you enter two rooms (17 and 18) given

over to Doge Francesco Morosini (1688-94), who is buried in Santo Stefano Church, and his victories in Greece against the Ottoman Empire. The works on display come from the family residence and were purchased by the city in 1894. In *Room 17*, at left, is the large triple lantern (17th century) taken from the galley on which Morosini was killed. On the walls are 17th-century canvases by ALESSANDRO PIAZZA presenting episodes from Morosini's war campaigns, naval and field cannons, and 17th-century arquebuses. In a showcase is the curious prayer book with a miniature pistol for the doge's self-defense. *Room 18* contains a marble bust of Morosini (1687) by the Genovese FILIPPO PARODI, who also did a bronze replica now kept in the Doges' Palace. The doge is portrayed in the guise of

the Venetian admiral, with his baton placed on a map of the Peloponnesus (or Morea), the Greek region he temporarily wrested from Turkish dominion. On the wall is the *Portrait of Doge Morosini on Horseback* (ca. 1688) by GIOVANNI CARBONCINO. The door to the right of this canvas leads to the section dedicated to small bronze sculptures. *Room 19* (small 15th-16th century bronzes from Venice and Padua): in the showcase at right are some singular oil lamps in the shape of a dragon, an acrobat, and two lizards fighting. The door at left leads to the Museo Archeologica, while the tour of the Correr Museum continues in *Room 20* (small bronzes for domestic use). Note, in the last showcase at right, the late 16th-century goblet made by the ALBERGHETTI workshop in Venice.

Room 21 (16th-century Venetian bronzes): at right, in the middle showcase, is a 16th-century door-knocker made by the workshop of Alessandro Vittoria that represents Neptune with sea horses. *Room 22* (small 16th- and 17th-century Venetian bronze pieces), features works by the workshops of Tiziano Aspetti, Nicolò Roccatagliata and Girolamo Campagna. The last-mentioned executed the five angels (ca. 1617 in the showcase at left; (they come from the high altar of San Lorenzo Church) who are holding the instruments of Christ's Passion.

Once out of room 22, you can choose one of two possible itineraries. Either continue into the next section dedicated to handicrafts and trades (*Rooms 48-51*), or go up a staircase at left that is rather tiring but will reward you with fine art treasures. Once on the top landing, the flight of stairs at left leads to the Museo del Risorgimento, now used for educational programs and temporary exhibitions, while the flight of stairs at right, past Rooms 23 and 24, leads to the ■ Pinacoteca (Picture Gallery). *Room 25* (Paolo Veneziano and 14th-century Venetian painting): on the left wall is a triptych with wings that can be opened. This work, by a 14th-century Venetian master, depicts *The Crucifixion, Episodes from the Life of Christ and Mary*, and *Saints and Prophets*. Besides the references to the Eucharist and the **salvific** function of Christ's blood, this panel has other interesting iconographic features. Chief are the cross in the shape of the tree of salvation; the Transfiguration related to the tree of Jesse; and, in the right wing, the Ascension and the Flight into Egypt, during which – according to apocryphal sources – a date-palm bowed before the Virgin Mary to offer her its fruit. In the lower scene concerning the Old Testament, the episodes of Moses and the Burning Bush and the sacrifice of Abraham are concurrent. Among the wood panel paintings, there is the Venetian-Cretan school triptych, *The Madonna and Child, Pietà* and *Saints* (14th century) with a touching expression on the Virgin's face. Noteworthy is Paolo Veneziano's mysterious *St. John the Baptist* (mid-14th century), which may have come from the church of San Pietro di Castello. In this portrait, the leader of the Venetian school of painting of that period carefully balances the delicacy and naturalness of his colors with the abstract and geometric forms typical of Byzantine icon painting. In *Room 26* there are two

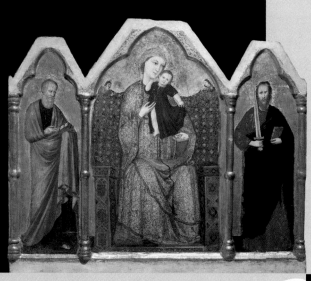

panels of polyptychs of *Three Saints, Scenes of Martydom and Angels* and *Consigning the Keys to St. Peter*, by LORENZO VENEZIANO, a 14th-century follower of PAOLO VENEZIANO. In the former work, distinguished by its delicate coloring, the figures are set in a three-lancet window in relief with interlacing arches. The drapery and postures reveal total acceptance of the canons of Gothic painting. *Room 27* (flamboyant Gothic): to your right is a marble statuette of *Doge Antonio Venier Kneeling* (late 14th century) by JACOBELLO DELLE MASEGNE, who also did the central rood screen in St. Mark's. This work seems to be an image on a Venetian coin sculpted in the round, while at the same time the face is rendered in a markedly realistic fashion. The two large fresco fragments on the wall nearby come from a house in the San Zulian neighborhood, in the San Marco district, and depict virtues and allegorical figures (mid-14th century). At right is the entrance to *Room 28* (Gothic painting): on the entrance wall, in his lovely *Madonna and Child between St. Paul and St. John*, the MAESTRO DELL'ARENGO distinguishes himself for the marked expressivity of the Infant Jesus. On the next wall, the *Crucifixion and Prophets* (14th century) by a Veneto painter highlights the salvific character of the Passion and the blood of Christ by utilizing symbols and allegories visualized during spiritual exercises. The busy figures around Christ, which have no wings, are Virtues associated with his stigmata. Humility sets the crown of thorns on Jesus' head. At the foot of the Cross are the figures of the blindfolded **Synagogue** and of Justice holding the bucket and the sponge soaked in vinegar. At left, on the altar mensa, the chalice is filled with a long gush of blood. On the side panel are an interesting *Madonna Suckling the Christ Child, Stories of Christ and of Saints* (13th century) by an unknown Veneto painter; works attributed to JACOBELLO DA BONOMO; a *St. Christopher* by STEFANO VENEZIANO, who also painted an *Enthroned Madonna and Child* (dated 1369) for the bakers' guild, whose headquarters were at the foot of the bridge at Madonna dell'Orto Church. In signing this work, VENEZIANO presents himself as "the parish priest of Sant'Agnese." The Madonna, sumptuously dressed and with a severe glance, is holding an ancient rose, the symbol of Christ's sacrifice.

Room 29 (origins of the International Gothic style): at left is a school-of-Veronese painting, *The Madonna and Child in the Garden* (mid-15th century), followed by *Angel Musicians* attributed to STEFANO DA ZEVIO (ca. 1379 - after 1438). On the long panel on the wall, the *Angel Appearing to St. Mamete (?) in the Desert* and *The Martyrdom of St. Mamete* are by the Venetian FRANCESCO DE' FRANCESCHI. St. Mamete was very popular in Byzantium and was known for having built an oratory where he preached the Gospel to animals. According to legend, he was killed by a trident. On the other side of the panel, the beautiful *Madonna and Child* (first half of the 15th century) holding a goldfinch is by the Venetian MICHELE GIAMBONO. Besides the works by MATTEO GIOVANETTI and JACOBELLO DEL FIORE, there are two cassone frontals with *Stories of Alatiel* (first half of the 15th century), a Tuscan school work that drew inspiration from a story in Boccaccio's *Decameron*.

In *Room 30*, at left, is the fine *Pietà* (ca. 1468) by the Ferrarese master COSMÈ TURA. The ashy, swollen face of the dead Christ is next to that of his mother, pale and filled with grief. The broken-hearted mother lifts one of her son's hands, perhaps to kiss the holy stigmata. Note Calvary in the background, whose spiral path refers to the tower of Babel, an allegory of human arrogance.

Room 31 (School of Ferrara): at left, after the refined *Portrait of a Gentleman* (second half of the 15th century) by BALDASSARE ESTENSE and the works by ANGELO MACCAGNINO, PIETRO DA VICENZA, GIORGIO CHIULINOVIC (known as LO SCHIAVONE) and LEONARDO BOLDRINI, are two fascinating paintings of the Madonna and Child by BARTOLOMEO VIVARINI. In these the angular Gothic linear style is felicitously combined with a palette that oscillates between soft, mellow hues and vivid background areas. In both works, the Infant Jesus squeezes his mother's thumb, as in some Byzantine icons that used this gesture to signify his fear of his future crucifixion.

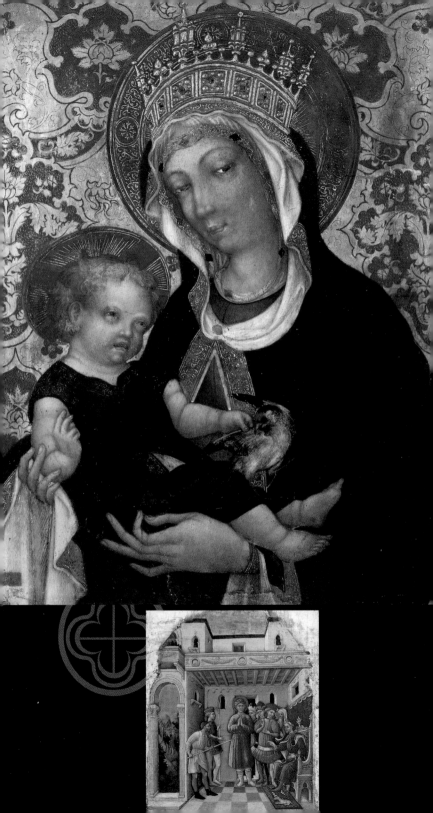

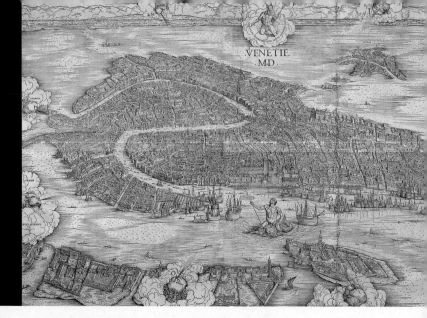

Room 32, known as the Sala delle Quattro Porte, is a large hall designed by VINCENZO SCAMOZZI. On the right-hand wall is a relief of the *Madonna and Child* attributed to JACOPO SANSOVINO and done in stucco and papier-mâché for the tabernacle of Corte Scotti, in San Luca. The adjoining wall has a showcase with the six pear-wood blocks for the splendid woodcut by JACOPO DE' BARBARI, *Perspective Plan of Venice* (1497-1500). In the reproduction of this work, published by Anton Kolb in 1500, one can appreciate the extraordinary task of documentation carried out by a large team of draftsmen who, from the top of the campaniles, made an accurate survey of the entire city and created a map crammed with details.

On high, Mercury, the god of commerce, watches over Venice. Behind him are the Alps, beyond which the Venetian Republic exported its products. At left one can make out Mestre and the waterway that connects it to the Cannaregio Canal. At the right end are the Arsenal and the Castello district before the heavy-handed changes and demolition carried out in the 19th century. Below, in the middle, the Basin of St. Mark is guarded by Neptune, god of the seas and navigation. Behind him is Piazza San Marco. The space used for the scaffold between the two columns in the Piazzetta is clearly seen. The Zecca and the Libreria had not yet been built. The Rialto Bridge is made of wood and has a small drawbridge. Below are

the luxuriant market gardens and gardens on the island of Giudecca.

The same room also has two large and interesting wooden models. One is of the Ca' Venier dei Leoni (ca. 1749), now the home of the Peggy Guggenheim Collection, designed by LORENZO BOSCHETTI and never finished. The other model, carved by the Paduan GIOVANNI GLORIA, corresponds to the design made by GIROLAMO FRIGIMELICA for the Villa Pisani at Stra (1719-21). Behind this model, on the wall, is an early 15th-century frontal from the Corpus Domini Church (which no longer exists), signed by the painter BARTOLOMEO DI PAOLO and by the woodcarver CATERINO D'ANDREA. The central scene of the frontal has *The*

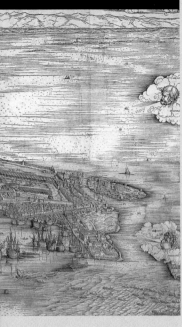

147 CENTER AND
BOTTOM PIETER
BRUEGHEL THE
YOUNGER,
*ADORATION OF THE
MAGI* AND DETAIL.

146-147 JACOPO
DE BARBARI,
*PERSPECTIVE PLAN
OF VENICE*.

147 TOP DIRK
BOUTS, *MADONNA
SUCKLING THE
INFANT JESUS*.

Presentation of Jesus at the Temple, while the twelve scenes on the sides narrate episodes from the life of Christ and from the Old Testament.

Room 33 (15th-century Flemish painters): at left is the *Adoration of the Magi* by PIETER BRUEGHEL THE YOUNGER (1564-1638), set in a busy, snowbound north European city. Other interesting works in this room are the visionary *Christ in Limbo* and the excruciating *Inferno*, painted in the late 15th century by skillful followers of HIERONYMUS BOSCH.

Room 34: at left is the *Pietà* (1475) by ANTONELLO DA MESSINA, who was in Venice in 1475 and 1476. Despite its being badly damaged by poor restoration, this painting, which may have come from the Doges' Palace, is to be appreciated for the innovative composition based on diagonals and the fine perspective rendering of Christ's body. In keeping with the customs of the time, the artist makes the setting of this episode, Jerusalem, look like Messina, where he was born, and puts San Francesco Church in the background. In *The Madonna Suckling the Infant Jesus*, Dirk Bouts draws inspiration from a Byzantine motif, but with gentility and extreme realism makes it a secular, family scene. Another fine work is the sad, painful *Crucifixion* by the Flemish master HUGO VAN DER GOES (1435-82).

Room 35 (15th-16th century Flemish and German painting): this is an interesting room with religious paintings by followers of PIETER COECKE VAN AELST and BARTHOLOMÄUS BRUY and by JOS AMMAN VON RAVENSBURG and RULAND FRÜAUF THE ELDER. Noteworthy are the esoteric *Temptations of St. Anthony* (ca. 1566), which can be attributed to PIETER BRUEGHEL THE ELDER; the brilliant *Risen Christ* (second half of the 16th century) by a follower of LUCAS CRANACH (perhaps his son); and the mystical *The Madonna in Glory Suckling the Infant Jesus, and Angel Musicians* by the German painter HANS FRIES, in which the moon and the sun, allegories of the Old and New Testament, and Samson

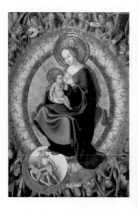

148 TOP HANS FRIES, *THE MADONNA IN GLORY SUCKLING THE INFANT JESUS, AND ANGEL MUSICIANS.*

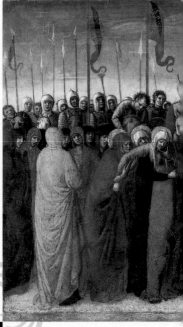

148 CENTER AND BOTTOM RIGHT GIOVANNI BELLINI, *TRANSFIGURATION* AND DETAIL.

148 BOTTOM LEFT GIOVANNI BELLINI, *PIETÀ WITH TWO ANGELS.*

148-149 JACOPO BELLINI, *THE CRUCIFIXION.*

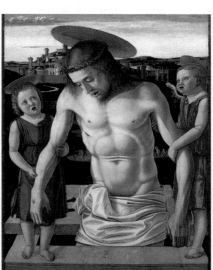

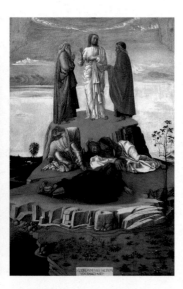

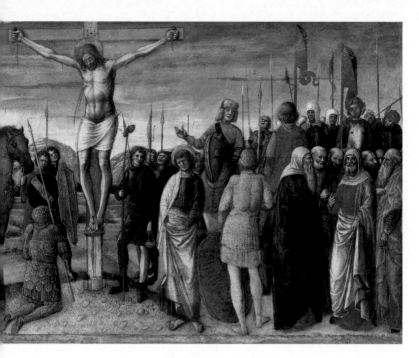

killing a Philistine with the jaw of a donkey, are at the foot of the Virgin Mary. *Room 36 (the Bellinis)*: among the works by this prestigious family of artists who led Venetian painting from the Gothic style to the early Renaissance style, mention should be made of the following. At right is the crowded *Crucifixion* scene (after 1450) by JACOPO BELLINI, in the center of which is the kneeling Roman army officer who converts to Christianity after having pierced Christ's ribs. On an easel is the *Madonna and Child* (or *Frizzoni Madonna*; ca. 1470) and further on a touching *Pietà* (ca. 1460) by GIOVANNI BELLINI. After is the *Transfiguration* (1455), again by GIOVANNI BELLINI: while Christ is manifesting his divinity to the three Apostles

on Mt. Tabor, Elijah (with a red cloak) and Moses appear at his side. This wood panel may have come from the high altar of San Salvador Church. On the nearby easel is the *Portrait of Doge Giovanni Mocenigo* (ca. 1479), which GENTILE BELLINI did not finish because he had to go to Istanbul to work at the court of Sultan Mohammed II. Lastly, on the next easel is the *Crucifixion* (1455), in which GIOVANNI BELLINI, drawing inspiration from the austere, sculptural linear style of his brother-in-law ANDREA MANTEGNA, paints like a miniaturist. Note Christ's white body, which looks like a statue, and the cartouche in Greek, which are probably references to a cultured patron. Going back into Room 32, you will see the door to *Room 37* (late 15th-

century Venetian artists), with works by GIOVANNI DI MARTINO DA UDINE, GIAMBATTISTA CIMA DA CONEGLIANO, BENEDETTO DIANA, PIETRO DUJA, JACOPO DA VALENZA, BARTOLOMEO MONTAGNA, ALVISE VIVARINI and LORENZO LOTTO. Of particular interest is LOTTO's *Madonna Crowned by Angels and Suckling the Infant Jesus* (1525-29?). *Room 38* has two works by VITTORE CARPACCIO: *St. Peter Martyr* (1514), part of a polyptych from Santa Fosca church; and the *Two Venetian Ladies* (early 16th century) with their bored expression, in company with symbolic animals while waiting for their husbands, who are out hunting coots, as the other piece of this painting (now in the Paul Getty Museum, Malibu) reveals.

Room 39 (Carpaccio and minor early 16th-century artists): among the works in this room painted by artists such as LAZZARO BASTIANI, VINCENZO DA TREVISO (known as VINCENZO DALLE DESTRE), MARCO PALMEZZANO, GIOVANNI MANSUETI and PASQUALINO VENETO, three are particularly interesting. At left, the *Praying Madonna and Child with the Young St. John the Baptist* (1500?) from the monastery of San Giacomo della Giudecca (which no longer exists), ascribed to VITTORE CARPACCIO but of uncertain attribution because of the marked inconsistency of the coloring. The rendering of the figures and their arrangement is similar to the painting kept at the Städelsches Kunstinstitut, Frankfurt. Note the sendal cloth covering the Virgin's head, with its fine range of white and markedly geometric drapery. A centaur

is on the Christ Child's bonnet, which may be identified as the sage and prophet Chiron. For its spontaneity and delicate colors, *The Gentleman with a Red Cap* (late 15th century) by a Ferrarese-Bolognese artist is noteworthy, as is *The Circumcision of Jesus*, dated 1499 and signed by MARCO MARZIALE, which is somewhat damaged but still stands out for the refined rendering of the fabric and the lovely rug whose Latin inscriptions are to be associated with those in Greek in the apse conch. *Room 40* has 16th-century works by GIROLAMO DA SANTACROCE, BOCCACCIO BOCCACINO, LORENZO LOTTO and ANDREA RICCIO, as well as 14th-18th century ivory pieces. Next to the exit door, note the tomb of Marcantonio Ciccio, known as Sabellico, the Venetian historian and humanist (1436-1506), carved by the workshop of PIETRO

LOMBARDO. The Ionic aedicule has a phoenix above the pediment, which is an allegory of resurrection. *Room 41* has works by 16th-17th century Greek icon artists, the so-called Madonna painters. Among these are DOMENICO THEOTOCOPOULOS (commonly known as EL GRECO) who is attributed with a *Last Supper*, GIOVANNI PERMENIATE, EMANUELE TZANE-BUNIALIS and TEODOROS PULAKIS. *Room 42* is given over to lovely majolica dating from the 15th and 16th centuries, most of which comes from Casteldurante, present-day Urbania, near Urbino, where the Della Rovere family promoted an important ducal factory that manufactured majolica and furnishings decorated with sacred or lay motifs. The same room also has *St. Dominic's Supper* signed by LEANDRO BASSANO (1557-1622).

150 COVER OF
THE CALKERS' GUILD
STATUTE.

151 LEFT VITTORE
CARPACCIO, *TWO
VENETIAN LADIES* AND
DETAIL.

151 RIGHT CIRCLE OF
ANTONIO RIZZO, *ALTAR
OF THE MADDALENA
FERRY.*

Room 43 has an 18th-century Corinthian order library from Palazzo Manin; a bronze lectern (15th century) made in England from the convent of San Zanipolo that has a two-headed eagle holding a dragon with its claws; and a gilded terracotta bust of Tommaso Rangone by ALESSANDRO VITTORIA. After leaving this room, go down the stairs to Room 14, then head left and enter *Room 45*, dedicated to the Bucintoro, the doges' luxurious ceremonial barge, fragments of which (1722-28) in gilded wood are on the wall; they are by ANTONIO CORRADINI and his workshop. The canvas by ANDREA MICHIELI (IL VICENTINO), *The Dogaressa Morosina Morosini Boarding the Bucintoro* (ca. 1595), is

related to the one by the same painter kept in Room 6.

After *Room 46*, with works by JOSEPH HEINTZ and his son, and *Room 47*, with Flemish paintings and a canvas attributed to CESARE VECELLIO, you enter the interesting section dedicated to Venetian crafts and trades (*Rooms 49-50*). Here, besides the many curious insignia of the guilds (16th-18th century) – which were originally kept in the **magistracy** office in the Palazzo dei Camerlenghi, Rialto – there are showcases with objects made by shoemakers, dyers, woodcarvers, coppersmiths, glass-blowers and potters. Especially interesting are the magnificent turtleshell combs (18th century) and, in the showcase next to the

exit of Room 49, the luxurious cover of the manuscript statute (1577) of the caulkers' guild, whose members had the most important job in the Arsenal.

Among the reliefs in *Room 51*, you should see the Lion of St. Mark at right (late 13th century) from the campanile of Sant'Aponal Church and considered the oldest one of its kind. Another interesting work, on the wall at left, is the small portable *Altar of the Maddalena Ferry*, ascribed to the circle of ANTONIO RIZZO (ca. 1430 -1499); in the middle is a Madonna and Child dated 1569. Last are the curious *Rooms 52* and *53*, dedicated to public and private games and entertainments in Venice.

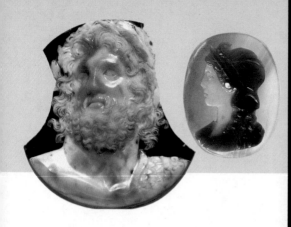

152 LEFT *CAMEO OF JOVE AEGIS*.

152 CENTER AND BOTTOM CAMEOS.

152 RIGHT MARBLE STATUE, IMPERIAL AGE, IN THE COURTYARD.

153 LEFT SUPPOSED PORTRAIT OF SULLA.

153 RIGHT *NAVAL BATTLE*, FRAGMENT FROM THE MUSEO ARCHEOLOGICO NAZIONALE, VENICE.

■ If you wish to continue your visit to the Piazza San Marco museums, you must go back to Room 19 of the Museo Correr, which communicates with the entrance to the **Museo Archeologico Nazionale di Venezia**, situated in the Procuratie Nuove building and established in 1923-26 after its collections had been kept in the Doges' Palace since 1812. COLLECTIONS: the origin of the National Archaeological Museum of Venice goes back to the bequest made in the 1500s by Domenico Grimani and his nephew Giovanni, and by Federico Contarini, thanks to which, in 1596, the Pubblico Statuario was

opened in the antechamber of the Libreria Marciana. Over the centuries the museum collection grew because of precious private donations and, in 1939, through the addition of the archaeological collection in the Museo Correr, which includes Egyptian and Assyro-Babylonian pieces. Besides Greek and Roman sculptures, inscriptions, portraits and reliefs ranging from the 5th century B.C. to the 3rd century A.D., there are Greek and Italic cinerary urns, jewels, coins, ivories, bronzes and ceramics dating from the 9th to the 3rd century B.C. If you arrive from the Museo Correr, the tour of the Archaeological

Museum (which, as noted, existed separately before becoming part of the St. Mark's museums itinerary) begins with Room XI and ends with Room X. While waiting for the 18 rooms to be renumbered and the works reorganized, as planned, we will make brief mention of the most famous or interesting pieces. *Room XI* (Roman reliefs): at left, the agitated *Naval Battle* (no. 6; early 3rd century A.D.) from an Attic sarcophagus that was part of the Giovanni Grimani bequest. *Room XII* (ivories, jewels and bronzes): in the showcase with gems and cameos is the splendid *Cameo of Jove Aegis*, the work of a Roman artist made of onyx and donated by Girolamo Zulian (no. 1, modeled after a Hellenistic work of the 2nd century B.C.). *Rooms XIII and XIV*

(Roman reliefs and cinerary urns): the bust of Marcus Aurelius (*Room XIII*; 16th-century copy) and the elegant amphora with pod patterns by a Roman workshop (*Room XIV*; second half of the 1st century B.C.). Turn right, and after having visited *Rooms XVII and XX* (funerary reliefs; Egyptian, Assyrian and Babylonian antiquities), you enter *Room XVIII* (4th-century B.C. originals, Roman copies of Greek originals): at right is the head of *Hermes Propylaios*, an Hadrianic-age replica of the original attributed to ALKAMENES (no. 20; third-fourth decades of the 2nd century A.D.). Retracing your steps, go to *Room XV* (reliefs, cinerary urns and ceramics) and then enter *Room I* (Greek inscriptions): at right, the foot from a colossal 4th-century A.D.(?) statue and,

on the left wall, four male busts (1st and 2nd century A.D.). *Room II* (numismatic collection). *Room III* (sculpture from the first half of the 5th century B.C.). *Room IV* (Greek originals from the 5th and 5th century B.C.): at left, the *Peplophoros* (no. 3; 410-400 B.C.), a work by the Attic school. *Room V* (5th- and 4th-century B.C. sculpture): at right, the statue of *Apollo Lykeios* (no. 1; 2nd century A.D.), a copy of the original by PRAXITELES; at left, a bust of Athena (no. 18; Roman copy) modeled after a bronze original attributed to the sculptor KRESILAS (5th century B.C.). In this room is the door that communicates with the Sale Monumentali (monumental halls) of the Biblioteca Nazionale Marciana. *Room VI* (Greek statues and reliefs, Roman reliefs): at left,

Dionysus and a Satyr (no. 7; Roman copy of a Greek original dating from the second half of the 2nd century B.C.) and, on the opposite wall, a head of a boy (no. 17; late 2nd century B.C.) sculpted by a workshop in Asia Minor. *Room VII*: in a showcase is a statuette of Victory (no. 10; first half of the 2nd century A.D.), a Roman work in Greek marble. *Room VIII* (Hellenistic sculpture): the statuette of a hermaphrodite (no. 5; late 2nd century A.D.) and, in the middle of the room, the three statues of Gauls. *Room IX* (Roman heads and busts): on the wall opposite the windows, a portrait of Marcus Aurelius (no. 25; 121-180 A.D.). *Room X* (gallery of Roman busts): at left, a bust of Lucius Verus (no. 9; 130-169 A.D.). *Rooms XVI and XIX* are no longer in use.

■ Now go back to Room V of the Archeological Museum, where you will find the entrance to the **Sale Monumentali (Monumental Halls)** of the **Biblioteca Nazionale Marciana**, situated in the Libreria di San Marco, by JACOPO SANSOVINO. For a tour of these halls it is best to begin from the broad staircase – part of which

154 THE MOORS ON THE CLOCK TOWER.

154-155 THE CLOCK TOWER AND PROCURATIE VECCHIE.

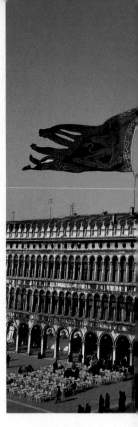

is not open to the public – and go to the top landing, the antechamber and the salon. If you face the Basilica, to your left is the **Procuratie Vecchie**, built to a model by the Tuscan architect GIOVANNI CELESTRO, who also worked on the Scuola di San Rocco in 1514. The work was entrusted to GUGLIELMO DE' GRIGI, under the supervision of the *proto* or chief architect of the Procurators of S. Marco, BAROLOMEO BON. These two architects designed the façade facing the square, characterized by a sequence of 50 identical arches, the last eight of which were finished in 1538 by JACOPO SANSOVINO, who replaced

BON. In the arcade of the Procuratie Vecchie, at the end of the Sotoportego de l'Arco Celeste, you will come to the **Bacino Orseolo**, a basin designed and built in 1869 by GIAMBATTISTA MEDUNA and FEDERICO BERCHET as a mooring for gondolas. Proceeding along the arcade, at the junction with the Sotoportego del Cavaletto you will see the former **Olivetti Shop** (no. 101), built by CARLO SCARPA in 1957-58 inside a 15th-century *fondaco*. On the side near the Basilica, the Procuratie Vecchie is connected to the **Torre dell'Orologio (Clock Tower)** (no. 174), attributed to MAURO CODUSSI. The tower was inaugurated in 1499. The following year it was decided to add the two side façades, which were finished in 1506, after part of the Procuratie Vecchie built by Doge Ziani was torn down. These changes highlighted the theatrical character of the Piazzetta, whose "proscenium," viewed from the lagoon, consists of the

two columns with the statues of the city's patron saints. The tower and its two wings – attributed to PIETRO LOMBARDO – transform the access way to the Mercerie into an ideal land city gate. The central passageway was conceived like the opening of a triumphal arch. With the two side columns on round plinths, CODUSSI anticipated the architectural solution achieved in the Bernabò Chapel in San Giovanni Cristostomo Church. The top story housed the face of the clock – the image of the universe – whose enamel work and gilding on copper were done by GIOVANNI FIORENTINO in 1497-98. On

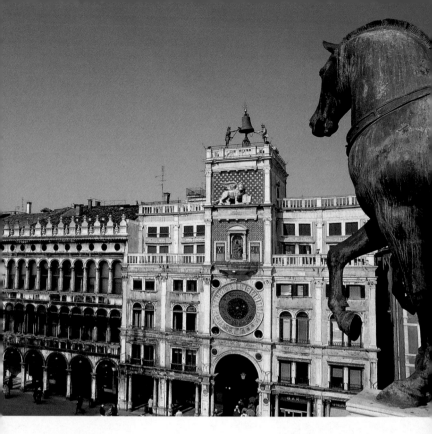

the outer ring the hand indicates the daily course of the sun, divided into 24 hours. Inside this are mobile bands that indicate the signs of the Zodiac, the months, days and the orbit of the moon, seen in its various phases, while in the center is the Earth, in keeping with the Ptolemaic theory of the universe.

Above the clock is a niche with a bronze statue of the Madonna and Child, attributed to ALESSANDRO LEOPARDI. To the left of this, the hours are indicated and to the right, the minutes. On Ascension Day and Epiphany these two faces opened and, thanks to an automatic device, from the window at left there emerged the statue of an angel, followed – along the semicircular balcony – by the Magi, who bowed before the Virgin Mary. These modest polychrome figures (1755), worked by a separate machine, were the work of GIOVAN BATTISTA ALGHIERO. From the 16th to the 19th century the clock underwent restoration and changes in its mechanism many a time. The present structure corresponds to the one conceived by BARTOLOMEO FERRACINA in 1753-57. Above the Virgin Mary is the Lion of St. Mark, the symbol of the Republic, in front of which once stood the statue of Doge Agostino Barbarigo. On top of the terrace, with a fine panoramic view, are the two giants (1496) known as the **Mori (Moors)** because of the dark color of the bronze. They were cast by AMBROGIO DE LE ANCHORE. These two automata, holding hammers, strike the hours by hitting the large bell (1496-97) surmounted by a cross, which were cast by SIMONE CAMPANATO. The building was restored in 1751-55 by GIORGIO MASSARI, who added the two recessed stories. In 1757, the architect ANDREA CAMERATA added the eight columns on pedestals that can seen along the two side arcades.

156 TOP AND 156-157 WORKSHOP OF JACOPO TINTORETTO, *ST. CATHERINE DISPUTING WITH THE DOCTORS*, PALAZZO PATRIARCALE.

156 CENTER PALAZZO PATRIARCALE.

156 BOTTOM PIAZZETTA DEI LEONI, DETAIL.

■ The nearby **Piazzetta dei Leoni**, dedicated to Pope John XXIII, was named after the two red Veronese marble lions sculpted by GIOVANNI BONAZZA in 1722. On the left side of this little square is the former **Church of San Basso**. The Corinthian-order façade looking onto the square (no. 315) is by BALDASSARE LONGHENA, who supervised the construction in 1676, after fire had damaged the building in 1671. The interior, with no aisles and with a chancel, is distinguished by tall composite pilasters. Between San Basso and St. Mark's is the **Palazzo Patriarcale**, construction of which was the last major change effected in the Piazza San Marco area. The new building, which marked the definitive transfer of the patriarchate from its former headquarters in San Pietro di Castello, incorporated the old rectory, the residence of the head prelate, and the banquet hall of the Doges' Palace around an inner courtyard. This was built by BARTOLOMEO MONOPOLA in the 17th century to receive foreign ambassadors. The façade, done by LORENZO SANTI and dated 1835, was finished in 1841 (as the frieze inscription tells us). Its pseudo-Mannerist style was the result of a compromise between the architect and the many proposals made by the Collegio Accademico. The ground floor has smooth rustication, two rows of windows alternating with gigantic Corinthian pilasters and a tall entablature with

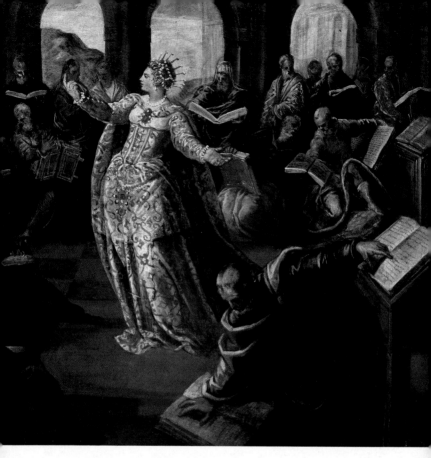

high reliefs representing ecclestiastical objects and instruments that are interrupted by the mezzanine windows. Among the paintings in the palazzo is a cycle of six canvases depicting *The Legend of St. Catherine of Alexandria* (1582-85) that come from the church dedicated to this saint in the Cannaregio district; they were painted by JACOPO and DOMENICO TINTORETTO and their workshop assistants. Going back through the tall arch of the Torre dell'Orologio, you enter the **Mercerie** (called Marzaria in Venetian dialect), the most famous

commercial street in the city and the main artery connecting Piazza San Marco and the Rialto. To your left, above the entrance arch of the Sotoportego (passage) and Calle del Cappello, is the relief of Giustina (or Lucia) Rossi (1841, dated) by PIETRO LORANDINI. On June 15, 1310, this woman dropped her mortar from her window, killing the standard bearer of Bajamonte Tiepolo's conspirators. This gesture was rewarded by the doge, who froze the rent paid by the Rossi family to the Procurators of S. Marco for their house and shop, and extended this privilege to

their descendants as well. At the corner of the Calle dei Baloni, on the columns of an old workshop (no. 215) there is a 15th-century relief with the emblem of the Scuola Vecchia di Santa Maria della Misericordia confraternity, recognizable by the initials S.M.V. (Santa Maria Vergine) and by the image of the Madonna being worshipped by the confreres. Farther on, at no. 783, is a small Gothic palazzo, **Ca' Molin**, with 14th-century trefoil double-lancet windows and the family coat of arms dating from the late 15th century surmounted by two dolphins.

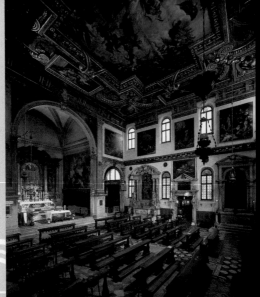

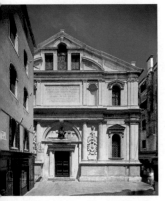

■In the square is **San Giuliano Church**, better known as **San Zulian**. HISTORY: probably founded in the 9th century, this church is mentioned for the first time in an 11th-century manuscript document and, according to some sources, was rebuilt after the fire of 1105. FAÇADE: in 1553 the Senate authorized the erection of a new façade, which was completed around 1559. The date 1554 carved on the ground floor probably refers to the completion of the works on the first section. The façade, with a pitched central mass divided into two sections, was financed by a physician from Ravenna, Tommaso Rangone. In order to celebrate his image as a scholar and healer, he commissioned JACOPO SANSOVINO with the construction, and kept the architect's model for himself, making arrangements to have it borne in procession during his funeral, which took place in 1577. Not being able to design a full-fledged portico because it would have blocked the street at the side and taken up much of the limited space in front, SANSOVINO set it back, superposing it onto the rest of the façade, which is characterized by pilasters on tall pedestals. In fact, in the middle of the façade one can make out the shape of a porch consisting of four elegant, cabled Doric half-columns and an Attic base. Above the Doric portal is the bronze image of Tommaso Rangone (1557) sculpted by ALESSANDRO VITTORIA. The statue of Rangone (who in his capacity as superior of the Scuola di San Marco had commissioned JACOPO TINTORETTO to paint the famous canvases with scenes from the life of Venice's patron saint), is holding sarsaparilla and guaiacum, the plants he used in his medicines to cure syphilis and yellow fever. The tablet he is holding, the reliefs behind him – depicting the celestial sphere and the earth, including the American continents – as well as the

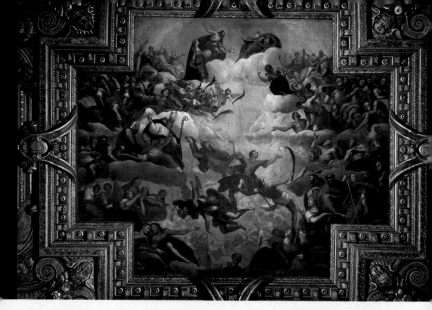

Greek and Hebrew inscriptions between the half-columns, which make up a complex and exclusive symbolism, all exalt Rangone's qualities and scholarly knowledge.

INTERIOR: the quadrangular, aisleless nave has a chancel and two apsidal chapels.

Consecrated in 1580, the church was rebuilt to a design by SANSOVINO after the roof collapsed while the façade was being rebuilt. Except for the two Corinthian pilasters that frame the chancel, the walls have no architectural framework and are divided horizontally only by a cornice. This choice may have been due to a lack of funds, but in any case is quite unusual in Venice and makes a church into a unique salon – much like the lecture hall of a religious school – in which the furnishings consist solely of the altars and paintings. Once past the entrance vestibule, above which is the choir and organ that FRANCESCO SMERALDI made in Corinthian style in 1584, you can admire the sumptuous gilded wood cornice on the ceiling. This work was executed right after 1587 for Girolamo Vignola by FRANCESCO DI BERNARDINO, to a design by SMERALDI. In the painting in the middle, with a cruciform profile, PALMA GIOVANE depicted *The Apotheosis of St. Julian* (1588-89), while in the side panels LEONARDO CORONA painted the allegorical images of eight Virtues. Charity lies in correspondence with the chancel. In order to remind worshippers that St. Julian was an imitator of Christ, in the upper part of the walls all around the ceiling is a cycle of twelve canvases dedicated to the Passion of Christ. These were painted by LEONARDO CORONA, GIOVANNI FIAMMINGO and PALMA GIOVANE (whose two scenes, *Ecce Homo* and *The Resurrection*, were painted ca. 1581-82). PALMA GIOVANE is also considered the author of the *Annunciation* in the spandrels of the central arch.

The lower part of the walls, on the other hand, is given over to images connected to local worship. Beginning from the right, on the inside façade, there are two large canvases by ODOARDO FIALETTI (1573-1638?). The larger one is *St. James, with Philetus by His Side, Orders the Demons Chained by the Angel to Bring Him the Sorcerer Hermogenes*, while the other is entitled *The Sorcerer Hermogenes Is Taken by the Demons before St. James*.

160 TOP ANTONIO
ZANCHI, MARTYRDOM
OF ST. JULIAN.

160-161 PALMA
GIOVANE, THE CAPTURE
OF CHRIST.

160 BOTTOM PAOLO
VERONESE, THE DEAD
CHRIST WITH ANGELS
AND SAINTS.

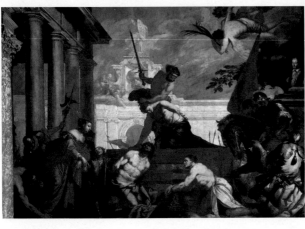

For the altarpiece in the nearby altar (1578-81), the confraternity of the Strazzaroli (cloth and rag vendors) asked PAOLO VERONESE to paint a moving *Pietà* (1582-84). The second altar, which was originally located on the opposite side and was moved because it blocked the view of the Santissimo

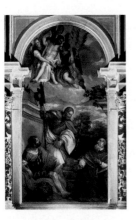

Sacramento Chapel, was sculpted by FRANCESCO DI BERNARDINO in 1579-83 to a design by ALESSANDRO VITTORIA and paid for by the guild of the Marzeri (haberdashers). The altarpiece, *Our Lady of the Assumption* (1583-84), is signed by PALMA GIOVANE. The two side statues, signed by ALESSANDRO VITTORIA, are of St. Catherine of Alexandria and St. Daniel the Prophet (ca. 1584). Going past the right-hand apsidal chapel dedicated to St. Charles Borromeo, you enter the CHANCEL, where Rangone was buried. The Corithinian-order high altar, attributed to GIUSEPPE SARDI (ca. 1621-1699), has: housed the body of St. Paul the Hermit since 1581. The altarpiece, *Coronation of the Virgin with Saints* (1544), is

signed by GIROLAMO SANTACROCE. The side canvases, painted in 1674 by ANTONIO ZANCHI, illustrate *The Passion of St. Julian* (left) and *The Martyrdom of St. Julian* (right). The richly decorated side chapel at left was reserved for the Santissimo Sacramento confraternity in 1544. The design of its Corinthian-order altar (1578-79) is attributed to the architect GIOVANNI ANTONIO RUSCONI, while the marble altarpiece, a *Pietà* (1579), was sculpted by GIROLAMO CAMPAGNA and the two side statues in glazed terracotta of the Madonna and St. John Evangelist (1583) are signed by ALESSANDRO VITTORIA. The stucco decoration on the ceiling (1583) was done by OTTAVIANO RIDOLFI. The subjects of the paintings on

the walls are related to the Eucharist. Among these, at right, is *The Last Supper* (ca. 1600) by the workshop of PAOLO VERONESE and, at left, *The Capture of Christ* by PALMA GIOVANE. On the counterfaçade are two canvases (1595) by SANTE PERANDA: *St. Roch Healing the Plague Victims* (left) and *St. Roch in Prison*. Once out of San Zulian Church you will see, on the façade of the palazzo at right (no. 606), a relief of St. George and the Dragon (1496, dated), which showed that the building was owned by the San Giorgio Maggiore abbey. In fact, the Marzaria (Mercerie) di San Zulian belonged to Doge Sebastiano Ziani and in 1192 was donated by his son Giacomo to the nearby monastery of San Giorgio. Continue to the Ponte dei Bareteri, a bridge offering a view of the apse of San Salvador Church. The palazzo to the right of the bridge over the Sotoportego de le Acque passage, was once the home of the **Ridotto Venier** (no. 4939), formerly a gambling house which still has 18th-century stuccowork inside. Among the ceiling beams over the entrance you can see the peephole to look outside. Along the Marzaria del Capitelo, at right (no. 4944), there is a 14th-century multiple window on the first floor with trefoil arches and a coat of arms of the Giustiniani family with a two-headed eagle (early 15th century). Farther on, at left (no. 4858), is a late 15th-century Gothic three-lancet window whose capitals are decorated with thick leaves. Not far away is the Capitello, or tabernacle, after which the Marzaria was named; it may have come from San Salvador Church. This shrine once contained a 17th-century painting by MATTEO INGOLI, which has been replaced by a 19th-century Madonna and Child. Turn right and go to no. 5016, **Palazzo Giustiniani-Faccanon**, whose tall Gothic façade overlooking the canal (visible from nearby Riva Tonda) has a six-lancet window with quatrefoil openwork on the second floor that dates back to around 1470. If you have extra time, you can go on to Itinerary 3, which begins at the nearby San Salvador Church.

3

162 TOP RIGHT VENETIAN SCHOOL, *SUPPER AT EMMAUS*, DETAIL, SAN SALVADOR CHURCH.

162 CENTER CAMPO SANTO STEFANO.

162 BOTTOM RIGHT VITTORE CARPACCIO AND ASSITANTS, *S. VITALE ON HORSEBACK AND SAINTS*, DETAIL, SAN VIDAL CHURCH.

This itinerary runs inside the San Marco *sestiere* or district, skirting the Grand Canal in the innermost area of this quarter. The district is dominated by two monastic centres: San Salvador and Santo Stefano. Besides its interesting monumental interior, the former owes its fame to the Scuola Grande di San Teodoro, dedicated to the first patron saint of Venice. The latter is the religious center of one of the most famous *campi* or squares in town, known for its ancient traditional feasts and prestigious palazzi, which are decorated with 16th-century frescoes. Turning toward Piazza San Marco, you will note two churches that were central to the history of Venetian Baroque art: the small, precious Santa Maria del Giglio, and San Moisè, with its pompous façade.

In the vicinity of the former, in the late 9th-early 10th century Doge Pietro Tribuno had a defensive embankment built to protect the city from the Slavs and Hungarians; this earthwork, which began on the island of Olivolo, in the Castello district, no longer exists.

AREAS OF SAN MARCO

START

END

Grand Canal

▶ MAIN SIGHTS

● *SESTIERE (District):* S. Marco.
● *CHURCHES:* [1] San Salvador;
[2] San Luca; [3] San Beneto; [4] San
Fantin; [5] Santo Stefano; [6] San
Vidal; [7] San Maurizio; [8] Santa
Maria del Giglio; [9] San Moisè.
● *PALAZZI:* [10] Contarini del
Bovolo; [11] Pesaro degli Orfei (or
Palazzo Fortuny); [12] Duodo; [13]
Gritti-Morosini; [14] Pisani-
Trevisan; [15] Loredan; [16]
Cavalli-Franchetti; [17] Pisani; [18]
Morosini a Santo Stefano; [19]
Bellavite-Terzi.

● *OTHER MONUMENTS:* [20]
Scuola Grande di San Teodoro; [21]
Teatro Goldoni; [22] Monument to
Daniele Manin; [23] Ateneo Vento
(formerly Scuola di San Girolamo or
Scuola di San Fantin); [24] Teatro
La Fenice; [25] Oratorio
dell'Annunciazione e di San Michele
Arcangelo; [26] Scuola di Santo
Stefano; [27] Monument to Nicolò
Tommaseo; [28] Scuola degli
Albanesi, [29] Calle XXII Marzo;
[30] Teatro del Ridotto.
● *MUSEUMS:* [31] Museo Fortuny.

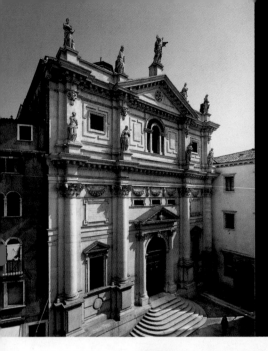

Itinerary		From San Salvador to San Moisè

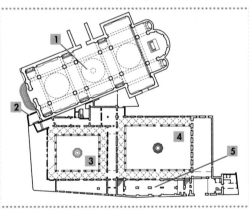

164 TOP LEFT
SAN SALVADOR CHURCH.

164 TOP RIGHT BUST OF
JACOPO GALLI, SAN
SALVADOR CHURCH,
FACADE.

165 MAIN CLOISTER,
SAN SALVADOR CHURCH.

■Along the open side of Campo San Salvador there is a **column** (1898) with an octagonal bronze capital commemorating the expulsion of the Austrians from Venice in 1848. This square is dominated by the **church** and former **monastery of Gesù Salvatore**, or **San Salvador**.

HISTORY: according to legend, this church was one of the first to be founded in Venice in the 7th century by St. Magnus, the bishop of Oderzo who fled from Altinum after the Longobard invasion. The site he had chosen – marked by a reddish cloud – lay in the middle of the

islands on which Venice was developing. From the outset this church was fundamental in local history thanks to its position *in visceribus urbis* (in the heart of the city), halfway between the Rialto market and the political-administrative area of San Marco. One of the priests

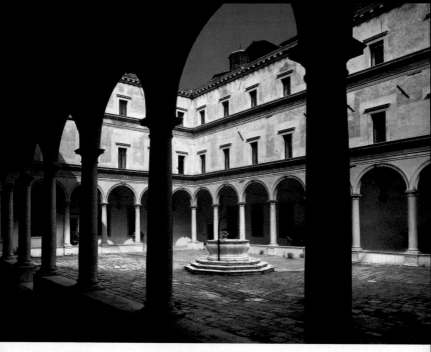

was Bonfiglio Zusto, who in 1141 introduced in Venice the rule of the Augustinian Canon Regulars. Thus, the clergy of San Salvador shared a common religious life that observed the order's life of poverty. By this initiative, which was supported by Rome but opposed by the bishop of Castello, Bonfiglio was killed in 1151. However, the support of the Papacy continued, and in 1177 Pope Alexander III consecrated the church on 29 August (the date of the Transfiguration) and granted indulgences to all those who visited San Salvador on that day. In 1291, one of the nine local congregations of the clergy was founded, and in 1442 the church and monastery were merged into the congregation of the Canon

Regulars of San Salvatore of Bologna. After a fire, the church and its bell tower were rebuilt in 1182-1209. The present church was rebuilt from about 1520 to 1665, the year of its consecration.

FAÇADE: designed by the Ticinese ANTONIO SARDI and built from about 1649 to 1663 with the help of Sardi's son GIUSEPPE. The first register, which lies on a tall base, has four composite half-columns on a pedestal standing against pilasters. The portal is flanked by Corinthian half-columns. In the keystone of the arch there is a lovely putto, on the cartouche of which is written "Plenary indulgence every day, as in San Giovanni Laterano in Rome." The 17th-century bust in the tympanum above this represents the merchant and parishioner

Jacopo Galli (d. 1649), who financed the building of the façade. The composite capitals are linked by festoons of fruit alternating with lion heads, the symbols of Easter and Resurrection. The four statues of Virtues – one of which is Charity – and those of the crown, dominated by the central placed figure of the Risen Christ, are attributed to the Luganese BERNARDO FALCONE (fl. 1659-94). Along the left side – in the Mercerie street – is the side entrance, dedicated to the Savior of the World. The surviving frescoes (*Transfiguration, St. Theodore fighting the dragon*, the *Canons receiving the rule of their order from St. Augustine*) are attributed to FRANCESCO VECELLIO (d. ca. 1559), Titian's brother.

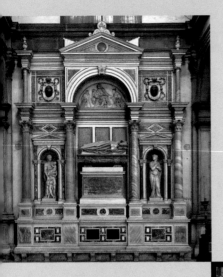

INTERIOR: Latin cross plan with two aisles and the nave ending in apsidal chapels. The design by GIORGIO SPAVENTO (d. 1509), which was highly approved by the prior, Antonio Contarini, dates from 1506, while much of the building was done by PIETRO LOMBARDO (d. 1515) and above all by his son TULLIO (d. 1532). The building technique drew inspiration from the three cupolas of St. Mark's Basilica. In the wake of the Byzantine revival inaugurated by MAURO CODUSSI in the preceding century, San Salvador once again symbolizes – by means of its architecture – the Republic of Venice as the bulwark and protector of Christianity. The plan of the old church, which, according to tradition, derived from the Holy Sepulcher in Jerusalem, was done away with, including the grating (if indeed it did exist) under which water flowed. The result of this rebuilding is truly majestic and the beauty of the austere architecture of the interior stems from the clear, simple proportions more than from complex decoration. The octagonal lanterns were designed by VICENZO SCAMOZZI at a later date. Running down the nave are three alternating arcades of varying width and height that create a splendid succession of triumphal arches. The church with its new additions was now on a higher level, and one of its original pavements can still be seen through an open

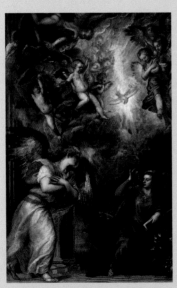

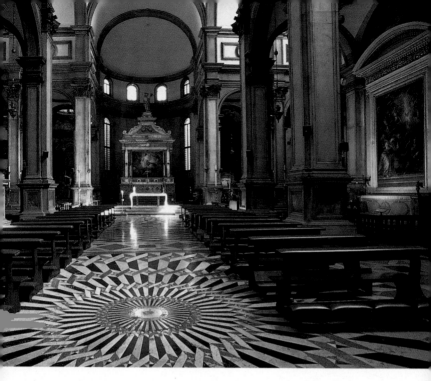

trapdoor near the chancel. The polychrome marble floor we see today dates from the 17th century and, besides reminding us of the geometric patterns used in Santa Maria della Salute, it is also a further reference to St. Mark's Basilica.

The first altar in the **right-hand aisle** is the *Santissimo Crocefisso*, which was reserved for the Holy Sepulcher congregation and, from 1507 on, included an important daily indulgence which is also announced in the façade of the church. This is followed by the *funerary monument of the Dolfin family*, the work of GIULIO DEL MORO, whose signature can be seen in the lovely central statue of the *Risen Christ*. The two busts, attributed to the Veronese sculptor GIROLAMO

CAMPAGNA (active till 1626), are effigies of the procurator *Andrea Dolfin* (d. 1602) and his wife, *Benedetta Pisani* (d. 1595). Above them are the statues of their protector saints. *The Virgin and Child* (or *Charity*) in the next altar is also by CAMPAGNA. In the nearby bay there is the sumptuous *funerary monument of Doge Francesco Venier* (d. 1556), executed by JACOPO SANSOVINO ca. 1561. The two side statues in niches – Charity and another Virtue – were signed by the Florentine artist but bear obvious traces of SANSOVINO's workshop as well. In keeping with an iconography dating back to the Middle Ages, the doge is depicted lying on his bier, while in the relief on

the lunette above him, attributed to ALESSANDRO VITTORIA and his workshop, he kneels together with his eponymous saint in front of a *Pietà* (1557-58).

■ On the next altar, purchased in 1559 by the merchant *Antonio Canovi*, known as *della Vecchia* (d. 1572), and set inside an elegant Ionic frame by JACOPO SANSOVINO, is a signed *Annunciation* (1560-64), one of the greatest masterpieces that TITIAN produced in his old age. In this work, Mary is surprised and greeted by the angel while she is reading the prophecy of Isaiah: "Behold, a virgin shall be with child, and shall bring forth a son, and they shall call his name Emmanuel." Behind her, a nuptial bed symbolizes the union with the Almighty.

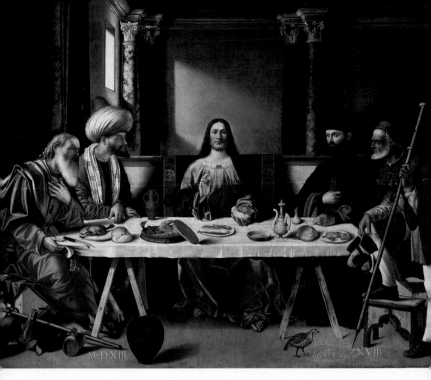

The Virgin Mary is lifting her veil to uncover her ear. The Incarnation takes place thanks to the Word of the Lord delivered by the Archangel. The Armenian Gospel of Infancy (6th century) relates that, while the Virgin humbly accepted the will of God, "the Word of God penetrated her through her ear [....] Thus she was purified like gold in fire. She became a holy and immaculate temple, the manor of divinity." The apocryphal Armenian Gospel explains the mystery of the Incarnation of Jesus by making an analogy with the burning bush Moses contemplated on Mount Horeb: "The bush burnt with fire and the bush was not consumed." This episode is mentioned in the Latin inscription painted along a step in the foreground of the painting: "fire that burns but does not consume." This play of references to the Old and New Testament is confirmed by a detail. On the floor is a glass vase with a special plant. Instead of the usual lily, or the more infrequent olive branch, Titian painted flowers whose petals are transformed into brilliant yellow-orange flames, whose fire is fed by the water in the vase – an allegory of Mary's purity. These erudite references, which the artist often adopted, were for the chosen few. The direct representation of the burning bush would have deprived the painting of its exclusive, esoteric character.

In the *right transept*, beyond the two side altars with the altarpieces by GIROLAMO BRUSAFERRO (ca. 1700 -1760) and, at left, FRANCESCO FONTEBASSO (1709- ca. 1768), you will see the *funerary monument of the Corner family* (second half of the 16th century) by BERNARDINO CONTINO. Two sacrophagi without statues lie between the Ionic columns. One must have been an effigy of Marco Corner and the other the beautiful Caterina Corner (d. 1510), who became Queen of Cyprus after the death of her husband, Giacomo of Lusignan. By means of the door leading to the monument, one can enter – upon request – the sacristy.

The apsidal chapel to the right houses the remains of

168 AND 169 BOTTOM
VENETIAN SCHOOL,
SUPPER AT EMMAUS
AND DETAIL.

169 TOP SIDE PORTAL,
ORGAN DOORS BY
FRANCESCO VECELLIO,
DETAIL.

169 CENTER GILDED
SILVER ALTARPIECE, HIGH
ALTAR.

St. Theodore the Martyr, the first patron saint of Venice, which were taken to the church in 1257. The altar, rebuilt in 1626-28, was exclusively reserved for the Scuola di San Teodoro, founded in 1258 next to the façade of the church. In the altarpiece of the *high altar*, TITAN painted the *Transfiguration* (ca. 1560), which was ruined by later attempts at restoration. During the celebration of the Transfiguration, this painting was lowered so that the congregation could see the silver-gilt and repoussé *altarpiece* back. This latter work is divided into parallel panels executed at different times. The central one (mid 15th century) represents the *Transfiguration*, while the one below (late 13th-early 14th century) depicts the four Evangelists and Prior Benedetto (d. 1309), who commissioned the original altarpiece.

At left, in the *Santissimo Sacramento chapel*, is the lovely *Supper at Emmaus* (dated to 1513), for a long time thought to be by GIOVANNI BELLINI but now considered of uncertain attribution and provenance. Among the many other works of art in San Salvador, certainly worthy of mention are the *Baptism of Christ* (in the left-hand transept) by the Flemish artist NICOLAS REGNIER (known as NICOLÒ RENIERI, 1590-1667) and, along the left-hand aisle, the sumptuous *Altar of the Luganegheri* (sausage makers) built in 1600 by ALESSANDRO VITTORIA, and the *altarpiece* (1600-03), painted by PALMA GIOVANE. This is followed by the side portal of the church (1530) and the choir by JACOPO SANSOVINO, the doors of the organ (ca. 1531) painted by FRANCESCO VECELLIO.

After exiting from the main portal of San Salvador, at left you will see the entrance (no. 4826) to the monastery (ca. 1540-63). Its two cloisters were built around 1540-70. The larger one, with round arches on three sides supported by elegant Doric columns resting on Attic plinths, is delimited on the canal side by a large room used as a refectory (1541-42). The stucco ceiling of this latter is decorated with frescoes depicting Scenes from the Old and New Testament (ca. 1545) attributed to FERMO GHISONI, a pupil of GIULIO ROMANO, while the frescoes in the ante-refectory (ca. 1933) are attributed to GIUSEPPE CHERUBINI.

Once back in Campo San salvador, on the left is the Scuola Grande di San Teodoro (no. 4811).

HISTORY: the body of St. Theodore the Martyr, Venice's first patron saint, was taken to San Salvador in 1257. The Scuola was dedicated to works of charity, in particular aiding the poor. The lay confraternity, made up chiefly of merchants and artisans, was accepted as part of the Scuole Grandi (or major confraternities) in 1552. Its first seat was built in 1580-81 by SIMONE SORELLA and rebuilt by TOMMASO CONTINI in ca.1608-13. FAÇADE: like

the nearby façade of San Salvador Church, this was designed and built by ANTONIO SARDI and financed by Jacopo Galli (d. 1649), a rich merchant and member of the Scuola. It is most likely that, given Sardi's advanced age, construction work was supervised from about 1649 to 1655 (plaques) by his son GIUSEPPE. The first register is articulated in four pairs of Ionic columns on a pedestal. This pattern is repeated in the second register, this time with

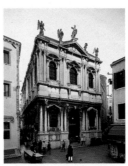

composite capitals. The keystone of the portal bears a sculpture of a winged putto holding a round shield with the letters "S" and "T," St. Theodore's initials. In the pedestal over this, flanked by two atlantes in the guise of putti, is the dedicatory plaque in honor of Jacopo Galli. In the middle of the crown is the statue of St. Theodore subduing a dragon, flanked by four angels (1657-58),

sculpted by BERNARDO FALCONE. The lower façade along the Calle del Lovo, articulated in a series of arches with elegant masks in high relief, is attributed to ANTONIO SARDI.

INTERIOR: along the right-hand wall of the SALA INFERIORE (Lower Hall) is a double staircase rebuilt by ANTONIO SARDI, who in 1661 appraised and surveyed the works carried out by the stone-carver FRANCESCO NATTORE. On the narrow landing, two niches contain the statues of Virtues. Antonio Lazzaroni, the vicar of the Scuola, commissioned the statue on the left, Charity (1662), while the right-hand statue, that has a subject not recognizable, dates from 1666. The steep stairway leading to the CHAPTER HOUSE and its portal, which repeats the motif of the Serliana opposite, was probably conceived by GIUSEPPE SARDI. While going up these stairs, visitors can admire two large canvases. On the wall to the left is a sweet, magical *Adoration of the Shepherds* by ANTONIO BALESTRA (1666-1740), while at right is a dramatic *Martyrdom of St. Christopher* by ANTONIO VASSILACCHI, known as L'ALIENSE (ca. 1556-1629), from the Scuola dei Mercanti della Madonna dell'Orto (merchants'

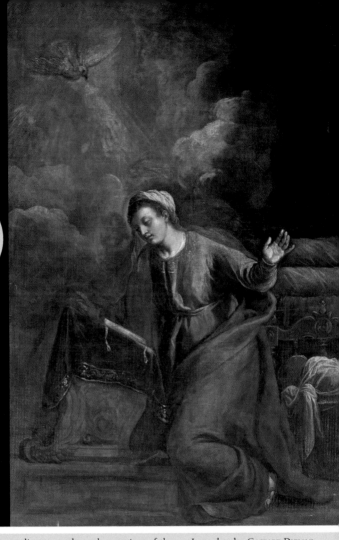

confraternity). The mediocre *God the Father* on the ceiling is attributed to TOMMASO BUGONI. Once inside the CHAPTER HOUSE you will note, on the inner façade of the entrance, the reliefs of *St. Mark and St. Theodore*, patron saints of Venice. On the wall opposite are two canvases by PALMA GIOVANE of the *Annunciation* (1595-ca. 1600) from the church of Santa Maria Maggiore. The elegant windows along the main side of the hall (and perhaps the cornices of the two side doors as well) were designed by BALDASSARE LONGHENA in 1669. On the ceiling, set between elliptical cornices, TOMMASO BUGONI painted the four Evangelists and, in the middle, *St. Theodore Presenting the Doge* (Paolo Renier?) *to the Virgin Mary* (1765). On the walls of the SALETTA DEI PATRONI are the *Martyrdom of St. Stephen* by LEANDRO BASSANO (1557-1622) and, to the right, *Jesus Entering Jerusalem* by GASPARE DIZIANI of Belluno (1689-1767). The paintings on the coffered ceiling, donated in 1692 by the superior of the Scuola, Iseppo Cargniana, represent, beginning from the portal, the *Trinity* – in which the Archangel Michael with the balance, the Virgin Mary and St. Peter are also depicted – *The Death of St. Theodore* (both executed by GIOVANNI SEGALA of Murano), and *The Cross Borne by an Angel*, of uncertain attribution.

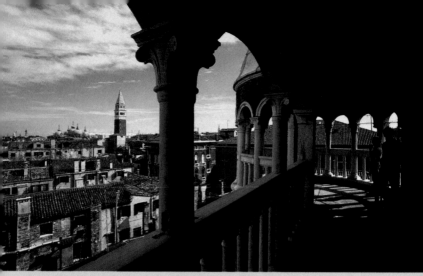

■ Once outside the Scuola di San Teodoro, head right and stop on the Ponte del Lovo, from where you can admire the **campanile of St. Mark's**. Once past this bridge you will catch sight of the entrance of the **Teatro Goldoni**, built in the 17th century by the Vendramin family and then rebuilt or restored several times. Turn left, into Calle dei Fabbri, where there are two lovely *Madonnas and Child* (17th century). One, in high relief, stands above street number 4738, while the other is situated after no. 4666. At Campo Manin, proceed to the left, in Calle de la Vida, until you reach **Palazzo Contarini del Bovolo** (no. 4299).
The FAÇADE with three superposed five-lancet windows overlooking Rio de S. Luca dates from the mid-1400s, while the extraordinary spiral staircase (called *bovolo* in Venetian dialect), which is attributed to the carpenter

GIOVANNI CANDI (d. 1506), dates from the second half of the 15th century. The top of the staircase affords a lovely panoramic view of the roofs of Venice. Above them you can see the city's tallest edifices, including (from right to left) the Teatro La Fenice, the dome of the Salute church, the bell-tower and domes of the St. Mark's Basilica, the church of Santi Giovanni e Paolo, and San Salvador church, recognizable for its three characteristic octagonal lanterns.
Back in Campo Manin, to the right is the Cassa di Risparmio bank, designed – not without heated controversy because of its rather grim exterior – by ANGELO SCATTOLINI and PIER LUIGI NERVI in 1964. In order to make room for the **Monument to Daniele Manin** – designed by LUIGI BORRO and cast in Munich in 1874 by FERD VON MILLER – the Town Council had the old San Paterniano

Church and its pentagonal bell tower demolished in 1869-75. Manin (1804-57), a lawyer and liberal patriot, headed the rebellion against Austrian rule in 1848-49 and died in exile in Paris. From the nearby Ponte de la Cortesia, to the right is the plaque indicating his house, and, beside the canal, the **San Luca Church**, containing works by PAOLO VERONESE and SEBASTIANO SANTI. Past the bridge, to the right, is **San Benedetto Church**, known here as **San Beneto**, which existed as far back as 1013 and was rebuilt, with the present façade with its

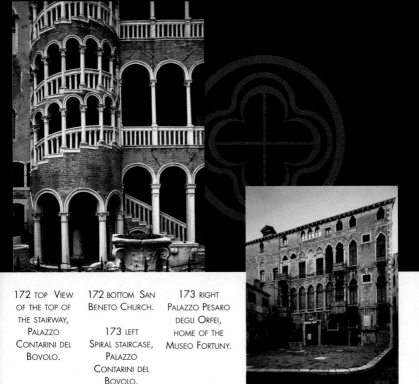

172 TOP VIEW OF THE TOP OF THE STAIRWAY, PALAZZO CONTARINI DEL BOVOLO.

172 BOTTOM SAN BENETO CHURCH.

173 LEFT SPIRAL STAIRCASE, PALAZZO CONTARINI DEL BOVOLO.

173 RIGHT PALAZZO PESARO DEGLI ORFEI, HOME OF THE MUSEO FORTUNY.

gigantic composite pilasters, from 1619 to 1695. In the interior, besides works by CARLO MARATTA, JACOPO GUARANA, SEBASTIANO MAZZONI, ANTONIO FUMIANI, GIAMBATTISTA TIEPOLO and GASPARE DIZIANI, don't miss the canvas by the Genoese priest BERNARDO STROZZI in the second altar at right, *St. Sebastian Attended by Holy Women* (mid 17th century). Facing Campo Manin is the **Palazzo Pesaro degli Orfei**, the home of the **Museo Fortuny** (no. 3780). This sumptuous residence, which also has a façade along the Rio de Ca' Michiel, was built by the Pesaro family, owners of the palazzo of the same name along the Grande Canal, in the first half of the 15th century, with late Gothic architecture and decoration. From 1786 on the building housed the Orfei Music Society, and in 1834 it became the home of the Società Apollinea, an association devoted to the study of music and fine art, which later moved to a building near the Teatro La Fenice. In the 20th century the palazzo became the residence of the Spaniard Mariano Fortuny y Madrazo (1871-1949), an artist and designer who was also interested in theater, photography and luxury handicrafts. Fortuny had eclectic taste influenced by the Belle Epoque, and designed and produced lamps, textiles, velvet, theater costumes and clothing that were appreciated throughout Europe. In 1956, in memory of her husband, Henriette de Fortuny bequeathed the palazzo and the works in it to the city of Venice. Besides the paintings, drawings, plaster casts, lamps and tapestries (19th and 20th century) that were made by Fortuny or that he owned, the museum houses 1,500 period prints and 11,000 photographic plates. Since 1979, the rooms on the ground floor (no. 3958) have been used for exhibitions, seminars, congresses and workshops, all revolving around photography, graphics, design, video and contemporary applied arts.

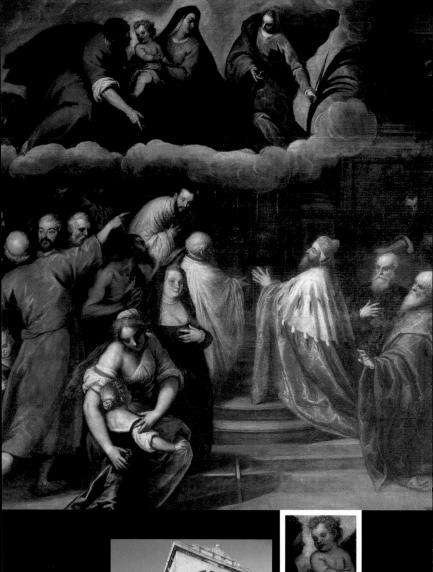

■ Proceeding along Rio Terà de la Mandola and Rio Terà dei Assassini, you will note, after no. 3639, a Gothic arch that was used as a floodgate before the *rio* (canal) was filled in. With the aid of a map, go to Campo S. Fantin and the **Madonna di San Fatino Church**, commonly known as **San Fantin**. HISTORY: this ancient building was rebuilt in 1506 thanks to a generous bequest by Cardinal Giovan Battista Zen. However, the vicissitudes of its construction are not at all clear. Again, the construction of this singular edifice, designed by SEBASTIANO MARIANI DA LUGANO in 1507, was carried out in 1516-22 by ANTONIO ABBONDI, known as LO SCARPAGNINO (d. 1549).

FAÇADE AND EXTERIOR: the main façade is characterized by a protuberant central section corresponding to the atrium, the three sides of which have a portal. The principal portal is flanked by Corinthian half-columns on a pedestal with fluted shafts and is crowned by a tympanum. All the walls of the exterior, including the apse – visible from the small square behind the church – have a casing of smooth Istrian stone rustication interrupted by trabeation supported by large modillion brackets. The upper section, which was built in a later period and has large thermal windows, does not fit in with the rest of the façade. INTERIOR: nave with two aisles, chancel elevated over the crypt. The two main bays, which are separated by a narrower one, and the use of two registers of pilasters on the piers, partly anticipate the building technique employed for San Salvador Church. The apsidal chancel (ca. 1549 - 1564) was designed by JACOPO SANSOVINO. By skillfully varying the surface of the existing masonry, the Florentine architect abandoned the system adopted by CODUSSI and the LOMBARDOS – four Corinthian columns on a base as supports of the large arches and the dome above them. Besides the funerary monuments and paintings by LEONARDO CORONA, ANDREA VICENTINO and SANTE PERANDA, there are notable works of art in the interior. In the right-hand aisle above the portal is the canvas *St. John the Evangelist, St. Roch and St. Theodore Ask the Virgin Mary to Free Venice from the 1630 Plague* (signed and dated 1630) by JOSEF HEINTZ; in the altar at the end of the nave, the miraculous icon, *The Madonna of Passion* (15th century?), brought to Venice from the Orient by the Pisani family; and among the interesting series of portraits, *Doge Alvise Mocenigo Giving Thanks to the Virgin Mary for the Victory at Lepanto* (1596) by PALMA GIOVANE, on the left-hand wall of the chancel. The church was the seat of the schools of devotion to the Holy Sacrament, St. Gaetano, and St. Mary of Justice and St. Jerome, as well as of two guilds, the Scaleteri (vendors of biscuits and sweets), who were devotees of St. Fantin, and, from 1690 on, the Gucchiadori e Calzeri di Seda (producers and vendors of stockings, shirts, gloves, light shoes and knitwear), who were devotees of the Madonna della Salute.

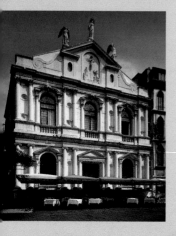

■ Next to the church of San Fantin is the former **Scuola di San Girolamo** (or **San Fantin**). HISTORY: the nearby church was the seat of two religious societies. One, founded in the Middle Ages, was named after St. Mary of Justice or St. Mary of Consolation and from 1411 accompanied, comforted and buried those condemned to be hanged. The other one, a simple devotional confraternity, was named after St. Jerome. In

1458 the confraternities merged, and although they maintained the two names, were commonly known as the Scuola dei Picai (the hanged) or Scuola della Buona Morte (Confraternity of Good Death). After a fire that broke out in 1562 the seat of the confraternity was rebuilt, enlarged with more rooms and decorated with beautiful paintings.
At present the building is the home of the Ateneo Veneto di Scienze, Lettere e Arti, founded in 1812. FAÇADE: designed and built before ca.1600 by ALESSANDRO VITTORIA, the façade has two

registers with four pairs of Ionic and Corinthian columns that stand on pedestals and are separated by a small niche. The windows on the first floor are surmounted by the lovely motif of the winged bucranium (a classical allegory of sacrifice), repeated in the central tympanum, in which there is a high-relief depiction of a Crucifixion attributed to ANDREA DELL'AQUILA. Above the cross is the allegorical theme of the pelican, while at its feet, besides the kneeling confreres, there are the patron saints of the Scuola, Mary and Jerome, who, as a Doctor of the Church, is represented with the model of the church in his hand. Above the tympanum, the statues of the Madonna and one of the angels are by ALESSANDRO VITTORIA.
INTERIOR: in the **Lower Hall**, now the **Aula Magna** or Great Hall, the coffered ceiling has a cycle of

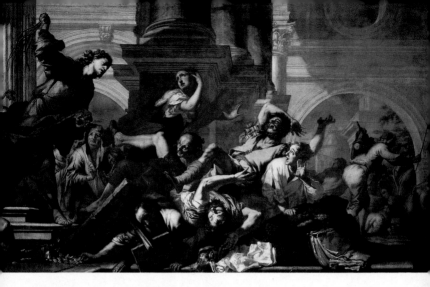

176 TOP
SCUOLA DI SAN
FANTIN, NOW ATENEO
VENETO.

176 CENTER
ALESSANDRO VITTORIA,

BUST OF TOMMASO
RANGONE, DETAIL.

176 BOTTOM
*APPARITION OF THE
VIRGIN MARY TO ST.
JEROME.*

176-177
ANTONIO ZANCHI,
*JESUS DRIVING THE
MERCHANTS FROM
THE TEMPLE.*

177 BOTTOM
FRANCESCO
FONTEBASSO, *SUPPER
AT THE HOME OF THE
PHARISEE.*

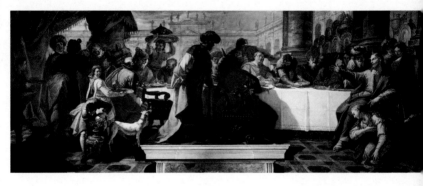

canvases dedicated to *Purgatory* and the figures of *Saints and Doctors of the Church* (1600). This theme is to be interpreted in an anti-Protestant key and in favor of indulgences, thanks to which the Catholic Church, besides reasserting the centrality of its spiritual function, was guaranteed a conspicuous source of income. Along the walls, the dramatic scenes of the *Passion of Christ* (1600-04) are the work of LEONARDO CORONA and BALDASSARE D'ANNA, while the canvases with the *Prodigal Son* and *Good Samaritan* (1670), which refer to the charitable works of the Scuola, are by ANTONIO ZANCHI. The bronze bust on the back wall by ALESSANDRO VITTORIA portrays Tommaso Rangone, the physician who financed the façade of San Zulian Church and the superior of the Scuola di San Marco. Visitors should not miss the upper rooms – once used as the confraternity's Albergo and Albergo Piccolo – which have fine canvases by JACOPO TINTORETTO, PAOLO VERONESE, PALMA GIOVANE, BERNARDO STROZZI, GIROLAMO and FRANCESCO FONTEBASSO, ALESSANDRO LONGHI, ANTONIO ZANCHI, GIOVANNI SEGALA and ERMANNO ZEREST.

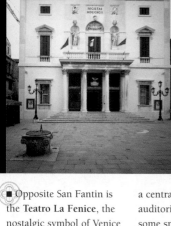

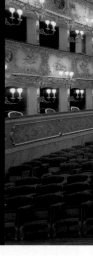

■ Opposite San Fantin is the **Teatro La Fenice**, the nostalgic symbol of Venice in decline and the temple of first-rate opera, concerts and dance productions. Built in 1790-92 by the Venetian architect GIANNANTONIO SELVA, the theater had a façade with a Neo-Classic portico (1792), which still exists, an atrium that was enlarged in 1937,

a central, horseshoe-shaped auditorium, a ballroom, some smaller halls and a canal entrance that can be seen from the *rio* behind the theater.

A large wooden model of the theatre (1790) designed by GIANNANTONIO SELVA is now at the Museo Diocesano di Arte Sacra. In 1807-08, SELVA added the imperial and royal box.

The theater was destroyed twice by fire (1836 and 1996). In the first case, it was rebuilt exactly as it was in only one year by TOMMASO and GIAMBATTISTA MEDUNA, but with new decorative elements, while the present, extremely difficult and long reconstruction, partly finished in 2003, was designed by ALDO ROSSI (d. 1997). Among the decoration irretrievably lost in the last fire are the Sale Apolinee with their 19th-century furnishings and, in the auditorium itself, the boxes decorated by LEONARDO GAVAGNIN and

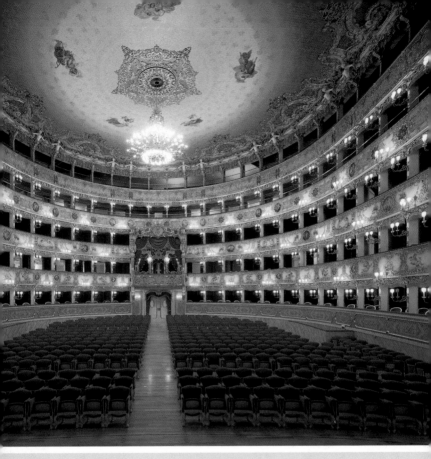

GIUSEPPE VOLTAN and the
paintings on the ceiling by
LEONARDO GAVAGNIN, framed
by the sculptural decoration
by OSVALDO MAZZORAN (1854).
By going along the Calle de la
Fenice and Calle Caotorta,
you will enter Campo S.
Angelo, which until the 17th
century was the venue of the
local bear hunt spectacle.
Walking toward you right,
you will note in the pavement
of the square a plaque
commemorating the
demolition of S. Angelo
church in 1837. Farther
along, at no. 3584, is **Palazzo
Duodo**, a Gothic edifice built
in the mid-15th century,
which was the home of the

composer Domenico
Cimaroso (1749-1801), while
along the opposite side of the
square is the elegant, multi-
colored **Palazzo Gritti-
Morosini** (no. 3832; second
half of the 15th century) and
Palazzo Pisani-Trevisan (no.
3831), build in the late 17th
century by an architect
obviously influenced by the
school of DOMENICO ROSSI.
Among the works kept in the
nearby, small **Oratorio
dell'Annunciazion e di San
Michele Arcangelo** (no. 3817)
are paintings attributed to
SANTE PERANDA (1566-1638)
and GIUSEPPE CESARI, known
as CAVALIER D'ARPINO (1568-
1640).

178 TOP AND 178-
179 AUDITORIUM
AND BOXES OF TEATRO
LA FENICE AND DETAIL
(BEFORE THE
1996 FIRE).

178 CENTER TEATRO
LA FENICE, ENTRANCE
FACADE.

178 BOTTOM
CAMPO
SANT'ANGELO.

SANTO STEFANO

1 Altar of
 St. Augustine
2 Large sacristy
3 Battistero
4 Funerary monument
 to Bartolomeo
 d'Alviano
5 Funerary monument
 to Jacopo Suriano
6 Tomb of Doge
 Francesco Morosini

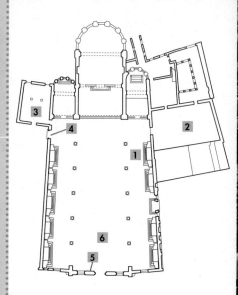

180 TOP SANTO STEFANO
CHURCH, DETAIL OF THE
ENTRANCE PORTAL.

180 CENTER ST. AUGUSTINE
BEING WORSHIPPED BY
MONKS, FORMER MONASTERY
OF SANTO STEFANO, PORTAL.

180 BOTTOM CAMPO
SANTO STEFANO: THE
CHURCH AND MONUMENT
TO NICOLÒ TOMMASEO.

180-181
VIEW OF CAMPO SANTO
STEFANO AND ITS
CHURCH.

Opening onto the Ponte
dei Frati is the portal of the
Augustine cloister of **Santo
Stefano Church**. The
polychrome bas-relief in the
pointed-arch lunette,
attributed to GIOVANNI
BUORA and his workshop,
depicts *St. Augustine being
worshipped by monks* (ca.
1485-90). Farther on, in the
small square, is the seat of
the **Scuola di
Santo Stefano**
(no. 3467),
which once boasted five
large canvases by VITTORE
CARPACCIO with *scenes from
the life of the saint* (1511-20)
that are now kept in various
collections. Of this
drastically rebuilt building
there remains a bas-relief
with a trefoil frame, with *St.
Stephen being worshipped by
the confreres* (mid-15th
century). On the opposite
side of the square is **Santo
Stefano Church**. HISTORY:
before moving to the
Sant'Angelo parish, the
Augustinians resided in the
Sant'Anna Monastery in the
Castello district, which they

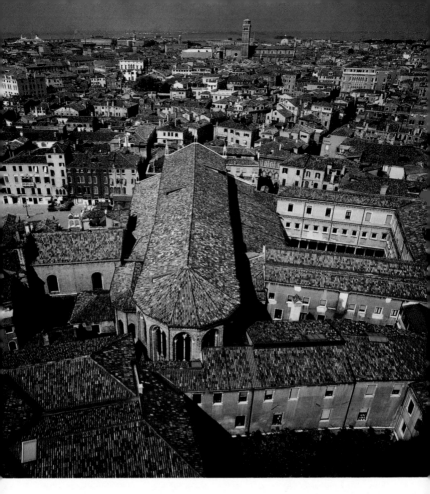

founded in 1242. In 1284, the Republic of Venice gave the Augustinian order the same role as the Dominicans and Franciscans and granted them certain privileges and the right to ask for alms. After this prestigious act of recognition, the brothers decided to build the new church of St. Stephen, the first stone of which was laid in 1294. The three cloisters built in different periods around the church bear witness to the success enjoyed by the Augustinian monastic community. In the first half of the 15th century the edifice was rebuilt as the church we see today.

FAÇADE: the two wings with doublet-lancet windows slope inwards with respect to the main body of the church, which is taller and pitched. The unusual, planned asymmetry is masked by the two masonry buttresses flanking the portal (1415- ca. 1430). Above this latter is an arch framed by two slender columns. The pointed intrados is embellished by a crown of seven trefoil arches and the elegant pyramidal archivolt is decorated with acanthus leaves whose broad, sinuous aspect remind one of the leaves that decorate the main crown of St. Mark's façade. In Santo Stefano, the acanthus plant – symbol of eternal life – looks like a flame rising to Heaven. In the crown of the arch is an angel bearing a cartouche surmounted by a benedictory Everlasting Father with an open book. It is likely that this splendid composition was meant to be the funerary urn of some eminent personage.

182 LEFT, RIGHT AND 183 TOP
*ADORATION OF THE MAGI,
MASSACRE OF THE INNOCENTS
AND FLIGHT INTO EGYPT*, AND
DETAILS, LARGE SACRISTY.

182 CENTER GIUSTINO
MENESCARDI, *ST. AUGUSTINE
DRIVES OUT THE HERETICS.*

183 BOTTOM
SANTO STEFANO
CHURCH, NAVE AND
SHIP'S KEEL CEILING.

INTERIOR: the nave and aisles gradually narrow, "telescopically," in the direction of the three apsidal chapels, thus lending greater depth to the church. This consciously planned illusionist expedient seems to have derived from medieval studies of optics – well known to the Paduan school – and to have prefigured, at least in part, certain experiments with perspective carried out during the Renaissance. But it also may have been due to insuperable building limits: since the apses had to be created in a limited space, the architects thought of widening the church and the nave in the direction of the façade. The slender red Veronese marble and Greek marble columns support two types of capital whose shape, highlighted by the gold on the ultramarine blue of the lapis lazuli, harks back to late 14th-century models. The nave is covered by a splendid five-lobate wooden ship's-keel ceiling, while the walls are cased with masonry with frescoed lozenge patterns, much like the dressing on the exterior of the Doges' Palace. Above the twelve Gothic arches are the frescoed figures of twelve saints and beatified Augustinians (1435- ca. 1446). The nine luxurious side altars, with straight or bent tympana, were rebuilt in 1705-43, except for the first one at left, which was redone ca. 1650. In the middle of the inner façade is the *equestrian monument to Domenico Contarini* (1644-50). The fourth altar in the right-hand aisle contains the altarpiece of *St. Augustine Drives Out the Heretics* (1736- ca. 1743) by GIUSTINO MENESCARDI. The Doctor of the Church who inspired the rule of the Augustinian Order is wearing a black habit and is holding the burning heart, the symbol of religious fervor. On the wall to the left of the altar is the interesting bronze relief of the *Virgin Mary and Child with Saints and Donors* (ca. 1493) attributed to GIOVANNI BUORA.

The next door leads to the SACRISTY, completed in 1525 (according to an inscription) on the initiative of the Augustinian general and architect, GABRIELE DALLA VOLTA. On the inner façade of the sacristy, under the large round window, is the crest of this friar, a winged dragon eating its own tail. This is an alchemical emblem of the *ouroboros*, the symbol of eternity, which refers to the green dragon or "Mercurius of the Sages" who safeguards a treasure accessible only to those pure in heart like children. The fine canvases on either side of this emblem and the round window, painted by GASPARE DIZIANI, depict the *Adoration of the Magi*, the *Massacre of the Innocents* and the *Flight into Egypt* (1733).

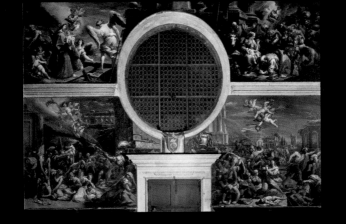

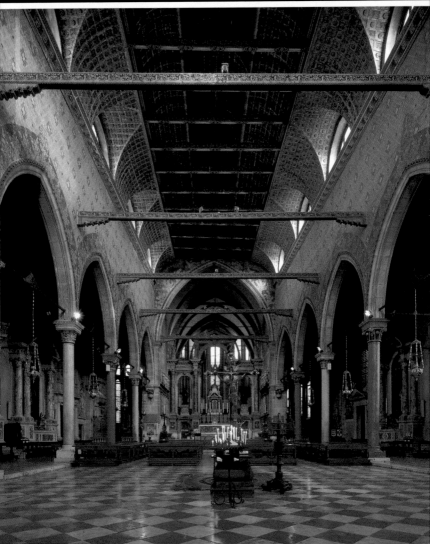

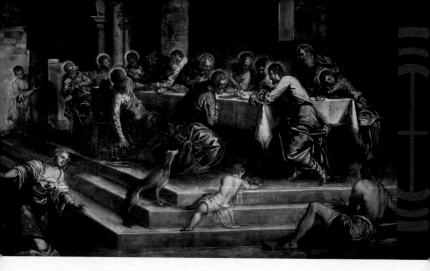

The large and small sacristies have for some time served as museums which, besides a good collection of silver liturgical instruments, house an interesting group of paintings from different areas. Among these latter are the works of artists such as BARTOLOMEO VIVARINI (Murano), BONIFACIO DE' PITATI (Verona), GIOVANNI AGOSTINO DA LODI (Lombardy), SANTE PERANDA and GIUSEPPE ANGELI (Venice), and ANTONIO TRIVA (Reggio Emilia). The main sacristy also boasts three large canvases by JACOPO TINTORETTO and his son DOMENICO, who was twenty when the works were painted. These canvases come from Santa Margherita Church: *Christ Washing the Disciples' Feet*, *The Last Supper* and *Agony in the Garden* (ca. 1580). In the Last Supper scene, the beggars, children and infirm refer to the theme of charity stated in the New Testament and mentioned in the proceedings of the Council

of Trent. In the *Agony*, Christ's head is bent as if he has fainted and he is sweating blood, a scene that closely resembles the one Tintoretto painted for the Scuola Grande di San Rocco in the same period. Drawing inspiration from the Gospel of St. Luke and representing the angel with the chalice, the artists clearly refer to the Eucharist.

Back in the church proper, to the right of the sacristy entrance is the *Monument to Lazzaro Ferro* (d. 1692), attributed to ANTONIO GASPARI and one of the best examples of Baroque funerary art in Venice. Behind the apsidal Santissimo Sacramento chapel is the elevated CHANCEL. This area consists of two bays and an apse with a groin vault. The side walls of the chancel contain the partitions that delimited the choir that once stood in the nave. This work is attributed to ANTONIO GAMBELLO (d.

1481), while four of the statues of the *Apostles and Saints* (ca. 1480) were the work of GIOVANNI BUORA. The high altar with its three arches, begun in 1620, is attributed to the unknown ANTONIO PUZO. In its stone tarsia frontal, BENEDETTO CORBARELLI executed *The Martyrdom of St. Stephen* (1656). The luminous apse, which was completed in 1443 (as the inscription tells us), is suspended over the *Rio del Santissimo* canal behind it. The mighty pillar at right boldly lies against the center-line of the support bridge. The *wooden choir* (1482-88), which was formerly in the nave, was begun by LEONARDO SCALAMANZO. Once past the left-hand apsidal chapel of the Archangel Michael, one enters the BAPTISTERY, which contains the f*unerary stele of Giovanni Falier* (1808) by ANTONIO CANOVA. The Ionic-order chapel was rebuilt by GABRIELE DALLA VOLTA, together with the adjacent cloister, after the

1529 fire. Once back in the LEFT AISLE, observe in a high niche a statue of St. Nicholas of Tolentino (second half of the 14th century). Like St. Roch and St. Sebastian, this Augustinian monk (d. 1305) was invoked as protection against the plague. His effigy also appears on the ceiling above the largest apse, with the lily – symbol of chastity – and a star on his chest that appeared in the sky during his birth or while he went to church at night. The figure standing above the baptistery door is holding the books of wisdom as well as a head that represents the divine star with human features, here perhaps interpreted as a Sun. Above the lintel is the *funerary monument to Barolomeo d'Alviano* (1628-33), which was executed by BALDASSARE LONGHENA and by the sculptor GIROLAMO PALIARI. Next comes the *Calafati altar*, with the altarpiece by GIROLAMO

BRUSAFERRO (1737), in which the patron saints of art, Mark and Foca, are depicted. Beyond the *altar of St. Stephen* is the *altar of St. Nicholas of Tolentino*. Nicholas is represented by a statue (1475-80) attributed to PIETRO LOMBARDO and assistants, in which he is holding a lily (which has disappeared) and an open book with the gilded head of the divine star on its pages. Santo Stefano church once was the home of a confraternity named after St. Nicholas which, after disagreements with the Augustinian friars, left in 1490 and later promoted the foundation of the San Nicola da Tolentino church. This altar is followed by two others: the *altar of the Addolorata* (Our Lady of Sorrows), supported by the German Calegheri (cobblers), and the *altar of the Madonna della Cintura*, used by the devotional school of the same name. The altarpiece by LEONARDO CORONO (1591-95) shows

the *Assumption of the Virgin Mary*, who is holding a rosary, an attribute of prayer, and the girdle (*cintura*). The apocryphal Gospels narrate that the Virgin's sacred girdle was cast from the sky at doubting Thomas, whose figure in the painting is replaced by Augustinian saints of solid faith. At the foot of this altar is the slab commemorating the burial here of the great composer Giovanni Gabrieli (1557-1612). In the inner façade is the lovely *funerary monument to Jacopo Suriano* (1488-93), attributed to GIOVANNI BUORA. At the beginning of the nave is the tomb of Doge Francesco Morosini, whose elaborate sepulchral seal (1694) was executed by the Genoan FILIPPO PARODI after designs by ANTONIO GASPARI. The bronze lectern nearby (ca. 1450), with an eagle clawing a dragon, is a Flemish work of the Dinant school, brought from Rhodes.

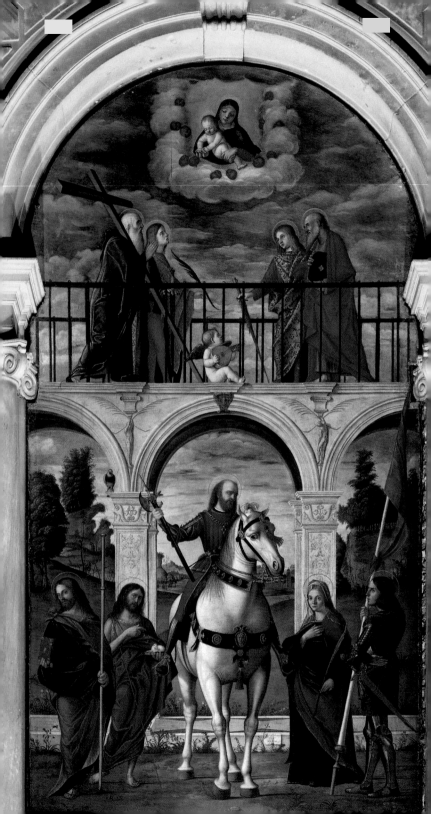

Having left Santo Stefano church behind us, we now proceed toward the square of the same name. In the middle of Campo Santo Stefano is the **Monument to Nicolò Tommaseo** (1882), by NICOLÒ BARZAGHI. Tommaseo (1802-74) was a man of letters, author and

I of Austria in 1838. In the interior are canvases with biblical scenes attributed to ANTONIO VASSILACCHI, known as L'ALIENSE (ca. 1556 -1629); a *Madonna and Child and four senators* (1553) by JACOPO TINTORETTO; 18th-century stuccowork attributed to

patriot who lived in Venice from 1840 to 1849 before being sent into exile. Unlike another famous patriot, Daniele Manin, he was opposed to Venice being annexed by the Kingdom of Piedmont. Farther on to the right is the long **Palazzo Loredan**, purchased in 1536 and remodeled to a design by ANTONIO ABBONDI (known as SCARPAGNINO; d. 1549), who also designed the portal, the beautiful Ionic multiple window and the staircase. The classicizing smaller façade (1618), close to the Palladian style, is framed by Ionic and Corinthian semi-columns and is attributed to VINCENZO SCAMOZZI and GIROLAMO GRAPIGLIA. Since 1891 the building has been the home of the Instituto Veneto di Scienze, Lettere e Arte, founded by Ferdinand

ABBONDIO STAZIO; and allegorical paintings by GIUSEPPE ANGELI (ca. 1709 - 1798). At the end of the square is the **Church of San Vitale**, known as **San Vidal**. HISTORY: founded by Doge Vitale Faliero (1084-96) and rebuilt in the 15th century, the church was rebuilt to celebrate the figure of Doge Francesco Morosini, who is buried in the nearby church of Santo Stefano. The work, which began in about 1696, was entrusted to the family architect, ANTONIO GASPARI. FAÇADE: built by ANDREA TIRALI in 1734-37 on a commission by the Doge Carlo Contarini (d. 1656). The portraits placed on the side urns, depicting Doge Contarini and his wife, are attributed to GIUSEPPE GNOCCOLA. The acroteria support four statues of Virtues and, in the middle,

a Risen Christ. The oldest part of the campanile dates from the 12th century. INTERIOR: a nave without aisles, divided by composite half-columns. The six side altars contain paintings by GIANNANTONIO PELLEGRINI, GIAMBATTISTA PIAZZETTA, SEBASTIANO RICCI, GIULIO LAMA and ANGELO TREVISAN. The sculpture works in the two central altars are by ANTONIO TARSIA; the lunettes above them, with the *Ascension* and *Resurrection*, were painted by ANTONIO VASSILACCHI (L'ALIENSE). Behind the high altar (1740) is an altarpiece by VITTORE CARPACCIO and assistants, depicting *San Vitale on Horseback and Saints* (signed and dated 1514). The sacristy houses *The Death of Sant'Ursicino* by GREGORIO LAZZARINI and a lovely *Martyrdom of San Vitale* (18th century).

■ In front of San Vidal Church are the garden and the modern wing of **Palazzo Cavalli-Franchetti**. Proceeding leftward, one enters a small square with the impressive **Palazzo Pisani** (no. 2809) made of Istrian stone, now the Benedetto Marcello Music Conservatory. The attribution of the main body of this edifice and its façade (1614-15), which faces the Rio del Santissimo , is still uncertain. The major extension work (1728-51) toward the Grand Canal – including two courtyards with superimposed loggias – and the addition of a second *piano nobile*, was partly done by the Paduan GIROLAMO FRIGIMELICA (d. 1732), who

also designed the Villa Strà on the Brenta River for the Pisani family.

At the end of Calle Streta is the **Palazzo Morosini** (no. 2803). Following the instructions in the will of Doge Francesco Morosini (the Peloponnesian, d. 1694), ANTONIO GASPARI merged two already existing palazzi by rebuilding their façades and interiors. To commemorate Morosini's land and naval victories against the Turks, reliefs of trophies were inserted in the lunette of the ground-floor Doric order portal, while the keystone of the entrance on the canal was decorated with a charming sea-horse. At the end of the 18th century GIANNANTONIO SELVA modernized the building and removed the most gaudy Baroque decoration. The precious art collections in the palazzo were sold at auction in

1894. On this occasion, the Correr Museum managed to purchase a series of paintings by PIETRO LONGHI, which are now on exhibit at the Ca' Rezzonico Museum. After skirting Campo S. Stefano for a brief stretch, turn right, in Calle del Spezier. From the S. Maurizio bridge you will see, to the left, the apse of Santo Stefano Church, which seems to be suspended over the canal. In Calle del Piovan is the former Scuola degli Albanesi (no. 2763). This confraternity was founded in 1442 and the headquarters – originally two stories high – were built between 1489 and 1502, while construction of the Ionic lozenge façade began in 1532. The three high reliefs over the ground floor represent the patron saints of the Scuola: the *Virgin Mary and Child, St. Gallo, and St. Maurizio*. The bas-relief between the two windows commemorates the

188 BOTTOM
DETAIL OF GOTHIC
PALAZZO, CAMPIELLO
DE LA FELTRINA.

189 TOP AND
CENTER PALAZZO
PISANI AT SANTO
STEFANO, DETAILS.

189 BOTTOM
PALAZZO MOROSINI
AT SANTO STEFANO,
DETAIL.

188 TOP CAMPO SAN
MAURIZIO AND, AT RIGHT,
PALAZZO BELLAVITE-TERZI.

Turkish siege of Scutari, Albania. This city was ceded to the Ottomans through the 1480 peace treaty and was then abandoned by its inhabitants, some of whom were invited to stay in Venice or were sent to the Fruili region to man the new Gradisca fortress. The Scuola, which was purchased in 1780 by the bakers guild (Pistori), once boasted a cycle of six large canvases of scenes from the *life of the Virgin Mary* (1504-08) by VITTORE CARPACCIO and workshop that was later sold to various collections in Venice, Bergamo and Milan. Farther on in the square is the **Palazzo Bellavite-Terzi** (no. 2760), the construction of which was financed by the wheat and oil merchant Dionisio Bellavite on the site of the former campanile of the nearby church of San Maurizio. The façade with its superimposed Serlianas was decorated with frescoes by PAOLO VERONESE (around 1555). Famous persons who lived in the palazzo were the libertine poet Giorgio Baffo (1694-1768) and, in 1803-04, the great author Alessandro Manzoni (1785-1873). On the left-hand side of the square is **San Maurizio Church**.
HISTORY: this ancient church was rebuilt at least three times. The building we see today was designed by the patrician PIETRO ZAGURI, who drew inspiration from CODUSSI and from SANSOVINO's church of San Geminiano, which no longer exists.
San Maurizio, consecrated in 1828, was completed by ANTONIO DIEDO. FAÇADE: in Neo-Classic style, designed by GIANNANTONIO SELVA (d. 1819). The reliefs and statues are by BARTOLOMEO FERRARI and LUIGI ZANDOMENEGHI. INTERIOR: a Greek cross plan with a central dome, small blind domes and large barrel-vault arches supported by a system of piers and Corinthian columns. The altars are the work of GIANNANTONIO SELVA. Once outside the church, head left into Calle Zaguri. Campiello de la Feltrina boasts a small, elegant **Gothic palazzo** (no. 2513) with triple – and quadruple – lancet windows whose shafts and capitals are made of alternating Istrian stone and Veronese marble.

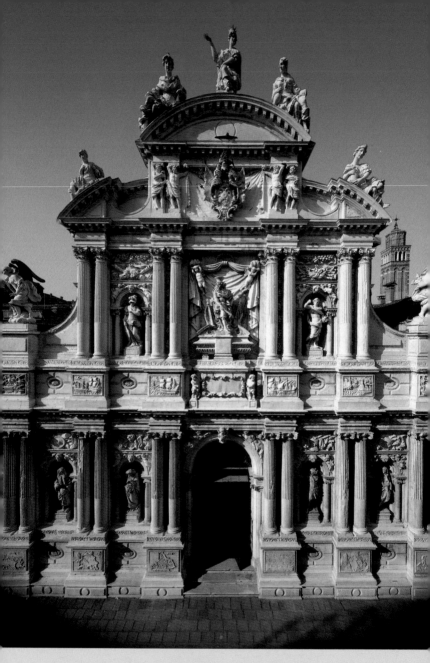

190 TOP AND 191
TOP CENTER SANTA
MARIA DEL GIGLIO
CHURCH AND DETAIL.

190 BOTTOM AND
191 LEFT VIEW OF
ROME AND MAP OF
CORFU, DETAIL OF THE
BAS-RELIEFS.

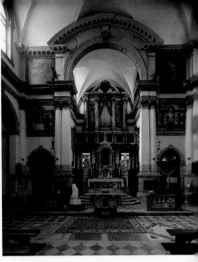

191 RIGHT NAVE AND CHANCEL, SANTA MARIA DEL GIGLIO CHURCH.

■ Past the bridge is **Santa Maria dell'Annunciazione Church**, also known as **Santa Maria del Giglio** or Santa Maria Zobenigo.

HISTORY: this church, originally called Santa Maria Giubenico or Zobenigo as it was founded by the Giubenica family, dates from the 9th century and was one of the five mother churches of the city.

FAÇADE: among the leading examples of Venetian Baroque, this façade was built in 1680-83 by GIUSEPPE SARDI (as the inscription tells us), thanks to the last wishes of Antonio Barbaro. Statues and reliefs celebrate the political, diplomatic and military virtues of Barbaro and his family. The bas-reliefs on the plinths represent the plans of the cities in which the Barbaro held prestigious positions in the local administration: Zadar, Iraklion (Crete's major city), Padua, Rome, Corfu and Split. The statues in niches, placed between luxurious cabled Ionic columns, are extraordinary examples of high fashion in men's clothes in that period. The sculptures portray leading young members of

the Barbaro family, the brothers of Antonio: Giovanni Maria, Marino, Francesco and Carlo. The columns on the second row are Corinthian. On their bases (as in the *Mocenigo monument* at the Mendicanti Church) are reliefs with a naval battle, prisons, and armed galleons. In the middle is the statue of Antonio Barbaro in the guise of the *Superintendent of Dalmatia*, perhaps one of the last works by JUSTE LE COURT (d. 1679), and at the sides, the allegories of *Honor and Virtue*.

INTERIOR: this has an aisleless nave and a deep chancel with a flat back wall. Each side wall has three altars separated by piers and Ionic columns. The central altar is framed by an arch that is larger than the side ones. The construction work, which was well advanced around 1680, is at present attributed to GIUSEPPE BENONI. Despite its small size, the church, consecrated in 1700, is one of the richest in Venice in terms of 18th-century art

works. The intercolumniation in the nave and along the side walls is occupied, in the upper register, by six lovely funerary monuments, surmounted in the attic section by six canvases by ANTONIO ZANCHI and GIAMBATTISTA VOLPATO that illustrate *scenes from the life of the Virgin Mary*. On the tall pedestals is a beautiful *Via Crucis* (1755-56) whose fourteen Stations of the Cross were painted by FRANCESCO ZUGNO, GIOVANNI BATTISTA CROSATO, DOMENICO MAGGIOTTO, FRANCESCO FONTEBASSO, GIUSEPPE ANGELI, GASPARE DIZIANI and JACOPO MARIESCHI. On the ceiling are the *birth*, *coronation*, and *assumption of the Virgin* (1690-96) by ANTONIO ZANCHI (d. 1722), who is buried in this church. Among the works on the inner façade, above the entrance is a *Last Supper* by GIULIO DEL MORO, who also sculpted the nearby statue of the *Redeemer*, at left.

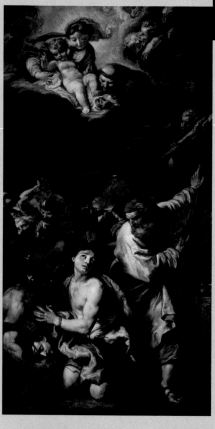

192 TOP JOHANN CARL LOTH, *VIRGIN MARY, ST. ANTHONY OF PADUA AND THE MARTYRDOM OF ST. EUGENE*, AND DETAIL OF SAME.

192 BOTTOM LEFT RELIQUARY BUST.

192 BOTTOM CENTER RELIQUARY OF THE HOLY THORN.

192 BOTTOM RIGHT OSTENSORY.

192-193 ANTONIO ZANCHI, *ABRAHAM APPORTIONING THE WORLD*.

On the next pedestal is a small and interesting high relief of *St. Jerome in his cave* (1468- ca. 1470) attributed to NICOLÒ DI GIOVANNI FIORENTINO. The saint's cave is filled with books on which the erudite hermit is meditating. Next to him is his inseparable companion, the lion, and to the right, the treacherous dragon, symbol of Evil and its temptations. The first altar at right, with an altarpiece by JOHANN CARL LOTH, belonged to the Barbaro family. Like the one

on the opposite wall, this altar was perhaps designed by GIUSEPPE SARDI. This is followed by the Chapel of Our Lady of Sorrow or the Cappella Molin. The bust of Girolamo Molin (second half of the 16th century) in the small vestibule is the work of ALESSANDRO VITTORIA. The showcases on the sides of the chapel contain one of the most precious collections of reliquaries, crucifixes and silver liturgical objects in Venice (mostly dating from the 17th-19th centuries).

Among the paintings, besides works by DOMENICO TINTORETTO, GIOVANNI ANTONIO PELLEGRINI, ANTONIO ZANCHI and FRANCESCO PONTEBASSO, there is the *Madonna and Child with the Young St. John the Baptist* by PIETER PAUL RUBENS (1577-1640). The bloated figure of the Virgin departs from the usual iconographic schemes, and even though her bared breasts belong to the suckling Madonna type, they somehow deprive the painting of all its sacred quality.

Back in the church, after the altar of San Gregorio Barbarigo is the Cappella del Battistero (Baptistery Chapel), with Baroque stuccowork attributed to DOMENICO PATERNÒ (1730). After the altar with the *Visitation* by PALMA GIOVANE (ca. 1581), you enter the SACRISTY. In addition to the *Annunciation* by ANDREA MELDOLLA (or SCHIAVONE, ca. 1505-1563) and the canvases by PIETRO MUTTONI (DELLA VECCHIA) and ANTONIO ZANCHI, a work worth observing is the small altar with the marble altarpiece by GIULIO DEL MORO and the frontal with the head of the Infant St. John the Baptist, attributed to the Florentine DESIDERIO DA SETTIGNANO (1428-64). In the CHANCEL, at either side of the precious 18th-century altar, are two statues by the Flemish artist HEINRICH MEYRING – the Archangel Michael and the Virgin Mary (late 17th century?) – which represent the *Annunciation* after which this church was named. Behind the altar there are works by ALESSANDRO VITTORIA, FRANCESCO SOLIMENA, ANDREA CELESTI and ANTONIO ZANCHI (the paintings in the organ choir, 1696-98), as well as two lovely paintings by JACOPO TINTORETTO – commissioned by the parish priest Giulio

Contarini and taken from the doors of a destroyed organ – which represent the *four Evangelists* (1557). In homage to the patron saint of the Venetian Republic, the figure of St. Mark, recognizable by the lion, is the one with the most brilliant halo. Once out of the chancel, in the last altar on the left-hand side is the grim *Martyrdom of St. Anthony* by ANTONIO ZANCHI. Among the many religious brotherhoods hosted in the church, mention should be made of the Santissimo Sacramento, the Annunciation, and St. Vincenzo Ferrer, as well as the Forneri (bread vendors) and Sartori (tailors). Having left Santa Maria del Giglio behind you, proceed, with the aid of a map, to nearby Calle XXII Marzo, whose name commemorates the day in 1848 when the Austrian garrison was driven out of the city. This

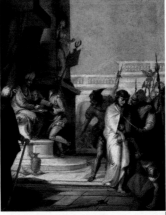

wide and straight "street" (an unusual sight in Venice) was inaugurated in 1880 (see the plaque over street number 2423) after the local city council authorized the demolition of an ancient area to favor building speculation. Along this *calle*, modeled after the new avenues in the European capital cities, the architects built Neo-Renaissance residences and commercial buildings.

194-195 ANDREA SCHIAVONE, *ANNUNCIATION*.

194 BOTTOM LEFT AND 195 BOTTOM JACOPO TINTORETTO, *THE EVANGELISTS MARK AND JOHN* AND DETAIL.

194 BOTTOM RIGHT JACOPO TINTORETTO, *THE EVANGELISTS LUKE AND MATTHEW*.

195 CENTER FRANCESCO FONTEBASSO, *CHRIST BEFORE PONTIUS PILATE*, IV STATION OF THE CROSS.

196 TOP
SAN MOISÈ
CHURCH.

196 BOTTOM LEFT
SACRISTY.

196 BOTTOM RIGHT
NICOLÒ E
SEBASTIANO
ROCCATAGLIATA,
*EPISODES OF THE
DEATH OF CHRIST*,
SACRISTY.

196-197 SAN
MOISÈ CHURCH,
VIEW TOWARD THE
HIGH ALTAR.

■ At the end of the *calle* is the **Church of San Moisè Profeta**, known as **San Moisè**. HISTORY: built in the 8th century, in 947 the church was rebuilt thanks to the financing of Moisè Venier, who named it after his patron saint. The church we see today was the result of further reconstruction undertaken in 1632.

composite, fluted columns on pedestals; on each shaft are sculpted arched lintels with cheurb's heads. The overexuberant sculptural decoration – part of which is attributed to HEINRICH MEYRING – accentuates the theatrical, bombastic nature of this façade. The main portal is surmounted by a truncated obelisk that supports the bust

FAÇADE. Begun in 1668 after a design by ALESSANDRO TREMIGNON and financed by the Fini family, the façade is the first example of Baroque decoration in Venice, followed by that in the Ospedaletto, the Scalzi and Santa Maria del Giglio churches. The ground-floor section has four enormous

of the procurator Vincenzo Fini (1606-60). The underlying pyramidal composition of allegorical statues was inspired – as were other figures on the façade – by the repertory entitled *Nove Iconologia*, which was published in Rome by Cesare Ripa in 1593 and then re-issued in

1603. The bust in the portal at left is of Girolamo Fini (1621-85), the brother of Vincenzo, while the bust at right is of his son Vincenzo (1662-1726). In the right-hand portal, the figure of the Old Man lying on the tympanum supports an octagonal cornice, inside which the portrait of the

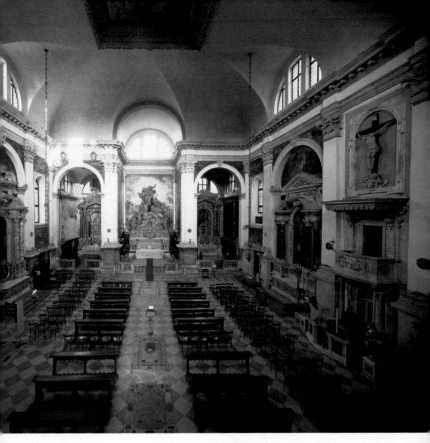

uncle Vincenzo is recognizable for his straight moustache. Above the thermal window is the *allegory of Fame*, who is indicating the Fini family crest above him. Among the five statues on the crown, the central one is of Moses, after whom the church was named.

INTERIOR: an aisleless nave with three apsidal chapels with flat back walls. On the ceiling, the Venetian NICOLÒ BAMBINI (1651-1736) painted Moses making water spout from a rock. Beginning your visit along the right-hand side, on the inner façade, next to the organ, you will see the *Martyrdom of St. Stephen* by the Venetian SANTE PIATTI (1687-1747?), followed, along the side wall, by the Vergine Addolorata Chapel and the beautiful vertical sequence of the baptistery, the pulpit, and the *Crucifixion* (1732) by the sculptor ALVISE TAGLIPIETRA. In the altarpiece of the second altar, PIETRO LIBERI (1614-87) painted the *Finding of the True Cross with Saints*, in which St. Helena is dressed as a female doge. Among the art works in the SACRISTY, which was restored by TREMIGNON in 1709 (as the inscription tells us) and can be visited upon request, mention should be made of the 18th-century series of *portraits of saints* by various artists and the vibrant, bronze altar frontal, that Antonio Damiani donated in 1779. This bas-relief, signed and dated 1633 by the Genoan NICOLÒ and SEBASTIANO ROCCATAGLIATA, depicts the body of the dead Christ being transported by angels. It is watched over by God the Father (center); at left, the Madonna, the Apostles and the Judaeans are looking at the empty tomb, and, at right, are the figures of Mary Magdalene, Veronica and some angels bearing the instruments of the Passion.

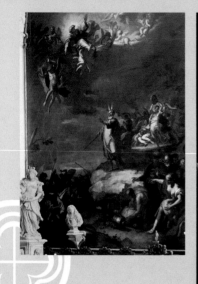

198 TOP AND CENTER GEROLAMO BRUSAFERRO, *PASSAGE OF THE RED SEA* AND DETAIL.

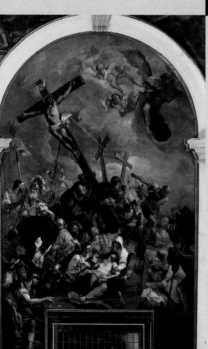

198 BOTTOM GEROLAMO BRUSAFERRO, *CRUCIFIXION*.

198-199 JACOPO TINTORETTO, *CHRIST WASHING THE DISCIPLES' FEET*.

Back in the church again, go to the right-hand apsidal chapel of St. Anthony of Padua; the two 18th-century canvases by DOMENICO BEVERENZA describe the *Presentation at the Temple* and the *Assumption of the Virgin Mary*. Along the lower side of both paintings, an anonymous added eight *Episodes from the life of St. Anthony*. In the CHANCEL, the theatrical and ungainly sculpture group depicting *Moses receiving the Tablets of the Law* and other persons impersonating the faithful and unfaithful Hebrews was executed by HEINRICH MEYRING in the second half of the 18th century. He undertook the work in response to a commission from Rocco and Giovanni Bonci, whose busts are in the side walls. The chancel contains other works

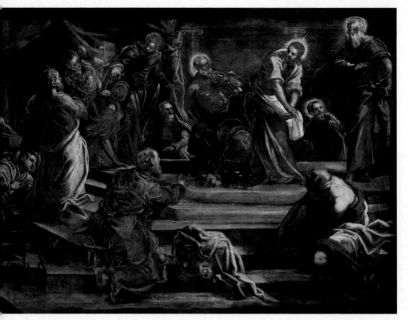

dedicated to Moses: the high relief of the *Jews Worshipping the Golden Calf* on the frontal; the canvases on the two side walls – by GIOVANNI ANTONIO PELLEGRINI (1675-1741) and GIROLAMO BRUSAFERRO (ca. 1700-1760) – depict the *Adoration of the Bronze Serpent* and, at right, *The Passage of the Red Sea*; the wooden reredos (ca. 1650) with scenes from the *Life of Moses* carved on the dossals. In the left-hand apsidal chapel, reserved for the Scuola del Santissimo Sacramento, in order to highlight the themes of the Eucharist and the humility of Christ, PALMA GIOVANE painted *The Last Supper* (dated 1585) and JACOPO TINTORETTO painted *Christ Washing the Disciples' Feet* (1585-90). In the left-hand section of this latter work

are the figures of a parish priest and two confreres. Past the Nativity of the Virgin Mary altar is the one dedicated to St. Peter, which was once reserved for the old blacksmiths' guild, whose headquarters stood next to the church (no. 1455). The altarpiece by the Venetian ANTONIO MOLINARI (ca. 1665-1735) represents the four patron saints of the corporation – St. Eligio, St. Liberale, St. Charles Borromeo and St. John the Baptist – together with Saints Peter and Joseph and the Madonna and Infant Jesus. In the large canvas on the inner façade, GIROLAMO BRUSAFERRO (ca. 1700 - 1760) painted a grandiose *Crucifixion* that draws inspiration from the one by Tintoretto in the Scuola di San Rocco. At the left, the Romans play dice for

Christ's robe, the symbol of the unity of the Church. This detail takes on special meaning in San Moisè, because from the 14th century on a large fragment of that very robe was kept in the church's Treasury. Once out of San Moisè, take the *salizada* (paved street) that flanks the church and then turn onto Calle Valleresso: at no. 1332 is the **Teatro del Ridotto**, where, in 1638, Marco Dandolo opened the first authorized casino (*ridotto*) in Venice. The building, whose vestibule has Ionic columns, was remodeled in 1768 by BERNARDINO MACCARUZZI, who employed first-rate stuccoists, while the allegorical frescoes are by JACOPO GUARANA. The Ridotto was closed in 1774, and since 1947 the main hall has been used as a theater.

St Mark's Basin

THE GATEWAY TO THE ADRIATIC

The Riva degli Schiavoni, along which one can enjoy a splendid and exciting panorama of the city and St. Mark's Basin, was named after the inhabitants of Dalmatia (also known as Schiavonia), which were allowed to moor along this quay and sell their wares – smoked meat, salted fish, sardines, candles, cheese, salami. In ancient times the only access to Venice was by sea. Once past the mouth of the port of the Lido and the Canale di S. Nicolò, ships skirted the island of Sant'Elena, finding the first, safe mooring along the Riva di San Biagio near the Arsenal, or proceeding as far as the Molo San Marco quay, in front of the Doges' Palace. In period views, the *riva* is depicted one of the most vital parts of city life. It was shown as crowded and with swarms of all kinds of boats and ships, with architecture quite different from what we see today: very diversified, a continuous alternation of religious and patrician buildings, shops, hospices for the poor, boat-building yards and wooden shacks. The first proposal to consolidate and widen this street flanking the water was put forward by CRISTOFORO SABBADINO in 1557. Between 1780 and

THE GATEWAY • 200 • TO THE ADRIATIC

Lagoon

13

5

11

12

END

4

200 TOP GIAMBATTISTA
CIMA DA CONEGLIANO,
ST. HELEN AND CONSTANTINE,
DETAIL, SAN GIOVANNI BATTISTA
IN BRAGORA CHURCH.

200 CENTER AERIAL VIEW OF
RIVA DEGLI SCHIAVONI.

201 GIAMBATTISTA CIMA DA
CONEGLIANO, BAPTISM OF
CHRIST, DETAIL, SAN GIOVANNI
BATTISTA IN BRAGORA CHURCH.

1796 work was done on the
street as far as the *Gardens*
in keeping with plans by
SIMONE STRATICO, a
hydraulics engineer from
Zadar, and supervised by
TOMMASO TEMANZA. The fall
of the Venetian Republic
and the closure of the
Magistrato alle Acque (the
Water Board: suppressed in
1808, revived in 1907)
ended construction. Work
was completed under the
Fascist regime, after 1932.

▸ MAIN SIGHTS
● *SESTIERE (district)*: Castello.
● *CHURCHES*: [1] Pietà; [2] Bragora; [3]
San Biagio; [4] Sant'Elena; [5] Sant'Isepo.
● *PALAZZI*: [6] Palazzo Dandolo (Hotel
Danieli), [7] Palazzo Navagero, [8] Palazzo
Gritti-Badoer, [9] Ca' di Dio.
● *OTHER MONUMENTS*: [10]
Equestrian monument to Victor Emmanuel
II, [11] Public Gardens, [12] Biennale
Pavilions, [13] Monument to Giuseppe
Garibaldi.
● *MUSEUMS*: [14] Museo Storico Navale.

Itinerary

From Riva degli Schiavoni to Sant'Elena

■ Immediately after the Palazzo delle Prigioni or Prison, opposite Ponte del Vin, to the left, is **Palazzo Dandolo** (15th century), now the Hotel Danieli. Despite reconstruction work on the ground floor, this building has maintained its original character, with a mezzanine with three-lancet windows and, on the main floor, a six-lancet window with elegant columns and capitals surmounted by a quatrefoil bull's-eye that imitates the nearby portico in the Doges' Palace. The side windows have a balustrade supported by corbels made up of lions' heads with long manes, an allusion to St. Mark's and the symbol of power and protection of the home. On the third floor is a broad window with eight lights; the roof is crowned by four

spires, a privilege reserved for those families that had a member who was an admiral. The nearby Ponte del Vin was named after the mooring reserved for boats that transported wine. A decree issued in 1348 prohibited the sale of wine in the area in order to curb the frequent brawls and murders there.

After the bridge one catches a glimpse of the arcade that leads to San Zaccharia Church and, farther on, to the *equestrian monument to Victor Emmanuel II* (1887) by the Roman ETTORE FERRARI, inaugurated in the presence of the king himself and Queen Margherita. This bronze statue portrays the king in a dominating pose, with his sword held high above him; against the tall pedestal, the statue of Venice has an aggressive lion of St. Mark lying at its

feet. In one of its paws the lion is holding a plaque with the results of the vote by which the city decided to become part of the Kingdom of Italy. On the side of the pedestal facing the Lagoon is a bronze bas-relief depicting the *king welcomed by the Venetians in Piazzetta San Marco* during his visit on 7 November 1866. At no. 4180 (Hotel Londra-Palace) a plaque commemorates the sojourn here of the composer Tchaikovsky in 1877, during which he composed his Fourth Symphony. The Ponte della Pietà affords a view of the campanile of San Giorgio dei Greci church: on the right-hand side of the Rio are *Ca' Cappello* and *Ca' Gritti*, purchased by the Pietà Church hospital in 1727 to house the ever-growing number of orphans.

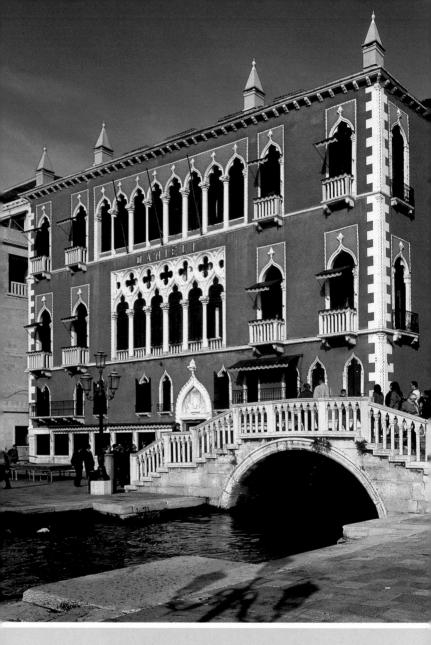

203 TOP
PALAZZO DANDOLO
AND PONTE DEL
VIN.

203 BOTTOM
THE KING
WELCOMED BY THE
VENETIANS IN
PIAZZETTA
S. MARCO,
MONUMENT
TO VICTOR
EMMANUEL II.

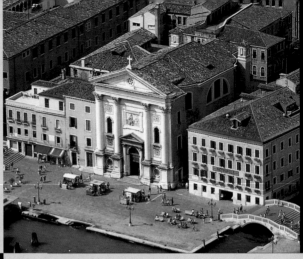

204 The Chiesa della Pietà and detail.

205 left Giambattista Tiepolo, *Assumption and Coronation of the Virgin Mary.*

205 right Giambattista Tiepolo, *Three Theological Virtues.*

After this bridge is the **Santa Maria della Visitazione church**, known as the **Pietà**.

■ HISTORY: the Franciscan Pietro d'Assisi went to Venice in 1340 and devoted his time to helping orphans. Drawing inspiration from similar institutions that already existed in other cities he founded the former Ospedale degli Esposti and also opened a foundling home for girls, who were entrusted to the care of the female lay confraternity of Santa Maria dell' Umiltà. The present church (1745-60), was designed by GIORGIO MASSARI to serve a two-fold function: as a place of worship and as a concert hall for the girls' choir, which was instructed and directed by famous maestros such as ANTONIO VIVALDI (1678-1741). The FAÇADE: was completed in 1906. The original elements of the church are the portal with Corinthian half-columns, the tall pedestals, and the two spiral tracery windows. ATRIUM: on the walls and lunettes are 19th-century *inscriptions* on the history of the Ospedale.

The INTERIOR was built entirely by Massari. There is a rectangular, aisleless nave with concave corners and a vaulted ceiling. The walls have four sets of arching flanked by giant paired Corinthian pilasters and terminate in an altar with curved architectural elements and a thermal window. The chancel has a flat end, choirs on the side walls, and a double choir on the inner façade. The main art works are in the chancel and on the ceiling. In the former, the *Visitation of Mary* altarpiece is an homage to the name of the church. This canvas was executed in the upper part by GIAMBATTISTA PIAZETTA (1754) and finished by his pupil GIUSEPPE ANGELI after the former's death. The scene takes place outdoors, on a staircase. The young Mary, accompanied by Joseph, pays a visit to the future parents of St. John the Baptist. Her red tunic evokes the theme of charity or compassion so dear to the Ospedale della Pietà. Zachary, the temple priest, is in the background. The old Elizabeth – whose features may be those of the person who commissioned the work, Elisabetta Cornaro Foscarini – is bending her head in humility to kiss the hand of the Virgin Mary, while a putto with joined hands invites the faithful to pray. To stress the intimate relationship between active and contemplative life, so characteristic of the Pietà, GIAMBATTISTA TIEPOLO frescoed the three *Theological Virtues* in an oval lunette (1754-55). These three figures were also to have been represented in statues that were to have been placed on the crown of the façade, but were never executed.

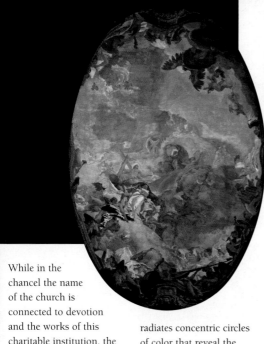

While in the chancel the name of the church is connected to devotion and the works of this charitable institution, the ceiling exalts the figure of Mary and the musical activity of the Pietà (in fact, the church is still used as a *concert hall*). The large oval fresco painted by GIAMBATTISTA TIEPOLO (1754-55) illustrates the *Assumption and Coronation of the Virgin Mary*. The middle of the oval is occupied by the head of God the Father, around which revolves the grandiose and astonishing construction of Paradise. God – who resembles Zeus – raises to the sky the crown he will place on Mary's head. His figure and those swirling around him are painted with extremely bold and dazzling foreshortening that underscores the sense of the immense distance between the viewer and the heavens. The dove of the Holy Ghost radiates concentric circles of color that reveal the presence of the celestial spheres and of divine wisdom. On a slightly lower level, a seated Christ is holding the Cross of His Passion. His glorious body, the sign of resurrection, evokes the image of Apollo. Under his feet is the Madonna, who is being lifted to Heaven by some angels. Mary, whose proud look reminds one of a Byzantine empress, seems to be resting on a celestial globe, the representation of the ether that envelops the sphere of the Universe, beyond which lies Paradise. Numerous angels are either flying or leaning against the frame of the fresco. Some of them hold or play musical instruments, while others sing hymns of glory. The scene, enhanced by a spectacular, theatrical atmosphere, evokes the music of the spheres and the angelic choirs, and exalts the musical activity to which the Pietà owed its fame.

Don't miss the five altars and their paintings. Beginning at right as you enter the church: the Madonna del Rosario altar (completed in 1855), with an altarpiece by FRANCESCO CAPPELLA (1761); the San Spiridione altar, the altarpiece of which is by DOMENICO MAGGIOTTO (1758-59); the chapel and altar of the chancel commissioned by the Foscarini family, with statues (1753) of *St. Mark* by ANTONIO GAI and *St. Peter* by ANTONIO MARCHIORI, and the *adoring angels* Michael and Gabriel by GIAN MARIA MORLAITER; Altar of *San Pietro Orseolo* (1764), with the altarpiece by GIUSEPPE ANGELI; Altar of the *Crucifixion* (placed here in 1762), with an altarpiece by ANTONIO MARINETTI. On the upper choir of the inner façade is *The Supper in the House of Simon* (1548), a canvas by ALESSANDRO BONVICINI, known as IL MORETTO, from the SS. Fermo e Rustico convent, Monselice.

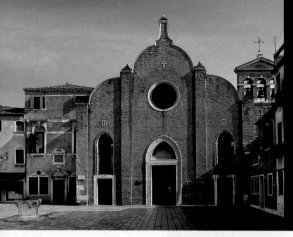

SAN GIOVANNI BATTISTA IN BRAGORA

1 Leonardo Corona, *Flagellation*
2 Vivarini, *Madonna and Child with Saints*
3 Chapel of St. John Almsgiver
4 Cima da Conegliano, *Baptism of Christ*
5 Vivarini, *Benedictory Christ*
6 Baptismal font

■ After leaving the church, at your left, past the Ponte del Santo Sepolcro is the **Palazzo** of the **Navagero** family (no. 4146), which boasted famous literati among its members. On the façade of this building and the adjoining one (no. 4143) two plaques indicate the house the Republic donated to the poet Petrarch, who described the port life along the Riva degli *Seniles* (1363-64). This building (Palazzo Barbo-Molin) was situated in neither of two positions indicated by the plaques, but stood at the corner of Calle del Dose.

The nearby former Aristide Cornoldi barracks (no. 4142) occupies the area where the church and hospital of the Franciscan nuns of the Holy Sepulcher once stood. This complex was founded in 1410 by Elena Celsi and took in poor women and women pilgrims on their way to the holy sites in Italy and the Holy Land. The façade has an

elegant portal by ALESSANDRO VITTORIA, with Corinthian half-columns with cable molding.

After crossing Calle del Dose you are in Campo Bandiera e Moro. The façade of **Palazzo Gritti-Badoer** (no. 3608) has a broad Gothic five-light window with pseudo-Corinthian capitals and, in a trefoil frame, the *cross coat of arms* of the Gritti family and a *patera* in Greek marble depicting a peacock with outspread wings standing on a globe (early 12th century).

■ In the Campo Bandiera e Moro is the **San Giovanni Battista in Bragora Church**. HISTORY: the meaning of Bragora or Bragola is the subject of various theories: a Byzantine locality, a square or market, a fishing site, as well as a muddy or marshy

area (*brago*), as this was originally. The anonymous and imaginative author of the *Chronica Altinate* lists this church among the mother churches founded by St. Magnus in the 7th century, while the first certain information dates from the 9th century. Most of the present edifice was reconstructed beginning in 1475. The adjacent building, to the left, was the Scuola del Santissimo Sacramento. FAÇADE: the simplicity of the undressed bricks and the four buttresses is consolidated by the sober decorative scheme, made more elegant by a crown with curved profiles. The two side entrances, aligned with the respective trefoil arched Gothic windows, seem to have been added at a later date. Centrally aligned are the main portal, a rose window, a small stone cross and a lunette crown that extends into a pedestal with mixed geometric patterns on which stands a statue of the *Risen Christ*. Before entering, note the

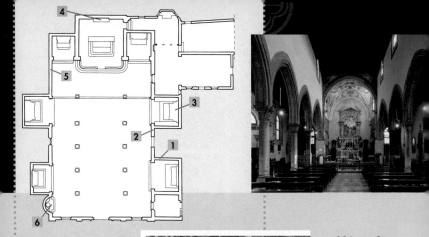

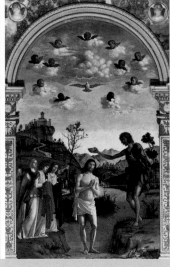

inscription commemorating the baptism of Antonio Vivaldi, which took place here on 4 March 1678. INTERIOR: a basilica plan with the chancel and rear chapels with flat end walls. The smooth surface of the shafts of the eight columns and calathus capitals, like the pointed arches that connect them and the ship's keel ceiling, all reflect the austere style of the façade. A sign of a different artistic and religious approach was introduced with the marble screen that divided the church diagonally to delimit the clergy choir (1486-1503). Of the original structure (demolished in the 18th century) commissioned by the parish priest Cristoforo Rizzo and designed and built by SEBASTIANO MARIANI, there remain only the two *piers* in the last bay and the *dossals* that were moved to the chancel. These are

characterized by candelabra in relief, brimming with flowers, fruit, birds – an allegory of the faithful who enjoy the delights of Paradise. Despite drastic rebuilding, the CHANCEL is still the spiritual and artistic heart of the church, in which are merged and superimposed the theological concepts of the three confraternities that were based here. In the

altarpiece, *The Baptism of Christ* (1492-94) by GIAMBATTISTA CIMA DA CONEGLIANO (frame by SEBASTIANO MARIANI, 1492-95), celebrates the name of the church. Among the many singular features of this work are the representation of the water of the Jordan River – symbol of eternal life – that retreats before the divinity of Christ, in keeping with the apocryphal gospels, while

FROM RIVA DEGLI SCHIAVONI • **207** • TO SANT'ELENA

206 TOP SAN GIOVANNI BATTISTA IN BRAGORA CHURCH.

206 BOTTOM PALAZZO GRITTI-BADOER.

207 TOP NAVE OF SAN GIOVANNI BATTISTA IN BRAGORA CHURCH.

207 BOTTOM GIAMBATTISTA CIMA DA CONEGLIANO, *BAPTISM OF CHRIST*.

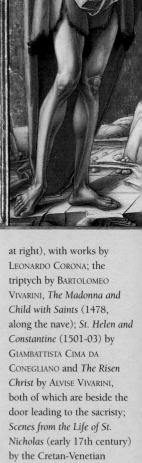

208 TOP CRETAN-VENETIAN SCHOOL, *SCENES FROM THE LIFE OF ST. NICHOLAS.*

208 CENTER AND BOTTOM GIAMBATTISTA CIMA DA CONEGLIANO, *ST. HELENA AND CONSTANTINE* AND DETAIL.

208-209 BARTOLOMEO VIVARINI, *MADONNA AND CHILD WITH SAINTS.*

the canvases on the walls (PARIS BORDON, *Last Supper*, 1560- ca. 1570; Palma Giovane, *Christ Washing the Disciples' Feet*, ca. 1595; FRANCESCO MAGGIOTTO, *Sacrifice of Abraham* and *The Apparition of the Angel before Elijah*, 1787) are the expression of the Scuola del Santissimo Sacramento, which exalted the Eucharist by combining the Old and New Testament. The altar statues of *St. John the Baptist* and *St. John the Almsgiver* (1689) by HEINRICH MEYRING, as well as the two confraternities of the same name, pay homage to the eponymous saint and to the saint who was patriarch of Alexandria, beloved for his compassion and whose remains are in the second chapel at right (canvases by JACOPO MARIESCHI, *St. John the Almsgiver Distributing Alms* and *The Removal to Venice of the Body of St. John the Almsgiver*, 1743). You should take a look at the following: the Beata Vergine Addolorata chapel (the first at right), with works by LEONARDO CORONA; the triptych by BARTOLOMEO VIVARINI, *The Madonna and Child with Saints* (1478, along the nave); *St. Helen and Constantine* (1501-03) by GIAMBATTISTA CIMA DA CONEGLIANO and *The Risen Christ* by ALVISE VIVARINI, both of which are beside the door leading to the sacristy; *Scenes from the Life of St. Nicholas* (early 17th century) by the Cretan-Venetian school (Capella di Santa Teresa d'Avila).

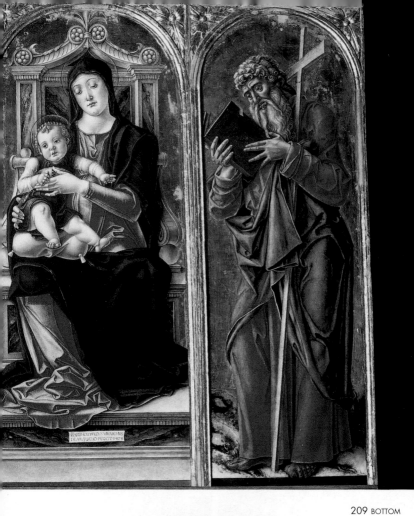

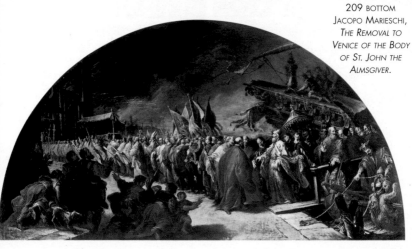

209 BOTTOM
JACOPO MARIESCHI,
*THE REMOVAL TO
VENICE OF THE BODY
OF ST. JOHN THE
ALMSGIVER.*

■ Now return to Riva degli Schiavoni and proceed in the direction of the Gardens, going past **Palazzo Gabrieli** (no. 4109). After the bridge there is the **Ca' di Dio**. This religious institute was founded in the 13th century to accommodate pilgrims, and, from 1623 on, also took in Venetian widows without an income. The austere building was restored, together with the church inside (with paintings by GIUSEPPE ANGELI), and enlarged in 1545-47 at the behest of Doge Andrea Gritti, after a design by JACOPO SANSOVINO.

Farther along the Riva are the former *Forni Militari* (military bakeries) and the *bread warehouses* that furnished bread to the Venetian fleet. The *portals* have late Gothic reliefs, patrician coats of arms and inscriptions. In particular, the portal at no. 2181 has flamboyant Gothic decoration and a tympanum with a geometric cornice, while the portal at no. 2179 is crowned by a statue of a woman seated on a throne flanked by two lions, an allegory of Fortitude. Now go over Ponte de l'Arsenal. The *rio* of the same name was widened in 1686. This area housed the customs, which was then transferred to the Salute.

■ Once past the Arsenal bridge, you are in Campo S. Biagio. To the left is the entrance to the **Museo Storico Navale** (no. 2148). HISTORY: the museum

(founded in 1922) consists of two buildings and is the property of the Italian Navy. The main one, opened in 1964, is an imposing and austere 14th-century storehouse built by the Republic to combat a serious famine and to preserve dry biscuits. The other building, called the *Padiglioni delle Navi* (Ship Pavilions), is not far away, at the end of the Fondamenta de l'Arsenal. MUSEUM: the main museum can be recognized by the two enormous anchors in front of the façade. GROUND FLOOR: display of artillery. *Room 1*: human torpedo conceived by the naval engineers Tesei and Toschi in 1935 and

used in World War Two. *Room 2*: dedicated to Angelo Emo (1731-92), the last admiral of the Venetian Republic: commemorative stele (1795) by ANTONIO CANOVA. This sculptor, angered by the fact that his remuneration was not forthcoming, threatened to replace the head of the admiral with the head of his own grandmother. The dispute came to a good end and a gold medal was coined on occasion of the inauguration (it is now in the Museo Correr). The stele also represents a floating battery invented by Emo.

210 TOP PALAZZO GABRIELI.

210 CENTER ANTONIO CANOVA, STELE OF ANGELO EMO, MUSEO STORICO NAVALE.

210 BOTTOM FORMER MILITARY BAKERIES, FLAMBOYANT GOTHIC PORTAL.

210-211 MUSEO STORICO NAVALE AND SAN BIAGIO CHURCH.

211 BOTTOM PONTE DI DIO AND CA' DI DIO.

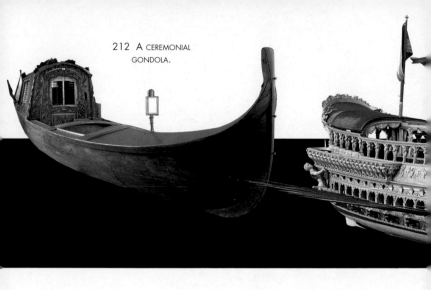

212 A CEREMONIAL
GONDOLA.

The room also contains a model of the battery used during the bombardment of Tunis in 1778.

Room 5: naval and fortress artillery, bombs and, on the walls, 18 models of maritime cities ruled by Venice. Don't miss, on the right-hand wall, *Corfu* (1692) and, in the second room, *Zadar* (1612, but as it appeared in 1566-70). The models reproduce the sites, the topography, and the relative size of the walls and buildings; the Superintendent of Fortresses, the senators and the military leaders used them in making decisions concerning strategy and military defense. Some of the models, kept in the Doges' Palace, were moved to the Arsenal in 1792. Other models were kept in a special hall in the Arsenal, built in 1778 and situated on the second floor of the Officina della Bussole e dei Modelli (Compass and Model Workshop). This hall is known as the Sala di Corfu

because it contained a large model of this island. The 184 objects, mentioned in a 1759 inventory compiled by Sergeant Rossini, were dispersed in the 19th century, probably after the restoration of some of them in 1872, or perhaps after they were put on exhibit during the International Geographic Congress of 1881. Our visit continues with ancient weapons, memorabilia from World War Two, crests, and models of boats and ships (*Room 7*). FIRST FLOOR: offices and library. Nautical instruments and maps from the 15th to the 20th century, navigation manuals with charts, models and drawings of buildings in the Arsenal. *Room 12*: four detailed maps of the *Arsenal of Venice* drawn by ABBOT MAFFIOLETTI (1797-98) and CARLO SPONGIA (1790). *Rooms 13, 14, 15, 16*: models of galleys, galliasses, vessels and, in *Room 16*, an

oil painting, *View of the City of Corfu*, dating from the mid-18th century. *Room 17*: in the middle of the room is the model of the *Bucintoro* made by PIETRO MANAO (ca. 1827), a long and sumptuous ceremonial vessel consisting of a section for the rowers and another one of covered loggias for the doge, his retinue and important guests. One such guest was Henry III of France, who was given a triumphal welcome in 1574. The Bucintoro was used for both civil and religious ceremonies, but above all for the trip to S. Nicolò del Lido on the occasion of the *Sensa*, the ceremony held on Ascension Day. During this event, the doge would throw a gold ring into the water, thus celebrating Venice's Marriage with the Sea. This vessel, the only one of its kind, was, together with the ceremony, one of the symbols of Venetian dominion of the Adriatic Sea, known as "*Mare*

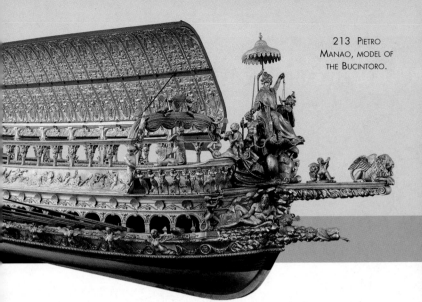

213 PIETRO MANAO, MODEL OF THE BUCINTORO.

nostrum" in the local documents and maps. The first affordable information we have on the ship dates from 1252, and the first pictorial representation is in a woodcut of Venice by Jacopo de' Barbari (1500). Over the centuries, this gala ship took on more and more wooden fretwork, which, besides exalting the pomp and regality of Venice, also asserted her maritime power and political centrality. The last specimen, dating from 1729, was destroyed by Napoleon's troops in 1798. The model on display, the most fascinating of the surviving examples, was commissioned by Marquis Amilcare Paolucci delle Roncole. Mermaids, heads of the winds and sea creatures made the Bucintoro an ideal chariot for Neptune and thus declared Venice's dominion of the sea. On the prow is the Lion of St. Mark, the symbol of power and faith. Behind it, arms and processional standards commemorate Venice's naval victories. A little above them is the figure of Venice in the guise of Justice holding a sword and balance, while a maidservant is handing her an olive branch as a sign of peace. The doge's umbrella and horn refer to his regality, while the pedestal in the shape of a shell alludes to Venus, who was born from the foam of the sea's waves. A polychrome sculpture of *Justice* (ca. 1526) that once decorated the prow of an old Bucintoro can be seen in the same hall. This female figure is seated on two lions, the symbol of Solomon's wisdom. Along the wall of the stairway leading to the second floor are some maps of cities – Genoa (1799), Ancona (1800) and Trieste (1799) by Abbot MAFFIOLETTI – and of the Padua, Polesine and Venice Lagoon territories (1800) by GIOVANNI VALLE. SECOND FLOOR: naval memorabilia and relics; models of steamships and warships; watercolors of the *Naval battle of Lissa* (19 July 1866) by IPPOLITO CAFFI; naval military uniforms. THIRD FLOOR: models of ships and, in particular, of the Venice Lagoon and the Adriatic (*Room 35*); Chinese junks and models of Oriental vessels. FOURTH FLOOR: restoration workshop; models of ships; collections of seashells. ANNEX (Padiglioni delle Navi): the entrance is near the Ponte de l'Arsenal. This section of the museum once was the home of the Officina degli Alberanti e Remeri, or workshop of the mast- and oar-makers. The three large workshops display gondolas, motorboats, fishing boats from Chioggia, tow boats, sailboats and river barges, the wreck of the *Elettra*, used by Guglielmo Marconi and, on the walls, plaster casts of marbles from Crete.

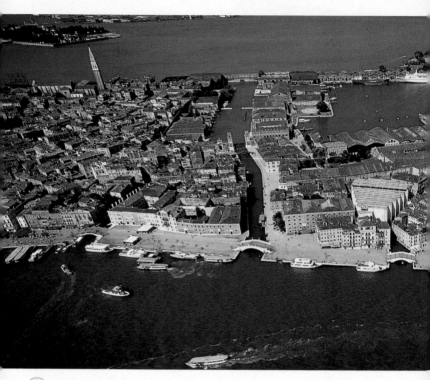

■ Once outside the museum, to your left you will see **San Biagio Church**, at which a military chaplain now officiates. HISTORY: up to the year 1511 this was the church of the Greek Orthodox community that had emigrated to Venice after the fall of Constantinople in 1453. Rebuilt in Corinthian style in 1745-52, perhaps after a design by FILIPPO ROSSI (1727-93), chief architect or master builder of the Arsenal. INTERIOR: an aisleless nave with Corinthian pilasters on pedestals; on the ceiling, a late Baroque fresco by GIOVANNI SCAJARO, *S. Biagio in Glory*. The five altars come from the church of Sant'Anna. On the left-hand wall of the chancel is the funerary monument with the heart of Francis Frederick, Archduke of Austria (d. 1847). Between the two altars on the left-hand wall is the tomb of Admiral Angelo Emo (d. 1792) with his statue by GIOVANNI FERRARI (known as IL TORRETTO), taken from the former Servi Church and placed here in 1818. As in Canova's stele in the Naval Museum, in this work Admiral Emo is portrayed with the floating battery he invented.

The many activities in this area are reflected in the numerous *scuole* (religious and trade confraternities) commemorated in this church. They include: San Biagio, San Gaetano da Siena, Beata Vergine Maria delle Grazie, Madonna del Soldo, Bereteri, Fritoleri e Furatoleri (cap-makers, doughnut vendors and vendors of cheap food), Cesteri (basket weavers and wicker craftsmen), Calafai (caulkers, carpenters, oar-makers and other specialized laborers in the Arsenal), Conzacanevi (hemp tanners) and Filacanevi (rope-makers). In the building to the right of the façade is a bas-relief of St. Biagio in bishop's garb and, on the façade toward the quay, a Latin inscription commemorating the reconstruction of the

church under the parish priest Jacopo Attardo (1752). From Ponte de la Veneta Marina (or Ponte de le Catene) you can see the Riva dei 7 Martiri, named after the execution of seven Venetians by the Nazis.

■ Along the broad quay one has a view of the public gardens (ca. 1932), the façade of the Marinarezza (1645-61) – the hospice for indigent sailors – and Ponte S. Domenego (designed by DUILIO TORRES, sculpted by NAPOLEONE MARTINUZZI). Once over the Ponte de la Veneta Marina you are in Via Garibaldi, opened in 1807 as Via Eugenia. To your right, at no. 1643, are

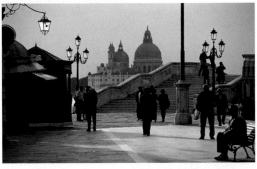

two commemorative plaques (1881 and 1982) dedicated to the navigators John and Sebastian Cabot. At no. 1310 is the entrance, with a Gothic portal (early 15th century), of the Ospedal de le Pute, a girls' orphanage that was closed in 1807. The lower relief, with the figures of three

saints (at right is St. Peter Martyr, recognizable by the hatchet with which he was killed), is surmounted by a tympanum bearing the figure of Christ Pantocrator. To the left, at no. 1302 Calle S. Domenego, above a portal with a round arch, a plaque indicates the birthplace of GIOVANNI BATTISTA TIEPOLO.

■ Back in Via Garibaldi, to the right is a wide and robust *entrance gate* (1810) of the **Giardini Pubblici**, which frames the statue of *Giuseppe Garibaldi* by AUGUSTO BENVENUTI (1885). To make room for the avenues and garden (1807-09), designed by architect GIAN ANTONIO SELVA, many old buildings had to be demolished. These included the San Domenico convent and church, San Nicolò di Bari church, the Ospedale di Messer Gesù Cristo (reserved for sailors) and its annex, the Seminario Ducale, the Concezione di

Maria (or Capuchin) church and convent, and the monastery and church of Sant'Antonio Abate. The interior of this last was depicted by VITTORE CARPACCIO in his *Apparition of the Crucifixes of Mt. Ararat*, now in the Accademia Gallery. The original garden, with a surface area of over 15 acres (6 hectares), was reduced ca. 1895 to make room for the pavilions of the International Art Exposition. ■ At the end of the avenue, after Largo Marinai d'Italia, to the left is the *Colonna della Vittoria* built in Pola, on the Dalmatian coast, in honor of Archduke Maximilian and taken here from the nearby Arsenal in 1929. In the garden precinct, at the beginning of the Gran Viale, is an *arch* (ca. 1542) attributed to the Veronese for his radio research by MICHELE SANMICHELI (1484-1559) that was removed from the Lando Chapel in Sant'Antonio di Castello

church, which was demolished. In the early 20th century, with the aim of creating an outdoor pantheon, various statues of famous 19th-century figures were placed in this area, They included the explorer *Francesco Querini* (1867-1899; sculpted by ACHILLE TAMBURRINI in 1905); the composer and patriot Giuseppe Verdi (1813-1901), by G. BORTOLOTTI; poet Giosuè Carducci (1835-1907) by A. DEL ZOTTO (1912); the poet and mayor of Venice Riccardo Selvatico (1849-1901) by PIETRO CANONICA (1903); and the Venetian patriot and follower of Mazzini, Gustavo Modena (1813-1861) by LORENZETTI. ■ Having left the Gardens behind us, on the water facing the Riva is the bronze monument to the *Partigiana* (1970) by AUGUSTO MURER dedicated to Italian women Resistance fighters and with cement and Istrian stone steps designed by CARLO SCARPA. Proceed on foot up to the historical entrance to

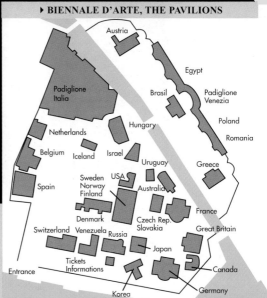

Austria
Egypt
Padiglione Italia
Brasil
Padiglione Venezia
Poland
Netherlands
Hungary
Romania
Belgium
Iceland
Israel
Uruguay
Greece
Sweden
Norway
Finland
USA
Spain
Australia
France
Denmark
Czech Rep.
Slovakia
Switzerland
Venezuela
Russia
Great Britain
Japan
Tickets
Informations
Canada
Entrance
Germany
Korea

217 CENTER
ITALIAN PAVILION, VENICE BIENNALE.

217 BOTTOM
UNITED STATES PAVILION, VENICE BIENNALE.

the **Biennale pavilions and exhibition grounds.** Since 2003, the new visitors' entrance is on nearby Viale Trento. Among the "founding fathers" of the Biennale international art exhibition were the mayor Riccardo Selvatico, Antonio Fradeletto, Secretary-General of the Biennale from 1895 to 1919, and Count Giuseppe Volpi di Misurata, president of the Biennale's administrative council, thanks to whom the Biennale was recognized as an autonomous body in 1930. Created as an international exposition of visual and applied art in 1895, the Biennale extended its range to include music (1930), cinema (1932), theater (1934) and architecture (1975). Since 1998 it has been a private cultural society and acquired new exhibition areas and theater space in the Arsenal. The first pavilion, called *Palazzo dell'Esposizione* and then *Padiglione Italia*, lies at the end of the entrance avenue. This building, opened in 1895, enlarged in 1897 and 1928, and remodeled in 1962 by CARLO SCARPA, was the venue for exhibitions of Italian art, from Carrà and Sironi to the Arte Povera movement. The pavilions reserved for foreign countries, also altered over the years, were built from 1907 (Belgium) to 1964 (Brazil). The British pavilion (1909) was built with theatrical flair by EDWIN ALFRED RICKARD on the top of the Montagnola on the site of a café-restaurant, and the Austrian one (1934, remodeled in 1954), situated beyond the Rio dei Giardini, was designed by JOSEPH HOFFMANN, one of the founders of the Viennese Sezession movement.

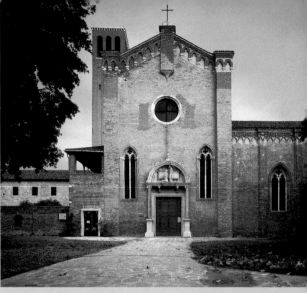

218 SANT'ELENA
CHURCH.

219 LEFT
SANT'ISEPO
CHURCH.

219 RIGHT JACOPO
AND DOMENICO
TINTORETTO, *ST.
MICHAEL AND
LUCIFER FIGHTING
FOR THE SOUL OF
MICHELE BON* AND
DETAILS.

■ Back in Riva dei Partigiani you can choose to abbreviate the itinerary by going to the church of San Giuseppe, or lengthen it as far as the Sant'Elena Church. In the latter case, proceed along the *riva*, go over the Ponte dei Giardini, past the Parco delle Rimembranze and Calle Buccari and, at the end of the avenue, is the grassy square in front of **Sant'Elena Church**.

HISTORY: the first hospice for the poor and for pilgrims, together with the convent, dates from the 12th century. The complex became more important after the arrival of the mortal remains of St. Helena (perhaps in 1211), the mother of Emperor Constantine and famous in the Middle Ages for having discovered the True Cross of Christ. To the Venetians St. Helena symbolized their mission as Crusaders and defenders of the faith in the East. In 1407, the monastery – at first managed by

Augustinian Canon Regulars – was entrusted to the Benedictine congregation of Olivetani monks of Siena and under the patronage of the Doge. Construction of the church began in 1439 and was supervised by GIACOMO CELEGA. The bell tower was rebuilt by FERDINANDO FORLATI in 1958. Two of the three original cloisters no longer exist; the only surviving cloister (15th century), despite alterations and its unfinished appearance, is still quite fascinating. The small corner columns are the cardinal points of the quadrangular space, which can be interpreted as the Carriage of the Church, the image of celestial Jerusalem at the end of the world and, hence, Paradise. The eight sides of the well refer to the number of eternity and, therefore, to God and, in this context, to the Holy Lamb, source of eternal life.

FAÇADE: the pitched central

mass in terracotta refers to the simplicity and spirit of monastic life. The only incongruous, albeit extremely elegant, element is the portal and the lunette with the sculpture group by ANTONIO RIZZO portraying the Venetian admiral *Vittore Cappello paying homage to St. Helena* (ca. 1470). The kneeling figure of Cappello is not to be understood only as a gesture of religious devotion, but also an the evocation of a public ritual. St. Helena was venerated by the bishop of the Castello district before the *Sensa* ceremony, and the admirals, when departing with their fleet, stopped in this church to pay tribute to the saint.

INTERIOR: the aisleless nave is covered by a ceiling with five ogival cross vaults with large windows on the right side. The terracotta polychrome medallions on which the groin ribbing converges represent *St. Nicholas*, the patron saint of

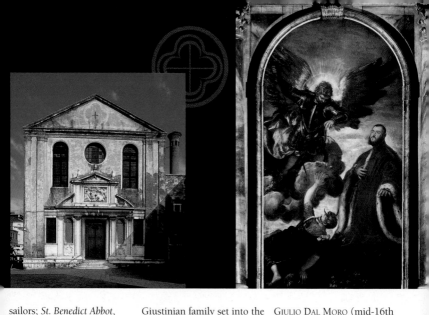

sailors; *St. Benedict Abbot*, patron saint and founder of the Benedictine order; a *lion of St. Mark*, the seal of the doge's patronage; *St. Helena with the True Cross*; and, lastly, the *coat of arms of the Olivetani order*, placed above the holy area of the apse and representing three hills (Calvary) surmounted by a cross which in turn is flanked by two olive branches. The painting on the high altar is a copy of the *seven founding saints of the Order of the Servi di Maria* by GIUSEPPE CASSIOLI (1865-1942). In the first chapel at right, built by the Borromeo family of Florence (1418-20), is kept the urn with the remains of the saint, once on the high altar.

Back into the nave and keeping to the right side, one enters the *Cappella Giustinian* (or *Cappella del Crocefisso*), inside which are some fine glazed terracotta medallions on the ceiling and the ceramic crest of the Giustinian family set into the capitals that support the main arch of the apse.

◼ Once back to the Giardini, at the end of the Riva dei Partigiani turn right toward the Largo Marinai d'Italia. Past the bridge, continue to your right along the street along the canal (*fondamenta*) until you reach **San Giuseppe Church**, known as **Sant'Isepo**. HISTORY: the Venetian Senate authorized the construction of this church and its annexed monastery in 1512. Later on, three cloisters, which still exist, were added to the complex.

The FAÇADE is made of bricks. The use of the architectural orders reveals an evident lack of ability. The gigantic, paired pilasters, lacking in classical proportions and pedestals, support a tympanum without a frieze. The portal, surmounted by a tympanum and a relief of the *Adoration of the Magi* attributed to

GIULIO DAL MORO (mid-16th century), is rather unsuccessful in trying to suggest a second, smaller façade.

INTERIOR: on the ceiling is a 17th-century fresco, *St. Joseph in Glory*, by PIETRO RICCHI, with an Ionic order perspective designed by PIERANTONIO TORRI. On the first altar to the right is a canvas by JACOPO and DOMENICO TINTORETTO, *St. Michael and Lucifer Fighting for the Soul of Michele Bon* (ca. 1581). In the chancel, consecrated in 1643 and financed by the procurator Girolamo Grimani (d. 1570), is the funerary monument of Grimani designed by ALESSANDRO VITTORIA, and in the apse are frescoes by PALMA GIOVANE. Along the left-hand wall, after the first altar, is the *tomb of Doge Marino Grimani* (d. 1605) *and his wife Morosina Morosini*, by VINCENZO SCAMOZZI, with figures by GIROLAMO CAMPAGNA.

5

220 TOP FRA ANTONIO
DA NEGROPONTE, VENETIAN
SCHOOL, *MADONNA
SUCKLING THE CHRIST CHILD,*
SAN FRANCESO DELLA
VIGNA CHURCH, DETAIL.

220 CENTER GIOVANNI
BELLINI, *MADONNA AND
CHILD WITH SAINTS,* SAN
FRANCESO DELLA VIGNA
CHURCH, DETAIL.

220 BOTTOM
SAN PIETRO DI
CASTELLO ISLAND.

▸ MAIN SIGHTS

● *SESTIERI (Districts):* Castello.
● *CHURCHES:* [1] San Francesco di
Paola; [2] San Pietro di Castello; [3] San
Martino; [4] San Francesco della Vigna.
● *PALAZZI:* [5] Patriarcale;
[6] della Nunziatura.
● *OTHER MONUMENTS:*
[7] Arsenale.

221 BOTTOM PAOLO
VERONESE, *HOLY FAMILY
WITH STS. CATHERINE AND
ANTHONY ABBOT,* SAN
FRANCESO DELLA VIGNA
CHURCH.

THE ARSENALE AND

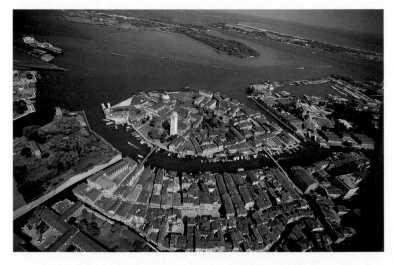

Darsena
Nuovissima

Darsena
Nuova

Dársena De le Galeazze

2

5

1

START

ITS SURROUNDINGS

The area covered by this itinerary is among the oldest in Venice. The plots of land around San Martino Church, known as "in Geminis" – an allusion to the *Gemini* (the Dioscuri, Castor and Pollux) – may have been populated by a colony from Ravenna or by Lombard colonists in the early 8th century, when the local government moved in 811 A.D. from Malamocco to the present-day St. Mark's area. The Olivolo-Castello area, where the ancient bishopric church of San Pietro once stood and which was named after an old stronghold, was already urbanized in the 8th and 9th centuries. The two islands, Gemini and Olivolo, enjoyed a strategic position since they offered the first mooring to those arriving from the sea. For centuries, pile dwellings, wooden houses, boat- and shipbuilding yards, warehouses, areas for markets, shoals and marshy terrain characterized the entire landscape of this area. This gradually began to change in the 12th century thanks to the creation of numerous convents and, later on, to the reclaimed land and the rise of the productive and military heart of Venice, the Arsenal.

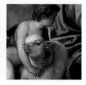

■ About halfway down Via Garibaldi, on the left-hand side and before the wide entrance gate to the Giardini, is the church of **Santi Bartolomeo e Francesco di Paola**.

■ HISTORY: when the Friars Minor founded by St. Francis of Paola, thanks to the intercession of Cesare Carafa, asked permission to found a seat for their order in Venice, the Republic assigned them the hospice and oratory of San Bartolomeo (late 13th century). Work on the new church was inaugurated by Doge Pasquale Cicogna in 1588. The campanile and

monastery with its cloister have since disappeared. FAÇADE: simple and dignified pitched central body, with two series of Corinthian pilasters, trabeation with a smooth frieze, and cornice with robust denticulation. On the second register there is a broad Serliana. The portal is flanked by two windows and crowned by two pedestals with pink columns and a tympanum in which is painted the emblem of the friars: the sun with the motto "Charitas." INTERIOR: altered in the second half of the 18th century, the

interior presents an original layout thanks to which the needs of the monastery, private worship and the instructions of the Council of Trent are blended harmoniously. The aisleless nave, which affords a direct view of the high altar to all worshippers, is partially surrounded by an atrium and by two wings with eight chapels that contain altars and tombs; above the chapels is the gallery. The plain ceiling has an interesting painting cycle by GIOVANNI CONTARINI (1549-1603) that illustrates episodes from the *life of Christ, the Evangelists and*

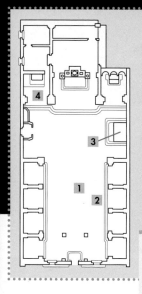

222 LEFT LORENZO
CANZIANI, HIGH
ALTAR, SAN
FRANCESCO DI PAOLA
CHURCH.

SAN FRANCESCO DI PAOLA CHURCH

222 RIGHT GIANDOMENICO
TIEPOLO, ST. FRANCESCO DI
PAOLA HEALS A POSSESSED
MAN.

223 LEFT GREGORIO
MORLAITER, ST. MARK, HIGH
ALTAR, DETAIL.

223 RIGHT SAN FRANCESCO
DI PAOLA CHURCH.

Doctors of the Church, the *Miracles of St. Francis of Paola*, and *scenes from the life of the Carafa family*, which commissioned the canvases and owned one of the chapels (to the left of the largest one). Other noteworthy works are: the Baroque altar with the body of St. Giacinto (fourth chapel) and numerous ex-votos; four canvases with the *Miracles of St. Francis of Paola* attributed to

FRANCESCO ZANCHI (1734-1772; right transept, the Rosario altar); the *Annunciation* by PALMA IL GIOVANE (right-hand apsidal chapel); the *high altar* by LORENZO CANZIANI and, on the side screens, statues of *St. Bartholomew* and *St. Mark* (after 1772), by ALVISE TAGLIAPETRA and GREGORIO MORLAITER; 18th-century canvases by various artists (above the gallery) representing the *Miracles of*

St. Francis of Paola, including the *Healing of a Soul Possessed* (1748) by GIANDOMENICO TIEPOLO. The church was the seat of the Scuola di Maria Maddalena and, as can be inferred from the inscriptions in the chancel, it was under the patronage of the Querini family. In the 18th century, it hosted the oar-makers' and caulkers' (Remeri and Calafati) guilds, which had been at San Biagio church.

224 TOP RIGHT AND BOTTOM MARCO BASAITI, ENTHRONED ST. PETER ON HIS THRONE WITH FOUR SAINTS, DETAIL.

224 CENTER PIETRO RICCHI, ADORATION OF THE MAGI.

225 TOP SAN PIETRO DI CASTELLO: THE CHURCH, CAMPANILE AND FORMER PALAZZO PATRIARCALE.

225 BOTTOM LEFT NAVE OF SAN PIETRO DI CASTELLO CHURCH.

225 BOTTOM RIGHT THE SO-CALLED THRONE OF ST. PETER FROM ANTIOCH.

■ After visiting the church, go left along Via Garibaldi. At the end of the street head right, along Fondamenta S. Anna. No. 1132: above the quatrefoil, a *monogram of St. Bernardino da Siena* is flanked by two Istrian stone *paterae* (late 12th-early 13th century). Once past the Ponte and Fondamenta de Quintavale, at the beginning of Calle drio el Campanile, you will see a relief sculpture of the *enthroned Madonna and Child handing the keys of the Kingdom to St. Peter*. As soon as you enter Campo di San Pietro you will see the compact *campanile* of St. Pietro di Castello (MAURO CODUSSI, 1482-90). To the right is the former **Palazzo Patriarcale** with a cloister. On the portal (no. 70) is the *crest of the Patriarch Lorenzo Priuli* who financed the works for the façade of the church. At right is the walled-in entrance surmounted by an aedicule with a multi-lobate arch and a relief of the *Madonna and Child seated between small trees* (mid-15th century).

■ To the left of the Palazzo Patriarcale is the **church of San Pietro di Castello**. HISTORY: the island of Olivolo is considered one of the original districts of Venice. The first church here was demolished in the 9th century to make room for San Pietro, which became the Cathedral of Venice and the bishopric of the Olivolo bishop. The first patriarch was San Lorenzo Giustiniani (1380-1455), great reformer and administrator of ecclesiastic customs and property. FAÇADE: designed by ANDREA PALLADIO in 1558 and completed by

FRANCESCO SMERALDI (IL FRACAO, 1594-96). The relief on the tympanum represents the *partriarchal Cross and the Keys of St. Peter*. INTERIOR: rebuilt after a fire (1603) by GIOVANNI GIROLAMO GRAPIGLIA, San Pietro was consecrated in 1642. On the cross vaulting is a hemispherical dome on a balustraed tambour. In the right-hand aisle there is what is believed to be the *throne of St. Peter from Antioch* (11th-12th century), which according to tradition was donated by Michael III, Emperor of the Eastern Roman Empire (842-67). On the third altar is *Enthroned St. Peter with Four Saints*, by MARCO BASAITI (1470-1530). On the walls of the Santissimo Sacramento chapel, to the right of the chancel, are two canvases (1658) whose subjects are typical of post-Tridentine Eucharistic worship: *The Punishment of the Serpents* (PIETRO LIBERO) and *The Adoration of the Magi* by PIETRO RICCHI.

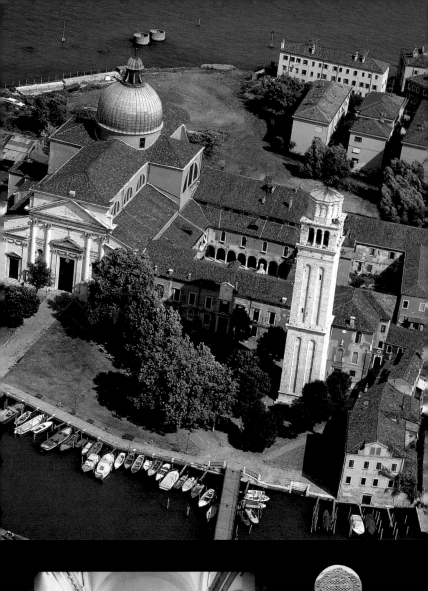

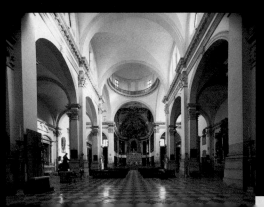

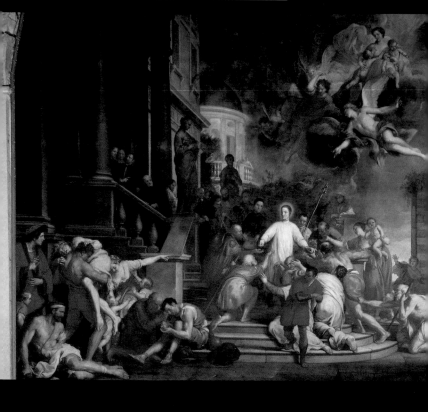
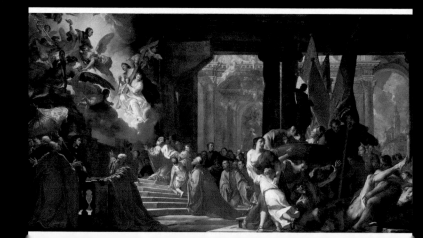

226 TOP, BOTTOM AND 227 TOP ANTONIO BELLUCCI, *DOGE NICOLÒ CONTARINI BEGS ST. LORENZO GIUSTINIANI TO FREE VENICE FROM THE 1630 PLAGUE*, AND DETAILS OF SAME.

226-227 *THE ALMSGIVING OF ST. LORENZO GIUSTINIANI*, BY GREGORIO LAZZARINI.

227 BOTTOM HIGH ALTAR, SAN PIETRO DI CASTELLO CHURCH.

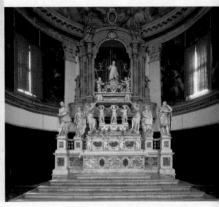

The chancel is dominated by the grandiose high altar, an ex-voto of the Venetian Senate for the war against the Turks in Crete. Begun in 1649 after a design by BALDASSARE LONGHENA, this polychrome marble altar abounds in statues by JUSTE LE COURT, FRANCESCO CAVRIOLI and BERNARDINO FALCONE. On the top is the urn with the remains of *St. Lorenzo Giustiniani* and his statue, which were invoked for protection against the plague. Among the frescoes and canvases that illustrate scenes from the life of the patriarch, two 18th-century paintings are worthy of mention: at right, *The Doge Nicolò Contarini Begs St. Lorenzo Giustiniani to Free Venice from the 1630 Plague* by ANTONIO BELLUCCI and, at left, *The Almsgiving of St. Lorenzo Giustiniani* by GREGORIO LAZZARINI. Once past the apse Cappella della Croce, you enter the *Vendramin funerary chapel*, designed by BALDASSARE LONGHENA and sculpted by MICHELE ONGARO (1644-84) and assistants. The black and white marble, the sacred and secular allegorical statues, and the two side reliefs all exalt the virtues of the patron, Cardinal Francesco Vendramin, and his meditation on death and the salvation of the soul. The nearby Cappella Lando – above the door of which is an altarpiece with *Sts. John, Peter and Paul* by PAOLO VERONESE and his workshop – is the only surviving part of the earlier Gothic church. In this chapel is a *bust of the benedictory St. Lorenzo Giustiniani* (late 15th century).

■ Once outside the church, cross over Ponte di S. Piero which has a view of the Arsenae. At the end of Calle large de Castelo, turn left onto Salizada Streta. This street is parallel to Rio de S. Daniel, once lined by the convent of the same name – which was turned into a barracks in 1806 – and its church, which was probably founded in the 9th century and was demolished in 1839. Along the Salizada are some simple houses whose plain façades reflect the humble character of this part of the city, once inhabited by artisans or families of modest means. An example of the minor architecture of this district is the small *Gothic palazzo* at no. 105-108, with two rows of trefoil windows, interlaced flamboyant arches, and *crests* (15th century). With the aid of a map, go to Campo Ruga. To the right is Campiello del

Figareto, named after a small fig tree (*figo* in dialect) that once grew there. In this square is a small unfinished *16th-century palazzo* (no. 329-330) with an off-center trefoil window and Ionic columns. Farther on, turn right and go over Ponte Rielo. The canal here has one of the best views of the minor architecture in the Castello district.
In Calle S. Gioachin you pass by the building that was the home of the *Ospedale dei Santi Pietro e Paolo*, the oldest hospice in Venice (1181), enlarged twice (1328 and 1350) and restored in 1698.
Above the portal (no. 450) is a late 14th-century *relief* portraying Peter and Paul, the eponymous saints of the hospice, and in the middle a *Madonna and Child*. The oratory of the Ospedale is along the *fondamenta*.
Back in Via Garibaldi, at no.

1820 is a *round Istrian stone shield* with a crenellated tower flanked by two rampant dragons and surmounted by the foliage of a tree. Turn right here into Calle Friziera. In the arcade are 14th-century columns with tall octagonal pedestals, smooth capitals with calathus, upside-down acanthus leaves and flower buds. This alley runs into Fondamenta de la Tana and Rio de la Tana. The view of this latter canal is dominated by the walls of the Arsenal's Corderie (the

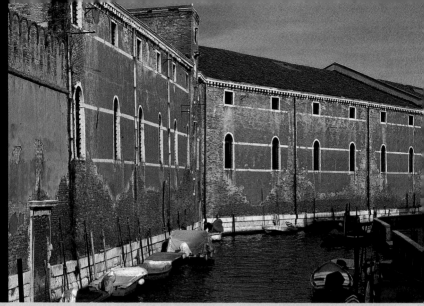

rope factory). At no. 1922 is a *coat of arms* with a praying angel (15th century).

On a level with no. 1923, on the wall of the *Corderie*, is an Istrian stone relief (1583) with coats of arms and the Lion of St. Mark carved on it; farther on, on the tower, is another *relief* (early 16th century) with the crests of magistrates and the walking Lion of St. Mark. Along the *fondamenta* is a *plaque* (at no. 2077) indicating the birthplace of the patriot Domenico Moro (1822-44). Go over the Austrian Ponte de la Tana and at the end of the street, at right, is a *portal*

that was once the land entrance of the Corderie. In the square were the headquarters of the Visdomini alla Tana, the three magistrates responsible for the manufacture of mooring ropes and cables for ships. On this side of the Arsenal there were the raw and processed hemp warehouses, the cast iron and bronze foundries, and the blacksmiths' workshops. At the end of the square, turn right, go past the former *guardhouse* (1829) – a Neo-Classical building designed by

GIOVANNI CASONI – skirt the former oar-making factory and, at the end of the Fondamenta de l'Arsenale, you will find the entrance to the extension of the Museo Storico Navale. On the wall is a large *shrine* (1570-77) made of Istrian stone that was removed from inside the Arsenal and placed here; it bears a relief of panoplies, a galley with its sail unfurled, a walking Lion of St. Mark, and crests. Fondementa and Rio de l'Arsenale were also called "della Madonna," from the name of the church, or sacellum, that was torn down in 1809.

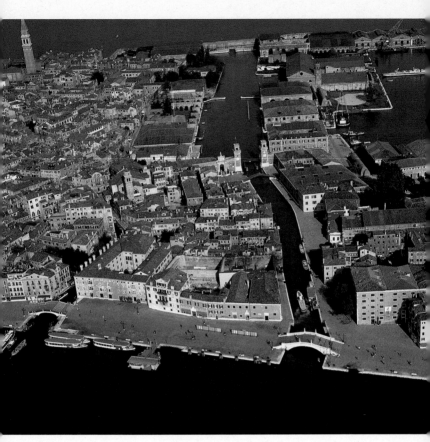

■ To the left is the canal entrance to the **Arsenale**, flanked by two venerable towers that were rebuilt in 1686; the one to the right, which also has a meridian (1919), was drastically restored in 1827-28. HISTORY: the term *arsenale* probably derived from *darsena*, a word of Arabic origin that means "dock." This vast and articulate complex of shipyards, depots and workshops for ships and artillery, warehouses, foundries and factories was founded around 1104. Its growth marked the various stages of Venetian expansion in the eastern Mediterranean and, from the 15th century on, the conquests on the mainland and the long conflict with the Ottoman Empire, during which the la Serenissima Republic lost the strategic islands of Cyprus and Crete. In the 1200s, private commissions in the Arsenale – which continued in the shipyards scattered throughout the city, the *squeri* or *tese* – were gradually excluded in favor of activities entirely controlled and planned by the state. At the end of the 15th century, the patrons were flanked by the *provveditori*, or superintendents, who were charged with inspection. They were responsible, among other things, for the woods, the water mills and putting out fires (entrusted to the local workforce, the *arsenalotti*). The Corderie rope factory was under the supervision of the *Camera del canevo* or hemp-shop supervisors, which in 1558 was replaced by the *Visdomini alla Tana* magistrates. The weapons and gunpowder division was managed by the *provveditori* of the artillery,

231 CENTER CLOCK
TOWER ON WATER
ENTRANCE.

231 BOTTOM THE
DARSENA NUOVA E
NUOVISSIMA.

230-231 THE
ARSENALE DOCKS.

231 TOP RIO AND
FONDAMENTA
DELL'ARSENALE.

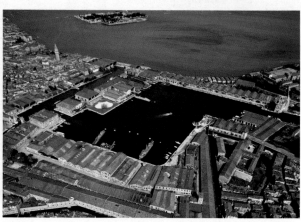

while the defensive system was run by the supervisors of fortresses, whose position was instituted in 1548. The specialized craftsmen – the *marangoni* (carpenters), caulkers, oar-makers and *alboranti* (mast-makers) – were headed by the *proti*, or chief architects.

The first major enlargment in the 14th century consisted of the creation of the Arsenale Nuovo, or New Docks (1325), made by fitting out the lake of San Daniele with a series of docks, shipyards and workshops (which no longer exist) crossed by the Canal delle Seghe and situated in the present-day Grande Darsena docks. The Arsenale Nuovo was flanked by the Arsenale Nuovissimo, construction of which began in 1473, and by the Canale and Vasca della Galeazze (16th century). In the 1500s, besides rebuilding some important structures, there was a long debate on whether or not to isolate and protect the perimeter of the Arsenale area with walls and canals. Many theoreticians – such as Baldassare Drachio and Vettor Fausto – or *provveditori* proposed or introduced technological innovations in the shipyard complex or in the annexes. The layout of the Arsenale remained the same until the 19th century, when the church and convent of Santa Maria della Celestia, situated opposite the Campazzo, were impounded and turned into timber warehouses (1810) and Piazzale dei Bagni was added in 1874. In the 20th century, the most important additions were the Nuovo Bacino (new dockyard, 1912) and the Casermette (barracks, 1916).

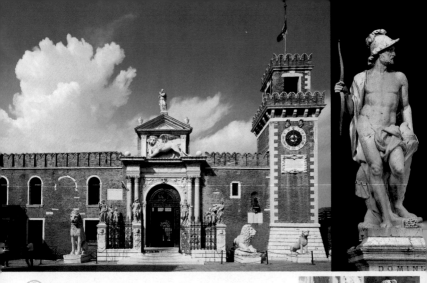

■ FAÇADE: the land entrance to the Arsenale is like a collection of marvels whose purpose was to glorify the maritime supremacy of the Venetian Republic. This small "outdoor museum" begins with the portal (1460), attributed to ANTONIO GAMBELLO or LUCIANO DI MARTINO LAURANA and considered one of the first examples of classicizing Renaissance architecture in Venice. The attic, crowned by a *rampant lion*, was added to celebrate the victory over the Turks at Lepanto on 7 October 1571, the day when St. Justina was also celebrated. The *statue of this martyr*, rendered in prayer by GIROLAMO CAMPAGNA, is on the top of the tympanum. The *terrace* with railing, on the pilasters of which are the names of the *provveditori*, was built in 1682. The panoplies and allegorical statues exalt the military power and wisdom

232 LEFT ARSENALE LAND ENTRANCE.

232 RIGHT ALLEGORICAL STATUES ON LAND ENTRANCE.

of Venice. The lions on either side of the gateway came from Athens (sent as war booty by Francesco Morosini in 1687) and from the Aegean island of Delos. On the walls, along the left-hand side, are *inscriptions* with verses by Dante (1265-1321) describing the "Arsenal of the Venetians" (*Inferno*, XXI, 7-15). ■ INTERIOR: past the atrium, which contains the sculpture of the *Madonna and Child* attributed to JACOPO SANSOVINO (1533), is a square. To the left is a *monument in honor of General Giovanni Mattia Schulemburg*, who defended

Corfu during the Turkish siege of 1715-16. Around the basin opposite, known as the Darsena Vecchia, was the original nucleus of the Arsenale (1104). One catches a glimpse of the Canale delle Galeazze, on which lies the long *Squadratori* or *Seghe building* designed by the architect GIUSEPPE SCALFAROTTO. It is 460 x 92.5 feet (140 x 28 m), with a height of 55.5 feet (16.80 m), and was originally built as a timber warehouse. To the right of the Darsena Vecchia is the *Casa del Bucintoro*, flanked by the Rio del Bucintoro, the canal

233 TOP DETAIL OF
LION OF ST. MARK,
LAND ENTRANCE.

233 BOTTOM THE
DARSENA VECCHIA E
NUOVA.

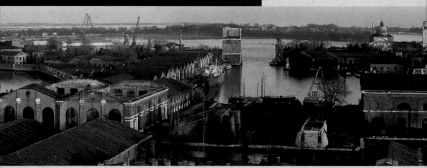

created in 1516 and now partly filled in. *View of Venice* (1500) by JACOPO DE' BARBARI shows us, in the interior of the Arsenale, the famous ceremonial vessel used by the doge on special occasions. The west façade of the building is attributed to MICHELE SANMICHELI (1555); its entrance is flanked by two rusticated Tuscan half-columns. From the square facing the entrance, go right. Once over the bridge, you are in Piazzale Vittorio Emanuele, which affords a view of the Grande Darsena and, at right, after the bunker, the former *Officina delle Bussole e dei Modelli* (Compass and Model Workshop). Its upper floor was occupied by the *Sala di Corfu*. The models of surviving fortresses are now kept in the Museo Storico Navale. The nearby green area was used as an open-air depot for artillery shells (Parco delle Palle).
The second of the two side streets leads to the *Corderie*,

rebuilt by ANTONIO DA PONTE in 1579-83. This vast rope factory, which measures 1050 x 70 feet (317 x 21 m), with a height of 40 feet (12.10 m), is characterized by gigantic brick columns. The upper floor was used for spinning the hemp, while the ground floor was used for making cables, ships' lines and other ropes. The factory, like the canal that skirts it, is also known as the Tana, a name that probably derived from Tanai, the city on the River Don where until 1281 the Venetians bought their hemp. The Corderie is now used for the Biennale art exhibitions.
Once back in the greenery area, proceed right along the Stradal di Campagna, which is flanked by many storehouses and workshops (Magazzini Marittimi) and ends in a tall portal attributed to MICHELE SANMICHELI, beyond which is the access way to the area once reserved for land

artillery.
After turning left, skirt the long series of warehouses (Officine di terra), which are flanked by the Rio de S. Gerolamo. Once in the Grande Darsena, go along the quay, known as the Gru Idraulica, as far as the *Gaggiandre*, two large covered wet docks with out of square beams that are attributed to JACOPO SANSOVINO (d. 1570) and plaques dated 1568 and 1573 (the *gaggiandra* was a sailing vessel without oars). The first of the two halls was also used as a chapel for the skilled workmen.
Beyond these wet docks – which are fascinating for the contrast of light and shadow created by the long roof trusses and the changing reflections of the water – is the Rio della Guerra, which leads to the *Porta Nuova*, the "New Gate" already standing in the 16th century and rebuilt in 1809 after a design by the French engineer LESSAN.

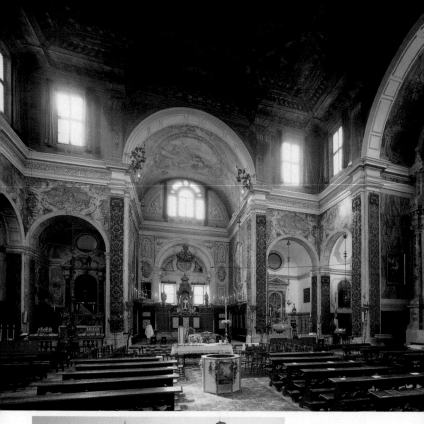

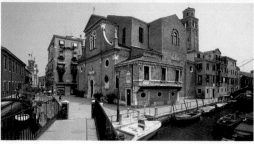

■ Having left the Arsenale via the Fondamenta de Fazza l'Arsenale, you will see the Purgatorio and Inferno bridges and the façades of residences that once belonged to the patrons and supervisors of the Arsenale.

A little farther on is the **church of San Martino**. HISTORY: this church was founded in the 10th century and rebuilt several times. In 1546 reconstruction work began after a design by JACOPO SANSOVINO (ca. 1540) and was finished ca. 1619. FAÇADE: designed by the engineer FEDERICO BERCHET and the architect DOMENICO RUPOLO, the façade was erected in 1897, as can be seen in the inscription above the entrance. INTERIOR: it has a Greek cross plan with

two aisles and eight chapels placed in pairs in the corners. The arm of the chancel is elongated and ends in a choir with a straight back wall. The ceiling is dominated by the fresco *St. Martin in Glory*, with *trompe l'œil* architectural painting by DOMENICO BRUNI and the central panel by JACOPO GUARANA (1746), which bears evident analogies with the compositional schemes adoped by Giambattista Tiepolo. St. Martin, in episcopal garb, is before the divine light and his ascent is accompanied by angel musicians. The monochromes along the walls, the work of MATTEO

234-235 SAN
MARTINO CHURCH,
HIGH ALTAR AND, AT
RIGHT, MAUSOLEUM
OF DOGE
FRANCESCO ERIZZO.

235 VENETIAN
SCHOOL,
MADONNA DELLA
PASSIONE AND
DETAIL.

234 BOTTOM SAN
MARTINO CHURCH
AND SCUOLA.

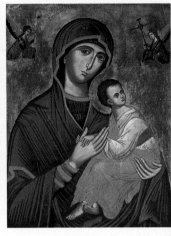

chapels done in the second half of the 18th century, there are other noteworthy works: an elegant small altar by TULLIO LOMBARDO and his workshop (ca. 1484), which comes from Santo Sepolcro Church; *The Resurrection* and *The Last Supper* by GIROLAMO DA SANTACROCE (1549, signed); in the sacristy, the frescoed ceiling by ANTONIO ZANCHI and DOMENICO BRUNI and the 17th-century Venetian school icon of the *Madonna della Passione*. Besides being the home of the Arsenale caulkers' guild and of the Sovvegno dei Musici e Suonatori (confraternity of musicians; 1691), this church was also the headquarters of several

ZAIS, portray the *Evangelists*, the *Virtues* and *scenes from the life of Christ*. At right, on the wall with the secondary entrance, is the elegant and luxurious *mausoleum of Doge Francesco Erizzo*, attributed to MATTEO CARNERI (1633). This doge decided to erect the monument in this position to establish a visual link with the façade of his palazzo, which stands on the other side of the canal and can be seen through the door. The architecture of this monument is composite. In the middle, the statue of the doge, portrayed while listening to entreaties, is meant to underscore his compassion.

The reliefs with panoplies in the intercolumniations allude to the doge's military feats. At left, the crossed batons refer to his being the commander of the land troops, while at right Neptune's trident alludes to his role as admiral.
Among the works in the largest chapel, mention should be made of the ceiling fresco cycle by FABIO CANAL (after 1763), depicting *The Holy Sacrament in Glory* and, at either side, *The Sacrifice of Isaac* and *The Sacrifice of Melchizedek*, intended as prototypes for the Last Supper and the Eucharist. In addition to the restoration work in the

confraternities, a sign of strong religious feeling. These include the Scuola del Santissimo Sacramento and Scuole di San Bernardino da Siena; the Compagnia degli Agonizzanti (1633), and the Sovvegno di San Filippo Neri (1633), of which there are six canvases in the sacristy with *episodes from the life of St. Filippo Neri*; the Sovvegno dell'Addolorata; the Compagnia dei Devoti di Santa Lucia, and an oratory of the Madonna of the Rosary (1649).

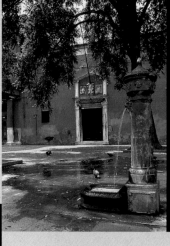

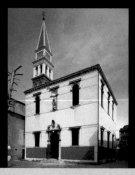

■ The *Scuola di San Martino* (whose statute dates from 1355) – next to the church – was built by the Arte dei Calafati or caulker's guild (ca. 1526-32) and was partly rebuilt in 1584 and restored in 1772. In the 15th-century *bas-relief* above the entrance, St. Martin is cutting his cloak in two.

■ If you want to take a break from this itinerary, you can go over Ponte Stroto or down the Fondamenta del Piovan and return to Riva degli Schiavoni. Otherwise, continue on to Ponte dei Penini and go to Campo de le Gorne – which has another section of the crenellated wall of the Arsenal and a high relief of the *rampant Lion of St. Mark* (1574) – and then go to Campo Do Pozzi, Ponte de la Scoazzera, Campo S. Ternita, Ponte del Suffragio (to the left of which is Palazzo Sagredo, at no.

3059) and, lastly, Campo de la Celestia. The church and monastery of the same name were dedicated to Santa Maria Assunta (Our Lady of the Assumption), commonly known as Celeste or Celestial (*de celaestibus*), which was corrupted to Celestia.

At left, in the distance, is the bell tower of San Francesco della Vigna, built by BERNARDINO ONGARINO in 1571-81 and altered in the 18th century. At the end of Calle del Cimitero is Campo de la Confraternita. To the right is the home of the *Oratorio* and Scuola delle Sacre Stimmate di San Francesco, which was founded in 1603 and later merged with the Scuola di Pasquale Baylon, the saint of the Eucharist, who was beatified in 1618 and canonized in 1690. The *statue of the saint* is in a niche on the façade, and on the portal is the *crest of the*

Scuola, recognizable for the two crossed arms (that of St. Francis is covered, that of Christ is bare), with stigmata and crowned by a cross. On the opposite side of the square is the **Palazzo della Nunziatura** (no. 1785), built by Doge Andrea Gritti in 1525, donated by the Venetian Republic to Pope Sixtus V in 1586; it has been restored or beautified several times by the papal legates or nuncios who lived there.

■ At right are the **church and monastery of San Francesco della Vigna**. Your visit should begin in front of the façade.

HISTORY: in the monastery garden – on an axis with the present-day sacristy – there was a church dedicated to St. Mark. According to legend, the Evangelist stopped at this site when, returning from Aquileia, he took refuge in

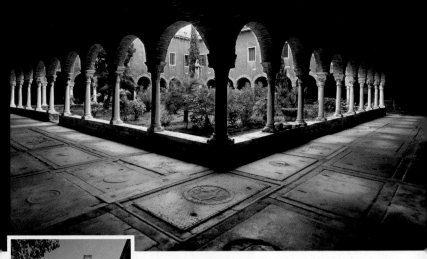

the lagoon during a storm. While resting in a boat, St. Mark had the so-called dream of predestination, during which an angel revealed to him that his body would find its final resting place precisely in that spot. This scene is depicted in one of the mosaics in the Cappella Zen in St. Mark's Basilica. Thanks to the good offices of the Marcimana family, this church was one of the first to be rebuilt in masonry (1037). The history of the church we see today began in the 13th century, when, after a generous bequest on the part of Marco Ziani (1253), the friars were given the surrounding land, which

was a vineyard, hence the name Vigna. The monastery was finished in 1257 and enlarged in 1300 and was then altered several times. The Gothic church, probably enlarged by MARINO DA PISA in 1300, was demolished in 1532 to make room for the present church.

FAÇADE: its construction was paid for by the brothers Marino and Giovanni Grimani. It was already under construction in 1565 after a design by ANDREA PALLADIO. The façade, despite its simple decorative scheme and harmonious proportions, introduces an obvious deviation or forced interpretation of the typical austere church as conceived by Sansovino: the striking stateliness of the tall pedestals incorporated into the base, and the giant Corinthian semi-columns. Thus the original architectural rigor desired by Doge Andrea Gritti is in a sense betrayed by the Grimani brothers, who were bent on celebrating the

virtues of their family. Palladio, who had already planned the façade of the nearby church of San Pietro di Castello, tried to unify and merge in a single plane the various heights of the chapels and nave in the interior. His idea, which he later developed in the churches of San Giorgio Maggiore and the Redentore, was to superimpose and combine the façades of two classical temples. One is of the prostyle type, placed in the middle and supported by huge columns, while the other is hexastyle, lower, visible at the sides, and supported by six smaller columns and reinforced at the corners by pilasters with entasis. The intercolumniation has statues of *Moses* and *St. Paul* by TIZIANO ASPETTI (1565-1607) and eight *dedicational inscriptions*, among which is the motto *Renovabitur* situated in the tympanum together with a relief of an *eagle with outspread wings*.

INTERIOR: an aisleless nave with five patrician chapels on each side elevated by three steps. At the ends of the transept are four other chapels, two of which are behind the high altar. This latter separates the square-shaped chancel from the choir, which has a straight back wall. The architecture is simple and modest, in keeping with the rigors of monastic life. The pillars

and pilasters, which are even with the walls, are Doric, made more refined with Tuscan elements or with other almost imperceptible additions such as the bases and the cabled echinus. The broad round arches support the ceiling, which was rebuilt and altered in 1569. San Francesco della Vigna was commissioned by Doge Andrea Gritti and designed by JACOPO SANSOVINO; construction began in 1534.

The original design called for a Latin cross plan with dome, but was later modified in accordance with suggestions made by the Minorite friar Francesco Giorgi, an expert in kabbalah and harmonious proportions, in a memorandum drawn up together with Titian and Sebastiano Serlio in 1535. Construction ended in 1572 and the church was consecrated ten years later. The dimensions and

proportions, based on the number three – the divinity of the Redeemer – refer to the Passion of Christ, the Church, and the Trinity. Once in the church, to your right is the Venetian school triptych attributed to ANTONIO VIVARINI (ca. 1420-before 1484) – *St. Bernardine of Siena with Saints Jerome and Ludovic*. This wood panel painting came from the earlier, Gothic church, and the subject leads us to believe that it was

238 TOP AND CENTER
PAOLO VERONESE AND
ASSISTANTS,
RESURRECTION AND
DETAIL.

238 BOTTOM
VENETIAN SCHOOL,
*ST. BERNARDINE OF
SIENA WITH STS.
JEROME AND LUDOVIC.*

238-239 SAN
FRANCESO DELLA
VIGNA CHURCH,
CAPPELLA SAGREDO
AND CHANCEL IN
BACKGROUND.

commissioned by the Scuola di San Bernardino da Siena (1450). The saint, who was in Venice in 1422, is portrayed with the *signum Christi* in his hand, the gilded disk that was shown to believers during sermons. Continuing along the right-hand side of the interior, we come to the second chapel, commissioned by Doge Pietro Badoer; this was the headquarters of the Scuola dell'Immacolata Concezione or Scuola dello Stellario (1630). The four canvases on the wall are from the Oratorio delle Sacre Stimmate. The third chapel, with lovely polychrome marble, once belonged to the Contarini Dalla Porta family. The altar of the fourth chapel has a *Resurrection* (ca. 1584) by PAOLO VERONESE and assistants. Here Christ, enveloped in a brilliant mandorla, is soaring in the air. His white body, with no sign of his Passion, radiates beauty. His arms are holding the triumphal vexillum, which is puffed up like a sail in the wind. The Redeemer triumphantly confronts the tree of sin, which is depicted at right as a fig tree. Below, the guards, either asleep or terrified, remind us that the mystery of the Resurrection cannot be grasped by those without faith. The fifth chapel, (Barbaro family) once housed the Scuola del Santissimo Nome di Gesù.

240 RIGHT
VENETIAN SCHOOL,
*MADONNA
SUCKLING THE
CHRIST CHILD.*

240 LEFT AND 241
FRA ANTONIO DA
NEGROPONTE,
*PRAYING MADONNA
AND CHILD* AND
DETAIL.

■ RIGHT TRANSEPT: in the altar of the Morosini della Sbarra chapel there is another work of art from the original church of San Francesco, the *Praying Madonna and Child* (signed, ca. 1540) by ANTONIO DA NEGROPONTE. This tempera painting on a wood panel, to which was added the lunette with *God the Father and the Holy Ghost* (early 16th century) by BENEDETTO RUSCONI (known as IL DIANA), is rich in medieval religious allegories and references to the songs of the Marian liturgy. The Virgin, whose sumptuous dress identifies her as queen of the heavens, is seated on a throne in the shape of a church. The architecture, flora and fauna – painted realistically in keeping with the Gothic, courtly decorative principles – all evoke the Garden of Eden. The rose bush, an allusion to Mary's purity ("a rose without thorns") is also the image of her virginity, a reference to the *hortus conclusus* ("garden enclosed") of the Song of Songs. On the side portal, known as the Holy Land portal, is the *Monument to Domenico Trevisan* (d. 1525), with excellently wrought reliefs and gilding. In the apsidal chapel (Giustiniani family), which may have been the home of the Scuola di St. Francis of Assisi founded by Friar Pietro (ca. 1346), there are paintings by SANTE PERANDA, FRANCESCO FONTEBASSO, JACOPO MARIESCHI and FRANCESCO MAGGIOTTO (who also painted the *St. Peter of Alcantara in Glory* on the ceiling).

CHANCEL: this was financed by Doge Andrea Gritti, whose tomb, in the right-hand wall, is attributed to VINCENZO SCAMOZZI (late 16th century). With their strong tone – as well as in some of the other patrician chapels in the church – the pink composite semi-columns, the pediment with a funerary urn in the middle, the crests and festoons all contrast with Gritti's original austere conception of the church. The high altar separates the chancel from the choir, which has an 18th-century organ by friar PIETRO NACCHINI and several paintings dating from the 16th and 17th century. Before leaving the chancel, at left is a *Madonna Suckling the Christ Child* (late 14th century) that belonged to the Santa Maria dell'Umiltà confraternity, which was founded in the mid-14th century by Friar Pietro and was based in the demolished Celestia church. The Infant, covered by a transparent veil, is holding a solar disk, which is leaning against the Virgin's breast, the symbol of divine wisdom.

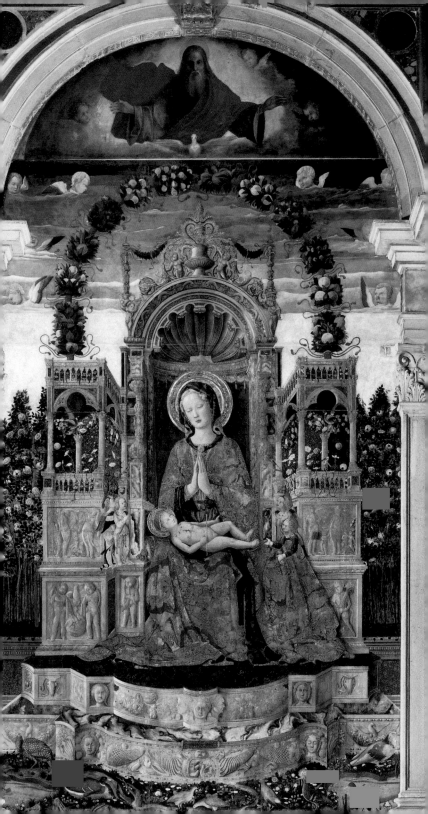

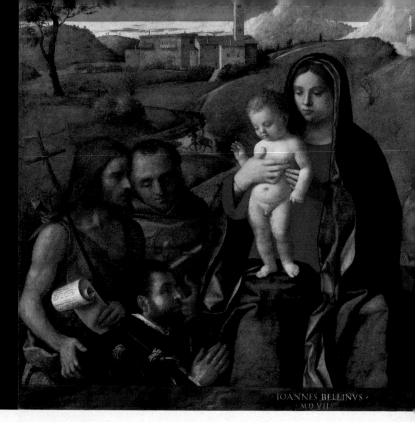

IOANNES BELLINVS · MDVII·

LEFT TRANSEPT: in the Giustiniani-Badoer chapel in the back section (ca. 1534-53) are reliefs and sculptures from the choir balustrade of the chancel (1491-95). The panels in the frieze (GIAMBATTISTA BREGNO and other sculptors) illustrate *episodes from the life of Christ* in a liturgical type of sequence that culminates in the salvific and pietistic panels on an axis with the altar depicting the *Crucifixion* and the *Mourning for the Dead Christ*. The lower register has *Prophets and Evangelists* (1498-1505) attributed to GIAMBATTISTA BREGNO, TULLIO e ANTONIO LOMBARDO. St. Mark is showed uttering the words in an open book: "*Pacem habete inter vos.*" This exhortation, which is not in the saint's Gospel, seems to have been inspired by the epilogue of St. Paul's *Second Epistle to the Corinthians* (13, 11), in keeping with a play of associations of which the theologians in this monastery were very fond. The altar, attributed to TULLIO or an anonymous sculptor, is dedicated to St. Jerome, who is portrayed in the middle. On the opposite side of the transept is the narrow chapel of San Pasquale Babylon, which belonged to the confraternity of the same name. Back in the nave, after the Madonna della Salute chapel, which belonged to the confraternity of the same name and has the *Holy Family with St. Catherine and St. Anthony Abbot* (1551 - ca. 1553) by PAOLO VERONESE, there is the Chapel of St. Bernard, with works by GIUSEPPE PORTA (known as IL SALVIATI), and the Sagredo Chapel by TOMMASO TEMANZA, which boasts the beautiful lofty figures of the *Four Evangelists* and the *medallions with the Virtues*, frescoed by TIEPOLO in 1743. After the Chapel of St.

Anthony Abbot, the altar of which has three statues by ALESSANDRO VITTORIA, and before the exit, there is the last chapel, which was built for the patriarch of Aquileia, Giovanni Grimani. The altarpiece is *The Adoration of the Magi* (1561-64) by FEDERICO ZUCCARI from Urbino, while the other paintings are by GIAMBATTISTA FRANCO (1498-1561), known as IL SEMOLEI. Make sure to visit the Santa Cappella, with the *Madonna and Child with Saints and Donor* (1507) by GIOVANNI BELLINI, and the sacristy, which has works by PALMA GIOVANE and others.

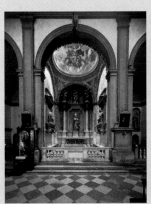

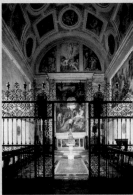

THE FOREIGN

244 TOP LEFT VITTORE CARPACCIO, *BAPTISM OF THE SELENITES*, SCUOLA DI SAN GIORGIO DEGLI SCHIAVONI, DETAIL.

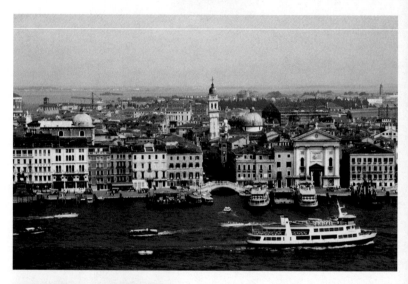

244 TOP RIGHT AND BOTTOM LUCA GIORDANO, *MASSACRE OF THE INNOCENTS*, MUSEO DIOCESANO D'ARTE SACRA, DETAILS.

244 CENTER THE DOME OF SAN ZACCARIA (LEFT) AND THE BELL-TOWER OF SAN GIORGIO DEI GRECI (CENTER).

The area covered by this itinerary is bordered to the east by the residential and artisan district of the old Arsenale. During the Middle Ages it looked totally different, as is the case with many other areas in Venice. The urban landscape was studded with shoals and malodorous places. One of these, called Fossaputrida (literally, "putrid ditch"), was donated to the Knights Templar in 1187 and used to build the church of San Giovanni Battista di Malta and the Santa Caterina hospital, which no longer exists. Starting in the 9th century extensive reclamation works were undertaken, thanks to the foundation of the two rich nuns' convents of San Zaccaria and San Lorenzo. In addition, the proximity of St. Mark's Square and the commercial quay of Riva degli Schiavoni stimulated the construction of patrician palazzi and lower-class residential areas, as well as the erection of the confraternities for foreign communities. These were the "schiavoni" from Dalmatia and the Greeks who had fled from Constantinople and other cities conquered by the Ottoman Turks or emigrants from the Greek islands under Venetian dominion such as Corfu who had come to Venice to seek their fortunes.

COMMUNITIES AND NUNS' CONVENTS

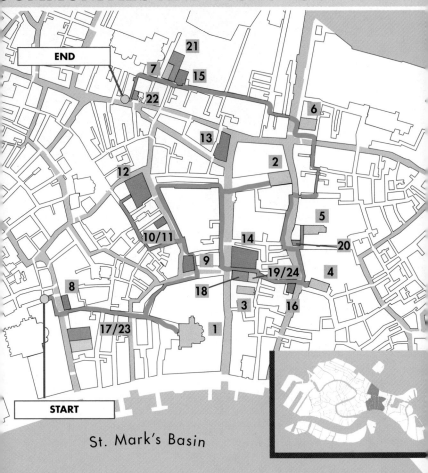

END

21

7

15

22

13

6

2

12

5

10/11

14

20

9

19/24

4

8

18

3

16

17/23

1

START

St. Mark's Basin

▸ MAIN SIGHTS

● **SESTIERE (District):** Castello.

● **CHURCHES:** **[1]** San Zaccaria; **[2]** San Lorenzo; **[3]** San Giorgio dei Greci; **[4]** Sant'Antonin; **[5]** San Giovanni Battista dei Cavalieri di Malta; **[6]** Santa Giustina; **[7]** Santa Maria dei Derelitti.

● **PALAZZI:** **[8]** Cappello-Trevisan, **[9]** Priuli a S. Severo, **[10]** Zorzi, **[11]** Zorzi-Bon, **[12]** Grimani in Ruga Giuffa, **[13]** Cappello, **[14]** Zorzi-Liassidi, **[15]** Salvioni-Cappello a Sant'Antonio, **[16]** Ca' Magno.

● **OTHER MONUMENTS:** **[17]** Sant'Apollonia cloister, **[18]** Collegio Flangini, **[19]** Scuola di San Nicolò dei Greci, **[20]** Scuola di San Giorgio degli Schiavoni, **[21]** Ospedaletto, **[22]** Corte Botera.

● **MUSEUMS:** **[23]** Diocesano di Arte Sacra, **[24]** di Icone ai Greci.

246 TOP CLOISTER OF
SANT'APOLLONIA CHURCH.

246 BOTTOM RIO DI PALAZZO
OR DE LA CANONICA.

247 LEFT PALAZZO CAPPELLO-
TREVISAN, DETAIL WITH THE
ARCHANGEL MICHAEL.

247 RIGHT LUCA GIORDANO,
MASSACRE OF THE INNOCENTS,
MUSEO DIOCESANO D'ARTE
SACRA.

| Itinerary | From San Zaccaria to Ospedaletto |

■ This begins at the Fondamenta de la Canonica, situated near Piazza San Marco, behind the Palazzo Patriarcale. On the opposite side of the canal, note the richly decorated façade of **Palazzo Cappello-Trevisan** (no. 4328). This edifice, built for the Trevisan family from the late 15th century to the early 16th century, is attributed to specialized craftsmen from Lombary. As was the case with other palazzi built in the same period, the owners attempted

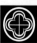

to justify the sumptuous façades by making a show of their religious feeling. On the ground floor, a marble inlay explains that the palazzo was built only in honor of and for the glory of God. At right, on the first floor, another marble inlay represents two allegories of Christ the Savior: a pair of dolphins and a pelican feeding its young with its own blood. Next to them, the vanity of temporal power is represented by a tiara, a mitre, a royal crown, a cardinal's red hat, and a military shield – depicted as if in a state of abandon. On either side of the second floor the Cappello family, in 1577, inserted two elegant early 16th-century high reliefs of the family crest and the Archangel Michael, holding, on the top of his spear, a crest crowned by three heads, an allegory of the three ages of man. Turn right after the bridge Ponte de la Canonica.

■ A bit farther on, at no. 4312, is the entrance to the Cloister of Sant'Apollonia, now home of the **Museo Diocesano d'Arte Sacra** (Museum of Diocesan Art). HISTORY: Sant'Apollonia church, which no longer exists, was built in the 12th century and stood next to Santa Scolastica church, which, before 1268, became the sacristy of the former. The porch of the Romanesque cloister (12th-13th century) is the only one of its kind in Venice. On the walls is the *Lapidario Marciano*, a collection of Roman (1st-4th century), Byzantine and Venetian-Byzantine (5th-11th century) stone carvings. On the first floor is the **MUSEO DIOCESANO**, founded in 1976 as the temporary home of the works of art from churches. The visit begins in Room A, where five paintings by JACOPO MARIESCHI are housed; the *Legend of San Romualdo* (ca. 1670) by JUSTE

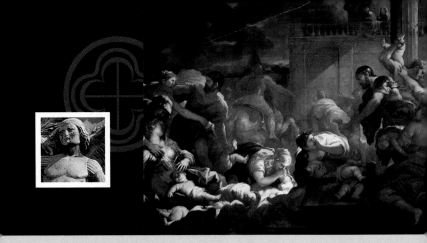

LE COURT. *The Massacre of the Innocents* (ca. 1674) by the Neapolitan LUCA GIORDANO is from Sant'Aponal church. At the end of the hall are many other works, some of which are from Sant'Antonin. The showcases in the middle of the room display missals, illuminated manuscripts, a 14th-century gradual from San Raffaele Arcangelo church and, in the first showcase at right, five confraternity statutes, including one dated 1363 belonging to the Santa Maria Mater Domini confraternity. Next to this last-mentioned display cabinet is the entrance to Room B, which contains canvases by PALMA GIOVANE (*Legend of St. Saba*, 1593) from Sant'Antonin church and – in temporary storage – the large wooden model of the La Fenice Theater (1790) designed by GIANNANTONIO SELVA. In Room C there are interesting works from the churches of San Clemente and Santa Teresa. The *Madonna del Carmelo* (ca. 1700) by

JACOPO GUARANA comes from this latter church: the Virgin in glory is holding the Infant Jesus, who has a rosary, and below them are the figures of Sts. Sebastian, Jerome and Roch. Going back to the entrance, proceed to the right-hand side. At your left is an embossed silver lamina of a Holy Sepulcher (1762) from Santa Maria Formosa church. Opposite this is a wooden statue of the Madonna of Loreto (1731) from San Lio church. In the corridor at right is *Christ among the Doctors* (ca. 1600) painted by GIOVANNI BATTISTA LAMBRANZI for the Scuola del Cristo at San Marcuola. Along the right-hand wall of the other corridor are two inlaid wooden dossals (1535-38) from the choir of St. Mark's by ANTONIO DE GRANDI and NICOLÒ ZORZI after a design by JACOPO SANSOVINO. The first dossal depicts the Fortress and the second depicts Faith. Room D contains liturgical objects, produced by Venetian goldsmiths in the 14th-19th century. This precious

collection includes reliquaries, some of which are made of glass. Besides the splendid hexagonal Ionic tabernacle crowned by a rock crystal, wood and gilded silver dome (1585) – from San Martino church in Murano – there are, at the end of the room at right, some Gothic works of jewelry; among the latter are the 14th-century ostensory and the late 15th-century capitular cross, respectively from San Pantalon and San Giovvani Battista in Bragora churches. The nearby display cabinet has an exquisitely wrought 15th-century processional cross from San Geremia; the ostensory (1378) known as Reliquary of the Virgins, from Sant'Eufemia, on Giudecca island; and the 15th-century capitular cross from San Giovannia Battista in Bragora. Lastly, on the wall between the windows is a tapestry with a *Virgin and Child in Glory* executed by ANTONIO DINI, after a design by GIAMBATTISTA TIEPOLO, for the church of Santa Maria Mater Domini.

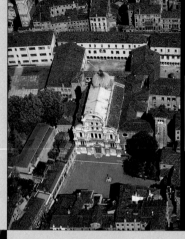

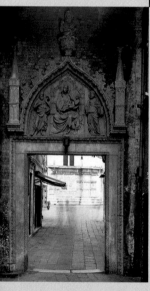

■ After leaving the Sant'Apollonia cloister, go along the short *fondamenta*, turn right, go through Campo SS. Filippo e Giacomo and over Ponte S. Provolo; farther along you will spot the old entrance to Campo S. Zaccaria, next to no. 4699. Above the lintel of the arch is a high relief by a Tuscan artist depicting the enthroned Virgin and Infant Jesus, flanked by St. John the Baptist and St. Mark (ca. 1420). Above this you can catch a glimpse of the figure of St. Zaccharias with the typical Phrygian cap worn by the prophets. In Campo San Zaccaria you can admire the elegant late 15th-century Lombard wellhead in the shape of a Corinthian capital, the caulcoles alternating with heads of cherubs. This sculpture, once kept in the Palazzo delle Prigioni, was placed here after being confiscated from an antiques dealer.

■ Opposite is the façade of **San Zaccaria Church**. HISTORY: the church and its adjoining convent for Benedictine nuns were built at the behest of Doge Giustiniano Partecipazio around the year 829 (although it is traditionally described as one of the original churches founded by St. Magnus in the 7th century). An ancient document states that the complex was constructed with the aid of the Byzantine Emperor Leo V the Armenian (813-20), who sent money and craftsmen from Constantinople. Although this document is now considered dubious, it was for centuries recognized as true, which confirms Venetian policy aiming at replacing Byzantium. The convent acquired many properties both in Venice and on the mainland. The new acquired political and religious prestige, together with the ownership of many precious relics, helped to transform San Zaccaria into an important pantheon of doges, much like the church of San Giorgio Maggiore, also Benedictine. The church was rebuilt after the 1105 fire. In the 15th century restoration was carried out, the two cloisters were built, as was the church we see today, constructed from 1458 to 1500. Initially the work on the new church was entrusted to the Venetian ANTONIO DI MARCO GAMBELLO (d. 1481) and then, after his

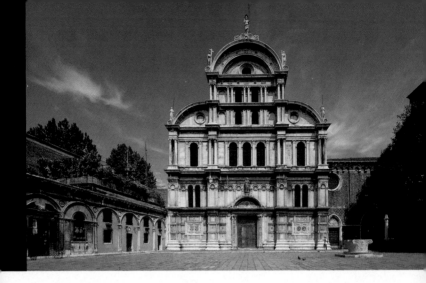

death, to his students LAZZARO DI NICOLÒ and VENIER, who in 1483 were replaced by the Bergamasque architect MAURO CODUSSI.

SCOLETTA" AND FAÇADE: the brick building situated to the right and called Scoletta dates from 1458. The construction, which bears traces of rebuilding and restoration, was used as a granary in the upper floor and, from 1608 on, housed the San Zaccaria and Santissimo Sacramento confraternities. The nearby Venetian-Byzantine bell tower (12th-13th century, restored in 1469) has a belfry with trefoil windows with slender octagonal columns and capitals with dosserets. As for the façade, the lower part, up to the level of the portal, was designed by GAMBELLO. When he was summoned to finish it, CODUSSI introduced Renaissance architectural elements without altering the proportions of the original Gothic plan. In fact, CODUSSI retained the four buttresses

that GAMBELLO had designed, but lightened them by inventing an alternation of paired columns and pilasters. The novelty of this façade lies in the trilobate lunette – completed in 1486, after the façade of San Michele in Isola – and in Codussi's skill in handling specialized laborers and craftsmen accustomed to old-fashioned working procedures. This can be seen in the many Corinthian capitals, which at times reveal modest workmanship and are often sculpted in different shapes, in keeping with a medieval tradition. On the other hand, the decorative details on the lunette crown and its trabeation are more uniform and refined. The refined nature of this structure is underscored by the bas-reliefs along the frieze and the archivolt: the animal hunting scenes, two putti separated by an amphora, wicker baskets overflowing with flowers and fruit, horns of plenty and a vase flanked

by two dragons, alternating with polychrome paterae – all seem to allude to the struggle between virtues and vices and to the transmutations of the soul. A disquisition of salvation woven by figures of classical and medieval tradition is flanked by the Christian message, and by the statues on the crown which celebrate the sacrifice and triumph of Christ. On high is the Risen Christ and, below him, four angels bearing the objects of the Passion: the sponge and reed, the cross, the column and the spear. Before entering the church, note the portal (ca. 1483), crowned by the statue of St. Zaccharias (1543-47), sculpted by ALESSANDRO VITTORIA but unfortunately damaged by atmospheric agents. On the top of the two side candelabra are the figures of two birds: at left is a phoenix above the pyre, the symbol of death and resurrection, and, at right, the eagle, St. John's symbol of ascension.

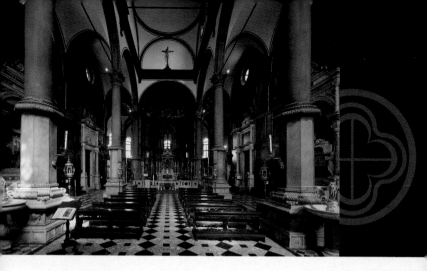

INTERIOR: ANTONIO GAMELLO conceived a late Gothic plan characterized by a broad nave ending in a polygonal apse and by two tall, narrow aisles which are connected by an ambulatory (the only example of this element in Venetian architecture) with four radiating chapels. The capitals, resting on smooth shafts and attributed to GIOVANNI ANTONIO BUORA, have splendid eagles with outspread wings represented in two different poses: in one the animal is on a festoon, while in the other it has its claws on the collar of the column. In 1453 Constantinople was conquered by the Turks and, with this new church Venice reasserted its Byzantine origin and proclaimed its role as the Christian bulwark against infidels. The ceiling of the church (1485-86), also designed by CODUSSI, consists of two tiers of arches. Along the aisle walls are four painting cycles.

The first one, located among the altars and dedicated to the life of Christ and of the Virgin Mary, was executed from 1600 and ca. 1717 by such artists as NICOLÒ BAMBINI, ANTONIO BALESTRA, ANDREA CELESTI, ALBERTO CALVETTI, and ANTONIO VASSILACCHI (known as L'ALIENSE). The second cycle, consisting of five small canvases arranged along the wall of the right-hand aisle, is the work of GIAMBATTISTA BISSONI (1574 - ca. 1634) and depicts some saints. These paintings come from a monastery in Padua. The third cycle, with works in different parts of the church, is dedicated to St. Zaccharias, to whom the church was dedicated. The fourth one, made up of six large canvases in the large lunettes of the two aisles, illustrates the major events in the history of the church and its relationship with the doge. These paintings were executed between 1684 and 1710 by ANDREA

250 (TOP) NAVE, (BOTTOM) PRESBYTERY AND HIGH ALTAR.

251 TOP LEFT BALUSTRADE OF THE HIGH ALTAR AND THE FUNERARY MONUMENT TO ALESSANDRO VITTORIA.

251 TOP RIGHT DANIELE HEINTZ, *DOGE PIETRO LANDO AT THE CONSECRATION OF THE CHURCH IN 1543.*

251 BOTTOM ANTONIO BALESTRA, *ADORATION OF THE SHEPHERDS.*

CELESTI, ANTONIO ZANCHI, ANTONIO ZONCA, GIANNANTONIO FUMIANI and Daniele Heintz.
Once in the right-hand aisle – built on the site of the left-hand aisle of the older church – note above you the

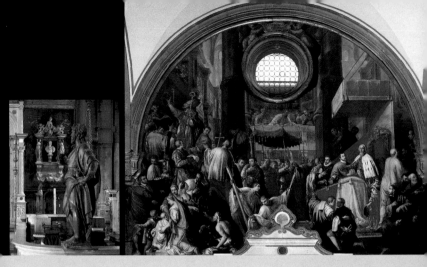

luxurious funerary urn of Marco Sanudo (d. 1505, inscription), the work of ALESSANDRO LEOPARDI. After the splendid early 16th-century altar with the *Virgin Mary and Infant Jesus and Saints* (1605) by PALMA GIOVANE, is *The Adoration of the Magi* (ca. 1717) by NICOLÒ BAMBINI. The next altar, which dates from before 1599, has the relics of St. Zaccharias. This is followed by a canvas on the walls by ANTONIO BALESTRA of *The Adoration of the Shepherds* (1704-08). In this work the Infant Jesus radiates a light – the symbol of divinity and salvation – whose warm, delicate hues illuminate the humble stable and the persons who have come there to pay homage to the King of Kings. Farther on is the Corinthian entrance – sculpted by ALESSANDRO VITTORIA in 1595 (as an

inscription tells us) – of the CHAPEL OF ST. ATHANASIUS. Among the paintings is the one on the Ionic altar, *The Birth of St. John the Baptist* (ca. 1563) by JACOPO TINTORETTO. Proceeding leftward, you enter the rear chapel of the Gothic church and, by going up the stairs at left, the former chancel, now called the Cappella di San

Tarasio. A short stairway leads down to the 10th-century crypt, in which eight doges were buried. This chapel, restored in 1444, has important frescoes among the ribs of the vault by ANDREA DEL

CASTAGNO and FRANCESCO DA FAENZA (signed and dated 1442) depicting God the Father, the four Evangelists and Sts. Zaccharias and John the Baptist. There are also three magnificent polyptychs by ANTONIO VIVARINI and GIOVANNI D'ALEMAGNA with ornate late Gothic frames made of gilded wood. At left is the

Polyptych of St. Sabina (signed and dated 1443) and at right is the *Polyptych of the Body of Christ* (1443). On the high altar is the *Polyptych of the Virgin* (1443). The three central panels, dated 1385, are

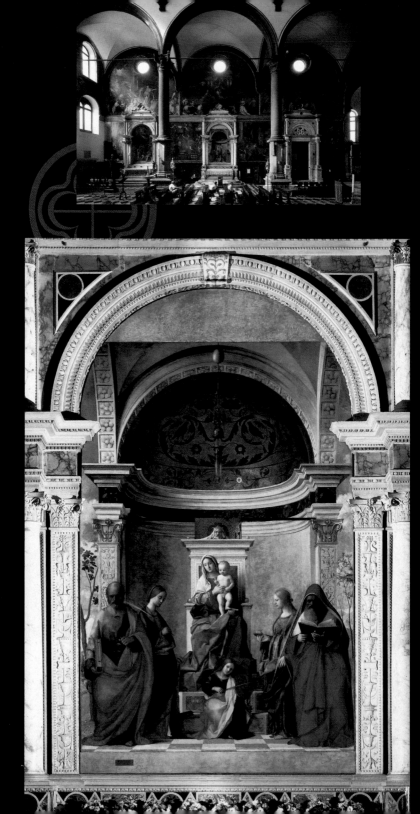

signed by STEFANO DA SANT'AGNESE, and on the reverse, an unidentified artist painted two rows of saints and, along the predella, *The Legend of St. Apollinare.*

Once back in the church, note the high altar, which was still being constructed in 1483 with the insertion of some stones taken from the Holy Sepulcher in Jerusalem. To underscore its sacredness, the altar area was marked off by a balustrade with precious inlay work and, on a line with the apse, was delimited by arches crowned by trilobate mullioned windows. Its four canvases (ca. 1600) are by PALMA GIOVANE. The central role of the altar is emphasized by the enormous fresco of *St. Zaccharias in Glory* (second half of the 18th century) by GIROLAMO PELLEGRINI, as well as by the hemispheric dome (ca. 1485) which is supported externally by another, larger dome made of wood and lead sheets, modeled after the dome in St. Mark's Basilica.

The ambulatory was designed to allow for the passage of Easter processions around the altar. The pavement of this fascinating corridor contains beautifully wrought tombs of Venetian noblemen. The third chapel has a *Circumcision of Christ* (early 16th century) attributed to GEROLAMO DA SANTACROCE and, at the end of the ambulatory (to the right and on the wall) is the Monument to Alessandro Vittoria (1602-08), designed by the sculptor himself and completed by his brother-in-law ALESSANDRO RUBINI. The two saints on the sides, painted by ANGELO TREVISANI in 1732, are George and, perhaps, Cristina or Ursula. Going toward the left-hand aisle you will see the entrance to the sacristy (construction of which began in 1488) and, in the last altar, dedicated to St. Jerome, the magnificent altarpiece by GIOVANNI BELLINI, *Madonna and Child with Saints Peter, Catherine, Jerome and Lucy (?),* signed and dated 1505. The altar and the architectural stone frame of the painting are attributed to PIETRO LOMBARDO. BELLINI conceived the architecture of his altarpiece as an ideal continuation of the frame, thus creating in the eyes of the beholder a window in perspective opening onto Paradise, which here is understood as the temple of

God. The scene is illuminated by soft light that is gradated with masterful skill. The figures are absorbed in profound meditation which, judging by their sad, melancholy look, concerns the passion and death of Christ. The pose of the Infant Jesus offers hope for the faithful: his left leg is raised in the typical gesture of the Risen. The ostrich egg hanging from the ceiling confirms this, since it is a symbol of Easter and, for this reason, was during the Middle Ages hung above tombs as an auspice of rebirth.

254 LEFT SAN
LORENZO CHURCH,
DETAIL OF HIGH ALTAR.

254 CENTER
RIO DE S. PROVOLO.

254 RIGHT
PALAZZO ZORZI.

255 LEFT
PALAZZO GRIMANI.

255 RIGHT
DETAIL OF PALAZZO PRIULI.

■ Once out of San Zaccaria: proceed to Campo San Provolo and along the Fondamenta de l'Osmarin. On the other side of the canal is the large bulk of **Palazzo Priuli a San Severo**. This building, constructed in the early 15th century by the procurator Giovanni Priuli, was famous for the frescoes on its exterior and its furnishings and tapestries. The façade along the canal has two rare, precious double-lancet windows at either end that are crowned by paired cusps and trilobate apertures. If you haven't got enough time for a visit, continue on your way along the *fondamenta* to San Giorgio dei Greci church. But if you have time, go over Ponte del Diavolo to your left, from which you can see,

at no. 4981/B, a relief of St. Lawrence (second half of the 14th century), probably placed there to indicate that this was the property of the monastery of the same name. At the end of Calle del Diavolo, turn left and go into Campo San Severo. The low, massive building at right (no. 5016/B-5017), built in 1829 by the Austrian government, was once a prison, which was constructed on the site of the old San Severo church. On the other side of the canal, at a level with the bridge, is **Palazzo Zorzi**, attributed to MAURO CODUSSI. Marco Zorzi asked the Bergamasque architect, whom he had met in the construction yard of San Michele in Isola, to modernize the older Gothic

buildings that belonged to him. Codussi, opting for the Corinthian order, dressed the old building with Renaissance architectural elements, redoing the land portal (no. 4930), the inner courtyard with a suspended passageway, and the long façade overlooking the canal, which has formal elegance enhanced by the pleasant rhythm of a complex mullioned window (1480-90). The balconies of the single-lancet windows (1682-96) are the work of ANTONIO GASPARI.

The adjoining building with its pointed arches is **Palazzo Zorzi-Bon**. Because of its size and the squaring of its windows with checkerboard friezes, the mid-14th century façade is one of the first of its kind. The palazzo, probably built on the site of earlier Veneto-Byzantine edifices, is connected on the lowest level with other buildings lining the Calle de l'Arco. The name of this street derives from the suspended Gothic arch (*arco*) that can

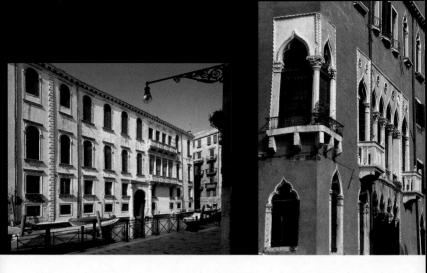

be seen from Ruga Giuffa. At the end of the street is the land entrance of Palazzo Zorzi-Bon (no. 4908), above which is a 14th-century double lancet window crowned by a 2nd-3rd century Roman bust of a man who was once adopted as St. George, the patron saint of the Zorzi family. From here, go to the end of the Fondamenta San Severo, which is the site of the **Palazzo Grimani**. Its austere façade over the canal distinguishes itself for the two quatrefoil windows that are off-center with respect to the portal below them (1553-59), which is attributed to MICHELE SANMICHELI. The building belonged to Giovanni Grimani, patriarch of Aquileia, and was transformed into a luxurious residence. Inside the palazzo is a large courtyard, a double flight of stairs and the splendid Tribuna or *studio delle antichità*, with a pavilion vault, which housed the most precious archaeological objects of the family collections. Artists such as GIOVANNI DA UDINE, CAMILLO MANTOVANO, FRANCESCO SALVIATI and FEDERICO ZUCCARI were summoned to do the frescoes and stuccowork in the interior.

■ From Fondamenta San Severo, turn at Borgoloco San Lorenzo, along which you will see two wellheads (13th and 14th cent.) used by the terraced houses built in 1665 by the nearby San Lorenzo monastery. Left of Ponte di San Lorenzo, at the junction with Rio de la Tetta, you can spot **Palazzo Cappello** (no. 6391), a 15th-century patrician residence. Rio di San Lorenzo is known for the recovery of the relic of the Cross that had fallen in the water. This episode was illustrated in a canvas of 1500 by GENTILE BELLINI, now in the Accademia. At the end of the square is the tall church of **San Lorenzo**, which became part of the nearby Benedictine nunnery. The church already existed as early as the 9th century, but what we see today is the result of rebuilding carried out in 1580-1616 after a design by SIMONE SORELLA. The façade is unfinished and the nave has two aisles with three large arches. The magnificent, impressive high altar with a double frontal was partly sculpted by GIOVANNI MARIA DA CANNEREGIO after a design by GIROLAMO CAMPAGNA, who also sculpted St. Lawrence and St. Sebastian in the side niches. It is not clear whether Marco Polo was buried in this church or, as a recently discovered document seems to indicate, in the demolished church of San Sebastiano. Go to the end of the Fondamenta San Lorenzo. On the other side of the canal is the sumptuous façade of **Palazzo Zorzi-Lisasside**, known as Palazzo Marinella, a mid-15th century residence which distinguishes itself for the fine marble dressing and the quatrefoil window on the *piano nobile*.

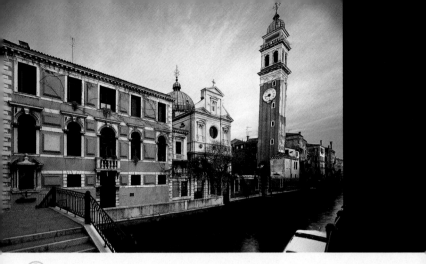

■ Once you have gone over the bridge and the nearby gallery, you will see **San Giorgio dei Greci**. HISTORY: relations between Venice and the Greek communities in the East date from the time of the Byzantine Empire and became closer after the Fourth Crusade (1204), when Venice took military and economic control of the eastern Mediterranean. The Greek community increased considerably and it already numbered 4,000 in 1478. However, in 1470, due to pressure on the part of the Catholic clergy – which accused the Greeks of being "schismatic" and "heretics" – and to political opportunism, Venice allowed the Orthodox rite to be performed only in the peripheral church of San Biagio near the Arsenale. In 1498, following the example of the Dalmatians and Albanians, the Greek community won the right to found a confraternity, the **Scuola di San Nicolò dei Greci**, whose purpose was to offer aid to Greek refugees.

Many of the confreres had become an integral part of the economic and cultural life of the city. During the 16th and 17th centuries some Greek scholars founded important printing shops which were fundamental in spreading the study of classical Greek culture and a critical knowledge of the liturgical texts of the Orthodox Church throughout Europe. In 1539, after long disputes with the patriarch of Venice, two papal bulls granted the construction of the present church of San Giorgio. To finance this work, a tax was levied on all Greek ships that arrived in Venice. The conception of the church and supervision of the construction was entrusted to SANTE LOMBARDO and, from 1548 on, to GIANNANTONIO CHIONA. FAÇADE: with two superimposed rows of pilasters and a crowning lunette that blocks the sight of the dome behind it, this façade was the work of

different people. Note, in the metope of the entrance portal, the relief figures of the objects of the Passion of Christ and, at either side, St. George and St. Nicholas, to whom the church and confraternity were dedicated respectively. Farther up is a mosaic of the Benedictory Redeemer and the dedicatory inscription of the church, dated 1561. The three upper roundels depict the intercession (deisis) of the Madonna and St. John the Baptist, while the other twelve roundels, on the other three sides of the church, contain images of the Apostles that are almost indecipherable.
INTERIOR: after the low vestibule or narthex with its three Ionic arches – surmounted by the women's gallery finished in 1576, for the construction of which ANDREA PALLADIO was summoned as a consultant – you enter the aisleless nave, with a dome above the center and ending in an iconostasis, behind which

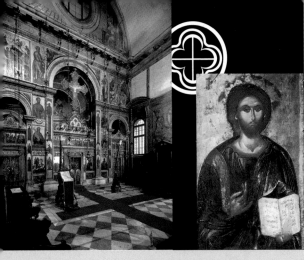

256 SAN GIORGIO DEI GRECI CHURCH.

257 LEFT THE ICONOSTASIS.

257 RIGHT DETAIL OF CHRIST PANTOCRATOR.

are three semicircular apses. Halfway along the right-hand wall, above the side entrance, is the Monument to Gabriele Seviros (1619), considered the first known work of BALDASSARE LONGHENA. The dome of the church, modeled after those on St. Mark's, was frescoed by GIOVANNI KYPRIOS, whose *Last Judgment* (1589-93) – portraying Christ Pantocrator, the Throne, the Deisis, the Apostles, angels and prophets – is in keeping with Byzantine iconographic canons. The iconostasis, which was still being built in 1566, is one of the finest examples of Greek culture in Venice. It is like a triumphal arch with three openings in which the glories of the Redeemer and his imitators shine forth. Christ, the Virgin Mary and the Church with its saints make up the golden veil beyond which the liturgy is celebrated. Three doors, the central one of which is called "royal," communicate with the Bima, or sanctuary, decorated with

works by artists such as TOMMASO BATHAS, GIOVANNI KYPRIOS, BENEDETTO EMPORIOS and MICHELE DAMASKINÒS. In 1574-77, Damaskinòs painted, in the two largest panels in the upper section, the *Nativity of Christ* and *Baptism of Christ* in which St. John is not holding the baptismal basin: in the Orthodox Church, baptism was carried out through immersion, not infusion. The pilasters of the iconostasis are connected by a series of small images, the icons of the feasts which, through the life of Christ, remind the faithful of the events of the liturgical year. These images were executed by DAMASKINÒS in the late 16th century, except for the central one, *The Last Supper* and *Sts. Stephen and Michael Archangel* (1517), which comes from San Biagio church. At the sides of the cross dominating the iconostasis, besides the Apostles Peter and Paul and the charitable healers Cosma and Damian, DAMASKINÒS

also painted Elijah and Moses, the prophets who appear during the Transfiguration of Christ. In 1663-64, EMANUELE TZANE-BUNIALIS frescoed, on the top of the pilasters, St. Simeon and St. Alypios, who were examples of supreme asceticism. Behind the icons, in specially created openings, there are precious relics such as those of the Cross of Sts. Basil the Great, Simeon and John Damascene. The most important work in the iconostasis is located to the right of the central door: a splendid Christ Pantocrator painted in Constantinople in the early 14th century and donated to the confraternity by the Grand Duchess Anna Notarà in 1528. This icon, framed by sixteen tiny busts of apostles and prophets, shows us a Benedictory Christ who, by means of the numbers two and three, reveals to believers the two dogmas of Christianity: the two-fold nature – human and divine – of the Redeemer, and the Trinity.

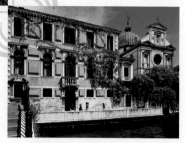

■ Once outside the church again, you can admire the leaning bell-tower built in 1592 and, behind the apses, the cemetery. To the right, toward the bridge, are two buildings designed by BALDASSARE LONGHENA in 1678-82. The larger one, which faces the canal, once housed the **Collegio Flangini** (no. 3412), named after the advocate from Corfu, Tommaso Flangini (d. 1648), who earned his degree at the University of Padua in 1598 and bequeathed a large sum of money for the construction of a university-level: high school.

The smaller building, with a charming Doric and Ionic Istrian stone façade, was the headquarters of the Scuola di San Nicolò dei Greci and also housed a hospital. Its first floor is now the **Museo di Icone dell'Istituto Ellenico di Studi Bizantini e Postbizantini di Venezia**, an icon museum inaugurated in 1959 and considered the best in Europe for its collection of Cretan School wood panel icons, illuminated manuscripts, documents, and liturgical objects and canonicals. The visit begins

in front of the small diagonal wall with the two oldest icons in the collection: (no. 1) *Christ in Glory and the Twelve Apostles* and (no. 2) *The Virgin and Child, Apostles and Saints*, both painted in the mid-14th century. A few steps behind these is no. 3, a painted wooden cross by a Venetian artist dating from the mid-14th century. Among the many icons in this room is the lovely icon (no. 14) of *St. George Fighting the Dragon* (late 15th century); note, on high, the benedictory hand between two disks of light, the symbol of God Almighty, which also appears in no. 15, *St. Eustache's Vision* (mid-16th century). These latter icons are two very interesting examples of landscape painting. Unlike Venetian Renaissance landscape, here the rocks behind the two warriors are painted in abstract, almost two-dimensional fashion. In fact, the aim of old Byzantine icons was not to capture the material quality of the world, but only its spiritual dimension. In *Noli me tangere* (no. 23, early

16th century), the divine nature of the Risen Christ is revealed by the thick gold highlights, while the human nature of Mary Magdalene is made manifest by the unusual chiaroscuro drapery. In painting no. 25, dating from around the end of the 16th century, GIORGIO KLONTZAS has introduced the Virgin and Child in the middle of a series of concentric bands – much like a cupola – among the sections of which are numerous biblical scenes, together with the classical allegories of the planets and signs of the Zodiac. The same artist also did the splendid portable icon in a glass shrine (no. 28), executed in the second half of the 16th century. The main scene, with the doors open, is *The Last Judgment*, and in the medallions are scenes from Genesis. On the reverse of the doors are the *Dormition of the Virgin, Adoration of the Magi*, and *Massacre of the Innocents*. In the *Last Judgment*, which KLONTZAS reproduces in a larger size in no. 27 (late 16th century), one notes, under the throne of the Judge, the red

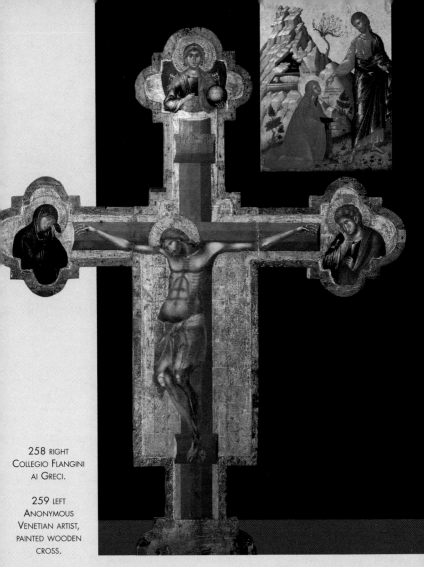

Phlegeton, the river of fire that drags the damned into Hell. Nearby, in another showcase is a copy of the *Story of Alexander the Great*, attributed to the PSEUDO-CALLISTHENES, with 250 miniatures by a 14th-century Byzantine artist. Besides the works of MICHELE DAMASKINÒS, EMANUELE LAMBARDOS, FRANGHIAS KAVERTZAS, VICTOR, GIOVANNI APAKAS, GIORGIO MARGAZINI, BENEDETTO EMPORIOS, ANTONIO MITARA, EMANUELE TZANE-BUNIALIS, COSTANTINO TZANES, TEODORO PULAKIS and GIOVANNI MOSKOS, the small room also has on display the icons of EMANUELE TZANFURNARIS, painted in 1594-1600. In the same room there are a 13th-century illuminated Evangeliary, the letter of Doge Leonardo Loredan, dated 1514, authorizing the construction of San Giorgio dei Greci, and interesting liturgical objects and canonicals dating from the 16th, 17th and 18th centuries. Immediately outside this small room you will see a papyrus from Ravenna (A.D. 554) and a wooden lectern (1663) with mother-of-pearl and tortoise shell decoration by NICOLA KAREKALS and his son GIOVANNI.

The itinerary continues in nearby **Calle de la Madonna** up to Salizada dei Greci. At no. 3416 is an inscription indicating the birthplace of Giacinto Gallina (1852-97), an epigone of playwright Carlo Goldoni. To the right, at the end of Calle dei Greci, above no. 3423, is a high relief of St. George fighting the dragon (1692). Retracing your steps, at right you will see the old Greek quarter and, at left, the enclosure

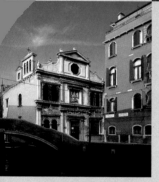

260 LEFT SCUOLA DI SAN GIORGIO DEGLI SCHIAVONI.

260-261 VITTORE CARPACCIO, ST. GEORGE AND THE DRAGON.

261 BOTTOM VITTORE CARPACCIO AND HELPERS, TRIUMPH OF ST. GEORGE.

wall of the cemetery and the apse of San Giorgio dei Greci. Turn right and proceed to the Sant'Antonin bridge, from which there is a view (along the Rio de la Pietà) of the elegant Ionic façade of Palazzo Salvioni-Cappello (no. 3463), built in the late 16th century, and the island of San Giorgio Maggiore. After the bridge is **Sant'Antonin church**, rebuilt from 1638 to 1682 by BALDASSARE LONGHENA, but deconsecrated in 1982.

Turn left, and at the end of the Fondamenta dei Furleni is the **Scuola di San Giorgio degli Schiavoni**. HISTORY: the Republic of Venice consolidated its relations with the cities and countryside of Dalmatia – then called Schiavonia by the Venetians – from the 13th century on. Along nearby Riva degli Schiavoni – the main mooring area for ships arriving from the east Adriatic coast – the Dalmatians enjoyed special

privileges to moor and sell their products. The Dalmatian colony founded its own confraternity in 1451, dedicating it to St. George, St. Triphonius and St. Jerome and setting up its headquarters in the Ospedale di Santa Caterina, at San Giovanni di Malta Church. The building was remodeled somewhat in 1451-55 and was then totally restructured between 1550 and 1586.

FAÇADE: the architect who designed the façade of the Scuola is unknown, but we do know that it was erected in 1551 under the supervision of the *proto* of the Arsenale, GIOVANNI DA ZAN. On the upper register, the windows are crowned by the Trigram or Signum Christi in relief, and the central panel is decorated with two high reliefs: a Madonna and Child, with

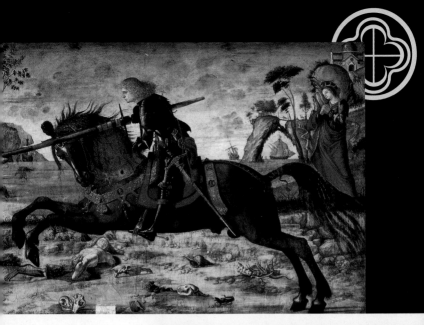

St. John the Baptist, St. Catherine and a devotee (mid-14th century) from the original hospital where the Scuola had its headquarters; and St. George fighting the Dragon (1551) by PIETRO DA SALÒ, a pupil of Sansovino.

■ INTERIOR, LOWER ROOM: the nine paintings in this room were moved from the room upstairs shortly before 1557, and some of them were cut or integrated so as to fit in the new spaces. These canvases, painted by VITTORE CARPACCIO and his workshop in 1502-07, are dedicated to St. Jerome, a native of Dalmatia, and to St. George and St. Triphonius, tutelary saints of the Dalmatian community, after whom the confraternity was named. In the first canvas at left is *St. George and the Dragon*. The terrifying monster,

symbol of evil, and the saint are seen in profile, much like a heraldic device. The setting is blood-curdling, as the terrain is strewn with horribly mutilated corpses as well as toads, lizards, serpents and shells, symbols of death and vice. In the background is a marsh as large as the sea mentioned by tradition; at left the inhabitants of the fabled city of Silene are observing the battle from afar, while at right, the king's daughter is praying with trepidation.

This work is followed by three other canvases which

confirm the contribution of Carpaccio's helpers. In *The Triumph of St. George*, the young knight is entering the city with the dragon tied by its neck with the princess's waistband and is about to kill it, while at left the king and his daughter, followed by the retinue, are entering the scene. Carpaccio gives free rein to his imagination by depicting in the background an edifice similar to the Holy Sepulcher and, at right, St. George's steed – recognizable by its harness – is courting the princess's mare.

The *Baptism of the Silenites* (signed and dated 1507?) illustrates an episode that took place before the dragon was killed. On the nearby small altar (1658) with relics is the *Virgin and* *Child* attributed to CARPACCIO and his son BENEDETTO. To the right is the fourth canvas, *St. Triphonius Exorcising the Daughter of the Emperor Gordianus*. This latter, seated under an elegant Renaissance loggia, is observing the young Triphonius – patron saint of the city of Kotar – while he is praying and exorcising the demon in the guise of a

262-263 VITTORE CARPACCIO, ST. JEROME AND THE LION.

262 BOTTOM AND 263 TOP VITTORE CARPACCIO, BAPTISM OF THE SELENITES AND DETAIL.

illustration of a famous legendary episode. A lion limps into the monastery of Bethlehem – here much like a Venetian monastery – and frightens the monks, who flee in all directions.

basilisk with a donkey's ears.

The next two works, also by CARPACCIO, are *The Calling of St. Matthew* (signed and dated 1502) and *The Agony in the Garden*. Both paintings have the crest of the donor in the lower part. Matthew was a tax collector and his office is rendered in accurate detail as if it were the shop of a money exchanger at the Rialto or the Ghetto.

After going past the sacristy door, you will see *St. Jerome and the Lion*, in which Carpaccio offers a literal

The absolutely calm St. Jerome goes to the beast and orders that his wound be cured. Carpaccio has painted an unusual but fascinating setting that has no fantastic architecture but simple, austere buildings, which are more in keeping with a monastery. In the *Funeral of St. Jerome* (signed and dated 1502) the setting is even more austere and melancholy, as befits the moving funeral in the foreground. In the courtyard we see the lion again, now quite tame and protecting the monastery

donkey at left. Lastly, *St. Augustine in His Study* (signed) – the best interior in Venetian painting – represents the moment when the saint, who is writing to St. Jerome, is struck by a light and hears the voice of Jerome, who tells him he is dead.

Note the stairway and the room upstairs – which was renovated in 1586, as an inscription tells us – with 15th- and 16th-century canvases and 17th- and 18th-century votive paintings with portraits of the confreres and views of Dalmatian cities.

■ Having left the Scuola, turn left and go to the nearby **San Giovanni Battista dei Cavalieri di Malta**. This church was perhaps already on this site in the late 12th century, when the plot of land was donated to the Order of Knights Templar by Gerardo, the archbishop of

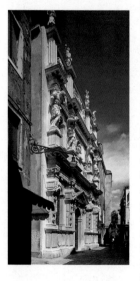

Ravenna. Among the art works inside is a *Baptism of Christ* by the school of GIOVANNI BELLINI. The church once contained the tombs of the confreres of the Scuola degli Schiavoni. Now retrace your steps, cross over the Ponte de la Comenda, and go along the *fondamenta* to the next bridge, which affords a view

of the apse of San Lorenzeo Church. Enter Corte Nova and, at left, next to no. 2867, there is an arcade transformed into the pleasant, folkloric Chapel of the Madonna alla Salute (17th century). This sacellum was erected by the local inhabitants as thanks for the continuous protection they received from the time of the plague (1630) to the Austrian bombardments during World War One. With the help of a map, go to Campo Santa Giustina. At the foot of Ponte del Fontego (no. 2841/A), note the small votive shrine covered by a semicircular baldachin erected in 1621 (as the inscription says) by the local Arte dei Barcaioli (boatmen's guild). The nearby former church of **Santa Giustina**, rebuilt by Augustinian nuns in the second half of the 15th century, was altered several times before being suppressed in 1806. The sumptuous Istrian stone, composite-order façade no longer has the busts, formerly placed on sarcophagi, and the lunette, which was replaced in 1844 by an attic. Construction of the church was commissioned by Giovanni Soranzo, procurator of S. Marco, and was begun by

BALDASSARE LONGHENA in 1636-37. Continue along Calle Zon. Once past Calle del Cafetier, along Barbaria de le Tole, at right, is the lovely Corte de la Teraza, with the remains of **Ca' Magno** (no. 6676/A-6689/A), which is noteworthy for the delicate, flowery Renaissance reliefs on the outdoor staircase and for the splendid late 15th-century wellhead. ■ Farther on, at right, are the **Ospedaletto** (no. 6691) and church of **Santa Maria dei Derelitti**. HISTORY: the old Derelitti hospice was erected in 1528 to take care of the many immigrants who came to Venice from the Italian mainland after a terrible famine. Among its sponsors were Girolamo Cavalli and Girolamo Miani, founder of the Ordine dei Somaschi. From the outset the institute also set out to care for the poor, the ill, and orphans. When the number of its guests increased – 600 around 1570 – the hospice area was enlarged in 1571 and 1582 and construction of a new church began in 1574, when Giovan Battista Contarini was governor of the Ospedaletto. During the 17th and 18th century, this latter was rebuilt and enlarged several times. Among other additions, this work included the building

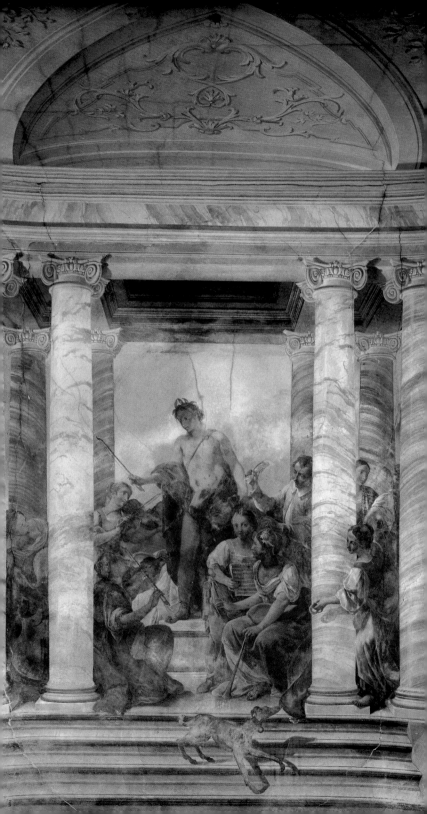

266
CORTE BOTERA.

266-267 GIAMBATTISTA
TIEPOLO, SACRIFICE OF
ABRAHAM, SANTA MARIA DEI
DERELITTI CHURCH.

of a courtyard reserved for girls (1662 - ca.1667), known as the Four Seasons courtyard, and of the spiral staircase (1664-66) by GIUSEPPE SARDI and the concert hall designed by FRANCESCO PATRON (1776). The orphans at the Ospedaletto, like those in the other large Venetian hospital-orphanages, were basically given a musical education. Because of its small size, the concert hall was reserved for a small, select public. Its elegant frescoes were painted by JACOPO GUARANA. On the ceiling is the *Triumph of Music*, surrounded by four Allegories painted solely in green. The back wall has a painting of a portico with paired columns, inside which Apollo himself is conducting a concerto for strings and winds played by the Muses, here in the guise

of the girl musicians from the Ospedaletto. The piece being played is an aria from *Antigone* by Pasquale Anfossi, one of the teachers at the orphanage, who is portrayed at right. A charming detail was introduced in this scene: one girl is holding a *buzzolà*, a small roll of dry bread, for a small greyhound.
The artist who did the painted architecture is AGOSTINO MENGOZZI COLONNA, whose signature is above the right-hand door. Farther up, GUARANA painted a grating behind which we see the faces of two young noblewomen.
FAÇADE OF THE CHURCH: Santa Maria dei Derelitti was built by BALDASSARE LONGHENA in 1670-74 and is a rare example of a combination of Renaissance and Baroque, seen in the grotesque style

decorative motifs. The façade is divided into three registers. The lowest stands on tall pedestals and has Ionic pilasters tapering downward; the pedestals are interrupted by robust dies with diabolical masks with donkey ears, a symbol of human vice. These are contrasted, along the pilaster faces, by the gifts of virtue, symbolized by the lion heads supporting luxuriant compositions of fruit by MARCO BELTRAME. The pediment of the Corinthian portal has a 16th-century Tuscan-school glazed terracotta sculpture group that is partly damaged, depicting a *Pietà and two angels praying*. The second register of the façade is dominated by the figures of four Telamones or Atlantes in the guise of pilgrims, attributed to JUSTE LE COURT. In the middle, within a shell, is the bust of the donor who paid for the façade, the merchant Bartolomeo Cargnoni (1674), mentioned in the

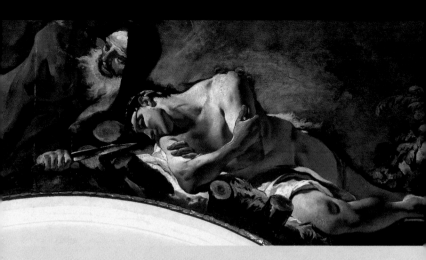

inscription below the bust that urges passers-by to engage in works of charity. The third register is an attic. At either end is a stork, the emblem of the Cargnoni family, and above this are the statues of the four Virtues. INTERIOR: the aisleless nave has a flat ceiling frescoed by GIUSEPPE CHERUBINI (1867-1960), and the walls have Ionic half-columns on tall pedestals. The three canvases on the inner façade – in a stucco frame and dated 1741 (?) – are attributed to PIETRO LIBERI and represent the four Evangelists: in the middle are Mark and Luke (1649), and at the sides, John and Matthew (1660-64). On the right-hand wall, after the first altar, is a marble bust of Bartolomeo Cargnoni (1663) by BERNARDO FALCONE. Above the arch is an oil painting by GIAMBATISTA TIEPOLO with the figures of the prophets Isaiah and Daniel. This canvas is part of a cycle placed above the arches painted by Tiepolo and other artists, with the figures of prophets, apostles, evangelists and Doctors of the Church (1712-25). In the second altar, FRANCESCO RUSCHI (ca. 1610-1661) painted the *Virgin and Child with St. Joseph, St. Carlo Borromeo, St. Veronica and St. Anthony Abbot*. The altarpiece was reconstructed in 1658 by ANTONIO SARDI and modified between 1676 and 1679 by LONGHENA. On the high altar is the *Coronation of the Virgin*, by DAMIANO MAZZA (1575-76). The two praying angels on either side are by TOMMASO RUER (d. 1696), to whom is attributed the statue of St. Sebastian in the niche at right (the sculptor of the statue of St. Francis at left is still unknown). The 16th-century altar, designed by PALLADIO, no longer exists, and the present one, with a ciborium, was built to a design by ANTONIO SARDI in 1658 and then altered by LONGHENA after the remodeling of the choir (1676-79), with grilles designed by FRANCESCO COSTA in 1748. Proceeding toward the exit, you will see the altar (1647-49) with the lovely altarpiece, *Christ on the Cross and St. Girolamo Miani with Orphans*, the work of GIUSEPPE ANGELI. There are two other altars with *Virgin and Child with St. John the Baptist, St. Anthony and St. James* (dated 1625, but the real date is 1652) by ERMANNO STROIFFI, and *Virgin and Child with St. Jerome and St. Anthony* (ca. 1680) by ANDREA CELESTI.

■ After your visit to the Ospedaletto, turn right and, having crossed over Corte Veniera, you will see, at no. 6282, the charming **Corte Botera**. At right is the beautiful façade overlooking the canal and, to the left, at no. 6279, a portal with a sculpted arch (12th century). On the keystone is the hand of God the Father flanked by the Sun and the Moon, respectively.

268 TOP LEANDRO BASSANO, POPE HONORIUS III CONFIRMS THE RULE OF THE DOMINICAN ORDER, SAN ZANIPOLO CHURCH.

268 CENTER SANTI GIOVANNI E PAOLO CHURCH, AERIAL VIEW.

268 BOTTOM GIOVANNI BELLINI, PRESENTATION OF JESUS AT THE TEMPLE, MUSEO QUERINI.

DOMINICAN RELIGIOSITY

Although this itinerary covers a relatively small area in Venice's historic center, it includes a great many monuments and works of art that revolve around two residential quarters. The first lies around the Dominican church of Santi Giovanni e Paolo, the largest in Venice and an important burial site for doges. Around this structure founded in the 13th century are other public and private complexes – such as the Scuola Grande di San Marco and the Mendicanti hospital – which have made this area the main center of Venetian religious and charitable activities. The second quarter is between Piazza San Marco and the Rialto. This area densely packed with streets and canals contains the homes of artisans, luxurious patrician palazzi and large markets or commercial centers. Among the residences that have been demolished, mention should be made of Palazzo Morosini-Tassis and Palazzo Morosini-Erizzo, both at S. Canciano and famous for their painting collections.

The limited space as well as the wealth and pride of its inhabitants led to the construction of small, precious churches. In some of these – such as Miracoli, San Giovanni Grisostomo and Santa Maria Formosa – PIETRO LOMBARDO and MAURO CODUSSI established the new architectural and decorative vocabulary of the early Renaissance in Venice.

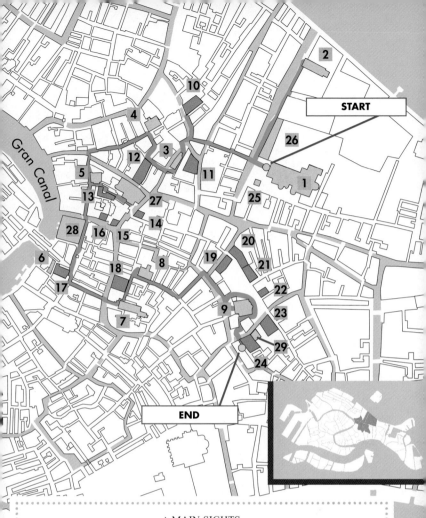

▶ MAIN SIGHTS

● **SESTIERI (Districts):** Castello, Cannaregio, S. Marco.

● **CHURCHES:** [1] Santi Giovanni e Paolo; [2] San Lazzaro dei Mendicanti; [3] Santa Maria dei Miracoli; [4] San Canciano; [5] San Giovanni Grisostomo; [6] San Bartolomeo; [7] Santa Maria della Fava; [8] San Lio; [9] Santa Maria Formosa.

● **PALAZZI:** [10] Widmann; [11] Soranzo-Van Axel; [12] Ca' Bembo; [13] Casa di Marco Polo; [14] Bragadin-Carabba; [15] Case Morosini; [16] Amadi; [17] Moro; [18] Gussoni; [19] Ruzzini; [20] Donà; [21] Casa di Sebastiano Venier; [22] Vitturi; [23] Trevisan-Malipiero; [24] Querini Stampalia.

● **OTHER MONUMENTS:** [25] Monumento Colleoni; [26] Scuola Grande di San Marco; [27] Teatro Malibran; [28] Fontego dei Tedeschi.

● **MUSEUMS:** [29] Querini Stampalia.

| Itinerary | From Santi Giovanni e Paolo to Santa Maria Formosa |

In a central position between the working-class quarters that revolve around the Arsenale and the Cannaregio district is **Santi Giovanni e Paolo Church**, better known as **San Zanipolo**, famous for the many tombs of doges and condottieri. HISTORY: the church was built thanks to the land donated by Doge Jacopo Tiepolo in 1234 to the Dominican friars, who came to Venice in 1226. According to a legend the doge dreamed that some white doves were playing in a meadow filled with roses and other flowers. The animals, which had a golden cross on their heads, represent the Dominicans, the new crusaders of the Catholic faith. Two angels filled the air with incense and God said: "This is the site chosen for my preachers." The skill with which the Dominicans reclaimed the land, the respect they showed for their vows of poverty (with the exception of books), the

special attention they paid to aiding the poor and to promoting popular faith, the central role they played in the Inquisition courts and in the struggle against heretics, their wise administration of bequests and income – these were the main reasons for the fortune and success of the Dominican order. San Zanipolo, the largest church in Venice, is the greatest expression of this success. In 1343 construction began with the apses. In 1368 the walling of the transept was finished. The erection of the nave continued until 1417, and in 1430, when the dressing of the façade was finished, the consecration ceremony was held. The adjacent monastery – now the home of the Ospedale Civile – was laid out around two cloisters. Among the surviving rooms, don't miss the long, wide corridor and, in particular, its two-ramp staircase (1664-66) built by BALDASSARE LONGHENA.
■ FAÇADE: the accentuated

vertical thrust of the façade, the four mighty buttresses, the large central rose window, and the deep niches at the sides of the entrance all bespeak the two-fold architectural style – late Romanesque and Gothic – of the church. The central pitched body, embellished by blind arches and trabeation in Istrian stone, is surmounted by three aedicules with the statues of *St. Jerome*, the champion of Catholic orthodoxy, *St. Dominic*, the founder of the Dominican order, and *St. Peter Martyr*, the first Dominican victim of the heretics. Above these, around the three pinnacles, are twelve statues of *Virtues, Saints* and *Martyrs*, the image of the celestial Church. On the top of the spires is the towering figure of *God the Father*, flanked by a *Lion* and *Eagle*, the allegorical expression of the divine nature of Christ. Close to the entrance, in the second niche from left, is the *Sarcophagus of Doge Jacopo Tiepolo and his son Lorenzo* (13th century;

the urn dates from 1278). The columns of the *Portal* (1459-64) were purchased at Torcello and are the work of BARTOLOMEO BON, who also did the capitals, while the other decoration was sculpted by various stonecutters. One of these latter was MAESTRO LUCA, who executed the majestic pointed arch crowned by a luxuriant encarpus whose festoons are an allegory of Easter and the Resurrection of Christ. The *wooden door* (1739) is surmounted by a bas-relief depicting the chief Dominican symbols. The dog with the torch in his mouth – here transformed into the trinitary symbol of the three candles – alludes to the mother of St. Dominic: in a dream, she imagined she had given birth to a dog which, with a burning torch, burned the whole world. The reference to the Dominican order as the defender of the orthodox faith is obvious. According to a popular play of words, Dominic's name had a two-fold meaning: *Domini custos*, or defender of the

SANTI GIOVANNI E PAOLO CHURCH

1 Pietro Lombardo, Funerary Monument of Doge Pietro Mocenigo
2 Giovanni Bellini (?), St. Vincent Ferrer Polyptych
3 Giambattista Piazzetta, St. Dominic in Glory
4 Stained glass window
5 Cappella del Rosario (Paolo Veronese)
6 Sacristy

Lord, and *Domini canis*, or the Lord's faithful dog. In the bas-relief, the eight-pointed star reminds us of the one that appeared on the head of St. Dominic during his baptism, which, according to tradition, illuminated the whole Earth. The lily, symbol of chastity, is an attribute of the saint, and the palm tree refers to the martyrdom of his friars.

Outside, on the right side of the church, is the elegant Gothic Cappella Salomoni (first half of the 15th century). Before arriving at the façade, you will see a splendid early 16th-century wellhead on which there are the coat of arms of the Corner family. Farther on is the **equestrian monument to Bartolomeo Colleoni** (1481-96). This bronze sculpture was designed by the Florentine ANDREA FRANCESCO DI CIONE, better known as VERROCCHIO (d. 1488), and cast by the Venetian ALESSANDRO LEOPARDI, who also executed the tall pedestal (dated 1495). Colleoni was one of the persons responsible for the expansion of the Venetian Republic on the mainland during the second half of the 15th century.

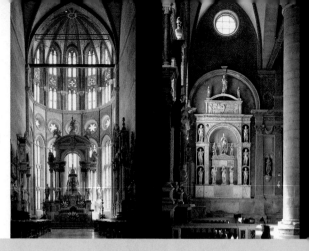

272 TOP LEFT HIGH
ALTAR AND APSE WITH
ITS DOUBLE MULTIPLE-
LANCET WINDOW.

272 TOP RIGHT
PIETRO LOMBARDO,
FUNERARY MONUMENT
OF DOGE PIETRO
MOCENIGO.

272 BOTTOM
ANDREA TIRALI, THE
VALIER FAMILY TOMB.

273 LEFT FUNERARY
MONUMENT OF
MARCANTONIO
BRAGADIN.

273 RIGHT GIOVANNI
BELLINI (?), ST.
VINCENT FERRER
POLYPTYCH.

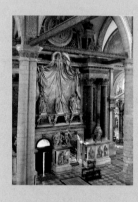

INTERIOR: the tall nave of
the church has two side
aisles and massive cylindrical
columns with octagonal
pedestals and capitals. Along
the head of the transept are
four chapels and the chancel.
The latter is bathed in light
coming from two rows of
seven double-lancet
windows, which alternate
with seven splayed rose
windows. The view of the

chapel with the high altar
was once partly obstructed
by a stone choir that was
situated in the fifth central
bay and demolished in 1683.
The two columns that
framed its entrance are the
only ones in the church with
trilobate shafts. The reliefs
on their capitals represent
some allegories of the
Eucharist. The austere
simplicity of the
architectural elements
embodies the original
spirituality of the Dominican
order, but the vastness of the
interior, the use of stone for
the columns and, above all,
the presence of at least 150
tombs in the floor and 52
sumptuous funerary
monuments along the walls,
betray the dominating role
played by private and public
patrons anxious to show off
their personal religious
sentiment as well as their
social and political status.
Along the lines of San
Giorgio Maggiore and San
Zaccaria, from the late 14th
century on San Zanipolo
became the most important
Pantheon in Venice.

On the inner façade of the
RIGHT-HAND AISLE is the
magnificent tomb of Doge
Pietro Mocenigo (d. 1476),
by PIETRO LOMBARDO. Unlike
medieval tombs, here the
deceased is portrayed
standing. He is dressed in
armor, a sign of his military
valor, and is wearing an
epitoge, the ermine surcoat
used for solemn occasions.
The tomb is flanked by two
bas-reliefs commemorating
Mocenigo's famous victories
(*The Conquest of Scutari* and
*Consigning the Keys of
Famagusta to Caterina
Cornaro*). The latter episode,
which took place in 1473,
marked the beginning of
Venetian dominion in
Cyprus. The religious theme
of salvation becomes clear in
the attic of this monument,
which has a relief of the
three *Marys at the tomb of
Christ* and a statue of the
Risen Christ. Continuing
down the nave, after the first
altar, which has an *Enthroned
Virgin and Child with Saints*
(1510-20) by an unknown
Venetian artist, is the
Monument to Marcantonio

Bragadin (1596). The architecture is attributed to VINCENZO SCAMOZZI. Bragadin (d. 1571) commanded the Venetian troops during the Turkish siege of Famagusta, when he was flayed alive and his skin, filled with straw and put on display and ridiculed by the victors, is now kept in the urn above his bust. On the second altar (1523) is the *St. Vincent Ferrer Polyptych* (second half of the 15th century), attributed to GIOVANNI BELLINI. This altar, which contains the relics of friar Tommaso Caffarini (d. 1434), was reserved for the St. Vincent Ferrer confraternity, founded in 1450. The polyptych, enclosed in a 16th-century wooden frame, has a predella with the *Miracles of St. Vincent Ferrer* attributed to LAURO PADOVANO, an attic with a splendid *Annunciation* and *Dead Christ Held up by Two Angels*, two side panels

with St. Jerome and St. Sebastian and, in the middle, the figure of the Dominican preacher St. Vincent Ferrer, who was canonized in 1458. Farther along the nave, on the pavement, is the *tomb slab of Alvise Diedo* (d. 1466), an elegant work with hidden meanings executed by PIETRO LOMBARDO. At right is the Cappella del Beato Giacomo Salomoni, built at the behest of the procurator of S. Marco, Alvise Storlato, and originally dedicated to St. Alvise. It was reserved for the Scuola del Santissimo Nome di Dio, founded in 1563. Its Baroque decoration was executed from 1639 to 1663. Besides the paintings on the sides by the Flemish artist PIETRO MERA and the stuccowork by the Veronese GIAMBATTISTA LORENZETTI, worthy of note is the altarpiece by the Paduan PIETRO LIBERI, *St. Louis of Toulouse and St. Mary Magdalene at the Foot of the Cross* (1650). The next interesting monument is the tomb of the Valier family

(1705 - ca. 1708), attributed to ANDREA TIRALI to a design by ANTONIO GASPARI. The black marble shafts of the Corinthian columns highlight the funerary character of this work, while the large ochre marble pall in the guise of a stage curtain underscores its propagandistic and theatrical aspects. On high are the statues of the doges Bertucci and Silvestro Valier (d. 1658 and 1700) and of the latter's wife, Elisabetta Querini (d. 1708), portrayed as an elderly woman wearing a splendid fur-lined *dogalina*, the dress of the doge's wife. The allegorical statues and the Virtues in high relief, situated on the pedestals, are signed by ANTONIO TARSIA, GIOVANNI BONAZZA and PIETRO BARATTA. On the central pedestal, MARINO GROPELLI sculpted the relief of the allegory of *The Victory of the Dardanelles*, when the Venetian fleet routed the Turks in 1656.

This monument has two doors. The one at right communicates with the Capella della Madonna della Pace, the name of which derives from the icon on the altar. This wood panel painting, which may date from the 14th century and which has been retouched several times, was donated to the friars in 1503 by Paolo Morosini.

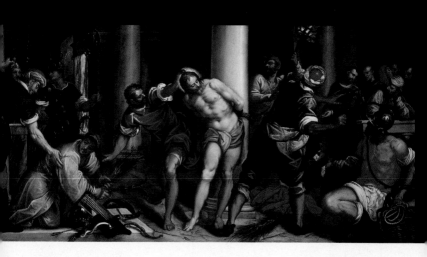

Beside the canvases by PALMA GIOVANE and LEANDRO BASSANO, on the right-hand wall there is a fine *Christ at the Pillar* by the Greek artist ANTONIO VASSILACCHI, known as L'ALIENSE (ca. 1556.-1629). At the bay just before the transept, at your right you will see the CAPPELLA DI SAN DOMENICO, begun in 1690. This chapel can be considered the figurative and religious heart of San Zanipolo. The architecture, attributed to ANDREA TIRALI to preparatory designs by ANTONIO GASPARI, is flanked by works aiming at extolling Dominican: principles and the founder of the order. The bronze high reliefs on the walls, conceived by the Bolognese sculptor GIUSEPPE MAZZA and cast by FRANCESCO MARCOLINI and GIOVANNI BATTISTA ALBERGHETTI, were commissioned by the monastery prior, Giovanni Francesco Gallo (d. 1722), who probably also inspired the complex iconographic program of the entire chapel. The relief in the middle of the wall at right represents *The Baptism of St. Dominic*. The saint, born in 1170 at Caleruega, a village in the province of Burgos, Spain, is here held up by his father, Felice Guzmán. The relief at left refers to the episode of the *Books of St. Dominic and the Albigenses undergoing trial by fire*, which was narrated by a biographer of the saint, Costantino Urbevetani. The relief at right, sculpted in wood by GIOVANNI BATTISTA MEDUNA in 1720, extols the Dominicans' vow of poverty by representing *Tribute for the Ferry*, a scene inspired by the tribute money St. Peter paid in Capharnaum. St. Dominic, having arrived near Toulouse, made a ferryman angry and the latter grabbed him by the tunic, demanding that he give the garment in place of the money he did not have to pay for the ferrying service. The saint, asking for divine help, found the money he needed on the ground. On the wall at left the side reliefs depict *The Exorcism of an Evil Spirit in a Woman* and *The Resurrection* by NAPOLEONI ORSINI. In the latter scene next to St. Dominic, a child is lifting his garment to urinate on Orsini, who died after falling from a horse. The boy alludes to the *puer mingens* or urinating child whose golden spray had tonic powers. His figure was well known to alchemists, among whom there were many eminent Dominican friars. The mastery over death that St. Dominic receives from Christ is therefore connected with alchemy, which again became fashionable in the 1600s, but had already been carefully studied by two eminent Dominican scholars, St. Albertus Magnus and St. Thomas of Aquinas. The last relief, situated in the middle, represents *The Death of St. Dominic*, which occurred at Bologna in 1221. Under the pallet on which the saint is lying, is his faithful dog, sad and grieving. In the background is the ladder

poor condition and illuminated in a particular manner, depicting the dog with the flaming torch in its mouth. This figure, also seen on the main entrance door of the church, might in this case refer to another anecdote in the life of St. Dominic. The saint used to spend the night in church, and when he was extremely tired, he would lay his head on a stone in front of the altar. The conch of the

274 ANTONIO VASSILACCHI (L'ALIENSE), CHRIST AT THE PILLAR.

275 LORENZO LOTTO, ST. ANTONINUS OF FLORENCE GIVING ALMS, DETAILS.

leading to Christ, which had appeared in a vision to Brother Gaulo, the prior of the Dominicans in Brescia, who is portrayed here.

The scene is crowned by a tympanum that has statues of Faith and Hope, Dominican and papal insignia, the heraldic devices of the Orsini family with the eel and triple tower. This crest implies the participation in the artistic work in this chapel of Pope Benedict XIII (1724-30) – whose personal name was Pietro Francesco Orsini – who, at the age of eighteen, became one of the friars in the San Zanipolo monastery under the name of Fra Vincenzo Maria. The crest also appears in the opposite tympanum, in which, besides the statue of Charity, there is a female figure holding a heart and a rosary. The flaming heart refers to St. Augustine, from whom St.

Dominic borrowed the rule for his own order, but it also alludes to the mystique of the Heart of Jesus, the ritual worship of which, after the Middle Ages, enjoyed a successful revival in the late 1600s. The rosary, which according to tradition was given to St. Dominic by the Virgin Mary, already existed in the 12th century, but was adopted in prayer during the 1300s, thanks to the San Pietro Martire confraternity. The numerous allegorical references to Dominican spirituality can be seen in the altar as well. Its four steps, joined to the three above the altar table, symbolize the cardinal and theological virtues. On the floor is an inscription on a black oval marble slab indicating the tombs reserved for the Scuola di San Domenico. On the fourth step, at the foot of the altar, is a relief in rather

apse has a fresco of *Christ with the Three Arrows*, attributed to GIROLAMO BURSAFERRO (1700- ca. 1760). When St. Dominic went to Rome to receive the pope's authorization to found his order, he had a vision in which Christ appeared to him while he was about to cast three arrows at the Earth to punish the pride, avarice and lustfulness of Man. The Virgin managed to dissuade her Son from doing so, saying that St. Dominic and St. Francis would save humanity through the virtues of obedience, poverty and chastity.

A worthy finishing touch to the iconographic program of the St. Dominic Chapel is *St. Dominic in Glory*, on the curved ceiling, painted on canvas by GIAMBATTISTA PIAZZETTA, together with the four *Allegories* (1727) in the spandrels.

The splendid wooden frame of the canvas (1726-27) was carved by PIETRO BERNARDONI. Thanks to sophisticated pictorial artifice that makes no use of architectural elements, the viewer, as if spellbound, is drawn into a dream-like sky that swirls upwards in a spiral. Dominican friars and nuns are witnessing the scene. Dominic, being carried by the angels, stretches himself toward the Virgin, who is waiting for him, while the sky resounds with celestial music. Above Mary, in blinding light, are the figures of the Trinity. After visiting the Cappella di San Domenico, observe that in the small altar at right is a reliquary of St. Catherine of Siena, who was canonized in 1416 thanks to the intervention of the Venetian Dominicans. Go into the right transept. After the *Coronation of the Virgin* by the school of GIAMBATTISTA CIMA DA CONEGLIANO, is the altarpiece with *St. Anthony Giving Alms* (1542) by LORENZO LOTTO. The protagonist of this scene is the Dominican friar Antonino Pierozzi, a follower of Giovanni Dominici and founder of the San Marco monastery in Florence, who was canonized in 1523 and is famed for his writings on charity and for his generosity toward the poor. In the canvas, two angels at his side are whispering to him, as per divine will, telling him how to make donations to the needy. Two deacons are following their instructions. The one at left is about to give coins to the group of poor persons, while the one at right is gathering the letters of supplication written by the "shamefaced poor," who belong to the middle or upper class and have suffered great misfortune. The end of the transept is dominated by a magnificent stained glass window begun in 1495 by a group of artists from Murano, including GIOVANNI ANTONIO DA LODI and perhaps BARTOLOMEO VIVARINI. All the subjects in the window – the result of careful study on the part of a local theologian – concern the exaltation of militant faith and the celebration of the Dominican order as defender of orthodoxy. Beginning from above, under the figure of God, flanked by the sun and moon, are the Annunciation and the prophets David and Moses. In the quatrefoil under this scene, part of the large Gothic window begun in 1460 and measuring 57.5 x 23 ft (17.40 x 6.90 m) are the Virgin and Child with St. John the Baptist, flanked by St. Peter and St. Paul. This is followed by quatrefoils with the symbols of the Evangelists, the four Doctors of the Church, and, in trilobate cusps, the Dominican saints Vincent Ferrer, Dominic, Peter Martyr and Thomas of Aquinas. The last four figures, done by GIROLAMO MOCETTO in 1510-15, extol the warlike virtues of Christianity. The first saint a left is Theodore – first patron saint of Venice – who, together with St. George, seen on the opposite side, was invoked for protection by soldiers. The two saints in the middle are the Roman officers John and Paul, to whom the church was dedicated, whose virtues – purity of soul, chastity and love of the poor – aptly reflect Dominican spirituality.

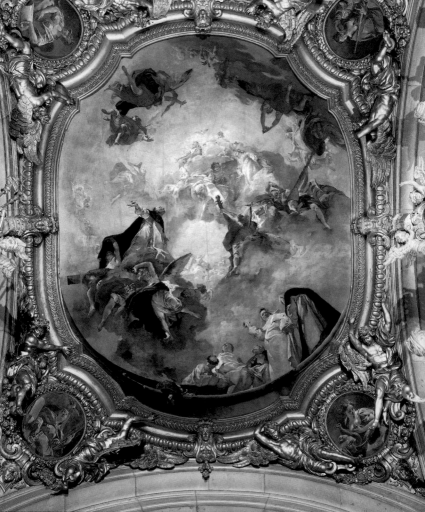

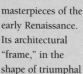

After observing the Cappella del Crocifisso, with works by ALESSANDRO VITTORIA (1524-1608) and the Cappella della Maddalena, which has interesting 14th-century tomb sculptures, you will come to the *broad chancel*. The impressive *high altar* (1625-74) is embellished with statues attributed to BERNARDINO FALCONE, FRANCESCO CAVRIOLI and CLEMENTE MOLI. At the beginning of the right wall is the *Monument to Doge Michele Morosini* (d. 1382). His figure was sculpted as if his corpse had just been brought into the church, in keeping with a medieval custom. Another splendid piece of funerary wall architecture is the *Monument to Doge Andrea Vendramin* (d. 1478) by TULLIO LOMBARDO and his workshop, which is certainly one of the great masterpieces of the early Renaissance. Its architectural "frame," in the shape of triumphal arch, the mythological figures of *Hercules and Perseus* – prefigurations of the death and resurrection of Christ – is connected with the themes of the *Annunciation* and the *Virgin and Child with Saints* situated on high, in an admirable synthesis of ancient culture and Christian devoutness. The two sensual winged mermaids on the top are a perfect example of this. In fact, they are to be understood as replacements of the sibyls that take the image of the Christ Child, savior of the world, to Heaven. According to another interpretation, they represent the soul of the deceased. At the beginning of the left wall is the *Monument to Doge Marco Corner* (d. 1368), among the statues of which is a *Virgin and Child* signed by NINO PISANO. In the left transept, after the Cappella della Trinità (reserved for the guild of the Ligadori, who packed merchandise and bound packages in the Fontego dei Tedeschi at the Rialto), in which there are many works by LEANDRO BASSANO and GIUSEPPE PORTA (known as SALVIATI), there is the chapel of St. Pius V. On the right wall is the *urn of Jacopo Cavalli* (d. 1385), by PAOLO DI JACOBELLO DALLE MASEGNE. On the left-hand wall is the *urn of Giovanni Dolfin* (d. 1361), by ANDREA DA SAN FELICE. The two reliefs depict the *Adoration of the Magi* and the *Dormition of the Virgin Mary*. At the head of the transept are the *tomb of Doge Sebastiano Venier* (d. 1578), the large tomb of Doge Antonio Venier, created in 1403 and attributed to DALLE MASEGNE, and the elegant *tomb of the dogaressa Agnese Venier* (d. 1410), her daughter *Orsola* (d. 1471), and her daughter-in-law, *Petronilla de Toco*.

■ Once past the portal you enter the CHAPEL OF THE ROSARY (Cappella del Rosario). Formerly called Cappella di San Domenico, it was used by the printers and booksellers' guild and in 1582 was ceded to the Scuola del Rosario confraternity (founded in 1575). Unfortunately, it was destroyed by fire in 1876. The two *wooden screens* along the side walls (1687 -ca. 1690), by GIACOMO PIAZZETTA and assistants, come from the former Scuola della Carità. Among the figures of Atlantes are eight scenes from the *life of Christ and Mary*. On the

wall above the entrance, the *Adoration of the Shepherds* (ca. 1558) comes from the Chiesa dei Crociferi and was painted by PAOLO VERONESE for the Scuola dei Tessitori di Panni di Seta (silk-cloth weavers' guild). Veronese makes a stark contrast between the shepherds and the image of the Virgin Mary, whose gestures are highlighted by her flowing stole. The same artist also executed the paintings on the ceiling (ca. 1560), which had been commissioned by the Jesuits and were brought from the church of Santa Maria dell'Umiltà: *Adoration of the Shepherds, Assumption of the Virgin* and *Annunciation*. The ceiling version of the *Adoration of the Shepherds*, instead of being set in a humble manger, takes place at the gate of Bethlehem, in keeping with the apocryphal Gospel, a scene more to Veronese's taste, since he was able to associate the figure of the Virgin with an elegant Ionic column, the symbol of

her virginity. In the *Annunciation* the architecture dominates the scene, becoming an example of both solemnity and virtuosity with the sinuous columns.

VERONESE also painted the canvases on the ceiling above the altar (ca. 1582), which were brought from San Nicolò della Lattuga. They represent the *Adoration of the Magi* and the *Four Evangelists*. The six statues by ALESSANDRO VITTORIA that decorate the walls of the chancel portray the *Prophets and Sibyls*. Bearing witness to an ancient world already aware of the "good tidings," these works are related to the 18th-century reliefs below them – the work of the sculptors GIAN MARIA MORLAITER, FRANCESCO and GIOVANNI BONAZZA, GIUSEPPE TORRETTO, LUIGI and CARLO TAGLIAPIETRA – that illustrate ten episodes from the *childhood of Mary and Jesus*. Behind the altar with its ciborium (ca. 1600) is the *Assumption* (1540-45) by GIUSEPPE SALVIATI.

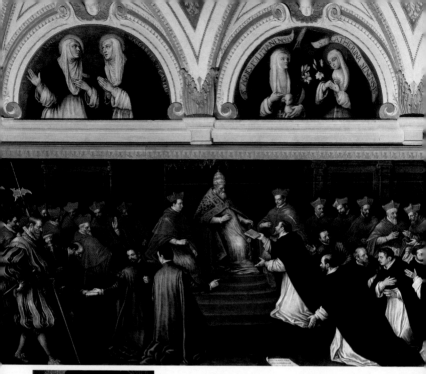

At the beginning of the left-hand aisle, on the wall, are three panels by BARTOLOMEO VIVARINI dated 1473 and representing *St. Dominic, St. Augustine* and *St. Lawrence.* The richly decorated sacristy has 17th-century canvases by artists such as PALMA GIOVANE, ODOARDO FIALETTI, FRANCESCO ZANELLA, PIETRO MERA, FRANCESCO FONTEBASSO, GIAN SISTO DE LAUDIS and MARCO VECELLIO that illustrate the life of St. Dominic and his order. Just

past the sacristy, on the wall of the aisle, is the *tomb of Doge Pasquale Malipiero* (d. 1462), sculpted by PIETRO LOMBARDO shortly after 1470. The doge's sarcophagus lies under a broad canopy symbolizing Heaven and is supported by two griffins, which symbolize the Resurrection. The winged shell is also a reference to rebirth, while the lunette above it has *a dead Christ borne by two angels,* a mortuary theme with the aim of inspiring pity and strong feeling in the beholder. Among the other tombs along the aisle, worthy of mention is the *Monument to Doge Tommaso Mocenigo* (d. 1423) by PIETRO DI NICOLÒ LAMBERTI and GIOVANNI DI MARTINO DA FIESOLE, and, opposite this, the *Monument to Doge Nicolò*

Marcello (d. 1474) by PIETRO LOMBARDO, which was brought from Santa Marina Church. The formal scenes in the former monument are modeled after late Gothic iconography, while in the latter the early Renaissance style bursts onto the scene in all its splendor. Note how, in the lunette above the sarcophagus, the Marcello family decided to employ official iconography by setting, at the side of the Virgin and Child and the doge, the two patron saints of Venice, Mark and Theodore. On the inside façade of the aisle is the austere and precious *Monument to Doge Giovanni Mocenigo* (d. 1485) by ANTONIO LOMBARDO. At either end of the base are two sculpted scenes: *The Baptism of Christ* and *St. Mark Baptizing Anianus and His*

Family. This latter episode has certain figurative analogies with a woodcut in the *Hypnerotomachia Poliphili*, with some variations to emphasize its salvific meaning in a Christian key. Anianus is portrayed as Adam, and his wife covers her breasts, in the typical gesture of Eve being cast out of the Garden of Eden. St. Mark is bending the fingers of his left hand, in order to remind us, with the numbers two and three, the Christian dogmas of the two-fold nature of Christ and of the Trinity. Lastly, in the middle of the inner façade of the church is the impressive *Monument to Doge Alvise Mocenigo (d. 1577) and his wife, Loredana Marcello*, which was begun by GIROLAMO GRAPIGLIA and finished, in 1646, by FRANCESCO CONTIN.

280-281 LEANDRO BASSANO, *POPE HONORIUS III CONFIRMS THE RULE OF THE DOMINICAN ORDER*, SACRISTY.

280 BOTTOM SACRISTY ENTRANCE PORTAL.

281 TOP LEFT FUNERARY MONUMENT OF DOGE GIOVANNI MOCENIGO, DETAIL.

281 TOP RIGHT LEFT AISLE AND, IN THE BACKGROUND, THE FUNERARY MONUMENT OF DOGE GIOVANNI MOCENIGO.

281 BOTTOM LEFT PIETRO LOMBARDO, FUNERARY MONUMENT OF DOGE PASQUALE MALIPIERO.

281 BOTTOM RIGHT PIETRO DI NICOLÒ LAMBERTI AND GIOVANNI DI MARTINO DA FIESOLE, FUNERARY MONUMENT OF DOGE TOMMASO MOCENIGO.

282 LEFT VITTORE DA FELTRE AND LORENZO DI VINCENZO DA TRENTO, WOODEN CEILING, SCUOLA GRANDE DI SAN MARCO AND DETAIL.

282 RIGHT AND 283 THE SIDE FACADES AND MAIN FACADE OF THE SCUOLA GRANDE DI SAN MARCO.

■ Once outside San Zanipolo, at your right you can admire the former **Scuola Grande di San Marco**. HISTORY: the Confraternity of St. Mark, founded in 1260 at Santa Croce church, moved to San Zanipolo in 1438 after obtaining, from the Dominican friars, the right to use the high altar and a plot of land next to the church, in which they could build their headquarters. The Scuola was one of the six Scuole Grandi, or major confraternities, and its many members belonged to the city's upper middle class. The first headquarters were destroyed by fire in 1485. Four years later, after having salvaged the surviving structures, the members commissioned PIETRO LOMBARDO to rebuild the Scuola and a new façade. The sculptor was assisted by the stonecutter GIOVANNI BUORA. In 1490, the two artists were replaced by MAURO CODUSSI and ANTONIO RIZZO. FAÇADE: the recovery of fragments not destroyed by fire, the contributions of four leading artists, and the radical restoration and rebuilding carried out in 1832, make for extremely uncertain attribution. Moreover, the realization of this sumptuous marble façade – one of the greatest examples of early Venetian Renaissance architecture – took place in a construction yard organized with medieval criteria, as was the case with San Zaccaria Church. LOMBARDO is to be credited with the overall architectural design, as well as certain decorative details executed by his workshop. The other artists were responsible for the design and part of the execution of numerous sculptural and architectural details. The façade is divided into two distinct sections with separate entrances. At left is the main portal, surmounted by the two windows of the Chapter House and by a taller tripartite crown which bear traces of certain decorative corrections made after CODUSSI's design. At right is the smaller portal, surmounted by the two windows of the Sala dell'Albergo. On the ground floor was the entrance of the Santa Maria della Pace chapel (which no longer exists), in which the miraculous icon was kept (it is now in the chapel of the same name in San Zanipolo). The figure of *St. Mark* towers over the top of the façade of the main doorway, while below him are the statues of the *Lion of St. Mark* (19th-century copy) and, in the niches in the two side crowns, the statues of *St. John and St. Paul*. The sculptures are an homage to the Senate of the Venetian Republic and to the Dominican friars of San Zanipolo, who were responsible for the

reconstruction of the Scuola.

In the lavish main portal framed by two columns on a triple pedestal, you will note the relief showing the *Scholars giving homage to St. Mark* – attributed to GIOVANNI BUORA – and the statue of *Charity*, which survied the fire. This façade has four scenes in perspective attributed to TULLIO LOMBARDO. The first two are around the main doorway and have a foreshortened view of the double figure, in high relief, of a *rampant Lion of St. Mark*, which can be interpreted as an homage to the patron saint of the confraternity. The other two architectural views, at either side of the smaller doorway, frame two scenes: *St. Mark Healing Anianus* and *St. Mark Baptizing Anianus*. These episodes refer to the works of the saint at Alexandria, Egypt and highlight his healing power and apostolic mission. The SIDE FAÇADE overlooking the Rio dei Mendicanti is

divided by pilasters with busts – either in relief or in tondi – of some confreres of the Scuola holding crosses or lighted candles. They can be recognized by the emblem, or "sign," of the Lion of St. Mark sewn on their processional habit. At the beginning of the wall is a plaque (1759) with the text of a decree of the Inquisitors and Auditors of the Scuole Grandi which, to ensure decorum and quiet in this spot, forbids loading or unloading merchandise or materials, depositing rubbish, playing games and fighting.

INTERIOR: the ground floor hall is divided into three aisles separated by columns on tall pedestals (1488-90). The sides of these latter have fine relief carvings of candelabra with many allegorical figures. In the first one, at right, there is the theme of the pelican, already described for the portal, and in the left-hand one there is the Lion of St. Mark. The two portals at either end of the right wall

are all that remains of the majestic double staircase (1494-95) designed by MAURO CODUSSI, which was demolished in 1819 and rebuilt in 1952 by ALDO SCOLARI. At the end of the hall is a vestibule added in 1533. At right, a stairway leads up to the Sala Capitolare, or Chapter House. The wooden ceiling (1518-35) with octagonal coffers was carved by VITTORE SCIENZA DA FELTRE: and by LORENZO DI VINCENZO DA TRENTO. This room and the adjacent one – the Sala dell'Albergo, with a ceiling (1504) decorated by BIAGIO and PIETRO DA FAENZA – housed the large canvases of episodes from the life of St. Mark, now kept in the Accademia Galleries, painted by GIOVANNI BELLINI, VITTORE BELLINIANO, GIOVANNI MANSUETI, PALMA VECCHIO, PARIS BORDONE, and JACOPO and DOMENICO TINTORETTO. The extension of the Sala Capitolare is the work of JACOPO SANSOVINO and ALESSANDRO VITTORIA (1546-63).

■Once outside the former Scuola di San Marco, go along the left-hand side to **San Lazzaro dei Mendicanti Church**.

HISTORY: Lazarus was the beggar in the parable who lay at the gate of the rich and greedy man's house. Tradition identifies him as the patron saint of lepers and beggars. The leprosarium of San Lazzaro was founded on the island of the same name in 1262 and was moved to the city proper in 1599, later

284 LEFT AND 285 RIGHT *JACOPO TINTORETTO, ARRIVAL OF ST. URSULA AND THE 11,000*

VIRGINS AT COLOGNE.

284 RIGHT *CHURCH OF SAN LAZZARO DEI MENDICANTI.*

285 LEFT *PAOLO VERONESE, CRUCIFIXION.*

converted into a hospital for lepers and beggars. The construction had began in 1605 and its work was followed by the Somaschan and, later, the Philippine. The church construction was under the supervision of the *proto* CESARE FRANCO, and after his death by the *proto* TOMMASO CONTIN.

FAÇADE (1664-69): thanks to a bequest on the part of the merchant Jacopo Galli, it was designed by ANTONIO SARDI and built by his son GIUSEPPE. This work consists of four composite half-columns on tall pedestals and flanked by smaller Ionic pilasters. Set back on the large notched pediment are the acroteria supporting three statues (1673). The one in the middle portrays *St. Lazarus* in bishop's garb. The

other, female statues represent two *Virtues*; the one at left may be *Charity*.

■INTERIOR: between the façade and the interior proper there is a large vestibule that was completed in 1639. In the inner façade is the *Monument to Lorenzo Dolfin* (1666-68), commissioned by his nephew Federico. This work, by GIUSEPPE SARDI, is in the shape of a triumphal arch with fluted Corinthian columns. The statues at the sides of the entrance, *Temperance* (left) and *Faith* (right), and the *two angels* and the *family crests* on the attic, are the work of the German MELCHIOR BARTHEL. On the side walls are monuments to two benefactors of the hospital: *Bartolomeo Bontempelli*

(1619) – by ANDREA DELL'AQUILA – and, at right, *Domenico Biava* (1657). The back wall is entirely occupied by the majestic *funerary monument to Tommaso Luigi Mocenigo* (d. 1654), built by his heirs in 1658-64 to a design by GIUSEPPE SARDI. In the entrance to San Lazzaro Church, in the middle of the attic, is the family coat of arms supported by two angels – works attributed to FRANCESCO CAVRIOLI – and four reliefs representing the *islet of St. Theodore* at left, and three *bastions on the fortress of Candia, Crete*. The interior of the church (1634-37), designed by FRANCESCO CONTIN, has no aisles, with four side altars in a narrow chapel and a square chancel. In the section around the doorway is the spectacular

inner façade of the *Mocenigo monument*. The two side statues (ca. 1655) – allegories of military virtues – are signed by the Flemish sculptor JUSTE LE COURT. At right is *Fortitude* and at left *Prudence*, to which the attributes of Justice were added in the 19th century. Towering on the upper level, of a composite order, is the statue of *Mocenigo*, surmounted by a statuette of the *Madonna in prayer*. Above the base of the two side obelisks are reliefs of two medals struck in Candia, Crete in honor of its heroic defender. On either side are two interesting high reliefs by the English sculptor JOHN BUSHNELL that illustrate the military exploits of Mocenigo against the Ottoman army. At left, *The Attack of the Turkish Troops against Two Bastions at Candia*, at right *The Naval Battle of Paros*. The side altars, designed by FRANCESCO CONTIN, were executed in

1639-44 for the hospital governors.

Once past the first one at right, which has the *Crucifixion* (before 1581) by PAOLO VERONESE, brought here from the San Salvatore degli Incurabili church, you will see the grating of the room originally reserved for the orphan girls' choir. On the same wall, some polychrome tarsia frames the *commemorative monument to the Mora brothers* designed ca. 675 by BASDASSARE LONGHENA. The choir was added in 1672 and enlarged in 1742. In the vestibule of the SACRISTY are statues of the *Madonna and St. Filippo Neri* (dating from 1664) by HERMANNO STROIFFI, as well as a 16th-century painted wooden *crucifix* and several reliquaries, some of which are in the shape of miniature altars (18th century). Back in the church, the CHANCEL boasts the *high altar* against

the wall, with Corinthian columns, dating from the 17th century. At the foot of the balustrade is the tomb of the Rezzonico family, in which the mother of Pope Clement XIII is buried. To your left, in the room that communicates with the cloister, is another wooden *crucifix* (16th century). After the altar with the altarpiece depicting *St. Helena Adoring the True Cross* painted by GIOVAN FRANCESCO BARBIERI (known as IL GUERCINO), there is the *monument to the family of Nicolò Cappello* (1600-67), the governor of the hospital, attributed to BALDASSARRE LONGHENA. Next to this is the *Arrival of St. Ursula and the 11,000 Virgins at Cologne* (1554-55) by JACOPO TINTORETTO, brought here from the San Salvatore degli Incurabili church.

■ After your visit to San Lazzaro, cross the Ponte Cavallo and enter the Cannaregio district. The lovely marble relief above the door of no. 6377 is an *Annunciation* attributed to JUSTE LE COURT; however, the diagonal composition and the skillfully wrought anatomic features betray 18th-century pictorial sensitivity more akin to the style of GIOVANNI BONAZZA, who was active in the Cappella del Rosario in the nearby San Zanipolo church. When you come to the Ponte del Piovan, to your right along the canal you will spot a small building (no. 5409-10), the side of which is dotted with paterae and fragments of a frieze in Greek marble (11th-13th century). These elements were meant to protect the house from evil influences, as can be seen by the cross situated near the second floor, and also

attest to the owners' connections with the East. Farther on is the massive façade of **Palazzo Widmann**. This building (no. 5403-04), attributed to BALDASSARE LONGHENA and finished in 1630, once had rich decoration in the interior and housed a famous picture gallery. The owners, who officially became Venetian patricians in 1646, also owned a chapel in the nearby church of San Canciano.

■ From Ponte del Piovan, proceed toward the nearby church of **Santa Maria dei Miracoli**. HISTORY: in 1409, Francesco Amadi had an image of the Virgin Mary painted for a capital, or an aedicule, situated in a street near Campo Santa Marina. This painting became extremely popular among the locals. In 1480, after the miraculous recovery of a widow, the Amadi family decided to move the image

into a chapel or oratory, the design of which was entrusted to PIETRO LOMBARDO. In 1481 the first stone was laid and the Patriarch of Venice, Maffeo Gerardi, dedicated it to the Immaculate Conception. The following year, Pope Sixtus IV – a Franciscan who instituted the Immaculate Conception holiday – exempted the church from all parochial jurisdiction. Thanks to the large, initial sum of 1,000 ducats – administered by Francesco di Marco Zen – precious marble from Carrara, Verona and Greece was purchased to dress the lower order of the church. A collection of another 6,000 ducats, deriving from the common people's piety and probably from certain wealthy families as well, made it possible to finish construction in a short time and to add fine decoration both outside and inside. In

having merged these requirements into a uniform architectural style that is basically classicizing (Renaissance) but is not without stylistic "contaminations" such as Romanesque-like elements. The façade consists of two tiers. The first is Corinthian and has an architrave, while the second, Ionic one is relatively low in order to obtain an effect of greater width. The large semi-circular pediment probably

1485, LOMBARDO was asked to design and supervise the construction of the largest chapel in the church. Three years later the building was finished. In 1489 it was decided to erect an adjacent convent to be used by the Clarisse nuns of Murano.

■ FAÇADE AND EXTERIOR: the architectural arrangement of the façade is repeated in the rest of the exterior of this church. Santa Maria dei Miracoli is one of the few: free-standing churches in Venice and the only one entirely dressed in marble. On the whole, it looks much like a jewel-box or holy ark and houses the miraculous painting of the Virgin. The splendor of the marble – most of which was replaced during the

restoration done in the period 1883-87 – reflects the religious need to glorify the purity of Mary and her Son by means of the colored light, which is a manifestation of God. The divine origin of colors was well known to Franciscan theologians, as was the centrality of the Cross – of which St. Francis was particularly fond – a theme reiterated in the interior of the church. For that matter, the influence of the Franciscan order in naming and managing the church is well-known, and certain architectural solutions adopted are evident manifestations of the desire to use the "Byzantine" features of St. Mark's Basilica. LOMBARDO is certainly to be credited with

derived from the one in the San Nicoletto della Lattuga church, which no longer exists. The small lunette above the door once had two figures, while in the middle there is still a charming bust of the *Madonna and Child*, sculpted by the Greek GIORGIO LASCARIS, who signed the work with the pseudonym of PIRGOTELES. Above this is a red stone cross surmounted by an octagonal inlay of the same color, an obvious homage to Franciscan spirituality: eight is the number of divine perfection and eternity, and in this context represents God the Father. The tondi in the spandrels on all four sides of the church contain the busts of *prophets* supported by cherubs,

testifying to the knowledge of God, of whom they are the bearers of the "good tidings"; and Mary, to whom the church was dedicated, is their queen. The façade has statues of the Archangel Gabriel and Virgin during the *Annunciation*. In Venice this theme is closely connected to the mythical foundation of the city, which took place on March 25; however, it may also be a reference to the name of the church itself. The upper frieze of the façade is decorated with a series of facing griffins next to a roundel. At the sides of the huge lunette are the statues

288 LEFT AND **289** LEFT *CHANCEL PIERS*, DETAILS OF THE BASES.

288 RIGHT *MADONNA AND CHILD*, MIRACULOUS IMAGE ATTRIBUTED TO NICOLÒ DI PIETRO.

289 RIGHT THE INTERIOR, LOOKING TOWARD THE ELEVATED CHANCEL.

of two *angels in prayer* who are facing Jesus. There are two doors on the right-hand side of the church. In their lunette crown is the bust of a prophet, while the reliefs on the antae portray *St. Jerome, the baptism of Christ, St. Clare and St. Francis in prayer*. The left side, on the other hand, seems to rise magically from the canal alongside it.

INTERIOR: this has an aisleless nave and an elevated chancel. Above the entrance is the choir gallery for the Clarisse nuns, connected to the nearby convent by an overhead corridor, which no longer

exists. Among the many relief motifs on the two supporting pilasters, the one at right has the lovely figures of *Adam and Eve* and the *tree of Good and Evil*. The largest panels in the coffered ceiling contain a *Virgin and Child* flanked by *St. Francis* and *St. Clare* (late 16th century), the work of a Venetian Mannerist painter. The *busts of the saints and prophets* (1528) painted in the spacious wooden barrel vault are of uncertain attribution; among the artists is PIER MARIA PENNACCHI (1464 - ca. 1515) from Treviso. At the sides of

the steps are the statues of *St. Francis* and *St. Clare* by GIROLAMO CAMPAGNA (ca. 1549 - ca. 1626), which come from the 16th-century altars that have been removed.

The unusual and anachronistic elevated CHANCEL, typical of a Romanesque abbey church, was built not only to make room for the sacristy, but was also probably owing to the desire to hark back to the older doges' churches. At the end of the balustrades are two marvelous ambos with a lectern resting on an eagle. On the sides of the stairway, which was

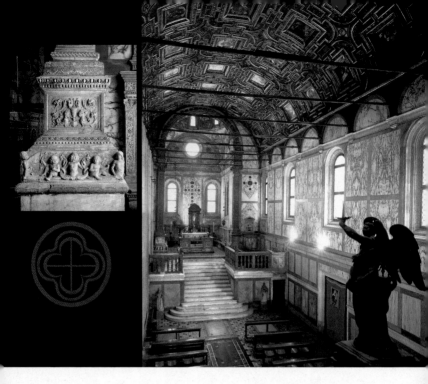

modified during the 19th-century restoration work, are four busts by TULLIO LOMBARDO of *St. Francis, St. Clare, the Archangel Gabriel and Mary*. The magnificent chancel, one of the masterpieces of early Venetian Renaissance architecture, underscores the Christological themes already introduced in the façade. The two tabernacles in the side walls once housed the Eucharist and relics. Their presence bears witness to the sacrifice of Christ and those who imitated him. To stress this point is the figure of the *Mystic Lamb*, sculpted in the keystone of the Corinthian triumphal arch. On a symbolic level, this sacrificial animal corresponds to the Eucharist chalice, and its

lofty position – *in excelsis* or on high in heaven – refers to the image of the risen and glorified Christ, in keeping with the narration in The Revelation of St. John the Divine. Its presence was certainly borne in mind by the person who conceived the series of prophets painted later on the ceiling. In fact, next to the Lamb is St. John the Baptist.

In this church, LOMBARDO uses the model already adopted in the chancel of San Giobbe Church, adding a tambour. The entire area – surrounded by a running stone bench – is filled with reliefs of Early Christian allegories taken from the classical iconographic repertory. The most interesting ones – portraying young winged

sea monsters – are sculpted along the base of the side pedestals supporting the pilasters of the triumphal arch. Above their double tails are seated putti, and in the background is a luxuriant garden in which we can make out some fig leaves. As in other Venetian churches or funerary monuments of that period, mermaids and tritons – the children of Neptune – could replace the prophets and sibyls, considered the messengers of Christ's coming. Inside the screen, beyond the side statues of *St. Peter* and *St. Anthony Abbot*, bronzes by ALESSANDRO VITTORIA (1524-1608), is the miraculous image of the *Virgin and Child* (1409), attributed to NICOLÒ DI PIETRO.

290 LEFT SAN CANCIANO CHURCH.

290 RIGHT PALAZZO SORANZO-VAN AXEL.

291 BARTOLOMEO LETTERINI, *MADONNA IN GLORY AND SAINTS*, SAN CANCIANO CHURCH.

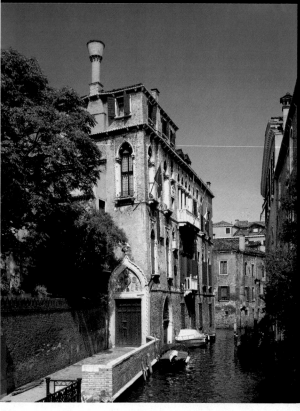

■ After your visit to the Miracoli church, take the Calle Caselli; at left you can see the main land entrance to **Palazzo Soranzo-Van Axel** (no. 6099). This building with an irregular plan was constructed in 1473-79 and is one of the most important examples of late Gothic civil architecture. The portal with an ogee arch, the balconies supported by lions' heads, the luxuriant foliage on the capitals of the quatrefoil windows overlooking the canal, and the lovely staircase, are all signs of sumptuousness and building and decorative skill that has

reached its apex. In the large inner courtyard are many Veneto-Byzantine paterae and a series of busts, statues and columns of different provenance, placed here in 1919 by the antiquarian Dino Barozzi.

Retracing your steps, at the end of Calle dei Miracoli, at left, is **Ca' Bembo** (no. 5999). Between the first and second floor is a curious mixture of 14th-, 15th- and 16th-century pieces probably commissioned by Gianmatteo Bembo, the nephew of the illustrious Cardinal Pietro Bembo. The statue in the niche portrays the fabulous wild man, or

homo silvanus, similar to the one in Campo San Trovaso. Instead of a club, this one is holding a solar disk, an allusion to the motto underneath that explains that "as long as the Sun revolves around the poles," some cities in which the patron occupied public offices "will bear witness to his acts." Passing through Campiello S. Maria Nova, turn left to get to the nearby **San Canciano** (or San Canziano) **Church**. HISTORY: the construction of the first church presumably dates back to 864, and according to tradition it was founded by citizens of Aquileia who had

MOLI sculpted the statue of San Maximus – the first bishop of Cittanova, in Istria – and the urn in which his remains lie. In the chancel, the 16th-century high altar is surmounted by an octagonal structure dating from the mid-18th century. The altarpiece, depicting God the Father and St. Canzio, St. Canziano and St. Canzianilla with the preceptor Proto (17th century), is attributed to PAOLO ZOPPO, from Brescia. The side paintings, *The Probatic Pond* and *The Multiplication of the Loaves*, were executed by DOMENICO ZANCHI (1747-1814). The chapel at left, dedicated to St. Venerando and then to the Holy Spine, contains a painting by NICOLA RANIERI depicting the Madonna and St. Filippo Neri (ca. 1635), which was commissioned by the parish priest Sebastiano Rinaldi. The Altar of the Immaculate Virgin, the second at left, was built in 1735 and financed by Flaminio Corner, historian of the Venetian Church and a resident of the nearby square named after him. Besides the Congregation of the Clergy (founded in 1200) and the San Filippo Neri devotional confraternity, San Canciano also housed the following Scuole: Santissimo Sacramento, the Madonna, San Massimo and San Rocco.

moved to the Venice Lagoon to escape from barbarian attacks. This was one of the churches under the jurisdiction of the patriarch of Grado, who lived in Venice. The building, renovated in 1330 and consecrated in 1351, was restored in 1550 and drastically rebuilt in the early 18th century by ANTONIO GASPARI – the church we see today.

FAÇADE: erected in 1706 (as the inscription tells us) thanks to a bequest from Michele Tommasi, the façade has six giant Doric pilasters and ends in a broken tympanum. The campanile

dates from 1532.
INTERIOR: the nave is bounded by two aisles marked off by Corinthian columns and ends in three areas with a flat back wall. The nave was elevated by GIORGIO MASSARI shortly after the mid-1700s. The four side altars (ca. 1730), dedicated to the Madonna, have canvases by GIUSEPPE ANGELI (ca. 1709-98) and BARTOLOMEO LETTERINI (1649-1745). The rich sculptural and stucco decoration in the right-hand chapel was commissioned by the Widmann family, whose palazzo overlooks the nearby canal. CLEMENTE

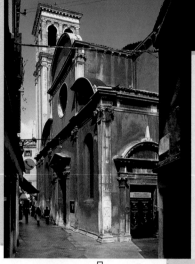

292 SAN GIOVANNI GRISOSTOMO CHURCH.

293 LEFT HIGH ALTAR AND APSIDAL CHAPELS OF SAN GIOVANNI GRISOSTOMO CHURCH.

293 RIGHT GIOVANNI BELLINI, STS. JEROME, CHRISTOPHER AND LOUIS.

SAN GIOVANNI GRISOSTOMO CHURCH

1 Giovanni Bellini, Sts. Jerome, Christoper and Louis
2 Sebastiano del Piombo, St. John Chrysostom and Saints
3 Pulpit commissioned by the parish priest Ludovico Talenti
4 Tullio Lombardo, Coronation of the Virgin

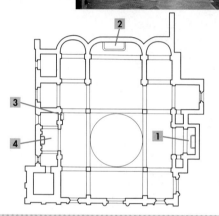

■ Once out of San Canciano, go down the Salizada di S. Canciano and, at Campiello Flaminio Corner, turn left until you arrive at the church of **San Giovanni Grisostomo**. HISTORY: this church dates from 1080, was destroyed by fire in 1475 and rebuilt by MAURO CODUSSI from 1497 on. When the architect from Bergamo died in 1504, the church was finished by his son DOMENICO and was consecrated in 1525. FAÇADE: the four pilasters with molded sides do not stand on pedestals. The frieze is interrupted by pulvins at the level of the Corinthian capitals. The trilobate pediment drew inspiration from Leon Battista Alberti, and the portal has an embrasured rose window over it. The bell-tower dates form the late 16th century. INTERIOR: drawing inspiration from the central cupola at St. Mark's and the layout of other ancient Venetian churches, CODUSSI designed a Greek cross plan around a blind cupola supported by tall arches. His choice fit in with the Byzantine origin of St. John Chrysostom, one of the Greek Doctors of the Church The austere volume is articulated in cubical sections connected by a network of Corinthian pillars on tall pedestals, round arches, and barrel and cross vaults. In the top part of the inner façade are the canvases that were once on the doors of the 16th-century organ that no longer exists; they are by the Bellini-influenced GIOVANNI MANSUETI (active in Venice from 1485 to ca. 1526), who painted St. Onophrius, St. Agatha, St. Andrew, and St. John Chrysostom (1504 - ca.1516). St. Onophrius was the co-titular of the parish and patron saint of the confraternity of the Tentori (dyers of fabrics, covers and sheets) that later moved to the church of Santa Maria dei Servi, in Cannaregio. In 1516 one of this anchorite's fingers was donated to the San Giovanni Grisostomo church. At right is a niche with the 18th-century bust of the Madonna delle Grazie, since 1918 the object of worship.

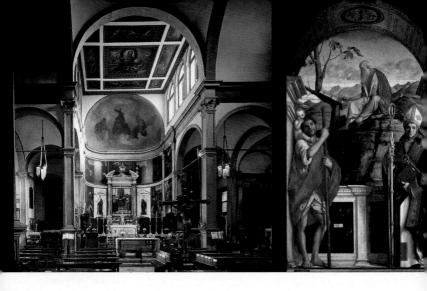

In the nearby chapel, used by the Intaiadori e Scultori in legno (Wood Carvers and Sculptors), is the magnificent altarpiece, *St. Jerome, St. Christopher and St. Louis* by the octogenarian GIOVANNI BELLINI (signed and dated 1513), commissioned by Giorgio Diletti (d. 1503). The three figures are framed by a massive arch coated with a mosaic with gold tesserae and with a polychrome balustrade in front of it. The two-fold reference to the Byzantine world and to the holy area of an ideal divine building is not new to Bellini and mirrors a major aspect of Venetian culture, which grew stronger after the fall of Constantinople in 1453. The three saints, selected by the patron Diletti (who did not choose his own patron saint), have been attributed with manifold and complex meanings, for the most part the result of arbitrary, sometimes far-fetched, theories. St. Christopher and St. Louis certainly embody two modes of active life, while St. Jerome, confined in the desert, was engaged in contemplation and, in particular, was taken up with the mystery of good and evil, as the fig tree (the symbol of Eden) with an incunabulum seems to tell us. The Greek inscription on the intrados of the arch belongs to the same context. It corresponds to the second verse of Psalm 14, evoking the contrast between the righteous and evildoers. To the left of the chapel is a small and elegant pulpit (dated 1525) financed by the parish priest Domenico de Bartolomei, over which is a statuette of St. Dominic. The next chapel, built by the Civran family in 1679, has, in the frontal, a charming relief, *The Flight from Egypt*.

Circling to your right, past the rear Chapel of the Blessed Virgin of the Rosary is the chancel. The high altar boasts the altarpiece painted by SEBASTIANO DEL PIOMBO before he moved to Rome: *St. John Chrysostom and Six Saints* (1510-11). This canvas, commissioned by Caterina Contarini, exalts the figure of the titular of the church, depicted while writing notes on a volume in Greek. This saint, who lived in the 4th century and was patriarch of Constantinople, was famous for his skill in oratory, hence the name Chrysostom, or "golden mouth." The church has an important relic of this saint that arrived here in 1204. DEL PIOMBO's painting distinguishes itself for its composition and light effects. The saints at the sides form the two conventional converging wings but are not positioned symmetrically. Furthermore, the saint, instead of being portrayed frontally, is seen in profile, and the front part of his face is shadowed.

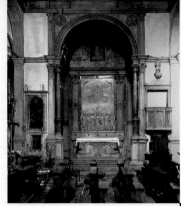

294 LEFT CAPPELLA BERNABÒ.

294 RIGHT AND 295 BOTTOM SEBASTIANO DEL PIOMBO, ST. JOHN CHRYSOSTOM AND SAINTS, AND DETAIL OF SAME.

295 TOP TULLIO LOMBARDO, CORONATION OF THE VIRGIN, DETAIL.

On the wall of the apse is a cycle of 16th- and 17th-century canvases, perhaps commissioned by the Scuola del Santissimo Sacramento, founded in the early 16th century. The episodes illustrated concern the life of St. John Chrysostom and Jesus Christ. On the ceiling is *God in Glory* (1674) by GIUSEPPE DIAMANTINI. On the frontal of the high altar there is *The Deposition of Christ*, a 17th-century relief which depicts, at right, the Virgin Mary swooning. On the left wall of the church is the pulpit (1503) commissioned by the parish priest Ludovico Talenti, surmounted by a statuette of the Madonna and Child. Talenti was a promoter and governor of the church designed by Codussi. In fact, thanks to his efforts, the pope granted an indulgence of ten years to collect the funds needed for the construction of the church, and he probably furnished the theological inspiration for the altarpieces by Bellini and Del Piombo.

At left is the chapel built for Giacomo Bernabò, a member of a family of rich silk merchants. The lavish architecture, whose elements were the work of several sculptors, is by CODUSSI and dates from 1499-1500. The triumphal arch opening is accentuated, at the sides, by the combination of a pilaster and a column on a cylindrical pedestal – an invention already adopted for the opening of the Clock Tower in Piazza San Marco. The marble altarpiece signed by TULLIO LOMBARDO and dated 1500-02, depicts *The Coronation of the Virgin* in an unusual iconographic scheme. Usually this episode takes place in the sky, which in this context is represented by the coffered barrel vault, on which appear God and the dove of the Holy Ghost, surrounded by angels. Here, on the contrary, Mary is kneeling before her Son. Her long, flowing hair is a feature typical of Mary Magdalene rather than of the Virgin Mary. In general, the apostles – after whom the chapel was named – witness Mary's Ascension, while in this chapel one is reminded

more of the Pentecost. At right is an apostle with Christ's features. This is James the Less, also known as Christ's "double." This was known to the artists of the time, but it may be that Tullio Lombardo wanted to pay homage to the patron of the chapel and his altarpiece, which has the same name. In the lunette there is an icon in relief of the Mother of God praying (13th century). The church had a great influence on local religious sentiment. Among the guilds that had their headquarters here, there were the Naranzeri (fruit vendors); the Passamaneri (makers of braids, ribbons, tassels and tapes), founded in 1593 and transferred to the Gesuati church; and the Scuole or confraternities of St. Anthony of Padua (perhaps the oldest in Venice), St. Anne, St. Joseph and the Santissima Croce.

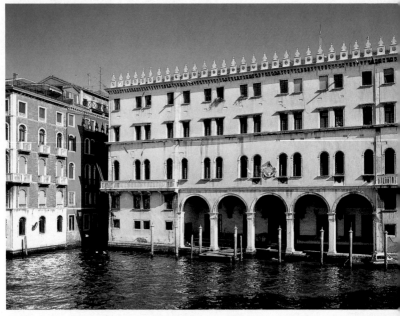

■ After leaving from San Giovanni Grisostomo by the side door, at left you can see what remains of the old Ufficio della Seta (silk bureau). In the early 1300s this district of Venice took in the Guelph citizens of Lucca, who specialized in silk manufacture. To your right, the year 1528 is carved above the entrance to the Corte seconda del Milion (or del Forno), and the year 1515 is inscribed at no. 5864. Just above this is a 19th-century plaque indicating that this was the house of Marco Polo, the Venetian traveler and merchant who dictated to Rustichello da Pisa a long and detailed account of his life and travels in the Orient. The Polo family houses were destroyed by fire in 1475. Proceed left to the access courtyard of the **Teatro**

Malibran, the famous theater inaugurated during the 1678 Carnival by the patricians Giovanni Carlo and Vincenzo Grimani, rebuilt in 1834, and completely renovated in 1919-20 to a design by the engineer MARIO DONGHI and with paintings by GIUSEPPE CHERUBINI. Go along the side of this building and turn right; the arcade there takes you to the Corte seconda del Milion. On the façades of the buildings are some Greek marble 12th-

century paterae. Number 5845 is the so-called House of Marco Polo (with some 14th-century remains) and, next to no. 5858, in the first arch of the arcade, you will see reliefs of animals enclosed in spiral plant motifs (late 13th century). In the nearby Fondamenta, on the Neo-Classic façade (ca. 1839) of the theater (no. 5850/B), there is another plaque (1881) indicating Marco Polo's house.
Along the Rio de San Lio

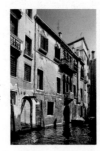

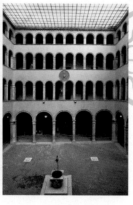

you can see, at left, the lovely façade of **Palazzo Bragadin-Carabba** (second half of the 15th century). Returning through Corte prima del Milion, turn left into Calle del Cagnoletto and go to Corte Morosini. Under the cusp of the entrance is a small 13th-century *patera* with two facing peacocks and, in the lunette, a high relief of a *crescent-shaped coat of arms* on a helmet with a drape (14th century). This charming, irregularly shaped courtyard with a brick pavement is surrounded by the **Case Morosini**, the main nucleus of which Marino Morosini founded in 1369. Along the walls are 11th-13th century *paterae* and Gothic windows dating from different periods. Retrace your steps toward Salizada San Giovanni Gristostomo

and turn right and stop at Ponte de l'Olio. To the left of this bridge, along the canal, you will catch a glimpse of the rich and elegant **Palazzo Amadi** (mid-15th century), which belonged to the family that promoted the construction of Santa Maria dei Miracoli Church. The water entrance has a beautiful pointed arch, over which (on the *piano nobile*) is a trefoil window with capitals in the shape of leaves dating from 1430-40. Once past the bridge you are in the San Marco district, and no. 5554 affords access to the courtyard of the **Fontego** (or Fondaco) **dei Tedeschi**, the most important of the warehouses and offices the Venetian Republic provided for foreign merchants. The earliest information regarding this *fondaco* dates

from 1228. The building was destroyed by fire in 1505 and was rebuilt – to a design by GIROLAMO TEDESCO – by GIORGIO SPAVENTO and ANTONIO ABBONDI (known as LO SCARPAGNINO) in 1505-08. The edifice stands out for its austere style and the functionality of its rooms, which were used as warehouses, offices and also lodgings for the German merchants. It is worthwhile exiting by the side door, because the outer entrance of the Fontego, attributed to SCARPAGNINO and dated 1507, has fluted Corinthian columns and is crowned by a *rampant Lion of St. Mark*. Only fragments remain of the frescoes by GIORGIONE and TITIAN that decorated the main façade of the Fontego, which are held elsewhere.

299 TOP PALMA GIOVANE,
PUNISHMENT OF THE
SERPENTS AND DETAIL, SAN
BARTOLOMEO CHURCH.

299 BOTTOM SAN
BARTOLOMEO CHURCH, SIDE
ENTRANCE.

■At the end of the alley opposite is the small side entrance to **San Bartolomeo Church**. HISTORY: according to tradition, this church dates from the year 840 and was dedicated to St. Demetrius, a martyr in Thessalonica. The church was renovated in 1170 and restored in the first half of the 18th century. EXTERIOR: the *bell tower* (1747-54) with an octagonal "onion" cusp was built by GIOVANNI SCALFAROTTO; above the rusticated entrance is a grotesque *mask* with an aureole. This deformed face may allude to the suffering of St. Bartholomew, who was whipped and then skinned alive. INTERIOR: the broad vestibule with two side chapels is connected to the nave with two aisles marked off by Corinthian half-columns placed against piers. The short transept is crowned by a dome on an octagonal drum and merges with the three rear chapels with straight back walls. On the right side of the vestibule is the sumptuous, polychrome marble Baroque *Chapel of the Crucifix*, the image of which was executed by a 17th-century sculptor. The two side marble statues – a *grieving Madonna* and *St. John Evangelist* (second half of the 17th century) – are signed with the initials of the Flemish sculptor HEINRICH MEYRING. The first altar in

the RIGHT AISLE, with four composite columns (ca. 1569), was built by the Arte di Portadori e Travasadori e Venditori da Vin (guild of transposrters, wine decanters, wine and wine vendors), founded in 1568 and whose members were devotees of All Saints' Day. The altarpiece by LATTANZIO QUERENA depicts *The Death of Francisco Saverio* (1836). The second altar hosted the guild of the Bombaseri (cotton-wool beaters and vendors of balls of cotton-wool and yarn), devotees of St. Anne and Archangel Michael. This latter saint is portrayed in the altarpiece (1798) by PIETRO NOVELLI. At the head of the RIGHT TRANSEPT is the entrance to the sacristy, through which one goes up to the Scoletta della Nazione Tedesca. This hall boasts a cycle of canvases on the *life of the Virgin Mary*. Above the exit portal of the SACRISTY is a large canvas by a follower of Tintoretto, SANTE PERANDA (1566-1638), depicting a spectacular and crowded composition, *The Gathering of the Manna*, a subject that prefigures the Eucharist. The right-hand rear chapel once housed the *Annunciation* altarpiece by JOHANN ROTTENHAMMER. The *Annunciation* and the delicate *Visitation* on the side walls are by MICHELANGELO

MORLAITER (1729-1806) and SANTE PERANDA respectively. In the CHANCEL, the early 18th-century *high altar*, the work of HEINRICH MEYRING, was officiated by the Scuola del Santissimo Sacramento. However, the three canvases (1593) by PALMA GIOVANE and the fresco on the ceiling by MICHELANGELO MORLAITER, instead of exalting the Eucharist, celebrate the figure of St. Bartholomew, to whom this church was dedicated.

Past the left-hand rear chapel, in the upper part of the head of the transept, is the grandiose *Miracle of the Bronze Serpent* (ca. 1595-1600) by PALMA GIOVANE. This subject prefigures the theme of the Cross as a sign of salvation. In the LEFT-HAND AISLE, after the altar with the titanic, Titianesque *St. Matthew* by LEONARDO CORONA of Murano (d. 1605), you will see the side entrance of the church, over which is a sweet *Dormition of the Virgin* by PIETRO MUTTONI, known as PIETRO DELLA VECCHIA (1603-78). In the vestibule of the church, the chapel at right, dedicated to San Niccolò, was used by the corporations of Bastazi and Sagadori (public grain vetters and bale porters) and, up to about 1692, by the Stagniari and Peltreri (tinsmiths and vendors of tin and pewter objects).

300 LEFT ANTONIO ZOTTO, CARLO GOLDONI MONUMENT.

300 TOP RIGHT CAMPO SAN BARTOLOMEO.

■ Leaving San Bartolomeo by the side door, proceed right to Campo San Bartolomeo. On the façade of **Palazzo Moro**, through which the Sotoportego del Pirieta arcade runs, there are important archaic Gothic capitals with rosetta or leave motifs. The *pirieta* was an artisan who made tin objects such as funnels. The **Monument to Carlo Goldoni** (1883), the famous playwright and ironic interpreter of 18th-century Venetian society, was sculpted by ANTONIO DAL ZOTTO.

Now go down Calle de la Bissa, which was once inhabited by Luccans. Its name derives from the word *biscia* (grass snake) because the street winds so much. On the nearby Ponte di S. Antonio at right, is the birthplace (no. 5613) of Riccardo Selvatico (1849-1901), the enlightened mayor of Venice and one of the founders of the Biennale Art Exhibition. Along the same side of the canal is **Palazzo Gussoni**. Its narrow and asymmetrical façade in polychrome marble and Istrian stone (late 15th century) was probably commissioned by Senator Jacopo Gussoni, the owner of a chapel behind the chancel in the neighboring church of San Lio.

■ After crossing over San Antonio bridge (which marks the beginning of the Castello district), turn immediately right into Campo San Lio and proceed to the **church of Santa Maria della Consolazione**, known as **Santa Maria della Fava**. HISTORY: the Amadi family, which lived along the nearby Rio del Fontego dei Tedeschi canal, put on outdoor display an icon of the Madonna which, with time, became increasingly popular. In 1480, by means of a decision like the one that led to the foundation of Santa Maria dei Miracoli Church, the patriarch granted authorization for the building of a wooden chapel where the icon could be placed. Since this building was constructed on the site of present-day Campo de la Fava, both the chapel and the future church were named after the Madonna della Fava. The official title – Santa Maria della Consolazione – refers to the Visitation of Mary to Elizabeth, a subject which Christians link with the theme of charity and works of compassion. Later on, the chapel was granted to the lay confraternity of St. Philip Neri. The Venetian congregation was founded in 1661 thanks to the initiative of the priest and painter Ermanno Stroiffi, one of whose paintings is in San Lazzaro dei Mendicanti Church. The first stone of the building we see today was laid in 1705 and

construction was carried out in two distinct periods. The design and supervision in the first phase (1705-15) were entrusted to ANTONIO GASPARI, while the second phase (1750-53) was supervised by GIORGIO MASSARI, who designed the chancel with the dome, the six altars and the ceiling. FAÇADE: this is unfinished. Note the tall stairway leading to the entrance – modeled after the nearby church of San Salvador and, to a lesser degree, the Redentore – and the monumental cornice of the portal, which is partly Palladian. The shell in the lunette is an allegory of the Virgin Mary. INTERIOR: the aisleless nave with rounded-off corners, the six side chapels, and the large chancel with a flat back wall, designed by GASPARI and reflecting the artistic policy laid down by the Council of Trent, were later adopted by MASSARI in the Gesuati Church on the Zattere. The walls bear enormous pilasters of a composite order on pedestals, which are staggered with niches containing the elegant statues of the four Evangelists and four Doctors of the Church in the West, the work of GIUSEPPE BERNARDI, known as IL TORRETTO (ca. 1694-1774). Among the Doctors, the figures of St. Gregory the Great in papal attire and St. Jerome are situated near the chancel. The high reliefs depicting scenes from the life of St. Philip Neri are ascribed to the same sculptor, who was Canova's teacher. The altarpieces in the side chapels are dedicated to the Madonna, whose cult was particularly dear to the members of the Philippine order and to St. Philip Neri himself, who was a friend and advisor of St. Charles Borromeo and who was canonized in 1622. The chapels communicate with one another and have a blind window that crowns a gilded wooden panel with rich high-relief decoration. The four stars on the corners and the dilated heart in the middle allude respectively to St. Philip Neri's veneration of Mary and to the spiritual ecstasy he achieved.

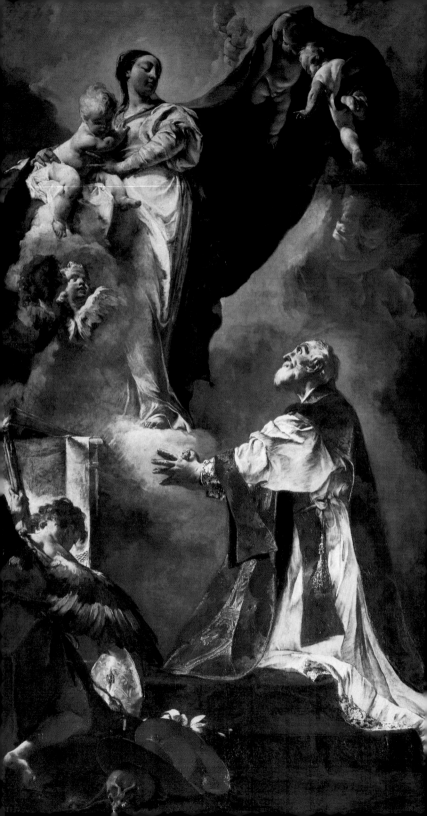

302 AND 303
GIAMBATTISTA
PIAZZETTA,
APPARITION OF THE
VIRGIN TO ST. PHILIP
NERI AND DETAILS.

In the first right-hand chapel there is a splendid canvas, *The Education of the Virgin* (ca. 1732), an early work by GIAMBATTISTA TIEPOLO. This subject, drawn from the apocryphal Gospel, shows the young Mary, wrapped in white silk garb, being taught how to read by Anne, her old mother. This scene was a favorite among the Philippine friars, who were famous for their didactic activities with children. The next chapel has the small, miraculous icon of the Amadi family for which the church was built. It lies in a Baroque marble frame with angels and portrays a *Madonna Odighitria* (15th century?) showing the Infant Jesus the path to salvation. The subject of the lovely, radiant altarpiece behind this, executed with large background areas by JACOPO AMIGONI, is the *Visitation* (1743) and represents the moment when Mary sings the Magnificat. The altarpiece in the third chapel, *The Madonna and Child with St. Gregory Barbarigo* (1761) is by GIAMBETTINO CIGNAROLI (1706-70). The Venetian prelate, the bishop of Padua, is kneeling in front of the young Virgin Mary at the foot of the altar, who

symbolizes Charity. On the pavement opposite this chapel is the tomb of the printer and book dealer Giambattista Albrizzi, which also contains the remains of his friend Giambattista Piazzetta (d. 1754).

A little farther on is the corridor leading to the SACRISTY, with 18th-century wooden furnishings, among which there stands out the credenza with a carving of *The Ecstasy of St. Philip Neri*, in which the saint is held up by angels flanked by two hearts, his attributes. When leaving the sacristy you will see paintings in the corridor at right, among which, on the left wall, is an *Adoration of the Magi* attributed to BENEDETTO CALIARI (second half of the 16th century) and a *Madonna and Child with St. Jerome and St. Catherine of Alexandria* by the Bellini school. Back in the church proper, there are works worthy of note in the CHANCEL: in addition to the organ (1754) by PIETRO NACHINI, on the high altar are the statues of two *angels* by GIANMARIA MORLAITER (1699-1792), and the sumptuous *frontal* (1738) made of gilded copper and silver, designed by GIORGIO MASSARI and executed by the goldsmith

PIERO GRAPPIN. Along the left side of the chancel is the *Crucifixion* by GREGORIO LAZZARINI (1655-1730). In the next chapel, GIAMBATTISTA PIAZZETTA painted the fascinating altarpiece of the *Apparition of the Virgin to St. Philip Neri* (1726). As if by magic, Mary materializes above the mensa of an altar covered with thick, cottony clouds. The special lighting effects are obtained thanks to the incomparable color scheme and subtle layers of yellow, ocher and siena. The Mother of God, despite her rather haughty expression – like that of an inaccessible noble woman – cannot be indifferent to the prayers of the saint, who is so motivated by faith and humility. On the stairs are a lily, a mitre, two cardinal's red hats, and a skull to remind us of the purity of Philip Neri, his meditations on vanity and his refusal to accept ecclesiastical offices. In the altarpiece of the third altar, JACOPO AMIGONI painted a *Madonna and Child with St. Francis of Sales* (1743). The bishop of Geneva, who earned a law degree at the University of Padua and was canonized in 1655, suggested to Giovanna Francesco Chantal to found the Order of the Visitation.

304 LEFT SAN LIO CHURCH.

304 RIGHT AND 305 BOTTOM TIZIANO VECELLIO, *SAN GIACOMO MAGGIORE* AND DETAIL, SAN LIO CHURCH.

305 TOP PIETRO LOMBARDO, *ST. MARK*, SAN LIO CHURCH.

■ After your visit to Santa Maria della Fava, retrace your steps and go to the **Chiesa di San Leone IX**, better known as **San Lio Church**. HISTORY: this church was perhaps founded in the 9th century and was rebuilt in the 16th century, consecrated in 1619 and restored in 1783, as a plaque tells us. FAÇADE: the modest façade has a lovely 16th-century Doric portal whose two fluted half-columns on pedestals and Attic base are similar to the drawing published in Andrea Palladio's 1570 treatise. Among the reliefs on the metopes one can recognize the papal insignias, an allusion to the titular of the church, Pope Leo IX. INTERIOR: the aisleless nave has four sumptuous side altars, an apse and a chancel with a flat back wall. On the ceiling, GIANDOMENICO TIEPOLO frescoed the *Apotheosis of St. Leo in Glory and the Exaltation of the Cross* (late

18th century). The angels are lifting the pope toward heaven and he is followed by his insignias; in the middle are the dove of the Holy Ghost and God the Father with his hand resting on the enormous cross of Christ. The Son of God is absent, but is referred to by the Eucharistic chalice below. The monochrome tondi represent the cardinal virtues in pairs: at the entrance are *Fortitude and Temperance* and, toward the altar, *Prudence and Justice.* Among the corner monochromes, which are partly damaged, the one in the back to the right depicts the insignia of the papal office supported by angels.

The lower part of the inner façade around the entrance is entirely occupied by tall wooden credenzas set into the wall and two long benches opposite them. These pieces of furniture were used by the corporations and confraternities as containers

for their precious vestments and liturgical objects. One of the wardrobes, which belonged to the Scuola del Santissimo Sacramento, has a plaque representing a chalice and bearing the date 1774. Above the entrance is a fine *organ* made by GIOVANNI CALLIDO in 1784. The choir parapet is divided into panels with scenes from the *life of David* painted by GAETANO ZOMPINI (1700-78). In the central panel – *David's Triumph* – the young shepherd displays the severed head of Goliath to the women of Israel, who are singing and dancing. Past the altar of St. Catherine of Alexandria, who was the first patron saint of this church, along the right-hand wall is a *Last Supper* (second half of the 16th century) attributed to MARCO DEL MORO, who was much influenced by Tintoretto and Veronese. On the second altar, which housed the body of St. Faustina, there is the altarpiece, *Apotheosis of St.*

which the three donors of the work are also portrayed. On the ceiling, the canvas of *Elijah Comforted by the Angel*, attributed to the Tiepolesque artist PIETRO MORO, is a Eucharistic prefiguration taken from the Old Testament. On the left pillar of the chancel is a 16th-century Cretan school icon of the *Virgin of the Passion*. The Christ Child is squeezing his mother's thumb and one of his

John Evangelist and St. Joseph with Other Saints, dated 1779 and signed by PIER ANTONIO NOVELLI. The first rear chapel, dedicated to the Madonna Addolorata, was designed by PIETRO LOMBARDO and assistants. The organization of the space is modeled after the central cupola of St. Mark's and "updated" with Renaissance stylistic elements and symbols that exalt the Passion of Christ. The bucranium and burning vase sculpted in relief on the two pilasters that frame the chapel are humanist symbols of sacrifice, and the eagle on the top of the arch alludes to the Ascension. The cupola is supported by large arches. The *four gilded Evangelists* on the spandrels represent the triumphal chariot of the Lord described in *Revelation* and *Ezekiel*. Along the base of the cupola is the fresco of the *prophets and angels with the instruments of the Passion*. The ribs of the

vault merge in a central medallion with the figure of a *benedictory God the Father*. The marble relief above the altar depicts a touching *Pietà with Saints* attributed to TULLIO LOMBARDO. The Madonna, made old both by her age and grief, has her mouth slightly parted. Among the saints are St. Nicholas with the three balls of gold and St. Helena, who is supporting the Cross. The terracotta tomb is traditionally considered to be Canaletto's. In the CHANCEL there is *The Dead Christ Held up by Angels and Adored by St. Leo and other Saints* (1615-19) by PALMA GIOVANE. On the right-hand wall is *Christ Washing His Disciples' Feet* (17th century) by the miniaturist ALESSANDRO MERLI, while at left, PIETRO MUTTONI (known as PIETRO DELLA VECCHIA) (1603-78), a pupil of Padovanino, painted a crowded and agitated *Crucifixion* (dated 1630) in

sandals falls off his foot as he sees the prefiguration of his future death on the Cross. The left rear chapel has a good canvas attributed to LUDOVICO GALLINA, *St. Barbara, St. Vincent Ferrer and St. Luigi Gonzaga*. Go past the sacristy door, crowned by the *Monument to Andrea Pisani* (d. 1669), and the altar of the Madonna of Loreto. Above the small altar there is a lovely pulpit with scenes from *Revelation* (such as *The Triumph of Faith*) attributed to GAETANO ZOMPINI (1700-78). The next altar was used by the guild of the Capelleri (woollen and fur hat-makers), devotees of the Apostle James the Major, portrayed here in a badly damaged canvas by Titian (ca. 1565) in the typical garb of a pilgrim.

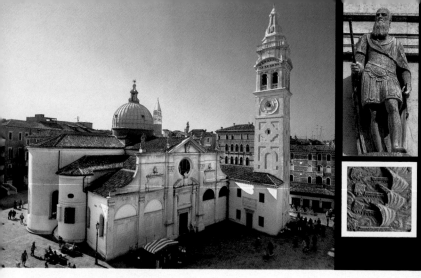

Having finished your visit of San Lio, go along the left side of the *salizada*, where you will see interesting types of minor 13th- and 14th-century architecture, in particular, two ancient types of double lancet window. One is Romanesque (12th or 13th century) and is in the small building crossed by Calle de le Vele (no. 5662); it has an elevated arch and a chalice-shaped capital. The other window is farther on, at no. 5690, and has a capital with tracery modeled after Byzantine or Ravenna capitals. Go down **Calle del Paradiso**, which is lined with buildings with wooden corbels. These buildings are connected at the bridge by a 15th-century Gothic arch, on both sides of which is a relief, in a lunette, of the Madonna of Mercy. On the inner side, two young nobles, a boy and girl, are at the Madonna's feet; thanks to their coats of arms, they have been identified as Pellegrina Foscari and Alvise Mocenigo,

who were married in 1491. However, the relief has stylistic features typical of an earlier period. Abreast of no. 5745 are the small walled pilasters of an old workshop that existed before the street was raised.

Once past the bridge, we arrive at the nearby **Santa Maria Formosa Church**. HISTORY: traditionally the church is considered one of the eight mother churches founded by St. Magnus in the 7th century. According to local legend, for the choice of the site, the bishop of Oderzo was guided by a white cloud from which the Virgin Mary appeared to him in an "indistinct form" – hence the name Formosa and the dedication to Purified Madonna, also known as Madonna della Candelora. Her feast day is February 2nd, and in paintings she is traditionally depicted in Jesus' Presentation at the Temple. In 943, while a procession of brides was going to the

Castello district to receive the bishop's benediction, the women were kidnapped by men from Trieste. The kidnappers were chased by the Venetians and caught at Caorle, where a furious battle broke out in which the Casseleri (chest-makers) distinguished themselves, managing to save the women and take them back to Venice. In commemoration of this event, which took place on the eve of the Candelora, or Candlemas, the doge would go every year to visit the church of the Casseleri. This gave rise to the feast of the Marys, during which the most beautiful girls in the city were received in the Doges' Palace by the doge himself, who then accompanied them in a procession to the Castello district, to the Basilica, along the Grand Canal and lastly to Santa Maria Formosa. In 1175 the church was rebuilt, modeled after the central Greek cross plan of St. Mark's. In 1492, thanks to a generous

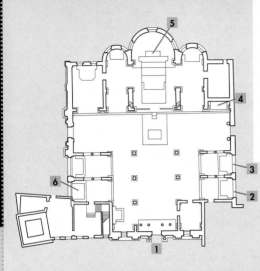

SANTA MARIA FORMOSA CHURCH

1 *Funerary Monument of Vincenzo Cappello*
2 Bartolomeo Vivarini, *Madonna of Mercy Triptych*
3 Palma Giovane, *Pietà and St. Francis*
4 Palma Vecchio, *St. Barbara Triptych*
5 Giulia Lama, *Madonna and Child with Saints*
6 Frutarioli (Fruit Vendors) Altar

306 LEFT SANTA MARIA FORMOSA CHURCH.

306 TOP RIGHT STATUE OF VINCENZO CAPPELLO.

306 BOTTOM RIGHT DETAIL OF THE FUNERARY URN OF VINCENZO CAPPELLO.

bequest by Andrea Bragadin, the church was rebuilt by MAURO CODUSSI (d. 1504). EXTERIOR AND FAÇADES: the 17th-century campanile was rebuilt to a design by FRANCESCO ZUCCONI, who introduced, perhaps for the first time, reliefs (along the canna) and a singular rounded cusp. The grotesque mask above the entrance of the campanile represented the deformed face of a leper. The building nearby (no. 5268 A/B) once housed the Scuola dei Casseleri e Frutarioli (fruit vendors). The façade overlooking the canal and the monument to Vincenzo Cappello (d. 1541) were built in 1542 in memory of this famous admiral of the Venetian fleet. This façade has four Corinthian pilasters on tall pedestals and is crowned by a pediment containing the family coat of arms. Between the portal with two Ionic columns and the sarcophagus is a connecting base with a relief of the flagship, flanked by dolphins and Neptune's trident. The statue of Cappello, who is depicted dressed as a Roman military leader holding a commander's baton, is signed by DOMENICO DI PIETRO GRAZIOLI DA SALÒ, a follower of Sansovino. The façade facing Santa Maria Formosa square was also built by the Cappello family, but this time toward the end of the 16th century. The four side arches are separated by Ionic pilasters, while the central section is delimited by two giant composite pilasters and crowned by a small pediment with the statues of the three theological virtues.
INTERIOR: in his construction of the interior, CODUSSI probably used the foundations of the earlier chancel and its side chapels, and rebuilt the apses (which can be seen from the square) and the wide transept. He also enlarged the church in the direction of the canal, creating a longitudinal plan on which he added four deep side chapels separated, along the dividing wall, by an elegant double-lancet window. This latter is the only decoration – which is extraordinarily creative – granted by the architect from Bergamo who, drawing his inspiration from the principles laid down by Leon Battista Alberti, organized the entire church in cubic sections with a network of austere columns connected by arches. In the inner façade of the right aisle is the funerary urn of Vincenzo Cappello (1541), under which is a bas-relief of a fleet of Venetian galleys in attack formation.

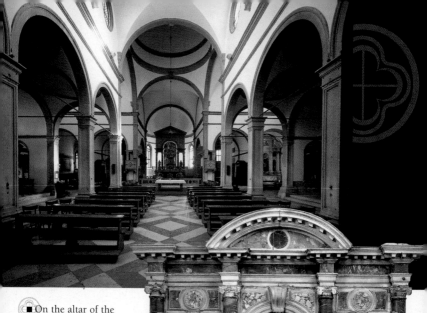

■ On the altar of the first chapel at right, used by one of the oldest Congregations, there is the wooden panel *Madonna of Mercy* triptych by BARTOLOMEO VIVARINI (signed and dated 1473). In the middle, under the Madonna's mantle, are some figures, among whom is perhaps the donor of the work, the parish priest Vettor Rosati. The two wings illustrate two major episodes in the cult of the Immaculate Conception, to which this chapel was dedicated. At left is *The Meeting of Anne and Joachim under the Golden Gate*. According to the legend, which was also painted by Giotto at Padua, Mary's conception took place when her parents embraced and kissed. The panel at right, on the other hand, describes *The Birth of Mary*.

In the Chapel of Our Lady of Sorrows, the altarpiece with a *Pietà and St. Francis* (early 17th century) is a work by PALMA GIOVANE that was poorly restored in the first half of the 19th century. The frontal in relief represents another Pietà, with Mary in the guise of the Mater Dolorosa. On her breast are the seven swords symbolizing the seven sorrows she suffered during the Passion of Christ, which had been prophesied by the old Simeon. Before continuing, note, in the middle of the transept, the cupola rebuilt by the engineer ALDO SCOLARI in 1921 after the Austrian bombardment of 1916.

The right-hand section of the transept has the altar of the Scuola di Santa Barbara, renovated by GIUSEPPE TORRETTO and GIOVANNI FREGON in 1719. The relief on the altar frontal represents *The Martrydom of St. Barbara*, who was decapitated by her father, who is seen at right fleeing, about to be struck down by divine lightning. Because of the thunder, this saint was the patron of Venetian artillerymen, called

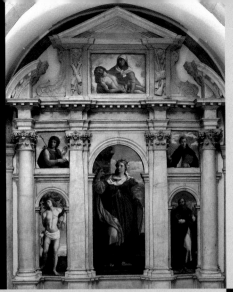

Holy Sacrament boasts the lovely statue of *Christ the Redeemer* (second half of the 16th century) above the tabernacle by GIULIO DEL MORO. In the left transept, the mediocre canvas above the double-lancet window painted by BALDASSARE D'ANNA is interesting for its subject matter: *Pope Pius Approving the Foundation of the Charitable Institution for the Liberation of Slaves* (signed and dated 1619). After the Chapel of the

308 TOP NAVE OF SANTA MARIA FORMOSA CHURCH.

308 BOTTOM AND 309 BOTTOM B. VIVARINI, MADONNA OF MERCY TRIPTYCH.

309 TOP PALMA VECCHIO, SANTA BARBARA POLYPTYCH.

bombardieri, whose Scuola was founded in 1500, with headquarters in the building next to the main façade of the church (no. 5266). The beautiful polytypch by PALMA VECCHIO shows St. Barbara with St. Sebastian, St. John the Baptist, St. Anthony Abbot and St. Vincent Ferrer (ca. 1509). In the middle of the painting, at the foot of the imposing figure of the saint, are two guns and a mortar. The tower behind her is the one in which she was imprisoned by her father. At left is the rear Chapel of St. Lorenzo Giustiniani. The statues of the saints were sculpted by GIROLAMO CAMPAGNA (ca. 1549-1626). The high altar, a triumphal arch, was rebuilt by FRANCESCO SMERALDI (known as IL FRACA) in

1592 for the Scuola del Santissimo Sacramento. The altarpiece, situated in the back, was painted by GIULIA LAMA, a parishioner and pupil of PIAZZETTA, and represents *The Madonna and Child with Saints* (1722). As the legend of the foundation of the church relates, the Virgin appears in glory on a cloud, and an angel presents her with the model of the church sent by St. Magnus, who is portrayed farther below in episcopal garb. The rear chapel at left, patronage of which was granted to the Grimani family, who lived in nearby Ruga Giuffa, was named after the painting on the altar, the *Madonna del Parto* (second half of the 16th century) and was used by the Casseleri (chest-makers) guild. The Chapel of the

Presentation of Jesus in the Temple is the Chapel of the Sacred Heart, which has the late 16th-century altar of the Frutarioli (fruit vendors) corporation, which was established in 1414 and whose patron was St. Jehosaphat, King of India. On the frontal is a high relief with charming putti with baskets of fruit. You should also visit the nearby sacristy and the oratory above it, which has works by GIAMBATTISTA TIEPOLO, GIAMBATTISTA SALVI (known as IL SASSOFERRATO), and others. On the nave wall is the altar built for Marco Querini in 1590; in a later period, the remains of St. Marina, brought from St. Marina Church and taken from Constantinople in 1231, were placed here.

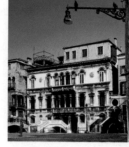

310 TOP PALAZZO TREVISAN-
MALIPIERO.

310 BOTTOM LEFT PALAZZO
VITTURI.

310 BOTTOM RIGHT
BARTOLOMEO MANOPOLA,
PALAZZO RUZZINI.

310-311 CAMPO
S. MARIA FORMOSA.

■Our itinerary continues by leaving from the side door in the left-hand transept. Campo Santa Maria Formosa is one of the best-known squares in Venice. Its large space was the theater of many festivities held to celebrate military victories or to welcome illustrious persons. Among these was the Ludi Mariani, or feast of

GABRIEL BELLA in a painting kept in the Querini Stampalia Museum. The Campo was the home of such illustrious personages as the poet and courtesan Veronica Franco (1546-91). Among the artists who lived in the parish were the architects Giovanni Scalfarotto (d. 1764) and Bernardino Maccaruzzi (d.

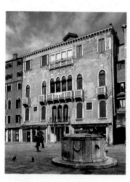

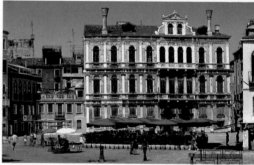

the Marys, which culminated in the procession of the doge. It was celebrated until 1379, when it was replaced by the famous popular festival of the Dodici Marie (twelve Marys) illustrated by

1798). The square also boasts some prestigious patrician residences. The short side is occupied by the large **Palazzo Ruzzini** (no. 5866), built at the end of the 16th century by BARTOLOMEO MANOPOLA. This building

has a façade overlooking the Rio del Pestrin and two entrances, but its proportions and the attention paid to architectural details are not particularly noteworthy. Going clockwise around the square, we see a Gothic

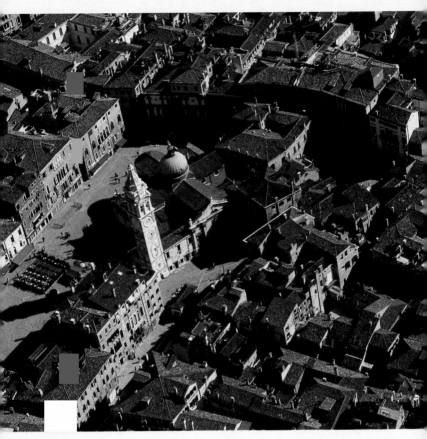

palazzo (mid-15th century) inhabited by Leone Graziani (d. 1852), a Venetian patriot who was exiled to Corfù. The cusp of its Gothic portal (no. 6123) is crowned by the mid-14th century bust of an ancient warrior and a notched aristocratic shield. The elegant four-lancet window with a serrated molding has capitals with fleshy leaf motifs dating from the early 15th century. The nearby **Palazzo Donà**: (no. 6126) is dominated by a splendid four-lancet window with late 14th-century capitals. Next is the **house of Sebastiano Venier** (no.

6129), who commanded the Venetian fleet that defeated the Turks at Lepanto in 1571, and **Palazzo Vitturi** (no. 5246), whose *piano nobile* boasts a splendid four-lancet window with two fretwork capitals that is crowned by a series of crosses and *paterae* in Greek marble (11th-13th century). Along the canal that skirts the square is the façade of **Palazzo Trevisan-Malipiero** (no. 5250), attributed to SANTE LOMBARDO (1504-60), the nephew of Pietro, and built over a 13th-century palazzo. The architectural composition and decoration

are Neo-Byzantine, a style that had grown popular in Venice a few decades earlier. The central four-lancet window with Ionic capitals is flanked by two windows separated by a small niche. The white Istrian stone is enlivened by round or shield-shaped inlay made of red porphyry, and in the middle of the crowning frieze is a tondo with the trigram of Christ, IHS, crowned by a small cross. The side portraits in relief – conceived as if they were medals or cameos – are probably illustrious men or emperors from antiquity.

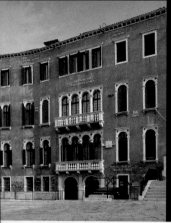

■ Proceeding on our right, on the street alongside the canal, go over a small bridge and enter the **Palazzo Querini Stampalia**, the home of the foundation and museum of the same name (no. 5252). HISTORY: after the conspiracy against the Venetian government, which they planned together with the family of Bajamonte Tiepolo in 1310, the Querinis were banished from the city and had to take refuge on the island of Stampalia (Astypalaea), in the Aegean Sea. The family was readmitted into the Maggior Consiglio, the sovereign legislative body of the Venetian state, almost a century later, in 1406. The family palazzo, which was probably finished in 1528 for the wedding of Francesco Querini and Paola Priuli, was restructured and beautified during the course of the 18th century. Despite later alterations and the loss of ten frescoes

by Tiepolo, the building, with its rich treasure of works of art, manuscripts, engravings and books, is the only example of a perfectly preserved Venetian patrician palazzo. The Fondazione Querini was created thanks to a bequest on the part of Count Giovanni Querini Stampalia, who died in 1869. The foundation is now particularly active in promoting exhibitions, seminars and meetings on contemporary Italian and international art.
FAÇADE: in order to have a good view of the façade, it is best to go to the nearby small square (*campiello*) where the original entrance is. The main body of the façade, flanked by wings of different widths, has an austere binary canal entrance separated by Doric pilasters and two slender Corinthian four-lancet windows whose decoration and polychrome marble inlay seem to have been

executed by the Lombardo or Buora workshops. The additions and reconstruction by CARLO SCARPA consist of the water entrance gates, the bridge and the plaque above. The neon light writings in two languages, arranged in disorderly fashion between the windows as if they were ancient inscriptions, are the work of JOSEPH KOSUTH and are entitled *The Matter of Ornamentation* (1997).
COLLECTIONS: the picture gallery is mostly made up of paintings belonging to the family, to which were added, in 1854, the canvases from a bequest of Gasparo Lippomano and the fifteen paintings by PIETRO LONGHI from the Donà delle Rose collection that were purchased in 1935. All told, the collection boasts over 400 14th-19th century paintings by Venetian, Italian and Flemish artists. Besides the terracotta bust of Letizia Ramolino Bonaparte (ca.

312 LEFT PALAZZO
QUERINI STAMPALIA.

312 RIGHT
CORRIDOR AND
CANAL ENTRANCE.

313 LEFT
ANTONIO DAL ZOTTO,
BUST OF ALVISE
QUERINI STAMPALIA.

313 RIGHT LUIGI
BORRO, BUST OF
GIOVANNI QUERINI
STAMPALIA.

1804) by ANTONIO CANOVA, the precious and elegant Sèvres soft-paste and hard-paste porcelain (1769), the stuccowork by South Tyrolean artisans and the tapestries, of particular historic and social interest are the paintings by the Venetian GABRIEL BELLA that describe the city's customs, ceremonies and festivities. The halls of the rich library on the first floor have portraits of the Sibyls and the members of the Querini family, as well as works by artists such as PALMA GIOVANE and the Milanese FEDERICO CERVELLI.

GROUND FLOOR: the new wing was acquired in 1988-89 and opened in 1999, following reconstruction during and after 1994 by the Ticino architect MARIO BOTTA. Starting off from the new entrance, Botta designed the monumental staircase and the roofed courtyard (2003), named after Giuseppe Mazzariol, and is now finishing the

auditorium. In the section standing against the old palazzo, which was once accessible via Campiello Querini, in 1959-63 CARLO SCARPA redid the garden, the *portego* (hall), the access to the canal, the entrance vestibule and the stairway leading to the library in 1959-63. In the garden, occupying what was a courtyard, Scarpa created an extraordinary microcosm in which nature and art, and the ancient and modern, are blended. Along the perimeter of the lawn – a sort of monochrome *tabula rasa* – is a series of pools and pavements on different levels composed of materials in different colors – cement, copper, bronze, mosaic, alabaster and Istrian stone – furnished with ancient sculptures. This rationally arranged area, filled with well-balanced, personal architectural evocations arranged for the most part on a horizontal level – the same one on which the

water from the pools flows or is deposited – merges with the irregularly shaped area with plants and bushes that moves upward. One of the main keys of Scarpa's creation can be noted in the so-called spiral pool situated next to the wellhead. The statue of an ancient lion keeps watch over the water in the rivulet that flows into the fountain, thus revealing its sacred character. Utilizing a creation of Frank Lloyd Wright, Scarpa reproduced in miniature, at the bottom of the pool, the plane projection of the nearby round wellhead and repeated the motif in a series of graded concentric circumferences that evoke the elegant rivulets in the Alhambra in Granada as well as the simplified shape of an Ionic capital. Entering the nearby hall, known as the Gino Luzzatto Hall, you can appreciate the elevation of the garden, undertaken as protection against

flooding. The same principle is applied in the room in front of the double water entrance, where a robust walkway and a fine landing stairway interact with the caprices of the tide and the ever-present salinity. No less original and interesting are the adjacent vestibule, the bridge over the canal, and the stairs – areas of research and creativity in which design, color and materials merge harmoniously to generate unexpected and unusual details.

MUSEUM: this is on the second floor and can be reached on foot via Scarpa's stairway. If you go up the new stairway designed by Botta, which is near the ticket office, you must then go through the museum halls to the Sala del Portego, where the visit begins. The Fondazione Querini is doing its utmost to re-create an 18th-century atmosphere in the halls through loving and meticulous research. Therefore, due to this restoration work, the location of certain art works may vary temporarily with respect to the information given below. The double door that communicates with the stairway is framed by luxurious Ionic columns, among which is the marble bust of Cardinal Angelo Maria Querini (1727-30) attributed to GIACOMO CASSETTI. The other busts, portraying *bravi*, are by ORAZIO MARINALI (1643-1720). The 18th-century *Allegory of Dawn*, frescoed on the ceiling, is by JACOPO GUARANA, who may have been assisted by his son VINCENZO. The lovely Ca' Rezzonico-type chandelier (mid-18th century) was done by the workshop of GIUSEPPE BRIATI. Proceeding toward the side of the hall overlooking the canal, you enter, at left, the

Sala SEBASTIANO RICCI, which has three *Allegories* by the artist from Belluno (1659-1734) as well as works by the Paduan PIETRO LIBERI, FRANCESCO MAFFEI from Vicenza, and ALESSANDRO VAROTARI, known as IL PADOVANINO. When you leave this hall, cross the Portego and go to the hall opposite, dedicated to GIOVANNI BELLINI: and with the Venetian master's *The Presentation of Jesus in the Temple* (ca. 1460), an oil painting on wood that imitates the painting by his brother-in-law, ANDREA MANTEGNA, with a similar subject now in the Staatliche Museen, Berlin. This subject, also known as *The Purification of the Virgin*, corresponds to the

Candlemas feast celebrated on February 2nd. The scene has none of the usual features and traditional setting in the Temple of Jerusalem, and has become truly human. The Christ Child, carefully wrapped in swaddling clothes, is about to cry because his young, ivory-complexioned mother has left him and he will be taken into the arms of the high priest Simeon. The next room is named after DONATO and CATARINO, authors of the scintillating: *Coronation of the Virgin* (signed and dated 1372). Also note the *Crucifixion* (third decade of the 15th century) with a solid gold background attributed to MICHELE GIAMBONO, the two fascinating *Sacred*

Conversations by PALMA VECCHIO, and an implacable *Judith* painted sometime between 1520 and 1530 by VINCENZO CATENA, who may have portrayed himself as Holofernes. The Sala JACOPO PALMA IL GIOVANE: contains the impressive *St. Sebastian* by the Neapolitan artist LUCA GIORDANO (1634-1705). The Sala PIETRO LONGHI has 30 works by this artist,

316 TOP AND 316-317 GABRIEL BELLA, *CARNIVAL FESTIVITIES ON THE THURSDAY BEFORE LENT.*

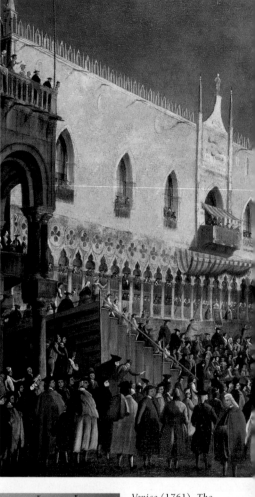

including the series of fine small paintings of the *Seven Sacraments* (before 1755-57). Among the other works by this genre painter, which are exquisitely wrought and depict Venetian life in the 1700s, especially noteworthy are the hunting scenes, including *Duck Hunting in the Lagoon* (ca. 1760), and peasant scenes such as the almost voyeuristic *Sleeping Peasant Woman* (ca. 1750), as well as *The Friary in*

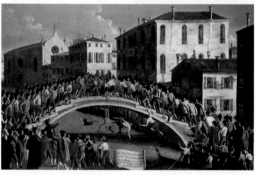

316 BOTTOM GABRIEL BELLA, *THE BATTLE BETWEEN THE CASTELLANI AND NICOLOTTI.*

317 BOTTOM GABRIEL BELLA, *THE CLOTHING OF A NOBLE WOMAN IN SAN LORENZO CHURCH.*

Venice (1761), *The Geography Lesson* (ca. 1752) and *The Lion House* (dated 1762). This last-mentioned work describes the comic spectacle of a charlatan during Carnival being kept at bay by small trained dogs in aristocratic garb.

In the Sala dei Ritratti or Portrait Hall, mention should be made of the portrait of the procurator Dolfin that GIAMBATTISTA TIEPOLO painted during his stay at Würzburg (1750-53) and perhaps brought here from Palazzo Dolfin,

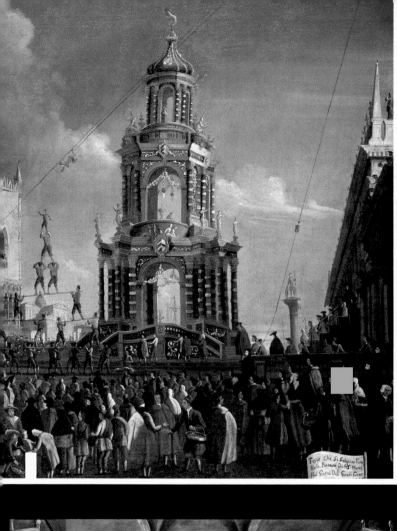

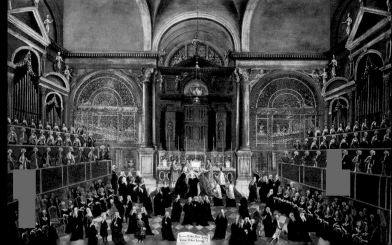

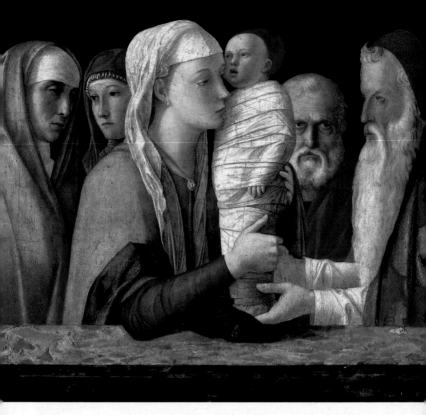

at San Pantalon. After
visiting the Salotto
Giuseppe Jappelli, retrace
your steps and go, at right,
into the Sala Donazione
Ada Morandi Padoan e
Romano Padoan, which
has *The Jewel* by the
Roman artist CAMILLO
INNOCENTI (1871-1961)
and the intriguing *Model*
by the Venetian ALESSANDRO
MILESI (1856-1945). Once
in the corridor, turn left
immediately and go into
the Sala di GABRIEL BELLA
(1730-99). The mediocre
works by this Venetian
painter, executed from
1779 to 1792, were
reproduced mostly in

engravings by other artists
and offer a treasure trove
of details concerning the
social life and architecture
of Venice in the 1600s and
1700s. This artist's
paintings depict festivities,
feasts, games, fairs and
festivals, processions and
other religious ceremonies,
with scenes of public or
government life. Among
the views, there are the
*Feast of February 2nd at
Santa Maria Formosa*, also
known as *The Festival of
the Twelve Marys*. In the
background of this work
we can see the "bull hunt,"
while in the foreground
there is the "goose hunt,"

in which some youngsters
are trying to wring a
goose's neck. At left a man
with his head covered is
absorbed in another cruel
game, trying to kill a cat
tied to the wall by butting
his head against it.
At the end of this hall is
the Camera da Letto, or
bedroom. The double bed
and two bedside tables
were made by a Veneto
cabinet-maker in the late
18th century, and the large
Murano blown-glass
mirror opposite is finely
carved. On the ceiling,
JACOPO GUARANA – perhaps
with the help of his son
VINCENZO – frescoed a

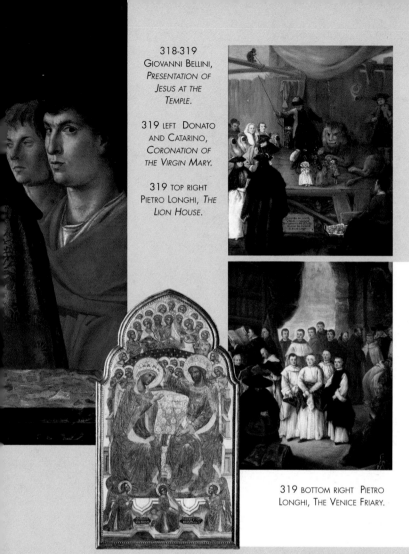

318-319
GIOVANNI BELLINI,
PRESENTATION OF
JESUS AT THE
TEMPLE.

319 LEFT DONATO
AND CATARINO,
CORONATION OF
THE VIRGIN MARY.

319 TOP RIGHT
PIETRO LONGHI, THE
LION HOUSE.

319 BOTTOM RIGHT PIETRO
LONGHI, THE VENICE FRIARY.

subject from Ovid,
Zephyrus and Flora. To the
left of the bed is the
magnificent oil panel by
the Florentine LORENZO DI
CREDI, *The Virgin and
Young St. John Adoring the
Christ Child* (ca. 1480).
The skillfully wrought
balance of the volumes and
the restrained matching of
primary and secondary
colors heighten the
atmosphere of humble,

submissive prayer. Mary's
violet garb and the Child's
crossed legs are a moving
evocation of the future
death of Jesus for the
believer to meditate upon.
The subject, set in Egypt,
in keeping with a tradition
going back to the
apocryphal gospels, is to
be interpreted as one of
the seven sorrows of Mary.
This room communicates
with a small dressing

room, or boudoir. Going
back to the Bella room,
turn left immediately to
visit the Salotto Rosso,
Salotto Verde and the Sala
degli Stucchi, with works
by PALMA VECCHIO and
GIAMBATTISTA TIEPOLO. The
last room is the Sala delle
Porcellane or Porcelain
Hall, with an elegant soft-
past and hard-paste
porcelain Sèvres dinner
service (1796).

THE NEW ROAD TOWARD EUROPE

▶ MAIN SIGHTS

● **SESTIERE (district)**: Cannaregio.

● **CHURCHES**: [1] Santi Apostoli; [2] Santa Sofia; [3] San Felice; [4] Santa Fosca; [5] Santa Maria Maddalena; [6] San Marcuola; [7] San Leonardo; [8] Santi Geremia e Lucia; [9] Scalzi.

● **PALAZZI**: [10] Ca' Falier; [11] Ca' d'Oro; [12] Donà-Giovanelli; [13] Correr; [14] Diedo; [15] Ca' Magno; [16] Donà; [17] Labia; [18] Manin-Sceriman.

● **OTHER MONUMENTS**: [19] Scuola dell'Angelo Custode; [20] Strada Nova; [21] Scuola dei Pittori; [22] Monument to Paolo Sarpi; [23] Scuola dei Lucchesi or del Volto Santo; [24] Scuola e Oratorio di Cristo Crocifisso; [25] Ponte delle Guglie; [26] Stazione Ferroviaria (railway station); [27] Ponte dei Scalzi.

● **MUSEUMS**: [28] Galleria Giorgio Franchetti (Ca' d'Oro).

320 TOP VITTOR CARPACCIO, ANNUNCIATION, C D'ORO, DETAIL.

320 CENTER INSIG OF THE BOCALERI, C D'ORO, DETAIL.

320 BOTTOM PON DEGLI SCALZI, AERIA VIEW.

321 JACOPO TINTORETTO, LAST SUPPER, SAN MARCUOLA CHURC DETAIL.

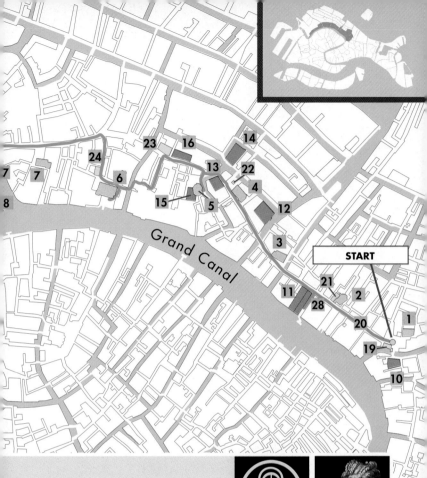

This itinerary starts off in the Santi Apostoli area and goes to the Stazione Ferroviaria (railway station) by means of a walking tour parallel to the pedestrian way on the left bank of the Grand Canal. The urbanization of this area, which also occurred along the north border of the Cannaregio district, began in the 10th-11th century. Unfortunately, the outer parts of this long area were partly changed or demolished in order to make Venice look like a modern European capital.

The filling in of the canal that began at the Ponte delle Guglie and went beyond Campo San Leonardo (1818) and the other canal that ran along the present-day Lista di Spagna (1844) laid the groundwork for the construction of the first railway station, which was inaugurated in 1861 after several churches and monasteries in the area had been torn down. On the opposite side, the opening of the Strada Nova (1867-71) brought about large-

scale demolition that radically altered the urban fabric. Despite these major changes, this section of Venice still has extremely interesting historic and artistic monuments, first and foremost the venerable churches of San Marcuola and San Geremia, which were renovated in the 18th century, and the Scalzi Church, which is the most important testament of Baroque art in Venice.

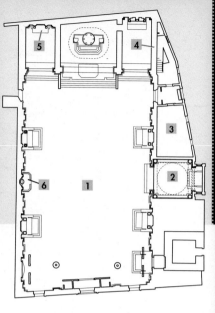

SANTI APOSTOLI CHURCH

1 Carlo Gaspari and Fabio Canal, *Communion of the Apostles and Exaltation of the Cross* (ceiling)
2 Cappella Corner
3 Sacristy
4 Venetian School, *Deposition and Entombment of Christ*
5 Madonna degli Alberetti
6 Font

322 CAMPO SS. APOSTOLI AND CA' FALIER.

323 LEFT GIAMBATTISTA TIEPOLO, *LAST COMMUNION OF ST. LUCY.*

323 RIGHT THE NAVE AND FRESCOED CEILING OF SANTI APOSTOLI CHURCH.

Itinerary

From Santi Apostoli to the Station

■ Past the small bridge in Campo SS. Apostoli that crosses over the canal of the same name, there is a view of the façade of **Ca' Falier** (no. 5643). The two paterae and two Greek marble panels, like the oldest part of the building, date from the second half of the 13th century. This palazzo was the residence of Doge Marino Falier (1354-55), who was beheaded for having tried to overthrow the aristocratic government and make himself lord of Venice. The building farther along the canal, with a Corinthian

entrance on the square, was designed by ANDREA TIRALI around 1713 to house the **Scuola dell'Angelo Custode** confraternity. On the opposite side of the square is **Santi Apostoli Church**. HISTORY: this church is considered one of those founded by the bishop, St. Magnus, who in the 7th century reputedly had it built on the spot where he had seen twelve cranes together. The church was built around 1020 and is first mentioned in a document written in 1094. Reconstruction began in 1549, and it was

consecrated in 1578. The campanile was renovated in 1601-09 under the supervision of FRANCESCO DI PIERO. The belfry was built around 1712 by ANDREA TIRALI to a design by ANTONIO GASPARI. FAÇADE: this is made of bricks and has a pitched central body. The only porch facing the entrance was the headquarters of the Scuola dei Santi Dodici Apostoli (Confraternity of the Twelve Holy Apostles), built in 1351. RIGHT SIDE: the small house after the campanile was purchased in 1619 by the

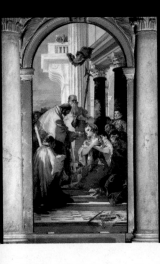
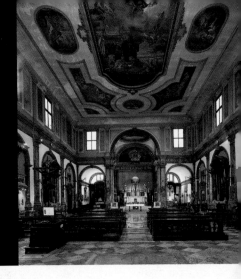

Scuola della Natività di Maria, founded in 1589. This is followed by the Corner family chapel and the sacristy. The rooms upstairs were the home of the local Scuola del Santissimo Sacramento, founded in 1511. INTERIOR: the aisleless nave anticipated the instructions of the Council of Trent. The walls, against which stand five side altars, have large arches that alternate with large Corinthian pilasters. During the restructuring work carried out in 1729-52, Ionic pilasters were set on the upper section. The frescoes on the flat ceiling, with quadratura architectural painting by CARLO GASPARI, were executed by FABIO CANAL in 1753. Their main subject is the communion of the Apostles and the glorification of the Cross. With a dizzying foreshortening effect by the ceiling of San Pantalon, GIOVAN ANTONIO FUMIANI conceived an unusual *Last Supper*, in which the

Apostles are not placed in the usual position. This work was restored in 1815 by GIAMBATTISTA CANAL. Along the right wall, there is the Renaissance-style Cappella Corner (or Cappella Cornaro; 1483-99), attributed to MAURO CODUSSI. The richly decorated composite columns on its four corners support a tall trabeation and then four arches crowned by a blind segmental dome. The column shafts, interrupted by an arched lintel, have tortile fluting in their lower section and straight fluting in the upper one. On the tall, cylindrical pedestals are elegant reliefs with symbolic motifs referring to the Passion, death, resurrection and ascension of Christ. On the right-hand wall of the chapel is the urn of Marco Corner (d. 1511), who commissioned the chapel, attributed to TULLIO LOMBARDO (d. 1532), while the tomb on the wall opposite, where Giorgio

Corner (d. 1540) is buried, is by one of Lombardo's followers. Both funerary monuments are crowned by an eagle in relief holding the head of the Medusa in its claws: this is an allegory of Vice being vanquished. Giorgio Corner was the brother of Caterina, the Queen of Cyprus who, in exchange for abdicating her throne, was given the town of Asolo by the Venetian Republic. Over the 16th-century altar of the Cappella Corner, GIAMBATTISTA TIEPOLO painted the *Last Communion of St. Lucy* (1745-46) to glorify the central role played by the Eucharist. Despite the horrible torture the saint underwent, her flesh still has a silken quality, but is of a straw yellow color because of her imminent death. The virgin receives Holy Communion in the same place where she was mortally wounded. The dagger lies at her feet, together with the traditional plate with her eyes on it.

324 LEFT AND 325
VENETIAN SCHOOL,
DESCENT FROM THE
CROSS AND BURIAL
OF CHRIST.

324 RIGHT
MADONNA DEGLI
ALBERETTI.

■After your visit to the Cappella Corner, go along the right (south) side of the church to the altar of the Scuola della Natività di Maria, built in 1597-99. The altarpiece by GIOVANNI CONTARINI, a follower of TINTORETTO, narrates three episodes from the birth of Mary (1599): an unusually young St. Anne fainting, the handmaidens preparing the water for her dressing, and St. Anne showing the infant Mary to Joachim. On the altar is a beautiful icon of the Madonna by a Veneto-Cretan icon painter (second half of the 16th century). In keeping with Byzantine iconographic tradition, the Infant Jesus has lost his right shoe out of fear of his future death on the cross.

From this altar, go into the short corridor of the side exit leading to the sacristy, which has the preparatory study for the central panel of the church's ceiling, by FABIO CANAL. The late 18th-century wooden crucifix on the altar (1818) of the right-hand rear chapel is a copy of the one in the church on the island of Poveglia, in the Venetian Lagoon. The cross is presented as a tree to remind us of the Tree of Knowledge. The two directions of knowledge place all of us at a fork in the road, which in ancient times was symbolically represented by the letter Y, here in the guise of Christ in an unusual position with his arms raised up. The fresco on the right-hand wall – one of the oldest examples of Venetian painting – represents two scenes from the Passion of Christ: the Deposition and the Entombment (late 13th century).

In the chancel, built in 1567, the entrance arch and blind elliptical dome (1754) supported by polygonal drum casing were rebuilt. The high altar (1821- ca. 1830), surmounted by a small round temple in Neo-Classical style, was designed by FRANCESCO LAZZARI.

The two side statues of St. Peter and St. Paul are by GIUSEPPE TORRETTO (ca.1711). The *Last Supper* on the right wall was painted in 1583 by CESARE DA CONEGLIANO, who shows us the courtyard of the Doges' Palace and the Scala dei Giganti in the background, and the Foscara staircase (which no longer exists) at left. The workshop of PAOLO VERONESE and his school executed *The Miracle of the*

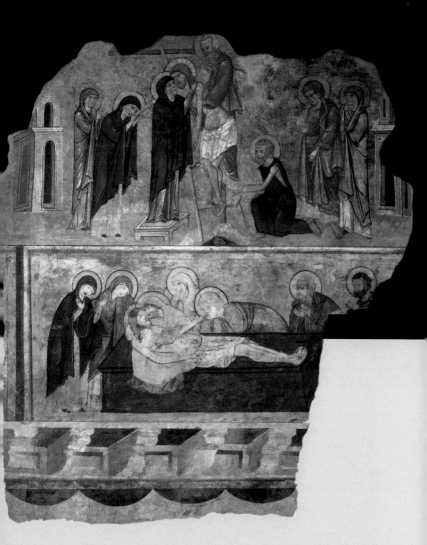

Manna (after 1588), which
is situated on the left-hand
wall. Outside the chancel,
on the sides of the new
altar, are two bronze
statues of angels bearing
candles with a horn of
plenty (early 17th
century), sculpted by the
workshop of GIROLAMO
CAMPAGNA.

The rear chapel at left was
reserved for the Scuola
dell'Angelo Custode
(Confraternity of the

Guardian Angel), which
had the angel included in
the altarpiece (1658- ca.
1660) by FRANCESCO
MAFFEI. On the altar is the
early 15th-century
Madonna degli Alberetti,
which belonged to the
Scuola degli Apostoli and is
attributed to NICOLÒ DI
PIETRO LAMBERTI. The
subject of this fine
sculpture piece with its
soft, sinuous drapery extols
the humility of Mary, who

is seated on the ground.
The many birds on the two
bushes at her side are
allegories of the faithful
who feed on Christ. Along
the left wall, after the altar
with the altarpiece by
GASPARE DIZIANI, is the font,
surmounted by the pulpit
on the railing of which
GIUSEPPE TORRETTO did a
relief of the Pentecost
(1756), or *the Descent of the
Holy Ghost onto the
Madonna and the Apostles.*

326 BOTTOM LEFT
AND RIGHT THE
UPPER MULTI-LANCET
WINDOW OF CA'
D'ORO, AND
DETAIL.

326 CENTER
SANTA SOFIA
CHURCH.

327 PALAZZO
COLETTI-DUODO
AND CA' D'ORO.

■ Once out of Santi Apostoli, go along the broad **Strada Nova**, designed in 1867 by Count PAPADOPOLI and inaugurated in 1871. This street was laid out to make the pedestrian way to the railway station more convenient, but unfortunately entailed the destruction of the Medieval and Renaissance urban fabric of this area. After house no. 4193 is the small entrance to **Santa Sofia Church**.
HISTORY: named after "divine wisdom," this church, which dates back to the 11th century, was rebuilt in 1568 and restored by ANTONIO GASPARI in 1698. The façade was hidden and disfigured by the front of the house built for the priest Don Missiaglia in 1872.
INTERIOR: the nave has two aisles separated by columns on pedestals. The workmanship of the Corinthian and composite capitals, and in particular the

lovely pattern of the unusual dosserets, have led scholars to speak of work done in the late 15th century akin to the style of CODUSSI. After the church was closed in 1810, it lost most of its art works and some altars as well. Some of the works now in the interior were donated by private citizens during the 19th century. Among these are paintings by LEANDRO BASSANO, GIAMBATTISTA MAGANZA, CARLO DUODO and DANIELE HEINTZ, as well as four 15th-century statues from Santa Maria dei Servi Church: on the inside façade are the physicians and healers St. Cosma and San Damiano, attributed to the RIZZO workshop; on the high altar, the apostles St. Luke and St. Andrew. On the small altar of the left aisle is a late 14th-century statue of a Madonna and Child brought from Santa Maria dei Servi and sculpted by ANDREA BEAUNEVEU. By means of slight inclinations of the heads and shoulders, the relationship between mother and child is rendered with great delicacy. Jesus is

holding a small bird, the symbol of the soul. Usually, this is a goldfinch, the allegory of the blood spilled on the Cross. Among the many confraternities in this church, there is the Scuola del Santissimo Sacramento, founded in 1507, and the Arte dei Depentori (painters and decorators' guild), which was already active in 1271. Once out of Santa Sofia, note the house at right, which belonged to the **Scuola dei Pittori**. The headquarters of this painters' confraternity (nos. 4186-90), which was partly demolished, was built in 1572 thanks to a bequest made in 1530 by the painter VICENZO CATENA. The two bas-reliefs on the capitals of the pilasters (nos. 4186 and 4190) depict St. Luke, the patron saint of the confraternity who, according to Byzantine tradition, painted the first portrait of the Madonna and Child.
■ Continuing down the Strada Nova, at the first *calle* at left is the **Ca' d'Oro**, home of the **Galleria Giorgio Franchetti** (next to no. 3932).

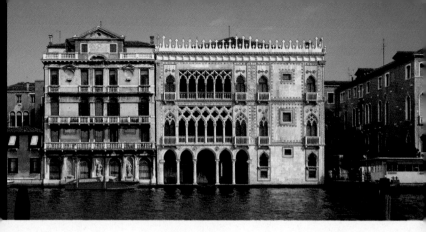

HISTORY: after buying a Veneto-Byzantine palazzo around 1412, the rich merchant Marino Contarini (d. 1441) commissioned the architects and sculptors MATTEO RAVERTI and GIOVANNI and BARTOLOMEO BON to begin building his residence in 1420 (they completed it around 1434). The building was rebuilt several times and was altered by the architect GIOVANNI BATTISTA MEDUNA after 1840. It was restored after 1896 by Baron Giorgio Franchetti, who eliminated the arbitrary additions and changes made earlier, renovated the deteriorated parts, and reconstructed the outdoor stairway and the gateway (no. 3933) between the street and the courtyard with the coat of arms of the Contarini family. Franchetti probably also added the 6th-13th-century reliefs on the walls on the portico along the canal. FAÇADE: the innovations introduced in the most elegant and famous palazzo façade on the Grand Canal consist of the uniformly asymmetrical decoration and carving of the whole, the replacement of the brick facing with sumptuous polychrome stone, and the rich sculptural decoration taken from other palazzi and grouped together into a single unit of extraordinary originality, clarity and harmony. The portico consists of two pairs of tall pointed arches with a wider round arch between them. The main multiple window (six lancets) has a series of entire quatrefoil openings and another one "cut" in half by a column, in keeping with a pattern used in Muslim decoration. In the six-lancet window on the top floor, which has more slender elements and bicolored column shafts, the quatrefoil openings have an irregular shape obtained by means of interwoven ogee arches. The name, Golden House, derives from the rich coloring of the stonework and above all from the gold leaf decoration of certain sculptural elements. MUSEUM: in 1916 Baron Franchetti bequeathed his palazzo and art collection to the state, with the proviso that the adjacent Palazzo Duodo be bought as well. His collection, enlarged by other works belonging to the state, was inaugurated in 1927. Later, after being closed for large-scale restoration, it was reopened in 1984. COLLECTIONS: the original nucleus of art works collected by Franchetti – especially during his stay at Dresden, Munich and Florence – was enlarged with other works from public repositories, the Accademia Galleries, the Archaeological Museum and also through the purchase of private collections. Besides Gothic and Renaissance sculpture and reliefs, there are 14th-15th-century polyptychs, 15th- and 16th-century bronzes and medals, paintings of the Venetian, Tuscan and Flemish schools, tapestries, frescoes from Venetian buildings, the terracotta maquettes belonging to the Farsetti Collection, another collection of ceramics, and fragments from digs carried out in Venice and the lagoon area.

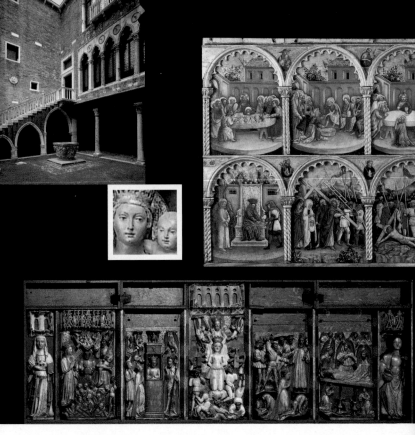

GROUND FLOOR: access is through a small garden and then the ticket office at left. The U-shaped building is traversed by the long hall (*portego*) that is connected to the courtyard that communicates with the side street.

Once inside, to your left you will see the torso of a youth, a 1st-2nd-century Roman copy of a Greek original, and a fragment of a porphyry column, under which are the remains of Giorgio Franchetti, who, suffering from an incurable disease, committed suicide in 1922. Beyond the arcade is the courtyard, delimited on two sides by the two-

flight staircase. The wellhead (1427-28), sold in the 19th century and purchased again by Franchetti, is by BARTOLOMEO BON, who sculpted the allegories of three Virtues: Fortitude, Justice and Charity. The mosaic pavement, an imitation of the one in St. Mark's, was laid out by Franchetti himself, who, on at least one occasion, was helped by the famous poet Gabriele D'Annunzio. Returning to the ticket office area, you can go up to the FIRST FLOOR. On the staircase are two interesting wooden polyptychs. The one with

high relief figures, dating from the late 15th century, is by DOMENICO DA TOLMEZZO, while the one painted with tempera is signed by SIMONE DA CUSIGHE and dated 1394. Once inside the Portego, note the surviving statues of a sculpture group depicting the *Massacre of the Innocents* (late 13th century), probably done by a Venetian sculptor. On the opposite wall is the 15th-century *Passion of Christ Polyptych*, attributed to ANTONIO VIVARINI. This painting came from the Dominican nuns' Corpus Domini Church once situated in the railway

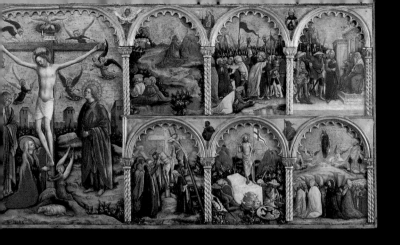

station area and torn down around 1811. The central scene of the crucifixion is flanked by twelve episodes which, by means of an elaborate narration based on meditations on Jesus from apocryphal sources, begin with the Last Supper and end with the Ascension. On the opposite wall is the fine *Passion of St. Catherine Polyptych* (15th century) with painted alabaster figures; it is by an English sculptor and comes from Santa Caterina Church in the Cannaregio district. Between St. Zita and St. Dorothea, placed on either end, there are five episodes with captions written in elegant Gothic letters. The central scene ("Rotacio Sancte Katerine") narrates the episode of the barbed wheel of torture that broke into pieces thanks to divine intervention.

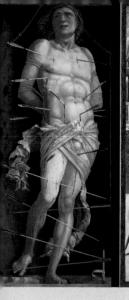
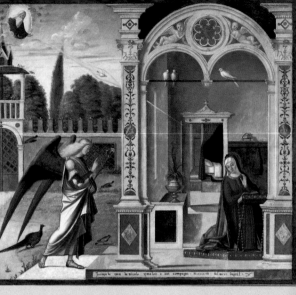

At the end of the wall, at left, is the marble chapel commissioned by Franchetti to house the masterpiece of his collection, the splendid, moving *St. Sebastian* that ANDREA MANTEGNA may have painted for Ludovico Gonzaga, the bishop of Mantua. In general, this saint's intercession was invoked against the plague, whose excruciating spasms were associated with the pain caused by the arrows of his martyrdom. But Mantegna also introduces an erudite and tragic vision of the vanity of life. The saint is pierced by sixteen arrows in keeping with traditional portraits of him. His executioners have done their job so quickly that the blood of the Roman soldier and Christian hero has just begun to flow. Behind the door, which resembles the

opening of a tomb, is the night of death. A coral, onyx and rock crystal rosary hangs from the lintel, an allegory of prayer and the Marian mysteries. The saint, his face contorted with pain, is looking at God, manifested in the light and the soft breeze. The invisible divine zephyr raises the edges of his long, tight loincloth and puts out a candle enveloped in a cartouche with an admonition in Latin: "Only divine things are eternal; all the rest is smoke."

The visit continues in Room I, which has seven charming versions of the Madonna and Child by 15th- and 16th-century Veneto artists, as well as a fine collection of bronze medals with portraits of illustrious 15th- and 16th-century figures. These works were executed by

artists such as PISANELLO and SPERANDIO SAVELLI. Among the medals by the Venetian VITTORE GAMBELLO (known as CAMELIO; ca. 1460-1537), note nos. 1 and 2, with portraits of the painters Giovanni and Gentile Bellini. In Room II are the handsome bronzes by the Paduan BARTOLOMEO BALLANO (ca. 1435-1497) and other sculptors, as well as three canvases that were part of a lost cycle painted in 1504-08 by VITTORE CARPACCIO for the Scuola degli Albanesi, whose former headquarters were in Campo San Maurizio. In CARPACCIO's *Annunciation*, dated 1504, the Archangel Gabriel is speaking to Mary, who raises the palm of her hand as a sign of greeting. The bed refers to her mystical union with God who appears in the heavens.

The other three works, *The Visitation* and *The Death of the Virgin Mary*, were partly painted by the artist's helpers. In the latter canvas, three confreres of the Scuola degli Albanesi are kneeling while they observe the scene. Among the works in Room III, mention should be made of the *Madonna and Child with the Young St. John the Baptist Flanked by St. Peter and St. Jerome* (early 16th century), attributed to FILIPPO DA VERONA. Once out of the hall, proceed to your left down the *portego*, on the wall of which is a series of fine bronze panels by VITTORE GAMBELLO and ANDREA BRIOSCO (IL RICCIO). The double portrait in Carrara marble signed by TULLIO LOMBARDO (1455-1532), in which this artist renders the busts of two young singers in ancient dress, draws inspiration from 15th-century Tuscan sculpture. The visit continues along the opposite wall of the *portego*. Past the four-lancet window overlooking the courtyard and the door of the outside staircase, you will see a lunette in high relief by JACOPO SANSOVINO (1486-1570) depicting the Madonna and Child in an unusual embrace. This work comes from the left altar in Le Zitelle Church. It was commissioned by Federico Contarini, procurator of San Marco. Continue up to the loggia overlooking the Grand Canal. Going back along the left wall of the hall, before the door of Room III is the *bust of Matteo Eletto* (first half of the 16th century), the parish priest of San Geminiano Church; this work is by BARTOLOMEO BERGAMASCO. Then there is the relief sculpted by the Lombardesque GIAN MARIA DA PADOVA (known as IL MOSCA; active around 1507-1573), which portrays *The Death of Portia*. The young matron, the daughter of Cato the Younger and symbol of marital faithfulness, gets ready to commit suicide by putting burning embers in her mouth after hearing of the suicide of her husband Brutus. Nearby is the bust of a boy attributed to GIAN CRISTOFORO ROMANO (1470-1512). The humanity and beauty of this figure is animated even more by the realistic detail of the half-closed lips and by the elegant damask attire with a collar decorated with the classic palmette motif on which hung a stone or medal, which no longer exists.

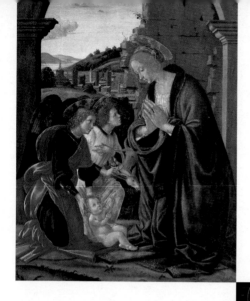

Room IV features 15th-century wood panel paintings that were part of Baron Franchetti's collection, mostly Tuscan school works by CARLO BRACCESCO, ANDREA and DOMENICO DI BARTOLO, PELLEGRINO DI MARIANO ROSSINI, BICCI DI LORENZO, GEROLAMO DI GIOVANNI DI BENVENUTO, JACOPO DEL SELLAIO, GIOVANNI BOCCATI, BIAGIO DI ANTONIO TUCCI, BERNARDINO DI MARIOTTO, ANTONIAZZO ROMANO and DOMENICO GHIRLANDAIO, among other artists. There are two particularly interesting works that illustrate, with variations, the theme of the Madonna dell'Umiltà. In the first of these, FRANCESCO BOTTICINI (1446-98) conceived an angelic Mary with delicate white skin and thin, tapering hands joined in prayer. On the ground is the Infant Jesus, whose nudity, childish behavior and halo reveal his human and

divine nature. Noteworthy qualities in this work are the anatomical foreshortening, highlighted by the colors of the clothes, and the color scheme in the background ranging from the green meadows to the sky blue mountains. In the second panel, to the left of the preceding one and attributed to RAFFAELLINO DEL GARBO (1466- ca. 1498), the episode takes place in the background and has more topographical

details. The arch alludes to the ancient city gate of Bethlehem, and the city can be seen in the background. The ox and ass refer to the Nativity, as do the two magnificent angels who have come to adore the Son of God. When you come to the small landing or Room V, go up the wooden Gothic stairway brought here from the Ca' dell'Agnello, or Agnus Dei, in the vicinity of the church of Santa Maria Mater Domini.

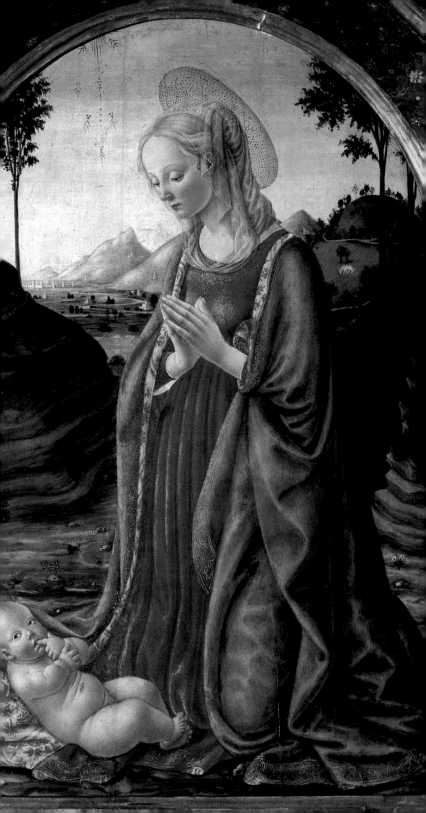

334 TOP TITIAN, *VENUS*.

334 CENTER VENETIAN BEAKER, JUG.

334 BOTTOM ROOM VII, SECOND FLOOR.

335 TOP GIROLAMO MACCHIETTI (ATTRIBUTION), *PROSPERPINA*.

335 BOTTOM SIGN OF THE BOCALERI.

SECOND FLOOR: on the wall opposite the stairway (Room VII) there is an enigmatic *View of a Square with Ladies at the Balustrade*, attributed to FLORIANO FERRAMOLO (ca. 1480 -1528). Also note the

portrait of Prosperina, attributed to the Florentine Mannerist painter GIROLAMO MACCHIETTI (1535-92). The young woman is holding the three-headed dog Cerberus on a leash and, as the wife of Pluto – which means "rich" – she has huge treasures and can afford to throw gold coins on the ground and hold a horn of plenty filled with jewels under her foot.

Room VII has 16th-century Flemish tapestries and four busts of illustrious

Italians by ALESSANDRO VITTORIA. Then, just past the entrance is the *Portrait of the Procurator Nicolò Priuli* (before 1545) by JACOPO TINTORETTO, followed by the sensual, opulent *Venus* (1560-ca. 65) by TITIAN, and the splendid full-length portrait of the Genovese Marcello Durazzo (ca. 1622-27) by the Flemish master ANTHONY VAN DYCK.

Once you are in the *portego* or long hall, continue left toward the loggia, and take the short stairway into the section of the gallery featuring ceramics, the original nucleus of which was the Luigi Conton

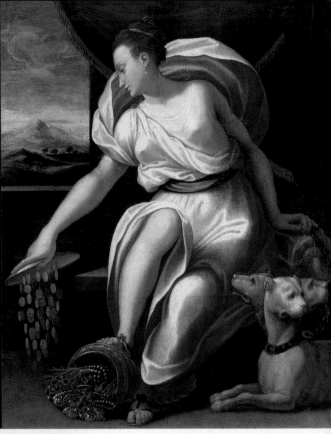

wall (16th century, restored in 1630 and 1729) is the insignia of the Bocaleri, the corporation of makers and vendors of jugs, pots and pans, tableware and terracotta objects that was

Collection, which was purchased in 1978. In the showcases of Room VIII is material dating back to the 12th-15th century, including fragments of glazed or graffito ceramics and majolica. The wood panel oil painting on the

connected with the Frari church.

Above, God the Father creates Adam out of clay, the raw material of potters. Below, the Archangel Michael, patron saint of the Bocaleri, defeats Satan, while on the sides are a

potter at his wheel and other workmen decorating ceramics.

The showcases in Room IX have many objects and fragments, most of which date from the 14th-17th century. Among these is a late 15th-century Venetian terracotta jug (showcase 11, no. 10) with the face of a young page. Among the temporary exhibits held in this room is the one dedicated to the majolica pavement from the Cappella dell'Annunziata in San Sebastiano Church. This has two tiles dated 1510 and was probably laid out by the Lando family in 1531-1541.

The visit continues by going back into the *portego*, or Room X, which features some large fragments of frescoes from the first half of the 16th century by GIOVANNI ANTONIO DE SACCHI, known as IL PORDENONE, TITIAN and, perhaps, DOMENICO CAMPAGNOLA. These works were part of a decorative

cycle that no longer exists and come from the convent of the Eremitani di Santo Stefano and from the Fondaco dei Tedeschi, near the Rialto Bridge. Room XI is given over to Flemish painters. Noteworthy works are the *Repentant St. James*, dated 1532 and signed by DANIEL HOPFER, which has

an original landscape streaked with light; on an easel, the *Crucifixion* with a cartouche in three languages, attributed to JAN VAN EYCK (ca. 1390 - 1441), with its view of a fantastic Jerusalem; another *Repentant St. James*, by JOACHIM PATINIER (ca. 1485 - 1524) and his workshop, with its refined color transitions and contrasts; *The Tower of Babel* attributed to JAN VAN SCOREL (1495-1562), with its vague, condensed background and the scene in the foreground with stone-cutters busy at work in a chaotic construction yard supervised by the giant Nimrod. The next two rooms

336-337 Jan van Scorel, The Tower of Babel.

336 bottom Joachim Patinier, The Repentant St. Jerome.

337 top Francesco Guardi, The Molo Looking toward the Salute.

337 center Gian Lorenzo Bernini, Allegory of the Nile.

337 bottom Francesco Guardi, The Piazzetta Looking toward San Giorgio.

feature Flemish and Dutch painters. In Room XII are 16th- and 17th-century canvases, while Room XIII has splendid 17th-18th century landscapes, animals and still lifes. Going back into the *portego*, you will come to two showcases with interesting terracotta maquettes from the collection of Filippo Vincenzo Farsetti (1703-74). In the first case, at right, there are the allegories of the Rio de la Plata and the Nile (ca. 1645) executed by Gian Lorenzo Bernini to display two of the four parts of the world in his planned Fountain of the Four Rivers in Piazza Navona, Rome

(1651). The four maquettes on the lower shelf are by Stefano Maderno (1576-1636). In the other showcase, the ten figures of heretics (1679-81) were done by Giacomo Piazzetta – the father of the famous painter Gian Battista – that were maquettes for the telamontes along the walls of the library in the Dominican convent at San Zanipolo Church. The *Laoccoōn* on the bottom of this case is attributed to Stefano

Maderno. On the nearby back wall, Francesco Guardi (1712-93), with his view paintings *La Piazzetta Looking toward San Giorgio* and *The Molo Looking toward the Salute*, sets Venice in a decadent atmosphere in which people and monuments seem to be about to vanish or melt away.

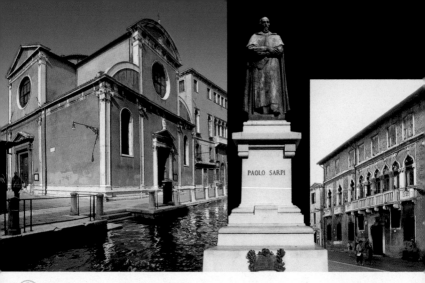

■ Once outside the Ca' d'Oro, turn left and after the Ponte Novo you will spot **San Felice Church**. HISTORY: this church may date back to the 10th century and, after restoration or reconstruction, was consecrated in 1267, only to be rebuilt in its present form in 1531-35 by a follower of Mauro Codussi, who drew inspiration from the church of San Giovanni Grisostomo.

FAÇADE: the lower section consists of columns and pilasters with smooth sides, surmounted by austere cubic capitals decorated with simple Ionic volutes. The main entrance, which faces the canal, is flanked by Corinthian half-columns and dates to 1535.

INTERIOR: the church has a central plan with a blind dome at the point where the nave and transept meet. San Felice has works by Jacopo Tintoretto, Giulio Del Moro, Domenico Cresti (known as Il Passignano), Lattanzio Querena and

Domenico Letterini. Leave from the side door of San Felice, turn right and a short distance away is the Pasqualigo bridge, which offers a view, at left beyond the Grand Canal, of Ca' Pesaro and, at right along the canal, the lovely, ethereal facade of **Palazzo Donà-Giovanelli** (no. 1192), with an elegant multiple Gothic window surmounted by seven quatrefoil openings (second half of the 15th century). This residence was a gift from the Republic to Francesco Maria I della Rovere, Duke of Urbino and commander of the Venetian land troops. It was later purchased by Count Andrea Giovannelli, who in 1847 commissioned Giambattista Meduna to modernize the interior. Among the main alterations made are the spiral staircase with Neo-Gothic and Orientalizing influences, illuminated by a dome with a rose window skylight, and the Neo-Renaissance decoration in

some rooms designed by Leonardo Gavagnin, Antonio dal Zotto, Antonio Zona and Giovanni Busato. The palazzo had many works of art, including *The Tempest* by Giorgione, which was purchased in 1932 by the state and placed in the Accademia Galleries. Farther on, on a line with Campielo de la Chiesa, is **Palazzo Vendramin** (no. 2400), a Lombardesque building that was being constructed in 1499.

Along the Strada Nova is **Palazzo Correr** (no. 2217), whose façade boasts an opulent six-lancet window with Gothic arches surmounted by a pine-cone motif (second half of the 15th century). The interior, which was altered over the centuries, was once decorated with frescoes by Giambattista and Giandomenico Tiepolo. These frescoes no longer exist. In the middle of the square in front of the palazzo is the **Monument to Paolo Sarpi** (1923), the Servite friar

338 LEFT SAN FELICE
CHURCH.

338 CENTER
MONUMENT TO
PAOLO SARPI NEAR
SANTA FOSCA
CHURCH.

338 RIGHT PALAZZO
CORRER.

339 CAMPO S.
FOSCA AND SANTA
FOSCA CHURCH.

(1552-1623) who was excommunicated in 1606 for having defended the Republic of Venice during the dispute between Venice and the papacy. The bronze statue (1892) was designed by EMILIO MARSILI and cast by G. VIANELLO.

■ Opposite this monument is **Santa Fosca Church.**
HISTORY: built after the 10th century, when the body of St. Fosca arrived in Torcello, this church was renovated in 1297 and then completely rebuilt between 1679 and 1733, the year it was reconsecrated (as the plaque states). FAÇADE: with a pitched central body and Corinthian pilasters on tall pedestals, the façade is of uncertain attribution, but we do know that it was built in 1741, thanks to the Donà family. The tympanum is topped by a statue of the Risen Christ flanked on the ends by two Virtues. The beautiful campanile, which can be seen left of the façade or from behind the apse, was

rebuilt after 1410. It has a trefoil two-lancet window belfry and is crowned by four Gothic shrines and a small onion dome dressed with sheets of lead.
INTERIOR: the aisleless nave has a flat ceiling, two small rear chapels and a chancel with a segmental blind cupola over it. The walls, on which are four precious side altars made of polychrome marble and a pulpit, are decorated with pilasters on tall pedestals with elegant composite capitals. There are works by PIER ANTONIO NOVELLI, JOHANN CARL LOTH, DOMENICO TINTORETTO, FELICE BOSCARATO and GIUSEPPE ANGELI, but special mention must be made of the following. In the right rear chapel, which has many relics, is the lovely icon signed by PETER KLA of a *Pietà with Two Saints* (early 17th century); in the chancel, the lavish Corinthian marble frame with four columns and a

double tympanum that encloses the altarpiece by FILIPPO BIANCHI (second half of the 17th century); above the door leading to the small Immacolata Chapel (at the end of the left wall) are two exquisite Veneto school paintings that were part of a Via Crucis cycle and that represent the first fall of Christ on his way to Calvary and the deposition from the cross (first half of the 18th century).

■ Outside Santa Fosca, the nearby S. Antonio bridge affords a view at right of **Palazzo Diedo** (no. 2386), built in 1710-20 by ANDREA TIRALI and boasting an impressive façade overlooking the canal. This was the birthplace of the architect ANTONIO DIEDO (1772-1847).

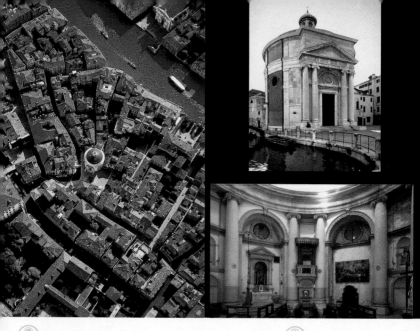

To your left after the bridge is **Santa Maria Maddalena Church**. HISTORY: the Baffo family founded an oratory in this area in 1222 that was soon transformed into a church. However, after the reconstruction of the altars in 1701 promoted by the parish priest Francesco Riccardi, the church was demolished in 1760 and rebuilt as we see it today – a Neo-Classical structure similar to the Pantheon in Rome – in 1763-78 to a design by TOMMASO TEMANZA. The Venetian architect, engineeer and historian is buried in the church he built drawing inspiration from the 17th-century models of the Salute and Santa Maria del Pianto churches. FAÇADE: this has a lobed perimeter and consists of a tympanum and attic supported by four Ionic half-columns. In the lunette of the portal is a relief of the symbol of divine knowledge: the eye of the Lord, set in the middle of an interwoven circumference and circle, the allegory of the Christian dogma of one God in three persons. INTERIOR: this is centrally planned, with six sides alternating with deep niches. The dome is supported by twelve Ionic columns, the symbols of the Apostles. Among the 18th-century canvases is *The Last Supper* by GIANDOMENICO TIEPOLO (1727-1804), which is at right as you enter the church.

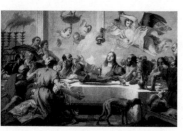

To the right of the Maddalena church, note the surviving portal of **Ca' Magno** (no. 2143), in the Gothic lunette of which is a high relief of a coat of arms (first half of the 15th century) supported by two angels and surmounted by the bust of St. Magnus, the mythical founder of the eight Venetian mother churches, seen here holding the model of a church with a hexagonal campanile. Proceeding along Rio Terà de la Maddalena, which was filled in in 1398, you will see, to your right, **Palazzo Donà** (no. 2343), which was modernized in the late 17th-early 18th century. Its massive stone façade, dominated by a running balcony and characterized by an enormous bust of a man on the entrance portal, is close to the architectural style of DOMENICO ROSSI. Farther on is the building that once housed the **Scuola dei Nobili**

340 TOP LEFT
AERIAL VIEW OF
SANTA MARIA
MADDALENA
CHURCH AND THE
GRAND CANAL.

340 BOTTOM LEFT
GIANDOMENICO
TIEPOLO, THE LAST
SUPPER.

340 RIGHT FAÇADE
TOP AND INTERIOR
OF SANTA MARIA
MADDALENA
CHURCH.

341 PALAZZO
DONÀ, DETAIL.

Lucchesi, also known as the **Scuola del Volto Santo di Gesù Crocifissio** (nos. 2360-64), which was founded in 1360. The "noble Lucchesi," specializing in silk manufacture, first lived between San Giovanni **Grisostomo** Church and Campo San Bartolomeo, and then were associated with the Santa Maria dei Servi Church, demolished around 1828. The patera (ca. 1398) on the façade of the former confraternity (no. 2363) are relief reproductions of the Volto Santo, or the crowned head of Jesus, whose original image is now in the San Martino Cathedral, Lucca. ■ Take the nearby street, Calle Larga Vendramin, turn right, and with the help of your map go the **Chiesa dei Santi Ermagora e Fortunato**, better known as **San Marcuola**. HISTORY: the earliest settlers in Venice, who had come to escape from the Longobard, founded parish churches on the two banks of the Grand Canal and situated on two islands in a vast area known as Lemeneo. The churches were Santa Croce and San Marcuola, named after two martyrs from Aquileia. This latter church owes its fame to the right hand with which St. John the Baptist baptized Christ, which was brought from Alexandria and donated to the aristocrat Andrea Memmo. Information concerning the original construction of the church is uncertain. Its consecration in 1332 seems to indicate that an earlier church had been restored or even rebuilt. The church we see today was built in 1728-35, thanks to the initiative of the parish priest Bartolomeo Trevisano, who entrusted the construction to GIORGIO MASSARI and, in part, to ANTONIO GASPARI. This church was consecrated in 1779. FAÇADE: this is unfinished and has a pitched central body. The tall pedestals must have supported four giant columns. The entrance is flanked by two Ionic half-columns surmounted by a trabeation and triangular pediment. INTERIOR: entering from the façade facing the Grand Canal, go left, on an axis with the wall opposite the high altar. Here there is the entrance to the Oratorio di Cristo Crocifisso, finished by MASSARI and conceived as the church vestibule. This was the space where the porch of the original church and an Augustinian hermitage once stood. The oratory is an elongated hall at the end of which is an independent entrance that communicated with the nearby headquarters of the confraternity of the same name. At the other end is the Corinthian altar, isolated by a balustrade with a wrought-iron gate dated 1750.

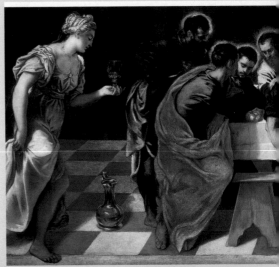

342 TOP LEFT AND
343 BOTTOM
FRANCESCO MIGLIORI,
ST. HERMAOGORAS
BAPTIZING ST. FOSCA,
SAN MARCUOLA
CHURCH.

342-343 JACOPO
TINTORETTO, LAST
SUPPER.

342 BOTTOM
FRANCESCO MIGLIORI,
THE MARTYRDOM OF
ST. HERMAGORAS AND
ST. FORTUNATO.

■ The space at the foot of the altar was reserved for the tombs of the members of the confraternity. In the canvas on the left wall, the only surviving one of a cycle that was dismembered and restored in 1781, NICOLÒ BAMBINI (1651-1736) painted a lovely *Deposition* that is made even more dramatic by the Virgin's fainting. The interior of San Marcuola has a square nave without aisles ending in a spacious chancel. On the walls are pilasters and composite columns on tall pedestals. The special, elegant, cabled spiral fluting in these pedestals was probably based on that in the Cappella Corner of the Santi Apostoli Church by Mauro Codussi. In each corner is a pair of smaller altars. The canvas on the ceiling, *Apotheosis of St. Hermagoras and St. Fortunato* (18th century) is by FRANCESCO MIGLIORI. In the lower part we can see the figure of Faith and other theological and cardinal virtues. Beginning our tour from the right, on the wall around the entrance is the altar of St. Helena and, on the right wall, the altar of St. Joseph. Then, counterclockwise, there are the Corinthian altars dedicated to St. Gaetano of Thiene, St. Anthony of Padua, St. Peter, the Madonna and Child, St. John the Baptist and St. Anthony Abbot. The 18th-century statues of the above saints are by GIANMARIA MORLAITER (d. 1782) and his workshop. Above the entrance toward the Grand Canal is a pulpit surrounded by canvases of different sizes. Among these, at the sides and above, are *The Agony in the Garden* and, at left, *Judas' Kiss* by ALVISE DEL FRISO (d. 1609). Over the next altar is the statue of St. Gaetano of Thiene, which differs from the other

sculpted images both in typology and in the use of colored marble. The saint, a Venetian and the founder, together with Giampietro Carafa, of the Theatine order, is portrayed in his kneeler kissing the feet of the Infant Jesus. The privilege of embracing the son of Mary or at least of touching him was reserved for those most zealous in their prayers and spiritual exercises, such as St. Anthony of Padua, portrayed in the nearby altar. To the right of this latter is the entrance to the small, noteworthy sacristy that has three canvases by MIGLIORI: on the ceiling, *Apotheosis of St. Hermagoras and St. Fortunato,* and on the walls, *The Martyrdom of St. Hermagoras and St. Fortunato* and *St. Hermagoras Baptizing St. Fosca.* The chancel – reserved for the Scuola del Santissimo Sacramento, as can be seen by the signs of the Eucharist chalice and the

monstrance sculpted on the two front pedestals – has four giant corner columns and a "velar" ceiling with *The Miracle of the Manna* by FRANCESCO MIGLIORI. At the sides of the fine high altar are statues of the saints to whom the church was dedicated, Hermagoras and Fortunato, attributed to MORLAITER. On the left wall is the agitated *Last Supper* (1547) by JACOPO TINTORETTO, illustrating the consecration of the Easter lamb and the discussion

among the Apostles after Jesus announces his coming betrayal. Bursting onto the scene are the virtues of Faith, at left, and Charity. At the foot of this latter, a child, the allegory of innocence, points at Judas, who is hiding the purse with the 30 pieces of silver. On the wall is the second pulpit, surrounded by other canvases, some of which were painted by IL PADOVANINO and by MIGLIORI. The exit is the door below the pulpit.

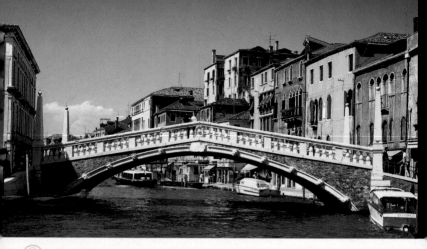

From San Marcuola, take the Rio Terà drio la Chiesa to the Capiello drio Ca' Memmo, where there is a wellhead built by the Provveditori di Comun and dated 1710. The building opposite this, with an Istrian stone facade that has a pitched central body and four Corinthian pilasters on pedestals, was the headquarters of the Scuola di Cristo Crocifisso. This brotherhood, associated with the Compagnia della Morte in Rome, was founded in 1644; one of its duties, besides worship of the Crucifix (as the dramatic 17th-century statuette above the entrance demonstrates), was to bury the corpses found in the water.

At the end of Rio Terà del Cristo, turn left and go to the square with the former church of **San Leonardo**, founded in the 11th century and rebuilt by BERNARDINO MACCARUZZI around 1794. The facade with its pitched central body has four Corinthian half-columns superimposed on pilasters. Besides the San Leonardo confraternity, established in 1395, this church housed the Scuola di Santa Maria della Carità, founded in 1260, which later moved to the church of the same name, now the home of the Accademia Galleries. San Leonardo was closed in 1807. Go to the end of Rio Terà San Leonardo, where to your left you will see a charming Neo-Gothic building (no. 1510) by the architect AMBROGIO NARDUZZI. The nearby **Ponte delle Guglie** was built in stone in 1580 by MARCHESINO DI MARCHESINI and rebuilt by the Provveditori di Comun in 1777, as the plaque tells us. A series of 18th-century busts of lions and monsters decorates the two outer cornices of the arch. From this bridge, at right there is a view of some tall buildings in the Ghetto Vecchio (Old Ghetto) and, beyond the Canal de Cannaregio, the impressive façade of Palazzo Savorgnan, while to your left is the façade of Palazzo Labia. Go down the bridge to the nearby Campo San Geremia, famous for the bull

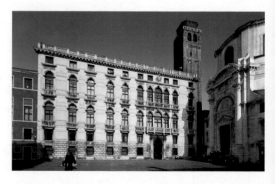

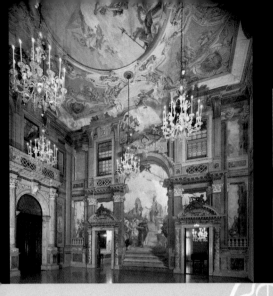

344 TOP PONTE DELLE GUGLIE.

345 TOP LEFT BALLROOM, PALAZZO LABIA.

344 BOTTOM FAÇADE OF PALAZZO LABIA IN CAMPO S. GEREMIA.

345 TOP RIGHT AND BOTTOM GIAMBATTISTA TIEPOLO, DETAILS OF THE FRESCOES IN THE BALLROOM.

hunts that once took place there.

■ At left is the **Palazzo Labia** (no. 275). The Labia were a family of Catalonian merchants who came to Venice in the 16th century and were admitted into the patrician class in 1646. To celebrate this event, Gian Francesco Labia had a new, prestigious residence built (perhaps by ANDREA COMINELLI), which was finished in the second half of the 17th century. One of its façades overlooks the Canal de Cannaregio. This has more luxurious stone dressing as well as Doric, Ionic and Corinthian pilasters, and is crowned by ovoid windows alternating with statues of crowned

eagles, the family coat of arms. The façade overlooking the *campo*, with heads of men and women, was enlarged to the left after 1720, perhaps by GIORGIO MASSARI, in order to add the magnificent ballroom in which GIAMBATTISTA TIEPOLO painted some splendid frescoes. Besides the *Bellerophon Riding Pegasus* on the ceiling, there are the masterful *Meeting of Antony and Cleopatra* and *The Banquet of Antony and Cleopatra* (1747-50), accompanied by the superb *trompe l'œil* architectural painting in Rococo style by the *quadratura* painter from Ferrara, GEROLAMO MENGOZZI COLONNA. These two episodes drawn from Roman

history are set in aristocratic 18th-century Venice and exude a theatrical, worldly atmosphere. In their meeting, Antony, in ancient dress, with a gallant gesture offers his arm to Cleopatra, who is lifting the train of her very fashionable dress. At right, a black servant is holding a greyhound. In the banquet scene, Cleopatra has changed her dress and, with the calculated nonchalance of a noblewoman, is exposing her ivory cleavage. A dwarf with shabby pants marks a contrast with the ostentatious opulence, while above some musicians are entertaining the diners. Among the other rooms in the palazzo are the chapel, the tapestry hall and the hall of mirrors.

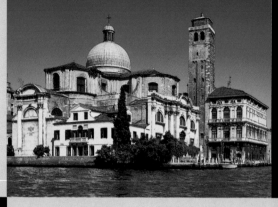

346 AND 347
INTERNAL AND EXTERNAL
VIEWS, CHIESA DI SAN
GEREMIA.

■ Next to Palazzo Labia is **Santi Geremia e Lucia Church**. HISTORY: considered one of the eight churches founded by St. Magnus in the 7th century, San Geremia probably dates back to the 9th century, and the oldest part of its tall bell tower was built in the 12th century. The new church was designed in 1754 by the Brescian priest CARLO CORBELLINI and it was consecrated in 1760. The cupola was built in 1828-29 to a design by the architect GIUSEPPE BRUNELLO. FAÇADE: this unusual façade serves to conceal the large curved right transept. The two unadorned and slightly convex wings are on the flat façade delimited by a tall stairway, two gigantic Corinthian half-columns and a broken lunette crown. INTERIOR: after entering through the portal on Campo San Geremia, the visit begins from the back of the façade, at left. In an attempt to create a universal church and pay homage to Venetian Renaissance architecture,

CARLO CORBELLINI devised an eclectic architectural configuration. The church has a Greek cross plan with apsidal arms on which is grafted a body with the longitudinal nave and two aisles obtained through the addition of four smaller corner chapels. The eight side altars (1760-70) at the beginning of the aisle and in the transepts are by ANTONIO and GIAN MARIA LAUREATO. Before going down the right-hand aisle, note on the inner side of the façade the canvas by PALMA GIOVANE, *The Meeting of Anne and Joachim at the Gate of Paradise* (1615-ca. 1620). Tradition has it that this episode gave rise to the Immaculate Conception of Mary. At the end of the aisle, after the altarpieces by PIER ANTONIO NOVELLI, FRANCESCO MAGGIOTTO and BERNARDO LUCADELLO, there is the Chapel of St. Magnus, which housed the remains of the bishop who founded eight Venetian churches, translated from Eraclea in 1206 and returned in 1965. A confraternity was founded in his honor in 1423. The altarpiece by PALMA GIOVANE represents the *Madonna and*

Child in Glory Observing St. Magnus Crowning Venice Flanked by Faith (1610- ca. 1620). In the rear chapel at right, the 1764 altar has a statue of the *Immaculate Virgin* sculpted by GIOVANNI MARCHIORI (after which the chapel was named) and, at the sides, others of St. Francis of Sales and St. John Nepomuk (second half of the 18th century). The canvases on the walls, by PALMA GIOVANE and from Santa Lucia Church, represent the *Madonna del Parto* (ca. 1615-18) and, at left, *St. Thomas Aquinas Receiving the Chastity Belt from Angels* (ca. 1610). In order to discourage St. Thomas from devoting his life to religion, his parents let a girl into his bedroom, whom he cast out with a firebrand, here painted at his feet. The mid-18th century landscape fresco on the back wall of the chapel, like the similar one in the chapel opposite, is attributed to GEROLAMO MENGOZZI COLONNA. On the right-hand wall of the chapel is the entrance to the sacristy. Among the paintings there by MICHELANGO SCHIAVONI, known as IL CHIOZZOTTO, who was a follower of Tiepolo, is

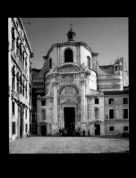

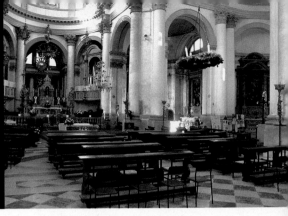

the central canvas on the ceiling, *St. Jeremiah Predicting the Fall of Jerusalem* (ca. 1770). Note, in the foreground, the allegorical female figure dressed, like a dogaressa, thus connecting Venice and the holy city of Jerusalem. Back in the church, go to the chancel, reserved for the Scuola del Santissimo Sacramento, founded in 1507. The sumptuous elevated marble altar built in 1709 by DOMENICO FADIGA is embellished with two side statues of St. Jeremiah and St. Peter, dated 1798 and signed by GIOVANNI FERRARI, known as IL TORRETTO. Above the altar is a lovely 18th-century baldachin in gilded wood, surmounted by a Eucharist chalice. The fresco on the back wall is attributed to AGOSTINO MENGOZZI COLONNA (second half of the 18th century), while the fine statue of the Risen Christ is by an unknown 18th-century sculptor. In the left-hand rear chapel, dedicated to the Madonna of the Rosary, there are the four canvases that covered the shutters of the organ in Santa Lucia Church, executed by PALMA GIOVANE,

representing the *Annunciation* and *St. Lucy and St. Augustine* (ca. 1620). Back in the church, along the left aisle you will see the Cappella del Crocifisso. On the altar, in a case framed by 17th-century marble putti, is an interesting statue of *The Dead Christ* (second half of the 16th century) – now in a recumbent pose, but thanks to its mobile arms it can also be placed on a cross – donated in 1602 by the Capuchin priest Francesco da Mula. It was invoked by the populace for its numerous miracles and for protection against the plague. Farther on, past the left transept, is the Chapel of St. Lucy, with the remains of the martyr from Syracuse and patron saint of sight, who is still very much venerated. The gilded Verona broccatello altar and the urn (1928-30) are the work of the Venetian architect GAETANO ROSSI, while the silver mask (ca. 1955) covering the saint's face was made by MARCELLO MINOTTO. The right-hand exedra leads to the second, small sacristy, which has been turned into a museum. Besides the two 17th-century epigraphs from

Santa Lucia Church and the canvases by PALMA GIOVANE and FRANCESCO FONTEBASSO, note the *Holy Family and the Infant St. John the Baptist* (second half of the 16th century) from the workshop of JACOPO TINTORETTO, in which St. Joseph is portrayed as a carpenter holding a plank of wood. Besides the boatmen's guild (Corporazione dei Barcaioli di San Geremia), whose members were devotees of St. Bartholomew, the church housed many religious brotherhoods, such as the Scuola della Beata Maria Vergine Assunta (or Scuola del Popolo), whose headquarters was located in rooms in the building adjacent to San Geremia and facing the square. ■ Once outside San Geremia Church, turn left into Rio Terà Lista di Spagna. Farther on, to your right, is **Palazzo Manin-Sceriman** (no. 168), founded by the Friziero family (from which St. Magnus descended) and rented by the Zeno family to Spain, which turned it into its embassy. The interesting monumental staircase with 18th-century frescoes was built during the 1759 restoration work promoted by Duke Josef Monteleagre.

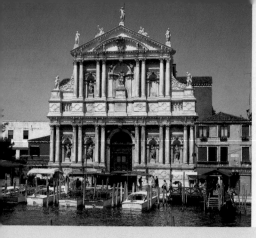

348
Scalzi Church.

349 VIEW OF THE HIGH
ALTAR.

■ Next is the **Santa Maria di Nazareth**, commonly known as the **Scalzi Church**. HISTORY: the reformed Carmelite Order or Scalzi (discalced or barefoot) was founded by St. Theresa of Avila, who drew inspiration from the tradition of Mt. Carmel and the reform implemented by the barefoot Franciscan friars. In 1562, St. Theresa founded the Convent of St. Joseph in Avila. Six years later, the first convent of the Scalzi friars was established in Duruelo, Spain, thanks to the efforts of the poet and theologian St. John of the Cross and of Anthony of Jesus. The first Carmelite order was founded in Venice in 1286 and was connected to the Carmini Church. The Scalzi friars came to Venice in 1633. Once they had obtained permission from the Senate to build a monastery, the friars purchased a plot of land in the parish of Santa Lucia in 1649. The following year, they commissioned BALDASSARE LONGHENA to build a temporary church and, in the meantime, to make designs for the construction of the present church. Already in 1652 the friars thought of enlarging the church, and LONGHENA showed them his design two years later. Construction began around 1654-56 and continued up to the consecration of the church (1705, as the inscription informs us). Longhena died in 1682 and was replaced around 1685 by the Carmelite GIUSEPPE POZZO, who redesigned the middle side chapels (1694) and the high altar. FAÇADE: this was built of Carrara marble in 1672-80 to a design by GIUSEPPE SARDI. It consists of two superimposed rows of paired Corinthian and composite columns on pedestals. The many statues were sculpted by CLEMENTE MOLI, FRANCESCO PENSO (known as CABIANCA), GIOVANNI BONAZZA and TOMMASO RUER. The niches on the lower section pay homage to four saints who were imitators of Christ: from left, St. Sebastian, St. Mary Magdalene, St. Margaret and St. John the Baptist. Note, in the spandrels of the Ionic entrance, the two allegorical figures and, on the keystone, the high relief with the rare and elegant motif of two putti. In the middle of the second order, the statue of the Madonna and Child is a glorification of St. Mary of Nazareth, to whom the church was dedicated. At left is the figure of St. Jerome, probably commissioned by Count Girolamo Cavazza, who financed the construction and who is buried in the Madonna dell'Orto Church. His coat of

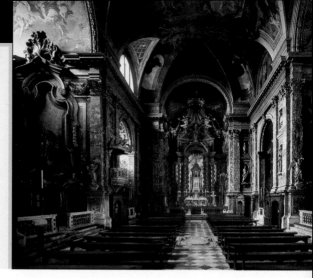

arms is on the tympanum of this façade. Next to St. Jerome is the figure of Faith. The empty niche once contained Hope, which fell and smashed to pieces in 1920. Above the right pedestal is St. Bartholomew. Along the sloping roofs are the statues of the Risen Christ (center) and, at either end, Adam and Eve liberated from Limbo. The two recumbent figures, erroneously identified as Cain and Abel, may be the Chosen Ones going up from Purgatory to Paradise. INTERIOR: considered one of the most important examples of Venetian Baroque art, the interior of the Scalzi consists of an aisleless nave with a chancel and choir. Along the side walls are two small chapels and a large one in the middle, separated by Corinthian pilasters on pedestals. The statues in the niches between the pilasters – attributed to BERNARDO FALCONI and GIOVANNI

MARCHIORI – represent seven Apostles (late 17th century), while the blind windows above them frame twelve busts of popes, bishops and presbyters (second half of the 17th century), attributed to CLEMENTE MOLO or GIOVANNI MARCHIORI. The original fresco on the ceiling by GIAMBATTISTA TIEPOLO, *Translation of the Holy House* (ca. 1743), was destroyed by an Austrian bomb in 1915. The surviving fragments and two oil sketches of this work are now kept in the Accademia Gallery. ETTORE TITO, who is buried in this church, replaced TIEPOLO's fresco with a large canvas, *The Council of Ephesus Proclaims the Virgin Mary Mother of God* (1929-34; 520 square meters). On the counterfaçade above the organ is a canvas in a lunette by GREGORIO LAZZARINI (1655-1730), *The Apotheosis of St. Theresa*. The first chapel at right, probably designed by LUDOVICO DAVID and financed by the

Giovanelli family (1683-85), is entitled *St. John of the Cross*, the founder of the Scalzi Carmelites and confessor of St. Theresa of Avila. His statue on the 18th-century altar may have been sculpted by BERNARDO FALCONI. The Angels holding up the cloud on which St. John is kneeling are by BERNARDO TABACCO, while those on the side are by GIOVANNI COMIN. The three Theological Virtues over the pediment are attributed to TOMMASO RUER. In the vault, the gilded eight-point stars are a Marian symbol frequently seen in Carmelite churches. The next chapel, built with funds from the Congregation of the Noble Matrons of St. Theresa, was designed by GIUSEPPE POZZO with the collaboration of ANTONIO GASPARI. The sculpture group decorating the luxurious Corinthian altar represents *The Ecstasy of St. Theresa* (late 17th century). In her description of her spiritual suffering, St. Theresa wrote of an angel that pierced

350 AND 351 TOP
GIAMBATTISTA
TIEPOLO, *DEATH OF
ST. THERESA* AND
DETAIL.

351 BOTTOM
CAPPELLA DELLA
SACRA FAMIGLIA
(CAPPELLA MANIN).

her heart with a burning arrow: "The pain was so acute that it made me groan, but the sweetness that accompanied it was such that I would have wished that that suffering should not end." Unlike the voluptuous rendering of Gian Lorenzo Bernini in his masterpiece in Rome, HEINRICH MEYRING uses restrained sensuality in his Venetian version. On the ceiling, GIAMBATTISTA TIEPOLO frescoed the *Death of St. Theresa* (1722-24) in Carmelite garb. The canvases on the walls by NICOLÒ BAMBINI (1651-1736) represent *St. Joseph Rushing to Help St. Theresa* and *The Miraculous Communion of St. Theresa*. Doge Carlo Ruzzini (1732-35) is buried in the second chapel. In the third chapel, the first to be built (in 1660) and financed by Giambattista Mora, there is the statue of St. John the Baptist (1660-72) on the altar, signed by MELCHIOR BARTHEL. The fresco of God the Father on the ceiling is by PIETRO LIBERI (1614-87). The triumphal chancel, with pillars made of red marble from France, was financed by Benedetto Soranzo, the procurator of San Marco. The altar, probably designed by BALDASSARE LONGHENA and later altered, was consecrated in 1717. Four elegant angels

adorning the altar frontal, attributed to GIOVANNI MARCHIORI, are holding up the symbols of the Eucharist: grapes, manna, lamb, and ears of wheat. The two side statues depict the figures of the founders of the Scalzi order, St. Theresa and St. John of the Cross. This Baroque setting was the work of GIUSEPPE POZZO. The eight tortile Corinthian columns with pillars behind them support a fastigium with overtones of BORROMINI'S style. The central figure of Christ Pantocrator and the two recumbent Sibyls on either side are of uncertain attribution. Above is a baldachin with a crown made of gilded wood. The slender temple between the columns is attributed to LONGHENA. Its eight small columns are made of oriental jasper and the façade is decorated with semi-precious stones. The Venetian school oil panel representing St. Mary of Nazareth flanked by eight prophets (early 15th century) was donated to the church by the nuns of the Sant'Anna Convent in the Castello district. Crowned by God the Father, Mary, in the guise of a new Eve, is seated on an apple tree and on her chest is the image of the Christ Child in a mandorla, in accordance with the Byzantine

iconography. On the back of the altar is another oil panel of the Madonna and Child by the BELLINI school (early 16th century). The ten statues on the side walls represent the Sibyls who, as prophetesses, were granted the privilege of heralding the coming of Christ. Those on the right are attributed to GIOVANNI MARCHIORI and those at left to GIUSEPPE TORRETTI. DOMENICO and GIUSEPPE VALERIANI executed the frescoes in the blind cupola of the chancel and choir. On the side walls of this latter area are two 17th-century canvases: at right, *Ecstasy of St. Theresa* by FRANCESCO CAIRO, and at left, *Madonna del Carmine and Saints* by MICHELE DESUBLEO. In the corridor at left, is the *Lamentation over the Dead Christ* by the Venetian GREGORIO LAZZARINI. In the sacristy are 17th-century walnut furniture pieces carved by ZUANE CINGHERLE and crowned by figures of Carmelite saints. Back in the church, make sure to see the chapel built for Sebastiano Venier (1657-68). The statue of St. Sebastian (1662-64) on the altar is signed by BERNARDO FALCONI, who also sculpted the five bronze panels on the frontal depicting the martyrdom, glory and deposition of the saint.

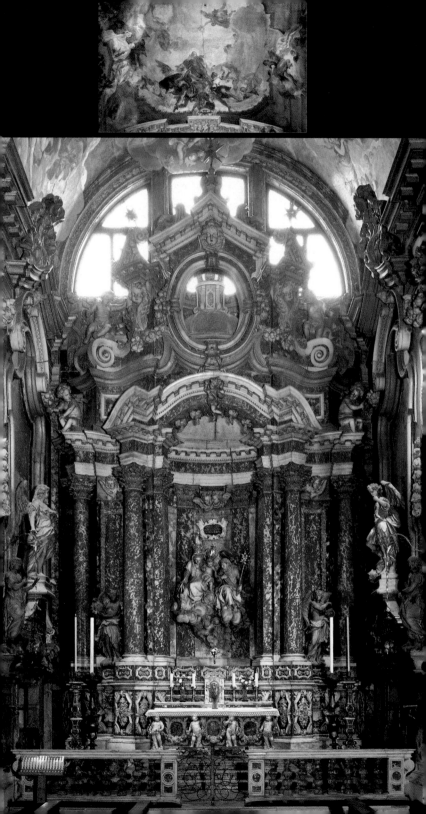

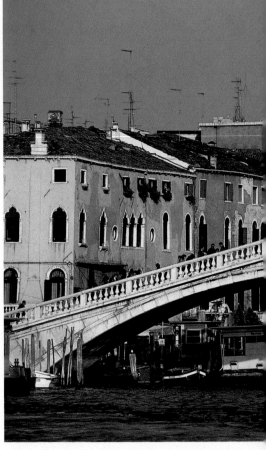

352 TOP AND 352-353 PONTE DEGLI SCALZI.

Note the paneled doors decorated with elegant polychrome marble inlay representing parrots and vases with flowers, the symbols of eternal life and virtue respectively. These are followed by the pulpit, attributed to GIOVANNI MARCHIORI, and the Holy Family Chapel (or Manin Chapel) designed by GIUSEPPE POZZO. In the central sculpture group, surrounded by angels and attributed to HEINRICH MEYRING, is the Virgin Mary holding a scapular. The presence of St. Joseph is due to St. Theresa's special devotion to him. According to tradition, while trying to found the first reformed Carmelite monastery, the Castilian saint had a vision in which she was given a golden chain by the Madonna and a white mantle by St. Joseph. The *Glory of Angels with the Holy Ghost* frescoed on the ceiling is by LOUIS DORIGNY (1654-1742). In the chapel is the tomb of Ludovico Manin, the last doge of Venice (elected in 1789, abdicated in 1797, died in 1802). The next chapel, begun in 1675 and finished – at least its decoration – in 1732 with funds donated by the Gussoni and Lumaga families, has a statue of the crucified Christ on the altar and a high relief with *Christ Falling on His Way to Calvary* on the frontal, both attributed to GIAN MARIA MORLAITER. GIAMBATTISTA TIEPOLO's fresco of the *Agony in the Garden* is on the vault. Over the altar in a glass case is an impressive 17th-century *Ecce Homo* in colored wax executed by a transalpine artist who depicts the moment when Jesus, his chest covered with the horrible signs of the flagellation, is about to be taken before the populace by two guards. When you leave the Scalzi church, continue to your right along Fondamenta

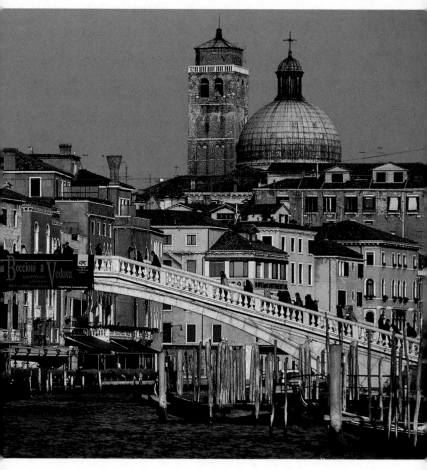

Santa Lucia. The large open area here was once occupied by the Scuola dei Nobili and the churches and monasteries of Corpus Domini and Santa Lucia, which were demolished to make room for the **Santa Lucia Railway Station**. This latter was inaugurated in 1861 after the construction of the lagoon bridge (1841-46) designed by TOMMASO MEDUNA and the iron bridge on the Grand Canal (1858). This bridge, **Ponte degli Scalzi**, was rebuilt in its present form in 1933 by the engineer EUGENIO MIOZZI. The new railway station, set back some 66 feet (20 m) from the original one, and with a 360-foot (110-m) Istrian stone façade, was designed by architect PAOLO PERILLI and inaugurated in 1954. The large mosaic above the ticket counters inside the station, *Venice, Universal City*, was made by AMBROSINI to cartoons by MARIO DE LUIGI. The bronze statue of *The Virgin Mary* (1959) to the left of the squar, is by the Venetian FRANCESCO SCARPA BOLLA, and the inscription at the foot of the statue was dictated by Pope John XXIII, who at the time was Patriarch of Venice. Continuing to your left along the *fondamenta* you will come to the place where the fourth bridge over the Grand Canal will be built: the design by the Catalonian architect SANTIAGO CALATRAVA calls for a glass, steel, Istrian stone and bronze construction. It was approved by the City Council in 2001.

354 TOP
SEBASTIANO RICCI,
PEASANT
WATCHING THE
ANGELS FINISH THE
STATUE OF THE
MADONNA AND
DETAIL, SAN
MARZIALE CHURCH.

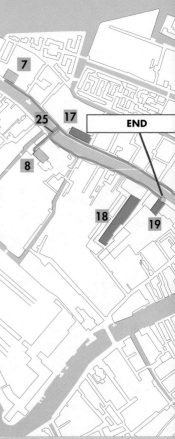

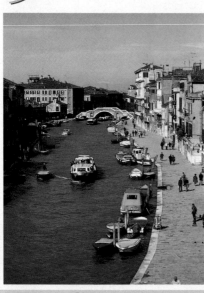

THE GATEWAY TO THE MAINLAND

This itinerary includes the most important sights in the northern section of the Cannaregio district. Over the centuries, the economic and residential development of this area situated at the junction of the waterways flowing from the mainland grew from ship-building, trading and handicrafts activities. Among these latter was textile production, as is manifested by the many guilds and by some place names such as Borgo Tentori (dyers' quarter), situated between San Girolamo and the Misericordia Church, or Fondamenta Ormesini, a name derived from the silk drapery that originated in Ormus (Hormuz) in Persia. Originally, the border between Cannaregio and the Lagoon was irregular and dotted with marshy plots of land, much like those in the Castello and Giudecca districts. It was this long strip of water and land that witnessed the rise of important monasteries and hospices which, besides healing souls and bodies, were from the 10th to the 14th century also engaged in land reclamation and the consolidation of the territory. In 1590-95, the Savi ed Esecutori alle Acque, the government body entrusted with safeguarding the lagoon and its canals, embarked on a wide-ranging campaign of land reclamation and filling in the northern borders of the city. This led to the construction of the Fondamente Nove, whose primary purpose was to facilitate the unloading of timber from Cadore.

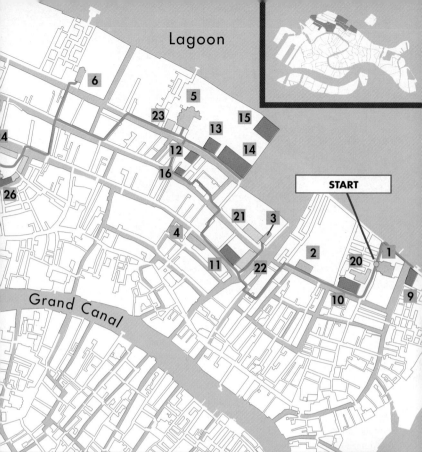

Lagoon

Grand Canal

START

354 BOTTOM CANAL DE CANNAREGIO.

355 BOTTOM JACOPO TINTORETTO, THE LAST JUDGMENT, CHIESA DELLA MADONNA DELL'ORTO, DETTAIL.

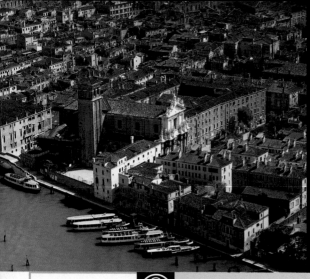

Itinerary From Gesuiti to San Giobbe

■ Situated on the northern edge of the city and near the landing stages for the boats to the islands of San Michele and Murano, is the church of **Santa Maria Assunta**, known as the **Gesuiti**, a monument that exemplifies the Venetian Baroque style.
■ HISTORY: this church stands in the area formerly occupied by Santa Maria Assunta dei Crociferi Church, known as the Crosechieri. The Crociferi (Bearers of the Cross) friars from Rome put up pilgrims on their way to the Holy

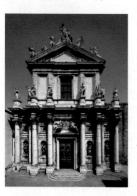

Land and aided the ill and the crusaders. The hospital order was recognized by Pope Alexander III in 1160. These friars came to Venice in the 12th century and, with financial help from the Gussoni family, built a church with an adjoining monastery, as well as a hospital-hospice with an oratory. These buildings were renovated after the death of Doge Renier Zen (1268), who bequeathed half of his fortune to the friars. The monastery was destroyed by fire in 1513 and was rebuilt in 1543. The Crociferi Order was suppressed by Pope Alexander VII in 1656. The possessions of the Venetian headquarters went to the Venetian Republic, which in turn gave them to the Jesuits in 1657. Relations between Venice and the Society of Jesus date from the preceding century, when its founder, the Spaniard St. Ignatius of Loyola, lived in

the city from 1535 to 1537. From the outset, the activities of the Jesuits, among whom was Francesco Saverio, were based on aiding the poor and ill, and educating young nobles. However, the local clergy and part of the patrician class – anti-Spanish and protective of Venice's independence from the Holy See – did not approve of the Jesuits' avowed fidelity and obedience to the pope and their growing religious and political influence over some nobles. The party of the "young people," headed by Leonardo Donà, set out to put reasons of state before papal prerogatives, and above all to maintain the right to try clergymen guilty of common crimes. The conflict broke out openly in 1606, when Pope Paul V excommunicated Venice and prohibited all religious services in its territory. The Republic retaliated not only by refusing to recognize the

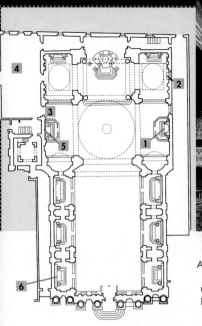

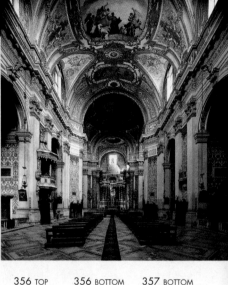

356 TOP
AERIAL VIEW OF
THE GESUITI
CHURCH AND
FONDAMENTE
NOVE.

356 BOTTOM
AND 357 TOP
FAÇADE AND
INTERIOR OF THE
GESUITI
CHURCH.

357 BOTTOM
THE MOCK
DOME FRESCOED
BY LOUIS
DORIGNY.

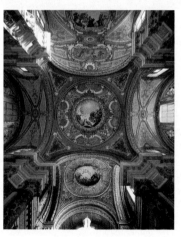

validity of the papal interdict, but went so far as to expel the Jesuits from its territory. Consequently, the Jesuit order had to wait for 50 years in order to be readmitted and authorized to take possession of the Crociferi. Construction of the new church began in 1714 and was finished in 1736, thanks to numerous benefactors, in particular Antonio Manin (d. 1732), who wanted to use the chancel as his family chapel. The design of the building (1710-13) was by DOMENICO ROSSI – the Manin family architect and nephew of GIUSEPPE SARDI – and modified by Father DONATO MORA. FAÇADE: designed by DOMENICO ROSSI and built by GIOVANNI CANZIANI and GIOVAN BATTISTA FATTORETTO in 1721-28. The rich array of sculpture executed by various artists – PIETRO BARATTA, GIUSEPPE and PAOLO GROPPELLI, FRANCESCO PENSO (known as IL CABIANCA), ANTONIO TARSIA and others – celebrates the original name of the church. Above the pediment is the *Assumption of the Virgin and Adoring Angels*, and the other statues portray the *Twelve Apostles* who witnessed the passage of the Virgin to Heaven. On the window sill there once hung a large marble drape sculpted in folds like damask that was perhaps held up by two angels. It is therefore possible that the large parapet alluded to the empty tomb in which Mary lay and the cloth was a reference to the shroud in which she was wrapped. In general he was replaced by Mark, the city's patron saint, flanked by Peter with the obvious aim of celebrating the Church of Rome and loyalty to the pope.

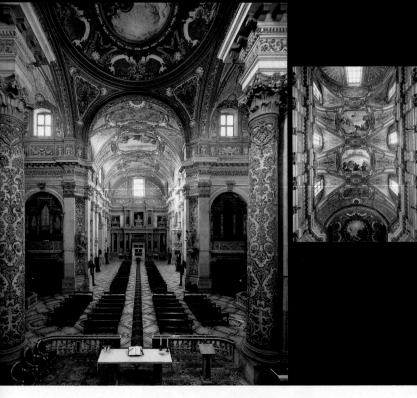

INTERIOR: the Latin cross plan with two rear chapels was a compromise between the rules laid down by the Council of Trent – and faithfully interpreted by the Jesuits – and the need to maintain some important funerary monuments and paintings from the old Crociferi church. The extraordinary green and white decoration on the walls that imitates damask (1725-31) – which serves the celebrative aims of the Manin family – is made of stucco with marble powder that in the transept is replaced by marble inlay. The unusual floor (1721-36) has an elegant play of intertwining geometric patterns based on the motif of the Greek cross. The vaulted CEILING is decorated with frescoes. The first two – *Abraham Adoring the Three Angels* and *The Vision of St. John the Evangelist* (1734) are by FRANCESCO FONTEBASSO and refer to the Trinity as well as the end of the world and the Last Judgment. The other two frescoes – *Triumph of the Name of Jesus* (1732) and *Angel Musicians in Glory* (1718-20) – are by the French artist LOUIS DORIGNY. The name of Jesus is symbolized by a dazzling trigram (IHS). Because of the persons who appear in this scene, the theme can be interpreted both as the Last Judgment and as the victory of the Church – personified by Peter and Mary – over the heretics, represented by the figures falling into Hell. On the counterfaçade is *the Lezze family tomb* designed by JACOPO SANSOVINO (d. 1570) and finished sometime after 1576.

The first chapel at right belonged to the silkweavers' guild. The altar, renovated in 1735, is crowned by a crest with the letters T and S, the initials of the guild (Tessitori di Seta). One of the putti flanking the crest is holding arrows referring to the martyrdom of St. Christopher, the patron saint of the confraternity. At the end of the nave, against the piers are sculpture groups by GIUSEPPE TORRETTI depicting four archangels: *Shealtiel, Gabriel, Michael and Raphael* (1726-28) and, on either side of the altar, the statues of *Uriel and Barachel* (1722-23), again by TORRETTI.

The RIGHT-HAND TRANSEPT is dominated by

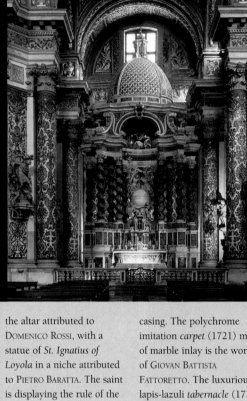

358 LEFT INTERIOR AND COUNTERFACADE, WITH THE DA LEZZE FAMILY TOMB.

358 RIGHT FRANCESCO FONTEBASSO, CEILING FRESCOES.

359 LEFT CHANCEL AND HIGH ALTAR.

359 TOP RIGHT GIUSEPPE TORRETTI, THE ARCHANGEL GABRIEL, DETAIL.

359 BOTTOM RIGHT GIROLAMO CAMPAGNA, TOMB OF DOGE PASQUALE CICOGNA.

the altar attributed to DOMENICO ROSSI, with a statue of *St. Ignatius of Loyola* in a niche attributed to PIETRO BARATTA. The saint is displaying the rule of the Society of Jesus, while at his feet an angel is vanquishing the seven-headed apocalyptic dragon, an allegory of Protestant heresy.

In the CHANCEL is the magnificent, lavish Baroque *high altar* (1716-20) designed by GIUSEPPE POZZO, brother of the more famous ANDREA, who was a painter and essayist. The architect, drawing inspiration from the high altar in the Scalzi Church, laid out ten tortile composite columns made of green marble to support a fantastic trabeation with geometric patterns and an ogival dome with scaly

casing. The polychrome imitation *carpet* (1721) made of marble inlay is the work of GIOVAN BATTISTA FATTORETTO. The luxurious lapis-lazuli *tabernacle* (1722) and the marble group above it (1720-22) are both attributed to GIUSEPPE TORRETTI. This latter work is the theological and visual fulcrum of the church. It depicts *Christ and God the Father seated on the globe of the universe held up by angels*, but it could also be called the *Holy Trinity*, the subject of which is prefigured by one of the frescoes on the ceiling. In fact, the dove of the *Holy Ghost* with mother-of-pearl feathers appears farther up and can be seen through a small window.

In the left-hand rear chapel of the Jesuits is the

Monument to Doge Pasquale Cicogna (d. 1595) by GIROLAMO CAMPAGNA, which was finished in the early 17th century. The figure of the doge, who also appears in the canvases of the nearby Crociferi Oratory, instead of lying on his bier as called for by tradition, is in the unusual pose of an elderly person with his head resting on his hands while he is sleeping.

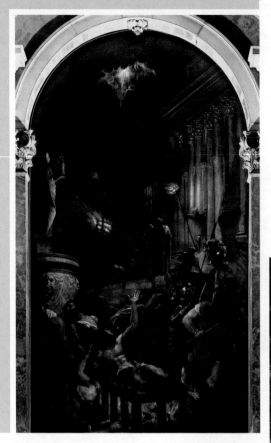

360 TOP LEFT TITIAN, MARTYRDOM OF ST. LAWRENCE.

360 TOP RIGHT PALMA GIOVANE, THE BEHEADING OF ST. JOHN THE BAPTIST.

360 BOTTOM AND 361 JACOPO TINTORETTO, *ASSUMPTION OF THE VIRGIN MARY* AND DETAIL.

■ In the SACRISTY there are twenty canvases by PALMA GIOVANE, painted for the Crociferi from 1589 to around 1625. Among these works, particular mention should be made of the one above the entrance, the cruel *Beheading of St. John the Baptist* (1610), as well as *The Miracle of the Manna* (1589-90) in the middle of the ceiling and the *Bronze Serpent* (1592-93) to the right of the small altar. On the altar of the LEFT-HAND TRANSEPT is the *Assumption* altarpiece (1555) that JACOPO TINTORETTO painted in the style of Veronese. The unbelieving Thomas is the only Apostle bowing his head toward the empty sepulcher dominated by the emblem of the Crociferi. The last chapel in the nave has the tragic *Martyrdom of St. Lawrence* (1548-58), one of the greatest masterpieces of TITIAN, commissioned by Lorenzo Massolo (d. 1557). In this work, the most beautiful night scene in all Venetian painting, illuminated by the glowing embers, St. Lawrence, tormented by the red-hot iron placed on his side, is about to be turned over on the grille, as he himself had requested. In the background, the soldier Decius and the prefect Valerianus are leaving the scene and going up the stairway of the Emperor Tiberius' palace.

362 ORATORIO AND OSPEDALETTO DEI CROCIFERI.

363 TOP PALMA GIOVANE, *DOGE RENIER ZEN AND HIS WIFE WORSHIPPING THE SAVIOR TOGETHER WITH THE BEARERS OF THE CROSS.*

363 BOTTOM LEFT PALMA GIOVANE, *SENATOR PASQUALE CICOGNA ATTENDS MASS.*

363 BOTTOM RIGHT PALMA GIOVANE, *POPE ANACLETUS INSTITUTES THE CROCIFERI ORDER.*

■ Once outside the Gesuiti Church, it is a good idea to take a walk along the Fondamente Nove as far as the austere **Palazzo Donà** (no. 5038), built by the *proto* FRANCESCO DI PIETRO from 1610 on for Doge Leonardo Donà (d. 1612). The doge was an opponent of the Jesuits and the papacy, and by having his residence built in an outlying area of the city and reverting to an essential, moderate architectural style, he intended to show his dislike for luxury, ostentation and the triumphalistic character of

classical "Roman" architecture. Going back to the facade of the Gesuiti, note, on the opposite side, the three plaques at no. 4902 stating that the headquarters of the Scuola dei Botteri (coopers) was here and was torn down in

1847. This confraternity housed JACOPO TINTORETTO's *Presentation of Jesus in the Temple*, now in the Accademia Galleries. The guildhall of the Scuola dei Varoteri (tanners) was also located in this area but was demolished to make room for the new façade of the church and was later rebuilt, at the expense of the Jesuits, in Campo Santa Margherita in 1725. Along the side of the convent were the guildhalls of the Sartori (tailors), the Passamaneri (makers of passamenteries, etc.), the Samiteri (silk-cloth weavers) until 1643, the Spechieri (mirror manufacturers), and the Scuola della Concezione di Maria (no. 4881), which was active as long ago as 1208, as the plaque tells us. Opposite the Jesuits' convent are the **Oratorio and Ospedaletto dei Crociferi**, which were built in the 12th century, converted into a hospice for elderly women and the poor in the early 15th century by the Prior Marino, and restored in 1549-63. Above the

entrance to the old hospice (no. 4905) is an early 15th-century bas-relief of an enthroned *Madonna and Child with St. Jerome* (?). The side entrance is crowned by the *Calvary scene, with three crosses* in relief. The same image is repeated on the door opposite the convent (no. 4878), and is the emblem chosen by the Crociferi Hospital Order to show their connection with the Holy Land and with St. Helena, who found the True Cross.

The side entrance leads to the Oratory, which was restored in 1553 and 1582. All the canvases in this small and precious chamber were executed by PALMA GIOVANE from 1585 to 1592. They are dedicated to four fundamental themes: the Passion of Christ and two prophets, the Assumption of the Virgin (patron of the hospital and church), the story of the Crociferi, and Doge Pasquale Cicogna and his devotion to the Crociferi. The works along the walls are distinguished for the splendid and simple portraits of figures of that epoch, who are captured in natural, spontaneous poses.

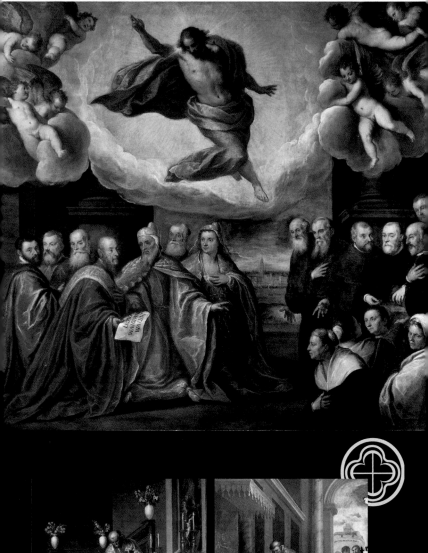

364 TOP AND CENTER PALAZZO ZEN, DETAIL.

364 BOTTOM SCUOLA VECCHIA DELLA MISERICORDIA AND SANTA MARIA DELLA MISERICORDIA CHURCH.

365 LEFT CANAL AND SCUOLA GRANDE DELLA MISERICORDIA.

365 RIGHT PALAZZO LEZZE AND SCUOLA GRANDE DELLA MISERICORDIA.

■ Walking toward the canal, turn right and skirt the **Palazzo Zen** (no. 4921), built in 1533-53 to a design by the patrician FRANCESCO ZEN (d. 1538), the son of Pietro, who was the Venetian ambassador in the East. The frescoes by ANDREA MELDOLLA (known as LO SCHIAVONE), JACOPO TINTORETTO and GIOVANNI ANTONIO SACCHIENSE (known as IL PORDENONE), which no longer exist, imparted a sumptuous tone to the residence of the descendants of Doge Renier, a patron of the Crociferi, despite the simplicity of the slender windows.

Along the *fondamenta* is one side of the former Church and monastery of **Santa Caterina dei Sacchi**, dating from the 11th century. Initially inhabited by the Sacchini friars, or Friars of the Penitence of Jesus Christ, the church was entrusted to the Augustinian nuns around 1289. Its Gothic interior with two aisles (mid-15th century) has been modified, especially in the chancel area. With the help of a map, go to the Ponte Racheta that crosses Rio de S. Felice, where you can see (next to no. 3603) one of the few old bridges in Venice that still has no railing. Go to the Campo de l'Abazia, with the **Santa Maria della Misericordia** church and abbey, also known as **S. Maria in Val Verde**, from the old name of the island on which it stands. Near this church,

which was founded in 939, the first hospice in Venice was probably built. One of its old headquarters dating from 1505 was situated along the Fondamenta de l'Abazia, in the nearby Corte Nuova (nos. 3555-67), where what remains of its lovely late 14th-century *portal* was reassembled at the entrance. Next to the church there was a small chapel dedicated to St. Cristina. The facade, built in 1651-59 at the expense of the philosopher and senator Gasparo Moro (d. 1671), is attributed to the Bolognese CLEMENTE MOLI, who also sculpted the *bust of Moro* and the two statues on the sides of the portal, *Perseverance* and *Mercy*.
Next to the church is the **Scuola Vecchia della Misericordia** (no. 3551). This brotherhood, founded in 1308, built its first headquarters (as well as a poorhouse) after 1310, after receiving a bequest from Giovanni Donato, prior of the neighboring church of S. Maria della Misericordia. The edifice was rebuilt three

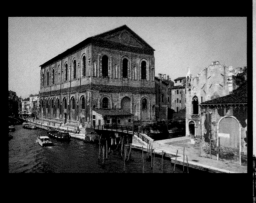

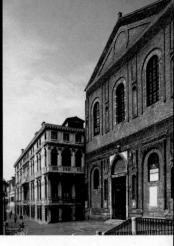

times in the 14th century. The façade, with a pitched central body and an elegant crown, was renovated in 1441. The poorly preserved portal has been attributed, with uncertainty, to BARTOLOMEO BON, a confrere of the Scuola, or to his workshop. At the end of the 16th century – after it had been decided to build a new hall in a zone nearby past the Rio della Sensa – the Scuola was converted into a hospice, and in 1643 was sold to the silk-cloth weavers' guild, which turned it into its guildhall.

In the middle of the intriguing small square is a 15th-century *wellhead* decorated with reliefs of figures of the confreres holding a tondo with the letters SMV, the initials of Santa Maria in Val Verde. Now retrace your steps to the impressive entrance façade of the former **Scuola Grande della Misericordia**. The building stands in the area formerly occupied by the hospice of the same name, built in 1386-89. The

old Scuola decided to build its new headquarters in 1497 and asked ALESSANDRO LEOPARDI and PIETRO and TULLIO LOMBARDO to begin working on it. These artists were replaced in 1532 by JACOPO SANSOVINO (as the *proto* or master builder), who presented a new model. Although it retained the traditional style of Venetian confraternities, his design introduced the striking image of clearly classical architecture in a peripheral zone of the city characterized by low, medieval buildings. The financial difficulties of the Scuola, the wars against the Turks, and the differing opinions between the Florentine architect and the confreres delayed construction of the building, so that when SANSOVINO died in 1570, it had not yet been finished. The two rows of paired columns in the lower hall were begun in 1576, and the staircase was built later to a design (1587) by FRANCESCO SMERALDI. In 1589, the Scuola officially

moved from the old site, transporting all its precious relics in a procession. Besides paintings by artists such as DOMENICO TINTORETTO, ANTONIO ZANCHI, GREGORIO LAZZARINI and others, the Scuola boasted a miraculous icon of the *Madonna* brought in 1665 from Korone in Greece. The icon is traditionally ascribed to a certain Fra' Lazzaro, who supposedly painted it in 421, the year of the mythical foundation of Venice.

To the left of the main facade of the Scuola Grande della Misericordia is **Palazzo Lezze** (no. 3597), which was already being built in 1624 by BALDASSARRE LONGHENA. The windows of this building are crowned by lovely busts and the smaller facade (no. 3598) has reliefs with mythological and alchemical motifs. The ballroom was embellished with frescoes by GIAN DOMENICO TIEPOLO and *trompe l'œil* architectural painting by GEROLAMO MENGOZZI-COLONNA.

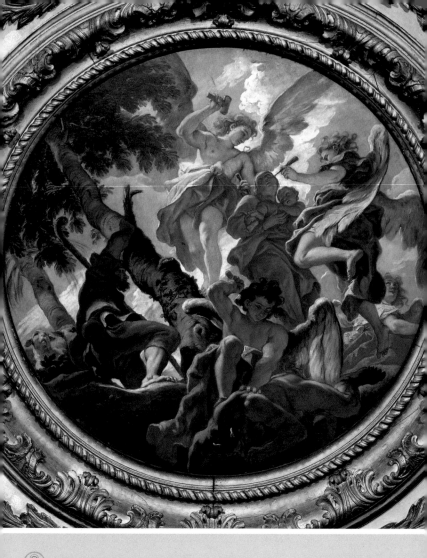

■ Not far away, on the other side of Rio della Sena, is **San Marziale Church**. HISTORY: the first church, with a nave and two aisles, had already been finished in 1133. The nave was interrupted by a choir, much like the one in the Frari church. The present church, with an aisleless nave, was built in 1693-1714 and consecrated in 1721.

INTERIOR: besides works by ANTONIO VASSILACCHI (known as L'ALIENSE), DOMENICO CRESTO (known as IL PASSIGNANO), ANTONIO ZANCHI, DOMENICO TINTORETTO and GIULIA LAMA, note the altarpiece on the second altar at right by JACOPO TINTORETTO, *Apotheosis of St. Martial with St. Peter and St. Paul* (1549). Originally, this painting decorated the high altar. One of the angels is holding the miraculous cane with which Martial, the bishop of Limoges, resuscitated the dead. The altar was rebuilt by the church chapter thanks to a bequest from Antonio dalla Vecchia in 1629 and a donation from the Convicini di San Marziale in 1697. This latter brotherhood, active since the first half of the 16th century, aided the poor and ill in the neighborhood. The side statues depict two disciples of St. Martial, *St. Valeria*

366 AND 367 CENTER SEBASTIANO RICCI, *RUSTICO OBSERVING THE ANGELS FINISHING THE STATUE OF THE MADONNA* AND DETAIL.

367 TOP SAN MARZIALE CHURCH.

367 BOTTOM LEFT JACOPO TINTORETTO, *ST. MARTIAL IN GLORY BETWEEN STS. PETER AND PAUL.*

367 BOTTOM RIGHT BEATA VERGINE DELLE GRAZIE ALTAR.

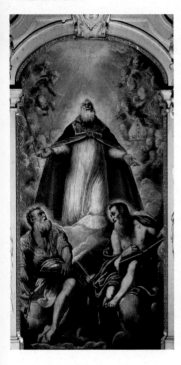

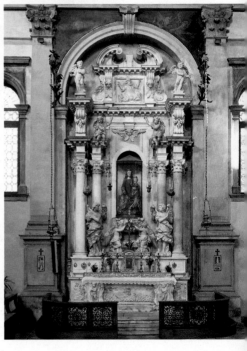

and *St. Austriclianus.* Since the Scuola del Santissimo Sacramento was granted the use of the CHANCEL, and it built the luxurious and theatrical *high altar* there in 1691-1704, attributed to TOMMASO RUER. Continuing your visit along the left wall, you will see the central altar, dedicated to the *Beata Vergine delle Grazie* (Blessed Virgin of Graces) and built in 1697

The Scuola of the same name, which was founded in 1409. In the niche is the wooden statue of this Virgin (late 14th century). This work reproduces an analogous image which, according to tradition had been sculpted in Rimini in 1286 by a shepherd named Rustico, with the help of angels, and which arrived miraculously in Venice from the sea. This episode, which is so important for

local religious sentiment, is also illustrated in the frescoes painted on the CEILING by SEBASTIANO RICCI in the early 18th century. Starting from the entrance, they depict *The Arrival of the Statue of the Madonna in Venice, St. Martial in Glory, Rustico Observing the Angels Finishing the Statue of the Madonna,* and, on an axis with the chancel, *God the Father in Glory.*

368 LEFT
SAN CRISTOFORO
PORTAL, DETAIL.

368 RIGHT THE
SCUOLA DEI
MERCANTI AND
MADONNA
DELL'ORTO CHURCH.

369 NAVE AND
CHANCEL OF
MADONNA
DELL'ORTO CHURCH.

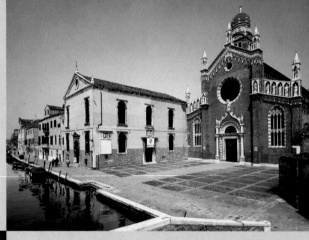

■ After visiting San Marziale, go back to the Fondamenta della Misericordia and, with the aid of a map, go to the Ponte dei Muti, which has a view of a former *squero*, the typical Venetian boat-building yard. Farther on, in Fondamenta dei Mori, is **Tintoretto's house** (no. 3399). Between no. 3398 and 3384/B are the four 14th-century statues of *Eastern merchants* and a porter known as the **Mori** (Moors). Traditionally, these merchants were three brothers who arrived in Venice in 1112 from Morea, in Greece, and settled here, taking the name of Mastelli. The most famous statue for the Venetians, set at the foot of the bridge, portrays *Sior Antonio Rioba*. At the end of Calle dei Mori, cross the Madonna dell'Orto bridge. The itinerary continues in Fondamenta Gasparo Contarini. On the other side of the canal is

Palazzo Mastelli, known as the **Cammello** because of the relief on its facade of a *Camel bearing a pack and following its Middle Eastern owner* (14th century). This building, which according to tradition was inhabited by the three Greek brothers mentioned above, was constructed with material taken from other buildings. Proceeding along the *fondamenta*, you will come to **Palazzo Minelli-Spada** (no. 3536), built by a follower of BALDASSARRE LONGHENA. Farther on is the long façade with a monumental double entrance of **Palazzo Contarini dal Zaffo** (no. 3539), which was the residence of Cardinal Gasparo Contarini (d. 1542), who is buried in Madonna dell'Orto Church. He was one of the main exponents of the reform of the Church before the Council of Trent. This building was famous for its rich interior decoration and the large park facing the lagoon, at the end of which is the **Casin dei Spiriti**. The building, which can be

entered through the nearby Sacca della Misericordia, was a meeting place for the leading "spirits" or figures of Venetian art and culture.

■ Now go back to the **Chiesa di San Cristoforo Martire**, better known as **Madonna dell'Orto**. HISTORY: the first church was built right after 1365, the year when Fra' Marco Tiberio de' Tiberi from Parma (d. 1371), general of the order of Humiliati monks, purchased the land. The present name derives from an event that occurred in 1377. The sculptor Giovanni de Santi set a statue of a *Madonna and Child* in his kitchen garden and with time it became very popular and venerated. Giacomo Condulmer, the steward of the local Scuola di San Cristoforo, decided to purchase the miraculous image with the explicit aim of increasing offerings for the church being built. During the 15th century, because of their rather unbecoming behavior, the Humiliati were expelled from the monastery twice and then finally banned

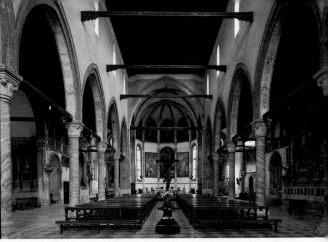

in 1462, when both church and monastery were transferred to the Canonici Secolari dell'Isola di San Giorgio in Alga. These canons, called Celestini because of the color of their habit, stimulated the development of the church by enriching it – up to 1668, when the order was dissolved – with precious art works.

FAÇADE: this is made of bricks, with a pitched central body and two lower side wings with large Gothic windows redone in the 19th century. The *portal* (1460-83), designed by BARTOLOMEO BON, is crowned by the statue of *St. Christopher*, after whom the church was originally named. The sculpture is attributed to NICOLÒ DI GIOVANNI FIORENTINO, as is the figure below it of the *Annunciate Madonna*, while the statue of the *Archangel Raphael* is thought to have been executed by ANTONIO RIZZO. St. Christopher – whose name in Greek means "bearer of Christ" – is depicted with his traditional staff, which he used to ford

the river. The lateral crowns of the façade are decorated with an unusual gallery of statues of the *Twelve Apostles* (ca. 1430-40), the work of Tuscan sculptors. The cornice of the rose window has a symbol that is repeated in the portal, the letter X, which in Greek is the initial of Christophoros and also alludes to the cross that he adored. The palm tree with roots is a clear-cut reference to the legend of this saint. At the behest of the Christ Child, he planted his staff in the earth, and the next morning he found it transformed into a date palm laden with fruit. The central crowns are decorated with a beautiful terracotta and Istrian stone frieze. Over the oculus is a roundel in high relief of the *Madonna and Child held up by two angels*, of uncertain attribution. The five late 17th-century statues inside the cusped tabernacles came from Santo Stefano Church in Murano. The 15th-century bell tower, completed in 1503, is decorated with

Lombardesque statues of the *Four Evangelists* and of the *Redeemer*.

INTERIOR: the nave and two aisles lined with ogee arches end in three chapels. The Greek marble columns are surmounted by robust and austere capitals decorated with corner rosettes and chignon-like motifs. On the first altar of the RIGHT-HAND AISLE is the altarpiece by GIAMBATTISTA CIMA DA CONEGLIANO, *St. John the Baptist with Saints Peter, Mark, Paul and Jerome* (1493-95). The painting introduces two focal points. The one at left – toward St. Peter and St. Mark, figures of the Church of Rome and Venice – is rendered through perspective, and the other one, in the middle, on St. John, by means of the composition. The ruins of a pagan temple – whose reliefs represent the vices – are countered by the allegorical edifice of the Church embodied by the four saints. The idol on the stone pedestal has been destroyed and replaced by the living statue of the forerunner of

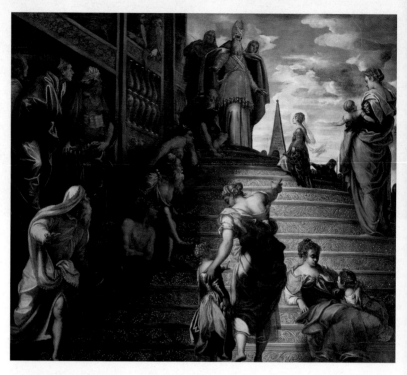

Christ who, contemplating the divine light, announces the new order. On the third altar, now the Altar of the Immaculate Virgin, the miraculous statue of the Madonna dell'Orto was put on display. Next is the rich, majestic *Tomb of Girolamo Cavazza* (d. 1681), who financed the construction of the façade of the Scalzi church. This work, designed in 1657 by GIUSEPPE SARDI, is decorated with allegorical statues by JUSTE LE COURT, FRANCESCO CAVRIOLI and the unknown sculptor CASSARINI, who hailed from Carrara. The fourth altar has the altarpiece with the *Martyrdom of St. Lawrence* (1638 - 1657) by the Flemish artist DANIEL VAN DEN DYCK. Next, on the wall, is *The Presentation of the Virgin*

Mary at the Temple (1552-53) by JACOPO TINTORETTO, originally situated in the two doors of the organ. Here, the young Mary confidently goes up the steep staircase of the Temple of Jerusalem. There are fifteen steps, just as there are fifteen gradual psalms. Watching the scene are poor people, mothers with children and other amazed onlookers whose figures are made vibrant by the clear, sharp light cutting diagonally across the canvas. On the lintel of the door underneath is a small high relief of a *Madonna and Child* (second half of the 14th century) attributed to aforementioned GIOVANNI DE SANTI, who, when he sold his miraculous statue, demanded that an intercessory mass be said daily for him. The Christ

Child is holding an epigraph on a cartouche that ironically reminds the Humiliati to keep the promise they made in this regard.

The CAPPELLA DI SAN MAURO, which communicates with the *Sacristy*, boasts the above-mentioned statue of the Madonna dell'Orto and the *tomb slab* (1392) with the emaciated figure of Giovanni de Santi, as well as the cycle of 28 canvases concerning *saints and beatified persons from Venice* (17th century), attributed to various artists. The first rear chapel contains the remains of Jacopo Tintoretto (d. 1594), his father-in-law Marco de' Vescovi, and his children Marietta (d. 1590) and Domenico (d. 1635), who were also artists. On the ceiling is a relief on a roundel

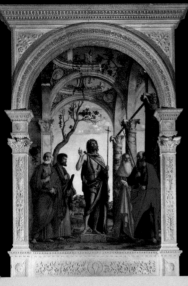

370 J. Tintoretto, *Presentation of the Virgin Mary at the Temple*.

371 top left Jacopo Tintoretto, *Moses Receiving the Tables of the Law and Worship of the Golden Calf*, detail.

371 bottom left Giambattista Cima da Conegliano, *St. John the Baptist with Sts. Peter, Mark, Paul and Jerome*.

371 right Jacopo Tintoretto, *Last Judgment*.

of the emblem of the local Scuola dei Mercanti and the *hand of the benedictory God the Father*. Of the eight canvases by JACOPO TINTORETTO in the CHANCEL, at least two deserve careful attention: *The Last Judgment* and *Moses Receiving the Tables of the Law* (above) *and the Worship of the Golden Calf* (below), executed in 1562-63 and donated by the artist to the church. In the *Last Judgment*,

a tall column of human beings – the Chosen – is being raised by the strength of Charity, which can be seen in the upper section with her children in front of Jesus. On bottom, sinful humanity is swallowed up by the water, while in the pool of fire the demons assail the sinners. One of them is attacking a naked young woman, the allegory of Lust. In the circle of the saints at right, just above the figure of St. Jerome

with his red cloak, are the portraits of two laymen – an old man and a young woman – that have not yet been identified. In the other canvas, at left, the theatrical worship of the golden calf, the symbol of idolatry and greed is contrasted with the adoration of the Law. The figure of Moses is shot through with a blinding divine light, while God the Father is supported and surrounded by ten wingless angels, an allegory of the Ten Commandments.

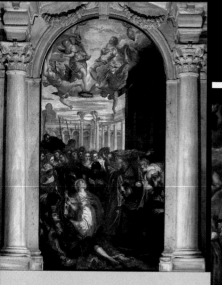

Among the works on the LEFT-HAND AISLE, the Cappella Contarini (1563) has *St. Agnes Raising Licinius from the Dead* (ca. 1577) by JACOPO TINTORETTO, and busts portraying some members of the Contarini family – including the famous cardinal Gasparo Contarini (d. 1542), a zealous reformer of the Church and a friend of St. Ignatius of Loyola, by DANESE CATTANEO, and his brother *Tommaso* (d. 1578), sculpted by ALESSANDRO VITTORIA. Among the works in the next chapel, the Cappella Morosini, on the left wall is an interesting *Crucifixion* (ca. 1579-80) by PALMA GIOVANE, which was brought here from Santa Trinita church in Castello when this latter was demolished. Here the triumphant Jesus is still alive and is looking toward the divine light. The group of figures with the swooning Virgin is placed to the right by the artist in order to make room, at the foot of the Cross, for the man soaking the sponge in wine flavored with myrrh and for the centurion Longinus, who is preparing the spear that will pierce Christ's side. The two eucharistic chalices along the lower edge of the painting demonstrate that the canvas was owned by the Scuola del Santissimo Sacramento. Next comes the Cappella Vendramin, on the right wall of which is a canvas by PALMA VECCHIO, *St. Vincent Ferrer with St. Dominic, Pope Eugene IV and the Blessed Lorenzo Giustiniani* (1523-24). This painting is a combination of the private devotion of the patrons who commissioned it, Vincenzo and Elena Valier, and the requests of the Canonici Secolari di San Giorgio in Alga, who wanted to commemorate the two prestigious founders of their congregation. The last chapel, Cappella Valier, was designed by Andrea and ANTONIO BUORA in 1523-27 and was the home of the small panel of *The Madonna and Child* (ca. 1478) by GIOVANNI BELLINI – until it was stolen in 1993.

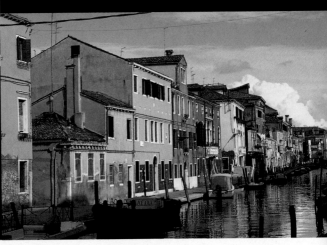

372 BOTTOM BUSTS
OF THE CONTARINI
FAMILY.

373 TOP LEFT OUR
LADY OF MERCY AND
SAINTS, SCUOLA DEI
MERCANTI, DETAIL.

373 TOP RIGHT AND
BOTTOM FONDAMENTA
DELLA SENSA.

Next to the Madonna dell'Orto is the building that once housed the Scuola di San Cristoforo, better known as the **Scuola dei Mercanti** (no. 3519), founded in 1377. Above the side portal is a high relief of *Our Lady of Mercy on a throne with the Christ Child in a mandorla being venerated by the confreres and St. Francis and St. Mark* (?) (late 14th-early 15th century), which was brought here from the Frari Church by the members of the Scuola di Santa Maria della Misericordia e San Francesco when the two confraternities merged in 1571. The headquarters of the combined Scuole were renovated around 1572 and later were furnished with precious canvases. Among the 92 paintings that were still there in 1806, which either disappeared or became part of different collections, there was the *Annunciation* by PAOLO VERONESE, now in the Gallerie dell'Accademia. Proceeding along the Fondamenta Madona de l'Orto, you will see Corte Cavallo, so named because it once housed the foundries in which ALESSANDRO LEOPARDI cast the famous *equestrian statue of Bartolomeo Colleoni* at San Zanipolo. Cross over Ponte Loredan and, at the end of the *calle* is the beginning of Fondamenta de la Sensa. "Sensa" is the Venetian word for the Ascension Day feast. On this occasion, the local courtesans usually went along the canal in a gondola to show themselves off to the crowd. This event (also known as *corso* and *fresco*) was illustrated by Gabriel Bella in a painting in the Museo Querini Stampalia.

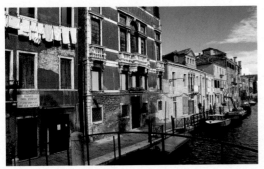

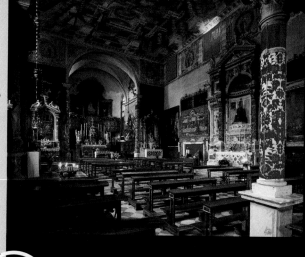

■ By turning right and taking Calle del Capitelo you will come to **San Ludovico Church**, better known as **Sant'Alvise**. HISTORY: legend has it that in 1388 St. Alvis appeared in a dream to the widow Antonia Venier, asking her to found a church and a monastery for Augustinian nuns in an out-of-the-way area of Cannaregio where strings for musical instruments were made. The church was completed in the first half of the 15th century. FACADE: made of bricks, it has a pitched central body framed by four tall pilaster strips, and two flat-roofed wings under which is a series of blind ogee arches. The portal has a pointed tympanum flanked by pillars and is surmounted by a poorly preserved statue of *St. Alvis on a throne* (1440-50) by a Tuscan sculptor. At left, an undated plaque has the text of a decree of the **Signori Esecutori contro la Bestemmia** that prohibits card and ball games. The rather large square in front of the church, like that of the Gesuiti church, was used for passionate football games witnessed by large crowds.
INTERIOR: aisleless nave and a chancel with an apse. The inside façade is occupied by a large gallery that communicates with the nearby convent. Stripped of its original Gothic elements and later elevated, the church is now dominated, from a visual standpoint, by the flat ceiling frescoed by ANTONIO TORRI and PIETRO RICCHI (known as IL LUCCHESE). A host of tortile columns seen from below leads the observer's glance toward the figures of God the Father and the *Eucharist Chalice* (second half of the 17th century). Besides the paintings by ANTONIO ZANCHI, PIETRO DAMINI, GIROLAMO DA SANTACROCE, AGOSTINO LETTERINI, STEFANO PAOLUZZI, ANGELO TREVISANI, the schools of BONIFACIO DE' PITATI and of PALMA GIOVANE, at the beginning of the right-hand wall are two preparatory canvases by PIETRO MUTTONI (known as PIETRO DELLA VECCHIA) for the outside mosaics of St. Mark's Basilica representing

The Removal of the Body of St. Mark from the Tomb in Alexandria and *The Saracen Customs Officers, Terrified by the Sight of Pork, Refuse to Inspect the Basket* (1660-63).

On the right-hand altar is the polychrome wooden statue of the *benedictory St. Alvis* (15th century), which is the Venetian name for St. Louis of Toulouse (1274-97). The young saint is wearing the bishop's mitre and with a crozier is holding a crown at his feet that is the symbol of his refusing the throne of Naples in order to become a Franciscan friar. To the left of the altar is the grille through which the enclosed nuns used to take Communion. At the end of the wall are two magnificent paintings by GIAMBATTISTA TIEPOLO: *The Flagellation* and *The Crowning with Thorns* (1738-40). In both these works Jesus is

depicted as a person patiently bearing his suffering. The flagellation is set in the colonnade of Praetorian Palace, while the crowning scene takes place in the Roman prisons, where there is a bust of Tiberius. TIEPOLO also executed the theatrical and large *Ascent to Calvary*, which was painted in the same two-year period and is on the right-hand wall of the CHANCEL. The master of Venetian Baroque painting makes use of his vast figurative and chromatic repertoire along the diagonal marked out by the cross. This is confirmed by the grieved expression of Veronica, who is recognizable by the veil with the holy Face, which contrasts with the triumphal procession of horsemen. At the summit of Calvary, which looks like a wave of earth, is another cross that cannot be the one that

Christ is carrying. Its "T" shape, the symbol of redemption, refers to Moses, the precursor of Christ, who set the brass serpent on a pole to save his people from divine punishment.

Going back to the nave, the *large Corinthian altar* in the middle of the left aisle is flanked by statues of *St. Dominic* and *St. Theresa,* and in a niche is a *Madonna and Child* with delicately wrought drapery by GIAN MARIA MORLAITER (1699-1792). On the counterfaçade are eight tempera wood panels by an anonymous 15th-century artist with scenes from the *Old Testament* that were brought here from the demolished church of Santa Maria delle Vergini. Among the religious confraternities in this area is the Scuola di Sant'Alvise, founded in 1402, with headquarters in the square (no. 3204) that were rebuilt in 1608.

Once out of Sant'Alvise, retrace your steps and, after having gone down Calle del Capitelo and Calle de la Malvasia, turn right and cross over the bridge (1865-66) to enter the **Ghetto**. The term "ghetto" derives from the Venetian word *geto* or *gheto*, which means "metal casting," since there were foundries here that manufactured bells, art works and artillery. The first Jewish people to arrive were Ashkenazim of German derivation who, following the example of other foreign communities in Venice, were called the German Nation. Once you are in the Campo de Gheto Novo, go along the left side, where the butcher

shops were located. Under the porch at no. 2912 is the sign of one of the three ancient pawnshops, known as the Banco Rosso. Turn left and go past the sotoportego, where you will come to the bridge that goes to the Gheto Nuovissimo, the new ghetto opened in 1633. Back in the Campo, go to the **Museo Ebraico**, or Jewish Museum, at no. 2902/B. Opened in 1955 and enlarged with later donations, it has many liturgical objects in silver, ritual textiles and curtains, holy books and manuscripts, most of which were produced in the 17th-19th century.

■ SYNAGOGUES: The word "synagogue" means "place of assembly." The ground floor rooms of this holy building were also used as rooms for study (*midrash*), assembly and administration. Since its functions were similar to

those of the many religious or trade confraternities and guilds in Venice, it was also given the name of *scola* or Scuola. The exterior is austere, while the interior – although without paintings or statues – is rich in architectural and plant-motif decoration, precious cloths and dedicatory writings, prayers and carved or embroidered quotations from the Pentateuch or the Psalms that attest to the primacy of the word over the image. For reasons of static equilibrium, the prayer room – always situated on the upper floors – has wooden furnishings based on two focal opposing points: the holy ark with the *Scrolls of the Law (Torah)*, and the pulpit or tribune of the officiating rabbi. The ark is oriented in the direction of Jerusalem and is illuminated by the "eternal flame" and covered by a lovely ornamented curtain (*parochet*). The seats along the sides are reserved for the

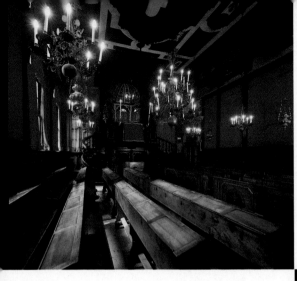

376 TOP LEFT INTERIOR AND WOMEN'S GALLERY OF THE SCOLA GRANDE TEDESCA.

376 TOP RIGHT AND 377 BOTTOM SCOLA SPAGNOLA, ORGAN AND DETAIL.

376 BOTTOM CAMPO DE GHETO NOVO.

377 TOP SCOLA LEVANTINA, INTERIOR AND RABBI'S PULPIT.

chief administrative officers (*parnassim*), similar to the cherubs who guarded the Holy Ark in the Temple where the Tables of the Law were kept. The holy ark and pulpit are connected by seats for the men and are surmounted by a women's gallery with grilles, much like those in the Early Christian basilicas. The synagogues in the Ghetto can be visited only with a guided tour, the itinerary of which changes in different periods of the year and according to the holidays of the local Jewish community. The **Scola Grande Tedesca**, or German Synagogue, situated over the Jewish Museum, was founded in 1528 and rebuilt in 1732-33 by Jews from central Europe. On the steps leading to the gilded wood Holy Ark is the date 1672. The small **Scola Canton** synagogue (no. 2902/A) was built in 1532. The gilding dates from 1780. The Holy Ark dates from 1672. The

Scola Italiana (no. 2894), recognizable by its Neo-Classical portico and small side lantern, was finished in 1575 and renovated in 1739 and again in 1789, as a plaque tells us. The *wooden Holy Ark*, with a balustrade and gate, was sculpted and donated by MENACHEM JOSHUA GUGLIELMI in 1842. Once out in the square, on the opposite corner, next to no. 2874/A, you will see two works by the Lithuanian ARBIT BLATAS, *Monument to the Holocaust* (1980) and *The Last Train* (date unknown). Proceed left, crossing the bridge that communicates with the Gheto Vecchio connected to the new one in 1541 to take in the Sephardic Jews who were expelled from Spain and Portugal in 1492. After going over the bridge, continue along the *calle*. Farther along, a short way before the Campiello de le Scuole and at left, is the **Scola Levantina** or Eastern Synagogue (no. 1228), built during the second half of the

16th century by BALDASSARE LONGHENA or an imitator, such as ANTONIO GASPARI (ca. 1670 - ca.1730). The restoration of the interior is attributed to the Belluno wood-carver, ANDREA BRUSTOLON (1662-1732). The sides of the Holy Ark have the date 1782. The carved wooden ceiling is also noteworthy.

The **Scola Spagnola**, or **Spanish** or **Western Synagogue** (no. 1149), was constructed in the second half of the 16th century and was probably rebuilt by BALDASSARE LONGHENA around the mid-1600s. The Ark area was restored in 1893 and the sides of the Corinthian niche have the date 1755.

Out in the *campiello*, go down Calle de Gheto Vechio. Above no. 1131 is an inscription with a decree (1704) against the marranos.

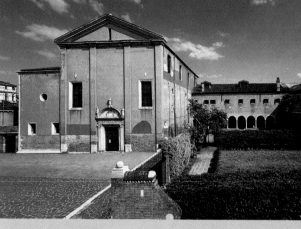

378 TOP SAN GIOBBE CHURCH.

378 BOTTOM LEFT PONTE DEI TRE ARCHI.

378 BOTTOM RIGHT CHURCH AND OSPEDALE OF SANTA MARIA DELLE PENITENTI.

■ After the *sotoportego*, or arcade under buildings, you will arrive at the broad waterway originally known as Canal Regio (royal canal). According to one theory, this was the origin of the name of the district of Cannaregio, while other scholars think that it derived from the ancient name of the area overrun with reeds called *cannarum regio*, or "cane region." Farther on at right is **Palazzo Nani** (no. 1105), built in the first half of the 16th century and later decorated with stuccowork (part of which has been preserved) by ALESSANDRO VITTORIA. Next is **Palazzo Surian-Bellotto** (no. 968), probably modernized by GIUSEPPE SARDI during the first half of the 18th century and characterized by Corinthian double Serliana multiple windows. Toward the end of the Fondamenta

de Cannaregio is the **Church/ Hospital of Santa Maria delle Penitenti**. This hospice for young women forced to become prostitutes out of poverty was founded in 1703 and was rebuilt in 1730 to a design by GIORGIO MASSARI. The church, located in the middle of the hospice structure, has an unfinished façade – much like the one on San Marcuola – with a courtyard and a cloister in the back. The building was begun in 1738 and finished by MASSARI in 1749. In the interior is an aisleless nave delimited by piers and Corinthian pilasters, as well as a short chancel. Among the works of art are early paintings by JACOPO MARIESCHI: on the ceiling, *The Madonna and Child with St. Lawrence Justinian in Glory* and *The Holy Trinity* (1743), which is iconographically

akin to the sculpture group on the high altar of the Jesuits attributed to GIUSEPPE TORRETTI; and, on the high altar, *Madonna of the Rosary and St. Dominic, St. Catherine of Siena (?), St. Lawrence Justinian, St. Margherita of Cortona and St. Mary Magdalene* (1744). Once outside the Penitenti church, on the other side of the canal you will see the long, functional Neo-Classical façade of the former central slaughterhouse or Macello (no. 873), which was finished in 1843 to a design by the engineer GIUSEPPE SALVADORI with the help of GIAMBATTISTA MEDUNA. Retracing your steps, cross over the **Ponte dei Tre Archi**, rebuilt in 1688, probably by ANDREA TIRALI, and renovated in 1794, and you will come to **San Giobbe Church**, also known as **Sant'Agiopo**.

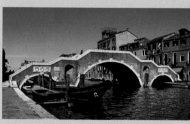

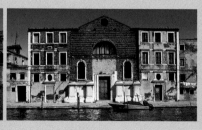

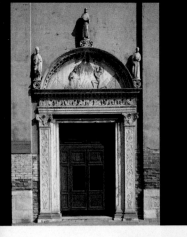

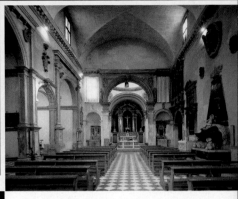

HISTORY: in 1389-90, Giovanni Contarini founded a hospice for the poor and an oratory named after the prophet Job, the righteous man who did not abandon his faith even when afflicted with great suffering. In 1434, the buildings were donated by Lucia Contarini (d. 1447) to Marco Querini of the Franciscan Observant congregation. At that time there was already a building or a small courtyard in which the Hermits of St. Jerome, from Montebello near Urbino, lived for three years. That same place must have hosted St. Bernardine of Siena (1380-1444) in 1443. This Franciscan ascetic and preacher was canonized in 1450 and the following year his friend, the future doge Cristoforo Moro, decided to build at his expense a chapel named after the saint while at the same time rebuilding the monks' dwellings. The vicissitudes of the construction of this chapel – for which Moro obtained special indulgences in 1454 – and the Gothic church have

379 TOP PORTAL AND INTERIOR, SAN GIOBBE CHURCH.

379 BOTTOM ST. MARK, DETAIL OF THE CHANCEL.

yet to be clarified. The church is attributed to ANTONIO GAMBELLO. FAÇADE: the original trefoil crown – built in the style of Codussi before the year 1500 – was replaced by a late 18th-century triangular pediment. The portal, somewhat influenced by Brunelleschi, is attributed to PIETRO LOMBARDO, who arrived in Venice around 1467. The doorway crown celebrated the Franciscan order: the high relief in the lunette depicts *St. Francis and Job kneeling* before the Divine Sun from which radiates a shower of flames like the ones on the heads of the Apostles during Pentecost. Aligned with this is the statue of *St. Bernardine of Siena,* who is holding the solar disk with the trigram, or initials of Jesus' name, flanked by *St. Alvis and St. Anthony.*

■ INTERIOR: aisleless nave with a chancel and choir in the rear. Before 1815, the three altars at right had the following altarpieces respectively, which were transferred to Room II of the Accademia Galleries: *The Agony in the Garden* (1510) by MARCO BASAITI, *The Virgin and Child with Saints* (1478) by GIOVANNI BELLINI, and *The Presentation of Christ in the Temple* (1510) by VITTORE CARPACCIO. These fine works have been replaced in San Giobbe with canvases by ANTONIO ZUCCHI, LATTANZIO QUERENA and BONIFACIO DE' PITATI. Next are the impressive *tomb of the French ambassador Count René Voyer Palmy d'Argenson* (1653-55, signed) by CLAUDE PERRAUL, and the altar of the Mestre-Marghera Barcaioli (ferry boatmen) confraternity, redone in 1585.

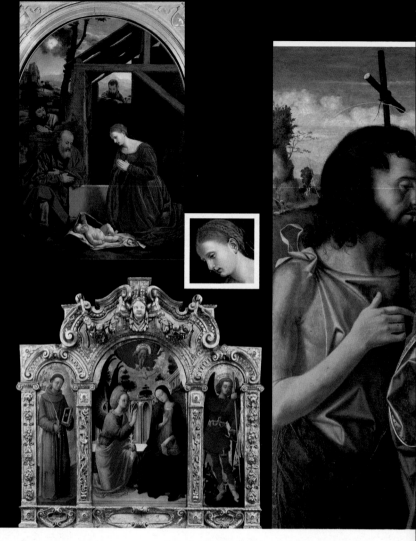

The altarpiece signed by PARIS BORDON portrays *St. Andrew* – patron saint of the confraternity – *St. Peter and St. Nicholas* (ca. 1565).

The figure of God the Father was added sometime before 1581 by an unknown artist.

At right is the CAPPELLA CONTARINI, where the old St. Job Oratory stood. The altarpiece is a *Nativity* (1540) by GIAN GIROLAMO SAVOLDO, in which Mary and Joseph are adoring the Christ Child with other figures behind them who should be shepherds but whose faces are those of real persons who were contemporaries of SAVOLDO.

On the counterfaçade of the SACRISTY, ANDREA PREVITALI, a follower of BELLINI, executed the *Mystic Marriage of St. Catherine* (ca. 1504) that also includes the figure of St. John the Baptist. The small chapel on the opposite side has a triptych by the Murano artist ANTONIO VIVARINI, *Annunciation and St. Francis and the Archangel Michael* (ca. 1447).

In the central panel, pervaded by delicate coloring and late Gothic draftsmanship, the young and frightened Mary shows us the palm of her upraised hand, in the typical gesture of greeting the angel.

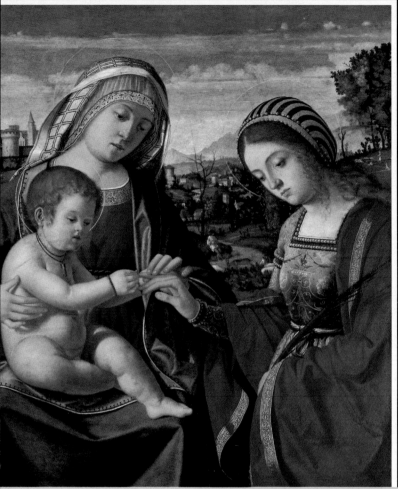

380 top Gian Girolamo Savoldo, *Nativity* and detail.

380-381 Andrea Previtali, *Mystic Marriage of St. Catherine.*

380 bottom and 381 bottom left Antonio Vivarini, *Annunciation and Saints,* and detail.

381 bottom right Paris Bordone, *Sts. Andrew, Peter and Nicholas.*

382 ANDREA
DELLA ROBBIA, *THE
REDEMEER AND
FOUR EVANGELISTS*,
DETAILS.

383 LEFT PIETRO
LOMBARDO,
CHANCEL DOME.

383 RIGHT
PALAZZO
SAVORGNAN.

■ Back in the church proper, note the splendid chancel built by PIETRO LOMBARDO for the heirs of Doge Cristoforo Moro, who had the earlier apsidal chapel transformed into a tomb for their relative, who died in 1471. This large area marked a strong break in the Gothic style of the church by introducing the typical Renaissance style. LOMBARDO most certainly drew inspiration from the Old Sacristy by BRUNELLESCHI in San Lorenzo Church, Florence, and from the chancel in San Michele in Isola that CODUSSI was building in that period (1468-78); but he was also influenced by the east dome of St. Mark's. In fact, the cupola over the chancel of San Giobbe and its eight windows rest on four spandrels, without a tambour. The luxurious decoration – which is by no means in keeping with the Franciscan vow of poverty – is the setting for the rich figurative series of statues and reliefs that celebrate faith in the resurrection of the flesh. The chancel opens onto the nave like an impressive triumphal arch on which are two family coats of arms. At either side, the statues of *Mary Annunciate and the Archangel Gabriel,* as can be seen in many Venetian tombs as well, affirm the deceased's faith in the mystery of the Incarnation. Mary is in the typical pose of her arms crossed over her chest, a sign of acceptance of divine will. The meaning of the figure on the keystone is uncertain, or deliberately ambiguous. The naked putto seated on an acanthus leaf while displaying a sphere, could be interpreted as the *triumphant Christ Child*, but his outspread wings lead one to think of an allegory of the soul of the deceased victorious over death. Farther down, on the inner sides of the piers, are *St. Luke and St. Mark,* the allegories of the death and resurrection of Christ respectively. On the intrados, the figures of the *prophets* – the link between the Old and New Testament – prefigure and herald the mystery of Christ and his victory over death. Confirmation of this is the *lamb* with the standard of the Resurrection placed on the top of the arch as an apocalyptic symbol of Christ. In this area are the medallions with the *Four Evangelists* supported by classicizing cherubs. They are the symbol of Christ and the good tidings, but in this context are to be understood as an allegory of the so-

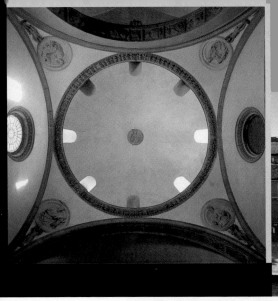

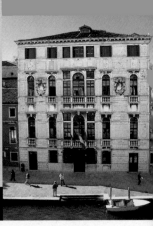

called Chariot of the Lord that appeared to Ezekiel and John and is the prefiguration of the Last Judgment and the end of the world. This is confirmed by the image of *God the Father* Pantocrator in the tondo on the top of the dome. Aligned with this image, in the middle of the floor is the *tomb of Doge Cristoforo Moro*, buried barefoot and in Franciscan garb. He is waiting for the Last Judgment, already depicted by the figures above, trusting in resurrection. In this regard, on the arched lintel above the Evangelists is a sculpted festoon filled with fruit, the symbol of Easter.

In the next chapels on the left side of the church there are works by ANTONIO ZUCCHI, the workshop of ANTONIO ROSSELLINO, and ANTONIO and TULLIO LOMBARDO. The Cappella

Martini, the penultimate, is particularly interesting, with its brilliant vault in glazed terracotta (1471-74) by the Florentine ANDREA DELLA ROBBIA.

■ After your visit to San Giobbe, retrace your steps and proceed to the right before you reach the Ponte dei Tre Archi. The buildings between nos. 570 and 619 are part of the Da Ponte hospice complex – now called Pia Opera Contarini – the original nucleus of which comprised the San Giobbe hopsice, founded by Giovanni Contarini. Along the facade, next to no. 614, note the small **Oratory of San Giobbe**, probably built in 1512. In the interior is the altarpiece by GIROLAMO PILOTTI, *Madonna and Child with Job Deprived of His Sons* (first half of the 17th century), while the fresco on the ceiling, dated 1771, *God*

the Father Speaking with Job, is attributed to GIAMBATTISTA CANAL.

Beyond the arch at no. 469 is the **former Saffa industrial area**, converted into a working-class housing development designed by VITTORIO GREGOTTI and Associates. Among the buildings lining the Fondamenta San Giobbe is **Palazzo Savorgnan** (no. 349), the residence of the nephews of the famous Friulan count, Giulio Savorgnan, the general superintendent of all the fortresses of the Venetian Republic, who designed the new town of Palmanova. The facade is attributed to GIUSEPPE SARDI (ca. 1621-699) and the stone interior decoration of the building – famous for its large park, which still exists – may have been finished by ANTONIO GASPARI (ca. 1670-ca. 1730).

10

384 TOP JACOPO TINTORETTO, *CRUCIFIXION*, DETAIL, SAN CASSIANO CHURCH.

END

22
27 9
8
20
21

THE RIALTO MARKET AND

384 CENTER CANAL GRANDE E RIALTO BRIDGE, AERIAL VIEW.

384 BOTTOM VINCENZO CATENA, BAPTISM OF ST. CHRISTINA, SANTA MARIA MATER DOMINI CHURCH.

▶ MAIN SIGHTS

● **SESTIERI (Districts)**: S. Polo, S. Croce.
● **CHURCHES**: [1] San Giacomo di Rialto; [2] San Giovanni Elemosinario; [3] San Cassiano; [4] Santa Maria Mater Domini; [5] San Stae; [6] San Giacomo dall'Orio; [7] San Zan Degolà; [8] San Simeon Grando; [9] San Simeon Picolo.
● **PALAZZI**: [10] Camerlenghi; [11] Dieci Savi; [12] Fabbriche Vecchie e Nuove; [13] Muti-Baglioni; [14] Moro; [15] Ca' Zane; [16] Ca' Viario-Zane; [17] Ca' Agnus Dei; [18] Ca' Pesaro; [19] Ca' Mocenigo; [20] Gradenigo; [21] Soranzo; [22] I.N.A.I.L.
● **OTHER MONUMENTS**: [23] Rialto Bridge; [24] Scuola dei Batti e Tiraoro; [25] Teatro anatomico; [26] Fontego dei Turchi; [27] Scuola dei Tessitori di pannilani.
● **MUSEUMS**: [28] Galleria Internazionale d'Arte Moderna e Museo d'Arte Orientale (Ca' Pesaro); [29] M. Civico di Storia Naturale (Fontego dei Turchi).

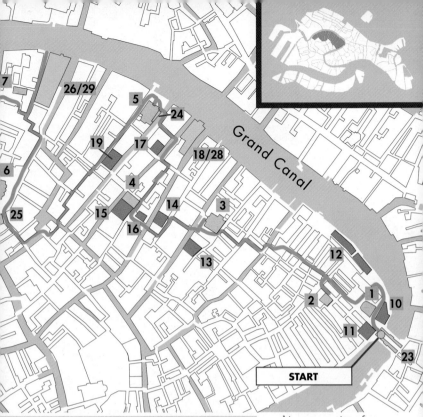

OLD WOOL-MAKING AREA

T his itinerary covers
the three basic areas
of the Rialto, San Giacomo
dall'Orio and San Simeone.
The first is famous for its
outdoor market, which
became the city's main
economic and commercial
center in the 11th century.
Later, the first public
buildings rose up there,
such as the one for weights
and measures (1164), and
the Magistrato al Sal
which, together with the
Ufficiali sopra Rialto,
governed the market
(1371). The Rialto square
became an international
meeting place for
merchants and financiers.

In its original porticoes was
a world map and a public
copy of Marco Polo's *Il
Milione*. Large banks rose
up here, taking deposits
and offering credit, trading
and foreign exchange
services, as well as
speculation, ship rental and
marine insurance. The
second area, around San
Giacomo dall'Orio church,
was originally called
Luprio. Various theories
have been advanced
concerning the origin of
this name. The one that
interprets the root *lup* as
meaning marshy or alluvial
soil is perhaps the most
plausible. Unlike the Rialto,

this zone consists of more
modest buildings which,
however, are no less
interesting, even from an
artistic standpoint. Then
there is the San Simeone
zone, situated next to the
last section of the Grand
Canal and once filled with
large market gardens and
empty areas. The space
available and the distance
from the city's central areas
led to the intense
development of wool
processing and its by-
products. Not far away
were the Chiovere, where
the woollen cloth was
hung out to dry, and
Santa Croce Church,
documented as early
as 774, after which the
sestiere was named.

386 TOP AND 386-387
ANTONIO DA PONTE, RIALTO
BRIDGE AND DETAIL.

386 BOTTOM THE GRAND
CANAL AND AT LEFT, THE
RIALTO ISLAND.

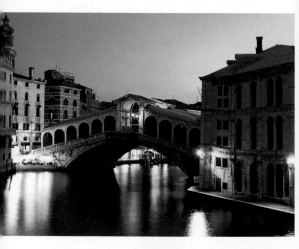

Itinerary

From Rialto to San Simeone

The Ponte di Rialto, or **Rialto Bridge**, is a symbolic city monument that was the only passageway between the two sides of the Grand Canal, linking the two main parts of the city, that is, the area of St. Mark's and Rialto island. Historic sources do not agree on the date of construction of the first wooden bridge (12th or 13th century), the last "version" of which is depicted in JACOPO DE' BARBARI's *View of Venice* (1500) and in *The Healing* of the *Madman* by VITTORE CARPACCIO. From 1499 on, accounts of its poor state of preservation and proposals for either restoring or rebuilding it became the order of the day. Giorgio Spavento (1502) was one of the first to propose making a stone bridge. For 80 years, many contrasting designs were presented by famous architects (Fra' Giocondo, Michelangelo, Palladio and Scamozzi) and the municipal *proti* (Giacomo de' Guberni, Dioniso Boldi), and there was no lack of opinions on the part of experts and public officials called upon to take a stand on the feasibility of building a permanent bridge – without its original mobile structure – with one or three arches. The single-arch idea was approved, as was the design by ANTONIO DAL PONTE, who also supervised the complex construction work (1588-91). On this occasion, two buildings were also erected

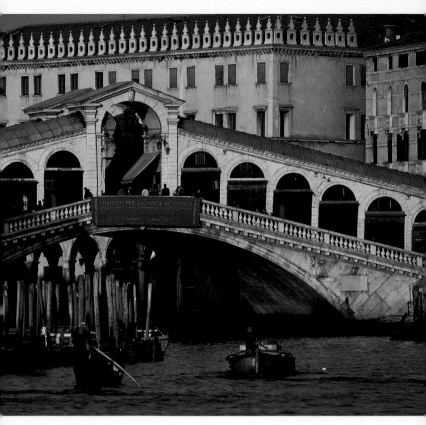

along the side of the Salizada Pio X in order to counterbalance the thrust of the bridge, whose one wide arch allowed a greater number of boats to pass under it.

The Istrian stone highlights the civic and monumental character of the bridge and yet, in keeping with its commercial, practical function, it has no excessive sculptural decoration. The bridge has two rows of shops, which were sold to private citizens to partially compensate the Republic for the expenses, and three thoroughfares – a central one and two side ones – for pedestrian, cart and goods traffic. The upper central section is traversed by a passageway partly covered by two round arches, on which are four tympana divided and decorated by heads of wise men sculpted by BATTISTA DI BERNARDINO. The pilasters are Doric, with smooth ashlars and a pulvinated frieze. On the side visible from the Riva del Vin, there are high reliefs of the Archangel Gabriel and the Virgin Mary. The dove of the Holy Ghost is situated on the keystone. The theme of the Annunciation, which is usually linked to a holy site, in this context cannot but refer to the mythical foundation of Venice, which took place on 25 March 421 (according to tradition, the Annunciation occurred on the same day).

On either side of the Archangel and Mary is an epigraph (1591) with the names of the three *Provveditori* in charge of the construction of the Rialto Bridge (Alvise Zorzi, Marcantonio Barbaro, and Giacomo Foscarini), surmounted by the coat of arms of Doge Pasquale Cicogna.

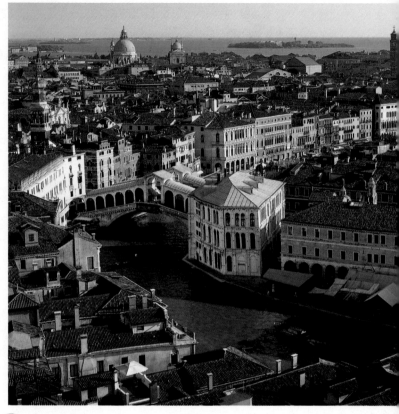

■ If you look at the market from the bridge, you will see, at right, **Palazzo dei Camerlenghi**, the city treasurers' building, whose name derives from the magistracy responsible for public finances. This palazzo was also the headquarters of the Giustizia Vecchia magistrate, where the insignias of the guilds and corporations were housed (they are now in the Museo Correr). The side of the building along the Grand Canal, which was finished in 1525, has an irregular architectural configuration, with pseudo-Corinthian pillars and pilasters, that resulted from the need to connect the earlier buildings of the prisons and the former

388-389 THE RIALTO BRIDGE AND ERBERIE MARKET.

388 CENTER AND BOTTOM RIALTO BRIDGE AND PALAZZO DEI CAMERLENGHI.

389 PALAZZO DEI DIECI SAVI.

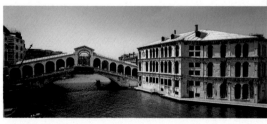

Gritti, who had promoted the simple, unassuming architectural style in San Francesco della Vigna Church, here in the Rialto palazzo (which represents the Venetian state) opted for a lofty style that is ennobled by the Istrian stone and the decoration with its allegorical figurations.

To the left of the bridge, the **Palazzo dei Dieci Savi alle Decime** was the home of the tax magistracy, which became a permanent institution in

inscription, perhaps dating from the 12th century, whose Latin text, addressed to those who worked in the tax magistracy, reads: "Around this church, may the law for merchants be just, the weights exact, and the contracts fair," while the inscription on the cross puts faith before commerce: "May your Cross, oh Lord, be the true salvation of this place." By skirting the Palazzo dei Camerlenghi, you will see, on one of its walled-up

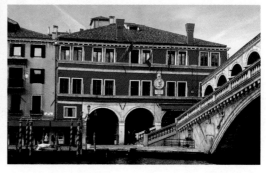

headquarters of the magistracy (1465-88). GUGLIELMO DEI GRIGI, a follower of SCARPAGNINO, may have had a hand in the construction. The entrance façade, built at the foot of the bridge as a replacement for the merchants' loggia, was perhaps finished in 1526-29 and has a more regular appearance. The Corinthian portal without a tympanum is like the one in the Fontego dei Tedeschi and is attributed to ANTONIO ABBONDI, known as SCARPAGNINO. The keystone has a high relief of a putto with a horn of plenty, an allegory of commerce and abundance. Doge Andrea

1477. The building, at the head of the Fabbriche Vecchie, was rebuilt in 1521. On the façade, above the epigraph is a tondo with a lion of St. Mark dating from 1848, and on the corner is a statue of Justice (mid-16th century) with a crown, scales and metal sword. This figure, with classical attire and hairstyle, is an obvious allegory of the function of the Savi, who were responsible for the 10 percent property tax. Once over the bridge, turn into the Naranzeria, the *calle* where oranges were once sold. The apse of San Giacometto at left is marked by a long

doors, an inscription that reproduces the text of a decree of the Magistrato al Sal that regulated the sale of vegetables from Chioggia, Pellestrina, Malamocco, Sant'Erasmo, Vignole, Giudecca, the Lido and Treporti (1688). Proceeding along the narrow Fondamenta de la Preson, you can enjoy an unusual view toward the Rialto Bridge. Retracing your steps, you can stop at the Erberie, the area facing the Grand Canal where vegetables were sold. The larger building here was part of the Fabbriche Vecchie and was finished in 1519 (no. 136A).

■ The smaller building, joined to the other one and perpendicular to the Grand Canal, is the **Fabbriche Nuove**, built by the Florentine JACOPO TATTI, better known as SANSOVINO (1555-56). The long, terraced building, which ends in the Campo de la Pescaria – now the area

390 TOP AND BOTTOM *THE COLONNA DEL BANDO WITH THE RIALTO HUNCHBACK* AND DETAIL.

390 CENTER FABBRICHE VECCHIE IN RUGA DEI ORESI, FRESCOES ON THE ARCADE CEILING.

390-391 ANTONIO SCARPAGNINO, FABBRICHE VECCHIE.

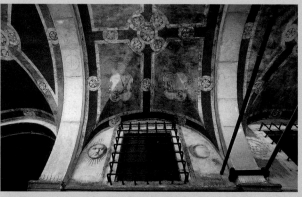

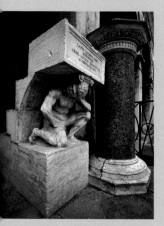

housing the colorful Rialto vegetable market – has a portico facing the Grand Canal, which is a modern version of the *fondaco* or merchant's warehouse. Going into the Sotoportego dell'Erberia, you now cross its intermediate covered passageway and enter Campo San Giacomo de Rialto. On 10-11 January 1514, the entire market area was almost ravaged by a terrible fire which destroyed shops, houses and many public offices with their archives. Among the reconstruction plans proposed, the Republic chose the one designed by SCARPAGNINO, who, since he was the *proto*, received the commission from the Magistrato al Sal. This state office was responsible for the production and sale of salt, governed the market activities, and was also responsible for public construction in Venice. Unlike other architects such as Fra' Giocondo, Scarpagnino proposed rebuilding the area by respecting to the full the former property boundaries. The buildings around the present-day Campo di Rialto, which are distinguished by their continuous arcade, are nothing more than an updated replica of what had existed before the fire. The only important variation was the demolition of a small church that may have been named San Giovanni Battista and was located where the Campo de la Cordaria opens out. SCARPAGNINO, who supervised the reconstruction from 1516 on, employed modular architecture for the Fabbriche Vecchie. The tall portico frames the ground floor shops and their mezza-

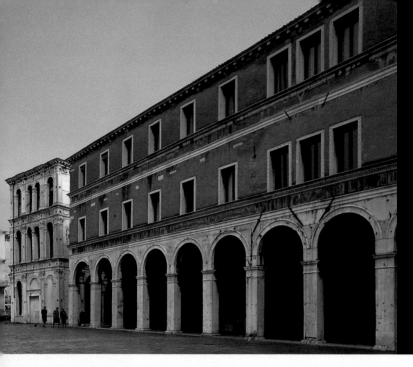

nines. The simple, robust pillars with round stilted arches support two stories with a plastered facade and a tall trabeation on which are windows without aedicules, in the Tuscan manner. The arcade that skirts the entire Ruga dei Oresi, which corresponds to the Drapperie (1520) is 373 feet (113 m) long, and has many frescoes on the ceiling crossings or the mezzanine lunettes. The scenes, which are rather mediocre, have both religious and secular subjects, such as St. Peter and St. Paul (nos. 75 and 76), instruments for measurement, the sun and moon (no. 65), the four Virtues (no. 61), the Madonna and Christ Child with St. Bernardino of Siena

(no. 56), biblical scenes (no. 54), and the four seasons (no. 52). SCARPAGNINO added another building to this one, which is situated farther inward. It is bounded by the Campo di Rialto Novo and Calle di Rialto Vecchio or Parangon. This latter term, which means "paragon," derives from the office that affixed the Republic's seal of quality on cloth and precious textiles such as silk which were "paragoned" to the standard samples kept in the office.

Campo di Rialto is 92.5 x 99 feet (28 x 30 m). The part that faces San Giacometto church was finished in 1520. It has a double arcade, the access sides of which are highlighted by half-columns,

a rarity indeed. This area was reserved for nobles and merchants and communicates with Calle de la Sicurtà, home of the marine insurance companies. The *sotoportego*, which goes as far as the church, was where the private banks were located; these were replaced by the Bancogiro, which the Republic founded in 1585. Protected by a railing, the Colonna del Bando (restored in 1836) was the column where public announcements and decrees were read to the populace. The side stairway is supported by a statue of an Atlas, known as the Gobbo di Rialto (Rialto Hunchback), a work attributed to PIETRO DA SALÒ (1541).

On the opposite side is **San Giacomo di Rialto**, commonly called San Giacometto. HISTORY: according to a legendary tradition, mentioned in the right pillar of the chancel (redone in 1600), the first inhabitants of Venice lived on this site. One of them, a

FAÇADE: a plaque on the entrance mentions drastic restoration work undertaken in 1531. The porch, restored in 1758, has retained its original appearance (perhaps dating from the 14th century), as can be seen in the upper part with five columns with capitals. This

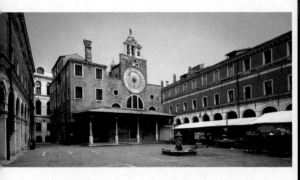

certain Entinopo, was an architect and carpenter who made a vow to build a church if a terrible fire would be subdued. The date of the dedication of the church named after St. James the Greater is 25 March 421, considered the day of the official birth of Venice, which, as we saw above, coincides with the date of the Annunciation. The humility of the Virgin Mary is thus related to the image of a state destined to defend the Christian faith. San Giacometto was therefore considered the oldest church in Venice and the symbolic site of its origin. Information concerning its rebuilding is quite uncertain. The church, administered by the Provveditori al Sal, was put under the dogeship's jurisdiction in 1532.

is the only original church porch in Venice that has survived. The clock above the 17th-century windows was redone in 1749; it is followed by a shrine with a high relief of the Madonna

392 CENTER ALTARE DEGLI OREFICI (GOLDSMITHS' ALTAR).

392 BOTTOM MARCO VECELLIO, ANNUNCIATION, DETAIL.

392-393 INTERIOR OF SAN GIACOMO DI RIALTO CHURCH.

392 TOP CAMPO AND CHURCH OF SAN GIACOMO DE RIALTO.

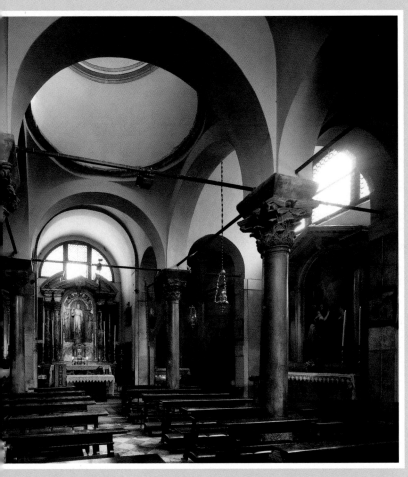

degli Alboretti (14th-15th century), the isolated wall over the roof with the church bells in a three-light window, and a copper statue of St. James.

INTERIOR: a plaque commemorates the last renovation (1599-1601). In 1933 the choir on the inside façade was removed. The columns date from the early 14th century. Their arrangement was used as a model in other churches in the Rialto area and in the city, since it had drawn inspiration from Byzantine architecture.

The six Greek marble columns with Corinthian capitals surmounted by a smooth pulvin mark out the interior of the church, which combines two basic plans: the one with a nave and two side aisles, and the Latin cross with a small dome. The altars and art works were commissioned by the guilds that worked in the market. Beginning from the right, note the *Wedding of the Virgin* by MARCO VECELLIO; the Altar of the Annunciate (early 17th century) – reserved for the Garbelladori and Ligadori de

Comun (wheat sifters and porters); the high altar, reserved for the Casaroli (cheese vendors), with the statue of St. James by ALESSANDRO VITTORIA (1600-08); at left, the Altare degli Oreficie (Goldsmiths' Altar), dedicated to their patron saint, St. Anthony Abbot, by VINCENZO SCAMOZZI (1601-03) and bronze statues by GIROLAMO CAMPAGNA (1603-05, signed). The church once housed the religious confraternity dedicated to the Madonna Assunta of Sedrina, a locality near Bergamo.

■ After going down the Ruga dei Oresi, at left you will come to **San Giovanni Elemosinario**. HISTORY: this church, called San Giovanni Nuovo in the 16th century, is named after the Patriarch of Alexandria, Egypt, who was very popular for his compassion and whose remains are kept in the church of San Giovanni Battista in Bragora, in the Castello district. The saint's relics were brought to Venice in 1249, but the earliest information we have on the Rialto church dates back to the mid-11th century. The church was placed under dogal jurisdiction, in particular under the Ufficiali alle Rason Nuove, an office established in 1396. CAMPANILE and FAÇADE: the campanile, placed along the Ruga Vecchia, collapsed in 1361 and was rebuilt around 1410. On the second order is a high relief of the saint and two beggars (1410). The church has no façade because the entrance side is occupied with shops and houses. Access is via house no. 479. Above the archway, the rooms of which were the headquarters of the Corieri Veneti guild (postal service employees), is a high relief of *St. John the Almsgiver giving charity to the poor* (ca.1538). INTERIOR: rebuilt after the fire of January 1514, probably by SCARPAGNINO under Doge Andrea Gritti (1523-38), as a plaque on the first pillar at right tells us. The affinities with the architecture of St. Mark's are quite evident. The church is a combination of two plans: a nave and two aisles with rear chapels with straight back

394 TOP LEFT CAMPANILE OF
SAN GIOVANNI
ELEMOSINARIO CHURCH.

394 TOP RIGHT AND BOTTOM
TITIAN, *ST. JOHN THE
ALMSGIVER* AND DETAIL, SAN
GIOVANNI ELEMOSINARIO
CHURCH.

walls, and a Greek cross with a central cupola. These reflect the religious values of the Western Latin and Eastern Greek-Byzantine worlds, in keeping with a formula eminently suited to the aspirations of Venice and her doges. The cupola, which has windowed cladding, is supported by four pillars which, unlike those in the Fabbriche Vecchie, are topped by a pseudo-Corinthian capital. The cupola frescoes by GIOVANNI ANTONIO DE' SACCHIS, better known as PORDENONE, (1531), illustrate the *Wain of the Church*: a benedictory God the Father, flanked by angels, Evangelists and Doctors of the Church. Along the right aisle, after the altar belonging to the Cimadori and Soppressadori di Panni (woolen cloth croppers and smoothers), in the middle of the wall is *The Miracle of the Manna* by LEONARDO CORONA (1590, dated). This painting anticipates certain compositional schemes that Tintoretto used in a canvas with the same subject in San Giorgio Maggiore. On the altar of the right-hand rear chapel, reserved for the Corieri Veneti mentioned above, PORDENONE painted the patron saints of this guild – *St. Catherine, St. Sebastian and St. Roch* (ca. 1535). In order to honor the saint to whom the chapel was dedicated, DOMENICO TINTORETTO painted, in the lunette over the altar, *The Empress Faustina and Her Lover Porphyrius Visiting St. Catherine of Alexandria in Prison*. During the reconstruction of the church, the CHANCEL – beneath which is the crypt – was enlarged toward Campo Rialto Novo in order to make room for a larger altar and to set an unusual and elegant segmental cupola in the ceiling. The high altar (1633), used by the Casteletti (the guild of the lottery clerks, instituted in 1734), is beautified by the fine canvas by TITIAN, *St. John the Almsgiver Giving Alms to a Poor Man* (1545). Here the Patriarch of Alexandria, direct heir of St. Mark, is surrounded by a warm, rich light with shadowy effects that, together with the soft light coming from the chancel, make the saint's gesture even more intimate and affectionate. The canvases on the side wall reveal the presence of a Scuola del Santissimo Sacramento in this church. *Christ Washing the Disciples' Feet*, at left, was painted by ANTONIO VASSILLACHI, known as L'ALIENSE (1556-1629), while the other three canvases are by LEONARDO CORONA (1561-1605). The altar in the left rear chapel was reserved for the Telarioli (cloth vendors), who were especially devoted to the glorification of the Holy Cross and St. Helena. Their confraternity probably commissioned the nearby painting on the wall depicting *Heraclius Taking the Cross to Jerusalem*, by PALMA GIOVANE (1595-99). In the left aisle you can admire an interesting fragment of a 6th-7th century bas-relief of a *Nativity*. On the counterfaçade is *God the Father, Doge Marino Grimani and Dogaressa Morosina Morosini* (ca. 1598) by DOMENICO TINTORETTO, in which appear the confreres of the guild of Gallineri and Buttiranti (chicken, egg and butter vendors), who had been granted use of the nearby altar by the doge. The adjacent *Adoration of the Magi* (1642) is by CARLO RIDOLFI, a follower of VERONESE and author of an important book on Venetian painting, *Le meraviglie dell'arte* (*The Marvels of Art*; Venice, 1648). San Giovanni Elemosinario, a veritable meeting place for the Venetian state and the trades of the Rialto market, was also the home of the guilds of the Biavaroli (cereal and legume vendors) and the Pesadori de Comun (public weighers).

■ Once outside the church, on the façade of the palazzo opposite is a splendid high relief of St. George and the Dragon (early 16th century). The saint, a warrior of God and prototype of the Crusader, is attacking the dragon to free the daughter of the king of Silene, in Libya, who had been offered as a sacrificial victim. This work in Istrian stone may have indicated a property owned by the Abbey of San Giorgio Maggiore. The area to the rear, accessible through Calle dei Do Mori, was known as the San Matteo quarter, after the church of the same name, which was demolished. With its many taverns and inns, this quarter was notorious for its prosperous prostitution trade; in fact, one of the first public

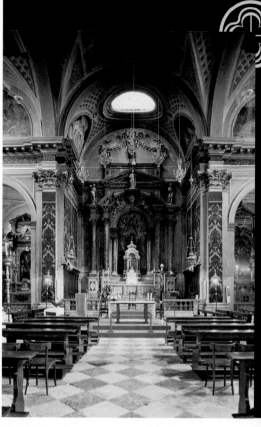

brothels, known as Il Castelletto, was set up here. Our itinerary continues along Calle dei Spezieri. At no. 379 (and no. 347 as well) the corner pillar has two 17th-century bas-reliefs with a pair of peaches, which may be the emblem of the fruit vendors' guild. In Campo de le Becarie (butcher shops), at the right, is the loggia of the Rialto fish market. This was the site of Ca' Querini, which was confiscated and demolished in the 14th century because the Querini family had taken part in the Bajamonte-Tiepolo conspiracy of 1310. On the first floor are the 13th-century windows of the Querinis' palazzo. At the end of the market, toward the Grand Canal, you can see the *Pescheria Nuova*, a Neo-Gothic structure designed by DOMENICO RUPOLO and CESARE LAURENTI in 1907. With the help of a map, proceed along Calle dei Boteri (coopers) and Calle dei Cristi until you reach Campo San Cassan. At the end of Calle del Camaniel there is a magnificent view of the Ca' d'Oro and, if you retrace your steps, another view of the 13th-century campanile (the belfry dates from the early 15th century) of **San Cassiano Church**. HISTORY: already documented in the 11th century, the church may have originally been an oratory of nuns dedicated to St. Cecilia. The two names of St. Cassian and St. Cecilia were used from 1523 on. Two reconstructions are documented: the first, celebrated with the consecration of 1376, and the second, which began in the first half of the 17th century

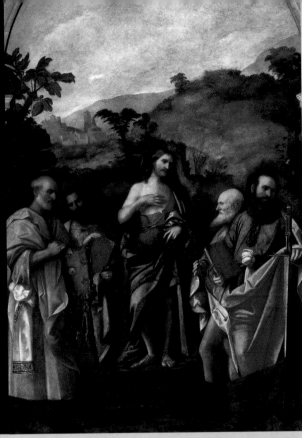

396 LEFT
ST. GEORGE AND
THE DRAGON, RUGA
VECCHIA SIDE OF
S. GIOVANNI
ELEMOSINARIO.

396 RIGHT
SAN CASSIANO
CHURCH, INTERIOR.

397 ROCCO
MARCONI, ST. JOHN
THE BAPTIST AND
SAINTS AND DETAIL,
SAN CASSIANO
CHURCH.

and was finished by 1663. The former Gothic church housed the famous altarpiece by ANTONELLO DA MESSINA, *The Madonna and Child with Saints* (1475-76), which was commissioned by Pietro Bon and disappeared sometime before 1648. The composition of this work, fragments of which are in the Kunsthistorisches Museum in Vienna, strongly influenced the Venetian painting of the time, especially artists such as Alvise Vivarini, Giovanni Bellini, Giorgione and Cima da Conegliano.

The façade, which was rebuilt several times, is not very interesting. INTERIOR: the area for the congregation is square, with a nave and two side aisles marked off by four enormous Corinthian columns. Three rear chapels were grafted onto this central space. The frescoes on the ceiling are by the Tiepolesque painter CONSTANTINO CEDINI. Starting from the right aisle, on the first altar is an oil panel attributed to ROCCO MARCONI, *St. John the Baptist with Sts. Peter, Mark, Paul and Jerome* (1515-20). This work is notable for the figures depicted in a sylvan area which, according to the figurative schemes of that time, alluded to the desert of the anchorites. Note the faces of Peter and Mark, at left, rendered in sfumato and in half-light. This work was commissioned by the Consorzio degli Osti e Caneveri (innkeepers' and wine cellar workers' confraternity) which, besides the altar, had its headquarters near the porch entrance of the church, which was demolished in the 19th century. This confraternity, founded in 1335 and originating in the church of San Matteo, was already in San Cassiano in 1488. The third altar houses the early 17th-century *Visitation* altarpiece by LEANDRO BASSANO, which came from the nearby rear chapel reserved for the Confraternity of the Visitation.

398 TOP AND
BOTTOM LEFT JACOPO
TINTORETTO, *CHRIST
DESCENDING INTO
LIMBO*.

398 BOTTOM RIGHT
JACOPO TINTORETTO,
*THE RISEN CHRIST
WITH ST. CASSIAN
AND ST. CECILIA*.

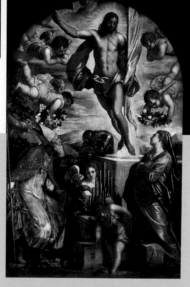

In the chancel, the altarpiece by JACOPO TINTORETTO, *The Risen Christ with St. Cassian and St. Cecilia* (1565), was executed under the guardianship of Zampiero Mazzoleni and restored by Giuseppe Calimpergh in the 17th century. Tintoretto, who hailed from the San Cassiano parish, painted this canvas, as well as the other two on the walls, for the Scuola del Santissimo Sacramento. The two titular saints of the church are contemplating the triumphant Christ hovering over his sepulcher. This episode is to be interpreted together with the two scenes flanking it, which

399 JACOPO
TINTORETTO,
CRUCIFIXION.

TINTORETTO painted in 1568. The *Crucifixion* expresses Christ's solitude, an image of a righteous man suffering. One infidel is handing another one the inscription that will be placed on the top of the Cross. Jesus, flanked by the two thieves, is still alive. His body is livid and bloodstained. At his feet are the tunic, the symbol of the unity of the Church, and the swooning Mary being held up by John. In the canvas at right, *Christ Descending into Limbo*, Satan is overwhelmed and the just, preceded by Adam and Eve, are liberated. Next to them appear the portraits of the members of the Scuola del Santissimo Sacramento, among whom is the superior, Cristoforo de Gozi.

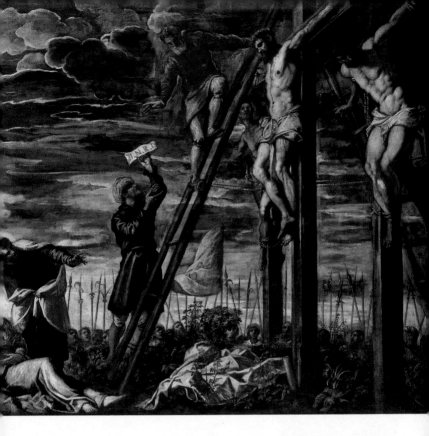

The resourcefulness of this confraternity also led to the creation of the triumphal high altar, with statues and reliefs by ARRIGO MEYERING and the stone-cutter BARTOLOMEO NARDI (1684-89). This theatrical and devotional "machine" glorifies the titular saints of the church and the theme of the Eucharist. In particular, note the bas-reliefs on the frontal depicting *The Supper at Emmaus*, *The Last Supper* and *Supper in the House of Simon the Pharisee*, with Mary Magdalene washing Christ's feet. The three panels are divided by the figures in high relief of four putti holding Eucharistic symbols taken from the Old and New Testament: a lamb, ears of wheat, grapes, and grains of manna. After the font in the left aisle, you can enter a small chapel or oratory built in 1746 for the abbot Carlo dal Medico. In the small altar in a niche, in the balustrade facing it and in the frame of the altarpiece, are inserted semi-precious stones such as cornelian, lapis lazuli, jasper and agate. The altarpiece, *Madonna and Child with St. Charles Borromeo and St. Philip Neri* (1763, signed and dated), is by GIAMBATTISTA PITTONI. In the middle of the wall opposite, ANTONIO BALESTRA painted *The Martyrdom of St. Cassian* (early 18th century). The old teacher, punished for not having worshipped idols, was given a death sentence by his own students. The artist depicts the body of the martyr diagonally, and on either side are children threatening the saint with a dagger and a board and cane. Besides the confraternity of St. Cecilia and St. Elizabeth, the church also hosted the Scuola of St. Anthony of Padua and the Scuola dei Salumieri (salted and dried fish vendors, who merged with the Casaroli, or cheese vendors) up to 1663, whose patron saint was St. Francis of Assisi.

The Rio de San Cassan is crossed by three bridges. Cross the Giovanni Andrea de la Croce (or de la Malvasia) bridge, the end of which is also the end of the San Polo district and the beginning of the Santa Croce district. To the left of the bridge, overlooking the canal, is the tall, dominating facade of **Palazzo Muti-Baglioni** (early 17th century). Our itinerary continues to the bridge of Campo Santa

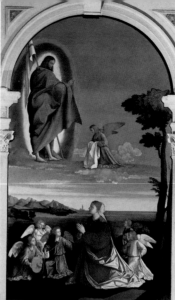

400 TOP
VINCENZO
CATENA, BAPTISM
OF ST. CHRISTINA,
SANTA MARIA
MATER DOMINI
CHURCH.

400 BOTTOM
CA' ZANE.

401 JACOPO
TINTORETTO,
DISCOVERY OF THE
TRUE CROSS,
SANTA MARIA
MATER DOMINI
CHURCH.

Maria Mater Domini, from which you have a view – at right and along the canal – of the exemplary Gothic façade of **Palazzo Moro** (late 14th century). The houses lining the *campo* are among the most emblematic and fascinating examples of minor late Byzantine and Gothic architecture in Venice. At left, with the bridge behind you, is the drastically altered facade of **Ca' Zane**. In the middle of the *campo* is an elegant wellhead (first half of the 15th century) in the shape

of a capital. On the smaller side of the square is the facade of **Ca' Viaro-Zane**. This branch of the Zane family, whose coat of arms is dominated by a walking fox, was involved in the Bajamonte-Tiepolo conspiracy. The palazzo is divided into two blocks. The right one (no. 2120-21), rare and elegant, is articulated around two five-lancet windows. The first multiple window (end of the 14th century) is embellished with a pedestal with bas-reliefs, five 13th-century paterae and white and green marble inlay, and is crowned by trefoil arches. At no. 2118 is a typical shop with pilasters with reliefs indicating it was once owned by the Scuola di Santa Maria della Misericordia; these depict a *Madonna and Child* (1575, dated inscription) and the letter "M" surmounted by a crown.

To the right is the small but lovely **Santa Maria Mater Domini Church**. HISTORY: according to tradition, this church was built by the Cappello family in 960 and dedicated to St. Christina. The present dedication, documented from 1128 on, derives from one of the main appellations of Mary, *Theotokos* (Mother of God), in conformity with the pronouncement of the Council of Ephesus. The church was rebuilt in 1504-40 thanks to the initiative of the parish priest Angelo Filomati, and the bell tower was rebuilt in 1740-43. FAÇADE: the architect is unknown. It was probably built sometime before 1540 by an architect other than the one who designed the interior. The small façade is tripartite and, despite the stone dressing, stands out for its simplicity, based on the proportions and the linearity of the cornices and

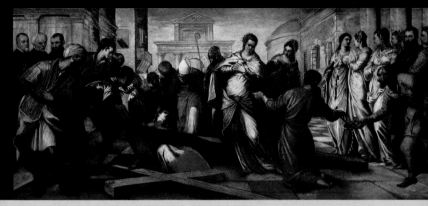

profiles. The four Corinthian pilasters on pedestals support an entablature with a smooth frieze. The two side bodies, which are lower, are connected to the central, taller one ending in a tympanum on an attic by means of two overturned imitation arches with volutes at their ends. The jambs and lintel of the portal have a singular splayed side. This detail, repeated in the round window above, has led scholars to attribute the work to SCARPAGNINO.

INTERIOR: the plan, consisting of a nave and two side aisles with an inscribed Latin cross, is an attempt at merging the plans of two other Rialto churches, San Giacometto and San Giovanni Elemosinario, which drew inspiration from St. Mark's Basilica. On the second altar at right (1520) is *The Baptism of St.*

Christina (ca. 1520), until very recently erroneously considered the martyrdom of the saint. This is one of the best paintings by VINCENZO CATENA, executed for the Scuola di Santa Christina, the titular of the altar. The saint was thrown into the waters of Lake Bolsena with a millstone tied around her neck, and was saved by angels, who took her to the shore, where she was baptized by Jesus, who in the painting appears on high in the guise of the Risen Christ, flanked by an angel holding a white baptismal dress.

The rear chapel at right was reserved for the Confraternità della Santissima Croce (later Confraternità del Suffragio), founded in 1551 with headquarters at the foot of the nearby Ponte del Cristo (no. 2116). This chapel once housed the *Discovery of the True Cross* by JACOPO

TINTORETTO (ca. 1561), now kept in the left transept. Here the artist depicts two episodes: at right, the discovery of the nails, shown to St. Helena by a kneeling figure; at left, Macarius, bishop of Jerusalem, is bowing before the ill woman cured by the Cross. Among the figures in the crowd are the portraits of some confreres. The church has the tomb of Antonio Maria Zanetti, the librarian of the Marciana Library and author of a precious catalogue of paintings entitled *Della pittura italiana* (On Venetian Painting, 1771). Besides the religious confraternity of Maria Mater Domini, founded in 1130, and the Scuola della Beata Vergine Maria, the church hosted the Congregazione del Clero and the Congregazione del Santissimo Sacramento.

402 BOTTOM
COURT AND WELL,
CA' PESARO.

402-403
CA' PESARO.

402 TOP AND 403 BOTTOM
CA' AGNUS DEI, DETAILS OF
THE FIVE-LANCET WINDOW.

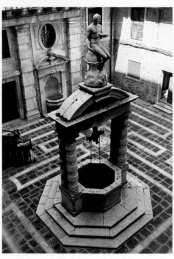

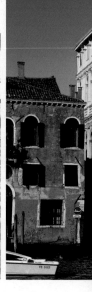

■ In Calle del Tiozzi, no. 2084 has a Gothic *portal* with a pointed arch. At the foot of Ponte del Forner is **Ca' Agnus Dei** (late 14th century). Above the water entrance is a tondo with the *Mystic Lamb* (mid-15h century), while over the five-lancet window are reliefs depicting the *Annunciation* and the symbols of the *four Evangelists*.

At the end of the *fondamenta* is **Ca' Pesaro**, home of the **Galleria Internazionale d'Arte Moderna** (no. 2076). HISTORY: the palazzo was commissioned by Francesco and Doge Giovanni Pesaro to increase the family's fame and prestige. Construction began in 1628 to a design by BALDASSARE LONGHENA. The first *piano nobile*, begun after the death of the doge (1659) by his nephew Leonardo, was finished in 1679. LONGHENA died in 1682 and the building was completed around 1710 by his pupil ANTONIO GASPARI. FAÇADE: the ground floor, which was being built in 1676 and has two canal entrances, is embellished with diamond-pointed rustication. The canal side of both main floors has seven majestic windows.

MUSEUM: after the Duchess Felicita Bevilacqua La Masa donated the palazzo to the city, the Galleria d'Arte Moderna was opened in 1902. The initial collections consisted of several donations. The palazzo was the home of the Bevilacqua La Masa Foundation, founded in 1905 to help young artists and to promote Venetian art and industry. The director Nino Barbatini, from 1907 to 1938, increased the number of 19th-century works and promoted the Ca' Pesaro artistic movement. After a long period of closure, the museum was reopened at the end of 2002. The restoration design was by

architect BORIS PODRECCA, assisted by MARCO ZORDAN. COLLECTIONS: these comprise 19th-century Italian and Venetian painting and sculpture, the works purchased from the Biennale, the Adolfo Wildt and De Lisi donations, the Ca' Pesaro movement works, and post-World War Two works by Italians and foreigners.

■ GROUND FLOOR: the entrance communicates with a courtyard whose 18th-century facade is of uncertain attribution. The well (ca. 1545), brought from the courtyard of the Zecca in 1905 and attributed to JACOPO SANSOVINO, has an octagonal well-curb with

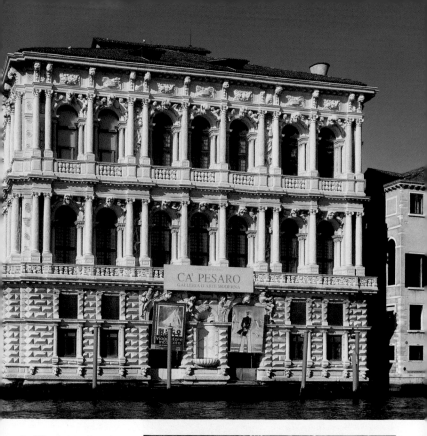

paired Tuscan rusticated columns. The statue of Apollo crowning it is an allegory of gold and was sculpted by DANESE CATTANEO. Once past the entrance courtyard, you enter the magnificent entrance hall or *portego*, which extends as far as the Grand Canal on the opposite side. Along the walls are some sculpture pieces, including, at right, the sorrowful, pregnant *Eve* (1948-49) by FRANCESCO MESSINA and, on the back wall, the pure, monumental marble *Nude* (1951-52) by ALBERTO VIANI, a pupil of ARTURO MARTINI. After the wide niche, you will find, on the landing, the

unfathomable *Cardinal* (1955) by the sculptor from Bergamo GIACOMO MANZÙ, who creates a masterful combination of his youthful preference for archaic sculpture, his interest in MEDARDO ROSSO, and his feeling for light effects. Along the monumental

staircase is *The Thinker* by AUGUSTE RODIN. This plaster sculpture with a black glaze reveals the French artist's passionate study of Michelangelo's works, in particular one of the famous figures of the damned in the *Last Judgment* in the Sistine Chapel.

404 LEFT GUSTAV KLIMT, *JUDITH II*, CA' PESARO.

404 RIGHT GIUSEPPE DE NITTIS, *THE WINDOW*.

405 NICOLÒ BAMBINI, *THE GLORIES OF THE PESARO FAMILY AND VIRTUES*.

FIRST FLOOR. *Room I* (19th-century Venice). Besides the View paintings or interiors by DOMENICO BRESOLIN, GUGLIELMO CIARDI, FEDERICO ZANDOMENEGHI, GIACOMO FAVRETTO, MARIO DE MARIA, PIETRO FRAGIACOMO, LINO SELVATICO, LUIGI NONO and the bronzes by URBANO NONO and ANNIBALE DE LOTTO, mention should be made of the View paintings by the Bellunese IPPOLITO CAFFI, in particular the virtuostic *Serenade Opposite Piazzetta San Marco* (1865), in which the space and the architectural backdrops of the buildings, immersed in the moonlight, reflect the brilliant reds and whites of the Bengal lights. Equally interesting is *Venice - Snow and Fog* (ca. 1842), a view of the silent Grand Canal.

Room II (19th-century Italy and MEDARDO ROSSO). The lovely wooden ceiling with putti (1682), commissioned by Leonardo Pesaro, has allegorical figures of Virtues and, in the middle, the *Glories of the Pesaro Family* by NICOLÒ BAMBINI (1651-1736). In the room there are works by TELEMACO SIGNORINI, GIOVANNI FATTORI, VITTORE GRUBICY DE DRAGON, GAETANO PREVIATI, GIUSEPPE DE NITTIS AND GIUSEPPE PELLIZZA DA VOLPEDO. Of particular interest, on the partition wall, is the original portrait of *Letizia Pesaro Maurogonato* (1901?), in which GIACOMO BALLA, before becoming part of the Futurist movement, took the principles of Divisionism to its extremes. The wall and the rather sketchy figure are splendidly enlivened by light effects obtained by means of colored marks like graffiti executed by means of an intuitive, passionate gestural procedure. This room also has some fascinating wax-over-plaster sculptures by MEDARDO ROSSO (1858-1928), the expression of an intimate world filled with secret memories and enveloped in a warm, gentle light.

The doors of the adjacent and spacious *Salone* (works from the Biennale) are topped by 18th-century stuccoes with frescoes of Virtues. This hall has been divided into two long corridors by means of partition panels and contains many works dating from the late 19th to the mid-20th century, purchased at the Biennale exhibitions. Starting from the corridor at right, note, on the wall, the folkloric *St. John Procession in Brittany* (1899) by CHARLES COTTET; the sunny atmosphere of *Sewing the Sail* (1896) by JOAQUIN SOROLLA Y BASTIDA, set in a typical Spanish patio with geraniums and

grapevines, whose shadows mingle with, and dissolve in, the blinding light of the sail. In the middle of the room, on a crosswise panel, is *Judith II*, dated 1909 and signed by GUSTAV KLIMT, one of the founders of the Vienna Secession art movement. The woman portrayed here should not be mistaken for Salomé, since her bared breast and mature age, and above all the head of Holofernes in a sack cannot but refer to Judith, the biblical heroine who saved her city from a siege. Instead of illustrating the allegory of virtue triumphing over vice, KLIMT interprets Judith as a *femme fatale*. Her eyes without pupils reveal her demonic nature, while her long, hooked fingers manifest her predatory instincts. The warm decoration of her hair and funereal clothing consist of abstract motifs that seem to annul her body, which is already pale with death.

Behind this panel is the plaster bust of the *Mysterious Sphinx* (1897) by CHARLES VAN DER STAPPEN. After the bronze statue *Bather* (1896-97) by MAX KLINGER, on the panel at left there is the refined portrait entitled *White Mask* (1907), signed by FERNAND KHNOPFF, a leading Symbolist painter. At the end of the hall, after turning left you will see a panel with the *Rabbi of Vitebsk* (1914-22), in which MARC CHAGALL depicts a rabbi in prayer through a singular combination of the figurative Cubism he had studied in Paris and the Suprematist experiments made in Russia by Casimir Malevich. Farther

on are VASILY KANDINSKY'S *White Zig-Zags* (1922) and PAUL KLEE'S *With the Serpent* (1924). Proceeding to your right, you will see the bronze statue of the *100-meter Sprinter* (1935) by ARTURO MARTINI. Next to this work, on the wall, is the desolate, gloomy *Urban Landscape* (ca. 1950) by MARIO SIRONI, followed by two works by CARLO CARRÀ: *Still Life with a Coconut Palm* (1949) and *Sunset at the Sea* (1927). At the end of the hall, turn right and enter *Room III*. In the middle of the ceiling with rich carved wooden decoration, GIAMBATTISTA PITTONI (1687-1767), a follower of TIEPOLO, painted *Jupiter with Peace, Justice and Minerva*. This room is entirely given over to the disturbing and refined Milanese sculptor ADOLFO WILDT (1868-1931), whose oeuvre is redolent

with symbolic meaning and references to the theater, or with meditations on the theme of death inspired by Baroque art. Immediately to your left is the commemorative bust of *Franz Rose* (1913, signed), a friend and patron of Wildt and, at right, *Proud Nature, Gentle Soul* (1912, signed). The lovely *Room IV* has works by FELICE CASORATI, MARIO SIRONI, MASSIMO CAMPIGLI, VASILY KANDINSKY, JUAN MIRÓ, CARLO CARRÀ, FILIPPO DE PISIS and GIORGIO MORANDI, among others. On the right wall are three works by GIORGIO DE CHIRICO: *Portrait of Lionello de Lisi* (1953, signed), the neurologist and art collector who acquired the paintings in this room; *Mysterious Baths* (1935); and *Troubadour*, a stale example of this artist's Metaphysical works of the 1910s. Also note, on the partition panel, *Composition* (ca. 1950) by the Chilean SEBASTIAN MATTA and *Build and Destroy*, dated 1940 and signed by the Parisian Surrealist YVES TANGUY.

On the ceiling of *Room V*, GIROLAMO BRUSAFERRO, a pupil of BAMBINI, painted *Jupiter with Juno and Iris* (18th century). This and the next room are given over to those artists who were receptive to European avant-garde movements and, as a protest against the Biennale's policy, exhibited their works in the group and one-man shows promoted by the Fondazione Bevilacqua La Masa from 1908 to 1920. In *Room V*, besides works by artists such as GINO ROSSI and UGO VALERI, note, at right as soon as you enter, the pastel signed by UMBERTO BOCCIONI, *Portrait of the Artist's Sister Reading* (1909). The next room, *Room VI*, has on the ceiling a fresco attributed to the Veronese ANTONIO BUTTAFOGO, *The Triumph of Hercules* (late 18th century). Among the artists of the Ca' Pesaro movement, noteworthy are the works by ARTURO MARTINI, GUIDO CADORIN and UMBERTO MOGGIOLI. In *Room VII* (post-World War Two international art) are the allegories of Virtues frescoed on the ceiling, attributed to GIAMBATTISTA CROSATO (ca. 1685-1758), while the central canvas is by ANGELO TREVISAN (1669-1753?). Along the walls are works by OSSIP ZADKINE, ALFRED MANESSIER, SEBASTIAN MATTA, HENRI MATISSE, ALEXANDER CALDER, MAX ERNST, HANS ARP and HENRY MOORE. Next are *Room VIII* (Italian art of the 1950s), with the noteworthy *Wind and Sun* (1958) by ANTONIO ZORAN MUSIC, and *Room IX* (Venice between the Fronte Nuovo delle Arti and Spatialism movements), which, besides the fascinating *G.G. 105* (1961) by MARIO DELUIGI, boasts *Sojourn in Venice* (1955) by TANCREDI, in which forms and colors reflected in the water are transformed into mosaic tesserae, producing an abstract space. At present, the SECOND FLOOR – which will house temporary exhibitions – is not open to the public, while on the THIRD FLOOR is the **Museo d'Arte Orientale**.

MUSEUM: the objects of Eastern art on exhibit were collected by Enrico di Borbone, Count of Bardi, during a journey he made with his wife to Indonesia, China and Japan from 1887 to 1889. The collection, dispersed when the works were sold in 1907-14, was sequestered by the Italian government and placed in Ca' Pesaro in 1925, where the artistic pieces were put on display. COLLECTIONS: most of the art works belong to Japan's Edo period (1614-1868). They are going to be moved shortly to a new home, the museum in Palazzo Marcello. Worthy of note are the 18th-century Japanese armor, the lovely sandstone statue of a Khmer divinity (Cambodia, late 10th century), the ceremonial hats made of lacquered wood (Room I), the Japanese ceramics and porcelain (Room IV), the 17th- and 19th-century Japanese paintings, and the Japanese lacquer (Room IX).

408 TOP
GIAMBATTISTA
PIAZZETTA, MARTYRDOM
OF ST. JAMES THE
GREATER.

408 BOTTOM LEFT AND
409 RIGHT
GIAMBATTISTA TIEPOLO,
MARTYDOM OF ST.
BARTHOLOMEW, SAN
STAE CHURCH.

408 BOTTOM RIGHT
AND 409 LEFT
INTERIOR AND
FAÇADE OF SAN
STAE CHURCH.

■ After crossing over the Ponte de Ca' Giovannelli, you come to the headquarters of the **Scuola dei Batti e Tiraoro** (no. 1980). Next to the Scuola is the church of Sant'Eustachio, better known as **San Stae**. HISTORY: in Venetian dialect, Stae is the abbreviation of Eustachio, the commander of Trajan's troops known for having seen the Crucifix between the horns of a deer while hunting. San Stae Church, documented in the year 1127, was also named after St. Isaiah and, probably in 1320, also after St. Catherine of Alexandria. The bell tower was rebuilt around the end of the 17th century, and a Baroque base (1702) was set over its entrance, along with the 13th-century *bust of an angel*. FAÇADE: this was financed by Doge Alvise II Mocenigo in 1709 after a competition won by DOMENICO ROSSI. The main body has four giant composite-order half-columns on tall pedestals that imitate those in the interior. These are echoed in four other smaller, Corinthian half-columns: two flank the entrance, and two are set back at either end of the facade, supporting the statues

of *Charity* (left) and another Virtue without attributes, perhaps *Prudence* (right). The upper pediment is dominated by the statue of the *Redeemer* and, at either side, those of *Faith* and *Hope*, attributed to ANTONIO CORRADINI. Above the portal tympanum is a *Glory of Angels*. One of the angels is holding a canvas depicting the Cross and St. Eustace. At the sides of the typmanum are allegorical statues of *Obedience* and, at right, *Humility* or *Patience*. The two side niches of the façade have statues of *St. Eustace* and *St. Sebastian* and above them are high reliefs of two episodes in the martyrdom of St. Eustace and his relatives: *The Lion Lowers its Head before St. Eustace* and *The Emperor Hadrian Has Eustace and His Relatives Thrown in a Red-hot Bronze Ox*. INTERIOR: the present church, begun in 1683 and finished much later, in 1745, was rebuilt to a design by GIOVANNI GRASSI. The aisleless nave is lined with seven marble altars, six of which are in the side chapels and one in the broad chancel with a vaulted ceiling. In the middle of the pavement is the tomb

slab of Doge Alvise II Mocenigo, which has an inscription in Latin, one of the most touching meditations on death to be found in Venice: "Fame and vanity are here buried together with the body." Over the entrance is the choir, with wooden sculptures and an organ (1722). In the CHANCEL are canvases representing Eucharistic themes, realized by 17th and 18th century artists (GIUSEPPE ANGELI, BARTOLOMEO LITTERINI, and GIUSEPPE TORRETTI) and depicting episodes from the life of the Apostles. Noteworthy among them are, on the lower right wall, *The Martyrdom of St. Bartholomew* (1722-23) by GIAMBATTISTA TIEPOLO and, on the lower left wall, *Martyrdom of St. James the Greater* by GIAMBATTISTA PIAZZETTA. The dramatic realism of this latter artist is countered by TIEPOLO'S less violent vision of suffering attenuated by an elegant dance. Some works in the SACRISTY depict scenes from the life of St. Eustace executed by the workshop of GIAMBATTISTA TIEPOLO, by BARTOLOMEO LITTERINI and by GIAMBATTISTA PITTONI.

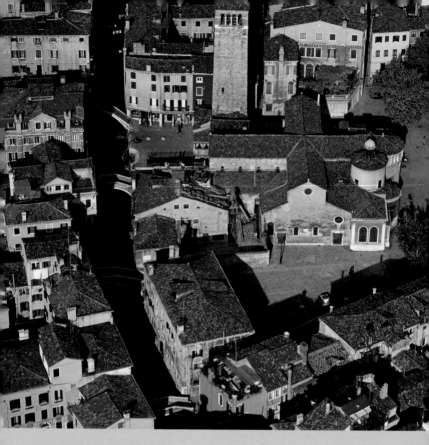

410-411 Aerial view of the Campo and Church of San Giacomo dall'Orio.

At the end of the *salizada* that skirts the church you will see, at left, **Ca' Mocenigo** (no. 1992), the home of the **Museo di Palazzo Mocenigo -Centro Studi di Storia del Tessuto e del Costume**. HISTORY: the prestigious Mocenigo family boasted seven doges, one of whom, Alvise II (1700-09), was from the San Stae branch of the family and had the façade of this church built. The palazzo (late 16th century-early 17th century, with alterations made in the interior in the early 18th century) housing the museum was designed by

411 San Giacomo dall'Orio Church, view from the left aisle.

SAN GIACOMO DALL'ORIO CHURCH

1 Column of verde antico stone
2 New Sacristy
3 Cappella del Santissimo Sacramento
4 Old Sacristy

an unknown architect. The MUSEUM was founded by the city in 1985 after the palazzo was donated by Alvise Nicolò Mocenigo in 1945. SECOND FLOOR: this features a selection of 18th-century Venetian clothes and accessories, on display in rotating exhibitions. The rooms

have frescoes or canvases by JACOPO GUARANA, ANTONIO STOM, GIAMBATTISTA CANAL and GIOVANNI SCAGIARO – a rarity indeed in late 18th-century patrician mansions.

 Now go along Salizada de Ca' Carminati as far as Campo San Boldo, whose name reminds one of the church of Sant'Agata and Sant'Ubaldo (the bishop of Gubbio), only part of the campanile of which has remained after the 1830 demolition. Once in Calle del Tentot, turn left for a brief visit of the fascinating Corte del Tagiapiera. This small square, elevated to avoid flooding, communicates with the canal by means of a gondola quay.

■ Retracing your steps you will come to the nearby **Church of San Giacomo dall'Orio**. We recommend going around its Renaissance apses and austere 12th-13th century campanile, and then taking the entrance in the Campiello del Piovan.

HISTORY: there is historical documentation of the existence of the clergy in the 10th century and of the parish in 1130. The church was dedicated to St. James

the Greater. The pilgrims from the Germanic areas who went to Compostela used Venice as a starting point. Historical sources tell us that on Easter Monday of 1495, the chaplain of the Scuola di San Giacomo (which is documented at least as far back as 1322), accompanied the pilgrims from the church to St. Mark's, where they embarked for Spain. As for the name "Orio," the various explanations are simply not reliable, so it remains a mystery.

INTERIOR: the Romanesque nave and side aisles, with their owl's-beak capitals and small round arches, date from the late 13th century. The transept, built over the earlier one and supported by pointed arches, and the splendid wooden ship's-keel ceiling were built after the 1345 earthquake. In the right transept is the Altar of St. Anthony (1764), with the *Madonna and Child with Sts. Anthony of Padua, Joseph, James the Greater, Lawrence and Sebastian* altarpiece painted by the parishioner GIAMBATTISTA PITTONI (1687-1767), who lived in the nearby Calle delle Oche.

On the right wall, the large canvas by PALMA GIOVANE illustrates the New Testament episode of the *Multiplication of the Loaves and Fish* (ca. 1614) in a Eucharistic key. At left is the famous *verde antico* column that may have been transported from Byzantium in 1204. The intense translucid effects produced by the smooth shaft with entasis make it look like a precious stone with milky streaks. The Ionic capital, whose slightly reduced proportions leads one to think it was taken from another column, is absolutely perfect. Nearby is the entrance to the NEW

the Tridentine doctrine of the sacrifice of the Mass. In the lunette at left is an *Ecce Homo* by GIULIO DEL MORO (signed), under which is *The Procession to Calvary* by PALMA GIOVANE (ca. 1604). The latter scene begins at left with Mary fainting for the first time, while in the middle is Simon the Cyrene holding up the cross and the kneeling Veronica about to dry the sweat off Christ's face with her veil. In the lunette on the wall opposite is *The Flagellation*, attributed to Titian's nephew, known as TIZIANELLO. Under this is *The Burial of Christ* (ca. 1604) by PALMA GIOVANE,

1808). Note, on the tambour wall, the figure of *Faith* and, above the cornice, the high relief of a *putto* in painted stucco. The relief, like the frescoed figures, helped to create the effect of being present in the congregation and, for the more learned, referred to the Tridentine doctrine formulated in 1551 of the Eucharist as "the bread of angels." On the triumphal arch of the chancel, renovated in 1498, hangs the 14th-century *Crucifix* (tempera on panel)

attributed to PAOLO VENEZIANO and taken here from San Beneto Church. At either end of the arms of the chancel are the sorrowful Madonna and St. John the Evangelist; on top is an angel in Byzantine dress. Despite the faded colors, under the feet of Christ one can still see the skull of Adam cleansed of sin by the blood of the Savior. After the chancel chapel at left, built in 1568 for the nobleman Dolzoni, on the nave wall is *St. Sebastian between St. Lawrence and St. Roch* (signed), by GIOVANNI BONCONSIGLIO, known as IL MARESCALCO (ca. 1470-1537), which can be appreciated for its perspective and Neo-Byzantine architectural setting. The door under this

SACRISTY, which contains works by FRANCESCO BASSANO and assistants, and by the workshops of BONIFACIO DE' PITATI and PAOLO VERONESE. The rear chapel at right was constructed by the Scuola del Santissimo Sacramento in the 16th century. The canvases on the side walls illustrate episodes from the Passion of Christ to highlight

in which the Virgin Mary swoons for the third time. The Eucharistic cycle is enriched with other later works: on the spandrels, *The Four Evangelists* by ALESSANDRO VAROTARI, known as PADOVANINO; 18th-century stuccowork; on the tambour and dome, frescoes with *figures of angels* by JACOPO GUARANA (1720-

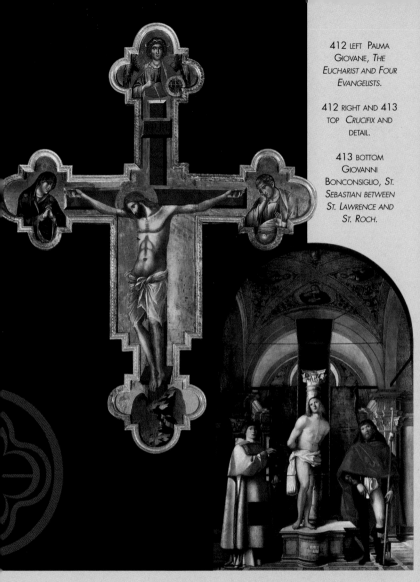

412 LEFT PALMA
GIOVANE, *The
Eucharist and Four
Evangelists*.

412 RIGHT AND 413
TOP *Crucifix* AND
DETAIL.

413 BOTTOM
GIOVANNI
BONCONSIGLIO, *St.
Sebastian between
St. Lawrence and
St. Roch*.

painting leads to the OLD
SACRISTY, whose painting
decoration was entrusted to
PALMA GIOVANE by the parish
priest Giovanni Maria da
Ponte. These canvases,
executed in 1575-81, are
among the first post-
Tridentine Eucharistic cycles
in Venice; in keeping with a
tradition derived from the
popularized medieval Bibles,
the paintings contain certain
episodes from the Old
Testament presented as
prototypes of the sacrifice of
Christ and of the Mass. In
one work, PALMA GIOVANE
paints the portrait of Da
Ponte kneeling before the
Madonna (1580-81). Once
out of the sacristy, on the
side walls of the Cappella di
San Lorenzo are two other
canvases by PALMA GIOVANE:
Martyrdom of St. Lawrence
and *St. Lawrence Showing the
Tyrant Valerian the Mass of
Poor People Aided by the
Church* (1581-82). San
Giacomo dall'Orio also
hosted the confraternities of
the Immacolata (founded in
1535), the Annunciazione
and the Madonna di Loreto
(founded in 1656).

414 TOP LEFT SAN
ZAN DEGOLÀ
CHURCH.

414 TOP RIGHT AND
415 TOP ST.
HELENA AND SAINTS
AND DETAIL, SAN
ZAN DEGOLÀ
CHURCH.

414 BOTTOM
FONTEGO DEI TURCHI.

415 BOTTOM
ANNUNCIATION,
SAN ZAN DEGOLÀ
CHURCH.

■ You exit from the church by the right transept door. The large building on the *campo* along the canal was once the home of the Osservatorio or **Teatro Anatomico** (no. 1570), built in 1669-72 as the headquarters of the physicians' and surgeons' guild. With the help of a map, go to the **Fontego (or Fondaco) dei Turchi**, home of the **Museo Civico di Storia Naturale** (no. 1730). HISTORY: the palazzo, which

belonged to the Pesaro family, dates from the 13th century, and from 1621 to 1838 was rented to the Turks to be used as a trading center. In 1864-1869 the palazzo was rebuilt by FEDERICO BERCHET and used as the home of the Museo Correr in 1887. FAÇADE: this has the

features of the typical *fondaco* or warehouse, with two corner towers connected by a long portico with horseshoe arches and surmounted by a spacious loggia. The many paterae date from the 11th to the 13th century, although some have been redone and do not belong to the original structure. MUSEUM: in anticipation of drastic restoration work, the museum was partly opened to the public in October 2003. COLLECTIONS: the Museo Correr epigraphic collection (ground floor): wellheads, coats of arms and inscription stones; the scientific collections of the Museo Correr and the Istituto Veneto di Scienze, Lettere e Arti. Botanical, zoological, paleontological and ethnological collections from private donations. On the ground floor you can visit the *Aquarium*, featuring the Adriatic Sea environment

and, in particular, the rocky formations. On the first floor is the new *Spedizione Scientifica Ligabue* (Ligabue Scientific Expedition) hall, which has on display the fossils of an *Ouranosaurus nigeriensis* dinosaur–one of the two existing specimens in the entire world–and of a *Sarcosuchus imperator* crocodile, both of which were found in the Sahara Desert in Niger in 1973.

■ Now go back to the end of Calle dei Preti, where you will see the **church of San Giovanni Battista Decollato**, better known as **San Zan Degolà**. HISTORY: the first documentation of the parish church, one of the oldest in this district, dates from 1007. The building was restored in 1213. FAÇADE: this was rebuilt in the early 1700s. INTERIOR: the plan is basilican, with the aisles separated from the nave by two rows of four Greek marble columns with 11th-century Byzantine-style Corinthian capitals and Gothic arches. The chancel

and two rear chapels have flat back walls. The chapels face East, in keeping with an old liturgical arrangement that identified the sun with Christ, and the East as the site of the Nativity. In 1939-45 wide-ranging restoration work was undertaken to recover the supposed original appearance of the church. Included in this was the demolition of the plastered and stuccoed ceiling and the reconstruction of the ship's

keel ceiling. In the left-hand rear chapel, dedicated to the Crucifix, remains of frescoes were discovered, probably dating from the late 13th century. These fragments are among the oldest examples of fresco painting in Venice and reveal the close

relationship between the city and Byzantine art. The fresco cycle includes an *Annunciation*, the symbols of the Evangelists, and portraits of saints, including the titular saint, St. John the Baptist, and the striking figure of St. Helena holding up the True Cross which she discovered in Jerusalem. On the outer wall facing the square is a *high relief* representing the freshly severed head of St. John the Baptist, set in a

basin and being shown to Salomé. This work formerly stood in the nearby building next to the bridge and was later placed on the church wall. According to an old tradition that became popular in the 16th century, the head was identified with

that of Biagio Cargnio, a butcher who was beheaded because he put the meat of children he had slaughtered into his sausages and meat and tripe soup. His house and shop – in the nearby *fondamenta* named after him, Riva di Biasio – were razed to the ground.

With the help of a map, go to the Lista Vecchia dei Bari (the word *bari* meant marshy, uncultivated terrain). In Sotoportego de la Chiesa, on the right-hand wall is a white Verona marble bas-relief of *St. Ermolao in prayer* (second half of the 14th century), which comes from a demolished building that housed the headquarters and hospice of the Scuola di Sant'Ermolao. Until recently, the old Venetians passing in front of this relief thought it was an image of St. Simeone raising his hands in a gesture of refusal. This is why, when looking at it, they used to say "San Simeone no me intrigo," that is, "Look, St. Simeone, I've got nothing to do with this."

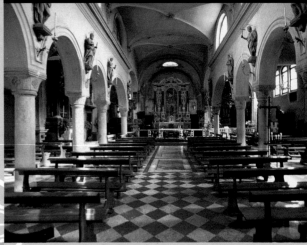

416 SAN SIMEONE
GRANDO CHURCH,
FAÇADE AND
INTERIOR.

417 JACOPO
TINTORETTO, *LAST
SUPPER*, SAN
SIMEONE GRANDO
CHURCH.

■ A little farther on, in the *campiello*, is the **church of San Simeone Profeta**, known as **San Simeone Grando**, documented as early as the 11th century. FAÇADE: this was built in the Corinthian order in 1757 and attributed to GIORGIO MASSARI, and restorations done in 1838 and 1861 made it rather flat and uninteresting. INTERIOR: this has a basilica plan and was drastically changed over the centuries. The left aisle is narrower than the other two. The ten columns are connected by round or segmental arches. Their shafts and capitals (with a flower in the middle of the

calathus) probably date from the late 13th century. The *statues of the twelve Apostles* by FRANCESCO TERILLI (1589 - ca. 1618), situated above the columns along the nave, introduce the congregation to the theme of the Credo and of Christian faith. These statues, originally polychrome and gilded, were painted the color of green marble around the mid-1700s. The other works are dedicated to the titular saint, the cult of Mary (quite widespread in the many local confraternities), or the cult of the body of Christ. At the beginning of the right aisle is the statue of the *Madonna of the Rosary* (figure, 17th century; cornice and angels, 18th century). This wooden sculpture is gilded and has polychrome lacquer, and was kept in the nearby small chapel, past the altar with the relics of St. Ermolao that was reserved for the Scuola of the same name, founded

in the early 14th century and suppressed in 1760. On the wall before this altar is *Presentation of Jesus in the Temple* (ca. 1610-1611, signed) by PALMA GIOVANE. This altarpiece, once placed on the high altar, depicts St. Simeone about to take the Christ Child in his arms from the Virgin Mary. The next chapel, Cappella del Rosario, was built in 1755, financed by the Soranzo family and by the Scuola del Rosario, to a design by GIORGIO MASSARI. The majestic altar, attributed to the workshop of the MORLAITERS, was partly executed by the stone-cutter LORENZO BON. Note the two side showcases filled with ex-votos in the shape of the sacred heart. The elegant, curved balustrade was finished in 1772. The Scuola del Rosario in this church was perhaps the first to be founded in Venice and, according to tradition, devotion to the rosary was

established here by St. Dominic himself during one of his sermons. The right-hand rear chapel dates from 1505 and was redone in 1772; it is dedicated to the Holy Sacrament, the Scuola of which was founded in 1560. The confreres, who worshipped the body of Christ, were granted a prestigious privilege, since the church had a glass case with a drop of Christ's blood that came from the reliquary in St. Mark's and was donated to the parish by Doge Reniero Zen (1234-68). The old high altar, given to the Scuola di San Simeone, no longer exists, but in the adjacent rear chapel there is a long inscription on the wall that states that the body of the saint, which was brought from Constantinople, was moved above the upper part of the altar in 1318. In the same chapel, dedicated to the Trinity, is a 13th-century marble sarcophagus and the

funerary stele with the monumental recumbent figure of *St. Simeeon the Prophet* (early 15th century) attributed to MATTEO RAVERTI. After this chapel, in the left aisle, one can enter the sacristy, which has an early 16th-century *Trinity* by a follower of BELLINI, GIOVANNI MANSUETI. God the Father on the throne is holding his crucified Son, surmounted by the dove of the Holy Ghost. Against the sky are the heads of the highest orders of angels: cherubs, seraphs and thrones. Going back to the left aisle, you will see the Altar of the Annunciation (1611), granted to the guild of the Garzoti and Argagnoti (woolen cloth combers and teasers), founded around 1608. At the foot of the Altar of the Visitation is the floor tomb of Ludovico Balbi. In the middle of the elegant lid (1471) is the family coat of arms with a rampant dragon inside a quatrefoiled cornice.

After the altar, at the beginning of the aisle, is the *Last Supper* (1561-63) painted by JACOPO TINTORETTO for the Scuola del Santissimo Sacramento. Here Jesus has just announced that one of his disciples will betray him. Judas, in the middle of the scene and with his back to us, is wearing a long yellow coat, the color of betrayal. The spiritual exercises of the time invited the faithful to imagine in detail the scene of an episode from the New Testament so as to empathize with the suffering of Christ. And this is exactly what TINTORETTO seems to be doing when depicting an old prelate at left, perhaps the person who commissioned the painting. The supper is nothing more or less than a visualization of this figure's meditations; he is praying, and his strong reaction of pity and emotion can be seen in his teary eyes.

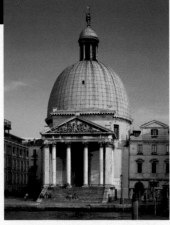

418 TOP SAN SIMEONE PICOLO CHURCH.

418 BOTTOM PALAZZO SORANZO.

418-419 INTERIOR OF SAN SIMEONE PICOLO.

■ Once out of the church, left of the Ponte de la Bergama, along the Rio Marin, is **Palazzo Gradenigo**, attributed to DOMENICO MARGUTTI, a pupil of LONGHENA. The plan of this building is irregular and its façade is asymmetrical. In fact, the four-lancet window of the drawing room is not in the middle, but is placed toward the land entrance, which has two portals. The first leads to the private wharf, while the other leads to the entrance courtyard. This palazzo was known for its richly decorated interior and vast garden. The venue of memorable feasts

and even of bull hunts, the building also had stables and a shed for carriages for those who wanted to visit the park. If you look past this building, you will see, on the same side of the canal, the **Palazzo Soranzo** (late 16th-early 17th century), with a regular plan. The *portego* or central hallway passes through the building and leads to the garden-park. The façade is symmetrical and filled with Istrian stone profiles and reliefs. Once at the Ponte dei Scalzi, turn left and go down Calle Nova de San Simeone, where you will find the **Palazzo dell'I.N.A.I.L.** (Istituto Nazionale per l'Assicurazione contro gli Infortuni sul Lavoro), designed by the architect GIUSEPPE SAMONÀ together with EGLE RENATA TRINCANATO (1951-56). Despite the unusual material used and the lack of decoration, this building is one of the most successful attempts at combining ancient and modern in Venice. The rigorously symmetrical façade

reveals a close study of Renaissance architecture. It is divided into rectangular units made of plain reinforced concrete. The central body, instead of containing the traditional drawing room, is used to house the main stairway. Back in the street, you can admire the **Chiesa dei Santi e Apostoli Simeone e Giuda Taddeo**, commonly known as **San Simeone Picolo**, just across the canal from the railway station. HISTORY: according to tradition, this church was founded in the 9th century and was consecrated in 1271. The original edifice was torn down in 1718 and the church we see today was

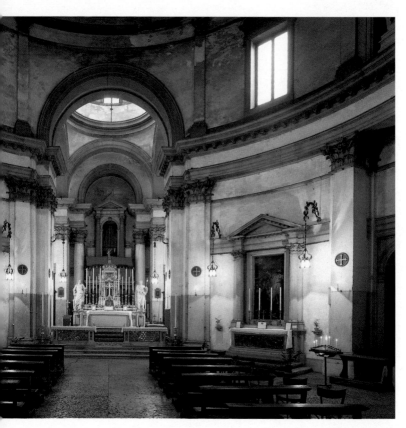

built from 1720 on to a design by GIOVANNI SCALFAROTTO, and was consecrated in 1738. FACADE: this is an eclectic gathering of some Palladian features drawn from the Redentore Church. It has a Corinthian-type portico, with classicizing variations, derived from the porch of the nearby Tolentini church. The name of the architect is carved on the architrave. The bas-relief on the tympanum, a work by FRANCESCO PENSO, known as CABIANCA, represents the martyrdom of St. Simeone and St. Jude. The elliptic cupola stands on a tall tambour; above the lantern is a statue of the Redeemer by MICHELE

FANOLI. INTERIOR: an elliptical, aisleless nave with four altars that alternate with niches, pilasters and Corinthian columns that support the dome. The chancel has apsidal side walls. Next to the sacristy is a small room known as the Purificatoio, or purificator. In the frescoed crypt are many tombs, including the one of the last *primicerio* (head prelate of San Marco). Starting from the right, the altarpieces represent *St. Francesco di Paola and Gaetano da Thiene* by ANTONIO MARINETTI, known as IL CHIOZZOTTO; *St. Simon, St. Jude and St. John the Baptist*, of

uncertain attribution (the altar was granted to the Scuola named after these saints); the Eucharistic cycle on the high altar, the work of various artists; the *Holy Family* by TOMMASO BUGONI, perhaps commissioned by the Scuola della Beata Maria Vergine; *Martyrdom of St. Dorothea* by ANGELO VENTURINI. The building next to the church (no. 697) was the headquarters of the **Scuola dei Tessitori di Pannilani** (woolen cloth weavers; 1559), whose confraternity, founded in 1553, was in San Simeone Grando Church before being transferred to San Simeone Picolo.

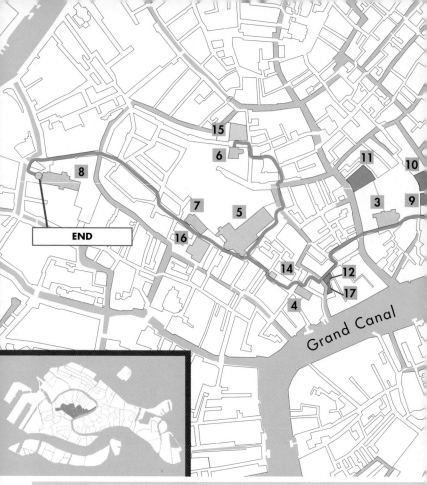

END

15

6

8

11

10

7

5

3

9

16

14

12

17

4

Grand Canal

FRANCISCAN RELIGIOSITY

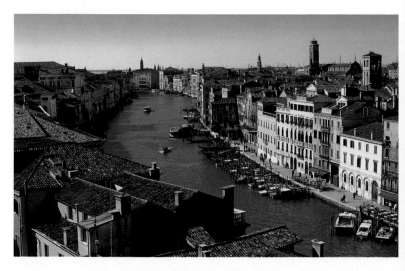

START

13
2
1

420 BOTTOM
GRAND CANAL
FROM RIALTO
BRIDGE.

421 TOP LEFT TITIAN
AND ASSISTANTS,
ANNUNCIATION,
DETAIL, SCUOLA
GRANDE DI SAN
ROCCO.

421 TOP RIGHT
G. TIEPOLO, JESUS
CONSOLES THE
PIOUS WOMEN,
DETAIL, SAN POLO
CHURCH.

421 BOTTOM
CHRIST CARRYING
THE CROSS, DETAIL,
SCUOLA GRANDE DI
SAN ROCCO.

▸ MAIN SIGHTS

● **SESTIERI (Districts):** S. Polo, S. Croce.
● **CHURCHES:** [1] San Silvestro; [2] Sant'Aponal;
[3] San Polo; [4] San Tomà; [5] Frari; [6] San Giovanni
evangelista; [7] San Rocco; [8] Tolentini.
● **PALAZZI:** [9] Tiepolo-Maffetti; [10] Soranzo;
[11] Corner-Mocenigo; [12] Centani.
● **OTHER MONUMENTS:** Scuole: [13] Tagiapiera;
[14] Calegheri e Zavatteri; [15] San Giovanni evangelista;
[16] San Rocco.
● **MUSEUMS:** [17] Casa di Carlo Goldoni.

This itinerary begins with the Riva del Vin, the main residential area on the Rialto island, with many offices and warehouses as well as hotels, inns, taverns and wine bars. The Ufficio del Vin, the Dogana da Terra, founded in 1414, and the Dogana da Mar were also here before being transferred to the Salute church area. This zone also had the residence of the Patriarch of Grado, who lived here until 1150 and whose status was in no way inferior to that of the bishop of Venice in Castello. Pedestrian communication between the Rialto and the nearby Campo San Polo, the home of neighborhood markets and public festivities, was opened in 1226. Beyond this area, there is the zone around the Frari Church where our tour ends. Once dominated by kitchen gardens and shoals., the district was later urbanized thanks to the skillful reclamation works promoted by the Franciscan monks and by some local families such as the Badoer. The area then became one of the most prestigious in Venice, both for its concentration of artisans, merchants and nobles, and for its churches and religious confraternities, which are so rich in tradition and fine works of art.

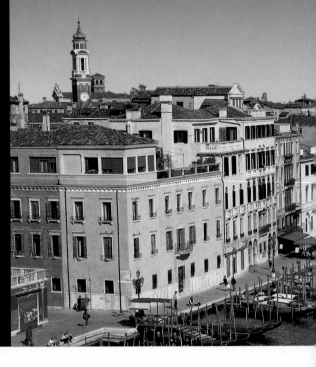

■ Our itinerary begins near the Rialto Bridge, along the Riva del Vin. Most of the buildings that once stood in this zone were destroyed by the terrible fire of 10-11 January 1514. Boats laden with wine moored along this *riva*. On the nearby *fondamenta* were the headquarters of the Ufficio del Vin, the wine customs office, and the adjacent Church of San Silvestro was the headquarters of the wine merchants' guild. The names of the *calli* that end on the Riva del Vin all refer to the public and private activities on this side of the ancient island of Rialto. The Calle Gambaro was famous for a

tavern there. On the pillar next to no. 726 is a bas-relief with the figure of St. Hadrian that has been related to the Mercanti da Vin (wine merchants). Actually, in the alley were the headquarters of the Travasadori e Portadori de Vin (wine decanters and porters), who were devotees of All Saints. The Calle della Madonna, with its characteristic buildings with corbel supports, may have been named after an image shown to the populace. The Calle dei Cinque was named after the Cinque Anziani (five elders) or *provveditori*, also known as the Signori alla Pace. This magistracy, here since 1341, controlled the

public brawls that were not serious. The office responsible for public order in general was the Ufficio dei Signori di Notte al Criminal. Calle del Sturion was named after the state inn and tavern of the same name whose sign was in the shape of a sturgeon (*storione*). In 1557 Nicolò Tartaglia died there. He was famous for his treatises on mathematics and ballistics that allowed Venice to become one of the first military powers to adopt nocturnal bombardments. The name of Calle del Paradise derived from the motto on the sign of a famous pharmacy.

At the end of the Riva del Vin,

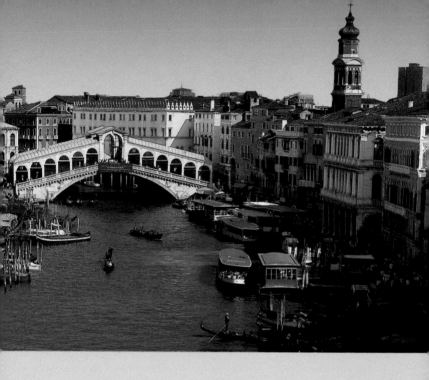

turn right and go along Rio Terà San Silvestro (or Rio Terà del Fontego, a reference to the public flour warehouse or *fondaco* that stood there). At left was the Palazzo dei Patriarchi di Grado (13th century) where, according to some historic sources, peace was made between Pope Alexander III and Emperor Frederick Barbarossa, thanks to the good offices of the Venetian Republic. When the patriarchate moved to San Pietro di Castello, the palazzo was sold to the San Rocco confraternity (1486), which occupied it until it too moved to its present headquarters. The late 13th-century bricked-up column to the right of no. 1093 may have belonged to the prestigious residence of the Patriarch of Grado.

Just around the corner is **San Silvestro Church**. HISTORY: this church, traditionally considered one of the oldest in the Rialto area, was under the jurisdiction of the Patriarch of Grado who, in the 12th century, took up residence in a palazzo nearby that no longer exists. This is the reason why San Silvestro, besides being a parish church, was also considered a mother church and had fifteen "branches," including San Bartolomeo, San Salvador, San Cassiano, San Giacomo dall'Orio, San Polo and Santo Stefano. After being rebuilt, the church was consecrated in 1422 and, around 1485, was merged with the pre-existing Oratory of Santa Maria dei Patriarchi e di Ognissanti. In 1451, following a decree issued by

Pope Nicholas V, Grado and Venice became part of a single diocese and the new patriarchate – whose first patriarch was Lorenzo Giustiniani – was moved to San Pietro di Castello. FAÇADE: built in 1909 by the architect GIUSEPPE SICHER, it rises over a double order of Ionic and Corinthian pilasters. The portal is crowned by a niche with the statue of St. Sylvester (17th century).

422 RIALTO BRIDGE, DETAIL.

422-423 THE RIVA DEL VIN AND RIALTO BRIDGE.

INTERIOR: in 1832 the parish priest, Don Antonio Sala, decided to tear down the old church and commissioned the Siennese architect LORENZO SANTI to build a new one. The work was completed in 1843 by GIOVANNI MEDUNA. The aisleless nave is interrupted, on the entrance side and the opposite side, by two Corinthian columns connected by an arch. On the flat ceiling, PIETRO FERRARI BRAVO frescoed the **lacunars**. If it were not for the four Neo-Classical side altars designed by SANTI and sculpted by GIANNANTONIO DORIGO, the interior would look like a palatial ballroom. At the beginning of the right-hand wall hang four 15th-century panels depicting *The Original Sin*, *St. Mary Magdalene in Glory*, *St. Sylvester* and *St. Daniel*. Farther down, on the first altar, is the *Baptism of Christ*

by JACOPO TINTORETTO, formerly in the demolished Altar of St. John the Baptist. No sooner does the baptismal water descend over Jesus' head, than the sky opens and the Holy Ghost appears in the guise of a dove. Christ's halo becomes brighter, shedding light around his body and down to his feet: the Son of Man is reborn and transformed into a body of light. A staunch believer, TINTORETTO interprets the baptism as a manifestation of Jesus' two-fold nature. A few steps away is the entrance to the small building that can be seen from the square and is attributed to the Lombard GIANNANTONIO CHIONA; it housed the Scuola dei Mercanti da Vino (1573-ca 1581), whose members were devotees of the Santissimo Croce (Holy Cross). Along the two main walls of the upper hall is a cycle of 17th-

century canvases given over to the *Story of the True Cross* (found by St. Helena), *St. Sylvester*, and the *Passion of Christ*. Some of these canvases can be attributed to GASPAR RHEM (or REM) and some date from 1611, 1612 and 1613. The three canvases on the ceiling (ca. 1757), painted by GASPARE DIZIANI, concern the Santissimo Croce. The small 17th-century altar comes from the Scuola dei Tagiapiera (sculptors and stone-cutters' confraternity) situated next to the nearby church of Sant'Aponal. On the frontal are the figures in relief of the patron saints of the confraternity. The empty space above the mensa, at the sides of which are the statuettes of *St. Peter* and *St. Paul*, was occupied by a painting, probably the *Four Crowned Saints* by VINCENZO CATENA (ca. 1515), now in the Accademia Galleries.

Descending the stairway, note above you a Baroque parapet on which is a relief of *Veronica's Veil*. According to apocryphal tradition, on the way to Calvary, a pious woman called Veronica gave a veil to Christ so he could dry his face covered with sweat, and when he gave it back to her the cloth had retained the print of his face. This icon, together with other images, is considered one of the prototypes of the True Face of Christ and was a cult object for the confraternities that were devotees of the Cross and the Passion. Now back in the church, go to the second altar on the right, where you will see *St. Joseph Presenting the Christ Child to God the Father*, by JOHANN CARL LOTH (1632-98). This rather unusual subject was commissioned by the Scuola di San Giuseppe and, both because of the gesture of Mary's husband and the angel

indicating the Christ Child, it is to be interpreted as an exhortation to the faithful to adore the Son of God. Mary's face in the half-light imparts sweet and touching lyricism to the scene. The wide chancel in the shape of an exedra is dominated by a Neo-Classical marble altar (1846) by the Roman AUGUSTO GAMBA, flanked by two praying angels by LUIGI FERRARI. Returning to the nave and going toward the exit, at the second altar note the painting of *St. Thomas* or *Becket Enthroned with St. John the Baptist and St. Francis*, a wood panel painting by GIROLAMO SANTACROCE (1520, signed and dated). This work was once in the Altar of the Barileri e Masteleri (coopers), which no longer exists. This guild had its headquarters in a building next to the church entrance that was torn down around 1820. Before leaving the church, on the right-hand

wall is an interesting polyptych depicting the *Enthroned Madonna, saints and scenes from the life of St. James* (14th century, touched up in 1756). The figure of St. Helena with the True Cross that was added by another artist in the upper panel might be proof that this work was owned by the Scuola dei Mercanti da Vino, which was founded in 1505.

424 LEFT JACOPO TINTORETTO, *BAPTISM OF CHRIST*, SAN SILVESTRO CHURCH.

424 RIGHT GIROLAMO SANTACROCE, *ST. THOMAS À BECKET ENTHRONED WITH SAINTS*.

425 LEFT JOHANN CARL LOTH, *ST. JOSEPH PRESENTING THE CHRIST CHILD TO GOD THE FATHER*.

425 RIGHT STONE-CUTTERS' ALTAR, SCUOLA DEI MERCANTI DA VINO.

■ Exiting from the church into the square, go down Calle del Luganegher until you reach **Sant'Apollinare Church**, known as **Sant'Aponal**. HISTORY: built in 1034 by the Sciavola family from Ravenna, the church was rebuilt in the 15th century and then restored in 1583.

FAÇADE: it has four buttresses surmounted by cusped Gothic shrines with statues connected by a profile with geometric patterns. The portal and windows were

altered in the 19th and 20th centuries. The bas-reliefs come from the exterior of the chancel. The 14th-century sculptural fragments above the portal may have come from a demolished altar in the church. Starting from below, the first bas-relief illustrates the *Doubting*

Thomas and the next one *The Agony in the Garden*. Under the rose window is the *Enthroned Virgin and Child*, an early 16th-century high relief, above which is a large Crucifix in relief (14th century). The figure at the foot of the cross is the

prophet Jonas, whose head was venerated in one of the church altars. The campanile, restored in the 15th century, has a trefoil belfry and an octagonal base in which many bas-reliefs and paterae (11th-15th century) were placed. The interior is not open to the public. The

building to the left of the church (no. 1252) once housed the guild of the Spezieri da Gross (spices merchants) and, from 1635 on, the **Scuola dei Tagiapiera** (sculptors and stone-cutters) as well. The *four crowned saints*, the patrons of this

latter confraternity, appear in a bas-relief on the second floor (1652). The headquarters had a small altar, now kept in San Silvestro Church. Continue along Calle de Mezo, Campiello dei Meloni, Calle de la Madonnetta and over Ponte de la Madonnetta until

you reach Campo San Polo. The farthest side of this square has a long Neo-Palladian building with a terrace built in 1840 by engineer G. BENVENUTI. The *campo* was once used as grazing and farmland, for drying the woolen cloth and other fabrics, and was also the venue for local markets and public festivities, such as the so-called bull hunts. The east side, opposite the apse of Sant'Aponal, was once crossed by a canal that was filled in 1761; it connected Rio de le Erbe, at left, with Rio de Sant'Antonio. The buildings on this side were connected to the square by private bridges. Walking along this side, you will notice **Palazzo Tiepolo-Maffetti** (no. 1957), attributed to DOMENICO ROSSI (1690 - ca. 1699). The austere composition of the façade was embellished by robust terraces with balustrades and expressive masks situated on the arches

of the first *piano nobile*. The entrance is flanked by the openings of a serliana and on its keystone is a head of Hercules covered with the Nemean lion's pelt, an obvious allusion to the power of the Maffetti family, which was admitted into the patrician class in 1654. On either side of this head were added two long modillions, whose thick volute and rinceau decoration are transformed into fantastic masks. Playful elements such as these, perhaps influenced by transalpine artists, are often to be seen in the façades of LONGHENA, with whom ROSSI served his apprenticeship as a stonecutter. The secondary façade of the palazzo can be seen from Ponte Cavalli. Farther on is **Palazzo Soranzo**, whose broad Gothic façade merges two distinct buildings (nos. 2169 and 2171). The bas-reliefs over the lintel of two of the three portals, characterized

by a central angel and two facing lionesses, date from the 14th century yet reveal distinctive features of Romanesque sculpture. The paired windows that alternate with the portals have elegant, small late 15th-century Corinthian capitals. In one of these (to the right of no. 2169) you can see that the calathus is enveloped in a labyrinth of wickerwork, a clear reference to the basket seen by Callimachus in Corinth, as narrated by Vitruvius. Undoubtedly, the oldest section of this palazzo is the one to the left. The capitals of the two four-lancet windows date from the first decades of the 14th century. The upper four-lancet window has a central patera (mid-14th century) representing Hercules fighting with the Nemean lion. The capitals of the six-lancet window at right are decorated with the fleshy foliage commonly used in the early 1400s.

428 LEFT AND 429
RIGHT G. TIEPOLO,
*VERONICA CLEANS
CHRIST'S FACE*,
DETAIL, SAN POLO
CHURCH.

428 RIGHT
G. TIEPOLO, *JESUS
CONSOLES THE
PIOUS WOMEN*.

429 LEFT
GIANDOMENICO
TIEPOLO, *JESUS
BEING UNDRESSED*.

■ Now cross the square to the apses of the **Church of San Paolo Apostolo**, commonly known as **San Polo**. At right, between the two windows of the sacristy, is a 14th-century Byzantine-influenced high relief of *The Enthroned Madonna and Child with St. Peter and St. Paul*. Above is another relief of *The Baptism of Christ* (14th century), in which two *putti* at left are holding up the Redeemer's robe. Aligned with the central apse is a Neo-Classical niche (1804) that frames a Greek marble statue of *St. Paul*, whose head and other parts were incorporated in the first half of the 15th century into a 4th-century B.C. Attic figure. At the top of the roof behind this section, standing out against the sky like a sudden apparition, is the full-length figure of an *angel* with a thurible (13th century). On the outer rear wall, at left and corresponding to the

Cappella del Santissimo Sacramento, are two high reliefs. Over a plaque on the wall dating from 1611 is an early 16th-century *Madonna and Child with Saints and Devotees*, under which two facing angels hold a garland with a coat of arms in the middle, on which is a Eucharistic chalice. Above the shrine a curtain on a semicircular baldachin (1702) opens out, revealing a slab on which is a *chalice with the standing dead Christ* in relief. The side entrance of San Polo, on the *salizada*, is highlighted by a luxurious, slightly embrasured late Gothic cornice. Before entering, note, at your left, the Corinthian façade of the Oratorio del Crocifisso and the campanile facing it (1362), over the base of which were inserted two splendid, pugnacious *lions* sculpted in the round dating from the 12th-13th century and perhaps taken from a

porch of the church.
HISTORY: San Polo is one of the oldest churches in Venice, founded in 837 by the doges Pietro Tradonico and Orso Partecipazio. The Romanesque building was rebuilt in the 15th century.
FAÇADE: this faces the canal and is now hidden by the Oratorio del Crocifisso opposite and by some houses. If you go into the nearby Corte del Cafetier, you will see the Gothic tracery rose window, with interwoven trefoil arches and irregular quatrefoils, surmounted by the bust of an *angel with a cartouche* (14th century) in high relief.
INTERIOR: basilica plan with a nave and two aisles, two apsidal chapels and a deep chancel. In 1586 the main apse was rebuilt thanks to a bequest left by Giovanni Soranzo. The nave was drastically altered by DAVID ROSSI, who inserted the twelve Ionic columns (1799-

ca. 1804). Our tour here begins from the *Oratory of the Crucifix*, whose entrance, at left, corresponds to the portal opening onto the nave. This small chamber was built sometime after 1505 to replace the Gothic atrium and to house an old icon of the crucified Jesus. Later on, thanks to Giandomenico Tiepolo, the oratory was beautified by a cycle of fourteen canvases dedicated to the *Stations of the Cross* (1747-49) on the walls and by an oval with the *Ascension of Christ* on the ceiling. The ritual of the ascent to Calvary was introduced by the Franciscans. The cycle in San Polo is the most prestigious in all the Venetian churches and, despite the contemporary 18th-century setting – necessary to involve the congregation – illustrates episodes and details from the Gospel or from medieval spiritual exercises. The artist painted different scenes

simultaneously. On high, behind a balustrade and next to Jesus, is the high priest Caiaphas, recognizable by his headdress similar to a tiara. But Jesus is wearing a white robe, the one worn by madmen and simpletons, which was imposed by Herod Antipas, tetrarch of Galilee. Below, the Judaeans are mocking the Son of God and demanding that he be condemned. And in fact, after the flagellation, Jesus appears with a crown of thorns and, in the foreground at left, a soldier is preparing the cross. During the spiritual exercises, the faithful had to visualize the scenes of the ascent to Calvary by identifying themselves with the various persons. In the fifth and sixth Stations we see Simon of Cyrene holding up the cross and Veronica about to use her veil to wipe the face of Christ. In both cases, the worshipper was invited to

become those two figures, carrying the cross and washing Jesus' face with his/her own tears. The aim of making the religious context and contents of the Via Crucis topical can be seen in the presence of Venetians in 18th-century dress in every Station. In the eighth Station, *Christ consoles the pious women*, who belong to the aristocracy and are showing the Redeemer their children. The source of the tenth Station – *Christ being undressed* – is apocryphal. In the foreground is a noble family. At left, an elderly man invites the faithful to participate in this sorrowful event; he is wearing the scarlet mantle worn by Venetian senators. Solely to achieve certain chromatic effects, Giandomenico Tiepolo does not have Jesus wear a red robe as in the other scenes, but covers him with a white tunic, already seen in the first Station.

Once out of the oratory, note, on the counterfaçade of the right aisle, the *Last Supper* (ca. 1570) by JACOPO TINTORETTO. For the first time, this artist represents the distribution of the Eucharist in the guise of bread. Jesus, with a theatrical gesture, stretches out his arms to communicate two apostles. Judas is also seated at the table, his back to the viewer and recognizable by the pouch with the pieces of silver tied to his belt. He is giving bread to a poor man, but his gesture of charity – unlike the apostle seated at right – is not sincere. TINTORETTO reminds us of the implacable judgment

pronounced by St. John (12, 6): "[...] not that he cared for the poor, but because he was a thief, and had the bag, and bare what was put therein."

On the first altar is the altarpiece by JACOPO TINTORETTO, *The Assumption of the Virgin Mary with Saints* (1576-77, signed). This work glorifies the cult of Mary as well as that of the saints, in accordance with the pronouncements of the Council of Trent in 1563. Among the saints, in the foreground we can see Veronica at right and Elizabeth of Hungary at left, whose presence is justified by the name of the probable patron of this painting, Elisabetta Soranzo. Among the other interceding saints are St. John the Evangelist, in the middle with a chalice

in his hand, flanked, on the opposite side, by St. Peter. St. Roch is recognizable by his red jacket and pilgrim's staff. Lorenzo Giustiniani, the first patriarch of Venice, is wearing a black cap.

Past the Madonna of the Rosary altar is the rear Cappella del Santissimo Sacramento, decorated with the typical motifs of this confraternity. On the walls, the canvases attributed to GIUSEPPE PORTA, known as SALVIATI (ca. 1520-ca. 1575), illustrate episodes from the Passion of Christ with the aim of exalting Holy Communion and the sacrifice of the cross. The frescoes above these, by GIOACCHINO POZZOLI (18th century), interpret episodes from the Old Testament as prefigurations of the Eucharist. In the chancel, on

430 LEFT PALMA GIOVANE, *ST. PETER SENDS ST. MARK TO EVANGELIZE AQUILEIA.*

430-431 JACOPO TINTORETTO, *LAST SUPPER.*

431 BOTTOM JACOPO TINTORETTO, *ASSUMPTION OF THE VIRGIN MARY WITH SAINTS*, DETAIL.

the sides of the high altar, note the bronze statues of *St. Paul* and *St. Anthony Abbot* by ALESSANDRO VITTORIA (1525-1608) and, along the walls, the canvases by JACOPO NEGRETTI, better known as PALMA GIOVANE (1625): at left, *Jesus Giving the Keys to St. Peter* and *St. Peter Sends St. Mark to Evangelize Aquileia*; at right, *St. Anthony Abbot, Assailed by Demons, Is Aided by Jesus* and *St. Anthony Abbot in Glory and Angels Casting Away the Demons*. The paintings concerning St. Anthony Abbot are to be related to the Scuola named after him, which had its headquarters in this church, while those concerning St. Mark might allude to a probable jurisdiction of the doges over the church. In the scene in which St. Mark is with Peter,

there is also St. Paul, the titular saint of this church, recognizable by his red robe and upraised finger as he is about to preach.

In the left aisle, between the two altars is a small chapel dedicated to St. John Nepomuk, the Bohemian saint who was beatified in 1721. In 1740, a relic of this martyr was donated to the church by Prince Frederick, the first-born son of Augustus III, king of Poland. For Nepomuk's altar, GIAMBATTISTA TIEPOLO painted *The Vow of St. John Nepomuk* (1754). In conformity with the iconographic tradition promulgated by the Jesuits, the artist depicts the prelate while he is contemplating the Crucifix and the Virgin Mary, to whom he consecrates his tongue. One

of the legends concerning this saint (who was born in 1340) says that he was martyred after refusing to violate the confessional secret. At the end of the nave, on the counterfaçade, is *St. Sylvester Baptizing the Emperor Constantine* (signed), by FRA COSIMO, also known as PAOLO PIAZZA (1557-1621). It may very well be that because of the subject that seems out of place in this church, this canvas came from San Silvestro Church.

■ Leaving the church, from Ponte San Polo you can see, at right along the canal, the tall Istrian stone of **Palazzo Corner-Mocenigo**, the construction of which was commissioned sometime after 1545 by Giovanni Corner to MICHELE SANMICHELI and was already finished in 1564. The classicizing six-story façade overlooking the canal is massive and impressive. The unusual number of water entrances (three) was due to the need to guarantee independent access to the many tenants. The two drawing rooms are illuminated by Serlianas, a type of window that was later adopted in many other Venetian palazzi.

If you turn left at the end of Calle dei Saoneri, you will reach the spot where Rio Terà dei Nomboli intersects Rio de San Polo, which offers a remarkable view of Ca' Corner-Spinelli, situated on the opposite side of the Grand Canal. Retracing your steps along Calle dei Nomboli, you will come to **Palazzo Centani** (or Zantani), with the **Casa di Carlo Goldoni**, as well as

the **Centro di Studi Teatrali**. HISTORY: this 15th-century Gothic palazzo has a courtyard (no. 2793) with a covered staircase supported by pointed arches on pillars. The simple, charming façade, which follows the course of the canal, is decorated with a four-lancet window with small inflected arches and trefoil intradoses. This was the house where Carlo Goldoni, the famous playwright who reformed comic theater, was born in 1707. MUSEUM: thanks to the initiative of Aldo Ravà, the palazzo became the headquarters of an Italian comic theater museum and, once purchased through public subscription, was donated to the city of Venice, which restored it in 1938. Since 1953 it has housed the Goldoni Museum and the above-mentioned Center of Theater Studies. FIRST FLOOR: once in the drawing room, illuminated by the Gothic four-lancet window, at right you will see the room dedicated to the life of Goldoni (1707-

93), with portraits of the Venetian playwright engraved by MARCO PITTERI and painted by ALESSANDRO LONGHI. Back in the main hall, at left is the doorway to another room given over to Goldoni, to the painter PIETRO LONGHI and to chamber theater, with *marionettes* and an *18th-century stage* brought here from the small Grimani family theater in Cannaregio.

Once out of the museum, go onto the bridge, which offers a view of the Gothic façade of the palazzo at left and, to the right of the bridge, **Ca' Bosso** (or Bosco; no. 2802). The pointed terracotta lunette (early 15th century) frames a late Gothic *bas-relief* (sometime after 1422?) with the monogram of St. Bernardino da Siena, a Eucharistic symbol dear to Franciscans. The water entrance has a horseshoe arch, on the archivolt of which are fragments of a bas-relief which may have come from the original building and which date from the 12-13th century, as do the paterae above the windows.

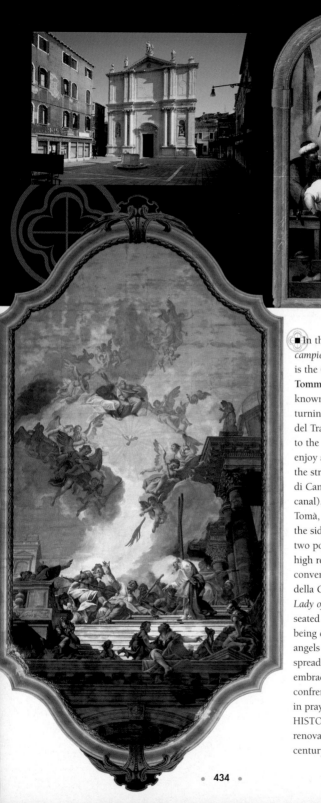

■ In the neighboring
campiello, or small square,
is the **Church of San
Tommaso Apostolo**, better
known as **San Tomà**. By
turning left toward Calle
del Traghetto, you can go
to the Grand Canal and
enjoy a wonderful view of
the stretch known as Volta
di Canal (the bend in the
canal). Returning to San
Tomà, along the façade of
the side wall, between the
two portals, you will see a
high relief from the
convent of Santa Maria
della Carità depicting *Our
Lady of Mercy* (1345?)
seated on a throne and
being crowned by two
angels while she is
spreading out her mantle to
embrace and protect the
confreres who are kneeling
in prayer before her.
HISTORY: the church,
renovated in the 14th
century and enlarged in

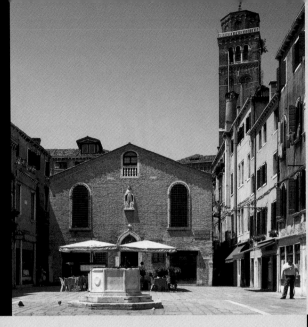

434 TOP LEFT
CAMPO AND
CHURCH OF SAN
TOMÀ.

434 BOTTOM LEFT
JACOPO GUARANA,
*MARTYRDOM OF ST.
THOMAS*, SAN
TOMÀ CHURCH.

434 RIGHT
GIOVANNI FAZIOLI,
*ST. MARK HEALING
ANIANUS*.

435 CAMPO SAN
TOMÀ AND THE
SCUOLA DEI
CALEGHERI AND
DETAIL.

1508, was entirely rebuilt in 1742. FAÇADE: built in Corinthian style by FRANCESCO BOGNOLO in 1742-1755. The group of statues on the top of the tympanum represents *Thomas' incredulity*. INTERIOR: this has an aisleless nave and six side altars; the chancel has a flat back wall. The ceiling fresco, *The Martyrdom of St. Thomas*, is by JACOPO GUARANA (1720-1808). In the second altar at right, reserved for the shoemaker's guild, GIOVANNI FAZIOLI painted *St. Mark Healing Anianus* (ca. 1789, signed). This canvas replaced another one with a similar subject painted by PALMA GIOVANE around 1593, which is now in the Accademia Galleries. The other altars have works by VINCENZO GUARANA, PIETRO TANTINI and ANTONIO ZUCCHI.

To the right of the façade of San Tomà is the fascinating Campiello del Piovan. Along the side of the church, above the door, is the sarcophagus of Giovanni Priuli (d. 1375). The image shows the senator and commander of the Republic lying on a bier, as was the custom then. At his feet is a dog, the allegory of faithfulness. The opposite side of Campo San Tomà is occupied by the **Scuola dei Calegheri e Zavatteri** (shoemakers and cobblers). This confraternity bought the building in 1446 and restored it in 1479. On that occasion PIETRO LOMBARDO sculpted the elegant bas-relief above the entrance depicting, with evident traces of color, *St. Mark Healing Ananius*. The legend relates that the evangelist broke a sandal while in Alexandria. While repairing it, the cobbler Ananius wounded his hand, which was healed by Mark. The theme of the healing of the patron saint of the cobblers allowed their guild to celebrate their trade while at the same time underscoring the link between Ananius – who later converted to Christianity and became a patriarch – with the patron saint of Venice. The high relief (mid-14th century) above the entrance, which was brought from the demolished church of Santa Maria dei Servi, illustrates *Our Lady of Mercy* receiving praying friars under her mantle.

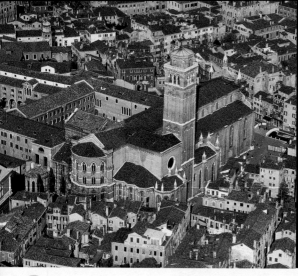

By going behind the Scuola and to the end of Calle Larga, you will reach the **Church of Santa Maria Gloriosa dei Frari**, known as the **Frari Church**.

HISTORY: in his *Superior Legend*, St. Bonaventure da Bagnoregio, a cardinal and Doctor of the Church, narrates the episode of St. Francis of Assisi (d. 1226) preaching to the birds in the Venice Lagoon. Doge Andrea Dandolo relates, in his *Chronicon Venetum* (ca. 1342), that St. Francis stopped in the city on his way back from a trip to the East. In reality, the saint went to Egypt in 1219 and this date has allowed scholars to affirm that he must have arrived in the lagoon in 1220. We know nothing else about this, but his stop in Venice certainly had an effect on the city. In fact, a few years after the pope approved the rule of St. Francis (1223), Doge Jacopo Tiepolo gave the Franciscan friars some land

where they could build a church and monastery. The property consisted of a pond known as *lacus Badovarius*, or Lake Badoer, the name of an old and prestigious Venetian family. Needless to say, the property was marshy and certainly subject to flooding. With patience, fatigue and skill, the Franciscans reclaimed the area and raised its level with fill. The first Frari (friars) church was founded around 1231. Some documents attest to its existence in 1234, together with the friars' modest residence. The edifice, perhaps made of wood and bricks, was demolished after construction of a new church, the first stone of which was laid in 1250. On that occasion the name of Santa Maria Gloriosa was used, referring to the Assumption of the Virgin Mary, an event dear to Franciscans (but proclaimed a dogma only in 1950 by Pope Pius XII). Work on the

third church, the one we see today, began with the apses a short time before the mid-1300s, and ended with the façade in 1441. This church was consecrated in 1492.

EXTERIOR and FAÇADE: the church is distinguished by its simplicity – in both the material used in the construction and the decoration. The surface of the walls and buttresses are made of terracotta reinforced in stone only at the base. The only exception to this are the Gothic aedicules, the round lintels of the rose windows, and the portals, in which the red Verona marble sometimes alternates with Istrian stone. Despite its huge size, the exterior on the whole reflects the original Franciscan ideal – derived from the Cistercians – of keeping the House of God as simple and austere as possible.

Two stylistic phases can be noted in the tall windows. The first, toward the apses, is characterized by two superimposed two-lancet

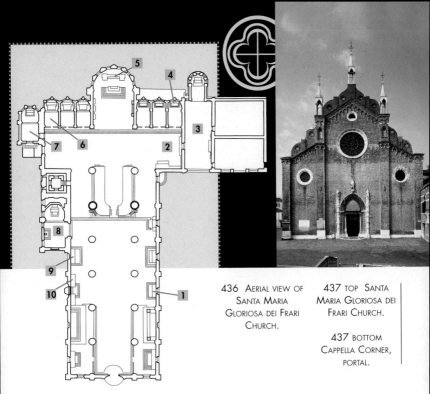

windows separated by a fascia with one or two quatrefoils with tracery. The second phase, noticeable toward the part of the side that merges with the façade, has superimposed two-lancet windows without an intermediate fascia. Along the side there are four Gothic portals that differ in workmanship and period. The main one, which affords access into the left aisle, is surmounted by a Greek marble high relief of the *enthroned Madonna and Child* (early 14th century), which may have come from the earlier Franciscan church. At the feet of Mary and Jesus are two Franciscan saints and, in the upper corners, two adoring angels.

The façade of the church is tripartite. The profiles are accompanied by a series of small blind arches. The singular crown with lobes probably dates from the second half of the 15th century. The Gothic portal with splayed fasciae is surmounted by the statue of the *Risen Christ* by

ALESSANDRO VITTORIA and the *Madonna* and *St. Francis*, attributed to BARTOLOMEO BON. The massive 230-foot (70-m) bell tower is the second tallest in Venice after the one in St. Mark's Square; it was erected by JACOPO and PIERPAOLO CELEGA in 1361-96. On the side of the bell tower that overlooks the canal are two contemporaneous works: a high relief of *St. Francis receiving the stigmata* and, above the belt course cornice, a terracotta shrine containing a statue of the *Madonna and Christ Child*. In keeping with an old custom that originated with the Benedictines, this latter sculpture is illuminated at night in order to guide the path and prayer of the passersby.

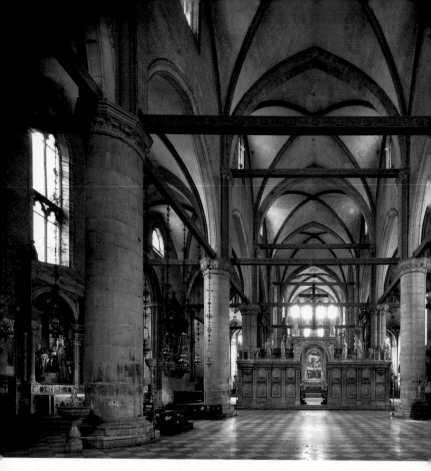

INTERIOR: the plan consists of a nave and two side aisles separated by twelve piers with cylindrical bases, octagonal abacuses and flattened capitals, decorated with clusters of leaves. The nave and aisles are connected by wooden tie beams; in the nave, at the end of each of the double beams there is a connecting pilaster strip, flanked by two ribs and surmounted by a pointed arch on which is the crossing. On the counterfaçade, above the *monuments to Alvise Pasqualigo* (1528; attributed to LORENZO BREGNO),

Girolamo Garzoni (1668) and *Pietro Bernardo* (after 1538; designed by TULLIO LOMBARDO), there are canvases by FLAMINIO FLORIAN representing the *Miracles of St. Anthony* (early 17th century). Anthony of Padua (1195-1231), a friend and disciple of St. Francis is one of the most venerated saints in the Catholic Church. The confraternity named after him moved to the Frari Church from San Simeone Profeta in 1439, and while the Venetian-controlled island of Crete was being besieged by the Turks, the Republic proclaimed

Anthony one of its patron saints (1652). RIGHT AISLE: another sign of the popularity of St. Anthony is the altar dedicated to him, the first one at right. This was finished in 1663 and is attributed to GIUSEPPE SARDI or BALDASSARE LONGHENA. It is decorated with sculpture by JUSTE LE COURT. In the second bay is the pretentious *Monument to Titian* (1838-52) by LUIGI and PIETRO ZANDOMENEGHI. In the third bay is the altar with the *Presentation in the Temple* altarpiece (ca. 1548) by GIUSEPPE PORTA (known as SALVIATI). In the upper part of

438-439 THE NAVE LOOKING TOWARD THE CHOIR.

439 TOP GIUSEPPE SALVIATI, PRESENTATION IN THE TEMPLE, DETAIL.

439 BOTTOM TITIAN, ASSUMPTION ALTARPIECE.

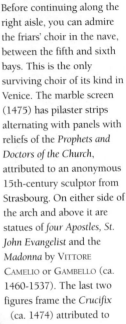

Mary, whose members were devotees of the Eucharist. In 1457, Maffeo Contarini, patriarch of Venice, granted 40 days of indulgence to those who visited the altar to worship the Signum Christi, the gilded disk above the altar mensa, framed by putti in relief. During the crucial moments of his sermons, St. Bernardino used to hold the Signum in his hand. This disk is bordered with rays and has the monogram IHS in the middle; it was used to reflect a blinding light on the congregation to produce an effect of awe.

Before continuing along the right aisle, you can admire the friars' choir in the nave, between the fifth and sixth bays. This is the only surviving choir of its kind in Venice. The marble screen (1475) has pilaster strips alternating with panels with reliefs of the *Prophets and Doctors of the Church*, attributed to an anonymous 15th-century sculptor from Strasbourg. On either side of the arch and above it are statues of *four Apostles, St. John Evangelist* and the *Madonna* by VITTORE CAMELIO or GAMBELLO (ca. 1460-1537). The last two figures frame the *Crucifix* (ca. 1474) attributed to ANDREA VERROCCHIO. This sculpture group constitutes the central theme of Franciscan thought, which views the suffering or dead Christ as the accomplishment of Man's salvation. The interior of the choir consists of three tiers of elegant late-Gothic wooden stalls (ca. 1470) carved by various artists, including MARCO and FRANCESCO COZZI.

this canvas, the Christ Child, after being circumcised, is presented to the high priest Simon. Joseph and Mary are watching at one side. An angel is holding the symbols of the Passion: the crown of thorns and the reed with the sponge soaked in vinegar. In the lower part are St. Paul, St. Helena, St. Nicholas, St. Bernardino da Siena, St. Augustine and St. Mark, whose names may also be those of some members of the Valier family, which commissioned the altarpiece. The altar was reserved for the Congregation of the Holy Name of Jesus and

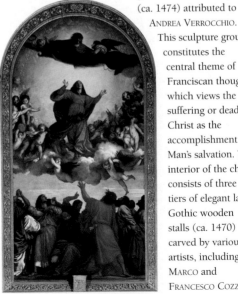

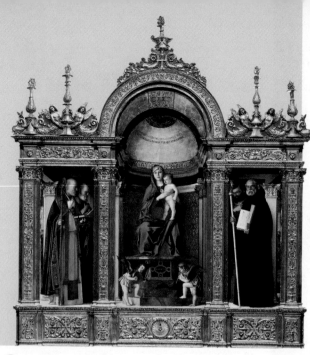

440 LEFT AND 441
GIOVANNI BELLINI,
MADONNA AND
CHILD WITH SAINTS
AND DETAIL.

440 RIGHT PAOLO
VENEZIANO,
MADONNA AND
CHILD WITH

ST. FRANCIS,
ST. ELIZABETH AND
DOGE FRANCESCO
DANDOLO AND HIS
WIFE, DETAIL.

■ Once past the altar of San Giuseppe da Copertino, with statues by ALESSANDRO VITTORIA, and the altar of St. Catherine, reserved for the guild of the Pistori (bakers), you enter the RIGHT TRANSEPT. In the middle of the back of this transept is the *Monument to Benedetto Pesaro* (ca. 1508), attributed to GIAMBATTISTA BREGNO and conceived as a triumphal arch affording access to the sacristy. This monument was built posthumously by the deceased's only son, Girolamo (1467-1550). SACRISTY: this room is filled with noteworthy art works. On the wall opposite the sacristy entrance is the *Altar of Relics* (1711), a Baroque work by FRANCESCO PENSO (known as IL CABIANCA), and ANDREA BRUSTOLON. The large high

reliefs concerning the Passion on Calvary illustrate the *Crucifixion*, *Deposition* and *Entombment* (which is in the middle). In the first scene, the figure of Mary Magdalene collecting the blood of Christ is related to the Holy Blood, the most prestigious relic in the altar, brought here from Constantinople and donated in 1480 by Melchiorre Trevisan. The apse at left houses the *Madonna and Child with Sts. Nicholas, Peter, Benedict and Mark* (1488) by GIOVANNI BELLINI, with the splendid classicizing frame carved by JACOPO DA FAENZA (signed). The theological meaning of the painting is still unclear. The inscription, which appears along the apse conch, may refer to the divine function of the Immaculate Conception,

which was approved by Pope Sixtus IV in 1478. Thanks to the skillful play of illusion between the frame and the painted perspective, this work places the viewer in an atmosphere of mysterious silence: it is one of BELLINI's greatest masterpieces. Note, at right, the imposing and austere figure of St. Benedict, whose face is surprisingly realistic. The saint is holding a Bible that is open to the page of *Sirach* that invites us to live according to the Law. In the adjacent hall of the chapter is the Monument to Doge Francesco Dandolo (1339-40), part of which consists of Paolo Veneziano's Madonna and Child Flanked by St. Francis and St. Elizabeth and by the Doge and Dogaressa (1339).

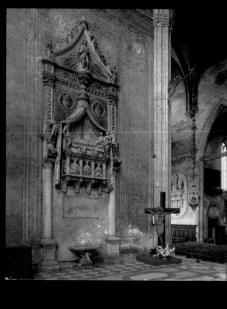

Leaving the sacristy, you can visit the *rear chapels*. The Cappella Bernardo, the first at right, is embellished with the polyptych by BARTOLOMEO VIVARINI, *Madonna and Child with St. Andrew, St. Nicholas of Bari, St. Paul and St. Peter* (1482, signed). The wooden frame with classicizing motifs is attributed to JACOPO DA FAENZA. In the upper part is the *Dead Christ*. Another moving figure of the *Dead Christ* (mid-14th century) is sculpted in bas-relief and gilded on the left pilaster and surmounted by an angel in a tympanum. After the Cappella del Santissimo Sacramento, there is the Chapel of St. John the Baptist, on the altar of which is the *statue of the saint* (1438) by DONATELLO, placed in a large wooden arched frame. This figure, sculpted for the Florentine Franciscans, is dressed in camel skin and covered with the mantle of Elijah. He is holding up his right hand in a declamatory gesture and his mouth is partly open to announce the coming of the Lamb of God, as is written in the cartouche in his left hand. CHANCEL: the high altar, attributed to LORENZO BREGNO (1416-18), is dominated by the large *Assumption* altarpiece (1516-18) by TITIAN, commissioned by Father Germano da Casale, then superior of the Inquisition in the Frari Church. This painting of Mary soaring into Heaven is the visual fulcrum of the church. The corporeal glorification of the Virgin Mary after her death became especially important in the 6th century, when the liturgical celebration of the Dormition of Mary began to gain popularity. This canvas was the first major commission that TITIAN had for a church, which he received the year of GIOVANNI BELLINI'S death. Doing away with architectural and landscape perspective, the artist introduced important compositional and iconographic innovations in his masterpiece. The Apostles, instead of witnessing the miracle in orderly, poised fashion, are gesticulating animatedly, and some are rendered with bold foreshortening and are silhouetted with the light behind them. Mary is ascending to Heaven. Her mantle is puffed up with the

divine wind that also raises her tunic, revealing, in an original way, her bare feet, the sign of the followers of Christ. Her face is that of a common woman who, however, is about to receive a crown, which is being held by an angel. Above her, the sky bursts open, and from a golden cloud there emerges God the Father in the guise of an elderly man animated by an athletic torsion.

The right wall of the chancel is dominated by the *Monument to Doge Francesco Foscari* (1457), attributed to NICOLÒ DI GIOVANNI FIORENTINO. This painting reveals certain fundamental features of the funerary architecture of the first half of the *Quattrocento*: the mixture of Gothic and classicizing elements; the image of the donor lying on the bier; the figures of angels and virtues; the canopy opened like a stage curtain (an allegory of Paradise and the curtain of the sky); the coat of arms of the patron; and lastly, the image of Christ on the crown. The left wall is occupied by the *Monument to Doge Nicolò Tron* (1473) by ANTONIO RIZZO. The architecture, with numerous

humanistic decorative motifs, reminds one of the opening of a triumphal arch whose superposed registers, consisting of niches and panels, have exquisitely wrought classical statues. The image of the doge appears twice, and the statues on the crown – almost an act of faith on the part of the deceased – illustrate the main episodes of the *Annunciation and of the Risen Christ*. Before leaving the chancel, note the late 13th-century *Crucifix* set on the pavement, a tempera on panel attributed to a painter (Umbrian or Tuscan) close to CIMABUE. This work may be the *Miraculous Christ* once in the Cappella del Crocifisso, which was removed and replaced by one in marble after the construction of the new altar.

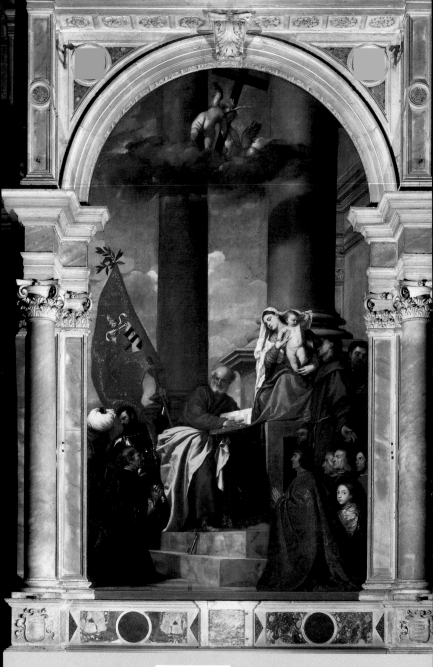

444 TOP TITIAN, *PESARO ALTARPIECE*.

444 BOTTOM AND 445 TOP LEFT MONUMENT TO DOGE GIOVANNI PESARO, DETAILS.

445 BOTTOM ALVISE VIVARINI AND MARCO BASAITI, *ST. AMBROSE ENTHRONED WITH SAINTS*.

In the first chapel to the left of the high altar, the Cappella dei Santi Francescani, BERNARDINO LICINIO painted the *Madonna and Child with Saints* altarpiece (1524, signed). In the Cappella di San Michele, the altar was conceded to the guild of Bocaleri e Scudelleri (makers and vendors of terracotta objects) in 1420. The last chapel was reserved for the Scuola dei Milanesi founded in 1361 and consisting of blacksmiths. On the altar, the altarpiece – representing

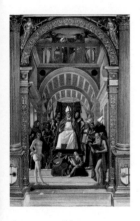

the patron of the confraternity, *St. Ambrose Enthroned with Saints* (1503) – was painted by ALVISE VIVARINI and finished by MARCO BASAITI. Here is the tomb of the great composer

Claudio Monteverdi (1567-1643). In the CAPPELLA CORNER, built in 1420 and once the property of the branch of the Piscopia family that owned salt flats in Cyprus, there is the stoup crowned by *St. John the Baptist* (ca. 1530) sculpted by JACOPO SANSOVINO, as well as the triptych by BARTOLOMEO VIVARINI, *St. Mark Enthroned with St. John the Baptist, St. Jerome, St. Paul and St. Nicholas* (1474). Now return to the transept and go down the LEFT AISLE past the entrance to the Cappella di San Pietro, with the *Monument to Bishop Pietro Miani* (1464), to visit the altar of the Immaculate Conception, reserved for the Scuola of the same name. Here is the famous altarpiece by TITIAN, *The Madonna and Child with Saints and Members of the Pesaro Family* (1519-26), better known as the *Pesaro Madonna* or *Pesaro Altarpiece*. Next to the Madonna, who is placed to the right, are St. Francis and St. Anthony of Padua. The Virgin seems to be seated on

an altar, at the foot of the steps of which is Jacopo Pesaro kneeling in prayer. He appears in the two-fold guise of defender of the Republic and of the Christian faith, since he defeated the Turks at Santa Maura in 1502 and later became bishop of Paphos. Interceding for him is St. Peter. At the top are two angels holding the cross of Christ's Passion. Heading toward the exit you will see the *Monument to Doge Giovanni Pesaro* (1660-69), designed by BALDASSARE LONGHENA and sculpted by MELCHIORRE BARTHEL and BERNARDO FALCONE. This is followed by the *Monument to Antonio Canova* (1822-27, signed) – a work by LUIGI ZANDOMENEGHI – and by the *Altar of the Crucifix* (1672), designed by BALDASSARE LONGHENA and with statues by JUSTE LE COURT. This altar, which was originally located in the opposite aisle was reserved for the prestigious Scuola della Passione, which arrived at the Frari in 1579.

CLOISTERS: because of their remarkable size they were called Ca' Granda. The first cloister, known as the "outer" cloister or Chiostro della Trinità, once housed the new chapter house as well as the present-day one, which can be reached via the sacristy. The wing opposite, now the reading room of the Archivio di Stato or State Archives, was the old "summer" refectory. In the middle of the cloister, surrounded by a portico surmounted by a balustrade and statues by FRANCESCO PENSO, known as IL CABIANCA (1712-15), there is the well made by GIOVANNI TROGNON and commissioned in 1712 by Father Antonio Pittoni. The adjacent cloister, also known as the "winter cloister" or Chiostro di Sant'Antonio, was built in the first half of the 14th century. The well, bearing a statue of St. Anthony, was commissioned in 1689 by Father Giuseppe Cesena. The cloisters also housed a library, a hospital for the friars, the Theology Faculty, the Inquisition courtroom, a cartographic workshop and a printshop. Among the people who animated the life in the Frari complex were Fra' Paolino da Venezia, professor at the Studio and author of the *Chronologia Magna* (ca. 1320), and father Vincenzo Coronelli, minister of the Franciscan Order in 1701-07, cartographer and geographer. Exiting from the side door of the Frari, among the buildings in the square is no. 3006, formerly the headquarters of the Scuola dei Mercanti di Milano e Monza (also known as the **Scuola dei Milanesi**), as well as the palazzo at no. 2999,

446 TOP THE CLOISTERS OF THE FORMER FRARI MONASTERY.

446 CENTER AND 447 CHIOSTRO DELLA TRINITÀ AND DETAIL.

446 BOTTOM PORTAL OF THE SCUOLA GRANDE DI SAN GIOVANNI EVANGELISTA.

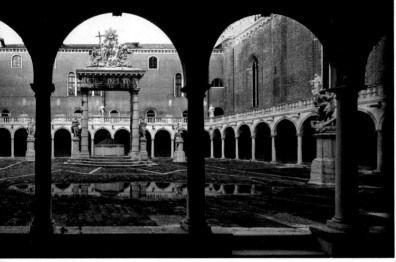

rebuilt in 1593, which housed the **Scuola della Passione** from 1572 on. Next to the façade of the Frari Church is the entrance building to the **State Archives**, built by Lorenzo Santi in the 19th century. The Archivio, which occupied the cloisters of the Frari, was founded in 1815. The itinerary continues over the bridge facing the Frari façade. With the aid of a map, go to the nearby Campiello della **Scuola Grande di San Giovanni Evangelista**. HISTORY: this confraternity was founded in 1261 at the church of Sant'Aponal and in 1307 it moved to San Giovanni Evangelist Church, situated opposite the present-day headquarters of the confraternity. After having obtained a plot of land from the Badoer family, in 1330 the Scuola began construction of a hospice for its confreres and rebuilt a hostel for women – the Badoer hospice, founded in the 13th century – reserving the upper part of the buildings for its own activities. In 1369, Filippo di Masseri (Meizières), the chancellor of the Kingdom of Jerusalem and Cyprus, donated to the Scuola an important fragment of the Cross which increased the prestige of the confraternity and the influx of worshippers. COURTYARD and FAÇADES: the small square opposite the Scuola was isolated because of the construction of a lavish enclosure with a portal designed by Pietro Lombardo in 1478-81 and restored in 1731 and 1881. The frieze bears an inscription that announces the two names of the Scuola: San Giovanni Evangelista and Santissima Croce. Once past the portal, at right you will see the entrance to the Scuola (no. 2454) and the windows of the original Gothic building. At the ends of the architrave are the figures of two kneeling confreres worshipping the pastoral staff, the official symbol of the confraternity. Above the lintel is a 14th-century bust of *St. John the Evangelist*. Along the wall at left, a high relief represents the *Confreres kneeling before St. John* (1349). This scene is crowned by another high relief executed in the same period with the bust of the *Madonna and Child*. The original of the inscription underneath this is kept in the ground floor of the building. At left, in an off-center position, the entrance and large Renaissance window, both made of polychrome marble and attributed to Mauro Codussi (d. 1504), were probably the work of the *proti* Gabriel Bianco, and Giovanni and Andrea Buora (1512).

448 Jacopo Marieschi, *St. John the Evangelist and the Book with Seven Seals, Scuola Grande di San Giovanni Evangelista.*

INTERIOR: the ground floor drawing room – with fragments of sculpture and inscriptions – communicates with the *piano nobile* by means of a double staircase conceived by Mauro Codussi (ca. 1498). The width of the frames a deep niche containing the statue of *St. John the Evangelist* sculpted by Gianmaria Morlaiter (1732-33). On either side of the statue are the entrances to the *Sala dell'Archivio* and the *Sala dell'Albergo Nuovo*, with four canvases depicting

stairs varies, but gradually increases upward in order to attenuate the inclination of the perspective and give visitors the impression that the climb is less steep. The spacious drawing room or SALONE and the adjacent chambers were thoroughly restored in 1727 - ca. 1788 under the supervision of Giorgio Massari (d. 1766) and his pupil Bernardino Maccaruzzi. At left is the *Sala della Croce*, with paintings by Francesco Maggiotto, Giovanni Segala, Gaspar Rem and others. The drawing room altar, designed by Massari,

the *Apocalypse* by Palma Giovane (1581-ca. 1584). In *The Four Horsemen of the Apocalypse* (1581), he places at left the Leviathan or ancient Serpent, the symbol of Hell in which soldiers, prostitutes and kings tumble. In the *Ten Thousand Crusaders* he portrays many confreres. The main drawing room once housed the cycle of canvases by Gentile Bellini now kept in the Accademia Galleries. At present, the walls are decorated with a cycle of canvases illustrating some episodes from the life of St. John. They were painted

from 1605 to 1760 by Jacopo Guarana, Jacopo Marieschi, Domenico Tintoretto and Sante Peranda. The remaining paintings, which were brought here from 1857 on, concern the life of Christ. *The Deposition* is by Andrea Michieli (known as Il Vicentino). The other two – *The Adoration of the Shepherds* and *The Adoration of the Magi* – are attributed to Antonio Balestra (1666-1740) and his pupil Pietro Longhi (1702-85). The canvases on the ceiling, the sole Venetian cycle entirely given over to the *Revelation of St. John*, were executed in

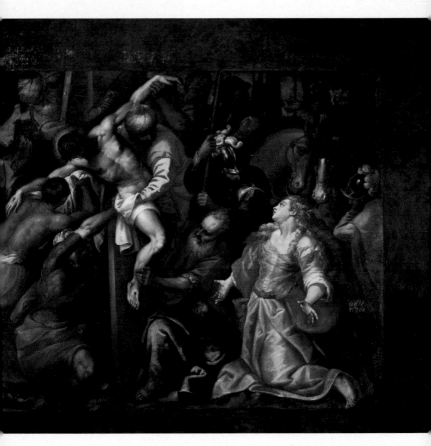

1732-62 by Edoardo Perini, Jacopo Marieschi, Gaspare Diziani, Giuseppe Angeli, Jacopo Guarana and Gian Domenico Tiepolo. In the middle of the ceiling, in an oval frame, Angeli painted a *Last Judgment*, in the lower part of which St. John, an exile in Patmos, is seated while writing the *Revelation* under divine inspiration. To the left is the resurrection of the dead and the chosen who rise to Paradise, while at right an angel shows the damned the key to the abyss. In the middle of the painting, an angel is playing the trumpet of the Last Judgment, and

above him is the triumphant Redeemer surrounded by saints and angels. While exiting from the Scuola, note above the *sotoportego* the façade of **Palazzo Badoer**, which belonged to the family of the same name. The entrance can be seen at the end of Rio Terà San Tomà. Originally, the building was quite elaborate and included one of the largest market gardens in Venice. At the end of Calle Vitalba, above the Sotoportego della Lacca, you can catch a glimpse of the new Badoer hospice (1414, inscription), which is still in operation.

448-449 Andrea Michieli (Il Vicentino), *Deposition*.

449 bottom Scuola Grande di San Giovanni Evangelista, drawing room.

450-451 JACOPO TINTORETTO, *St. Roch Captured at Montpellier*.

451 BOTTOM JACOPO TINTORETTO, *Jesus Heals the Blind, Maimed, Dumb and Lame*.

450 SAN ROCCO CHURCH AND DETAIL OF THE FACADE.

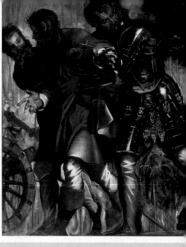

■ On the side opposite the Scuola is **San Giovanni Evangelista Church**. Founded in 970 by the Badoer family, it was entirely rebuilt in the 15th century and restored several times from the 16th century on. INTERIOR: on the nave ceiling is *St. John the Evangelist Adoring the Reliquary of the Cross*, by JACOPO MARIESCHI (1711-94). Above the entrance are the *funerary* urn and bust of Gian Andrea Badoer (d. 1566), by DANESE CATTANEO. Next are the Cappella dei Morti (now Cappella di Lourdes); the portal leading to the garden, surmounted by the *Monument to Angelo*

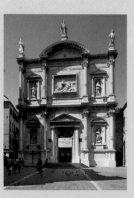

Badoer (d. 1571) by DANESE CATTANEO; the Cappella di San Giacomo (or Cappella della Croce), with a lavish late Baroque reliquary; and the sacristy, which houses an interesting 16th-century *Crucifixion* attributed to FRANCESCO MONEMEZZANO or LAMBERTO SUSTRIS. Back in the church, next to the sacristy entrance is a small altar with the *Coronation of the Madonna and Angel Musicians* altarpiece by ANDREA MICHIELI, known as IL VICENTINO (ca. 1539-ca. 1614), commissioned by the Badoer family. The Gothic chancel (first half of the 15th century) has fresco decoration, gilded bas-reliefs and, on the walls, two canvases with Eucharistic motifs. At right, the *Crucifixion* (1626, signed and dated), by DOMENICO TINTORETTO, at left *The Last Supper* by JACOPO MARIESCHI. On the altar, *St. John the Evangelist Writing the Revelation* by PIETRO LIBERI (1614-87). As you leave the chancel, at right you will see the small chapel of Giovanni

Matteo Badoer, which has a little altar. In order to follow the itinerary, you must now retrace your steps to the apses of the Frari church, next to which is Campo San Rocco. On the shorter side of the *campo* is **San Rocco Church**. HISTORY: the Scuola di San Rocco gained ownership of the body of its patron saint in 1485 and asked BARTOLOMEO BON to build a new church and its first headquarters (known as La Scoletta) at the right of the present-day façade (no. 3052). The bulk of the construction work went on from 1489 to 1508. The building was rebuilt in the 18th century and the side entrance is one of the few remaining parts of the original church. FAÇADE: this was rebuilt in 1765-71 by BERNARDINO MACCARUZZI so as to mirror the façade of the Scuola di San Rocco at its left. The fluted columns on pedestals are Corinthian and composite. Along the central axis is the glorification of the patron saint of the church, while on the sides the Venetian Church is exalted.

In fact, above the lunette-shaped tympanum is a statue of St. Roch. In the registers beneath this there are reliefs of *St. Roch Healing the Plague-stricken* by GIAN MARIA MORLAITER and *The Glory of St. Roch*, a bronze copy of the stone original sculpted by GIOVANNI MARCHIORI (1743, signed). Starting from above left, the statues by MARCHIORI and MORLAITER represent the saints Girolamo Emiliani, Pietro Acotanto, Lorenzo Giustiniani, Gregorio Barbarigo, Gerardo Sagredo and Pietro Orseolo.
INTERIOR: this was rebuilt from 1725 on by GIOVANNI SCALFAROTTO, who utilized the old rear chapels and the cupola. The most prestigious paintings in this church are dedicated to St. Roch. The two canvas on the counterfaçade (1582-86), painted by JACOPO TINTORETTO and taken from the wings of an organ that was destroyed, represent *St. Roch Introduced to the Pope* (Urban V) at right, and the *Annunciation*, which was touched up quite a lot by SANTO PIATTI in 1738. Once past the first altar at right, you will find the so-called *Probatic Pond* or *Pool of Bethesda* (1559) by TINTORETTO, which, however, does not illustrate the episode narrated by St. Mark (2, 1-12), but the miracles of Jesus on the shore of Sea of Galilee. Thus, the correct title of this painting should be *Jesus Healing the Blind, Maimed, Dumb and Lame*, according to St. Matthew (15, 30-31), who is portrayed here with a white beard next to Christ who is healing a woman. Above this canvas is one in which TINTORETTO depicts the saint's incarceration: *St. Roch Captured at Montpellier* (1580-85). The saint, who returned to his native city while it was being besieged by the King of France, was mistaken for a spy and taken to prison, as can be seen in the left side of the picture.

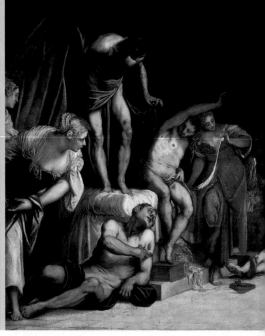

The most touching and familiar scenes of St. Roch were painted by TINTORETTO in the four canvases in the chancel. On the right wall, below, is one of the first nocturnal scenes in Venetian painting, *St. Roch Healing the Plague-stricken* (1549); Roch, while traveling to Rome, stopped in the Latium village of Acquapendente, which was suffering from an epidemic of the plague. He went to the hospital where the poorest victims were, aiding and healing them through the sign of the Cross. St. Roch seems to be slashing through the horrendous darkness of the hospital, of poverty and of the plague with his sanctity. The saint, who is

healing a young man who is showing him a bubo on his thigh, has the typical symbols of pilgrims: the staff on which he is leaning, the pilgrim's mantelet and scallop-shell, the ancient emblem of the traveling devotees of St. James heading for Santiago de Compostela. Above this canvas is *St. Roch Praying in the Forest* (ca. 1580; with additions at the sides by SANTO PIATTI, 1729), in which the saint is isolated in a forest near Piacenza while praying to be cured of the plague. Here the landscape was painted by a pupil of Tintoretto's, PAOLO FIAMMINGO. Roch's faith is rewarded and he is healed and helped by a small dog with a loaf of

bread in its mouth for him to eat. On the other wall, below, is another masterpiece by TINTORETTO – the poet of the oppressed and humble – *The Dying St. Roch in Prison Invoking the Lord* (1567). Suspected of espionage, he is imprisoned in Montpellier. The prison, like the hospital, is a place filled with suffering, as dark as the kingdom of the damned. Through the grating of a well emerges the head of a young man with only one eye and without one hand. The saint, lying on a humble bed and being aided by two old men, entrusts his soul to God, while an angel, in a blaze of light and color, announces his death and imminent glory

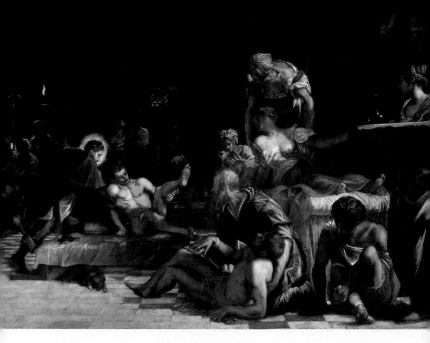

452 LEFT J. TINTORETTO AND
PAOLO FIAMMINGO, *ST. ROCH
PRAYING IN THE FOREST, DETAILS.*

452-453 JACOPO
TINTORETTO, *ST. ROCH HEALING
THE PLAGUE-STRICKEN.*

453 BOTTOM JACOPO
TINTORETTO, *THE DYING ST. ROCH
IN PRISON INVOKING THE LORD.*

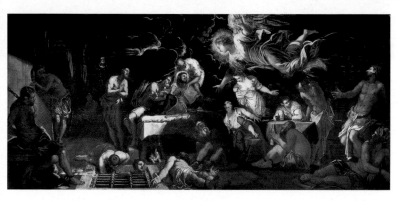

in Heaven. Farther up is another canvas, *St. Roch Healing the Animals and the Needy* (1567). TINTORETTO, together with an assistant, concentrates here on the charity of the saint who heals everyone, even wild animals. Behind them are the needy. St. Roch, imitating Jesus, heals the multitude. These paintings are a perfect frame for the elegant high altar – the work of VENTURINO FANTONI from Bergamo and assistants (1571-24) – where the body of St. Roch is kept; it was stolen by the confreres in 1485 and placed here in 1520. Besides the sacristy, you should also see the works by PORDENONE, SEBASTIANO RICCI, GIUSEPPE ANGELI and GIOVANNI MARCHIORI.

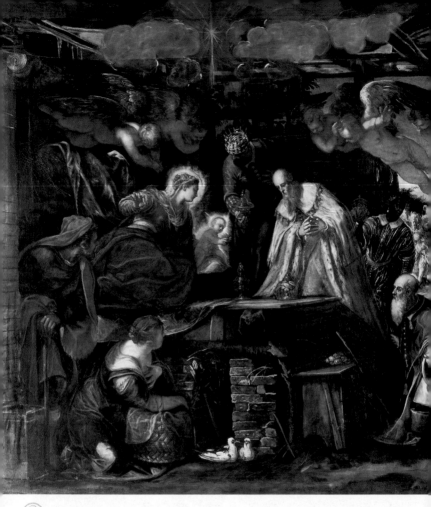

■ To the right of the church as you leave is the **Scuola Grande di San Rocco**. HISTORY: this confraternity founded in 1478 originated from the fusion of earlier confraternities in the San Zulian and Frari churches. Until 1486, the Scuola, famous for its aid to the poor, the ill and the plague-stricken, was housed in the former residence of the patriarch of Grado, next to San Silvestro Church. Once the Scuola had the remains of St. Roch (1485), the confreres first set about

building the church and the *scoletta* or little Scuola, and then, with the increasing number of members, began to build a new, prestigious home. The construction work, marked by disputes, second thoughts and wrangles with the construction yard supervisors, lasted from 1516 to about 1560. FAÇADE: the triumphal façade is a declaration of the desire to vie with the other Scuole Grandi in Venice in both architecture and prestige. With this in mind, the Scuola

summoned Bartolomeo Bon to supervise the construction. The ground floor was built in 1516-42, characterized by two-lancet windows with an oculus, modeled after those by Codussi in the nearby Scuola di San Giovanni Evangelista. In 1524-26, the *proto* Sante Lombardo built the back façade along the Rio de la Frescada, while his son Tullio did the decoration. In 1527, the work was passed on to Antonio Abbondi (known as Scarpagnino), who completed the main façade and the portal with its

454-455 JACOPO TINTORETTO, *ADORATION OF THE MAGI, SCUOLA GRANDE DI SAN ROCCO.*

455 TOP LEFT AND 455 BOTTOM JACOPO TINTORETTO, *ANNUNCIATION* AND DETAIL.

455 TOP RIGHT SCUOLA GRANDE DI SAN ROCCO, ENTRANCE FACADE.

rounded off corners, and introduced the double row of columns. After his death in 1549, he was replaced by GIANGIACOMO DEI GRIGI, who was fired in 1560.

The contribution made by SCARPAGNINO was decisive. The two series of four Corinthian columns delimit the two halls and impart a new triumphant tone to the façade. Among the small coffers sculpted on the lower face of the lintel, there are two with the initials IHS and SR, or Jesus the Savior and St. Roch, the two central figures

of the centuries-old religiosity of the Scuola. INTERIOR: the SALONE INFERIORE (Lower Hall), built by BARTOLOMEO BON, is modeled after the hall in the Scuola di San Marco. It consists of three aisles separated by Corinthian columns on tall octagonal bases and a beam ceiling. Along the walls there are eight large canvases that JACOPO TINTORETTO painted from 1581 to 1587, dedicated to the infancy of Jesus and the life of the Virgin Mary. With this cycle, the artist completed his vast

and extraordinary decoration of the interior of the Scuola, which he had begun in 1564. The first canvas, set at the beginning of the left aisle, is the *Annunciation*. A row of angels fly in the wake of the luminous flight of the Holy Ghost dove, which is majestically indicated by the Archangel Gabriel. Proceeding along the wall, the next work is *The Adoration of the Magi*. In *The Flight into Egypt* the main character is the landscape, represented with surprisingly rapid brushstrokes and great skill.

456 TOP TITIAN
AND ASSISTANTS,
ANNUNCIATION.

457 TOP JACOPO
TINTORETTO,
MASSACRE OF THE
INNOCENTS.

457 BOTTOM
CHRIST CARRYING
THE CROSS.

456 BOTTOM
MONUMENTAL
STAIRCASE.

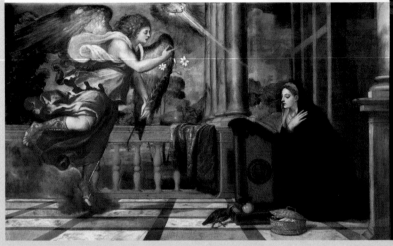

In *Massacre of the Innocents* the artist draws inspiration from RAPHAEL'S *The Fire in the Borgo,* in the Vatican, but also resumes the experiments with space and light he had made in *St. Roch Healing the Plague-stricken* in the church of San Rocco. This *Massacre of the Innocents* painted in the Renaissance by Tintoretto is one of the most cruel and innovative. We must bear in mind that the image of the bare-breasted Madonna and Child is one of the favorites of this artist, since it stands for Charity. In *The Massacre of the Innocents* at the Scuola di San Rocco, not only the infants, but also their mothers are massacred. In the background are two women. One, in a stream, is lifting a child toward the other on the bank. Probably the artist wanted to refer to the rescue of the young St.

John the Baptist. The last canvas, along the opposite, right aisle, depicts two women saints reading in the forest. They are traditionally identified as *St. Mary Magdalene* and *St. Mary of Egypt,* but there is no iconographic detail that corroborates this interpretation. The two women are dressed alike and look alike; what is different is the landscape. Therefore, it may well be that this is only one person. Continuing along the right aisle, we come to the *Circumcision of Jesus* and the *Assumption of the Virgin Mary.* Both canvases show the rather large-scale contribution of the artist's workshop, particular of DOMENICO TINTORETTO, his son and pupil. The MAJESTIC STAIRCASE was designed by SCARPAGNINO and built in 1544-58. The

paintings along the last flight are given over to the theme of the plague and the infirm. At right is *The Virgin Appears before the Plague Victims* (1666) by ANTONIO ZANCHI; in *Venice and St. Mark, St. Roch and St. Sebastian Invoke Divine Aid against the Plague* (1673), PIETRO NEGRI refers to the pestilence of 1630 and depicts the Salute Church. On the cupola, GIROLAMO PELLEGRINI (17th century) frescoed *St. Roch Presents the Poor Infirm to Charity*. SALA GRANDE, or upper hall: the wooden benches around the hall, by FRANCESCO PIANTA IL GIOVANE (1665 - ca. 1670), have allegorical figures, including a caricature of Tintoretto. On the right wall are an altar by FRANCESCO DI BERNARDINO; statues of *St. John the Baptist* and *St. Sebastian* by GIROLAMO

CAMPAGNA; an altarpiece by JACOPO TINTORETTO and assistants, *The Glorification of St. Roch* (ca. 1588); wooden reliefs illustrating *Episodes from the life of St. Roch* by GIOVANNI MARCHIORI (1743, signed). In front of the altar are some masterpieces by GIAMBATTISTA TIEPOLO, and JACOPO and DOMENICO TINTORETTO and others. Among these, note at left the *Annunciation* by TITIAN and

assistants (1542-43) and *Christ Carrying the Cross* (ca. 1510), attributed to GIORGIONE. This latter work was considered miraculous and was kept in the church of San Rocco. One of the tormentors is approaching Christ to tie a rope around his neck. This episode marks the beginning of the Via Crucis and anticipates the first words of Christ, when he praised the Cross.

This hall houses one of the most extraordinary cycles in Venetian painting. JACOPO TINTORETTO began from the ceiling with scenes and figures from the Old Testament, works executed in 1575-81 (the rhomboid

Serpent (1575-76), a prototype of the Crucifixion. On either side, along the central axis, are *Moses Striking the Rock* and, toward the altar, *Gathering the Manna*, both executed in 1576-77. The former canvas

panels were redone by GIUSEPPE ANGELI in 1778), and then worked on the canvases placed on the walls (1578-81) whose subject was the life of Jesus. The program was in keeping with the religious spirit inspired by the principles of the Counter-Reformation, exalting baptism, the Eucharist and the virtues of charity, which was also the aim of the Scuola. The Old Testament themes on the ceiling were echoed by the New Testament ones in the canvases, hence the apparent chronological confusion of these latter. In the middle of the ceiling is *The Brazen*

anticipates baptism, the latter the Eucharist. The cycle of canvases begins on the wall opposite the grand staircase, at left, with *Adoration of the Shepherds*. Mary is lifting the veil covering the Child to show his human, as well as divine, nature. In *The Baptism of Christ* Jesus is kneeling humbly to receive the Holy Ghost. In the background is a sketchy depiction of the Virgin swooning during the Passion. Like Christ on the cross, Christians, through baptism, die and attain new life. This canvas is followed by *The Resurrection*. This episode skips over others in

the life of Christ, but is justified by the scenes on the ceiling: *Ezekiel's Vision of the Resurrection* and the already-mentioned *Brazen Serpent*. Continuing toward the right, you next see *The Agony in the Garden*. Drawing inspiration from St. Luke's Gospel, TINTORETTO paints Christ's perspiration as drops of blood, and by means of the angel displaying the chalice, he reasserts the Eucharistic implications of this episode. *The Last Supper* is related to the scenes on the ceiling of the manna and the Passover. Among the canvases on the opposite wall, mention should be made of *The Pool*

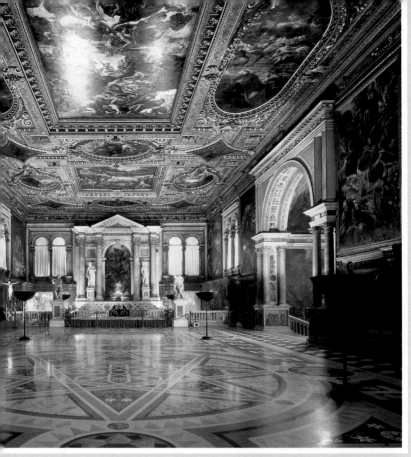

of Bethesda, at right, as a fine example of how the Gospel was interpreted by the Scuola. In the foreground, the paralytic healed by Jesus is moving off with his pallet. The Redeemer is healing a girl with the plague. Other women bear signs of syphilis and, in the background, there is a crowded Venetian brothel. Thus, the eternal vices are associated with the modern scourge of venereal diseases. Evangelical narration is superimposed on reality. The Messiah manifests himself in the present and saves – like the brazen serpent held up by Moses – those who believe in him.

458 TOP AND **459** BOTTOM JACOPO TINTORETTO, *THE BRAZEN SERPENT* AND DETAIL.

458 BOTTOM JACOPO TINTORETTO, *POOL OF BETHESDA*.

458-459 SCUOLA GRANDE DI SAN ROCCO, UPPER HALL.

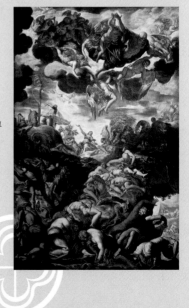

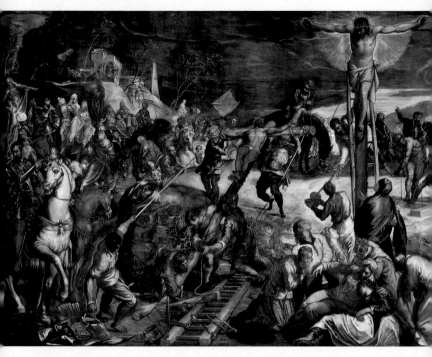

To the right of this canvas is the entrance to the SALA DELL'ALBERGO: the oval in the middle of the ceiling, *St. Roch in Glory* (1564), is the first painting TINTORETTO did for the Scuola. Besides the allegorical figures set around this canvas, the artist also painted the canvases on the walls. The large *Crucifixion* is one of his masterpieces and can be considered the most spectacular image of the cult of the Cross in Venice. Like a skillful stage director, Tintoretto illustrates in the middle of the scene the epilogue of the drama of Calvary: it is the sixth hour, when the earth is covered with darkness. The Mother of God lies on the ground as if dead. A soldier holds out

the sponge soaked in vinegar; and the Son of Man, with his head bent, dies. Suddenly a solar light, the symbol of victory, radiates from his body. At his side and in the background, in a space created by crossing diagonals, are the crowd and the guards preparing the other crosses with the two thieves. Among the paintings on the entrance wall, the *Ascent to Calvary*, to the right as you enter, has a special iconographical scheme. The cross weighing heavily on the shoulders of Christ is held up by Simon of Cyrene as well as another person. In the Sala dell'Albergo, the observer is urged to take part in the ascent: the Gospel becomes

a sort of miracle play, an invitation to participate directly in the Passion, according to the words narrated by St. Matthew: "If any man will come after me, let him deny himself, and take up his cross, and follow me." This exhortation seems to have been embraced in all its significance in this work; in fact, two other persons are holding up the crosses of the thieves. The idea of piety and compassion manifested at the Scuola Grande di San Rocco thus takes on a universal character and cannot but evoke, in one of the noblest and most eloquent of forms, the religious sentiment and charitable spirit of the Scuola's members.

460-461 Jacopo
Tintoretto,
Crucifixion.

461 top and
bottom Jacopo
Tintoretto, *St. Roch
in Glory* and detail.

461 center
Jacopo Tintoretto,
Ascent to Calvary.

462 TOP AND 463 TOP LEFT JOHANN LISS, *ST. JEROME INSPIRED BY THE ANGEL*, AND DETAIL, TOLENTINI CHURCH.

462 BOTTOM, 463 TOP RIGHT AND BOTTOM FAÇADE AND INTERIOR OF THE TOLENTINI CHURCH.

■ When you leave the Scuola, proceed left and, with the help of a map, go to Ponte delle Sechere, where you leave the San Polo district and enter Santa Croce. At the end of Calle de Ca' Amai, at left, is the entrance of the **Istituto Universitario di Architettura di Venezia** (Faculty of Architecture, or IUAV), designed by CARLO SCARPA in 1972 and built by SERGIO LOS in 1984-85. The tripartite façade is foreign to Venetian architectural tradition and creates an unexpected sensation of separation from the city. The sliding glass gate, weighed down with a panel of Istrian stone, and the protruding marquee, only accentuate the deliberately conceived formal incongruities of this façade. The courtyard is more interesting and well balanced, and warmth is imparted by the use of terracotta flooring and the poetic invention of the basin. Its profiles are nothing more or less than the Istrian stone cornice of a door from the refectory in the convent where the Faculty is located. Next to this entrance is the **church of San Nicolò di Tolentino**, better known as **Tolentini**. HISTORY: the regular clergymen of San Gaetano da Thiene (St.

Cajetan), known as the Theatines, whose order was founded in Rome in 1524, obtained an oratory from the San Nicolò da Tolentino confraternity (1528) that in 1591 was converted into a church and adjoining convent. The Theatines – among whom were Cajetan himself, Giovanni Pietro Caraffa, who became Pope Paul IV, and the beatified Venetian Giovanni Marinoni

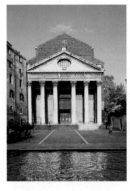

– distinguished themselves by helping the infirm. The design of the church was entrusted to VINCENZO SCAMOZZI, who in 1595 abandoned the project because of disagreements with the Theatines, who were responsible for the difference between the original design and the church we see today. The Tolentini Church was consecrated in 1602.

FAÇADE: the porch was built by ANDREA TIRALI in 1706-14. The six Corinthian columns support a tympanum with an undecorated frieze and ovate window. INTERIOR: this was planned in conformity with the principles laid down by the Council of Trent. It consists of an aisleless nave with a barrel vault and three chapels on each side. At the ends of the transept are two large chapels with altars that are a sort of frame for the chancel, behind which is the choir. On the main crossing is a cupola, which is hidden on the exterior by a tambour with a conical cover. The stucco and fresco decoration and the altars date mostly from the 17th and 18th century. In that same period many paintings were executed by artists such as GAETANO ZOMPINI, PALMA GIOVANE, SANTE PERANDA, GIROLAMO FORABOSCO, LATTANZIO QUERENA, the Frenchman NICOLAS REGNIER, the German JOHANN LISS, and BERNARDO STROZZI. In the chancel is the high altar by BALDASSARE LONGHENA (1672), with statues by JUSTE LE COURT, while on the left wall is the *Monument to the patriarch Francesco Morosini* (d. 1678), a Baroque work by FILIPPO PARODI that betrays the influence of BERNINI.

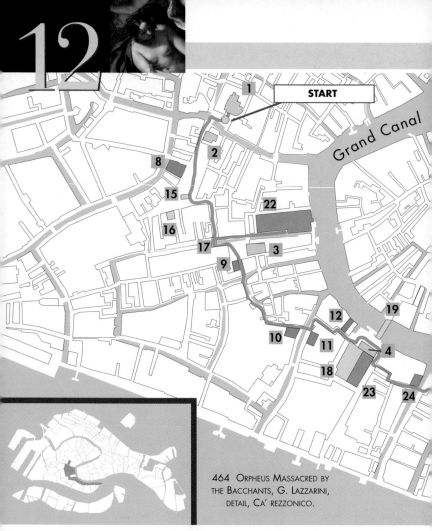

464 ORPHEUS MASSACRED BY
THE BACCHANTS, G. LAZZARINI,
DETAIL, CA' REZZONICO.

T he various sites in
this itinerary lie in the
inner part of the Dorsoduro
sestiere that are located along
the canals and *calli* leading
to the Grand Canal. The first
area on this tour extends
through Santa Margherita
and San Barnaba squares.
The former *campo* in
particular owes its
construction and
commercial success to its
role as a link between the
Mendicoli island – famous
for fishing – and the nearby

traffic thoroughfare of the
Grand Canal. This zone and
those around it witnessed
the construction of old
Veneto-Byzantine palazzi
and warehouses, remains of
which can still be seen in
some buildings on the Rio di
Ca' Foscari (no. 3367) and
in the Corte del Fontego
(no. 3425). The second area
of the itinerary was the
home of three major, old
monastery complexes: Santa
Maria della Carità Church,
the Abbey of San Gregorio

and, toward the tip of the
Dogana da Mar, the Umiltà
and Trinità churches, which
were demolished or
incorporated to make room
for the Basilica della Salute
and its monastery. During
the 19th century these
religious structures
underwent alterations. Now,
starting off from Campo San
Barnaba, the route that links
them includes one of the
city's museum areas, second
in importance only to St.
Mark's.

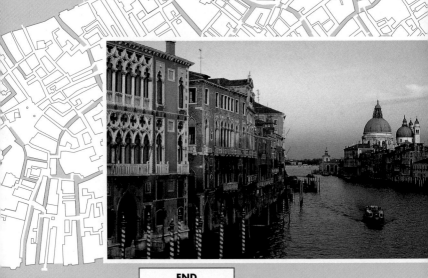

END

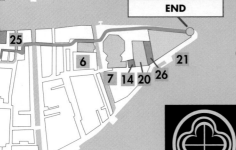

465 TOP THE
GRAND CANAL
AND SALUTE
BASILICA.

465 BOTTOM THE
FORMER DOGANA
DA MAR AND THE
SALUTE BASILICA.

▸ MAIN SIGHTS

● **SESTIERE (district):** Dorsoduro.
● **CHURCHES:** [1] San Pantalon;
[2] Santa Margherita; [3] San Barnaba;
[4] Santa Maria della Carità;
[5] Anglicana di San Giorgio;
[6] San Gregorio;
[7] Basilica della Salute.
● **PALAZZI:** [8] Ca' Foscolo-Corner;
[9] Casin dei Nobili; [10] Bollani;
[11] Basadonna-Giustinian;
[12] Gambara; [13] Ca' Venier dei
Leoni; [14] Seminario.
● **OTHER MONUMENTS:** [15]

Scuola dei Varoteri; [16] Ospizio
Scrovegni; [17] Ponte dei Pugni;
[18] Scuola della Carità;
[19] Ponte de l'Accademia;
[20] Oratorio della Santissima Trinità;
[21] Dogana da Mar.
● **MUSEUMS:** [22] M. del Settecento
Veneziano (Ca' Rezzonico);
[23] Gallerie dell'Accademia;
[24] Galleria d'Arte di Palazzo Cini;
[25] Collezione Peggy Guggenheim;
[26] Raccolta lapidaria e Pinacoteca
Manfrediniana (Palazzo del Seminario).

■ Along the Rio de Ca' Foscari is the tall San Pantaleone Church, commonly called **San Pantalon**. HISTORY: the present-day church was rebuilt in 1667–ca. 1680 to a design by FRANCESCO COMIN. The campanile was built in 1732 by BARTOLOMEO SCALFAROTTO. INTERIOR: an aisleless nave with six side chapels that alternate with massive composite half-columns on pedestals. The second chapel is dedicated to the titular, St. Pantaleon, who was known for his knowledge of medicine and miracle-working powers. In the chapel altar, PAOLO VERONESE painted *St. Pantaleon Healing a Boy* (1588). The third chapel, dedicated to San Bernardino da Siena, once belonged to the guild of the Laneri (wool workers and vendors). The chancel is dominated by the monumental Baroque tower altar by GIUSEPPE SARDI (1668-71), with four statues by TOMMASO RUER. The evangelical subjects of the canvases on the walls are connected to the theme of the Eucharistic supper and of charity. At left, *The Multiplication of the Loaves and Fish* (1693) by ANTONIO MOLINARI and to the right, *The Pool of Bethesda* (1684-87) by the Parisian artist LOUIS CHERON. *The Triumph*

of the Eucharist and *Jesus in the House of Martha and Mary*, both by GIOVAN ANTONIO FUMIANI (late 17th century). To the left of the chancel is the Cappella del Sacro Chiodo, which boasts precious works of art: three panel paintings by PAOLO VENEZIANO dedicated to the life of Mary. This chapel also has a small Venetian school altar (1380-90); *Coronation of the Virgin* (1444) by ANTONIO VIVARINI and GIOVANNI D'ALEMAGNA.

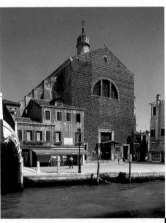

You should ask the custodian to let you visit the Oratory of the Madonna of Loreto (1734). CEILING: *Martyrdom and Glory of St. Pantaleon* (1684-1704) by GIOVAN ANTONIO FUMIANI is the largest canvas painting in the world. This work measures about 443 square meters and consists of 40 canvases sewn together. The scene opens with an

extraordinary perspective that reveals a strong preference for theatrical Baroque with the aim of eliciting astonishment and awe in the onlooker.
The painting begins from the spandrels between the large windows, in which the Apostles are depicted, with the theological and cardinal virtues in the corners.
The space overflows with figures.
Among these – at left, with your back to the entrance – is the young St. Pantaleon, covered with a white sheet and, on the opposite side, the Emperor Diocletian, with a red chlamys and scepter in his hand, who is ordering the saint's martyrdom.

466 AND 467 BOTTOM PAOLO VERONESE, *ST. PANTALEON HEALING A BOY*, SAN PANTALON CHURCH.

467 TOP SAN PANTALON CHURCH.

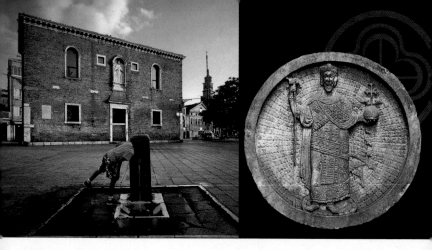

■In the nearby Campiello de Ca' Angaran, between the two doors of nos. 3717 and 3718, there is a fine Greek marble roundel of a Byzantine emperor (Constantinople, late 12th century). Heading back toward San Pantalon, once over the bridge you are at the former church of **Santa Margherita**. Founded in the 9th century and one of the oldest in Venice it was entirely rebuilt in 1687 by the architect GIAMBATTISTA LAMBRANZI. Once you are in Campo Santa Margherita – one of the most fascinating squares in Venice – you will see, along the side flanking the church, the building that housed the devotional confraternities of Santa Margherita and the Santissimo Sacramento. The niche on the third floor (no. 3429/B) has a statue of St. Margaret and the dragon. The arms of this late 15th-century and the dragon were added in the 17th century. The virgin of Antioch, devoured and then vomited by Satan

– who had appeared to her in the guise of a dragon – was invoked by women about to give birth. Walking along the right side of the square, you can admire **Ca' Foscolo-Corner** (no. 2931), the entrance of which is surmounted by a finely decorated terracotta arch and lunette and in the middle of which is the coat of arms of the Corner family (first half of the 14th century). The nearby building that stands in an isolated position in the *campo* once housed the **Scuola dei Varoteri** (tanners and fur vendors), whose members were devotees of the Virgin Mary and St. Elizabeth. This guild, the first documentation of which dates from 1271, established its headquarters here in 1725. The bas-relief ornamenting the façade comes from the guild's earlier headquarters in Cannaregio (at the church of Santa Maria dei Crociferi, which no longer exists) and portrays Our

Lady of Mercy (1501). Not far away is the **Ospizio Scrovegni** (no. 3041), a hospice still in operation that was founded thanks to a bequest from the Paduan Maddalena degli Scrovegni (d. 1428) and then rebuilt in 1762. Continue to your left along the Rio Terà Canal and, in line with the Ponte dei Pugni, turn left again and go down to the end of the *fondamenta*. No. 3139 was the house of the painter Teodoro Wolf Ferrari (1878-1970).

■At the end of the *fondamenta* is **Ca' Rezzonico**, home of the **Museo del Settecento Veneziano** (Museum of Eighteenth-century Venice, no. 3136). HISTORY: in 1667, the procurator Filippo Bon asked BALDASSARE LONGHENA, a pupil of SCAMOZZI, to design the palazzo. In 1682, when the famous Venetian architect died, the building had not yet been finished. Work proceeded slowly under the supervision of ANTONIO

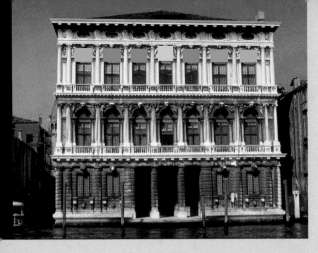

GASPARI until the palazzo was purchased by Giambattista Rezzonico in 1750 and was finally finished by GIORGIO MASSARI in 1752-58. This latter architect also designed the grand staircase (the banister has two charming putti – Winter and Autumn – by JUSTE LE COURT) and the ballroom. Once past the majestic Doric order land entranceway, to your left you will see a garden (now used as an epigraphic museum) and an elegant apsidal basin above which stands the enormous coat of arms of the Rezzonico family. At right, after going by a short portico-vestibule, there is the *portego*, which leads to the Grand Canal. This long hall, supported by massive Doric columns, is illuminated by the soft light coming from a large central courtyard. The palazzo changed owners several times and unfortunately most of its precious furnishings have

been lost. Among the illustrious persons who lived there was the English poet Robert Browning (1812-89). In 1935 the palazzo was purchased by the city of Venice.
FAÇADE: unlike the Ca' Pesaro façade, this one designed by LONGHENA offers no major innovations and drew inspiration from the Renaissance Palazzo Corner della Ca' Grande designed by SANSOVINO. However, the first two stories of Ca' Rezzonico are impressive for the marked plastic quality of the architectural elements and sculptural decoration. The intention of imparting a strong pictorial and decorative imprint on the façade is evident right from the ground floor, along which are columns and pilasters in a sophisticated combination of the Doric and rusticated column, with an egg-shaped echinus. MASSARI, on the other hand, built the second, Corinthian-order floor and the mezzanine

with small ovate windows alternating with the characteristic small fluted pilasters in the shape of an overturned obelisk trunk.
MUSEUM: this was opened in 1936 by the city government.
COLLECTIONS: furnishings, paintings and some of the frescoes from private bequests to the Musei Civici (civic museums) or purchased by the city under the supervision of Nino Barbantini and Giulio Lorenzetti. In 2001 the prestigious Martini Picture Gallery was opened to the public, and in 2002 the Mestrovich Collection.

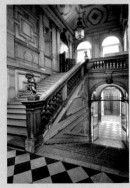

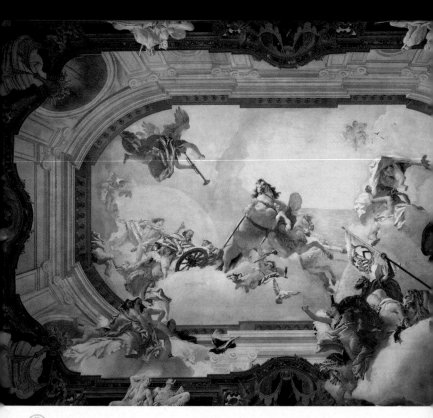

■ Go up the staircase to get to the FIRST FLOOR.
Ballroom (I): this is the largest private room in Venice, reserved for special occasions. The elegant triumphal arch framing the entrance, which may be attributed to MASSARI, has composite capitals and smooth shafts with a decorated ring at the level of the entasis. The frescoes illustrating majestic architectural members along the walls – in which the pattern of the composite capitals on the entrance is repeated – and on the ceiling are by PIETRO VISCONTI, while *Apollo's Chariot* on the ceiling is the work of GIOVAN

BATTISTA CROSATO. The young god is depicted in the guise of Phoebus, the god of light, and is to be interpreted as an emblem of civil concord, musical harmony and the aspiration for perfection through wisdom. His mission is universal, as can be seen by the allegories of the four continents along the molding of the fresco. At the foot of the god is Europe incarnated by Religion, next to which is the model of a round church. The figure of Apollo, the episodes from his life illustrated in the monochromes, and the other images of pagan divinities, all celebrate the virtues of the Rezzonico family, whose

large painted coat of arms seems to be floating in the air on the wall opposite the entrance. Continuing to your right, you enter the *Sala dell'Allegoria Nuziale* (II), whose name derives from the subject of the fresco painted in 1757 by GIAMBATTISTA TIEPOLO together with his son GIANDOMENICO and GEROLAMO MENGOZZI COLONNA for the wedding of Ludovico Rezzonico and Faustina Savorgnan – the *Nuptial Allegory*. The bride descends from the sky on Apollo's chariot. This golden vehicle is an auspice of nuptial concord and harmony, while the blindfolded Cupid and the

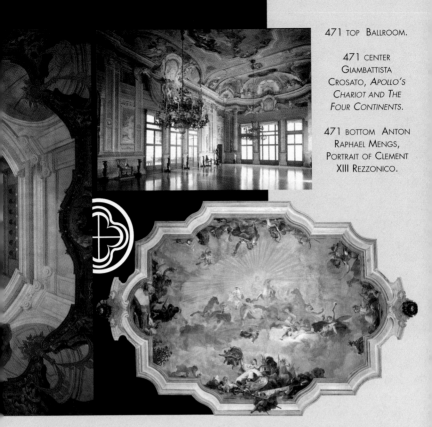

471 TOP BALLROOM.

471 CENTER GIAMBATTISTA CROSATO, *APOLLO'S CHARIOT AND THE FOUR CONTINENTS.*

471 BOTTOM ANTON RAPHAEL MENGS, PORTRAIT OF CLEMENT XIII REZZONICO.

470-471 GIANDOMENICO TIEPOLO AND ASSISTANTS, *NUPTIAL ALLEGORY*, CA' REZZONICO.

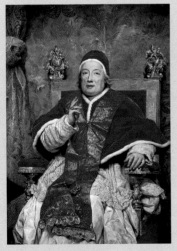

white dove – attributes of Venus – announce eternal love. The delicate *Madonna and Child with St. Joseph and St. John the Baptist* situated in the small chapel is by FRANCESCO ZUGNO, and the *Portrait of Clement XIII Rezzonico* (1758) is by the Neo-Classical painter ANTON RAPHAEL MENGS. Carlo Rezzonico, the son of Giambattista, was elected pope in 1758. In the *Sala dei Pastelli* (Pastels Room, III) there are many interesting portraits – examples of psychological studies – by 18th-century artists such as MARIANNA CARLEVARIJS, ROSALBA CARRIERA, GIAN ANTONIO LAZZARI and LORENZO TIEPOLO. The three 17th-century Flemish tapestries after which the next room (Tapestry Room, IV) is named, illustrate *The Legend of Solomon and the Queen of Sheba* and come from Palazzo Barbi Valier, at Santa Maria Formosa. Also note the lacquered door representing chinoiserie against a yellow background, one of the few original pieces of furniture left.

472 TOP
GIAMBATTISTA
TIEPOLO AND
GEROLAMO
MENGOZZI
COLONNA,
ALLEGORY OF MERIT.

472 BOTTOM AND
472-473
GREGORIO
LAZZARINI, *ORPHEUS
MASSACRED BY THE
BACCHANTES* AND
DETAIL.

473 BOTTOM
GIULIA LAMA,
*MARTRYDOM OF ST.
EUROSIA.*

The *Sala del Trono* (Throne Room, V), which was the nuptial chamber of Ludovico Rezzonico and Faustina Savorgnan, is furnished with precious, refined furniture, attributed to the sculptor ANTONIO CORRADINI, which once belonged to the Barbarigo family. At left is the luxurious throne, which was used by Pope Pius VI in 1782. On the ceiling is the marvelous *Allegory of Merit* (1757) by GIAMBATTISTA TIEPOLO and GEROLAMO MENGOZZI COLONNA.

After exiting from this room, cross the long *portego* and enter the *Sala del Tiepolo* (Tiepolo Room, VI) on the opposite side. Among the works of art is the walnut wood bureau-secretary with mirrored fronts and, above the fireplace, the *Head of an Old Man* with its warm color rendered with fluid brushstrokes, by GIANDOMENICO TIEPOLO. The ceiling fresco is by his father GIAMBATTISTA: *Nobility and Virtue Vanquish Perfidy* (1744-45), which came from Palazzo Barbarigo, in Santa Maria del Giglio. Nobility, holding the simulacrum of Minerva, is accompanied by a young winged Virtue with the Sun on her bared bosom, the symbol of corporeal vigor. These allegories were taken from Cesare Ripa's *Nova Iconologia*, but with some variations, such as the laurel garland, the mark of invincibility, which unexpectedly falls from Virtue's hand. This latter's dress, whose color changes from orange to yellow, is an extraordinary achievement of Tiepolo's skill in applying color. After the narrow passageway (VII) with 18th-century Venetian ceramics and *The Martyrdom of St. Eurosia* by GIULIA LAMA, you enter the *Library* (VIII), whose credenzas come from the bequest of Gatti Casazza. The next room, the *Sala del Lazzarini* (Lazzarini Room, IX), houses three canvases with mythological subjects from the house of Abbot Teodoro Correr at San Stae. One of these, on the wall opposite the entrance, was painted by GREGORIO LAZZARINI: *Orpheus Massacred by the Bacchantes*. This episode, taken from Ovid's *Metamorphosis*, concerns the moment when Orpheus, the legendary poet and musician who now despises women because of the tragic loss of

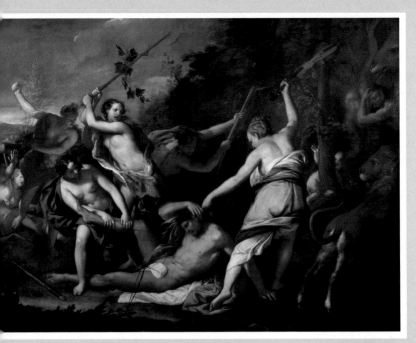

his wife Eurydice, is brutally attacked and torn to pieces by the Bacchantes or Maenads. Some women are holding the thyrsus – the Dionysian symbol of fertility – and the one at right is raising Orpheus' viol to strike him with it. The five oval canvases on the ceiling with mythological figures come from Ca' Nani and are by FRANCESCO MAFFEI. The *Sala del Brustolon* (Brustolon Room, IX) boasts canvases by artists such as JACOPO AMIGONI, NICCOLÒ RENIERI and PIETRO RICCHI. The furniture was made by the wood-carver from Belluno ANDREA BRUSTOLON (hence the name of the room) for the Venier family (1706, signed). Among these pieces are the sumptuous ebony and boxwood chairs with allegorical figures. But the outstanding work is the

vase-stand console at right, whose massive shelf is supported by a lovely figure of Hercules in the guise of Atlas, flanked by the Hydra and Cerberus. Above this shelf, a group of three chained Moors – an allegory of vanquished vices – supports the central vase, while at the sides two recumbent old men (allegories of rivers) are supporting the side vases. The visit continues by going back into the *Sala del Portego* (XI), on axis with the door leading to the Throne Room. At left, among the marble busts, note the one by FILIPPO PARODI portraying a sensuous Lucretia, the virtuous woman who, raped by Sextus, stabbed herself to death out of shame. On her breast we can see the wound made by her dagger. Farther

on, at right is the elegant Ionic portal that frames the stairway entrance by GIORGIO MASSARI, flanked by two statues by the 16th-century sculptor ALLESANDRO VITTORIA. In front of the opposite door is a fine gilded sedan chair. The wooden statues (1722-27) of divinities and virtues are by ANDREA BRUSTOLON.

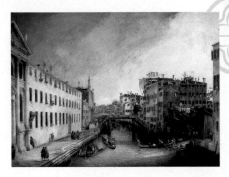

■ The stairway leads to the SECOND FLOOR, which houses the 18th-century picture gallery known as the *Portego dei Dipinti* (XII), with works by GIUSEPPE ANGELI, DOMENICO MAGGIOTTO, PIETRO BELLOTTO, BERNARDO STROZZI, FRANCESCO ZUCCARELLI, and the landscape painters LUCA CARLEVARIJS, MARCO RICCI and GIUSEPPE ZAIS. Continuing your visit toward the right, moving counter-clockwise, note the many interesting canvases by FRANCESCO ZUCCARELLI. It is also worthwhile stopping at the wall opposite to see the View paintings by the young ANTONIO CANAL, better known as CANALETTO: *The Grand Canal Seen from Ca' Balbi toward the Rialto* (ca. 1720) and *Rio dei Mendicanti* (ca. 1723). In the former work, the façades of the palazzi along the Grand Canal are illuminated by the changing effects created by the oncoming storm, with unexpected warm tones produced by the old and worn plaster on the buildings: the old age of Venice thus becomes a feast for the eyes. In the second

canvas the white, diaphanous light accentuates the silent, sad atmosphere of this hospital and hospice built to house and aid the poor. Other paintings in this hall are *Mucius Scaevola* by GIANNANTONIO PELLEGRINI; the splendid and dramatic *Alexander the Great before the Dead Darius* (ca. 1745) by GIAMBATTISTA PIAZZETTA; *Portrait of Marshal Mathias von der Schulenburg* (a military leader and fortifications expert who served the Venetian Republic) by ANTONIO GUARDI. At the end of the hall, at right, is the entrance to the *Villa Zianigo rooms* (XIII) with the joyous, carefree frescoes from the Villa Tiepolo at Zianigo, near Mirano, by GIANDOMENICO TIEPOLO. In *The New World* (signed and dated 1791), the people are crowded in front of a modest dwelling surmounted by a lantern, in which a rudimentary device consisting of lens and candles projects images of exotic places. All the figures, like moths around a lamp, are irresistibly attracted by

the marvelous images being projected inside. In the room at right are the roguish, amusing scenes of Punchinello (1793-97), together with the exuberant acrobats. The room at left is a reconstruction of the private chapel at the Villa Tiepolo. The two side monochromes (1759), inundated with bright light and impregnated with deep religious feeling, have as their subject Girolamo Miani, the founder of the Somaschi order and rector of the Venetian Incurabili hospital at the Zattere. Going back, you can visit the desecrating *Camera dei Satiri* (Satyrs' Chamber, ca. 1773). The marvelous, unrivaled monochromes in this room, populated with satyrs, centaurs and Bacchantes, anticipate the blasphemous atmosphere of the Punchinello and his tumbler friends. Despite the usual mythological figures, partly because of their immediacy and fresh quality these scenes communicate joyous participation in the world of transgression, without any religious qualms.

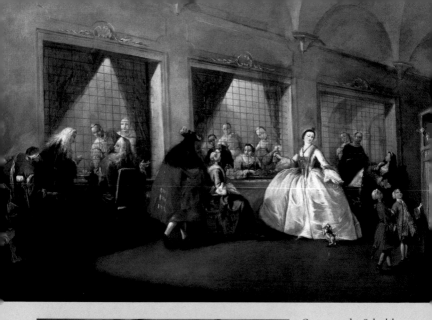

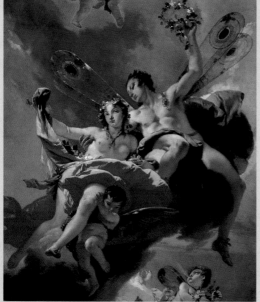

Once past the *Sala del Clavicembalo* (Harpsichord Room, XIV), you will enter the Passage (XV), which has the *Signboard of the Arte dei Coroneri* (the rosary-makers' guild), restored in 1750 and attributed to FRANCESCO GUARDI. The adjacent *Sala del Parlatorio* (Parlor Room, XVI) has two canvases by FRANCESCO GUARDI: the *Nuns' Parlor at San Zaccaria* and *The Ridotto*. In the former, at left, some nobles are conversing with their relatives who are members of the nunnery. In Venice, it was common practice to force the daughters of aristocratic families to become nuns in order not to divide the family patrimony into several dowries. These "converts" are wearing the characteristic hood that even covers their throats. Despite the grille of the *parlatorio* or locutory, the atmosphere is relaxed and permissive: a woman is playing with her

476-477 AND 476 BOTTOM FRANCESCO GUARDI, *NUNS' PARLOR AT SAN ZACCARIA* AND DETAIL.

476 CENTER GIAMBATTISTA TIEPOLO, *TRIUMPH OF ZEPHYR AND FLORA*, DETAIL.

477 TOP PIETRO LONGHI, *THE WASHERWOMEN*.

477 BOTTOM PIETRO LONGHI, *EXHIBITION OF A RHINOCEROS IN VENICE*.

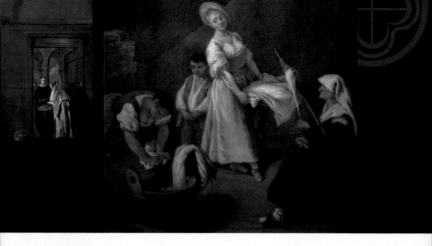

little dog and two elegantly dressed children are watching a puppet show. In the *ridotto* or gambling hall, the nobles – who are wearing masks so as not to be recognized – are conversing or playing cards. In the background, at left, some of them are in a small room where coffee is being served. The Rococo furniture with yellowish-green lacquerwork in the Sala del Parlatorio comes from Palazzo Calbo-Cortta, near the Scalzi Church.

You now have to retrace your steps to continue your visit, crossing the Portego dei Dipinti and going into the *Sala del Longhi* (Longhi Room, XVII). The oval painting on the ceiling by GIAMBATTISTA TIEPOLO, *The Triumph of Zephyr and Flora*, comes from Ca' Pesaro. The theme is based on Ovid's narration, but instead of the usual depiction of the moment when Zephyr

reaches Flora, it shows the nymph already transformed into lovely Spring. This invention is a clear reference to the wedding of Antonio Pesaro and Caterina Sagredo (1732), for which this canvas was painted. In the same room are the exquisite little scenes of daily life in Venice as seen through the attentive, and at time pitiless, gaze of PIETRO LONGHI (1702-85), a friend of playwright Carlo Goldoni. Proceeding counter-clockwise, note, at left, *The Artist's Studio* and *The Horseback Ride*. Along the next wall, on a line with the fireplace, are genre paintings of popular personages such as *The Spinster* and, below this, *The Washerwomen*. Farther along is the patrician world, described in *The Moor's Letter* and *The Toilette*. On the shortest wall are *Exhibition of a Rhinoceros in Venice*, *The Doughnut Vendor*, *The Essence Vendor*, and *The*

Morning Chocolate. On the last wall are *The Alchemists*, *The Giant Magrat* and, in the middle, *Portrait of Francesco Guardi* (1764). The *Sala delle Lacche Verdi* (Green Lacquer Room, XVIII) was named after the luxurious Eastern-influenced furniture with gilded gesso decoration that comes from Palazzo Calbo-Crotta. On the right-hand side of the room is a curious canvas, *The Frozen Lagoon*, painted by a follower of FRANCESCO BATTAGLIOLI.

478 THE SALA
DELL'ALCOVA.

478 CENTER AND **479**
EGIDIO MARTINI PICTURE
GALLERY.

478 BOTTOM SALA X,
EGIDIO MARTINI PICTURE
GALLERY.

■ Going past the *Sala del Guardi* (Franceso Guardi Room, XIX), you come to the *Sala dell'Alcova* (Bedroom, XX). This 18th-century bedroom with a green lacquered crib comes from Palazzo Carminati, near San Stae. The soft, delicate *Praying Madonna* above the headboard is by ROSALBA CARRIERA. In the little room at right is the 17th-century toilette service, a wedding gift with the coats of arms of the Pisani and Grimani families, made by craftsmen from Augsburg. By going through the small room on the left, you can visit the boudoir with a ceiling frescoed by JACOPO GUARANA.

Going back into the Portego dei Dipinti, you will find the stairway leading to the THIRD FLOOR, which houses the prestigious Egidio Martini Picture Gallery. This collection was opened to the public in 2000 and includes canvases from different schools dating from the 15th to the 20th century. It is the result of the patient and loving personal research carried out by Martini – a painter,

restorer and art historian – in over sixty years of study and labor. Among the 16th-century paintings in the Sala di Ingresso (entrance hall), note, on the left wall, *St. Matthew and the Angel* (ca. 1580) by the Ferrarese artist SEBASTIANO FILLIPO (known as IL BASTIANINO); *St. John the Baptist* by the Veronese PAOLO FARINATI; and *Rea Silva with Her Sons Romulus and Remus* by the

Dutch painter LAMBERT SUSTRIS. On the partition wall opposite, besides the works by GASPARE DIZIANI, there is a charming, graceful canvas by JACOPO AMIGONI, *Child Playing with a Small Bird* (1729-39). After visiting the entrance hall, continue to your left to the end, to *Room I*, featuring painters active in Venice and the Veneto in the 15th and 16th centuries. Among the many paintings here, note, proceeding counter-clockwise, the lovely *Holy Family* (ca. 1520) in which PALMA VECCHIO tries to reconcile the perspective rigor of the figures with his palette; the *Madonna and Child* (early 16th century) by the Ferrara artist BOCCACCIO BOCCACCINO, who, harking back to the sacredness of Byzantine icons, shows us a Virgin of his time, who is lovely with her solar colors and

hypnotic glance; the magnificent *Madonna and Child with St. Elizabeth*(?) *and St. Leonard* (ca. 1510) by GIAMBATTISTA CIMA DA CONEGLIANO, who draws inspiration from GIOVANNI BELLINI. This painting was executed for a private citizen and is one of the many examples of mental prayer, during which the worshipper – in this case the boy kneeling at right – visualizes the persons to whom he is praying. In *Portrait of a Noblewoman with Her Son*, BERNARDINO LICINIO creates a silent and profound relationship between the two figures thanks to their gestures and above all their glances. This artist, a pupil of GIORGIONE, captures the slight asymmetry of the woman's face, displaying his mastery of the art of portraiture. Lastly, in the two small panels of *Christ Laid on the Cross* and *The Ascent to*

Calvary, GIOVANNI ANTONIO DE' SACCHIS, better known as IL PORDENONE (ca. 1483-1539), in order to illustrate the Passion, draws upon a Franciscan meditation on the life of Christ, in which the various preparatory phases of the crucifixion are described.

Room II features works by 16th- and 17th-century artists. In addition to the canvases by LAMBERT SUSTRIS, GIOVANNI CARIANI and JACOPO TINTORETTO, note the delicate *Mystic Wedding of St. Catherine* by POLIDORO DA LANCIANO, and the dazzling dawn which from a distance invades the nocturnal scene of the *Adoration of the Magi* by the Ferrara painter IPPOLITO SCARSELLA (known as IL SCARSELLINO).

■ To get to *Room III*, which has large canvases, you must go up the nearby inner staircase. Moving counter-clockwise, notable

works are the *Sermon of Christ* (ca. 1544) by a young JACOPO TINTORETTO; *The Tiburtine Sibyl Announces the Birth of the Redeemer to the Emperor Augustus* (1540?) by BONIFACIO DE' PITATI; the titanic figures of the Lombard artist PAOLO PAGANI (1655-1716) in *Samson Taken Prisoner*; the dizzying and theatrical *Fall of the Giants* (ca. 1694) by the Veronese ANTONIO BALESTRA; and lastly, the sensual, powerful *Diana* by the Paduan PIETRO LIBERI (1614-87), lying on her symbol – the crescent – while the breeze from Olympus raises her long veil.

Now go down into Room II to get to *Room IV*, which features 17th-century Venetian painting. Among the works by GIULIO CARPIONI (1613-79) are the entertaining *Small Faun with a Mask* and *The Reign of Hypnos*, which has a personification of Sleep. Make sure to see the dramatic *Raising of the Cross* (ca. 1669) by the Florentine SEBASTIANO MAZZONI, who was active in Venice and much influenced by TINTORETTO in the definition of dynamic space obtained through diagonals, strong chiaroscuro contrasts, and use of a fluid, condensed brushstroke in the construction of figures and their clothing. Among the most successful paintings by the Titianesque ALESSANDRO VAROTARI, known as IL PADOVANINO (1588-1649), is *Venus and Mars with Two Cupids*, an allegory of love victorious over war which the artist enriches with the mirror motif, usually attributed to vanity, which in this case is to be interpreted as a veiled allusion to the primacy of painting – capable of representing an object seen from various vantage points simultaneously – over sculpture.

In *Room V*, among the paintings by PIETRO VECCHIA, note, at left, *Pandora's Box* (ca. 1640) and, moving counter-clockwise, the full and sensual forms of *St. Christine*, enveloped in a leaden light, a fine work by PIETRO RICCHI, known as IL LUCCHESINO (1606-75). *Room VI* really consists of two rooms. In the first one is *Susanna and the Elders* (before 1648?) in which PALMA GIOVANE creates the figure of the Babylonian heroine through simple, puffy volumes that contrast with the velvety quality of her long hair, and the *Portrait of St. Jerome* (after 1630), in which the Genoese BERNARDO STROZZI (1581-1644), who was active in Venice, succeeds in merging the religious theme of meditation on death with the melancholy

480 SALA III,
EGIDIO MARTINI
PICTURE GALLERY.

481 TOP SALA VII,
EGIDIO MARTINI
PICTURE GALLERY.

481 BOTTOM SALA
VI, EGIDIO MARTINI
PICTURE GALLERY.

sadness of those who feel alone. In the second room there are the sensual and delicate works by PIETRO LIBERI, as well as the violent struggle between Lucretia and Sextus Tarquinius, in which FICARELLI (known as IL RIPOSO) paints the young woman supplicating with an intense glance that seems to be directed at the viewer.

In the middle of *Room VII* there is the fine *Portrait of Doge Giovanni II Corner* (1719-22) by GIAMBATTISTA TIEPOLO. Keeping to your left and going into the next room, note, among the canvases by GIANNANTONIO PELLEGRINI, the moving *Venus and Adonis* and *Bacchus and Ariadne*. In the middle of the back wall is the splendid, tragic *Death of Sophonisba* by the Venetian GIAMBATTISTA CROSATO (1697-1758), who was active in Piedmont. At right, after *The Temptations of St. Anthony* by SEBASTIANO RICCI (1659-1734), there is the splendid, sophisticated *Venus with Satyr and Cupid* (1713-16?) by the same artist. The goddess, in the guise of a young, curvaceous courtesan, points both at the sleeping Cupid – the allegory of Love and, perhaps, of the vanity of earthly pleasures – and at an old faun in the half-shadow, the symbol of Lust. On the panel in the middle of the room is a *Resurrection of Christ* (1700-05) in which SEBASTIANO RICCI manifests the influence of Titian as well as the compositional patterns of Veronese.

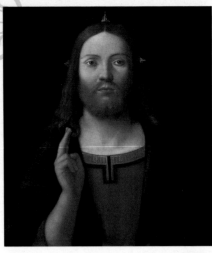

In *Room VIII*, given over to MARCO RICCI (1676-1730), among the fine landscapes, influenced by the fable-like visions of Salvator Rosa, is *The Seastorm* and *Waterfall, Mill and Washerwomen*, both of which were painted in the late 17th-early 18th century. *Room IX* contains some 19th-century view paintings of Venice; for its bold, structural brushwork, the most interesting one is *San Giovanni e Paolo Canal* by EMMA CIARDI (1879-1933). Retracing your steps, you will reach *Room X*, which is filled with paintings by artists such as FRANCESCO GUARDI, PIETRO LONGHI, NICOLA GRASSI, CARLO INNOCENZA CARLONI, FRANCESCO ZUGNO, ALESSANDRO LONGHI, GIANDOMENICO TIEPOLO, FRANCESCO FONTEBASSO and GASPARE DIZIANI. The following works deserve attention: the delicate and fascinating pastels of *Christ Giving His Blessing* and *Spring* by ROSALBA CARRIERA

(1675-1757); the fine composition in *Boy with a Fife* by GIAMBATTISTA PIAZZETTA (1683-1754); the three canvases by GIAMBATTISTA PITTONI (1687-1767) in the central section of the room. At the end of the room, at right, is the entrance to *Room XI*, along which is the reconstruction of the 18th-century pharmacy at Campo San Tin, known as "Ai do San Marchi." Its three rooms have interesting walnut wood furniture as well as majolica vases for spices and medicines (mid-18th century). Our visit: continues in *Room XII*, featuring 18th-century landscape paintings, the most noteworthy of which are, at right, *Landscape with a Large Waterfall* and the fantastic *Seastorm with Natural Rock Arch* by ANTONIO MARINI (1668-1725). The next and last room, number *XIII*, is given over to early 19th-century painters.

Now go down the stairs to the ground floor and, going along the hall toward the Grand Canal, go up a short stairway to visit the Ferruccio Mestrovich Collection, which was opened in 2002 and has works by artists such as BENEDETTO CARPACCIO, GIAMBATTISTA CIMA DA CONEGLIANO, UBALDO GANDOLFI, JACOPO AMIGONI, ALESSANDRO LONGHI and PAOLO SCORZIA. In *Room I*, don't miss the touching, sculpturesque *Deposition* (ca. 1580) by JACOPO TINTORETTO and his workshop, and, at right, the notable *Sacra Conversazione* by the Veronese artist BONIFACIO DE' PITATI (ca. 1487-1553). In *Room II*, at right, note the fascinating *Christ Giving His Benediction* by the Venetian BENEDETTO RUSCONI, known as IL DIANA (ca. 1460-1525), and the *Madonna del Rosario* in 18th-century attire by FRANCESCO GUARDI (1712-93).

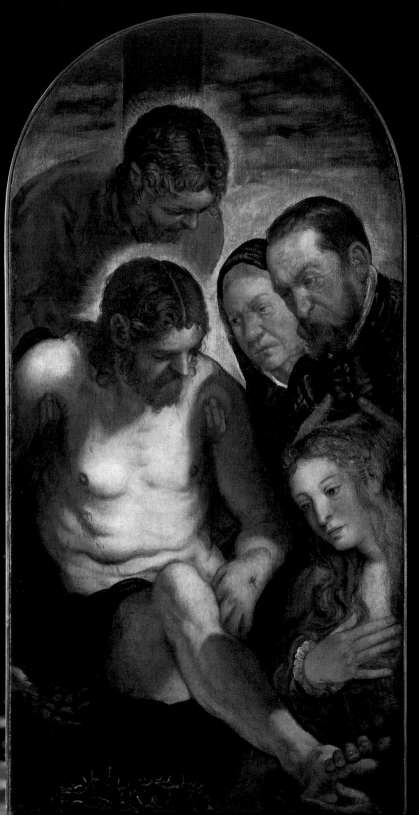

■ Having finished your tour of Ca' Rezzonico, retrace your steps along the *fondamenta* to **Ponte dei Pugni** (literally, "Bridge of Fists") point of the cruel battles with staves authorized by the Republic until the 18th century between two rival factions, the Castellani from Castello and the Nicolotti from Dorsoduro. The nearby square is dominated by **San Barnaba Church**. In 1736 the church was rebuilt to a design by a follower of Massari, LORENZO BOSCHETTI. The 11th-century bell tower, one of the oldest in town, was altered in the 14th century and restored in 1882. The composite-order façade was modeled after the one on the Gesuati Church. Among the art works in the interior are the two canvases by PALMA GIOVANE on the side walls of the chancel: *The Last Supper* (1587), commissioned by the

Scuola del Santissimo Sacramento, and *The Way to Calvary* (ca. 1601), which may have come from another church. The fresco on the ceiling, *The Triumph of Faith*, is attributed to COSTANTINO CEDINI (1741-1811). We now go to the Sotoportego del **Casin dei Nobili**. The *casini* in Venice were gambling houses that sometimes also included brothels. Already in the Middle Ages the Republic of Venice, well aware of their social and economic function and the advantages that accrued for the state, began to manage these establishments. If you observe the ceiling of the *sotoportego* on a line with no. 2767, you can still see the peephole used to check those who asked to enter. After crossing over Ponte Lombardo, you are in the fascinating Fondamenta dell Toletta. At Ponte de le Meravegie you can see, at right along the Fondamenta

Toffetti, **Palazzo Bollani** (no. 1073), which has 17th-century decoration and 18th-century stuccowork in the interior. Along the Fondamenta de Ca' Bragadin is the 17th-century **Palazzo Basadonna-Giustinian** (no. 1012). If you go along Calle Contarini-Corfù you will find the land entrance to the palazzo of the same name (no. 1056), surmounted by the family crest (18th century). A little farther on is the square with the former church and Scuola of **Santa Maria della Carità**, now the home of the **Gallerie dell'Accademia**. HISTORY OF THE CHURCH: Santa Maria della Carità, which lies opposite the Ponte dell'Accademia, dates from the early 12th century and was entirely rebuilt by the Regular Lateran Canons of St. Augustine. The church, built by BARTOLOMEO BON and his workshop, was

terracotta can be seen along the Rio Terà Antonio Foscarini.

HISTORY OF THE SCUOLA: one of the oldest Scuole Grandi in Venice, the Santa Maria della Carità confraternity was established in 1260 at San Leonardo church in Cannaregio. Later, the confreres moved their headquarters to the Giudecca island, where they founded an oratory named after St. James the Greater,

begun in 1441 and finished around 1452. The church was closed in 1806 and its precious art works were removed. The following year it was divided into two stories, since it had been decided that it was to be the new home of the Accademia di Belle Arti (Fine Arts Academy), which had been founded in 1750 at the Fonteghetto della Farina under the name of Accademia di Pittura. In the square, to the right of the façade, is a small façade made of Veronese red marble. Its entrance (no. 1050) was originally the only access to the cloister and the Scuola. The portal is flanked on high by two reliefs with the figures of St. Leonard and St. Christopher (1387 and 1384 respectively), co-patrons of the Scuola, and is surmounted by a high relief with an aedicule-type cornice depicting the

Madonna and Child with Angels and Confreres (1345, dated) and, in the tympanum, the emblem of the Scuola della Carità, consisting of a Greek cross and two concentric circles. The inner courtyard, rebuilt in 1442, was altered several times. Note, on the right, the inscription with the list of the teachers at the painting academy and, next to this, the old entrance to the Scuola (late 14th century). The large monastery cloister was rebuilt to a design by ANDREA PALLADIO around 1561-70. The building was drastically altered: first, changes were made after the 1630 fire, and then the structure had to be adapted to house the Accademia di Belle Arti (1807), the work of which began in 1811 under the supervision of GIANNANTONIO SELVA. A still intact façade with austere, masterful trabeation in

and in 1344 they began construction of their long-term home in the Carità convent. The headquarters of the Scuola were renovated in 1442. Their façade, which is the entrance to the Accademia Galleries, was modified in 1756 by BERNARDINO MACCARUZZI to a design by GIORGIO MASSARI. FRANCESCO LAZZARI gave it its present Neo-Classical appearance in 1830 and also replaced the emblems of the Scuola with the two side bas-reliefs of the *Instruments of Architecture and Painting* in honor of the Accademia di Belle Arti.

■ **THE GALLERIES:** these house the most prestigious collection of Venetian and Veneto painting in the world. The picture gallery was originally used by the students of the Fine Arts Academy, but already in 1817 it was opened to the public, albeit for a short period.

THE COLLECTIONS: most of the works of art come from 19th-century bequests, from closed churches and confraternities and from some purchases made by the Italian state. Besides the Gabinetto di Disegni (drawing collection) – which boasts the famous *Vitruvian Man* (ca. 1490) by Leonardo da Vinci – the museum has a famous restoration facility. Once

past the entrance, designed by CARLO SCARPA, you enter the ground floor of the Scuola della Carità, now closed off by barriers to house the ticket office. At the end of the double staircase, designed by BERNARDINO MACCARUZZI in 1765 and with statues by GIANMARIA MORLAITER, you enter Room I. This large hall, commissioned in 1461, was the chapter house of the Scuola reserved for religious ceremonies and assemblies. The striking gilded coffered ceiling (1461-84) with heads of cherubs was carved by MARCO COZZI. Once past the gate you immediately see the *Coronation of the Virgin* polyptych (ca. 1350) by PAOLO VENEZIANO. In this

magnificent masterpiece, the style of this master of 14th-century Venetian painting mirrors the cultural role Venice played as a link between East and West. Side by side with Byzantine, Romanesque and Gothic influences, there is the splendid softness and equilibrium of a typically Venetian concept of color. The theme of the coronation of the Virgin, seen in other panels in this room, as well as the representation of Paradise in a courtly key, celebrate the Madonna as Queen of the Heavens but also as the Mother of God and of the Church. These roles are personified by the figures of the saints (above), including St. Clare at left and St. Francis at right.

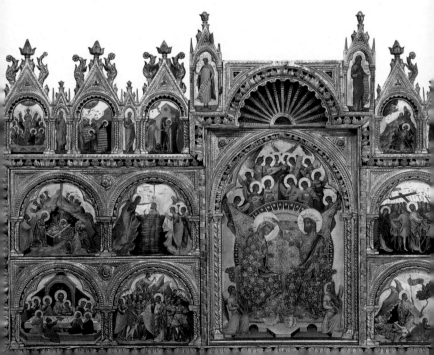

486-487 PAOLO
VENEZIANO,
*CORONATION OF THE
VIRGIN POLYPTYCH.*

487 TOP LEONARDO
DA VINCI, *VITRUVIAN
MAN.*

487 BOTTOM
JACOBELLO DEL FIORE,
TRIPTYCH OF JUSTICE.

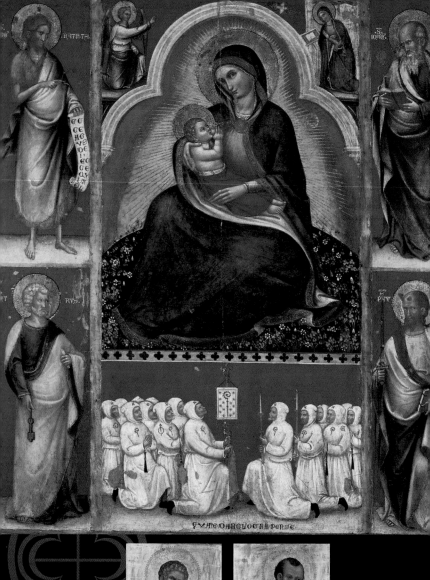

488 TOP
GIOVANNI DA
BOLOGNA,
MADONNA OF
HUMILITY.

488 BOTTOM LEFT
LORENZO
VENEZIANO,
ST. PETER.

488 BOTTOM RIGHT
AND 489 RIGHT
LORENZO
VENEZIANO, ST.
MARK AND DETAIL.

489 LEFT
JACOBELLO
ALBEREGNO,
POLYPTYCH OF THE
APOCALYPSE, DETAIL.

On the reverse of the panel supporting the triptych is the *Madonna of Humility* with the Madonna in the middle suckling the Christ Child (1380-85, signed) by GIOVANNI DA BOLOGNA. This subject, quite common in Cretan and Venetian circles, exalts the humanization of divinity. In the lower panel the confreres of the Scuola di San Giovanni Evangelista are kneeling before their emblem, the crozier against a star-studded background. They are wearing the white habit of the flagellants, typical of the Scuole Grandi and of the devotees of this expiatory practice. The two side panels by LORENZO VENEZIANO, which come from a polyptych, represent *St. Peter* and *St. Mark* (signed and dated 1371). The solid gold background, an expression of the presence and infinite grandeur of the divine, and the faces of the two apostles are typical of the Byzantine vocabulary, while the rendering of the drapery – aiming at defining space and volume – expresses the felicitous combination of elegant Gothic linearity and a plastic style mindful of Giotto and the Paduan school. Farther along, in the middle of the room and in a showcase, is a 15th-century Crucifix in silver and rock crystal by the Venetian school that came from the Scuola Grande di San Teodoro. At right is the *Polyptych of the Apocalypse* (second half of the 14th century) by JACOBELLO ALBEREGNO, from San Giovanni Evangelista church in Torcello. In the central panel, the elderly St. John, kneeling and in the guise of a scribe – is having the vision of the end of the world. Above him appears God the Father on a throne, with the mystic lamb placing its hooves on the book of the seven seals. God is enclosed in a mandorla frame, the symbol of light, supported by the animals "full of eyes before and behind," symbols of the four evangelists and the chariot of the Church. On either side are the venerable old men, the allegory of the Old and New Testaments, while below are the martyrs of Rome. On the side panels there are other episodes, such as the Harlot of Babylon, who is holding the golden chalice of Lust and is seated on the beast with seven heads, an allegory of Nero and Satan.

At the end of the hall is the large, splendid *Annunciation and Saints* (begun in 1537) by LORENZO VENEZIANO, also known as the *Lion Polyptych*, which came from the demolished church of Sant'Antonio in Castello. In the magnificent wooden frame, which is the image of the City of God from which saints and prophets appear, the Romanesque style has been abandoned in favor of Gothic. The theme of the Annunciation (used as noted in many panels in this room and one of the most common motifs in Christian iconography) was the object of special devotion on the part of the Venetians, since its date, March 25, coincides with that of the mythical foundation of the city. Mary has her arms crossed over her breast, the typical gesture of the servants of God, also known as the gesture of humility. At her feet, at right, is the donor, Domenico Lion. The upper panel, with God the Father, is attributed to BENEDETTO RUSCONI (known as IL DIANA). At left is another work, *The Coronation of the Virgin* (mid-15th century) by MICHELE GIAMBONO. Here Giambono highlights the figures of the saints, almost entirely eliminating the stalls on which they are seated, and bearing in mind the teaching of Gentile da Fabriano, he accentuates the gold leaf and plaster decoration. At the foot of the

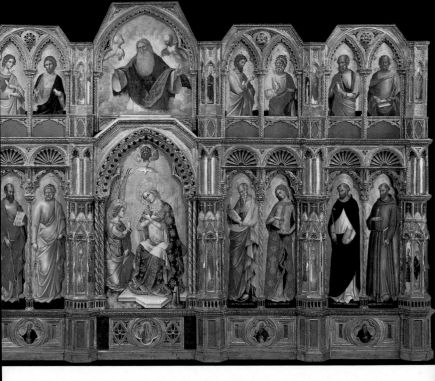

putti bearing the instruments of the Passion are the four Evangelists. St. Luke, the patron saint of painters, is holding a small icon in which, instead of the usual Madonna and Child, there is the Madonna being crowned by angels, as befits the subject of the altarpiece. Continuing counter-clockwise, there is the sad *Madonna and Child* (ca.1440) by the Muranese ANTONIO VIVARINI, which can be appreciated for its soft flesh tones and the transparency of the veil covering Jesus, under which we can perceive his male, hence his human, "nature." Again at left, you can admire the elegant *Madonna of Mercy* (1436, apocryphal date and signature) by JACOBELLO DEL FIORE. The Madonna's mantle is bordered with gilded plaster and is fastened by an enormous almond-shaped fibula in which is Christ the Judge – in the guise of Emanuel – seated on a rainbow, the sign of the covenant between God and Man. The iconographic type is that of the Odighitria Madonna who indicates the True Way, but it is rendered with many different eschatological meanings related to the Annunciation, which is depicted in the two upper quatrefoils. The merciful Madonna is the defender of those who, like her, believe in the mystery of incarnation and are humble servants of God. On the other side of the partition, MICHELE GIAMBONO, in *St. James the Greater and Saints* (ca. 1450) concentrates on the psychology of the figures through his rendering of their glances. At left, on the wall, is the polyptych of the *Praying Madonna and Child* (after 1427, signed) by the Bolognese artist MICHELE DI MATTEO, which came from Sant'Elena Church. Note, in the upper panel with the Crucifixion, the crowded Calvary scene influenced by Central Italian iconography and, in the figure of Mary Magdalene to the right of the Virgin Mary, the Gothicizing drapery and richly decorated hood and mantle.

Returning to the end of the room, you enter *Room II*, featuring large 15th-century altarpieces, with works by VITTORE CARPACCIO and MARCO BASAITI. Among the masterful paintings by GIOVANNI BELLINI, especially noteworthy is the *Enthroned Madonna and Child with Saints* (ca. 1478, signed), which was originally kept in San Giobbe church and is one of the masterpieces of the Quattrocento. Bellini leads Venetian painting away from the international Gothic tradition and with the utmost mastery places it in a world balanced and restrained by perspective rationality and the ineffable softness of naturalistic light. In the following *Madonna of the Orange Tree between St. Jerome and St. Louis of Toulouse* (1496-98), GIAMBATTISTA CIMA DA CONEGLIANO tackles the theme of the Sacra Conversazione. Whereas Bellini in the nearby St. Job

Altarpiece depicts Heaven with the architectural image of a church much like St. Mark's Basilica, Cima da Conegliano views Paradise as the Garden of Eden. In fact, behind the figures is a harmonious landscape that reminds one of the Veneto mainland which had just been conquered by the Venetian army. After going through *Room III*, which has interesting works by CIMA DA CONEGLIANO, SEBASTIANO DEL PIOMBO and others, you enter the small *Room IV*. Beginning from your left, note the *St. George* (ca. 1446) by ANDREA MANTEGNA. The young knight is standing over the dragon he has killed; his pose is classical and he is on the threshold of a door that opens onto a fantastic landscape. This device is an obvious homage to LEON BATTISTA ALBERTI, who already in 1435 had spoken of perspective as a window opening onto the world. In another oil panel, PIERO

DELLA FRANCESCA depicts *St. Jerome* (ca. 1450) next to the donor, Girolamo Amadi di Agostino. Among the other paintings in this room, see the angular and mysterious *Madonna and Child* by the Ferrarese COSMÈ TURA and, on the partition wall, the *Madonna and Child between St. Catherine of Alexandria and St. Mary Magdalene* (ca. 1500) by GIOVANNI BELLINI. Here the Venetian master has succeeded in merging the theme of the Sacra Conversazione with the iconographic type of the Madonna of the Passion. Equally moving is this artist's handling of light. On the one hand there is the earthly, soft, grazing light that unveils the flesh and its beauty; on the other there is divine light, invisible but contemplated by the Son of God.

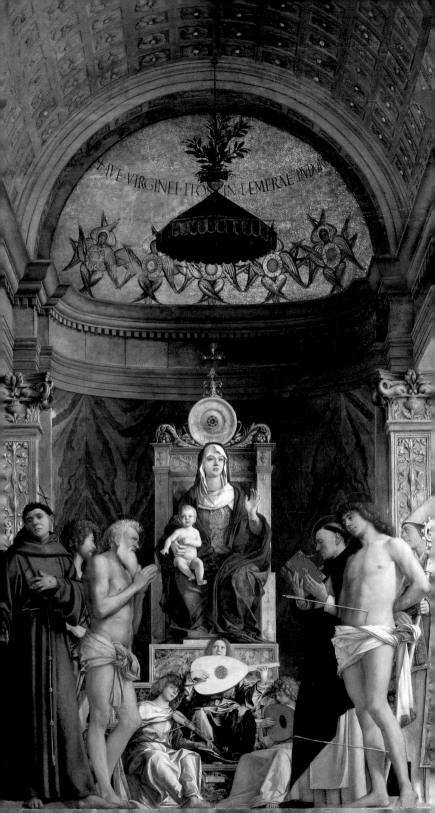

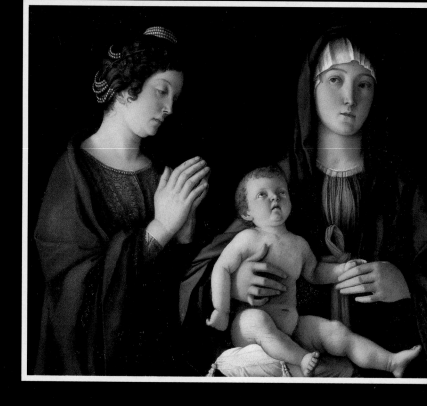

In *Room V*, which is also
small, among the many
magnificent works by
GIOVANNI BELLINI, one that
should be carefully
observed is the *Pietà*
(1505, signed). The
flattened pyramid
composition of the
grieving mother and her
son – whose body is a
matchless essay in
anatomic perspective –
and the dream-like nature
of a fantastic Jerusalem in
the background, as well as
the precise rendering of
plants and flowers, all
reveal Bellini's interest in
German and Flemish
painting, which he
tempers with his delicate,
moving rendering of tonal
values. On the opposite
wall are two masterpieces
by GIORGIONE. At left, *The
Old Woman* (after 1505)
admonishes the vanity of
the viewer who thinks
that youth is eternal and
presents herself as an
example, withered by
time, as the inscription in
her hand says. Despite the
didactic and religious
aims of this work, the
artist has produced a
magnificent portrait
whose incomparable
glance is redolent with
humanity and
compassion.
At right is the famous
Tempest (ca. 1505),
whose title derives from
the lightning striking the
clouds. The
interpretations scholars
have given for this
painting have not
succeeded in removing
its aura of mystery. The
only certainty – which
can be verified by anyone
willing to contemplate
this work at any length –
is that in this landscape
Venetian colorism has
reached one of its
heights.

494-495
GIOVANNI BELLINI,
MADONNA AND
CHILD BETWEEN ST.
CATHERINE OF
ALEXANDRIA AND ST.
MARY MAGDALENE.

495 TOP
GIORGIONE,
TEMPEST.

495 CENTER
GIORGIONE, OLD
WOMAN.

495 BOTTOM
GIOVANNI BELLINI,
PIETÀ.

496 LEFT AND 497 BOTTOM PAOLO VERONESE, *VENICE RECEIVING THE HOMAGE OF HERCULES AND CERES*.

496 RIGHT JACOPO TINTORETTO, *ST. LOUIS, ST. GEORGE AND THE PRINCESS*.

497 TOP LORENZO LOTTO, *PORTRAIT OF A GENTLEMAN IN HIS STUDIO*.

Room VI features three great masters of 16th-century Venetian painting: TITIAN, VERONESE and TINTORETTO. The first is perhaps best represented in his titanic, impressive *St John the Baptist* (ca. 1540), located between the two entrance doors of this room. The forerunner of Jesus is set, like a link, at the junction of two ideal planes that intersect diagonally: the one crossing the hand that indicates Jesus and the one delineated by the light coming from the right. Among the paintings by VERONESE, *Venice Receiving the Homage of Hercules and Ceres* (1576-ca. 1578) – placed high up on the wall and recognizable by the interesting frame – is certainly the most compelling one, so fraught with political meaning. Originally this work decorated the ceiling of the Magistrato alle Biave in the Doges' Palace. "Biave" in Venetian dialect means "fodder" and, more in general, "cereals." This magistracy was responsible for the city's food administration. It may be that Ceres, the goddess of harvests, can be identified as the allegory of the city of Brescia and its territories, from which the Venetian Republic got most of its cereals. The figure of Hercules, accompanied by Peace, is perhaps an allusion to the strength of the fortifications of Bergamo, the avant-garde defensive system toward the boundary with Milan's domain.

Among the works by TINTORETTO, on the left wall are three canvases with *Episodes from Genesis* (1550-53), in which the landscape is rendered with

rapid, summary brushstrokes, as well as *St. Louis, St. George and the Princess* (ca.1552), commissioned by Alvise Foscarini and Giorgio Venier at the end of their term as Magistrati al Sale. The artist uses only one source of light but it has a different intensity on the various figures, thus establishing an ideal hierarchy. The princess, whose twisting figure was inspired by the so-called serpentine, is certainly the most brilliant. According to popular tradition, she was identified with St. Margaret, who had defeated the dragon (Satan). Tintoretto knew of this, and in fact places the woman over the dragon and paints around her profile the usual flash of light used to indicate saints. *Rooms VII and VIII* are also well worth visiting, and a must is the famous and enigmatic *Portrait of a Gentleman in His Study* (1528-30) by Lorenzo Lotto. *Room IX* is a bookstore.

497 CENTER
TITIAN, ST. JOHN
THE BAPTIST.

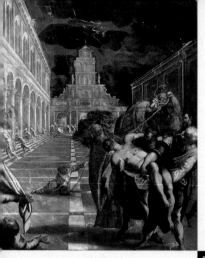

Room X has one of the most amazing achievements of PAOLO VERONESE, *Supper in the House of Levi* (1573, dated; 18.5 x 34.25 feet). The original title of this grand work, which came from the refectory of the Dominican convent of San Zanipolo, was *The Last Supper*, but Veronese changed it after being interrogated by a tribunal of the Inquisition. The Holy Office charged the artist with having inserted too many extraneous figures around the table where Jesus and his disciples were seated. According to the judges, some of them were clearly inappropriate, such as the dwarf and the Moor, or even vulgar, such as the disciple between the columns who is cleaning his teeth with a fork. And other details troubled the judges even more, since they smacked of Protestantism: the two "German" halberdiers, and above all, the man leaning over the balustrade, whose handkerchief is soiled with blood, which was not respectful of the Supper, linked to the Mass and to the blood of Christ. Veronese defended himself cautiously and warily, yet he took the courageous stand that artists had the right to creative independence – something certainly not in keeping with the pronouncements of the Council of Trent, which considered artists "mute theologians" or diligent and rigorous illustrators of the Holy Scripture. The tribunal ordered that the painting be corrected, but the matter was solved by a purely formal

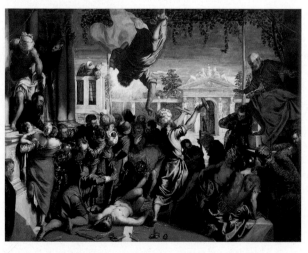

compromise, as Veronese merely changed the title of the work. Proceeding counter-clockwise, you will see the *Allegory of the Battle of Lepanto* (ca. 1573) by the workshop of VERONESE. Venice had lost one of its major possessions, the island of Cyprus, but on 7 October 1571, with the help of the leading Christian nations, managed to defeat the Turkish fleet. That day was dedicated to St. Justine, whose figure, recognizable by the dagger, appears in the sky. At her side, besides Faith, are St. Roch and St. Mark (patrons of the Republic), who, together with St. Peter, are interceding with the Virgin Mary. Among the large canvases by JACOPO TINTORETTO in this room, particular attention should be paid to the *Translation of the Body of St. Mark* and *St. Mark Frees a Slave*, both painted in 1562-66 for the Scuola Grande di San Marco. In the first work, set in

Alexandria, we see the moment when some devout Christians manage to seize the corpse of St. Mark, which was about to be burned. Tintoretto sets the scene in an imaginary square that is quite similar to the Piazzetta in St. Mark's, at the end of which is the clock tower. The setting seems to be a literal interpretation of what is narrated in the *Legendario Marciano* (12th-15th century) "[...] suddenly there raged a violent hurricane and the fury of the winds was unleashed: thunderbolts and flashes of lightning, followed by thunderclaps, resounded with frightening clangor, pursuing one another in the sky. Even the sun, they say, hid its rays from sight. The rain poured down, striking the earth with incredible force, from morning to evening [...]." Among the "compassionate, God-fearing men" who transported the body of the

patron saint of Venice, there is the portrait of a senator with his ermine-lined robe and, at right, next to the dromedary, the face of Tommaso Rangone, Grand Superior of the Scuola, who commissioned this cycle of canvases. Rangone is also portrayed at left in *St. Mark Frees a Slave*. Indeed, the title of Tintoretto's magnificent painting should be *St. Mark Coming to the Aid of a Castellan*. This episode, also taken from the *Legendario Marciano*, concerns a nobleman, here depicted at right, who discovers that, despite his orders to the contrary, his castellan had gone to Venice to pay homage to the body of St. Mark; he therefore tells his soldiers to torture his underling. Thanks to the intervention of the saint, here portrayed in bold foreshortening, the sharpened staffs, hammers and axes broke into pieces before the astonished onlookers.

On the opposite wall are two more masterpieces by VERONESE: *The Annunciation* (1578), from the Scuola dei Mercanti at the Madonna dell'Orto Church, and *The Crucifixion* (1582), which was originally placed in the small church of San Nicolò della Lattuga, near the Frari church. In the middle of the same wall is the grandiose *Pietà* (1575-76), which TITIAN painted for his own tomb at the Frari but died before he could finish it; some details were finished by PALMA GIOVANE, as the inscription tells us. This is a nocturnal scene made spectral by the shimmering artificial light of a torch and of the fire in the glass bowls on the roof of the tympanum. In the background are two prototypes of Christ: Moses and the Hellespontine sibyl, an allegory of the Passion on Calvary. In the flashing light of the gilded mosaic on the conch is the pelican gashing its flesh with its beak to feed its young with its blood, an allegory of Charity and of Christ's sacrifice on the cross. On the opposite side, on the ground, is a small icon in which two persons – Titian and his son Orazio – are adoring the Virgin and invoking her aid against the plague then ravaging Venice. The old man kneeling in front of Christ is Nicodemus. His figure, which is quite unusual here, has often been identified as a self-portrait of Titian. The body of Christ is enveloped in the pallor of death. His chest is rendered with vibrant, stringy, even dotted brushstrokes in which anatomic design gives way completely to pure color. *Room XI* contains masterpieces by artists such as LEANDRO BASSANO, JACOPO TINTORETTO, LUCA GIORDANO, BERNARDO STROZZI, BONIFACIO DE' PITATI and PORDENONE. In the upper part of the room there are frescoes transferred onto canvas by GIAMBATTISTA TIEPOLO and GIROLAMO MENGOZZI COLONNA that came from the Scalzi Church (ca. 1743). The large round canvas (diameter 5 meters) by GIAMBATTISTA TIEPOLO, *Exaltation of the True Cross* (ca. 1745) was taken from the demolished Church of the Capuchins, in Castello. In the corridor, which is *Room XII*, are some marvelous, lyrical landscapes, by 18th-century artists such as MARCO RICCI, GIUSEPPE ZAIS, FRANCESCO ZUCCARELLI, and ANTONIO and GASPARE DIZIANI, while the adjoining rooms feature works by JACOPO DA PONTE (better known as JACOPO BASSANO), PALMA GIOVANE, TITIAN and JACOPO TINTORETTO (*Room

XIII); 17th- and 18th-century artists such as ANNIBALE CARRACCI, BERNARDO STROZZI, DOMENICO FETTI, JOHANN LISS, MATTIA PRETI, SEBASTIANO MAZZONI and PIETRO MUTTONI (known as PIETRO DELLA VECCHIA) (*Room XIV*). In the next corridor, *Room XV*, you will find canvases by 17th- and 18th-century artists, including GIAMBATTISTA and GIANDOMENICO TIEPOLO, FRANCESCO SOLIMENA, GIAMBATTISTA PITTONI, GIANNANTONIO GUARDI, and GIOVANNI ANTONIO PELLEGRINI. The small adjacent rooms deserve careful attention. *Room XVI* features canvases with mythological subjects by the young SEBASTIANO RICCI and GIAMBATTISTA TIEPOLO, while *Room XVIa* is particularly interesting, with the humorous subjects by GASPARE TRAVERSI and GIUSEPPE ANGELI, as well as the sensual and enigmatic *Fortune Teller* (1740) by GIAMBATTISTA PIAZZETTA and *Judith and Holofernes* (1730-40) by his pupil GIULIA LAMA. *Room XVII*, given over to 18th-century Venetian masters, is worth a visit. Among the small canvases, note the view paintings or *capricci* by MICHELE MARIESCHI, ANTONIO CANAL and BERNARDO BELLOTTO, the view paintings and landscapes by FRANCESCO GUARDI and MARCO RICCI, the canvases by GIAMBATTISTA TIEPOLO, PIETRO LONGHI, GIAMBATTISTA PITTONI and others, and the pastel drawings on paper by ROSALBA CARRIERA, including a self-portrait executed ca. 1746. The survey of 18th-century painting continues with *Room XVIII*, with works by GIUSEPPE MORETTI, ANTONIO MARIA VISENTINI and others, and sculpture by ANTONIO CANOVA. *Room XIX* features paintings by 14th-15th century artists such as GIOVANNI AGOSTINO DA LODI, ANTONELLO DE SALIBA, MARCO BASAITI, BOCCACCIO BOCCACCINO and others. At the end of the room, at right, note *The Apparition of the Crucifixes of Mt. Ararat in Sant'Antonio di Castello Church* by an anonymous painter, in which the interior of a Venetian church is depicted in detail.

Room XX boasts the splendid
Miracles of the Cross cycle from
the Scuola Grande di San
Giovanni Evangelista. This
cycle was commissioned to
glorify the Scuola and the
miracle-working power of its
Reliquary of the Cross, which
was donated in 1369 by
Filippo de Mezières, Grand
Chancellor of the Kingdom of
Cyprus and Jerusalem. Besides
the paintings by BENEDETTO
RUSCONI (known as IL DIANA),
LAZZARO BASTIANI and GIOVANNI
MANSUETI, there are lovely
canvases by VITTORE CARPACCIO
and GENTILE BELLINI that are
"journalistic" accounts of the
city of Venice and its
inhabitants. CARPACCIO'S

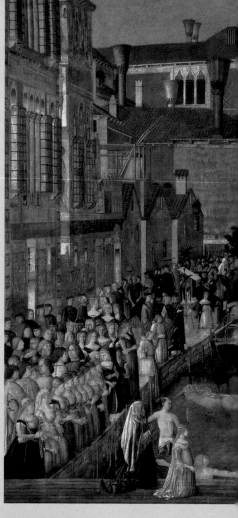

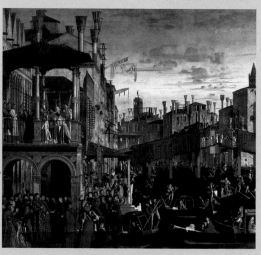

Miracle at the Rialto Bridge
(1494?) shows the Grand
Canal filled with gondolas,
with the old wooden Rialto
Bridge in the background,
over which a procession is
passing. A crowd lines the
Riva del Vin, and above it, in
the loggia (which was part of
the residence of the patriarch
of Grado that was later
demolished), the miracle of
the healed madman is taking
place. In *The Procession in St.
Mark's Square* (signed and
dated 1496), GENTILE BELLINI
narrates the public ceremony

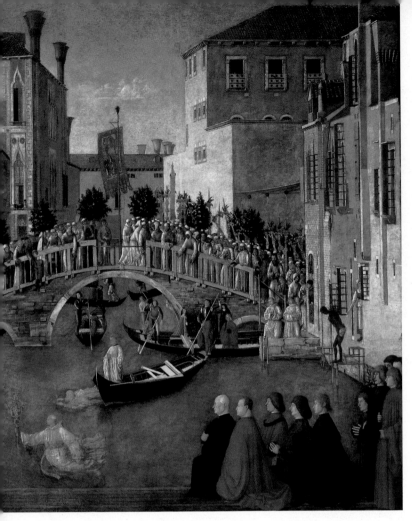

celebrated on April 25, St. Mark's Day. On that occasion in 1444, Jacopo de' Salis' son, who was seriously wounded, was cured. In the foreground are the confreres of the Scuola in white robes. The square has its old terracotta paving. In the middle of the scene is the resplendent Basilica, the old mosaics of which are depicted in detail, with their illustration of the translation of the body of St. Mark and its arrival in Venice on the portals. Today, the only

remains of these mosaics are above the Sant'Alipio portal, at left. *The Recovery of the Relic of the Cross at the San Lorenzo Bridge* (signed and dated 1500) describes a procession during which the holy relic – kept in a crystal cross – fell into the San Lorenzo canal but floated instead of sinking. Many confreres dived into the water to recover it, but the cross, animated by an invisible power, eluded everyone's grasp except that of the

superior of the Scuola, Andrea Vendramin, who brought it back. Waiting for him on the left bank is the Queen of Cyprus, Caterina Cornaro, with her retinue. Following the canons of the best Venetian tradition, GENTILE BELLINI makes the scene topical: according to historic chronicles, in fact, this episode took place at the end of the 14th century. Among the personages of that period are members of the Bellini family, seen at right.

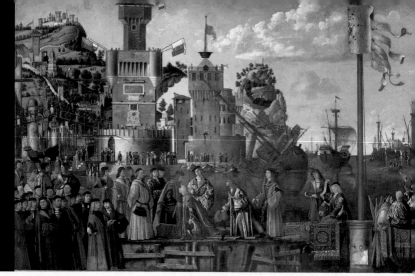

In *Room XXI* is the arresting cycle by VITTORE CARPACCIO, *The Legend of St. Ursula* (1490-95, signed) from the Scuola di Sant'Orsola, which once stood on the site now occupied by the parsonage of San Zanipolo. The setting conceived by Carpaccio, so rich in references to Venetian sites, customs and ceremonies, mirrors the taste and demands of the Scuola's members, all of whom were aristocrats. Every episode in the legend of St. Ursula is articulated in a marvelous spatial construction created by the artist's passionate and yet well-balanced vision, which merges rigorous perspective, the classical and Neo-Byzantine architecture then in vogue in Venice, and a knowledge of illustrated atlases or accounts of travels made in the East, which were a fruitful source of inspiration. There are many versions of the life of St.

Ursula, but scholars think that Carpaccio drew inspiration from Jacobus de Varagine's *Golden Legend.* King Maurus of Brittany had a daughter named Ursula, who was "honest, wise and beautiful." *The Arrival of the English Ambassadors in the Breton Court* illustrates the moment when the ambassadors ask the king to give his daughter in marriage to an English prince, while at right Ursula is laying down the conditions for her acceptance of the proposal: she had to be accompanied by ten virgins, each of which was to be accompanied in turn by a thousand other virgins; she was to have a retinue of one thousand virgins for herself; she was to be allowed to make a pilgrimage to Rome, and her future husband had to be baptized. In *The Departure of the Ambassadors*, these latter

receive the conditions of the marriage contract drawn up by a young secretary of the chancery and consigned by the king. In *The Return of the Ambassadors*, the King of England is handed the King of Brittany's reply by his messengers. In *The Meeting and Departure of the Betrothed* (1495, dated), at left the English prince takes leave of his father and the English court, while at right he arrives in Brittany and pays homage to the queen (?). On the quay, Ursula, with her fiancé at her side, is saying farewell to her father, while in the distance the 11,000 virgins are boarding the ship that will take them to Rome. In *The Dream of Ursula* (dated 1495), an angel appears in a dream, announcing the virgin's coming martyrdom. *The Meeting with the Pope* is set under the walls of Castel Sant'Angelo in Rome. *The*

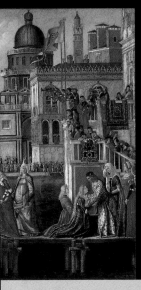

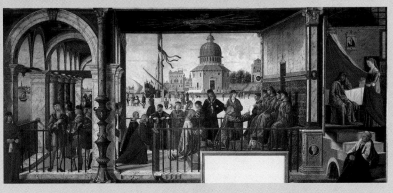

Arrival in Cologne (dated 1490) is the first canvas that Carpaccio painted for this cycle. Hearing about the arrival of the group of Christian pilgrims, the army of the pagan Huns sets off for Cologne. In the foreground, a soldier in armor is reading the secret dispatch sent by two Roman traitors. In *The Martyrdom of the Pilgrims and Funeral of St. Ursula* (dated 1493), at left we see the horrendous massacre of the virgins: "as soon as they saw them, the barbarians attacked and massacred them, like wolves descending onto meek lambs." Pope Siricius has his throat cut. Behind him, an arrow pierces the face of Cardinal Vincenzo. A Hun is thrusting his sword into the chest of the prince, lying on the ground. The kneeling Ursula is about to be killed by an arrow. The leader of the Huns is not the soldier but rather, as the sources tell us, the finely dressed archer about to shoot an arrow. To the right of the column, the solemn funeral of Ursula is taking place; as was the custom, her body is exposed on a bier. In *The Glory of St. Ursula and Her Companions* (dated 1491), Ursula, the bride of Christ, is about to be received in Heaven. She is on a pedestal of palms held together by a ring of seraphim. Two angels are about to crown her, while God the Father, dressed in the red robe of Charity, outstretches his arms, showing her the way to Paradise.

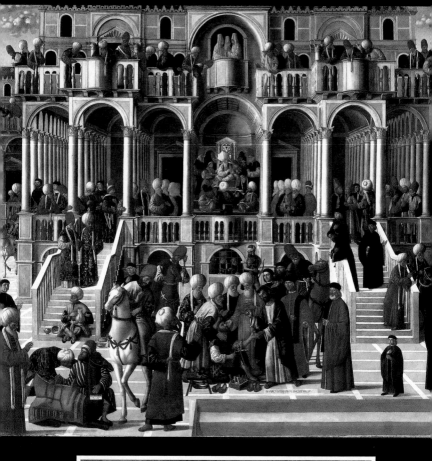

506 TOP
GIOVANNI
MANSUETI,
ST. MARK HEALING
ANIANUS.

506 BOTTOM
PALMA GIOVANE
AND PARIS
BORDONE, (?),
TEMPEST.

507 GIOVANNI
MANSUETI, SCENES
FROM THE LIFE OF
ST. MARK, DETAIL.

Now go back to Room XVIII, which affords access to *Room XXII*, with four Neo-Classical reliefs by ANTONIO GIACCARELLI, RINALDO RINALDI and JACOPO DE MARTINI. *Room XXIII*, accessible from Room XVIII or Room XXII, corresponds to the upper part of the former Carità church. The room is often used for temporary exhibitions. To your left, in line with the counterfaçade of the church, are canvases brought from the Sala dell'Albergo of the Scuola Grande di San Marco, situated in San Zanipolo Church. The visit follows the chronological order of the episodes concerning the legend of St. Mark. In *St. Mark Healing Anianus* (1518-25, signed), GIOVANNI MANSUETI, a disciple of GENTILE BELLINI, illustrates a miracle worked in Alexandria. The patron saint of Venice heals the wound that the cobbler Anianus got while repairing one of Mark's sandals. MANSUETI pays less attention to the miracle itself than to the perspective and theatrical setting. However, the central view of the sultan's palace stems from 14th-century compositional models – perhaps inspired by the Paduan school – and not from Carpaccio's elegant and vibrantly colored views. The artist's reconstruction of

Mamluk society is more interesting, which he "modernized" by depicting the dress and ceremonies of the Ottomans. Mansueti manifests the same aims in his *Baptism of Anianus* (1518, signed), now in the Brera Art Gallery, Milan, and in the *Scenes from the Life of St. Mark* (1525-26, signed). After a stay in Pentapolis, St. Mark returns to Alexandria (the splendid *Sermon at Alexandria* by GENTILE and GIOVANNI BELLINI [1504-07] in the Brera Art Gallery, Milan, concerns this period of the saint's life). According to the *Legendario Marciano* (12th-15th century), the pagan priests, concerned about the many converts to Christianity, decided to capture Mark. In *The Baptism of Anianus*, MANSUETI illustrates this episode at right, under the sultan's loggia. In the middle, in the church built by the Christians, Mark is being arrested while saying mass. At left, in prison, the saint is comforted by an angel and by Christ, who "looks the same as he was when he was with his disciples [...] He said to him: 'Peace be unto thee, Mark, my evangelist!'" These are the famous words *Pax, tibi, Marce, evangelista meus* written on the open book held by the saint or

the Lion of St. Mark in paintings or sculptures. *The Martyrdom of St. Mark* (1515-26) was painted by GIOVANNI BELLINI and finished by his pupil VITTORE BELLINIANO after his death in 1516. Here St. Mark is being dragged and beaten, and his martyrdom is witnessed by some confreres of the Scuola, who are horrified and unable to help the saint. The other canvases in the cycle describe two miracles wrought by St. Mark after his death that are closely connected to the history of Venice and the legend of the fisherman's ring, which originated in the 1300s and was published for the first time by Marcantonio Coccio in 1487. In the *Tempest* (1527-34?), PALMA GIOVANE and PARIS BORDONE (?) illustrate the original entrance to the Venice Lagoon. At left is the tower of the San Nicolò del Lido castle, which no longer exists, and in the distance is Venice. A night storm and a ship filled with devils are threatening the city. St. Mark is in a small, fragile boat, dressed in a red tunic, and by making the sign of the cross sinks the ship and calms the storm. The saint is flanked by St. Nicholas and St. George, and an old fisherman is at the stern.

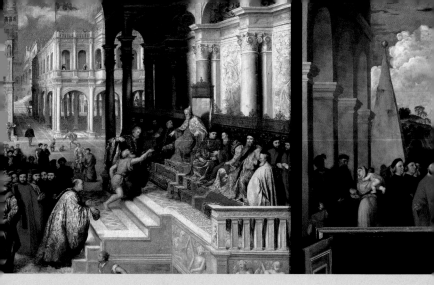

This latter, the only witness to the miracle, receives a ring from St. Mark that is to be shown as proof of their meeting. This episode is described by PARIS BORDONE in *The Ring Is Consigned to the Doge* (1550-55?). The old fisherman, having described the miracle, hands the ring over to the doge, who is here depicted as Andrea Gritti. The relic, known as the Fisherman's Ring, is kept in the Treasury of St. Mark's Basilica. On the walls of *Room XXIII* there are other important works by 15th-century artists whose style lies somewhere between the medieval and Renaissance tradition. Among these are LAZZARO BASTIANI, JACOPO, GENTILE and GIOVANNI BELLINI, ALVISE and BARTOLOMEO VIVARINI, CARLO CRIVELLI and ANDREA DA MURANO. For the elegant workmanship of Gothic carving, observe the polyptych (signed and dated 1470) by the Veronese BARTOLOMEO GIOLFINO, situated on the wall before the left chapel in the rear. *Room XXIV* was once the Sala dell'Albergo of the Scuola della Carità, where the meetings of the confraternity's governing bodies were held. Among the works kept in this hall right from the beginning are the *Enthroned Madonna and Saints* triptych (dated 1146) by ANTONIO VIVARINI and GIOVANNI D'ALEMAGNA, and the reliquary donated to the Scuola by Cardinal Bessarion in 1463, as well as the *Presentation of Mary in the Temple* (1534-39) by TITIAN. The *Quadreria* or picture gallery, which has an additional collection opened to the public in 1994, is in the Palladian wing. It can be visited by appointment only.

508 BOTTOM
JACOPO TINTORETTO,
PRESENTATION OF
JESUS IN THE TEMPLE.

508-509 TITIAN,
PRESENTATION OF
MARY IN THE
TEMPLE.

509 BOTTOM
ANTONIO VIVARINI
AND GIOVANNI
D'ALEMAGNA,
ENTHRONED
MADONNA AND
SAINTS.

508 TOP PARIS BORDONE, THE
RING IS CONSIGNED TO THE
DOGE.

To get there, go through the door in Room XV and up the oval staircase designed by ANDREA PALLADIO. The hall, consisting of a long corridor whose walls are covered by a great deal of paintings, is fascinating. Most of the works in this collection are by NICOLÒ DI PIETRO, LAZZARO BASTIANI, VITTORE CARPACCIO, GIOVANNI MANSUETI, BARTOLOMEO MONTAGNA, FRANCESCO BISSOLO, CIMA DA CONEGLIANO, MARCO BASAITI, BENEDETTO RUSCONI (known as IL DIANA), ROCCO MARCONI, PALMA VECCHIO, PARIS BORDONE, JACOPO BASSANO, PAOLO VERONESE, PALMA GIOVANE and many others. About halfway down the right-hand wall you can admire two canvases by JACOPO TINTORETTO, a marvelous *Presentation of Jesus in the Temple* (1554-55) and a dramatic *Pietà* (1559-60). In the former work, besides the star shining on

the head of the young Jesus, note the curious slip made by the artist: he forgot to paint Mary's feet. In the second work, Christ's face is immersed in the darkness of death. The shadow is cast by the inconsolable Mary Magdalene, who is bending over with her arms outstretched. A more controlled conception of human suffering and grief is evident in the touching and sensual *Deposition* (1664-74

by the Neapolitan artist LUCA GIORDANO. Among the other 17th- and 18th-century artists, mention should be made of DOMENICO TINTORETTO, ALESSANDRO VAROTARI, FRANCESCO MAFFEI, GIOVANNI ANTONIO FUMIANI, GREGORIO LAZZARINI, GIAMBATTISTA PIAZZETTA, MICHELE MARIESCHI, FRANCESCO ZUGNO, GIAMBATTISTA and GIANDOMENICO TIEPOLO, ALESSANDRO LONGHI and DOMENICO PELLEGRINI.

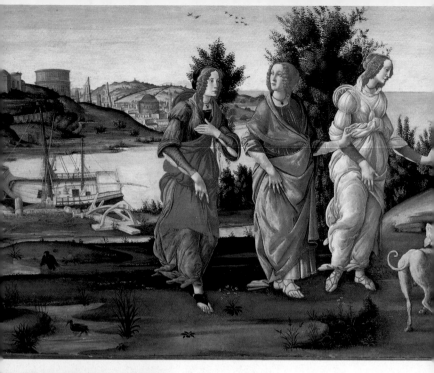

510-511 S. BOTTICELLI AND ASSISTANTS, JUDGMENT OF PARIS.

511 PIERO DI COSIMO, MADONNA AND CHILD WITH TWO ANGELS AND DETAIL.

510-511 S. BOTTICELLI AND ASSISTANTS, JUDGMENT OF PARIS.

510 BOTTOM FILIPPO LIPPI, MADONNA AND CHILD, SAINTS, ANGELS AND DONOR AND DETAIL.

Once out of the Accademia, note to your right the Accademia bridge, built in 1934 to a design by the engineer EUGENIO MIOZZI to replace the older iron bridge designed by the engineer G.H. NEVILLE and opened to the public in 1854. With the help of a map, go to the Piscina del Forner,

where there is the Palazzo Cini, home of **Giorgio Cini Foundation Art Gallery** (no. 864), with a fine collection of Renaissance paintings and *objets d'art* collected by the entrepreneur and art patron Vittorio Cini, who lived in the palazzo until his death in 1979. There are fourteen paintings by Ferrarese masters such as COSME' TURA, ERCOLE ROBERTI, LUDOVICO MAZZOLINO, LORENZO COSTA and BATTISTA DOSSI. Among the Tuscan school paintings, besides the ones by PIERO DELLA FRANCESCA, FILIPPO LIPPI and JACOPO CARRUCI (better known as PONTORMO), there is the *Judgment of Paris* (1485-88)

by BOTTICELLI (ALESSANDRO FILIPEPI) and his workshop, and the charming *Madonna and Child with Two Angels* (1505-10) by PIERO DI COSIMO. Among the objects, there are a hope chest dating from 1340-60 and probably of Sienese origin, and a Neapolitan sedan chair (1770-85), as well as 275 pieces of a porcelain table service (1785-95) made by the Cozzi manufacturers in Venice.

In nearby Campo San Vio is the **Anglican Church of St. George**, built in 1926 to a design by the engineer MARANGONI in memory of the British soldiers who died on the Italian front in World War One.

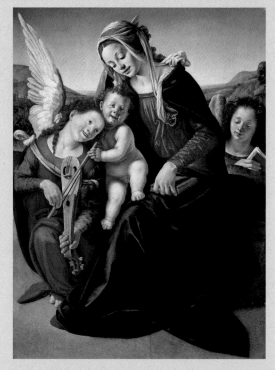

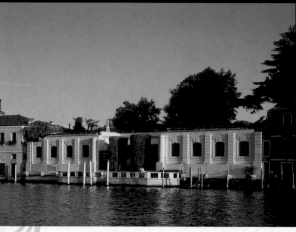

■ After going down the side street you come to the enchanting *fondamenta*, at the end of which is **Ca' Venier dei Leoni**, home of the **Peggy Guggenheim Collection** (no. 704).

HISTORY: the massive Ca' Venier dei Leoni, designed by LORENZO BOSCHETTI in 1749, was left unfinished, which is part of its charm, as can be seen in the long façade, interrupted on the ground floor, overlooking the Grand Canal. In 1948, the building was purchased by Peggy Guggenheim, who became a passionate collector of art works of the first half of the 20th century, in particular Cubist, Surrealist and abstract art.

The collection is still the most important one of its kind in Italy. After her death, Ca' Venier was taken over by the Solomon R. Guggenheim Foundation in New York City, which changed it from a home into a museum. At the end of the large courtyard, named after Sandro d'Urso, is the *Cascata digitale* (*Digital Falls*, 2003), which FABRIZIO PLESSI created by placing, at the end of a textural cor-ten steel window, a rather blurred and granular video image of a waterfall accompanied by the noise of an air conditioner. In the right-hand section of the small courtyard with a well-curb is the original, magical wrought-iron *gate* (1961) with coloured glass "stones" by CLAIRE FALKENSTEIN: (1909-98). A short stairway takes you

to the NASHER SCULPTURE GARDEN: besides works belonging to the museum, this outdoor collection also includes pieces from the Raymond and Patsy Nasher Sculpture Collection in Dallas, Texas.

This tree-lined garden articulated in three communicating spaces has works by artists such as HENRY MOORE, RAYMOND DUCHAMP, BARRY FLANAGAN, MIRKO, MIMMO PALADINO, JOEL SHAPIRO, ROSALDA GILARDI and ULRICH RUCKRIEM. At left, along the right-hand wall you will see the blue neon sign: *Se la forma scompare, la sua radice è eterna* ("The form may disappear, but its root is eternal"; 1982-89) by MARIO MERZ.

This phrase by the Turin artist is an anachronistic paraphrase of the spiritual

teachings of Kandinsky and Malevich. Opposite the pseudo-medieval throne with fragments of a 12th- century frieze, is the *"Leoni" Woman* (1947, cast in 1957) by ALBERTO GIACOMETTI. This indefinite, thin, elongated figure evokes the shadow of a spirit wandering in silent space.

By following the wall of the garden, next to the round table, note the surreal and poetic *Amphora-Fruit* (1946?, bronze, cast in 1951) by JEAN ARP. A little further on you will come to the corner where the ashes of Peggy Guggenheim (1898-1979) are buried; next to them are the remains of her fourteen dogs. In the nearby flowerbed are the *Two Figures* (1950-52) by LUCIANO MINGUZZI.

Proceeding clockwise, you will come to *Tauromachy* (1953, bronze) by GERMAINE RICHIER, a cross between Picasso and Giacometti. The nearby stairway leads into the Ca' Venier dei Leoni, where Peggy Guggenheim lived and where the most prestigious works in her collection are located. The sequence of works described here may vary for reasons of available exhibition space or because of temporary loans of works to art shows. Once past the entrance, go left into the so-called dining room, which features works by artists such as PABLO PICASSO, GEORGES BRAQUE, MARCEL DUCHAMP, UMBERTO BOCCIONI, FERNAND LÉGER and FRANCIS PICABIA. Of special interest, on the

right-hand wall, is *The Poet* (1911) by PICASSO, in which the artist has clearly abandoned naturalistic painting. The figure is represented from different points and his portrait is the simultaneous depiction of fragments viewed from various perspectives. Therefore, painting becomes an audacious and personal play of thought and memory expressed by means of a simplified palette, the antithesis of the fiery world of colors in nature and its visual perception. Going counter-clockwise, next to the window is the *Maiastra* (1912?, bronze) by CONSTANTIN BRANCUSI. The mythical bird of Romanian folklore here becomes an idol whose form, drawn from solid geometry, projects it into a dimension of absolute purity.

Our next stop is the former kitchen, featuring Futurism and abstract art. GINO SEVERINI expresses one of the key concepts of the Futurist movement, dynamism, in his *Sea=Dancer* (1914). The curved planes defined by the movements of the body and the skirt are transformed into color – applied in slashes – and even spill over onto the frame, the inviolable boundary of static, academic painting. This vision in movement gives rise to the equally dynamic association of light on the waves of the sea. Having already embarked on the road to abstraction, of which he was one of the pioneers, the Russian VASSILY KANDINSKY, in his *Landscape with Church (with Red Spots)* (1913), frees nature from its outlines and its perspective depth, almost depriving it of any shape and creating pure sensations aroused by color.

After going down the west corridor, with works by MARC CHAGALL, PAUL KLEE and others, you enter the living room, given over to Constructivism and the De Stijl movement, which rose up respectively in Russian and Holland. In *Composition* (1938-39), PIET MONDRIAN, already a "veteran" abstract artist, conceives the canvas as a stained-glass window whose "pattern" is created by fields of light and color and by the lines separating them. The perfection of this painting is the result of a gradual "purification" of the figurative and expressive and of a hidden and skillful calculation of geometric and numerical proportions.

This room communicates with the former library, featuring Surrealism and artists such as CONSTANTIN BRANCUSI, GIORGIO DE CHIRICO, MAX ERNST, JOAN MIRÒ and YVES TANGUY. Back in the entrance hall, on the walls are works by PICASSO and, in the middle, the painted aluminum and wire *Mobile* (1941) by

ALEXANDER CALDER, a magical work redolent with naturalistic and infantile evocation, a sort of anti-sculpture in that it has no base and its constantly mutating form is determined by casual movements of air. The nearby terrace on the Grand Canal is dominated by *The Angel of the Citadel* (1948, cast in 1950?) by MARINO MARINI. This sculpture is the last of a long series of equestrian statues placed in Venice from the 1300s on. Marini's horseman has no identity. He is an angel, in ecstasy - with an erection that Marini thoughtfully created as a separate piece, in case Guggenheim wished to remove it before company arrived. (After the phallus was stolen and recast more than once, it was permanently soldered onto the sculpture.).

516 TOP MAX ERNST, *THE ATTIREMENT OF THE BRIDE*.

516 BOTTOM AND 517 PAUL DELVAUX, *THE BREAK OF DAY*, AND DETAIL.

Going back into the entrance hall, you can enter the spacious room dedicated to Surrealism. At left is the ghastly, Kafkaesque *Woman with Her Throat Cut* (1932, cast in 1940) by ALBERTO

GIACOMETTI, placed on a wooden base similar to the one used for the 1942 Surrealist show held in New York, "Art of this Century." At right, by the same artist, is the *Headless Woman* (1932, plaster), one of Giacometti's most ethereal and delicate female portraits, set in a world suspended between Cycladic and Greek sculpture. Along the right-hand wall, the German MAX ERNST, who married Peggy Guggenheim, in *The Forest* (1927-28) describes nature with the hallucinatory glance of the unconscious, and in *The Attirement of the Bride* (1939-40) and *Anti-Pope* (1941-42) places the viewer before hermetic enigmas filled with erotic overtones. On the wall opposite the entrance is *Empire of Light* (1953-54) by the Belgian RENÉ MAGRITTE. This artist is figurative, but introduces the viewer to a paradox: a house in a forest at night stands under a brilliant

daytime sky. The painter represents two opposite moments in the same space, signs of the maximum presence-absence of light.

Other Surrealist works are in the east corridor, while the former guest room is given over to the Abstract Expressionism of JACKSON POLLOCK. In *Alchemy* (1947), the exponent of Action Painting uses oil, aluminum and string. Unlike Kandinsky or Mondrian, his abstract art is highly gestural, at times chaotic and spontaneous, at other times regular and with a marked rhythm, like American Indian dances. The pictorial space has no center. The color, which in some cases is applied by dripping, covers the entire surface in a hypnotic, inextricable pattern.

In the former bedroom is the magical *Bedhead*, made in silver by ALEXANDER CALDER, while in the former wardrobe room there are sculptures

by ARP and MOORE. At the end of the corridor is the passageway leading to the "*barchessa*" wing, which boasts the prestigious Gianni Mattioli Collection. This Milanese art-lover (1903-77) purchased Futurist masterpieces and rare paintings by GIORGIO MORANDI and AMEDEO MODIGLIANI. Among the Futurist works, note the preparatory drawing for *The City Rises* (1910) and *Matter* (1912) by UMBERTO BOCCIONI; *Interventionist Demonstration* (1914) by CARLO CARRÀ; *The Solidity of Fog* (1912) by LUIGI RUSSOLO; *The White Horse* (1919) by MARIO SIRONI.

Once out of the *barchessa*, go back to the Sculpture Garden and proceed left, in the two outdoor areas, which feature other art works. The innermost space has JENNY HOLZER's *Garden Bench* (2001). Retracing your steps, go up the nearby stairs that lead to the separate wing of the museum, which is used for temporary exhibitions and also houses the Museum Café, with interesting photographs of artists and of Peggy Guggenheim.

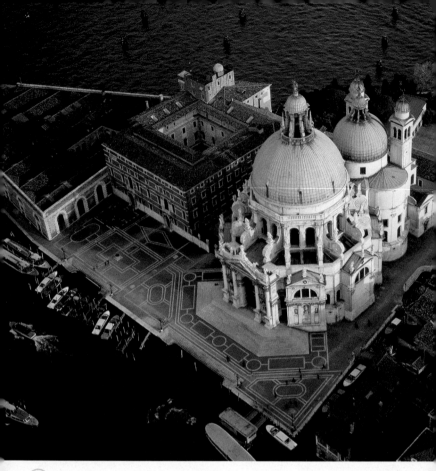

After your visit to the Guggenheim Collection, turn left and proceed straight ahead until you come to the characteristic Campiello Barbaro. Farther along, at the end of Calle del Tragheto, you will see the Grand Canal. During the Festa della Salute (November 21) a temporary bridge is built here. In the distance you can see Santa Maria del Giglio. At the end of the street is the former church of **San Gregorio**, rebuilt in Gothic style in the mid-15th century by ANTONIO DA CREMONA. The façade, with a pitched central mass, has a portal and rose window, as well as two superposed, tall and narrow double-lancet windows that are much like the type on the apses of the Frari Church. Along the canal you can see the exterior of the three apsidal chapels of San Gregorio Church.

Once over the Ponte de l'Abazia, you come to **Santa Maria della Salute Basilica**. HISTORY: in the late 1630s, while a terrible plague was raging, the Senate made a vow to build a new church dedicated to the Virgin Mary, in the hope of divine aid in putting an end to the epidemic. In 1630-31, about 682,000 persons died in Venice and on the mainland. Among the designs proposed, the city opted for the one presented by BALDASSARE LONGHENA. In his proposal, the young architect explained that, in order to ennoble the building he had decided upon a central plan, which was something new for Venice, and that its shape should resemble that of a crown because the church was dedicated to the Madonna. The first stone was laid in 1631. Around

Miani (or Emiliani; 1481-1537). The friars were housed in an adjoining monastery, now the Seminario Patriarchale. As is the case with the celebrations of the Redentore Church on Giudecca island, the Venetian Church continues to celebrate the feast day of the Salute (November 21), during which, in order to shorten the procession route, a temporary bridge of boats is laid out over the Grand Canal, off Campo del Tragheto, near Santa Maria del Giglio Church. EXTERIOR AND FAÇADE: the church consists of two bodies, both of which are surmounted by a cupola and set on a tall socle or stylobate. This expedient allowed LONGHENA to make the tall structure even more visible, turning it into one of the most spectacular sights in the city and a favorite subject for artists of all periods. Its changing chiaroscuro effects are the result of the architect's masterful skill in highlighting the plastic qualities of the architecture and sculpture. The façades along the octagonal perimeter of the main body seem to suggest movement outward, as if the church,

driven by invisible inner forces, were expanding and occupying the space around it. The spiral volute buttresses that counteract the outward thrust of the cupola have an unusual shape that was achieved by enlarging the volute of an Ionic capital, the Marian

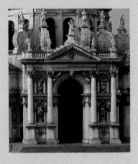

classic order *par excellence*. The entrance façade, unlike the side ones, which are of the Corinthian order, is wider and has giant composite half-columns. Its view is enhanced by the triumphal canal quay, at the sides of which are the heads of two cherubs at water level, which were perhaps placed there to allude to the basilica as the Ark of the Covenant. The sumptuous façade abounds in statues and reliefs. On the two spandrels that lie over the entrance, the Sibyl of Cumae and Eritrea allude to the Annunciation and

1674, the basilica was almost finished, while the sculptural and architectural decoration, both inside and out, were completed around 1687, when the official consecration took place.

Of the 17th-century churches in Venice, the Salute is undoubtedly the most prestigious, and it also one of the few that has retained its original appearance. The church was placed under the religious management of the Somaschi, whose order was founded by the Venetian saint Girolamo

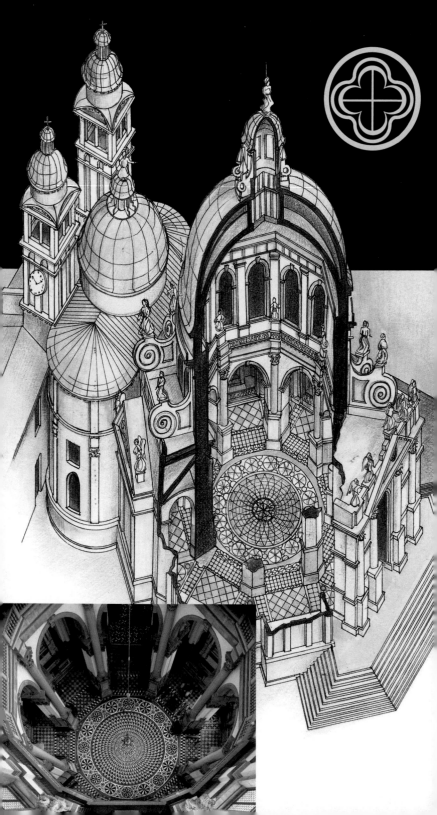

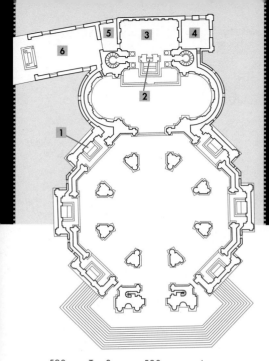

521 BOTTOM CUPOLA LANTERN AND STATUE OF THE VIRGIN.

520 TOP THE SALUTE BASILICA, CUTAWAY.

520 BOTTOM INTERIOR OF THE SALUTE BASILICA.

the virginity of Mary, while in the four niches the Evangelists (ca. 1660) by TOMMASO RUER refer to the good tidings in the New Testament. The eight-pointed star in the middle of the tympanum is the symbol of Mary as our spiritual guide (*stella maris*) and path to salvation. The Virgin Mary's glorification is achieved in the statue crowning the tympanum, which depicts the *Crowned Madonna and Child* (ca. 1663), or Regina Coeli. And the other statues, scattered around the building like members of a heavenly choir, refer to Mary's virtues as Mother of God and allegory of the Church. At the apex of this extraordinary holy theater, above the cupola lantern, is the wooden statue of the Virgin Mary (a 19th-century copy of the original). Her figure, taken from the Revelation of St. John, evokes the triumphant "[...] woman clothed with the sun, and the moon under her feet, and upon her head a crown of twelve stars." The eight obelisks around the lantern and the staff held by Mary are the distinguishing signs of the prestigious military office of Capitan da Mar, or admiral. The Madonna therefore takes on the role of protectress of the Venetian Republic on the seas. This is confirmed by the statue of St. Mark, the patron of Venice, in the nearby smaller lantern. It may be that the allegories crowning the church reflect the anguish and hopes of those difficult years, when the Ottomans conquered the island of Crete (1669) and the Venetians managed to regain, temporarily, the Peleponnesus, often called the Morea.

522 Madonna della Salute.

523 top Interior of the Salute Basilica.

523 bottom Salute Basilica, main cupola.

INTERIOR: this has an octagonal plan with an ambulatory and six radiating chapels. Each of the piers is delimited internally by two Corinthian half-columns and, toward the central area, by a giant composite column. The broad chancel, widened at the sides by two wide exedrae, was inspired by Palladio's design for the Redentore church. The high dome, modeled after the one in St. Mark's Basilica, consists of an external wooden drum cased with lead and an inner drum made of masonry. The statues in the interior – prophets, apostles and saints – are divided into cycles with the aim of glorifying Mary and the Church. Note the marvelous polychrome marble floor, in the middle of which are five ancient roses – the symbol of Christ and his sacrifice – around the inscription (dated 1631): *Unde Origo, Inde Salus*. Here "Salus" has a two-fold meaning: physical health (referring to the plague) and spiritual salvation. Therefore the phrase is to be interpreted as a biblical precept:

"Salvation comes from God."

Each altar in the six chapels, executed in 1656-74, is dedicated to a mystery in the life of Mary, except for the second at left, which is dedicated to St. Anthony of Padua. The altarpieces in the first three altars at right were painted by the Neapolitan artist LUCA GIORDANO between 1674 and 1677, those on the first two altars at left are by PIETRO LIBERI, and the altarpiece on the third altar at left was painted by TITIAN, and partly by his son ORAZIO VECELLIO. This latter work (1546) is entitled *The Descent of the Holy Ghost* (or *Pentecost*) and came from the Santo Spirito in Isola Church. The chancel revolves around the majestic high altar conceived by LONGHENA and crowned by marble statues sculpted by JUSTE LE COURT (1670-74). The two side figures, St. Mark and St. Lorenzo Giustiniani, exalt the apostolic and patriarchal origins of the city. The central group, which is the masterpiece of this Flemish sculptor, represents the *Madonna and Child Ridding Venice of the Plague*. This is an allegory that summarizes the history of the Salute basilica. Venice appears in the guise of a dogaressa who, richly attired, is kneeling before Mary to beseech her help, while at right, the plague is in the guise of a decrepit old woman shouting and fleeing.

The *Madonna della Salute* icon (12th century?; touched up in later centuries) was brought to the church from Candia, the capital of Crete (conquered by the Turks), and is still a popular object of worship in Venice. As she is indicating the Lord with her left hand, this Madonna is part and parcel of the church's iconographic program. In fact, her image belongs to the iconographic type known as the Odighitria, which means "She who shows the way."

Behind the altar are three areas: the smaller sacristy, the choir, and the ante-sacristy, which contain works by artists such as BARTOLOMEO BON, TULLIO LOMBARDO and GIUSEPPE PORTA (known as SALVIATI).

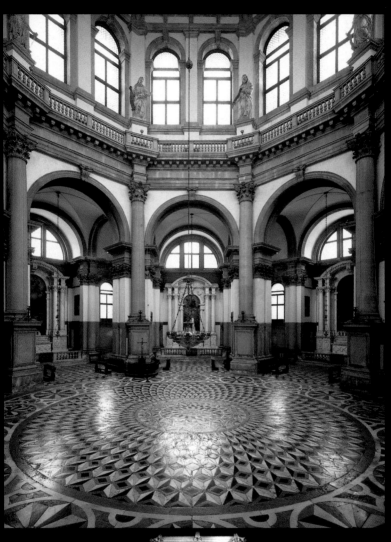

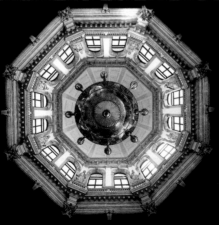

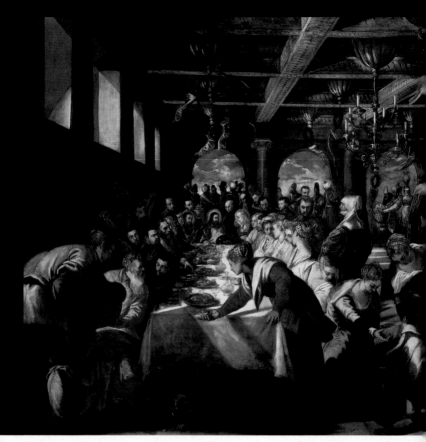

A visit to the great sacristy is recommended, since it is used as a picture gallery. This room connects the church with the Seminario Patriarcale. Most of the paintings in this sacristy are by 16th-century artists. The three canvases on the ceiling – *Cain and Abel*, *The Sacrifice of Isaac*, and *David and Goliath* (1542-44) – are by TITIAN and his workshop and come from Santo Spirito in Isola. Among the other notable works are three canvases by GIUSEPPE PORTA and the panel with *St. Roch, St. Jerome and St. Sebastian* attributed to PORDENONE on

the wall of the main entrance; *The Prophet Jonah and Samson* by PALMA GIOVANE on the right wall and, in the middle, *The Marriage at Cana* (signed and dated 1561) by JACOPO TINTORETTO, which comes from Santa Maria dei Crociferi Church. Unlike the guests in Veronese's great painting of the same subject, Tintoretto's are dressed more simply, much like artisans or middle-class Venetians. At the end of the long table, Jesus is speaking with the mother, who has just asked him to help the bride and groom, who have

no wine for their guests. The table is overflowing with food, but the elegant glass goblets are empty. In the foreground, a servant is pouring the water used for the purification rites and which, thanks to Christ's miracle, will turn into wine. Besides celebrating the sanctity of marriage, this subject was interpreted as a prototype of the Eucharist. On the side walls are eight tondi painted by TITIAN and his workshop depicting the Evangelists and the Doctors of the Church (1542-44). St. Matthew has been identified as a self-portrait of Titian.

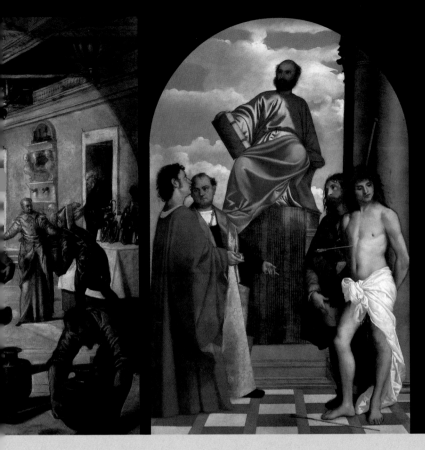

This master also painted the beautiful altarpiece, *St. Mark Enthroned between Saints Cosmass, Damian, Roch and Sebastian* (ca. 1510), which comes from the altar of St. Mark in the church of Santo Spirito in Isola, which was demolished. This work exalts the miracle-working power of the patron saint of Venice. At his feet, at left, are the two physician saints, Cosmass and Damian. One of them is holding a small bottle which may contain treacle, which at the time was considered a cure-all. The other is indicating St. Roch who, in turn, is showing us the already incised plague bubo on his thigh. Next to Roch is the totally isolated figure of St. Sebastian, whose help was invoked against epidemics. The message to the faithful is quite clear: the cure, obtained through the intercession of the saints, comes from Heaven, toward which St. Mark is looking. Before ending your visit in the Salute, note, above the door of the left-hand wall, the votive panel in chased silver by ANTONIO BONACINA, *St. Anthony Saving the Venetian Fleet from the Plague* (1687).

524-525 JACOPO TINTORETTO, *MARRIAGE AT CANA.*

525 TITIAN, *ST. MARK ENTHRONED AND SAINTS.*

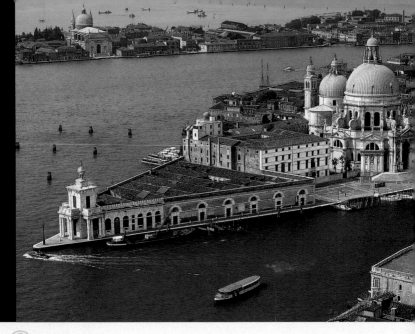

■ After leaving the church, at left you will see the Palazzo del Seminario (no. 1), designed in 1671 by BALDASSARE LONGHENA and entrusted to the Somaschi fathers. Since 1817 it has been the home of the **Seminario Patriarcale**. Along the walls is the **Raccolta Lapidaria**, a fine collection – partly the work of Abbot Giannantonio Moschini (1773-1840) – consisting of various works such as funerary epigraphs and tombstones, bas-reliefs, memorials, tombs, busts and statues dating from the 1st century to the 17th century. At the end of the arcade at left is the entrance to the **Oratorio della Santissima Trinità**, originally built by the Teutonic Knights in the late 13th century and rebuilt at

the end of the 17th century. On the counterfaçade is the elegant marble funerary urn of the procurator Giannantonio Stella (d. 1525), which was brought here from San Gemigano Church, which no longer exists. On the landing of the 17th-century grand staircase are statues of the patron saints and founders of the Somascan order – St. Augustine, Pope Paul II, St. Girolamo Miani and Pope Pius V – sculpted by the school of JUSTE LE COURT. There is also the soffitto decoration with *St. Girolamo Miani in Glory* by ANTONIO ZANCHI (1631-1722) and, outside, the charming garden where the Umiltà church stands.
At the end of the staircase, at left, is the entrance to the antechamber of the

Pinacoteca Manfrediniana, where there are interesting 14th- and 15th-century reliefs. Most of this picture gallery was bequeathed to the Seminary by Marquis Federico Manfredini, from Rovigo (1743-1829), who collected the works during his long stay in Florence at the court of the grand dukes of Tuscany. Among the works noteworthy is the extraordinary sculpture group of the *Madonna and Christ Child with One of the Magi and St. Joseph* (13th century) by a great master of the school of ANTELAMI.
In *Room II*, at right, there are five terracotta busts by ALESSANDRO VITTORIA, including, in the middle, one of Doge Nicolò da Ponte (1578-85) and, at left, the fine *Penelope* by the Sienese artist DOMENICO BECCAFUMI

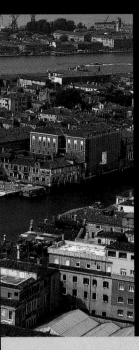

(1486-1551) and a bust by GIANLORENZO BERNINI. Among the many paintings in Room III, there is the sweet and melancholy *Portrait of Lucrezia Minerbetti* by ALESSANDRO ALLORI, a terracotta bust of the Somascan father Amadei, a youthful work by ANTONIO CANOVA, the sketch of *The Holy Family and St. Clare* by GIOVAN FRANCESCO BARBIERI, better known as GUERCINO (1591-1666), the large canvas by FRANCESCO FONTEBASSO (1709-69) of *St. Francis of Paola Healing a Blind Child* and, in the showcases in the middle of the room, the monochrome sketch by the German artist ANTON RAPHAEL MENGS (1728-79) of *Perseus and Andromeda.* As you leave the Pinacoteca, at the end of the corridor at right is the Library; on its ceiling are three canvases by ANTONIO ZANCHI, SEBASTIANO RICCI and NICOLÒ BAMBINI. Proceeding along the inner corridor, you come to the vestibule of the refectory. In the refectory is a large canvas, *The Last Supper* (signed), on the back wall, by the Dominican GIOVANNI SISTO LAUDIS (ca. 1583-1631), an amateur painter influenced by Veronese and Tintoretto. Once out of the Palazzo del Seminario, proceed to your right along the canal street lined by the former Magazzini del Sale (salt warehouses), which end in the massive, triangular ex-**Dogana da Mar** (customs house), rebuilt to a design by GIUSEPPE BENONI in 1667. This building is characterized by a jutting body resting on paired Doric columns and pilasters with rusticated shafts. The control tower for maritime traffic is surrounded by a balustrade and surmounts one of the most famous sculptures in Venice, the work of BERNARDO FALCONE, known as the Palla d'Oro (golden ball). This is an image of the universe supported by two bronze telamones and crowned by a statue representing Fortuna who, like an acrobat, is standing on one leg while displaying a small standard. Thanks to a mobile pivot and the wind, the figure serves as a weathervane that helped boatmen and also reminded the Venetians of the caprices of Fortune. This theatrical Baroque invention concealed the gradual decline of Venetian maritime supremacy.

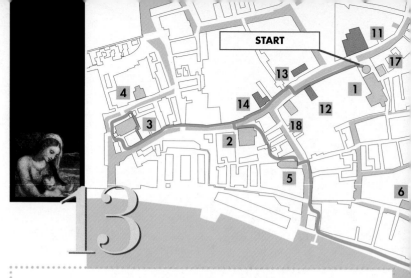

START

FISHERMEN AND CHURCHES

This itinerary covers two main urban areas, both in the Dorsoduro district. The first one, which goes from the Carmini Church to the Angelo Raffaele and Mendicoli churches, is one of the oldest in Venice. The island of San Nicolò dei Mendicoli was its hub, both because of the waterway connecting it to the mainland, toward Fusina, and because of its flourishing fishing trade.

The inhabitants enjoyed special privileges, such as the right to elect their own *gastaldo*, a steward or guardian, who was called the Doge of the Nicolotti, who, besides taking part in the water procession during the Ascension Day feast, had the right to a stall in the profitable Rialto fish market.

The second area is the Zattere, whose long and fascinating street along the Giudecca Canal was in many ways similar to the Riva degli Schiavoni. *Squeri* (shipyards and boatyards), quays and piers, modest houses and many warehouses (which can also be seen in the old maps) reveal the original shipbuilding and port functions of this zone. The present-day Zattere, with its palazzi, Scuole and churches, originated with the construction of the long *fondamenta* in 1519.

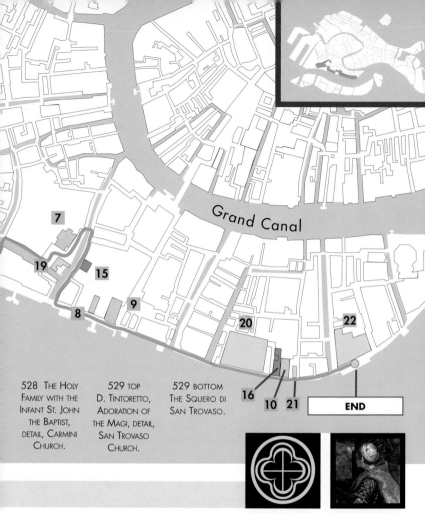

Grand Canal

7

19

15

8

9

20

22

16

10

21

END

528 THE HOLY FAMILY WITH THE INFANT ST. JOHN THE BAPTIST, DETAIL, CARMINI CHURCH.

529 TOP D. TINTORETTO, ADORATION OF THE MAGI, DETAIL, SAN TROVASO CHURCH.

529 BOTTOM THE SQUERO DI SAN TROVASO.

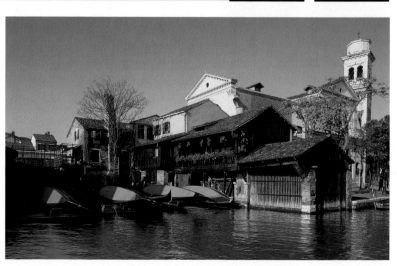

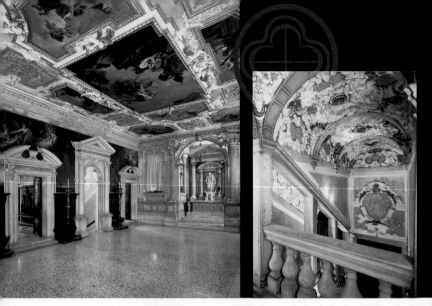

■ In the immediate vicinity of Campo Santa Margherita, along the short Calle de le Scuole, is the **Scuola Grande di Santa Maria del Carmelo**, better known as **Scuola dei Carmini**. HISTORY: this confraternity, which was officially founded in 1597, was already active in 1591 and probably originated in a women's charitable institution known as the Pinzocchere dei Carmini. These pious women, who

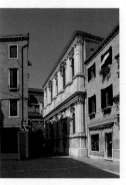

lived in a house called Santa Maria della Speranza, were devotees of the Virgin Mary, and in 1300 were recognized as tertiaries of the Carmelite friars in the nearby monastery. They were responsible for making the scapulars, the two small squares of cloth fastened together by ribbons or strings that the Carmelites had to wear under their clothes to enjoy the privilege – approved by Pope Clement VII in 1530 – of their souls being freed from the sufferings of Purgatory on the Saturday after their death. The scapular was not a talisman, but testimony of a person's love of the Virgin Mary. It was also called *pazienza*, hence the name of the nearby Calle de le Pazienze, in the houses of which a great number of these manifestations of hope

were manufactured. The scapular cult is connected to the Carmelite order, and the Scuola dei Carmini, although consisting of laymen, is still the repository of this form of devotion, which dates back to the mid-12th century. The building that is the home of this institution was constructed in 1627-38 to a design by FRANCESCO CAUSTELLO. FAÇADES: the construction of the two façades (1668-70) was entrusted to BALDASSARE LONGHENA. The rather small size of the main façade led the architect to use low paired half-columns and very tall pedestals. The capitals on the ground floor are Corinthian, while those on the upper floor are composite. The side façade, on the other hand, is articulated in three registers and has pilasters and pilaster strips, and the ground floor

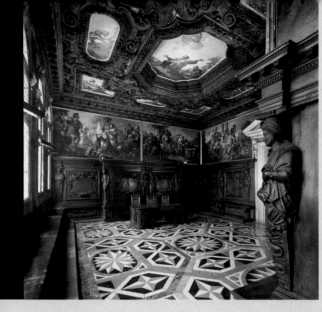

has a rusticated wall. Note the flagstaff with the flagpole for the standard of the Scuola, topped by a gilded statuette of the *Madonna del Carmelo*. INTERIOR: the ground floor is dominated by the wide chapel, on the walls of which are monochrome representations of the *theological virtues* and some *episodes from the life of Christ and Mary*, conventional works by NICOLÒ and GIOVANNI BAMBINI (1728-39). The altarpiece is the *Madonna del Carmelo* (1728) by SANTO PIATTI. Having gone up the double-ramp stairway with lavish stucco vaulting by ALVISE BOSSI (1728-29) and frescoes by SANTO PIATTI, you enter the CHAPTER HOUSE, which contains the statue of a *Madonna and Child* by BERNARDINO DA LUGANO. The walls are decorated with eight 17th-century paintings representing the miracles of the Virgin Mary, the life of Jesus, and the cult of the scapular, by ANTONIO ZANCHI, AMEDEO ENZ, SANTO PIATTI and GREGORIO LAZZARINI. The extraordinary ceiling (1740-49) with the sophisticated stuccowork by ABBONDIO STAZIO is made even more astounding by nine paintings by GIAMBATTISTA TIEPOLO. The purpose of this cycle was the glorification of the Madonna del Carmelo. In the central canvas, TIEPOLO portrays St. Simon Stock (d. 1265), the English Carmelite who, according to tradition, had the privilege of receiving the scapular from the Virgin Mary. This friar, seated on a platform, has his eyes closed, in the typical act of meditative contemplation. Below him are bones and skulls that evoke the resurrection of the dead and the Last Judgment. At right, the flames of Hell are devouring a terrified soul while with anguish he notes another person in prayer who is leaving Purgatory and is rising to Paradise. On high, in one of the most amazing achievements in foreshortening and luminism in Venetian painting, a cluster of angelic creatures serves as a sort of triumphal chariot for the ineffable and pure Virgin Mary, whose imperious glance is worthy of the queen of the heavens. In the Sala dell'Archivio (Hall of Archives) can be seen wooden framework carved by GIACOMO PIAZZETTA (father of Giambattista), canvases by GIUSTINO MESESCARDI, GAETANO ZOMPINI and GIAMBATTISTA PIAZZETTA. The canvases in the adjacent room, used as a meeting hall for the brotherhood's chancery, are by AMBROGIO BON (1697), a pupil of Johann Carl Loth, ANTONIO BALESTRA (1700-03), GIUSTINO MESESCARDI (1749-53) and ALESSANDRO VAROTARI, better known as IL PADOVANINO (1634-40).

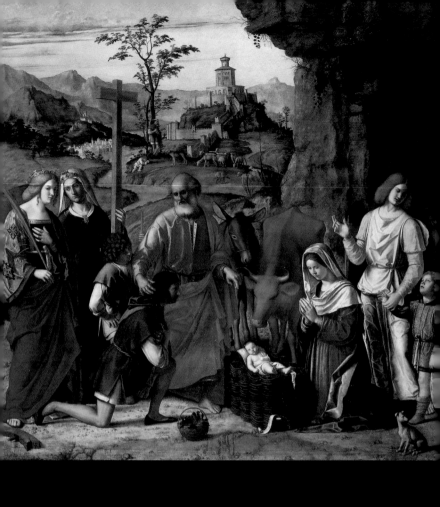

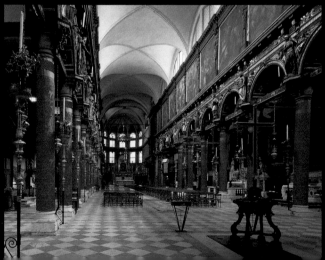

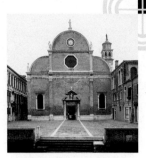

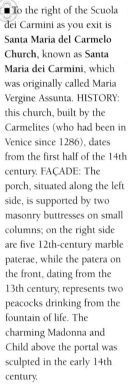

■ To the right of the Scuola dei Carmini as you exit is **Santa Maria del Carmelo Church**, known as **Santa Maria dei Carmini**, which was originally called Maria Vergine Assunta. HISTORY: this church, built by the Carmelites (who had been in Venice since 1286), dates from the first half of the 14th century. FAÇADE: The porch, situated along the left side, is supported by two masonry buttresses on small columns; on the right side are five 12th-century marble paterae, while the patera on the front, dating from the 13th century, represents two peacocks drinking from the fountain of life. The charming Madonna and Child above the portal was sculpted in the early 14th century.

The brick façade facing the square has tall pilaster strips used as buttresses and is surmounted in the middle by a lunette tympanum and on the sides by two half-lunettes (early 16th century), influenced by the works of Mauro Codussi. Starting from the top, the statues – attributed to Giovanni Buora – represent the Redeemer, the Annunciation, Elijah and Elisha. These last two, prophets and hermits at Mount Carmel, are considered the founders of the Carmelite order. The round window with a 16-point wind rose that has a rose in the middle, is an allegory of the Virgin Mary, who is the star of the sea and flower of Carmel. The campanile, built by Giuseppe Sardi, is crowned by a bronze statue of the Madonna del Carmine, a copy sculpted by Romano Vio in 1982 that replaced the 17th-century original, which was destroyed by lightning. INTERIOR: a basilica plan with a nave and two aisles marked off by a double row of eleven columns and a composite pier joined by wooden tie beams. The church underwent many alterations. For example, the chancel and its side chapels were rebuilt in 1507-14, probably by Sebastiano Mariani da Lugano, and the nave and aisles were elevated and large windows were built in the 17th and 18th century. The counterfaçade has a grandiose monument to Jacopo Foscarini (d.

1602), procurator of San Marco, *provveditore* responsible for the Rialto Bridge, and admiral of the Venetian fleet. Along the RIGHT AISLE, the second, Baroque-style altar commissioned by Father Zaccaria Vai (1676) has the *Adoration of the Shepherds and Saints* altarpiece (1509-11, signed) by Giambattista Cima da Conegliano. The figure of the kneeling shepherd has been identified as Giovanni Calvo (or Calbo; d. 1509), who is buried at the foot of the altar. The figure of the praying Mary is noteworthy for the pure colors and draftsmanship. Behind her, Tobias, accompanied by his dog and the archangel Raphael, is looking up toward the divine light. The saints on the opposite side, Catherine and Helena, may allude to some member of the donor's family. The cross of St. Helena is oriented in perspective toward the splendid landscape in the distance, and in particular toward the city on top of the hill, a probable allegory of the celestial Jerusalem that will arise at the end of the world.

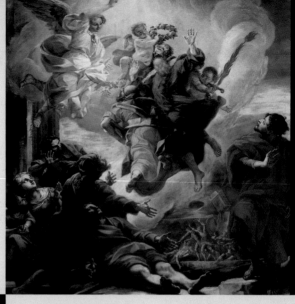

534 LEFT CHIESA DEI
CARMINI, CLOISTER OF
THE FORMER
MONASTERY.

534 RIGHT SANTO
PIATTI, *GLORIFICATION
OF ELIJAH AND ENOCH*.

535 TOP LEFT AND
RIGHT LORENZO
LOTTO, *ST. NICHOLAS
IN GLORY AND SAINTS*.

535 BOTTOM LEFT
ANDREA MELDOLLA,
*THE ADORATION OF
THE MAGI*, DETAIL.

The next, third altar, already finished in 1663, is reserved for the nearby Scuola dei Carmini, also known as the Confraternity of the Habit, a reference to the scapular that every devotee must wear in order to have the privilege of being relieved of the flames of Purgatory on the Saturday after his death. The mediocre altarpiece, *Madonna del Carmelo with Saints* (1595), is by PASE PACE and by GIOVANNI FONTANA (1725). At the sides of the altar, the statues of *Virginity* (left) and *Humility* (1722-23) are by ANTONIO CORRADINI and GIUSEPPE TORRETTI respectively. The two elegant, flowing bronze figures of *candle-bearing angels* (1617-18, signed) situated on the corners of the balustrade are by GIROLAMO CAMPAGNA. The five wooden frontals representing *The Miracles of the Madonna* (1724) were carved by FRANCESCO BERNARDONI, a pupil of GIACOMO PIAZZETTA. The *tabernacle is* by GIOVANNI SCALFAROTTO. *The Glorification of the Scapular* (1709) is the theme frescoed by SEBASTIANO RICCI on the ceiling. The stuccowork was done by PIETRO BIANCHINI to designs by ABBONDIO STAZIO. The scapular, represented twice, is held up by angels and, as a painted inscription says, it is "an ornament of Mt. Carmel." Inside the lantern are the outlines of two dark clouds. This may be an allusion to the darkened sky seen by Elijah, and the mirror in the middle, which has become completely black, may have reflected the rays of the sun, in order to create the effect of rain in the guise of light.

Past the entrance to the sacristy, which should be visited, is the altar of the guild of the Compravendi Pesce (fish and bird wholesale dealers), made in 1548. The members of this guild were devotees of the Madonna of Purification, adored in the *Presentation of Jesus in the Temple*, the altarpiece by the young JACOPO TINTORETTO (1541-42). At the end of the aisle, on the right side of the Cappella Civran-Guoro apse, is the vibrant *Lamentation of the Dead Christ* (ca. 1476), a bronze bas-relief by the Sienese FRANCESCO DI GIORGIO MARTINI. Among the persons witnessing this scene are Federico di Montefeltro (the Duke of Urbino, recognizable by his hooked nose), his young son Guidubaldo, and the duke's brother, Ottaviano Ubaldini della Carda. Once

in front of the chancel, note the 17th- and 18th-century canvases on the walls by MARCO VICENTINO, PALMA GIOVANE and GASPARE DIZIANI, based on those of the cult of the Holy Sacrament.

LEFT AISLE. Proceeding toward the exit, you will see the altar of the confraternity of St. Albert, the Carmelite bishop, and the Cappella Malipiero. The next altar, built by the Carmelites, has the imposing figures of the founders of the Carmelite order, *Elijah* and *Elisha*, attributed to the sculptor TOMMASO RUER (d. 1696). Elijah, at left, is holding the flaming sword, only the hilt of which remains. The prophet used this to kill the worshippers of Baal. Elisha, at right, is wearing the fur mantle given to him by his master, Elijah, which is the symbol of the Anchorites. He is in the guise of the

servant: in fact, he is holding a pitcher with which he poured water over the hands of Elijah. A little farther on is the altar of the Scuola dei Mercanti or merchants' brotherhood (1527), whose members are devotees of St. Nicholas, patron of sailors. The confreres asked LORENZO LOTTO to decorate their altar with *St. Nicholas in Glory between St. John the Baptist and St. Lucy*. This fine painting is distinguished in its lower section by a splendid view of the sea during a storm. At right are St. George fighting the dragon and the daughter of the king of Silene. The presence of this warrior saint is explained by the fact that the Vicar of the Scuola had the same name and that he probably helped to pay for this painting.

NAVE: the early 17th-century wooden decoration

portrays patriarchs, prophets, evangelists, doctors and Carmelite saints. The 24 large canvases (1666 – ca. 1730) are by various artists, including GIOVANNI ANTONIO PELLEGRINI, GASPARE DIZIANI, GIROLAMO BRUSAFERRO and PIETRO LIBERI. The two choirs (1653) are decorated with paintings, three of which are by ANDREA MELDOLLA, known as LO SCHIAVONE (ca. 1545), which come from the choir, demolished in 1653.

Once out of the main entrance of the Carmini church, at left you can enter the cloister of the former monastery (no. 2613), which was rebuilt around the mid-17th century. The wellhead in the middle, with the Carmelite crest, is dated 1762. On the upper floor is a fresco by GASPARE DIZIANI executed before 1732.

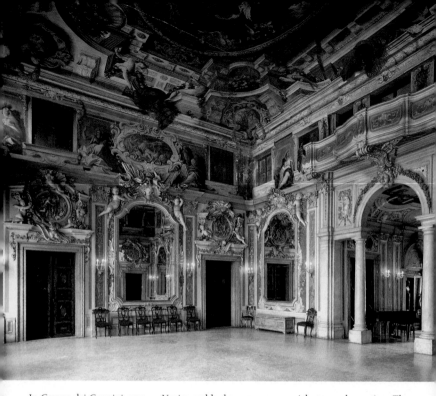

In Campo dei Carmini, you can see, past the canal, the impressive **Palazzo Foscarini** (nos. 3464-65), with its façade of superimposed Ionic and Tuscan order serlianas. This was one of the most luxurious residences in

Venice and had an enormous garden that housed a library – built for Doge Marco Foscarini (d. 1763) – and a collection of ancient statues. In the interior some rooms have preserved their 18th-century décor, including some stuccoes by the Bolognese GIUSEPPE MAZZA. Proceeding along the Fondamenta del Soccorso, you will come to the gorgeous **Ca' Zenobio** (nos. 2396-98), the work of ANTONIO GASPARI, a pupil of Longhena. The long façade has an unusual combination of windows in the middle of the main floor in which an Ionic Serliana is joined to Tuscan side windows. In the interior of the palazzo, on a line with the colonnaded atrium, there is the stupendous ballroom with its

rich stucco decoration. The illusionistic frescoes are by the French artist LOUIS DORIGNY, a pupil of Simon Vouet who also did paintings in the Gesuati Church. The vestibule, which has a lower ceiling, is decorated with paintings by LUCA CARLEVARIJS, a friend of the Zenobio family. The building at the end of the garden, built by TOMMASO TEMANZA around 1767, housed a fine library. From the *fondamenta* past the canal you can see the collection of statues and architectural elements of **Casa Busetto** (no. 2530) and, in particular, on the right side of the garden, five fluted drums and the capital of a Doric column from the temple at Cape Sounion in Greece. Farther along the *fondamenta* are the **Ospizio**

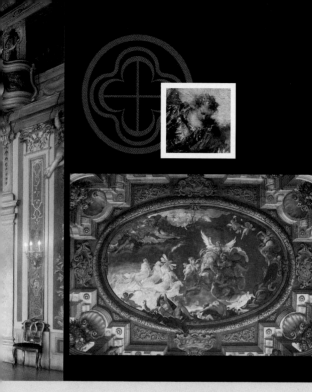

del Soccorso (nos. 2585-87) which, thanks to the initiative of the poetess Veronica Franco (ca. 1580), was used as a hospice for former prostitutes, and the neighboring **Oratorio di Santa Maria del Soccorso** (no. 2590), which was consecrated in 1609. At the end of the *fondamenta* you can admire the façade of **Palazzo Ariani-Cicogna** (no. 2376), situated beyond the Rio dei Carmini. The six-lancet window, the only one of its kind, which derived from French Gothic models, is surmounted by a double band of tracery obtained by intertwining circumferences and quatrefoils (mid-14th century). Retracing your steps, cross over the Ponte del Soccorso and, at left, the Ponte de l'Anzolo, in front of

which is **San Raffaele Arcangelo Church**, considered one of the city's original churches but really dating from the 11th century. The present building, designed in 1618 by FRANCESCO CONTIN (the façade was rebuilt in 1735), once housed the altar of the Barcaroli del Traghetto da San Raffaele a Lizza Fusina, the ferrymen who were devotees of the Madonna

and Archangel Raphael and whose confraternity was founded in 1508. The interior has works by BONIFACIO DE' PITATI, PALMA GIOVANE, MICHELANGELO MORLAITER and GASPARE DIZIANI. The railing of the sumptuous organ built by AMIGAZZI around 1750 is decorated with five canvases concerning the legend of Tobias (ca. 1750) that can be attributed to GIANNANTONIO GUARDI.

■ Leaving the church, turn left and, once past the Ponte de le Piova, go along the narrow Fondamenta Lizza Fusina until you reach the Campiello dell'Oratorio – whose name derives from the small building used in 1760 as the Oratory of San Filippo Neri e San Giacomo – and the church of **San Nicolò dei Mendicoli**. HISTORY: the Mendigola is one of the islands on which Venice was built. The original church, dedicated to the martyr San Niceta, stood over the ruins of a military structure that probably dated back to the 7th century. The name "Mendicoli" or "beggars" derives from the poor fishermen who lived on this island and who were also called *nicolotti*. The church of Byzantine inspiration dates back to the 12th century and has a basilica plan, but was rebuilt and altered several times over the centuries. FAÇADE: this has a pitched central body with a rose window surmounted by a tiny 12th-century two-lancet window. The portico, rebuilt in 1903, has some remains found during the restoration.

A clock built in 1764 was added to the austere 12th-century campanile (1100). INTERIOR: you enter by way of the side door (mid-18th century) and begin your visit from the right aisle. The nave and two aisles are separated by columns whose capitals have pointed, beak-like leaves. Some of the capitals in the shape of hook-bills have the coats of arms of the patron families, and two bear the dates 1361 and 1364. After the Cappella Balbi, you will find the Cappella di San Niceta, home of the Scuola di San Niceta, on the urn of which are depicted the *martyrdom of this saint*, the *discovery of his body and his translation* (Veneto school, first half of the 16th century). CHANCEL: the wooden statue of *St. Nicholas* (15th century) stands in a large niche (1767). The saint, in bishop's attire, is portrayed with three golden spheres, the symbol of the bags of money donated to save three young girls from prostitution. The NAVE is richly decorated with a cycle

dedicated to Christ and his imitator, St. Nicholas. The wooden dressing of the arches (late 16th century), which is older than that in the Carmini church, is attributed to ANTONIO DE ZUANE (known as DANA), and to the gilder BALDISSERA DE VELMO. The statues of the *Apostles* – keepers of the mystery of salvation – correspond, on a line with the aisles, with the gilded wooden statues of *angels*. The three arches that cut the nave in two (ca. 1580) are surmounted by a Crucifix and by the statues of the *Virgin Mary* and *St. John Evangelist*, sculpted by the Veneto school in the 17th century. The twelve canvases on the walls are dedicated to the life of Jesus and were painted by various artists, including ALVISE BENFATTO, known as DEL FRISO (1554-1609). The three panels on the ceiling are dedicated to St. Nicholas, the patron of sailors and the *nicolotti*. The two paintings at the ends are by LEONARDO CORONO (1561-1605), and those in the middle are by FRANCESCO MONTEMEZZANO (ca. 1540-ca. 1602).

■ Back in the little square, go along the Fondamento Tron. Past the canal you can see the Carmelite nuns' convent and the church of Santa Teresa, usually called **Le Terese**, which was built by the *proto* or chief architect ANDREA COMINELLI in the second half of the 17th century. Besides the Scuola del Cristo, this church housed the Compagnia di Sant'Orsola, or sisterhood of the "Poor Ursulines" devoted to teaching doctrine and titular of a hospice for women. Along the canal side street, at no. 2209/A, there is still a hospice built thanks to a bequest by Giovanni Contarini (1492) to house five women, preferably of noble families. Once past the characteristic 18th-century block of row houses, you will come to Fondamenta Rielo. The wall along Fondamenta

Barbarigo once belonged to the hospice of the tertiaries of St. Francis, which was founded in 1207 to aid pilgrims on their way to the Holy Land. Above the door (no. 2364) you can see a bas-relief of the stigmata of St. Francis (15th century). Farther on, opposite the bridge, is a wooden Crucifix (15th century?) in a sort of showcase (1853, dated) with Corinthian pilaster strips. You will then pass the church of San Raffaele and go to the nearby **San Sebastiano church**, famous for the many fine paintings by PAOLO VERONESE.

HISTORY: the first church was built in 1455-68 thanks to the initiative of Fra' Bartolo da Cesena, a member of the order of the Hermits of St. Jerome, and was associated with the Roman basilica of St. John Lateran in

1493. The church we see today, begun in 1506 and consecrated in 1562, was built by ANTONIO ABBONDI (known as SCARPAGNINO), who also built the campanile (1544-47). FAÇADE: this was built in 1548, as an inscription tells us, and is articulated in two registers bounded by four pairs of Corinthian columns on pedestals surmounted by a large tympanum crowned by the statues of St. Jerome, St. Catherine of Alexandria and, in the middle, St. Sebastian, the titular of the church. The inner sides of the entrance portal have three bas-reliefs in medallions with figures of saints connected to the local cult. At left is the martyrdom of St. Sebastian, whose aid was always invoked during epidemics of the plague. At right, St. Jerome in the desert refers to the Hermits of St.

Jerome, called Gerolomini, whose order was founded in 1380 at Montebello, near Urbino, by the Blessed Pietro Gambacorta da Pisa. On the architrave, *The Communion of St. Onofrio* pays homage to another hermit after whom the high altar of the church was named.

INTERIOR: the wide vestibule, bordered by two small altars, opens out into the aisleless nave which, unlike the façade, has only one architectural order, with Corinthian columns. The six side chapels are surmounted by a gallery. Over the chancel, which is flanked by two chapels, is a blind cupola on a round drum redone in the 1700s. The altarpiece by

FEDERICO BENCOVICH (1725-30) in the first chapel at right portrays The Blessed Pietro Gambacorta, who in 1380 founded the Hermit Order of St. Jerome, or Hieronymites, at Montebello, near Urbino. In the second chapel, the elegant marble sculpture group of the *Madonna and Child with the Young St. John the Baptist* (1577), in which the allegory of Charity is also represented, is by TOMMASO LOMBARDI DA LUGANO (signed), a pupil of Jacopo Sansovino. In the third chapel, the Baroque altar – dedicated to the intercession of the deceased and entrusted to the Dame della Buona Morte sisterhood – has a *Crucifixion* (1581) by PAOLO

VERONESE. This is followed, in the short right-hand transept, by the Monument to Livio Podocataro (1556-57), among the columns of which JACOPO SANSOVINO placed an austere smooth shaft with a Corinthian capital. The statue of the deceased, who was archbishop of Nicosia and a friend of Pietro Bembo, lies on the bier. Next to the nearby Chapel of St. Jerome is the chancel. The letter "S" traversed by an arrow is carved on the pedestals; this is an emblem of the Confraternity of St. Sebastian, which was already in this church in 1470. In 1532 the chapel passed under the jurisdiction of Cataruzza Cornaro.

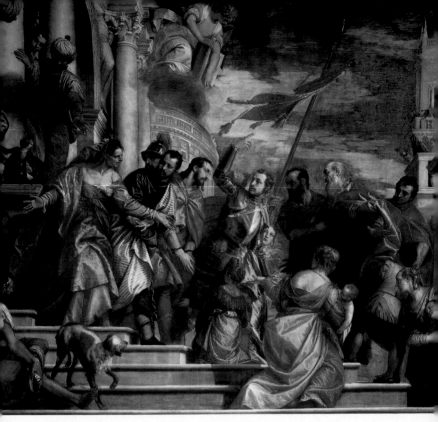

The relief on the altar frontal, the work of PIETRO BARATTA, represents *St. Sebastian Attended by the Pious Women*, while the *Madonna in Glory with Saints* altarpiece (ca. 1562) is by PAOLO VERONESE. This artist also painted the two canvases (1565) on the side walls, *Martyrdom of St. Sebastian* and, at left, *St. Mark and St. Marcellinus Exhorted to Martyrdom by St. Sebastian*. In the former work, St. Sebastian is tied to a bed and is about to be bludgeoned and flogged. In the latter, the twin brothers are already chained, while their mother (left) and their wives and relatives, in Venetian dress, are pleading with them to renounce their faith in Christ. In the middle of the scene, St. Sebastian, in the guise of a leader of the Venetian army, is exhorting the brothers to submit to the martyrdom.

The nearby rear Chapel of the Annunciation had a lovely glazed majolica floor (first half of the 16th century) that is now in the Galleria Giorgio Franchetti, in the Ca' d'Oro. The short left transept contains the choir and organ. The organ shutters, painted by PAOLO VERONESE, represent *The Presentation of Jesus in the Temple* on the outside and the *Pool of Bethesda* on the outside (1559-60). On the right-hand wall is a bust of Veronese sculpted in the early 17th century by MATTEO CARNERI; the great artist is buried (d. 1588) under the floor next to his brother, Benedetto Caliari (d. 1591). The nearby door leads to the SACRISTY, whose ceiling was decorated by VERONESE (1555, dated). Going toward the church exit, you will immediately see the Cappella Grimani, with frescoes by ANDREA MELDOLLA (known as LO SCHIAVONE), two fine statues (ca. 1565) and a bust by ALESSANDRO VITTORIA, and a small canvas by VERONESE, *The Madonna and Child with St. Catherine and Friar Michele Spaventi* (ca. 1578). In the third and last chapel, the altar was rebuilt by the

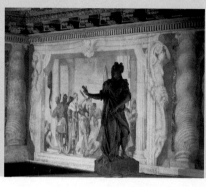

confraternity of the Carcaroli del Traghetto di San Barnaba (gondoliers), which since 1503 was the owner of a floor tomb restored in 1768 and 1796. The church was further beautified by a large pictorial cycle commissioned by Abbot Bernardo Torlioni, the convent prior, and painted by PAOLO VERONESE. The ceiling (1556), with panels containing paintings of angels, virtues, flowers and fruit, is dominated by three large canvases dedicated to the Old Testament heroine Esther, the prototype of the Madonna and of her role as intercessor during the Last Judgment. In the middle is *Esther Crowned by Ahasuerus*.

The figures, set on one of the diagonals, are rendered by a dizzying foreshortening effect and are wearing 16th-century attire. The scene toward the exit depicts *The Repudiation of Vashti*, the first wife of the Persian king Ahasuerus (Xerxes I), while the painting toward the chancel, dominated by two fiery steeds, celebrates *The Triumph of Mordechai*, Esther's uncle. The paintings along the walls are divided into two registers. The upper one (1558), with virtuoso tortile columns (which are quite foreign to the simple architecture of the church), has *St. Sebastian before Diocletian* and *The Martyrdom of St.*

Sebastian, as well as Prophets and Sibyls, allegories of the birth and Passion of Christ that converge ideally toward the archivolt of the chancel, on the spandrels of which are frescoes of the Annunciation. On the lower register (ca. 1560) there are Evangelists and Apostles, who testify to the good tidings. This late humanist scheme to merge the Christian and pagan worlds is synthesized in the four stucco statues on the corners of the gallery railing by GIROLAMO CAMPAGNA (signed), which portray the Annunciation, and toward the vestibule, the sibyls of Cumae and Erythrae.

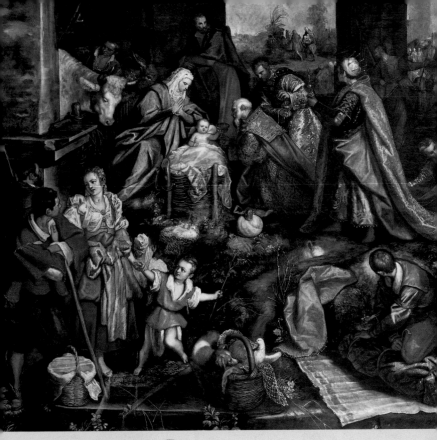

After going over the bridge in front of the church, proceed along the Fondamenta San Biagio until you come to the Fondamenta Zattere al Ponte Longo, which opens onto the Canal de la Giudeca. With the help of a map, you will reach the Fondamenta Zattere at Ponte Longo: No. 1473 was the headquarters of the **Scuola dei Luganegheri** (sausage- and lard-makers, grocers and soup vendors), founded in 1462 and transferred here in 1681. The building was restored by a follower of Baldassare Longhena and its façade (1684) has a large niche with a statue of *St. Anthony Abbot*, the patron of the guild. Turn left, along Calle Trevisan. The bridge offers a view, at your left, of the former convent and **Ognissanti Church**, which the Benedictine nuns began to build in 1505 with a Lombardesque portal and consecrated in 1586, as the inscription tells us. At the end of Fondamenta Bonlini is the square with the **Chiesa dei Santi Gervasio e Protasio**, known as **San Trovaso**. HISTORY: the church is extremely old. Some sources say it dates from the 8th century, but the

544-545 AND 544 BOTTOM DOMENICO TINTORETTO, *ADORATION OF THE MAGI* AND DETAIL, SAN TROVASO CHURCH.

544 CENTER THE SCUOLA DEI LUGANEGHERI.

545 TOP S. TROVASO CHURCH AND RIO.

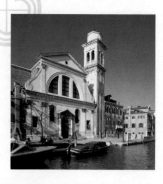

SAN TROVASO

1 Cappella Clary
2 Domenico Tintoretto, *Adoration of the Magi*
3 Cappella Milledonne
4 Cappella del Santissimo Sacramento
5 Palma Giovane, *Madonna in Glory, with the Christ Child and Saints*

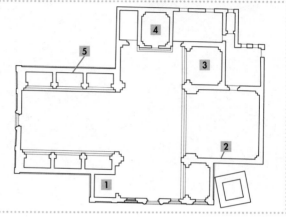

first documentation we have dates from 1028. The building as we see it today was constructed in 1584, probably to a design by FRANCESCO SMERALDI, a pupil of Andrea Palladio, and was consecrated in 1657. In the 19th century drastic restoration was carried out, especially on the altars. FAÇADES: they have two registers of Corinthian pilaster strips and are distinguished by a portal with Ionic columns and an unusual thermal window. INTERIOR: Latin cross plan, with six chapels along the nave that alternate with giant Corinthian pilasters. The large, out-of-scale chancel is

flanked by two chapels of a different size with flat back walls. The earlier church, which collapsed in 1583, stood along the present transept. In the first chapel at right is the altar (1626-28) of the Squerarioli (boat builders in private shipyards), in the third chapel are the ashes of St. Francesco di Paola. CHANCEL: the two canvases on the side wall, taken from Santa Maria Maggiore Church, are by DOMENICO TINTORETTO and illustrate, at right, *The Adoration of the Magi* and, at left, *The Expulsion of Joachim from the Temple* (before 1587). The former work

drew inspiration from the painting Jacopo Tintoretto did for the Scuola di San Rocco, and describes episodes related to the birth of Christ. The Virgin in prayer and St. Joseph off to one side refer to the Nativity. The angels – in the upper part of the painting and rather hard to see because the canvas was cut – and the shepherds in the lower section refer to the first public adoration of the Christ Child. In the two little scenes in the background, the artist depicts the presentation of Jesus in the Temple and the flight into Egypt. The sacristy is well worth a visit, with its Baroque furnishings and numerous paintings.

The left rear chapel was built in 1577 by Antonio Milledonne, the illustrious secretary of the Consiglio dei Dieci (Council of Ten). For the decoration of his tomb, Milledonne asked JACOPO TINTORETTO to paint *The Temptations of St. Anthony Abbot* (ca. 1577). The patriarch of monasticism, here depicted as an Anchorite, is hounded by the Vices, especially Lust and Licentiousness, which are personified by two alluring Venetian courtesans. But the elderly saint – who some have identified as the portrait of the donor – is victorious and, raising his head to the sky, prepares to receive Jesus, who has come to aid him. The

same chapel also has *St. Chrysogonus on Horseback* (ca. 1444) by MICHELE GIAMBONO, who was clearly influenced by Gentile da Fabriano. This saint was one of the titulars of San Trovaso and the painting is an exquisite example of a finely balanced mixture of the decorative style of International Gothic and the plastic values of the Renaissance. The Cappella del Santissimo Sacramento is a treasure trove of works of different styles and periods, all exalting the Eucharist. Among these are the fine gilded marble altar; the two side statues of David and Melchizedek (18th century), prototypes of Christ, which are in the style of GIOVANNI

MARCHIORI; and *The Last Supper* (1564-66) by JACOPO TINTORETTO. In this last-mentioned work, Judas is seated at right, in the half-light of sin, and is about to put his hand in his plate. Peter is standing, declaring his faith in Jesus, but the latter announces that his disciple will deny him thrice. Next to Judas, Tintoretto has painted the objects described by St. Luke: "[...] he that hath a purse, let him take it, and likewise his scrip, and he that hath no sword, let him sell his garment, and buy one." Going toward the nave, in the altar of the second chapel is the altarpiece by PALMA GIOVANE, *The Madonna in Glory, with the Christ Child*

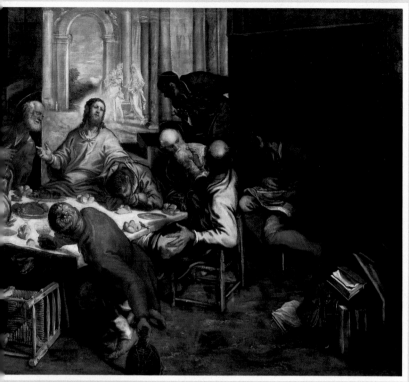

546 LEFT JACOPO TINTORETTO,
THE TEMPTATIONS OF ST.
ANTHONY ABBOT.

546-547 AND 547 BOTTOM
RIGHT JACOPO TINTORETTO,
LAST SUPPER AND DETAIL.

547 BOTTOM LEFT MICHELE
GIAMBONO, SAN
CHRYSOGONUS ON
HORSEBACK.

547 BOTTOM CENTER PALMA
GIOVANE, MADONNA IN
GLORY, WITH THE CHRIST CHILD
AND SAINTS.

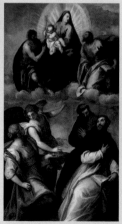

and Saints (1600-10),
commissioned by Domenico
Lione. The Virgin is flanked
by St. John the Baptist and
St. Mark, who intercede for
the donor's family; below
them are other saints:
Dominic, Francis and Lucy
(patron saint of sight and
recognizable by the eyes on
a pewter plate).

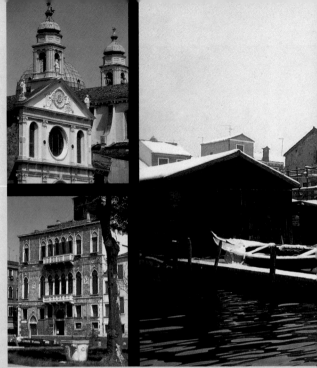

548 TOP SANTA
MARIA DELLA
VISITAZIONE
CHURCH.

548 BOTTOM LEFT
DETAIL OF THE
PORTAL, SANTA
MARIA DELLA
VISITAZIONE
CHURCH.

548 BOTTOM RIGHT
CA' NANI
MOCENIGO.

548-549 THE
SQUERO DI SAN
TROVASO.

Exiting by the side door, you will see, past the canal, the Gothic façade of **Ca' Nani-Mocenigo** (no. 960), built in 1460-70 and characterized by two robust four-lancet windows with trefoil arches and two elegant coats of arms in high relief. In the square of San Trovaso church is the Casa Brass (no. 1083), the walls of which are decorated with many paterae and reliefs (11th-15th century). One of these latter, on the first story at right, portrays a *Homo silvanus* (14th century). In the Middle Ages, this legendary figure, recognizable by his body being completely covered with hair, was known for his wisdom. He was probably modeled after the prophet Elijah. In this relief, the wild man indicates the sky – a typical gesture of St. John the Baptist – and is holding a club, an attribute of Hercules and a sign of strength. Once over the Ponte San Trovaso, turn right and go along Fondamento Nani. Halfway down you will see, past the canal, the **Squero di San Trovaso** (17th century), the oldest boat building and repair yard in Venice. The name derives from *squara*, or team of carpenters. Besides the inclined plane for the boats, this *squero* has three areas: a covered dockyard, a gondola mooring that communicates with the canal, and the workshop, surmounted by a house with a wooden running balcony. Farther on, turn left, along the Zattere, until you come to the **Santa Maria della Visitazione Church**.

HISTORY: the Gesuati order, known for its devotion to the name of Jesus and founded in 1355 by the Blessed Giovanni Colombini, settled in Venice in 1390. Thanks to a donation from Marquis Francesco I Gonzaga, the brothers were able to build an oratory and a monastery. The former was replaced by the church; construction began in 1494 and the consecration took place in 1524. The monastery (no. 919) was rebuilt in the 16th century and a second cloister, attributed to GIORGIO MASSARI, was added. The Gesuati order, which had the privilege of accompanying the dead to their burial place and also had the exclusive right to distill brandy, was suppressed in 1668. The

monastery and church were then purchased in 1669 by the Dominican fathers, who built a new church in the vicinity, Santa Maria del Rosario. The Visitazione church underwent many alterations and, after a generous bequest on the part of the Venetian aristocrat Apostolo Zeno, it was converted into a library around 1750. FAÇADE: the pitched central body – attributed to FRANCESCO LURANO DA CASTIGLIONE – rests on a pedestal and consists of two registers of Corinthian pilasters, topped by a broad tympanum that in turn is surmounted by the statues of the Redeemer in the middle, flanked by St. Jerome (patron of the Gesuati order) and, perhaps, St. Joseph. This Renaissance façade – and the interior as

well – has the recurring motif of the emblem of the Gesuati, a trigram similar to St. Bernardino da Siena's sign of Christ: a disk from which twelve rays radiate and inside which are the initials IHS, *Iesus Hominum Salvator* (Jesus, Savior of Men). For example, this trigram can be seen in the Lombardesque portal, both in the candelabras sculpted along the pilaster sides and in the inner part of the architrave, where it is supported by two tritons. These sea creatures evoke the pagan world and, in particular, the Old Testament prophets. They are counterbalanced by two kneeling angels sculpted in the tympanum, emblems of the New Testament. The two jambs of the portal are also decorated with two

high-relief tondi representing two pairs of Gesuati, devotees of the rosary whose identity is uncertain. INTERIOR: designed by FRANCESCO DA MANDELLO, it consists of a simple, aisleless nave, a chancel surmounted by a blind cupola, and a choir. Among the architectural elements from the demolished oratory that decorate the area around the inside of the entrance are lovely Corinthian columns with cabled shafts that rest on round pedestals. The paintings on the wooden panels of the ceiling, of uncertain attribution, portray saints and prophets (early 16th century) and, in the middle, *The Visitation*, in honor of the titular of this church.

550 TOP AND 551 RIGHT GESUATI CHURCH, FACADE AND INTERIOR.

550 BOTTOM GIAMBATTISTA PIAZZETTA, STS. LODOVICO BERTRANDO, VINCENT FERRER AND GIACINTO, AND DETAIL.

551 LEFT GIAMBATTISTA TIEPOLO, MADONNA WITH THREE DOMINICAN SAINTS.

GESUATI CHURCH

1 Giambattista Tiepolo, *Madonna with Three Dominican Saints*
2 Gian Maria Morlaiter, *The Glory of Angels* and Giambattista Piazzetta, *St. Dominic*
3 Giambattista Piazzetta, *Sts. Lodovico Bertrando, Ferrer and Giacinto*
4 Jacopo Tintoretto, *Crucifixion*
5 Sebastiano Ricci, *Saint Pius V and Dominican Saints*

■ Next to the Visitazione church is the **Chiesa di Santa Maria del Rosario**, known as the **Gesuati**, among the most illustrious examples of 18th-century architecture and religious art in Venice. HISTORY: in 1669, the nearby monastery of the Gesuati order and the Visitazione Church were purchased by the Dominicans, who had been in Venice since the 13th century. Thanks to their successful activities and the increasing size of the congregation, they decided to build a new, larger and more prestigious church in the area between the earlier monastery and the Rio Antonio Foscarini (now filled in), which linked the Grand Canal and the Giudecca. The construction work, which began in 1725, was entrusted to the architect GIORGIO MASSARI, who also designed the church, the altars and the main furnishings inside. In order to finance this work, the Dominicans got permission to ask for offerings from all the religious and lay confraternities in the city. The church was consecrated in 1743. FAÇADE: Massari opted for the pitched central body scheme already used in the nearby church of the Visitation, but altered its proportions and added majestic decoration, abandoning the sober elegance that the Gesuati favored in order to display – albeit on a limited surface – the grandeur of the Dominician order. The entrance stairway, the four giant composite half-columns flanked by a skillful play of translation among pilaster strips, and the superb pediment – are all

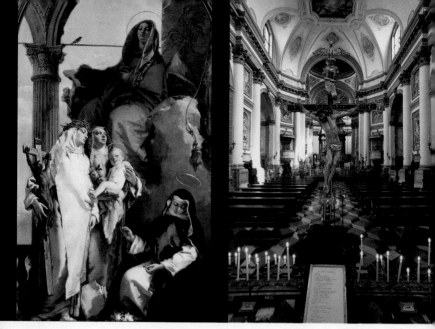

confirmation of this architect's vision. The niches house enormous statues of the four cardinal virtues: above, *Prudence* by GAETANO SUSALI and *Justice* by GIOVANNI FRANCESCO BONAZZA; below, *Fortitude* by GIUSEPPE BERNARDI TORRETTI and *Temperance* by ALVISE TAGLIAPIETRA.

INTERIOR: the plan was inspired by the principles of the Council of Trent, already in use in Venice since the 16th century. The interior consists of an aisleless nave, six side chapels connected by a corridor, a chancel surmounted by a cupola with a lantern and an elliptical choir. The nave has rounded corners and paired Corinthian half-columns with smooth shafts. The first chapel at right houses a magnificent altarpiece, *Saints Rosa of Lima, Catherine of Siena and Agnes of Montepulciano Receiving the Christ Child from the Virgin Mary* (1748) by GIAMBATTISTA TIEPOLO. This painting revolves around the meditation on Christ's death. St. Agnes – associated with the lily, the Dominican symbol of purity – is contemplating a small crucifix tied to a string. The same sign is reproduced several times on her mantle. St. Rosa, thanks to the invocations uttered during her intense meditation, is holding the Christ Child in her arms, whom the Virgin Mary has handed to her. The child is holding a splendid rose in his hand, a reference to the saint's name and a symbol of the sacrifice on the cross. At left, Catherine of Siena – canonized thanks to the initiative of the Venetian Dominicans – appears in the guise of the imitator of Jesus, as she is holding the crucifix and wearing a crown of thorns. But the true protagonist of this fine painting is the warm, soft light, which manifests God the Father's love of humanity. In the second chapel, the elegant high relief of *The Glory of Angels* (1739) is by GIAN MARIA MORLAITER and the portrait of *St. Dominic* (1743) was painted by GIAMBATTISTA PIAZZETTA. This latter also executed the splendid altarpiece in the third chapel, *St. Lodovico Bertrando, St. Vincenzo Ferrer and St. Giacinto* (1738). The triumphant high altar in the chancel has a ciborium and a luxurious tabernacle designed by GIORGIO MASSARI, who also designed the two facing pulpits in the nave. Proceeding toward your left, you will come to the chapel housing *The Crucifixion* (1563-65) by JACOPO TINTORETTO, which came from the neighboring Visitazione Church and was badly restored in the 18th century.

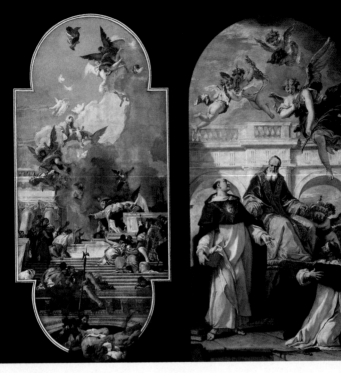

Once past the Cappella del Rosario, you come to the little room that houses the *Virgin of the Rosary* statue (18th century). The following chapel boasts the altarpiece by SEBASTIANO RICCI dedicated to Dominican saints, *Pope Pius V, St. Thomas Aquinas and St. Peter Martyr* (1730-33), which is the complement of the canvas by Tiepolo in the opposite chapel that portrays Dominican women saints. Pope Pius V is portrayed by GIAMBATTISTA TIEPOLO during his *Vision of the Victory of Lepanto*, the fresco in the lunette above the portal. Situated in the intercolumniation of the nave are the two sculpture cycles (1743-55) by GIAN MARIA MORLAITER: in the lower register are six statues of patriarchs, high priests and the apostles Peter and Paul;

in the upper one, eight reliefs with scenes of miracles and apparitions from the life of Jesus. This "sermon" in images begun in the lower part of the church continues in the upper part with splendid frescoes (1737-39) by GIAMBATTISTA TIEPOLO: *The Cult of the Rosary* along the nave, *Four Evangelists* in the chancel, and *David Playing the Cithara, Four Prophets* and *The Holy Trinity* in the choir. The monochromes on the ceiling illustrate the fifteen *Mysteries of the Rosary* and, in one of the quatrefoil panels, *The Triumph of the Rosary*. On a line with the inside façade, at left, is the beginning of the first of the Joyful Mysteries, the *Annunciation* or the divine maternity of Mary. Lastly, in the three

scenes on the ceiling the founder of the order and the cult of the rosary are celebrated. Between the two panels, *The Glory of the Order* and *The Glory of St. Dominic*, there is the staggering perspective of the *Institution of the Rosary*. St. Dominic is distributing the rosary that he received from the Virgin Mary, who appears in glory. ■When you leave the Gesuati Church, continue to the left along the Zattere. After crossing over the bridge you are at the former **Ospedale degli Incurabili** (no. 523). This institution, supported by the Theatine brotherhood, the Compagnia del Divino Amore, was founded by noble laymen in 1522 to give aid to victims of syphilis. Hence the name "Incurables," since there was no remedy for this disease at

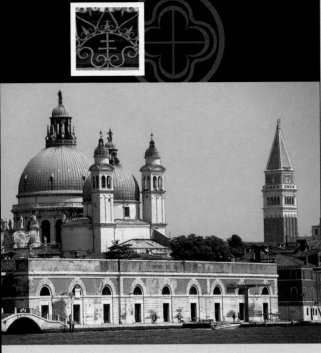

the time. Among the other persons who were active there were St. Ignatius of Loyola and Francesco Saverio. The huge building, rebuilt in 1572 and perhaps finished by ANTONIO DA PONTE, had two infirmaries and a laundry. It was articulated around a cloister, where the elliptical-plan church of the same name stood before it was demolished in 1831. This building will be the home of the new Accademia di Belle Arti Museum. Continuing your walk, you will come to the Condominio Cicogna, known as the **Casa alle Zattere**. Next to it is the **Spirito Santo church**, built in 1483 thanks to the initiative of the Augustinian nun Maria Caroldo and rebuilt in 1506 to a design by ANTONIO ABBONDI (known as LO SCARPAGNINO). In 1520, after the construction

of the Zattere *fondamenta*, the church apse was torn down and replaced by the present-day façade, which was finished in 1524 by GIACOMO DE BERNARDIS under the supervision of SCARPAGNINO. Among the art works in the church, mention should be made of the Monument to Paolo Paruta (ca. 1651), an illustrious historian of the Venetian Republic, attributed to BALDASSARE LONGHENA. The church is flanked by a building that once housed the **Scuola dello Spirito Santo**, which was founded in 1492. The building, constructed in 1506, was rebuilt by ALESSANDRO TREMIGNON (1680). The façade by FRANCESCO DE BERNARDINI (1580) has the same pitched central body as the façade of the church. The emblem of the double or

patriarchal cross, which can be seen in the window gratings as well as in the façade of the church, is the emblem of the Ospedale di Santo Spirito in Saxia, in Rome, with which the nuns of the Spirito Santo Church in Venice were associated. Once at Ponte Ca' Bala you will see the Fondamenta Ca' Bala. At the first cross street, Calle Querini, no. 252 was the residence of the American poet, translator and critic Ezra Pound (1885-1972). Just after the bridge is the massive and austere façade of the **Magazzini del Sale** (nos. 258-266), the former salt warehouses, also called the **Saloni**, which were built in the 15th century and rebuilt by ALVISE PIGAZZI round the mid-19th century. If you want a pleasant walk, continue down the Zattere to the Punta della Dogana da Mar.

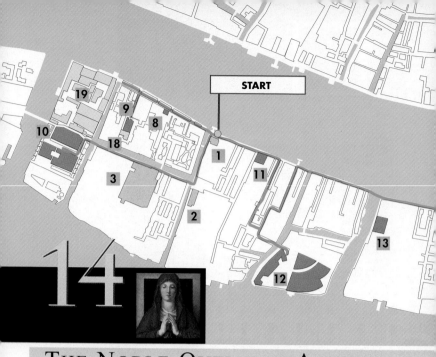

THE NOBLE OUTLYING AREAS

Giudecca island,
which is over 1.25
miles (2 km) long, is
separated from Venice proper
by a wide and deep canal
known as the Canale Vigano.
Originally inhabited by
fishermen and market
gardeners, the Giudecca –
also called Spinalonga –
became the home of
important monastic and
charitable institutions which,
in the 13th and 14th
centuries, promoted
reclamation and urbanization
works. At the end of this
long and laborious
development stage, the
Giudecca, divided into eight
islands, was like a sequence
of three parallel areas. The
first one, toward the canal,
was characterized by the

present-day *fondamenta*,
which was finished around
1536 and on which there
were mostly private and
religious buildings. The
second area, under the
jurisdiction of the first one,
once consisted of kitchen
gardens and private gardens.
The third area was made up
of uncultivated land and had
no embankments. At the end
of the 15th century, the
Giudecca had important
patrician residences that were
used as country villas to host
concerts and cultural
conferences and the like. As
early as the 13th century, its
distance from the city
favored the transfer of
polluting activities connected
to tanning, which were,
however, restricted to the

Convertite church zone. In
the 19th century, after the
suppression of many
churches and monasteries,
large areas were occupied by
factories, workmen's
quarters, warehouses,
barracks and prisons. The
enormous buildings that still
stand make the Giudecca one
of the leading areas for the
study of industrial
archaeology and in the
conversion of factories and
office buildings into
residential areas. This
itinerary ends with the island
of San Giorgio Maggiore, one
of the city's leading spiritual
and artistic centers, where
Benedictine religious
devotion and the Venetian
state have co-existed so
admirably for centuries.

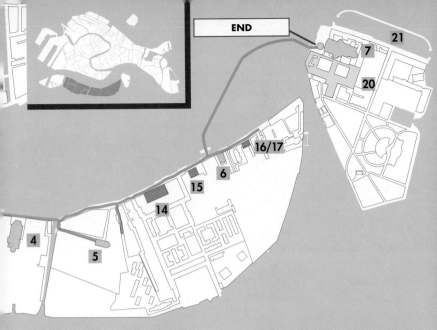

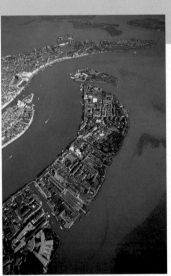

▶ MAIN SIGHTS

● **SESTIERE (District):** Dorsoduro.

● **CHURCHES:** [1] Santa Eufemia;
[2] Santi Cosma e Damiano; [3] Convertite;
[4] Redentore; Santa Maria degli Angeli; [5]
Santa Croce; [6] Zitelle; [7] San Giorgio
Maggiore.

● **PALAZZI:** [8] Maffetti; [9] former
Dreher area; [10] former Stucky-Trevisan
area residential neighborhood;
[11] Accademia dei Nobili; [12] former
Junghans area residences: Building D
(known as Il Dado), Building F (known as
Formaggino); [13] Casino Baffo; Rocca
Bianca; [14] new residences in the
Fondamenta de la Croce; [15] Minelli;
[16] Mocenigo; [17] Nani-Dandolo.

● **OTHER MONUMENTS:** [18] ex
Birrerie Veneziane; [19] Mulino Stucky;
[20] Fondazione Giorgio Cini; [21] Darsena
di San Giorgio Maggiore

554 TOP ALVISE
VIVARINI, PRAYING
MADONNA WITH
JESUS AND TWO
ANGELS, DETAIL,
REDENTORE CHURCH.

555 LEFT
BARTOLOMEO

VIVARINI, SAINT ROCH
AND AN ANGEL,
DETAIL, SANT'EUFEMIA
CHURCH.

555 RIGHT THE
GIUDECCA CANAL
AND ISLAND.

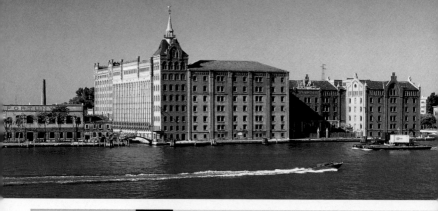

Itinerary From Giudecca to San Giorgio

Once you get off at the Palanca landing stage, you can begin your exploration of the island with a brief detour to see the Mulino Stucky. If, however, industrial architecture doesn't interest you, you can start off at your right, from Sant'Eufemia Church.

In order to get to the former Dreher Brewery, cross over the Ponte Sant'Eufemia. At no. 801 you enter the former Birrerie Veneziane (Venetian Breweries) area, later called the Dreher Brewery, which was built in 1902 as the Venetian Distillery and was then converted into a

brewery. To the left are the warehouses and depots, and at the end you can see the tall structure called the **Fabbrica degli Spiriti** (spirits factory), transformed into a noteworthy residential block around 1980-85 by the architects GIUSEPPE GAMBIRASIO and BRUNO MINARDI. At the end of the *fondamenta*, along Rio de San Biagio, you can see the large side façade of the former **Mulino Stucky** flour mill. This factory, built in Dutch Neo-Gothic style, was designed by the German architect ERNEST WULLEKOPFT for the entrepreneur

Giovanni Stucky in 1882 and closed down in 1954. This area once included the church of Santi Biagio e Cataldo and the adjoining Benedictine nuns' convent founded in 1186.

To continue this itinerary, go back to the **Church of Sant'Eufemia**. HISTORY: the founding date of this church, originally dedicated to the martyrs and saints of Aquileia – Eufemia, Dorothea, Tecla and Erasma – is uncertain and is probably the 9th or 10th century. What is certain is that the Gothic church was consecrated in 1371 and was later altered, especially in the 18th century, when it was consecrated anew (1761). FAÇADE AND EXTERIOR: the façade has a taller, pitched central body. The lunette over the portal has a bas-relief that was originally painted and may have been commissioned by the local confraternity of San Rocco: *The Enthroned Madonna between St. Roch and St. Eufemia* (early 16th century) by an anonymous artist whose style is close to that of BREGNO. The Doric columns on the porch (1899) on the left side of the church, are from the choir designed

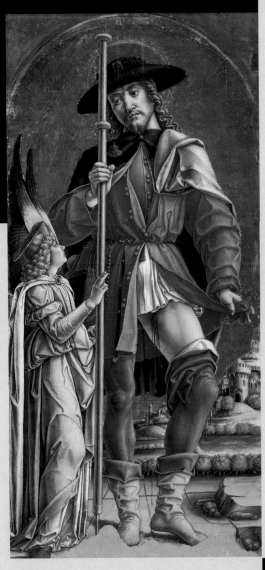

The chancel has an altarpiece by BARTOLOMEO GIORDA, *Madonna and the Four Aquileian Saints* (1634). In the second half of the 16th century the Santissimo Sacramento confraternity commissioned some works that were to glorify the Eucharist: *The Miracle of the Manna* from the Veronese school and, on the left wall, *Last Supper* by ALVISE BENFATTO (known as ALVISE DEL FRISTO); an altar crowned by the Eucharist chalice and with a luxurious tabernacle (sealed and dated 1684); the ceiling fresco attributed to GIAMBATTISTA CANAL (1745-1825), *The Sacrifice of Melchizedek*. CANAL also did the frescoes on the ceilings dedicated to the titular saint: *The Baptism of St. Eufemia* over the left aisle, *St. Eufemia in Glory* over the nave, and *The Body of St. Eufemia Arriving in the Lagoon* over the right aisle. Before exiting, note the touching marble *Pietà* by GIANMARIA MORLAITER (1699-1782) on the Addolorata altar (the first along the left aisle).

by MICHELE SANMICHELI for Santi Biagio e Cataldo Church, which was torn down to make room for the Mulino Stucky. INTERIOR: a basilica plan with two aisles separated from the nave by columns with interesting 11th-century Byzantine capitals. The first altar as you go down the right aisle has the stupendous *St. Roch and an Angel* (1480), surmounted by a *Madonna and Child*, both by BARTOLOMEO VIVARINI. Proceeding past the Cappella della Madonna del Rosario and the small baptistery, you will see the apsidal chapel dedicated to the Blessed Giuliana da Collalto.

556 TOP AND 557 BOTTOM THE MULINO STUCKY.

556 BOTTOM SANT'EUFEMIA CHURCH.

557 TOP B.VIVARINI, *ST. ROCH AND AN ANGEL.*

Once out of Sant'Eufemia, turn left and go down the entire length of the *fondamenta* to the former church of Santi Cosma e Damiano, known as **San Cosmo**. Founded by the Benedictine abbess Marina Celsi and built in 1481-1498, the church has a modest façade with a pitched central body and four giant Corinthian pilaster strips and served as the model for the cathedral at Palmanova, in the Fruili region. Past the Ponte Lagoscuro and past the Sotoportego de la Vechia, which offers a view of charming workingmen's houses, you will arrive at the former church, convent and hospital of Santa Maria Maddalena, commonly known as the **Convertite**. This institute, an offshoot of the Ospedale degli Incurabili at the Zattere, was founded around 1525 to house converted prostitutes (*convertite*). The adjoining convent of Augustinian nuns was built in 1543. The church, placed under the jurisdiction of the Patriarchate, was built thanks to the donations of the Bergamesque merchant Bartolomeo Bontempelli dal Calice and was consecrated in 1579. The church we see today was renovated in the early 18th century. The Convertite was then closed in 1806. It is not open to the public because since 1857 it has been used as a women's prison. In 1271 this area became a center for tanning, which is a significantly polluting process. At the end of the *fondamenta*, cross over Ponte de le Convertite and, keeping to your left, you will come to the **residential neighborhood in the former Stucky-Trevisan area** (1984-87), designed in 1981 by Gino Valle, a distinguished architect from Udine, for the city of Venice. The brick masonry, accompanied by cement elements, is of excellent quality and is similar in color and texture to the curtain of the nearby Mulino Stucky. The housing units, arranged in a grid plan that is perhaps too compact, decrease in height in the direction of the lagoon, while the two sides bordered by canals are delimited by a façade with twin turrets. After visiting this sight, go back to San Cosmo and walk along the façade of the former convent. Here, through a gate, you can catch a glimpse of the old cloister and, a short distance farther on, at left, the Campazzo, one of the few residential areas in which, instead of the usual road pavement, there is the original grassy land. Heading in the same direction, at the end of the narrow street and,

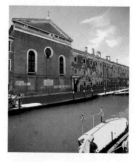

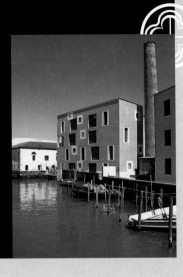

558 TOP LEFT SAN
COSMO CHURCH.

558 TOP RIGHT
CAMPAZZO SAN
COSMO.

558 BOTTOM
CHURCH, CONVENT
AND HOSPITAL OF THE
CONVERTITE.

559 BUILDING D,
OR THE DADO,
FORMER JUNGHANS
AREA.

Once over the Ponte Piccolo, above the beginning of Calle de l'Ospedale you will spot an inscription commemorating the presence, in this *calle*, of the Ospedale di San Pietro (no. 322), founded in 1316 to aid the poor, thanks to a bequest by Pietro Brustolado, and rebuilt in 1568. At Ponte Longo, along the *fondamenta* along the wide canal you will see the 18th-century **Casino Baffo** (no. 254), inhabited by the poet Giorgio Baffo (1694-1768), known for his erotic and scurrilous verse. Farther along, in Fondamenta San Giacomo, nos. 218 and 224 are what remains of the Viscontian residence known as the **Rocca Bianca** (late 15th century). Note the lunette above the portal and the five-lancet window with its composite capitals and, between no. 212 and 217, the bas-relief with a lion's head and acanthus racemes (early 16th century), the symbol of resurrection and eternal life. At no. 211/A is the entrance to a new shipbuilding area that was developed in the buildings of the Neville mechanical constructions company (1906), which were later used by the former Cantieri Navali Officine Meccaniche di Venezia. Nearby, in a small square, once stood the San Giacomo church and monastery, which were torn down in 1837. The church, consecrated in 1371 and rebuilt in 1603, was founded by the Servi di Maria from Cannaregio and placed under the doges' jurisdiction.

on an axis with no. 604/B, turn left and go along Calle Longa up to the Fondamenta Sant'Eufemia. On the *fondamenta*, at no. 607, is the former home of the **Accademia** (or Collegio) **dei Nobili**, founded in 1619 to house and educate the children of impoverished noble families. The building, which was originally built in the Gothic style, has two 16th-century Ionic four-lancet windows. Continue along the *fondamenta* to the Redentore Church. If you are interested in contemporary architecture, you can make a detour onto Calle del Forno and, with the help of a map, reach the **former Junghans area**, where the Herion Brothers watch factory once stood (1878). The main building in this area, recognizable in the old maps by its fan shape, was built in 1943, when the convent and church of Sant'Angelo were demolished. The area was the object of a vast urban reclamation program

undertaken by the city government. The buildings were constructed in different styles, some of questionable taste. Mention should be made of **Building D**, or **the Dado**, which CINO ZUCCHI built in 1999-2000. Its façades reiterate the theme of the palazzo on water. Here, decoration and symmetry are considered "blasphemous": the profiles of the white window cornices vary in width and are arranged in disorderly, asymmetrical fashion. Not far away is **Building F**, designed by LUCIANO PARENTI (1999-2000), called the **Formaggino** (small piece of cheese; no. 494) because of its triangular shape, but really more like a luxury seaside establishment because of its stone dressing, pharaonic stairwell with glass walls, and its tall bulk crowned by two dizzying balconies. With the help of a map, go to Calle de l'Olio and from there to Fondamenta Sant'Eufemia.

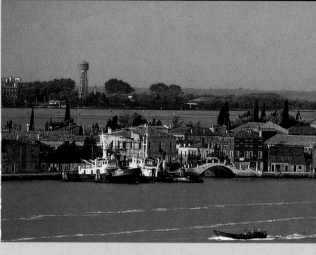

■A short distance away is the church of **Gesù Cristo Redentore**. HISTORY: the Redeemer church, managed by the Capuchins, was built at the behest of the Senate in thanksgiving for the end of the terrible plague that raged in 1575-57. The doge and the entire Republic made a vow to go to this church once a year. On that occasion (and as still occurs nowadays) the solemn procession went across the Giudecca Canal on a specially built temporary bridge made of boats. The Redentore confraternity is a combination of devotion to the Capuchin order and the

state. The order, which grew up in the Marche region of Italy, harked back to the original Franciscan rule. Among its precepts, which were truly revolutionary for those setting out to preach in a rich city like Venice, the members were forbidden to take part in funerals and processions, to own buildings, and to receive any recompense whatsoever for preaching. The first small Capuchin church, Santa Maria degli Angeli, commissioned by Fra' Bonaventura de Centis, was built in 1536 and is still inside the monastery. The first monastery rose up in 1539 and hosted Fra' Bernardino da Siena, who in 1542 left Venice to avoid being accused of heresy by the Inquisition. The Capuchin friars distinguished themselves here for confessions, sermons, and their aid to the ill and plague-stricken. In 1577 the first stone of

the new church was laid. The day chosen for this occasion was May 3, during which the discovery of the True Cross by St. Helena was celebrated. After the death of Palladio in 1580, the edifice was finished by Antonio Da Ponte. During the course of building, the Capuchins – in light of the majestic structure of their church and worried about violating their vow of poverty – asked Pope Gregory XIII for a special dispensation, which he granted them. For the same reason, the friars were able to persuade the Senate to prohibit burials inside the church, which therefore preserved its original appearance. The church was consecrated in 1592. FAÇADE: this is a sophisticated elaboration of the themes Palladio had already tackled in the churches of San Francesco della Vigna and San Giorgio Maggiore. The impressive

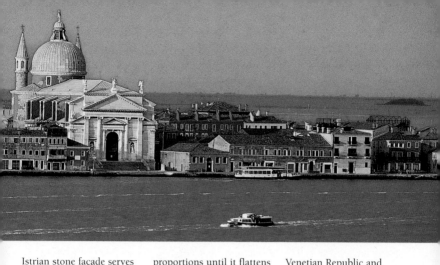

Istrian stone façade serves as a sort of stage wing and triumphal entranceway for the long procession moving perpendicularly over the bridge of boats. Some architectural elements suggest that both Palladio and the Republic had set out to merge the shapes of three models of church design in the Redentore. The fifteen steps of the stairway evoke Solomon's Temple. The broad pediment surmounted by an attic refers to the Pantheon in Rome, while the majestic dome flanked by two bell towers that almost look like minarets reminds us of the Holy Sepulcher. Once again, the Venetian state, like Rome and Jerusalem, proclaims and celebrates itself as the champion and bulwark of Christianity. Thanks to an attenuated chiaroscuro, the architecture of the façade seems to become rigid geometry made up solely of

proportions until it flattens out and dissolves in a dazzling white. And just as the introduction of a good sermon must clearly present the main themes that will be discussed, so the façade of the Redentore – a play of the relationships between the Corinthian- and the composite-order elements – is nothing else but an extremely clear announcement of the architectural motifs in the interior.

The lead-clad wooden figure of the Risen Christ or Redeemer above the lantern and attributed to GIROLAMO CAMPAGNA (ca. 1549 - after 1626) was the only statue on the exterior of the church for almost a century. The other works were sculpted toward the end of the 17th century. The modest statues in the niches of St. Mark (attributed to TOMMASO RUER, d. 1696) and St. Francis (by JUSTE LE COURT's circle) refer to the

Venetian Republic and Capuchin devotion. The crucifix held by St. Francis consists of two tree trunks, referring to the second tree in Eden, the source of eternal life that was hidden from the sight of Adam and Eve. The figures of St. Anthony of Padua and St. Lorenzo Giustiniani above the wings of the façade and attributed to TOMMASO RUER, were chosen for their fame and for their miraculous power in subduing the plague. St. Anthony in particular was also invoked in 1646 to protect the Venetian fleet against the plague and the Turks.

The statues of Faith holding the cross and Eucharist chalice and two adoring angels along the cornice of the attic, attributed to JUSTE LE COURT's circle, summarize the fundamental teachings of Capuchin and Franciscan thought, based on the cult of the body of Christ.

INTERIOR: this is divided into three distinct areas. A broad, aisleless nave flanked by six communicating side chapels which, besides housing the members of the annual Redentore procession, gives the congregation a fine view of the high altar – in conformity with the Council of Trent's pronouncements. For lovers of architecture there is a subtle Mannerist touch here: the capitals of the giant half-columns, unlike those on the façade, are Corinthian instead of composite. The second area in the interior is the chancel, decorated with a polychrome marble floor, surmounted by the balustraded dome, and opened on the sides by two exedrae with Corinthian pilasters and windows. This served as an area reserved for the doge and the Signoria, hidden from the view of the common worshippers. This choice was certainly made out of consideration of the ceremonial and liturgical needs that derived from the

rituals in St. Mark's Basilica, even though the elements adopted by PALLADIO spring from his studies of central-plan Roman temples and baths. The third area, reserved for the Capuchin friars, includes the choir and the two sacristies. Seen from above, their shape is that of the letter *tau* so dear to Franciscans and known, in Venice and in Christian thought, as the prefiguration of the Cross and the symbol of healing and eternal life. An intense and diffuse light – quite unusual for the Venetian churches of the time – and the skillful use of white hues that oscillate between biscuit and pearl, create unity and harmony of light, space and architecture. To use Palladio's own words, this effect of whiteness befits churches, since "the purity of the color and of life pleases God to the utmost." As soon as you enter, the inside façade, like the outside one, is a two-fold glorification of the Venetian state and the

Capuchin Order. The two lunettes over the entrance represent *Venice's Vow for the End of the Plague* (early 17th century?), a monochrome by the Capuchin friar PAOLO PIAZZA and, below this, *St. Felice da Cantalice Receiving the Christ Child from the Virgin* (1663-78), attributed to PIETRO MUTTONI (known as PIETRO DELLA VECCHIA). All the minor altars in the interior are decorated with an 18th-century frontal and by an altarpiece dedicated to an episode in the life of Jesus. Among these paintings are, in the first chapel at right, *The Adoration of the Shepherds* (1580-89) by FRANCESCO BASSANO, a nocturnal scene populated by humble persons; in the third chapel at right, *The Flagellation* (ca. 1588) by DOMENICO TINTORETTO, which is interesting for its foreshortening and chiaroscuro; in the third chapel at left, *Deposition* (ca. 1600) by PALMA GIOVANE, notable for its off-center

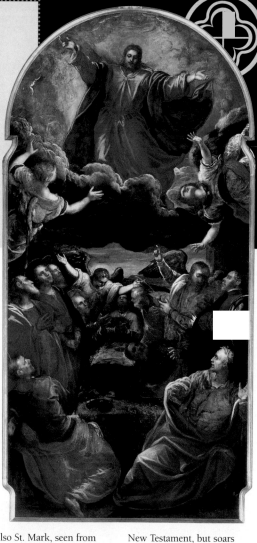

562 INTERIOR OF THE REDENTORE CHURCH LOOKING TOWARD THE HIGH ALTAR.

563 LEFT FRANCESCO BASSANO, *ADORATION OF THE SHEPHERDS*, DETAIL.

563 RIGHT DOMENICO TINTORETTO, *ASCENSION*.

perspective, in the direction of Calvary, and its gloomy atmosphere. Then in the first chapel at left is *The Ascension* (ca. 1588) by DOMENICO TINTORETTO, which is singular in that it shows how Capuchin devotion was permeated with elements taken from apocryphal Scriptures, in keeping with the meditation practiced by the Franciscans. Among the Apostles in the *Ascension*, in homage to Venice there is

also St. Mark, seen from behind at left, even though he was not one of those who witnessed this event. If you take a look at the ground, you will see the print of Jesus' right foot before he ascended. Among those present there are two Venetian patricians (without haloes) and probably the persons who commissioned this painting. The Redeemer is not being held up by angels as is narrated in the

New Testament, but soars upward by himself in a fiery sky: "[...] while they beheld, he was taken up; and a cloud received him out of their sight." (Acts, 1, 9).
Before going into the chancel, note the three steps in front of it, which are also in front of all the side altars. The number three – signifying the theological virtues and the Trinity – announces the passage from the congregation to the church's holy area.

There are five steps on the high altar, which is the number of Christ's wounds. Around Him and his Church – depicted in the bronze statues by GIROLAMO CAMPAGNA (St. Mark and St. Francis) and the Bolognese GIUSEPPE MAZZA – is the entire iconography of this marble altar, sculpted by CAMPAGNA, while the tabernacle was redone by TOMMASO RUER around 1682. The high relief on the front represents three Stations of the Cross: the first fall, the Mother of Jesus, and Veronica. In the small attic on top of the tabernacle there is a relief of the *Agony in the Garden*, and on the wall behind the altar are three episodes in one high relief (Mary fainting, the Deposition and the Preparation of the Tomb). Crowning this stupendous figurative machine conceived as the image of Calvary, is the huge, somber bronze crucifix by GIROLAMO CAMPAGNA, an expression of

Christ's sacrifice to save humanity. At his feet, under the small dome, are bronze angels holding up the instruments of the Passion. Past the magnificent semicircular colonnade are the friars' choir, with its simple 18th-century stalls, and, at right, the first sacristy. A long visit in the latter is highly recommended, because it contains many art works. First there is the series of paintings depicting the *Madonna and Child* by

artists such as ALVISE VIVARINI (ca. 1500), LAZZARO BASTIANI (late 15th century), FRANCESCO BISSOLO (late 15th century), PASQUALINO VENETO (early 16th century), ROCCO MARCONI (early 16th century), PALMA GIOVANE (ca. 1581), as well as the elegant gilded bronze statue of the same subject attributed to JACOPO SANSOVINO (mid-16th century). In all these works the Christ Child appears in two different poses: sleeping, an allusion to his death on Calvary, and in the act of blessing, to manifest his divinity, which dispenses grace and forgiveness. Furthermore, note the five surviving panels attributed to the school of FRANCESCO BASSANO that were taken from the high altar. Their subjects – *The Miracle of the Manna, The Offering of the Loaves, The Last Supper, The Supper at Emmaus, The Resurrection* – celebrate the Eucharist, drawing inspiration from the pictorial cycles so popular among the Santissimo

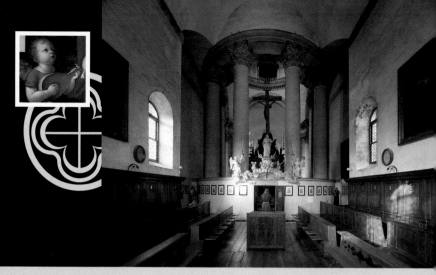

Sacramento confraternities. Two other paintings represent the history of this monastery. *The Baptism of Christ* (ca. 1561) by PAOLO VERONESE and the splendid *St. John the Baptist in the Desert* (ca. 1566, signed) by JACOPO BASSANO come from the small church of Santa Maria degli Angeli. In the first work, the patrons, Bartolomeo Stravazino and his father Giovanni, can be seen. In addition to *The Ecstasy of St. Francis* (1620)

by the Caravaggioesque CARLO SARACENI, there is a series of 18th-century ivory *crucifixes*; the wooden *crucifix* of the suffering Christ flanked by four Evangelists (18th century); and the two precious polychrome glass reliquaries made in Murano (ca. 1755). These were donated by the noted glassblower GIUSEPPE BRIATI and are kept in the credenzas. Then there are architectural reliquaries, and the busts-*cum*-reliquaries,

made of wax and kept in glass domes, portraying twelve Capuchin saints (19th century), which are surprising for their macabre realism. Besides the second sacristy, known as the Coretto dei Laici or Laymen's Little Choir, the monastery also has three cloisters, a kitchen garden and a pharmacy that began operating in the second half of the 16th century and boasts jars dating from the 17th and 18th century.

564 TOP LEFT AND 565 TOP LEFT ALVISE VIVARINI, MADONNA AND CHILD WITH TWO ANGEL MUSICIANS.

564 TOP RIGHT LAZZARO BASTIANI, MADONNA AND CHILD.

564 BOTTOM PAOLO VERONESE, BAPTISM OF CHRIST.

565 TOP RIGHT FRIARS' CHOIR.

565 BOTTOM JACOPO BASSANO, ST. JOHN THE BAPTIST.

566 TOP PALAZZO MINELLI OR CASA DEI TRE OCI.

566 BOTTOM AND 567 BOTTOM ANTONIO VASSILACHI (L'ALIENSE), MADONNA AND CHILD, ST. FRANCIS AND FEDERICO CONTARINI, ZITELLE CHURCH.

567 TOP LE ZITELLE CHURCH AND FORMER ALBERGO.

■ When you leave the Redentore church, head right and pass over the Ponte della Croce, at the foot of which is a short *fondamenta* with the access way (not open to the public) to **Santa Croce Church**, which was documented as early as the 14th century and was rebuilt in 1508-15. Its modest façade, with slender pilasters, still has its original Gothic proportions. The interior, which is now empty, has a choir loft (1699), an aisleless nave, a chancel and two side chapels. Its richly ornamented altars (which have been removed) once contained precious relics, including the body of St. Athanasius, patriarch of Alexandria and Doctor of the Church, and the Blessed Eufemia, niece of St. Lorenzo Giustiniani and abbess of the adjoining Benedictine nuns'

convent. While walking along the Fondamenta de la Croce, you can spot, toward the Zattere, the smaller cupola of the Salute Church and the astronomical observatory of the nearby Seminario Patriarcale. At no. 110 is an inscription with a decree issued by the Magistrate of Waters in 1642 that prohibits throwing refuse and rubble into the water. Going back to the *fondamenta*, at no. 53 are the **Fondamenta de la Croce residences** built around 1995 and designed by VALERIANO PASTOR. The plaster façade is crowned by a controversial post-modern balustrade. The narrow inner courtyard is articulated along a series of columns and cylindrical brick structures. This is followed by the eclectic and Neo-Gothic **Palazzo Minelli**, modeled after the windows in the Doges' Palace and designed and inhabited by the painter MARIO DE MARIA (d. 1924). Because of the splendid windows with

pointed arches and semi-circular balcony, this building is known as the Casa dei Tre Oci, or House of Three Eyes. Next you come to the church of Santa Maria della Presentazione, better known as **Le Zitelle**. HISTORY: the Ospedale delle Zitelle was founded in 1559 by the Jesuits, who had arrived in Venice in 1550. The hospice was established to house good-looking but poor unmarried girls (*zitelle*) who could have been easy prey for the flourishing prostitution racket in Venice. The girls were given a good education and were encouraged to get married or become nuns. Construction work on the new hospice began around 1575, while the church, perhaps built under the supervision of the *proto* SIMONE SORELLA, was begun in 1581 and consecrated in 1588. The modest architecture of this structure makes the common attribution to Andrea Palladio improbable. On the

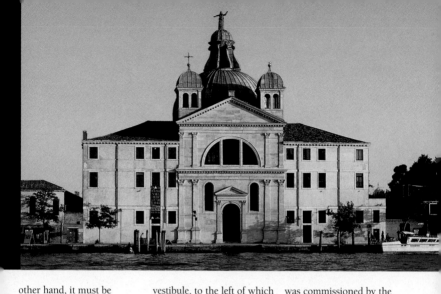

other hand, it must be stressed that the Zitelle type of structure, consisting of a hospice with the church incorporated in the middle, became a model for other building complexes such as the Pietà hospice, whose façade, conceived by GIORGIO MASSARI, was never finished.

FAÇADE: the Zitelle Church has a pitched body with Corinthian pilasters. The upper section is dominated by an enormous thermal window that in terms of position is similar to the one on the two façades of San Trovaso Church. On the sides of the pediment are small bell towers that are out of proportion with the façade and that partly block our view of the cupola behind them, which is crowned by a statue of the Madonna.

INTERIOR: on the inside façade, above the entrance, is *The Nativity of Mary* by PIETRO RICCHI and, at the sides, two canvases attributed to the circle of PALMA GIOVANE. Past the

vestibule, to the left of which is the sacristy, you enter the square aisleless nave with rounded-off corners. The walls of the nave are divided by a sequence of numerous Corinthian pilasters on pedestals that alternate, in the upper part, with a series of twelve quite mediocre canvases whose subjects include episodes from the life of Christ. On the right-hand altar is *The Agony in the Garden with the Donors Elisabetta and Pasquale Foppa* (ca. 1618) by PALMA GIOVANE, while on the left-hand altar is *The Madonna and Child, St. Francis and Federico Contarini* by ANTONIO VASSILACHI, known as L'ALIENSE (1556-1629). Federico Contarini, who is buried at the foot of this altar, was a famous art collector. In the corner at right is an elegant statue of the Madonna del Rosario (1761) by GIANMARIA MORLAITER.

The high altar, attributed to the *proto* JACOPO BOZZETTO,

was commissioned by the Bergamo merchant Bartolomeo Marchesi (d. 1586), who was also one of the governors of the Zitelle. The altarpiece, *The Presentation of Mary in the Temple* (1586), is attributed to FRANCESCO BASSANO. Among the persons witnessing the scene, at right and just above the allegory of Charity, are the portraits of Marchesi and his wife, Girolama Bonomo.

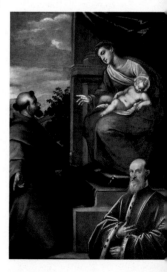

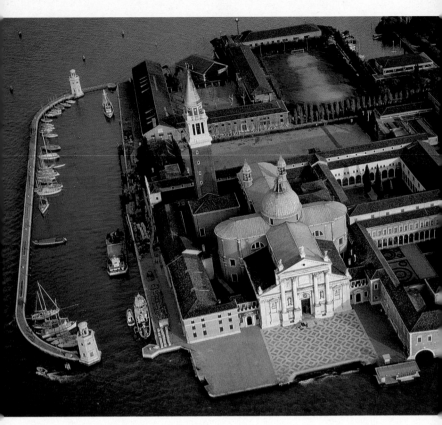

■ Exiting from the Zitelle, continue to your right, where, at no. 20 Fondamenta San Giovanni, is **Palazzo Mocenigo** attributed to FRANCESCO CONTIN. After passing by an interesting small Gothic building (no. 13), at no. 10 is a surviving side door of **Palazzo Nani-Dandolo**, which belonged to the latter family and was then purchased by the Nani, becoming the home of a philosophical academy founded by the humanist Ermolao Barbaro. Retrace your steps to the Zitelle landing stage, take the *vaporetto* (water bus) to nearby San Giorgio Maggiore

Island. As soon as you land you are in front of **San Giorgio Maggiore Church**. HISTORY: situated at the junction of the Grand Canal and the Giudecca Canal, San Giorgio Island – called Insula Memmia in ancient times and later Isola dei Cipressi – owed its future development to the initiative of two doges. Giustiniano Partecipazio (827-829) founded the first church there, dedicated to St. George, the patron saint of armies, and Tribuno Memmo (979?-991) donated the entire island to the Benedictine Giovanni Morosini in 982 and exempted the monastery

from any religious jurisdiction. Morosini (d. 1012) became the first abbot of the island and one of his pupils from the Venetian patriarchate was St. Gerardo Sagredo. From the 11th century on the monastery received many generous donations and imperial and papal privileges; most important of all, it managed to acquire precious relics. Among these was the body of St. Stephen (1110), the prototype of the Christian martyr, who became the co-titular of the church, in honor of whom a devotional brotherhood was founded. In Venice, St. Stephen's Day was

568-569 SAN GIORGIO
MAGGIORE ISLAND.

569 TOP SAN GIORGIO
MAGGIORE CHURCH AND
CONVENT, DETAIL.

569 BOTTOM SAN GIORGIO
MAGGIORE, STATUE OF THE
TITULAR SAINT.

celebrated together with Christmas as a holiday of light. On that occasion, in the evening thousands of floating candles called *ludri* were lowered into St. Mark's Basin and the doge, accompanied by a retinue of noblemen and noblewomen, paid homage to the tomb of the saint. Around 1204 the body of St. Lucy was also brought to the island. The flow of pilgrims during her feast day (December 13) in 1280 was so large that many persons died because of a storm in the lagoon. Therefore, her body was transferred to Santa Lucia Church, in Cannaregio. Around 1324, the monks

gained possession of one of St. George's arms and, in 1462, part of his skull. The fine library the prestige gained by the aid the Benedictine monks offered to the ill, the rich treasury of relics, and the origin under the doges of the monastery of St. George – all added luster to the church. It was the chosen burial site of the leading personages in Venice. The Benedictine church was rebuilt after the earthquake of 1223, thanks to Doge Pietro Ziani (1205-29), and ANDREA PALLADIO made a design for the new church in 1565. In his studies, the great architect took into consideration a preceding project drawn up in 1521-22 and attributed to Alessandro Leopardi or Tullio Lombardo. The model for the new church was finished in 1566, and the first stone was laid in that same year. Among the stonecutters supervised by PALLADIO, there were GIAN GIACOMO DE' GRIGI, and ANDREA and

GABRIELE DALLA VECCHIA. FAÇADE: as was the case with the old façade of San Francesco della Vigna church, Palladio tackled a crucial problem in his architectural research and creation. This was managing to design the façade of a church by merging, in coherent fashion, the difference in height between the aisles and the nave. The façade, built in 1597-1611 by the *proto* SIMONE SORELLA, was designed by PALLADIO, but many art historians have expressed doubts concerning certain details. His plan is simple and effective, and had a great influence on European architecture for over two centuries. The central mass, corresponding to the nave, is occupied by a tetrastyle front with four giant composite half-columns on tall pedestals and surmounted by a wide tympanum. The side wings, which correspond to the aisles, end in paired Corinthian pilasters. In

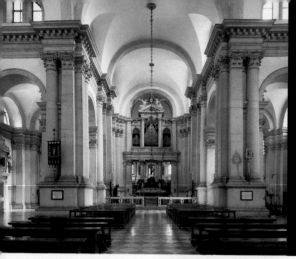

order to heighten the uniformity of the whole, the pilasters are repeated on either side of the paired semi-columns and support a continuous trabeation over the portal. The statues summarize the history of the church and monastery. The figures of the titulars of the church, St. Stephen and St. George (signed) by GIULIO DEL MORO, are in the niches on either side of the portal, while the flanking monuments to the doges Sebastiano Ziani and Tribuno Memmo refer to the foundation of the church and its donation to the Benedictines. The reliefs above the saints depicting a mitre, crozier and palm refer to St. Benedict's post as abbot of the Montecassino monastery and to the martyrdom of the Benedictine saints. The statue of St. Benedict is over the right-hand pitch, while on the opposite one is the statue of St. Mark, patron saint of Venice. Crowning the tympanum is the statue

of the Redeemer, attributed to ANTONIO TARSIA (ca. 1663 -1739), and the two praying angels flanking it are a variation of the subject depicted on the high altar inside. A statue of St. George surmounted the dome.

INTERIOR: a nave and two aisles traversed by a transept with apsidal ends and surmounted in the middle by the dome. The church was roofed in 1581, one year after the death of Palladio (d. 1580). The nave, conceived to host the doge's procession, has giant columns on pedestals that are crowned by composite capitals with simplified decoration – an echinus without egg-shaped molding and leaves without venation – to attenuate the chiaroscuro contrasts. There

are six side altars, built sometime after 1591. The apsidal chapels are here replaced by two altars placed at the end of the aisles. Two pairs of columns separate the spacious chancel from the apsidal choir. The internal façade is occupied by the Monument to Doge Leonardo Donà (1606-12), on the sides of which the complex sculptural decoration begins with the four stucco figures of the Evangelists by ALESSANDRO VITTORIA (1524-1608). The four Doctors of the Church, made of wood painted white and situated below the other statues, are by GIAMBATTISTA DE FLORIO. On the internal façade of the right aisle is the Monument to General Lorenzo Venier (1677) and, in the nearby niche is a statue by GIAMBATTISTA ALBANESE (1573-1630) portraying St. Mauro Abbot, a monk and disciple of St. Benedict. Among the altarpieces along the right aisle, on the first altar is *The Adoration of the Shepherds*

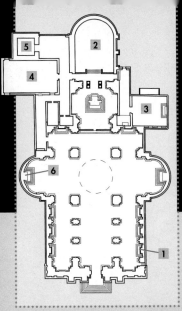

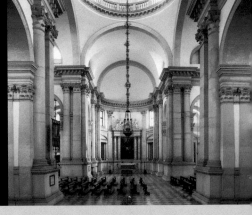

570 TOP AND 571 TOP
SAN GIORGIO MAGGIORE,
LEFT TRANSEPT AND NAVE.

570 BOTTOM JACOPO
BASSANO, *ADORATION OF
THE SHEPHERDS*, DETAIL.

571 BOTTOM SEBASTIANO
RICCI, *ENTHRONED VIRGIN
AND SAINTS*.

(1582), a late work by
JACOPO BASSANO, notable for
its effective noctural setting
and the expressive portraits
of some figures; on the
third altar, *The Martyrdom
of St. Cosmas and St.
Damian* (1592) by
DOMENICO TINTORETTO and
assistants is dedicated to
the two miracle-working
saints venerated on the
Giudecca, whose bones
were taken to San Giorgio
Maggiore; on the altar in
the right transept, *The
Coronation of the Virgin*
(dated 1708) by SEBASTIANO
RICCI, who drew inspiration
for the diagonal
composition from Titian's
The Madonna di Ca' Pesaro
in the Frari church, and
from Veronese for the
colors. The middle of the
transept is dominated by
the balustraded cupola,
which was finished in 1575.

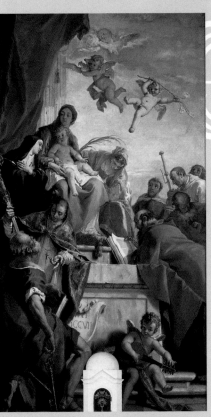

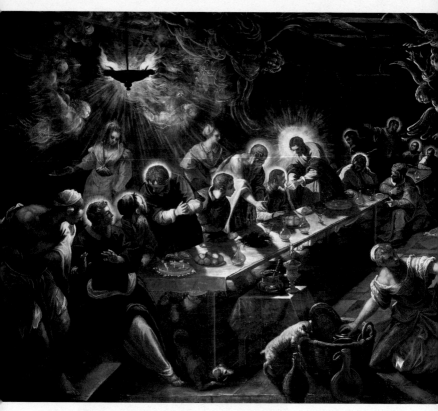

In the chancel, note the four statues in niches that glorify the Church and the Benedictine order: St. Peter and St. Paul by FILIPPO PARODI and, above these, St. Columbanus (the Irish hermit who wrote a severe Rule for the order) and St. Placido, a disciple of St. Benedict, by GIAMBATTISTA ALBANESE. The visual fulcrum of the chancel is the *high altar* (ca. 1591), designed by ANTONIO VASSILLACHI (known as L'ALIENESE), crowned by a series of sculptures. The central group, sculpted by GIROLAMO CAMPAGNA, consists of the Four Evangelists and the Holy

Trinity (1592-93) and the two praying angels (signed and dated 1644) at the ends are by PIETRO BUSELLI. At left, the wood reliefs on the frontals (ca. 1593) by the Venetian woodcarver JACOPO ZANE deal with the theme of sacrifice to God with the *Jewish Passover*, *Abraham Sacrifices Isaac* and *The Sacrifices of Abel and Cain*. The upper section is dominated by the large canvas by JACOPO TINTORETTO, *The Hebrews in the Desert* (1592-94), formerly entitled *The Gathering of the Manna*. This painting does not depict the gathering of the manna or the refusal to eat

it. But the divine food is clearly recognizable on the ground, white and "like coriander seed." The scene illustrates various episodes from Exodus simultaneously. In the foreground at right, we see the elderly Aaron and his brother Moses. The many figures absorbed in various activities remind us of human time and, by antithesis, allude to God's discourse on the holiness of the Sabbath, the day consecrated to the Lord. On the right wall, the wood reliefs illustrate *The Martyrdom of St. Stephen* – titular of the church – *The Agony in the Garden* and *The Meeting with the Disciples at*

Emmaus. Above this is the extraordinary canvas by JACOPO TINTORETTO, *The Last Supper* (1592-94). Jesus is speaking with an Apostle, while on the other side of the table, Judas is seated alone, in the attire of a heretic and the image of haughtiness. Next to him are the rag, sponge and large basin – symbols of humility – that Christ used to wash his disciples' feet. On the right a maid is handing a servant a tray overflowing with manna. This is not a gesture of refusal, but rather a clear allusion to the fact that this celestial food is no longer necessary because of the Eucharist. The triumph of this sacrament is confirmed by a fantastic invention on the part of Tintoretto. As if by magic, the smoke coming from the oil lamps is transformed into the evanescent, thin figures of angels.

Their presence, also underscored by the two statues on the high altar, is a precise reference to what was asserted in the 1551 Council of Trent: in reply to the Protestants' criticism, the Eucharist was defined "the bread of angels."

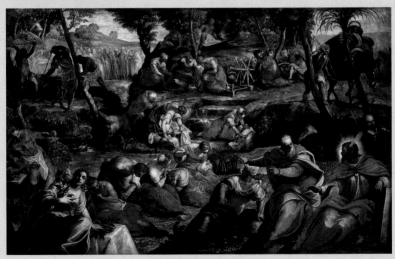

572-573 AND 572 TOP
JACOPO TINTORETTO, *LAST SUPPER* AND DETAIL.

573 BOTTOM JACOPO
TINTORETTO, *THE HEBREWS IN THE DESERT.*

From the chancel you enter the majestic choir (finished in 1589), which has a polychrome marble floor and a balustrade with lovely bronze statuettes of the titulars of the church, St. Stephen and St. George (1594-96) by the Genoese sculptor NICOLÒ ROCCATAGLIATA. The sumptuous wooden stalls were carved by GASPARE GATTI, the Flemish carver ALBERT VAN DER BRULLE and LIVIO DEI COMASCHI from Piacenza. Van der Brulle also did the 48 reliefs on the frontals illustrating episodes from the life of St. Benedict taken from a treatise by Father Angelo Sangrino published in Rome in 1598. Next to the right-hand balustrade is a door. Before the small stairway is the floor tomb of the Venetian monk Pietro, the Prior of

Constantinople, who in 1110 brought the body of St. Stephen to Venice. At the end of the corridor is the *Chapel of St. Paul the Martyr*, also known as the *Chapel of the Dead* or of the Deposition. Its altarpiece is a moving *Deposition* (1593-94), considered to be the last painting by JACOPO TINTORETTO. Like Titian with his *Pietà* in the Accademia Galleries, Tintoretto presents us with a heart-rending meditation on the meaning of Christ's death. His body, spotted with blood from the beating and flagellation, is already in a state of rigor mortis and in the shape of the cross. The traces of blood, the symbol of love, stand out against his white shroud. In the middle ground, Mary has fainted and is lying on the ground as if dead. Her arms repeat

the shape of the Cross made by her son's body. Above this chapel is the monks' nocturnal choir, in the altar of which is a painting of *St. George and the Dragon* (signed and dated 1516) by VITTORE CARPACCIO and assistants, which may have come from the Santa Maria del Pero abbey in Treviso. At right, at the foot of a tree, the princess is praying. Behind her, St. Stephen is being stoned to death. In the group of onlookers is Saul (St. Paul), at whose feet are the clothes laid down by the two witnesses who accused Stephen of blasphemy. At left, in the desert, are two hermits: St. Jerome reading a book and, perhaps, St. Onofrio or St. Benedict near the thorny bush. Back in the choir, go through the side door at left and take the elevator up the campanile, a

visit that is highly recommended because of the stunning view it affords. Before the elevator there is the original statue of the angel (now replaced by a copy) on the top of the 18th-century campanile that was badly damaged by lightning in 1993. After going down the campanile, along the corridor at right is the sacristy, which has two 16th-century statues of St. Mark and St. George and a 17th-century wall clock, as well as works by such artists as PALMA GIOVANE and SEBASTIANO COSSER, Jacopo Tintoretto's son-in-law. At the end of the corridor is the Monument to Pietro Civran, which was rebuilt by BALDASSARE LONGHENA in 1638; the Gothic tomb slab with the figure of the deceased dates from 1395. Back in the church, above

the nearby door is the fine Monument to Vincenzo Morosini (d. 1588) and his two brothers, sculpted by ALESSANDRO VITTORIA. The altar at the end of the left aisle has the *Risen Christ and St. Andrew* altarpiece (ca. 1585) by DOMENICO TINTORETTO and assistants. Going toward the exit, note the altar of the left transept, which is dedicated to St. Stephen, and its altarpiece by DOMENICO TINTORETTO, *The Martyrdom of St. Stephen* (1594). Once past the altars dedicated to St. George and the Virgin Mary, there is the altar of St. Lucy, whose body used to lie in rest in this church. The altarpiece, *St. Lucy Dragged to the Brothel* (1596), is by LEANDRO BASSANO. In the background, at right, is Lucy's suitor reporting her to the judge Pascasius.

574 TOP AND BOTTOM RIGHT JACOPO TINTORETTO, *ENTOMBMENT OF CHRIST* AND DETAIL.

574 BOTTOM LEFT CHOIR.

575 TOP VITTORE CARPACCIO, *ST. GEORGE AND THE DRAGON*.

575 BOTTOM DOMENICO TINTORETTO, *MARTYRDOM OF ST. STEPHEN*.

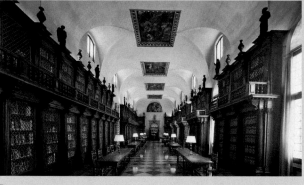

■ Outside the church, you can continue your visit by heading left, where you can visit the former monastery, which is now the home of the **Giorgio Cini Foundation**. Count Vittorio Cini instituted a cultural and artistic foundation to honor the memory of his son Giorgio, and in 1951 he began the long and large-scale restoration of the monastery. As soon as you enter the monastery, you will see the CHIOSTRO DEI CIPRESSI (cloister of cypresses). This was designed by ANDREA PALLADIO, begun in 1579 but still being built in 1646. It stands out for the majesty and rhythm of the arches supported by paired Ionic columns, to which correspond the same number of windows crowned by tympana or segmental lunettes situated on the upper, roofed corridor. Halfway down the second side, turn right to go into an open area with a lawn. The structure at left is the refectory, while the one at right, formerly used as a novitiate and enlarged by BALDASSARE LONGHENA in 1657, houses the *tapestry* collection. By going along the main path into the park, you will come to the fascinating TEATRO VERDE, which was inaugurated in 1954 and designed by LUIGI VIETTI and ANGELO SCATTOLIN. Retracing your steps, go back into the second cloister, known as the Chiostro degli Allori by ANDREA BUORA in 1517-26. Returning to your starting point, the second cloister, you can go into the Refectory, designed by ANDREA PALLADIO in 1560-61. This structure is divided into three monumental halls built in a simple, austere manner. The sides of the main wall have two ritual basins (ca. 1561) designed by PALLADIO, while in the middle is the portal, designed by NICOLÒ TAGLIAPIETRA. On the left-hand wall is a copy by an anonymous artist of Veronese's *The Wedding at Cana*, the original of which, now in the Louvre, was situated on the back wall of the refectory. The choice of the Lord at a banquet was therefore quite appropriate for this hall. In place of Veronese's huge canvas (1562-63; 22 x 30 feet/26.70 x 9.9 m), unsuitable *Marriage of the Virgin* by DOMENICO TINTORETTO. The ceiling is tripartite. The ends

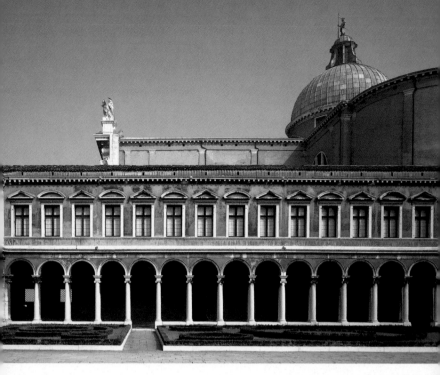

have barrel vaulting, while the middle has cross-vaulting, where the elegant cornice is interrupted; in the lacunars of this latter are reliefs of the classical ancient five-petal rose, the symbol of the wounds and Passion of Christ. The visit continues by returning to the first cloister, which opens onto the magnificent monumental double staircase (1643-45) designed by BALDASSARE LONGHENA decorated with religious and civil allegorical motifs. In fact, on the ceiling is *Jacob's Vision* (1664-74) by the French artist VALENTIN LEFÈVRE and, on the first landing in a niche, *The Allegory of Venice* sculpture by FRANCESCO CAVRIOLI (d. 1670). Cavrioli sculpted Venice as a dogaressa seated on a singular throne, at the sides of which are the Lion

of St. Mark and a nude figure of an old man that may be the symbol of vice vanquished. Going back into the corridor, which has canvases of many saints by BONIFACIO DE' PITATI and assistants, go past the door at the end and enter, at left, the fascinating, luxurious library designed by BALDASSARE LONGHENA along the wing linking the two cloisters. Among the pieces kept here are many drawings by GIAMBATTISTA PITTONI (1687-1767) This long, tall room (1641-53, signed) has preserved its original bookshelves made of walnut wood and the running balcony with

Corinthian columns carved by the German sculptor FRANZ PAUC. The wooden statues crowning the shelves portray illustrious scientists and artists. The five canvases on the ceiling depicting *The Triumph of Wisdom* (1663-65) are by the Luccan artists GIOVANNI COLI and FILIPPO GHERARDI, while the lunettes above the portals have mythological subjects.

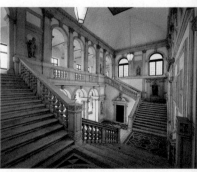

▶ MAIN SIGHTS

[1] SAN MICHELE IN ISOLA
● *CHURCHES*: San Michele
Arcangelo Church; Cappella Emiliana;
Cimitero di Venezia (Venice Cemetery).

[2] MURANO
● *CHURCHES*: San Pietro martire;
Santa Maria degli Angeli;
Santi Maria Assunta e Donato
● *PALAZZI*: Ca' Contarini-Mazzolà;
Ca' da Mula; Palazzo Giustiniani;
Palazzo Trevisan.
● *OTHER MONUMENTS*: Oratorio
di Santo Stefano; Ospizio Briati.
● *MUSEUMS*: M. Vetrario.

[3] MAZZORBO
Santa Caterina Church;
working-class quarter, Sant'Angelo
campanile; Ridotto Mazzorbo.

[4] BURANO
● *CHURCHES*: San Martino
Cathedral; Santa Maria delle Grazie.
● *PALAZZI*: del Podestà;
della Comunità.
● *OTHER MONUMENTS*: Cappella
di Santa Barbara.
● *MUSEUMS*: M. del Merletto.

[5] SAN FRANCESCO DEL DESERTO

[6] TORCELLO
● *CHURCHES*: Santa Maria Assunta
Cathedral; Santa Fosca.
● *PALAZZI*: del Consiglio; dell'Archivio.
● *OTHER MONUMENTS*: Cappella
di Santa Barbara.
● *MUSEUMS*: M. di Torcello
(Lacework Museum).

[7] SAN SERVOLO

[8] SAN LAZZARO DEGLI ARMENI
Monastery; Church; Museum.

[9] LAZZARETTO VECCHIO

[10] LA GRAZIA

[11] SAN CLEMENTE
Church.

[12] SANTO SPIRITO

[13] POVEGLIA

[14] IL LIDO
● *CHURCHES*: Santa Maria
Elisabetta; San Nicolò; Santa Maria
Nascente (Ospedale al Mare);
Santa Maria Assunta (Malamocco).
● *PALAZZI*: Casa Rossa;
Palazzetto del podestà and Canonica
arcipretale (Malamocco).
● *VILLE*: Mon Plaisir; Eva.
● *OTHER MONUMENTS*:
Sacrario militare di Venezia (Venice
War Memorial); Lido Cemetery;
Jewish Cemetery; Old Jewish
Cemetery; Fortezza di San Nicolò;
Sant'Andrea Fort (Vignole);
Serraglio; Forte Ridotto;
Mario Marinoni Theater (Ospedale
al Mare); Hotel Hungaria; Blue Moon;
Planetario di Venezia; Grand Hotel des
Bains; ex Casinò municipale;
Palazzo della Mostra del Cinema;
Albergo Excelsior; Forte and Murazzi
(sea wall) (Malamocco); Ottagoni;
Forte Alberoni.

THE ORIGINS AND MODERN VENICE

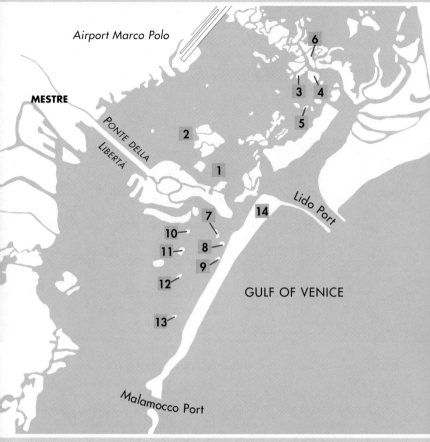

Airport Marco Polo

MESTRE

PONTE DELLA LIBERTÀ

6

3 4

5

2

1

Lido Port

14

7

10

8

11

9

12

13

GULF OF VENICE

Malamocco Port

T he first description of the Venice Lagoon dates back to a letter written in 537 by Magnus Aurelius Cassiodorus, a resident of Ravenna and minister of King Theodoric. But the first illustration of Venice and its islands was published in a woodcut only in 1528: for obvious lack of space and in order to simplify, the artist, BENEDETTO BORDONE, depicted the lagoon as a round area dotted with islands, in the middle of which is the enlarged image

of the city. Despite the alterations caused by the tides and other natural phenomena, as well as continuous human intervention, the lagoon, which is the largest in the Mediterranean, has retained the main geographic features that marked the economic fortune of Venice a few centuries after the death of Christ. The humid, brackish water environment–covering a surface area of 550 square kilometers and with an average width of 10-12

km–is situated in a crucial communications hub between Europe and the eastern Mediterranean. Venice rose up at the crossroads between the maritime routes in the Adriatic Sea and the land and river routes that began in the Veneto and Friuli regions and allowed merchants and travelers to reach the major areas in the Po River valley and also the countries beyond the Alps. But before Venice thrived commercially and became a leading city,

580 GONDOLAS AND
REFLECTIONS.

580-581 VENICE
LAGOON, SATELLITE VIEW.

the main towns in the lagoon area were Malamocco and Torcello. The former urban settlement was founded in the middle of the Lido, the long, thin strip of land that separates the Venice Lagoon from the sea and that owed its fortune as a port of call to the ancient sea route linking Ravenna and Aquileia. The great emporium of Torcello, on the other hand, developed thanks to its vicinity to the mainland, especially with Altinum, whose shores were praised by the Latin poet Martial for their healthy climate. Around the 6th century, the lagoon inhabitants –who practiced fishing, farming and fowling–were already famous for their skill as boatmen and traders who went up the rivers into the Veneto mainland and the Po Valley. Among the most sought-after products in that time were salt–necessary to preserve food–and timber, needed to build boats, buildings and embankments and also used for heating and cooking. The former resource came mostly from the Chioggia salt flats (later replaced by those in other countries), while the wood came from the Italian mainland, in particular the forests around Treviso and Cadore. The areas that benefitted most from timber traffic were the islands in the northern lagoon–Torcello, Mazzorbo, Burano and Murano–since they lay between the Sile River, down which the timber was transported, and the vast Venetian area between San Francesco della Vigna, near the Arsenale, and the Sacca della Misericordia. The Benedictine monasteries played a crucial role in the urbanization of the Venice Lagoon. Founded in the outlying localities or islands, they became avant-garde "laboratories" of experimentation in the techniques of reclaiming the shoals and excavating the *fosse* and *scomenzere*, the artificial canals that connected two bodies of water. Later on, these monastic centers, thanks to

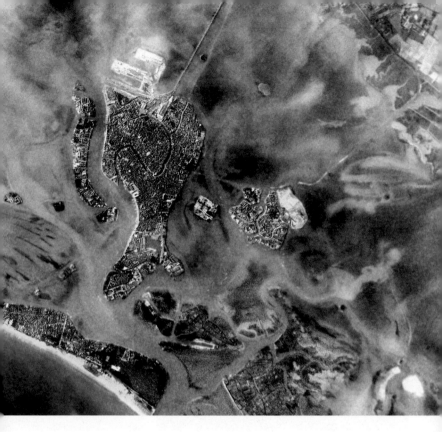

the work of the nuns and monks, set the example for the future urban and agricultural organization of Venice with their kitchen gardens, vineyards, wells, embankments, churches, dormitories, hospices for pilgrims, and hospitals. The Benedictine monasteries flourished until the 12th century, when other religious orders appeared on the scene–the Augustinian, Franciscan, Dominican, Carmelite, and Camaldolite. The Venetian state is to be credited with the continuous works of military and hydraulic maintenance and defense of the lagoon. The first works concerned the littoral belts, which were

subject to the frequent high waves caused by storms and were the delicate defensive bulwark against any attack from the sea. In 1275, the "supervisors of the shores" were established. The defense system of the San Nicolò di Lido port, the main access way to the city, dates from the 11th century and is documented from 1253 on. Modernized several times from the early 15th to the 17th century, these fortifications were the linchpin of a system that extended as far as Chioggia. In the 18th century the long littoral sea wall known as the *Murazzi* was built. Even though the works along the lagoon boundary near the

mainland were carried out later, they had a lasting and enormous effect, since they saved the lagoon from flooding and silting due to the action of the rivers. The Magistrato alle Acque (Magistracy of the Waters), responsible for the rivers and lagoon, was founded in 1505. From the mid-15th century to the 17th century, canals were excavated to extend lagoon navigation and to divert the course of rivers such as the Brenta and Bacchiglione (1550)–the work of the hydraulic engineer CRISTOFORO SABBADINO–the mouth of the Po with the Taglio di Porto Viro (1556-1604), and the Piave Vecchia and the Sile (1683).

SAN MICHELE IN ISOLA

■The island closest to the Fondamente Nove is San Michele, which became the seat of a prestigious Camaldolite hermitage in 1212. As soon as you land, in the middle of the small square you will see **San Michele Arcangelo Church**. HISTORY: the original church, consecrated in 1221, made up of jambs flanked by pilasters and crowned by a tympanum and a statue of the *Madonna and Child* (15th century). On the upper register there are two characteristic curved cornices that correspond to the aisles and, in the tall central section, a rose window, Ionic pilasters and

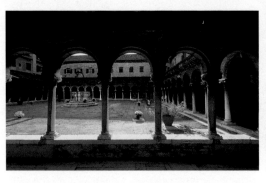

was rebuilt in the seconds of the 15th century by MAURO CODUSSI. FAÇADE: already begun in 1469, the façade was appreciated by the Venetian monk Pietro Dolfin, who had closely followed its construction, for the elegance of its smooth rustication and the novelty of the classicizing decoration. The dazzling white of the Istrian stone can be seen from away in the lagoon and the façade was the same color as the Camaldolite monks' habits. The first register has four pilasters with pseudo-composite capitals. The entrance (1470), attributed to LORENZO DA VENEZIA, is

a large lunette crowned by the statue of the *Redeemer* (early 16th century). INTERIOR: once past the outer portal of the cloister at right – which is surmounted by the Gothic cusp framing the statue of the titular, *The Archangel St. Michael Killing the Dragon* (ca. 1430), by a Tuscan sculptor – you enter the side door. The visit begins from the main entrance. After the atrium and choir, the church has a nave with two aisles separated by three large round arches on Corinthian columns whose capitals have no leaves, and ends in two deep side apses and an apsidal chancel with a blind

dome (ca. 1482) over it. Though it was renovated, the church structure has retained its original Gothic style. On the inside façade is the Monument to Cardinal Giovanni Delfino (d. 1622). The bust of the deceased and the statues of Faith holding a chalice and Prudence with a mirror are attributed to PIETRO BERNINI, the father of Gian Lorenzo Bernini. The two canvases on the side walls, with episodes from the life of Moses, are by GREGORIO LAZZARINI (right) and ANTONIO ZANCHI (left). The exquisite choir loft was made around 1480. The 5-arch Lombardesque-style structure has, on the upper

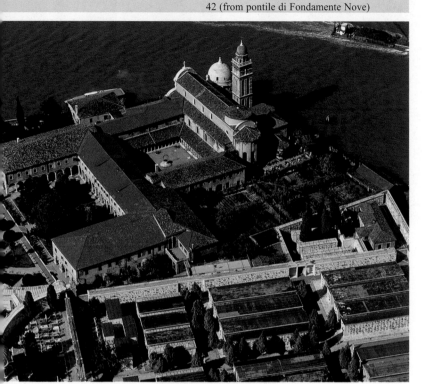

floor, the wooden choir signed by ALESSANDRO BEGNO, (1534). The statues by JUSTE LE COURT and MELCHIORRE BARTHEL, placed in the inner niches, represent *St. Jerome* (1695) and *St. Mary Magdalene*. The right-hand chapel with an apse (1475) was financed by Marco Zorzi, while THE CHANCEL (1485) was paid for by Andrea Loredan. On the sides of the four square piers are reliefs with Eucharistic motifs, the Loredan coat of arms, and the figures of St. Benedict and St. Romuald, revered by the Camaldolite order. The high altar (1686) by SANTE TROGNON was decorated in 1687 by the statue of *Archangel St. Michael Killing the Dragon* by PIETRO CALLALO and, at the sides, the statues of *St. Benedict* and *St. Romuald* by FRANCESCO PENSO (known as CABIANCA).

582 SAN MICHELE ARCANGELO CHURCH, 15TH-CENTURY CLOISTER.

582-583 AERIAL VIEW OF THE CHURCH, CONVENT AND CEMETERY OF SAN MICHELE.

583 CENTER ANONYMOUS TUSCAN ARTIST, ST. MICHAEL KILLING THE DRAGON.

583 BOTTOM SAN MICHELE CHURCH AND THE CAPPELLA EMILIANA.

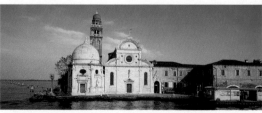

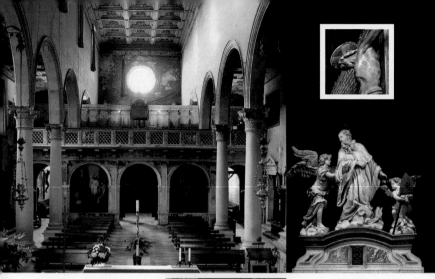

584 TOP LEFT NAVE AND GALLERY, SAN MICHELE CHURCH.

584 TOP RIGHT CRUCIFIXION, DETAIL.

584 CENTER RIGHT GIACOMO PIAZZETTA, ST. ROMUALD IN GLORY BETWEEN TWO ANGELS.

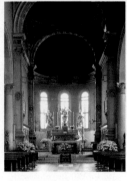

In the chapel with apse at left, which was financed by Pietro Donà (d. 1500), there is an altar surmounted by a marble group by GIACOMO PIAZZETTA, father of the famous painter Giambattista, representing *St. Romuald in Glory between Two Angels* (1699). At the foot of the founder of the Camaldolite order, among the clouds, is the order rule. In his *Life of the Blessed Romuald* (1042-43), St. Pier Damiani says that the Benedictine monk spent some time in the Venice Lagoon. The nearby SACRISTY, attributed to CODUSSI and dating from 1485, has a ceiling (1712-13)

frescoed by ROMUALDO MAURI and contains wooden credenzas carved by the Camaldolite friar GIACINTO SAVORINO (late 17th century). Besides the lovely Lombardesque basin, note the small chapel in which abbot Pietro Boldù (d. 1495), who financed the construction of the sacristy, is buried. In the left aisle of the church is the Santa Croce Chapel (1478-80) designed by CODUSSI. Note the elegant entrance portal with the statue of St. Helena and, on the floor, the earthen seal of the tomb of Pietro Priuli, procurator of St. Mark's and patron of the

chapel; also, on the inside façade of the aisle is the cross made of polychrome paterae built in honor of the Relic of the Cross kept here. Once back in the atrium of the church, at right you enter the **Cappella Emiliana**, built for Margherita Vitturi (d. 1485) to honor the memory of her husband, Giovanni Battista Emiliani. The building is dated 1530, as an inscription tells us, but was really built by GUGLIELMO DE' GRIGI, of Bergamo, in 1527-43. EXTERIOR: the hexagonal chapel to the left of the façade of San Michele Church has fluted Corinthian columns on pedestals on the corners and is crowned by a dome on a tambour. The two statues in niches portray St. Margaret and St. John the Baptist and were sculpted by GIOVANNI BATTISTA DA CARONA. INTERIOR: the portal in the church atrium leads to a small pentagonal Ionic vestibule with lovely polychrome marble inlay both on the floor (1540) and

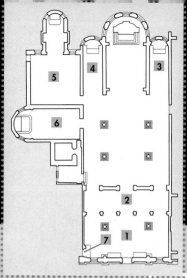

584 BOTTOM CHANCEL.

585 CAPPELLA EMILIANA.

the walls. Each corner has paired composite columns. The high-relief marble altarpieces (1539) of the three altars, sculpted by GIOVANNI BATTISTA DA CARONA, represent the Annunciation, Nativity and Adoration of the Magi. The CLOISTERS: exiting from the side door of the church you can admire the campanile (1456-60) with terracotta Gothic decoration, which was restored in 1912, as well as the 15th-century cloister where the architect GIUSEPPE JAPPELLI (1783-1852) is buried. The monastery, which still has its original chapter house (restored in the second half of the 16th century), was famous for its fine, well-stocked library and scriptorium. It was in this latter that the mathematician and expert in hydraulics, FRA MAURO, a Camaldolite monk, conceived, in the mid-15th century now kept in the

Marciana National Library. The nearby Large Cloister with only three sides is attributed to GIOVANNI BUORA and was built in 1501-75. In its interior is a portrait of *Margaret of Cortona* by GIANDOMENICO TIEPOLO. This painting comes from the Franciscan church of San Bonaventura, in Cannaregio, which was suppressed in 1810. The cloisters communicate with the **Venice Cemetery**, designed by GIANNANTONIO SELVA and inaugurated in 1813. The decorative scheme (1872) was the work of ANNIBALE FORCELLINI from Treviso. Among the many tombs designed by famous architects and decorated with fine statues or mosaics,

particularly worthy of mention are the chapel of the family of Angelo Bettiolo by GIUSEPPE TORRES, which has a Madonna by O. LICUDIS and a mosaic on a cartoon by U. MARTINA (in the outer semicircle, section XI).

Among the famous persons buried here are the composer Luigi Nono (Clerical-religious section, left semicircle), the art historians Pietro Paoletti (section VIII-b, ossuary) and Giulio Lorenzetti (section XII, at the Capella di San Rocco), and the Russian composer Igor Stravinsky, whose tomb was designed by GIACOMO MANZÙ (section XIV, Orthodox Church). In the Protestant section (XIV) are the remains of the American poet and translator Ezra Pound and John McAndrew.

MURANO

■ The next stop after San Michele island is Murano, well-known for its glass manufacture and – before their destruction – for its wealth of monasteries, churches and patrician palazzi with gardens. Get off at the first landing stage, Colonna, and walk along the Fondamenta dei Vetrai and the canal of the same name. The presence of glassblowers in Venice is documented as far back as 982, and the oldest archaeological finds of glasswork dates from the 7th century. The furnaces were transferred to Murano in 1291. In order to guard the secrets of the Venetian glassblowing technique, the master glassblowers enjoyed notable privileges, while at the same time being prohibited from leaving the city. Along the Fondamenta is **Ca' Contarini-Mazzolà** (no. 28), with a late 15th-century Ionic four-lancet window. On the first floor of no. 335 is a high relief of *St. John the Baptist Being Adored by the Confreres of the Scuola of San Giovanni dei Battuti* (early 16th century). On the other side of the canal, on Fondamenta Daniele Manin, are the Gothic residences of the Obizi and Sodeci families (no. 6). This can be recognized by its portico with a three-lancet window flanked by a marble panel with birds and peacocks (12th-13th century). At no. 71 is a small Gothic palazzo with 14th-century capitals and, at the

end of the street, **San Pietro Martire Church**. HISTORY: built in 1363-1417 after a bequest made by Marco Michiel (d. 1349), this church was run by Dominican friars. The building was rebuilt and enlarged after the 1474 fire and consecrated in 1511. In 1806 the church was closed and its paintings were moved to the Accademia Galleries. Thanks to the initiative of Don Stefano Tosi, the church was reopened and decorated with paintings from the other suppressed churches and monasteries in Murano. FAÇADE: this is made of bricks and has two low wings, a taller pitched central body, an early 16th-century portal and a rose window. INTERIOR: this has a Gothic plan, with two aisles and a

nave divided into four bays whose columns are surmounted by arches and wooden tie-beams, two deep apsidal chapels, a wide chancel and a trussed roof. Along the right aisle, the first altar is Baroque and has the *Virgin and Child in Glory with St. Nicholas, St. Charles Borromeo and St. Lucy* altarpiece (1620 – ca. 1628) by PALMA GIOVANE. Farther along, on a line with the third bay, is the *Madonna and Child between St. Augustine and St. Mark, Who Is Presenting Doge Agostino Barbarigo*, signed by GIOVANNI BELLINI and dated 1488. Among the many paintings in this church are the large canvases by BARTOLOMEO LETTERINI – *The Wedding at Cana* (1723) and *The Multiplication of the*

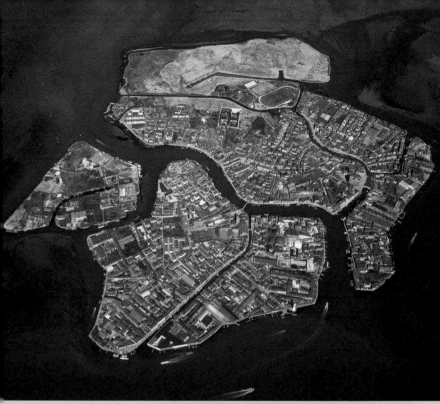

586 TOP AERIAL VIEW, SAN PIETRO MARTIRE CHURCH AND ITS CAMPANILE.

Loaves and Fishes (1721) – situated on the side walls of the chancel, as well as others signed by JACOPO TINTORETTO and workshop, MARCO ANGELO DAL MORO, PIER MARIA PENNACCHI, GREGORIO LAZZARINI, DOMENICO TINTORETTO, FRANCESCO DA SANTA CROCE, GIOVANNI AGOSTINO DA LODI, PAOLO VERONESE, GIUSEPPE PORTA (known as SALVIATI) and ANTONIO ZANCHI. If you have time, pay a visit to the sacristy, which boasts paintings by various artists and assistants, as well as the splendid atlantes and paneling with episodes from the life of St. John the Baptist (1666 – ca. 1672) carved by PIETRO MORANDO. In the adjacent rooms there is a parish museum which has the lovely

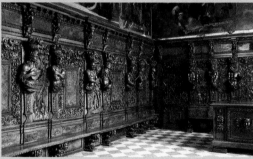

Assumption (1510-13) by GIOVANNI BELLINI, a wooden statue of the enthroned Madonna and Child (1700), reliquaries, silver and gold liturgical objects, and crosses and wooden sculptures borne in processions. At the foot of the campanile (1498-1502) is the CLOISTER (after 1474, partly demolished in 1840), which has a wellhead dated 1348 that was restored in 1748.

586 TOP AERIAL VIEW, SAN PIETRO MARTIRE CHURCH AND ITS CAMPANILE.

586 BOTTOM GIOVANNI BELLINI, MADONNA AND CHILD, WITH ANGELS, SAINTS AND DOGE AGOSTINO BARBARIGO, SAN PIETRO MARTIRE CHURCH.

587 TOP AERIAL VIEW OF MURANO.

587 BOTTOM PIETRO MORANDO AND ASSISTANTS, ATLANTES AND PANELING.

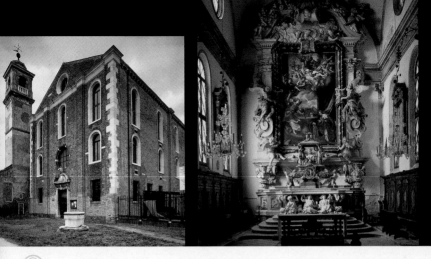

■ When you leave San Pietro Martire, cross the bridge of the same name and, after the square and the street at left, you will find the **Oratorio di Santo Stefano**, a 16th-century chapel with Doric half-columns and frescoes on the dome – *The Trinity*, *The Evangelists* and *The Doctors of the Church* (1718-20) – attributed to Bartolomeo and Agostino Letterini. Now go back to Fondamenta dei Vetrai and head right to the Canal Grande. Near Ponte Longo is the **Ca' da Mula** (no. 153), built in the late 1400s, with two large side windows with tracery decoration in a pointed arch, and four ocula with tracery. Among the sculpture pieces (11th-16th century) decorating the façade, note the two bas-reliefs: *Ship with Sailors and a Mermaid in the Waves* and *Bear Hunt*, both dating from the second half of the 14th century. On either side of the central four-lancet window are two coats of arms in relief of the Diedo family (second half of

the 16th century). Now go over Ponte Longo. If you have time, you can head left to the end of Fondamenta Sebastiano Venier to the portal (no. 53) surmounted by a lunette-shaped bas-relief with a beautiful Annunciation (early 16th century). Past this portal is the small *campo* facing **Santa Maria degli Angeli Church**, founded by Giacomina Boncio in 1188. The adjacent Augustinian nuns' convent, known for its piety and strictly enforced isolation, grew over the centuries and acquired the income of other convents that closed and are now in ruins. The church has a façade with a central body that was redone and an Ionic portal, and was rebuilt in 1498-1529. INTERIOR: this consists of a nave without aisles that has been somewhat damaged over time. Some art historians think the painted panels on the ceiling were done by Pier Maria Pennacchi and Nicolò Rondinelli, an

assitant of Giovanni Bellini. The paintings exalt the figure of the Madonna, placing around the theme of the *Coronation of the Virgin* the images of four Doctors of the Church, the symbols of the Evangelists. Besides works by artists such as Palma Giovane, Giuseppe Porta, Alessandro Vittoria and Pietro Damini, behind the high altar is the *Annunciation* altarpiece (ca. 1537) by Giovanni Antonio Sacchiense.

■ Once out of the church, go back to Ponte Longo and proceed along the Riva Longa and the Fondamenta Marco Giustinian until you reach **Palazzo Giustiniani**, home of the **Museo Vetrario di Murano** (no. 8), the Murano Glass Museum. HISTORY: this Gothic building was the residence of the bishops of Torcello and was restructured in the 17th century and then lived in by Bishop Marco Giustiniani in 1659. The Glass Museum was founded in 1861 by its first director, Abbot Vincenzo Zanetti.

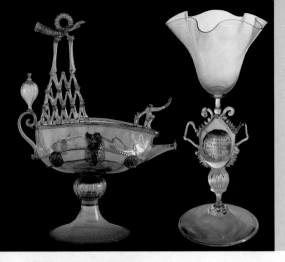

588 SANTA MARIA DEGLI ANGELI CHURCH, FAÇADE AND HIGH ALTAR.

589 TOP LEFT AQUAMANILE IN THE SHAPE OF A SHIP, MUSEO VETRARIO DI MURANO.

589 TOP RIGHT CHALICE WITH COIN, MUSEO VETRARIO DI MURANO.

589 BOTTOM PALAZZO GIUSTINIANI HOME OF THE MUSEO VETRARIO DI MURANO.

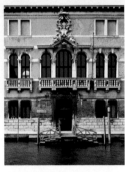

COLLECTIONS: after the reorganization made in 1932, the Cicogna, Correr and Molin collections were brought to the museum, as was a collection from the necropolises of Zadar, Enona and Asseria. GROUND FLOOR: in the atrium are reliefs from some now demolished Murano buildings and churches. At the beginning of the large staircase is the access, at left, to the so-called Archaeological Hall. Here there are showcases with molten-glass bead necklaces dating from the 1st century A.D., blown-crematory glass cinerary urns (1st century A.D.), tomb furnishings,

small amphorae and jugs made either by being blown into molds or shaped by hand. In showcases 4 and 7, note the mold-blown bottles and the pressed and ground goblets (1st century A.D.). In case no. 22 there is the: "Argonauts' Flask" (2nd century A.D.) and, in case no. 28, a fragment of a floor (2nd century A.D.) from the Villa of Lucius Verus, on Via Cassia. At the top of the staircase, at right on the landing of the FIRST FLOOR, is the entrance to the Sala Didattica managed by the Experimental Station for Glass. Going back onto the landing, go into the main hall and turn left, into the Sala del Quattrocento, which has plates, bowls and goblets as well as the aquamanile in the shape of a ship (16th century, showcase 10) and the Barovier Cup (ca. 1470) in blue glass with polychome enamelwork. Cross the hall again to visit the Sala del Cinquecento, which houses the two-handle cistern with fine filigree (late 16th

century, showcase 12), and the Sala del Seicento, which has on display a tracery basket (17th century, showcase 17). Go back to the main hall and then into the Sala del Settecento. As soon as you enter, on your right is a table center in the shape of a garden with a fountain (19th century, from an 18th-century model); a fruit-stand (18th century, showcase 15); and the two-handled chalcedony cups sprayed with aventurine (17th century, showcase 7). There is another room with furniture, paintings, glass objects and mirrors with glass frames dating from the 18th century. Now go back to the main hall, which is given over to 19th- and 20th-century production. On the ceiling, FRANCESCO ZUGNO frescoed the *Triumph of St. Lorenzo Giustiniani* (18th century). Note, in the central showcase, the table piece in the guise of an Italian-style garden (18th century) from Palazzo Morosini, in Campo Santo Stefano, Venice.

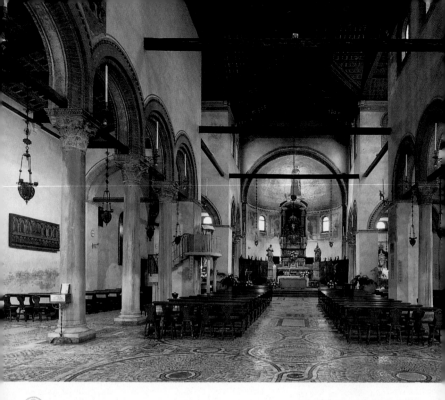

■When you leave the Glass Museum, turn left and go to the **Basilica dei Santi Maria Assunta e Donato**. HISTORY: mentioned in a document dating from the year 999 and already existing in 950, this church was rebuilt in 1125-41, and then again by the architect TOMMASO MEDUNA in 1866-73. FAÇADE: this is Romanesque and made of brick. At the base of the two buttresses are two octagonal pedestals (2nd century A.D.) which may have come from Altinum; they are decorated with bas-reliefs. The baptistery, documented in the 10th century and demolished in 1719, once stood in front of the entrance. The campanile is a robust Romanesque structure built at the same time as the church and made elegant by the pilaster strip patterns. EXTERIOR OF THE APSE: the fascinating brick and stone apse may have been built by the Byzantine artisans who worked on St. Mark's Basilica in the 12th century, but it was drastically rebuilt during the 19th-century restoration. INTERIOR: Latin cross plan, with a nave and two aisles delimited by Greek marble columns with composite and Corinthian capitals that may date from the 6th or 12th century, above which are segmental dosserets surmounted by stilted arches connected by tie-beams. There are also a transept,

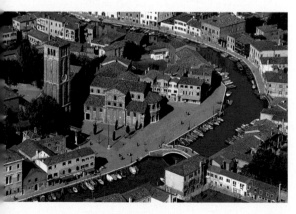

590-591 INTERIOR OF SANTI MARIA ASSUNTA E DONATO.

590 BOTTOM AERIAL VIEW OF SANTI MARIA ASSUNTA E DONATO.

591 LEFT APSE OF SANTI MARIA ASSUNTA E DONATO.

591 RIGHT THE VIRGIN MARY, DETAIL.

an Ionic-order work by GIOVANNI ALVISE PIGAZZI which includes the frontals of some sarcophaghi (4th-9th century). Back in the left aisle, note the polychrome wooden icon of *St. Donato Being Adored by Donato Memo, Podestà of Murano, and His Wife*, with inscriptions in Venetian dating from 1310. Having ended your visit to the basilica, along Fondamenta Andrea Navagero is **Palazzo Trevisan** (no. 34), which was finished in 1557 and can be recognized by the large Serliana on the main floor. This building, which belonged to Camillo Trevisan (d. 1564) and is of uncertain

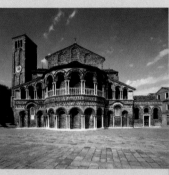

chancel, and two end chapels with flat back walls. The most fascinating part of the church is its pavement, made of mosaics, marble and vitreous paste and dated at 1141. In the CHANCEL, restructured by ANTONIO GASPARI in 1695, between the tabernacle and the crown sculpted by the stonecutter LAUREATO on the Baroque high altar, is the Sarcophagus of St. Donato, chosen as the patron saint of Murano in 1400. In the middle of the gilded mosaic in the large apse conch (restored in 1922), is the standing figure of the Virgin Mary. On the wall below the apse, NICOLÒ DI PIETRO frescoed the figures of four enthroned Evangelists (ca.1404). Along the wall of the left-hand aisle is the *Pala*

Feriale, a tempera on wood panel executed in the mid-1300s by a disciple of PAOLO VENEZIANO. In the middle of the lower register is a standing dead Christ flanked by twelve saints in the other small trefoil arches. On the upper register, the central panel has the *Dormition of the Virgin*, while the side ones represent, from left to right, Saints Stephen, Heliodorus (?), John the Baptist, Mark, Donato and Lorenzo. These are followed by the lunette-shaped panel painting of the *Enthroned Madonna and Child with Saints and Donor*, signed by LAZZARO BASTIANI and dated 1484. The door underneath this leads to the Cappella di Santa Filomena (1866-73),

attribution, was one of the most prestigious residences in Murano. Above a door on the ground floor porch there is a stucco relief by ALESSANDRO VITTORIA and some figures frescoed by PAOLO VERONESE. Farther along the Fondamenta is a small Gothic palazzo (no. 51B) with a five-lancet window with trefoil arches (late 14th century). If you wish to go on to Burano, it is best to take the boat on the Faro, before which is the **Ospizio Briati** (1752-53), once a hospice for the impoverished widows of glass-blowers.

592 MAZZORBO ISLAND, SANTA CATERINA CHURCH.

593 TOP AERIAL VIEW OF BURANO AND MAZZORBO.

593 BOTTOM LEFT INTERIOR OF THE SAN MARTINO CATHEDRAL.

593 BOTTOM RIGHT GIAMBATTISTA TIEPOLO, *CRUCIFIXION*.

MAZZORBO

■ Once you get off the landing stage, turn right and, after the elbow bend in the long *fondamenta*, you will arrive at **Santa Caterina Church**, the only surviving monument of the four monasteries and five churches built on this island from the 7th to the 17th century. HISTORY: the original church may date back to 783. The church and the demolished Benedictine nuns' convent, built at the end of the 13th century, were probably rebuilt in the early 14th century. The building was restored in a heavy-handed manner in 1922-25. FAÇADE: of the original, only the entrance portal remains, crowned by a Gothic lunette with a high relief of *The Wedding of St. Catherine, with the Abbess Elizabeth and a Procurator of the Monastery*, dated 1368. On the lovely campanile, under the cornice of the belfry, there is a relief portraying St. Catherine (mid-16th century). The belfry has the oldest bell in the Venice Lagoon, signed by the master bell-maker LUCA DA VENEZIA, dated

1318 and brought here from Sant'Angelo Church. INTERIOR: after the portal is an atrium with Ionic columns (1552) made by PIETRO LIMA, son of ALBERTO. On the walls are fragments of cornices and plutei dating from the 9th-11th century. The relief of the *Enthroned Madonna and Child with Angels* dates from the beginning of the 14th century. The elegant entrance portal, made of red Veronese marble, dates from the late 16th century. The interior has an aisleless nave, a choir loft for the nuns supported by two 14th-century columns, a chancel with a flat back wall, and a lovely painted wooden ship's-keel ceiling. CHANCEL: the high altar (ca. 1572) was sculpted by the Veronese stonecutter CRISTOFOLO DI SOMENICO ZORZI and commissioned by Emilia Podacattaro Michiel, who also commissioned the *Baptism of Christ* altarpiece (1572-75) by GIUSEPPE PORTA (better known as SALVIATI). The young woman kneeling before Christ is not the Virgin Mary, but is the portrait of the donor. To

the right of the altar is an urn with a statuette of Mary as a child (18th century?). Once out of the chancel, to your right you will see one of the small 16th-century altars with the marble altarpiece with the full-length figure of St. Catherine (14th century) holding a cross and the martyr's wheel. To continue your visit of Mazzorbo, go down the *fondamenta* and turn right. Once past the cemetery and the athletics field, you will come to the **working-class quarter** designed by GIANCARLO DE CARLO and finished in 1985. Once you are near the long bridge that connects Mazzorbo and Burano, at your left you will see, in the middle of a public park, the **campanile** of the demolished church of Sant'Angelo. On your way to Torcello, you can admire the rest of Mazzorbo left of the Canale dei Borgognoni. On an islet, hidden by the vegetation, is the **Ridotto di Mazzorbo**, an artillery battery built in 1838 in place of the old church and monastery of Sant'Eufemia, inhabited by Benedictine nuns.

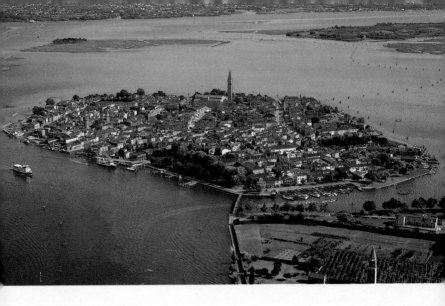

BURANO

■ This island was placed under the jurisdiction of nearby Torcello in the 14th century. Once you land here, go along the tree-lined Via Adriana Marcello and, after Calle San Mauro, turn left. With the help of a map, go to the square named after the famous composer from Burano, Baldassare Galuppi (1706-85), where the **San Martino Cathedral** stands. This has no façade or main portal; one enters through the side door that leads into an atrium. HISTORY: perhaps dating from the 11th century, the church was rebuilt several times.

INTERIOR: Latin cross plan, nave with two aisles supported by Neo-Classical piers with Corinthian and pilasters on pedestals, chancel and apsidal chapels with flat back walls. Along the right aisle, after the first altar, there is the *Adoration of the Shepherds* (1732) by FRANCESCO FONTEBASSO. Among the paintings in the right-hand apsidal chapel, on the wall are *The Flight into Egypt* by GIOVANNI MANSUETI (1470-1526/27), *The Wedding of the Virgin*, and a *Nativity* with the shepherds in the foreground and the Magi in the background. In the

CHANCEL, the Baroque altar (1673) has the statues of the patron saints of Burano on either side, St. Albano and St. Martin, by GIROLAMO BONAZZA. The altarpiece on the left wall depicts *St. Mark Enthroned with Saints Benedict, Nicholas, Alban and Lawrence*, dated 1541 by GIROLAMO DA SANTACROCE. On the wall of the left aisle, on a line with the penultimate bay, is the *Crucifixion* (1725) by the young GIAMBATTISTA TIEPOLO, who was influenced by the large canvas that JACOPO TINTORETTO did for the Scuola di San Rocco.

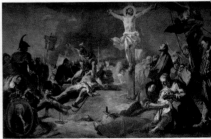

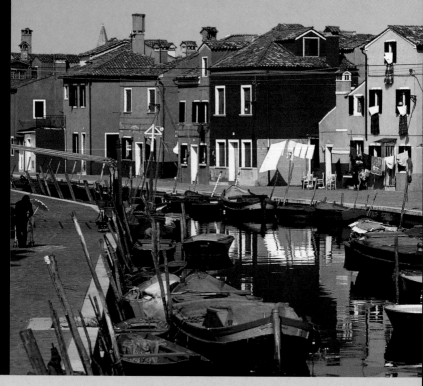

■ As soon as you leave the atrium of the church, at left you will see the **Cappella di Santa Barbara**, which was finished in 1926 on the foundation of an old hospital. The chapel contains the remains of St. Barbara, which were brought to Torcello in 1811. In the middle of the square, the base-*cum*-flagstaff, dated at 1767, has reliefs of St. Martin and St. Alban. A short distance away is the former **Palazzo del Podestà**, now the home of the **Museo del Merletto** (Lacework Museum; no. 187). This building, designated as the residence of the Podestà of Torcello in the 16th century, housed the Scuola dei Merletti (lace-making school)

of Murano, founded in 1872 to revive a handicrafts tradition dating from the second half of the 15th century. On the façade, the two round crests – one of which depicts *St. Martin Giving away His Mantle* (ca. 1480) – are by ANTONIO RIZZO. The museum, opened in 1981, has on display precious examples of Venetian lace produced from the 16th to the 20th century. The adjacent building was the **Palazzo della Comunità** (no. 183), which from the 13th century on was used as the meeting place of the Town Council, with 40 members. Once you are in nearby Rio Terà Pizzo, go down Calle de la Comun Seconda to the Rio

della Giudecca. The building on the other side of the canal is what remains of the church of **Santa Maria delle Grazie** and the Capuchin nuns' convent. Cross over the nearby bridge and proceed along the canalside. The houses here are examples of age-old Buranese domestic architecture. The variety of colors on the façades serve to mark property boundaries. Once at Rio di San Mauro, skirt the Fondamenta Cavanella and return to the landing stage. If you have extra time, you can continue to your left and walk to the island of Mazzorbo, or, if you have a boat, you can even visit the nearby island of San Francesco del Deserto.

SAN FRANCESCO DEL DESERTO

This island between Burano and Sant'Erasmo can be visited by reservation only and is reached by private boat. According to tradition, in 1219-20 St. Francis of Assisi stopped here on his return journey from Egypt. Here he reputedly performed the miracle of preaching to the birds (which GIOTTO frescoed in the Cappella degli Scrovegni, Padua) and also founded a wooden oratory. The first Franciscan church at San Francesco del Deserto dates from 1228-33. At

the end of the 13th century many rooms had already been added to the church, including the sacristy, the chapter house and a cloister. After the 1453 restoration another cloister was built. Unfortunately, the restoration effected in 1921-23 significantly mutilated the architecture of this complex, which, however, is still fascinating.

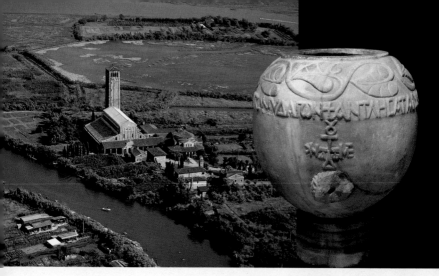

TORCELLO

■ A flourishing town in an archipelago near the mainland, the island of Torcello lay on a major water route between Ravenna and nearby Altinum. The earliest Roman settlement, verified by archaeological research, dates from the second half of the 1st century A.D. In the 7th century, the citizens of Altinum migrated to the island to escape from Longobard invasions and devastation, and in 638 they moved their episcopal see there as well. This marked the beginning of gradual, intensive building activity which, together with the development of trade, made Torcello the political and economic hub of the Venice Lagoon, at a time when Venice was beginning its quest for independence. The remains of the most ancient kiln for glass-making were found in Torcello. The later rise of Venice and the damage caused by the silting and flooding of the Sile River

596 TOP LEFT AERIAL VIEW OF TORCELLO.

596 TOP RIGHT ACQUASANTIERA, TORCELLO MUSEUM.

596 BOTTOM PONTE DEL DIAVOLO AND THE CATHEDRAL CAMPANILE.

597 TOP WELL RING, TORCELLO MUSEUM.

(which had not yet been diverted) led to the decline of Torcello, which, having prospered up to the 12th century, witnessed the loss of its population as the island was virtually abandoned. When you disembark, to your right go down the Fondamenta di Borgognoni, past the Ponte del Diavolo (which has no parapet) until you reach the area with some historic buildings from Torcello's golden age. At left is the **Torcello Museum** (no. 20). HISTORY: the museum was founded in 1870 by Count Luigi Torelli and enlarged by the Venetian scholar Cesare Augusto Levi.

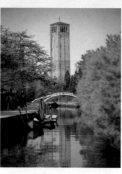

It consists of two adjoining Gothic buildings, the **Palazzo del Consiglio** and **Palazzo dell'Archivio**. The former houses the medieval and modern exhibitions. On the GROUND FLOOR there are fragments of stones and epigraphs (6th-9th century), cubic wellheads (1st and 10th century), fragments of mosaics from the nearby Cathedral (7th and 9th-12th century), Byzantine objects of the Constantinople school (5th-13th century), and examples of medieval paterae, tiles and capitals (11th-13th century). As soon as you enter, note, at your right, the 6th-century oval

597 CENTER PALA D'ORO, TORCELLO MUSEUM.

597 BOTTOM PALAZZO DEL CONSIGLIO, HOME OF THE TORCELLO MUSEUM.

stoup and, at left, the wooden statue of the *Enthroned St. Anne with the Virgin Mary* (14th century; no. 69) by a sculptor from the Umbria-Marches region. The most noteworthy object in this room is the *Pala d'Oro* or golden altarpiece (second half of the 13th century) placed in a wooden frame, which once stood in the Cathedral. The remains of gilded silver leaf made in Venice depict *The Enthroned Madonna and Child* in the middle, flanked by the symbols of the Evangelists Luke and Matthew, the expression of Christ's human nature. On the sides, on two registers, are the surviving figures of the Archangels Gabriel and Michael and eight saints and prophets. On the FIRST FLOOR there are bronze and ivory objects, icons (13th and 15th century), and precious sculpture pieces and polychrome wood reliefs (15th-16th century). On the walls are four paintings taken

from the demolished Sant'Antonio monastery that were part of a cycle dedicated to the *Life of St. Christine of Bolsena* (1585-1602). Among these canvases, attributed to CARLETTO CALIARI, son of PAOLO VERONESE, is *St. Christine in Prison Being Fed by the Angels* (no. 126), notable for its qualities and the setting, which reminds one of the Doges' Palace prisons. Among the other canvases in this room, note the two organ shutters with an *Annunciation* (nos. 116-117) by BENEDETTO CALIARI, painted after a drawing by PAOLO VERONESE. After visiting the Palazzo del Consiglio, go along the left side of the grassy area, where there is a collection of marble pieces: an 8th-century cubic wellhead with Greek crosses, coats of arms (15th-17th century), 14th-15th century

reliefs, a relief of St. Bartholomew from Santa Caterina church in Mazzorbo, and a 9th-century sarcophagus. The adjacent Palazzo dell'Archivio houses the archaeological section. In the ground floor arcade there are Roman sculptures and inscriptions. In the room on the FIRST FLOOR, via an external starway, there are sculpted heads dating from the 2nd and 3rd century, Roman gems, fragments of frescoes from a Roman villa (1st century A.D.), tombstones (1st century), ceramics and bronze objects. Note, on the back wall, the statue of Asclepius and the head of Serapis (1st and 2nd century respectively).

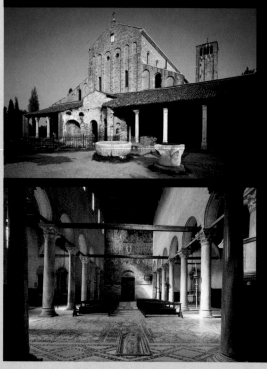

■ Exiting from the museum, to your left is the **Cathedral of Santa Maria Assunta**. HISTORY: the Cathedral was built in 639 at the behest of the Exarch of Ravenna, Isaac, on the property of Mauritius, the governor of the Byzantine province of Venice. It was dedicated to Mary, the Mother of God, and renovated in the 9th century and then completely rebuilt in 1008 under Bishop Orso Orseolo with its present name of Our Lady of the Assumption. Unfortunately, because of the wide-ranging restoration campaign undertaken in the 19th century, the mosaic decoration in the interior of the Cathedral was badly damaged and/or poorly redone by GIOVANNI MORO, who was tried and condemned for what he had done.

FAÇADE AND EXTERIOR: in front of the broad porch are the ruins of the baptistery, which was demolished in 1892. Its floor is on a lower level than the church, since it was built in the late 7th-early 8th century and is the oldest part of the Cathedral (it is even older than the first St. Mark's Basilica). The brick façade of the church consists of two broad wings and a central body with pilaster strips connected by small arches. Under the two central oculi you can see the horizontal line that corresponds to the reconstruction carried out after the earthquake of 1117 had damaged the church right up to the apse. Beginning your visit at left, you can see the long north body of the church, which in the 13th century was added next to the adjoining aisle. In the apse area, which was restored in the 19th century, note the entrance to the pseudo-crypt, which contains the Cathedral's precious relics. The campanile, which may date from the 11th century, was altered several times over the centuries. It is said that near the apses there once stood a small church, San Marco, founded by Rustico of Torcello, one of the two persons who brought the evangelist's body from

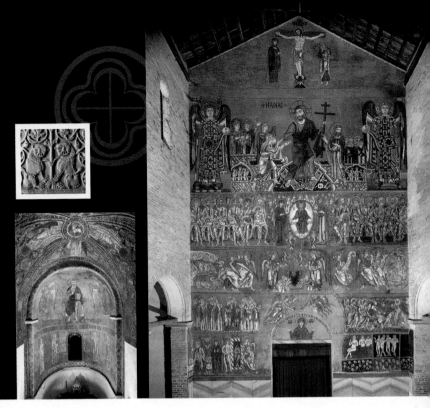

Alexandria to Venice. INTERIOR: the church has a basilica plan, with a nave and two aisles and semicircular apses. The Greek marble columns, with Corinthian capitals and segmental dosserets in red marble, support stilted arches connected by tie-beams. The masonry work above the columns was restored in the first half of the 15th century. In the inside façade of the nave is the triumphal and fascinating *Last Judgment* mosaic, done by a master craftsman who had studied in Salonica and restored by a Greek mosaicist in the 12th century. Starting from the top, under the *Crucifixion* (redone in the 19th century)

are five other registers of mosaics depicting *Christ's Descent into Limbo (Anastasis)*, with the liberation or resurrection of the ancestors and patriarchs; *Christ Sitting in Judgment with the Interceding Virgin Mary and St. John the Baptist (Deesis)*, flanked by the archangels Michael and Gabriel and the Apostles; *The Preparation of the Throne for the Last Judgment (Etymasia)* and, on either side, the resurrection of the dead; *The Weighing of the Souls (Psychostasia)*, which are contended for by the Archangel Michael and two demons, with the righteous on one side and the damned with Satan holding the Anti-Christ on the other; on the

sides of the portal, *The Gate of Paradise* with St. Peter, and *Four Circles of Hell*. The Latin inscription crowning the lunette of the portal refers to the praying Mother of God underneath: "Oh Virgin, with your prayer ask pity of the Son of God and extinguish all sins."

Under the sectile pavement with elegant geometric motifs is another mosaic pavement dating from the 9th century. At the end of the right aisle is the apsidal Santissimo Sacramento Chapel, with fine mosaic decoration (second half of the 11th century, later restored several times).

The CHANCEL is separated from the nave by an iconostasis surmounted by a

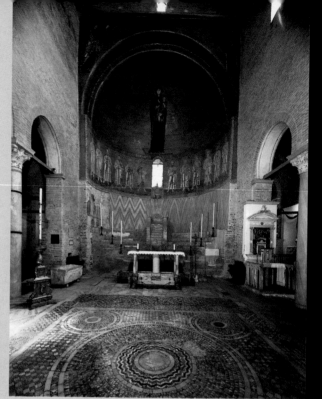

600 LEFT CAPPELLA
DEL SANTISSIMO
SACRAMENTO, DETAIL.

600 RIGHT
CHANCEL AND
BISHOP'S THRONE.

601 TOP SANTA
FOSCA CHURCH.

601 BOTTOM
INTERIOR AND
CHANCEL.

Venetian school wooden crucifix (1420-25). The frieze, dating from the same period, is a tempera on wood panel by ZANINO DI PIETRO depicting *The Virgin Mary and Child with the Twelve Apostles*. Between the columns supporting the frieze are four exquisite Veneto-Byzantine marble plutei (11th century). On the floor in front of the iconostasis is the stone slab marking the tomb of Bishop Paolo of Altinum (15th century) and, at left, the 11th-12th century ambo. Access to the chancel is through the right aisle, near the small altar of St. Cecilia. The lovely sectile floor may have been redone after the 1117 earthquake. The mosaic scene above the conch arch represents the Annunciation. This is followed in the broad, gold-ground conch, by the standing *Madonna and Child* in which Mary is represented as the so-called Odighitria, indicating her son with her right hand as the way to salvation. In the band below this are hieratic figures of the twelve Apostles. Despite three different restorations, these scenes have retained the character they had when first executed in the second half of the 12th century. The two frescoed figures of bishops underneath the apostles are even older. The semicircular apse is occupied by a tall brick stairway with the bishop's throne in the middle. Between this latter and the window is the mosaic bust of the first bishop of Altinum, St. Heliodorus (mid-19th century reconstruction). The saint's relics lie at the foot of the altar. Leaving from the chancel, at left is an inscription dated 639 – the first written document in the history of Venice – commemorating the foundation of the first Cathedral of Torcello.

As you leave the Cathedral, you will see **Santa Fosca Church** at your left.

HISTORY: built as the martyrium of the saint from Ravenna, whose relics were brought to Venice perhaps around the end of the 10th

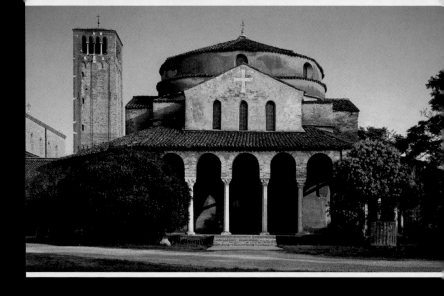

century, the Veneto-Byzantine church we see today has been dated, not without controversy, somewhere between the 11th and 12th century. FAÇADE: if you stand in front of the main entrance you will see that this structure made mostly of brick has a Greek cross plan. Over the portico, on the sides of the central body with rounded corners, there are four smaller upwardly protruding, pitched structures with three narrow windows surmounted by a cross. The pentagonal perimeter has Corinthian columns connected by segmental arches. In the back, the central apse – crowned by a sawtooth motif frieze – has two tiers of small blind arches. On the exterior of the sacristy is a bas-relief, *St. Fosca Being Worshipped by Her Confreres* (early 15th century).

INTERIOR: the fascinating articulation of spaces and volumes is the result of the masterly fusion of a central, Greek-cross nucleus and another basilical type that ends, to the east, in the chancel, which has barrel vaulting, and the two small side aisles with cross vaulting. The Greek marble columns have Corinthian capitals and red marble dosserets. In order to appreciate the geometric refinement of this architecture, note the four corner pillars that form an ideal square and, looking upward, the progressive, imperceptible transformation of the walls into a circumference. The present-day wooden casing replaced the original one, which may have been conical or domed.

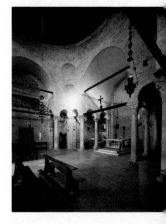

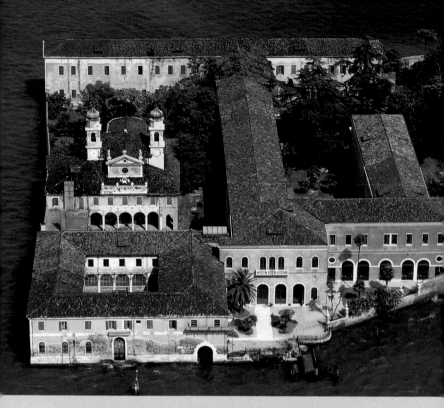

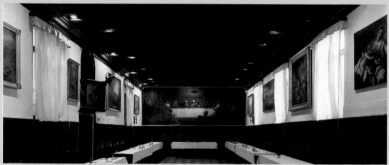

VAPORETTI (WATERBUSES):

from Venezia: no. 20 (from pontile di San Zaccaria, Monument); Lazzaretto Vecchio cannot be reached by public transport.
To visit San Lazzaro degli Armeni reservation is required.

SAN SERVOLO, SAN LAZZARO DEGLI ARMENI AND LAZZARETTO VECCHIO

■ Before the area of the Biennale Gardens and the Sant'Elena quarter opposite were reclaimed, they were washed by a large channel which, to the north, communicated with San Pietro di Castello Church, and to the south flowed into St. Mark's Basin and continued into the Canale del Lazzaretto. There is an important group of islands along this channel. The first one is SAN SERVOLO, now the home of the European Foundation for the Training of Artisans in Preserving Architecture, and of the Venice International

leprosy, it was decided to build a hospital on the site to house and cure them. This was probably the first *lazaretto* (leper hospital) of its kind in Europe, founded even before the more famous one on the nearby island of Lazzaretto Vecchio, which was established in the 15th century. In Venice, leprosy was called *mal di San*

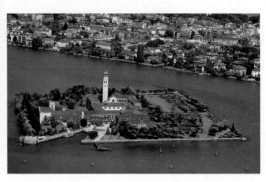

University. This site, inhabited by the Benedictines in the 9th century, was run by Benedictine nuns from the 12th century to 1715, when a hospital for soldiers was built there, managed by the San Giovanni di Dio Hospitaler Friars. From 1734 to 1749, these latter rebuilt San Servolo Church, which was designed by GIOVANNI SCALFAROTTO. Later on, part of the structures of the old monastery were converted into a psychiatric hospital, closed in 1978. The next island is SAN LAZZARO DEGLI ARMENI, which as early as the 12th century began to provide shelter for the pilgrims on their way to the Holy Land. Since many of them came down with

Lazzaro, after Lazarus, the beggar in the Gospel parable who was a leper, hence the origin of the word "lazaretto." The island was used for a period as a refuge for the poor, and in 1717, donated by the Venetian Republic to Abbot Mechitar (d. 1749) of the Armenian monks' Congregation of St. Anthony Abbot, which professed the Rule of St. Benedict. Venice had had trade relations with the Armenian kingdom of Cilicia ("Lesser Armenia") since the 13th century. The small Armenian church of Santa Croce in the San Marco district dates from the 15th century and boasts a beautiful 17th-century altar. The Armenians also had a cemetery on San Giorgio

Maggiore island; this was closed when Palladio's church was built. Once you land on this island, you go into a paved open area with the bronze statue of Abbot Mechitar (1962) by ANTONIO BAGGIO and a commemorative cross, or *khatchkar* (14th century). Inside the **Monastery** is an 18th-century cloister that communicates with **San Lazzaro Church**. In the atrium of this latter is the Gothic sarcophagus of Costantino Zuccoli (14th century). Inside the church itself there are 18th-century marble altars, paintings by FRANCESCO MAGGIOTTO and FRANCESCO ZUGNO. In the adjoining refectory is a *Last Supper* (1780) by PIETRO NOVELLI.

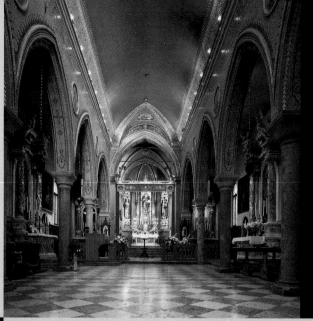

A broad staircase decorated with paintings leads to the first floor, which houses the Gallery of Armenian Painters – with a cell with an exhibition of clothing, miscellaneous objects and books that belonged to Abbot Mechitar – and other rooms reserved for the Armenian Library, with paintings by artists such as LUCA LONGHI, BERNARDO STROZZI and SEBASTIANO RICCI, and with Armenian, Greek and Indian works of art. Besides the ceilings frescoed by GIAMBATTISTA TIEPOLO and FRANCESCO ZUGNO, among the many works on display are the mummy of an Egyptian, Nemenkhet Yousouf (15th century B.C.), porcelain, and Armenian silver (17th and 18th century). There is also a round building, inaugurated in 1970 to a design by ANTON ISBENIAN, containing precious Armenian manuscripts from the 9th to 18th century. The monastery ran a famous publishing house and printing press, founded in 1796 but no longer in operation, as well as the Museum of Art and Science (not open to the pubic), the ceiling of which was painted by the Venetian ANTONIO PAOLETTI. The last island on this tour is LAZZARETTO VECCHIO, situated near the Lido and originally inhabited by Augustinian Fathers who built the church of Santa Maria di Nazareth and a hospice for pilgrims going to the Holy Land. After 1423, the island was used as a lazaretto and placed under the jurisdiction of the Health Magistracy.

LA GRAZIA, SAN CLEMENTE, SANTO SPIRITO AND POVEGLIA

No public transportation service to these islands

■ The Malamocco district, situated on the Lido and dating back to the 5th and 6th century, was an ancient port in a strategic position along the routes that linked Ravenna and Padua with Torcello, Altinum and Aquileia. The first island on this route is LA GRAZIA. This was first used by the Benedictine monks at San Giorgio Maggiore to house the pilgrims on their way to the Holy Land, but was then ceded in 1412 to the hermits of the San Girolamo da Fiesole congregation, who built the church of Santa Maria delle Grazie, which was famous for a miraculous icon of the Madonna. The

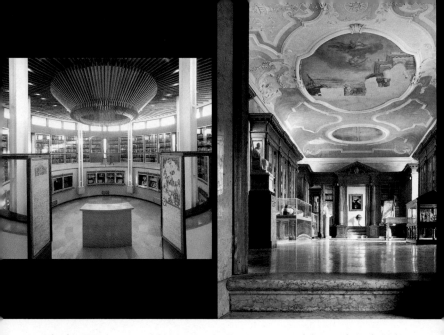

next island is SAN CLEMENTE, also used since the Middle Ages to house pilgrims going to the Holy Land. Some of the buildings were also used as a lazaretto. In 1432, the island was granted to the canons of the Santa Maria della Carità monastery in Venice and in 1645 it was purchased by the Camaldolite congregation of Monte Rua, which rebuilt and decorated **San Clemente Church** with new art works (1653-1750). During construction work, attributed to ANDREA COMINELLI, the façade (ca. 1488) was restored, but without eliminating the traces of the Codussi-influenced architecture. Among the 17th-century artists who helped decorate the interior of the church, mention should be made of JUSTE LE COURT, FRA' FELICE DA CAMALDOLI, BENEDETTO MARCHETTI, FRANCESCO RUSCHI, PIETRO RICCHI, ANTONIO ZANCHI, ANGELO TREVISANI, GIAMBATTISTA PITTONI, GREGORIO LAZZARINI and JACOPO MARIESCHI, whose works are now in storerooms waiting be placed in their proper setting. Next is the island of SANTO SPIRITO, now abandoned but inhabited as early as the 12th century, first by the Regular Canons of the Rule of St. Anthony and then, in the early 15th century, by the Cistercians. Before reaching Malamocco, you will go to the island of POVEGLIA, inhabited in the 5th century by refugees from Padua and Este. In 1570-73, the island was fortified with an artillery platform, isolated by a canal and ideally linked to the nearby fortified octagonal platforms (*ottagoni*) on the water.

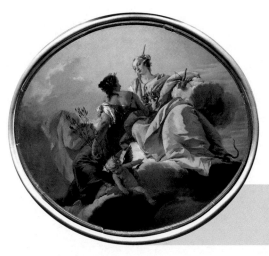

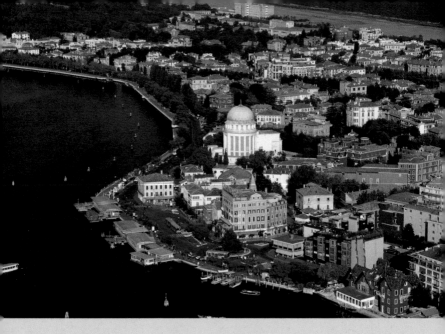

THE LIDO

■ After disembarking, cross over the square to **Santa Maria Elisabetta Church**. This building, constructed in the 16th century as an oratory and transformed into a church in 1627 was consecrated in 1671. The aisleless interior has Corinthian pilaster strips and four side altars. Among the works of art, note the high altar in the chancel with a polychrome marble tabernacle (second half of the 17th century) and, on the Madonna del Rosario altar (1634), a late 15th-century wooden polychrome *Pietà* and a Madonna and Child (16th-century). Once out of the church, proceed along the Riviera to the **Sacrario Militare di Venezia (Venice War Memorial)**, built in 1933 to a design by GIUSEPPE TORRES but already planned as a church in 1917. Continue your walk along

the right-hand side of the Riviera, where there are some Neo-Gothic villas. In Via Cipro is the **Lido Cemetery**; proceeding you will come to the **Jewish Cemetery**, along the Riviera San Nicolò, you can see the entrance gate of the **Old Jewish Cemetery**; (14th-17th century), which can be visited by reservation. Along the Riviera, after the ferryboat dock, note at right the wall of the **Fortezza di San Nicolò**, conceived by General SFORZA PALLAVICINO and built by FRANCESCO MALACREDA in 1570-73 to protect the Lido from a Turkish invasion. HISTORY: this Benedictine church built in the first half of the 11th century was renovated in 1316. This church is famous because it houses part of the remains of St. Nicholas (patron saint of sailors), and also because during the annual Sensa ceremony, the doge, with a great number of

VAPORETTI (WATERBUSES):

from Venezia, nos. 1, 6, 51 and 52; Poveglia and the Octagons are not served by public transportation.

BUS:

Lido, Piazzale Santa Maria Elisabetta: A and B.

606 AERIAL VIEW OF THE LIDO.

607 TOP LEFT GIROLAMO PELLEGRINI, VENICE PAYING HOMAGE TO ST. NICHOLAS, SAN NICOLÒ DI LIDO CHURCH.

607 TOP RIGHT AND BOTTOM GIOVANNI DA CREMA AND CAMILLO DI SAN LUCA, WOODEN CHOIR AND DETAIL.

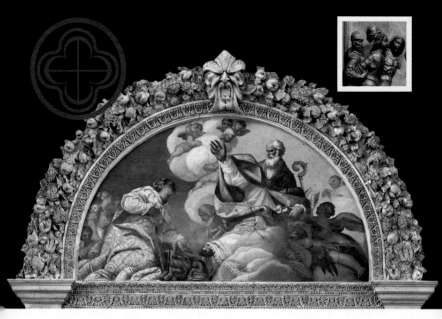

boats in his retinue, came here to celebrate the ritual of the marriage of Venice and the sea by throwing a wedding ring into the sea. The present-day church, built on a different site from that of the original church, was begun by TOMMASO CONTIN in 1626 and finished by MATTEO CIRTONI in 1629. The monastery was rebuilt in 1530. Now go back outside. FAÇADE: the tall pitched central brick-built body was never finished and is flanked by two wings and a campanile. The Ionic-order entrance is crowned by the 17th-century Monument to Doge Domenico Contarini (1043-70). INTERIOR: an aisleless nave with giant Corinthian piers and six communicating side chapels and a chancel with a choir behind it. In the corner, in eight niches, are the statues of the Doctors of the Church and, toward the altar, the

Evangelists (second half of the 17th century). On the inside façade is a fresco by GIROLAMO PELLEGRINI, *Venice Paying Homage to St. Nicholas* (late 17th century), crowned by a stucco festoon. The altarpiece in the first chapel at right, by DOMENICO MAGGIOTTO, depicts *Saints Benedict, Mauro, Placido and Scolastica before Divine Knowledge* (1760). The sumptuous Baroque altar (1629-34) in polychrome marble inlay is by COSIMO FANZAGO. The fastigium consists of a sarcophagus with the remains of the bishop-saints Theodore the Martyr, Nicholas the Great, and Nicholas "the paternal uncle," stolen by the Venetians at Myra, Turkey in

1099; the saints are portrayed in the three wooden statues above the sarcophagus, which are attributed to GIOVANNI DA CREMA. Behind the altar is the lovely choir made of walnut wood and dated 1636, in which GIOVANNI DA CREMA, with the collaboration of CAMILLO DI SAN LUCA, illustrated 27 *Episodes from the Life of St. Nicholas*. In the direction of the exit, in the third chapel at right is an *Ascension* signed by PIETRO MUTTONI, known as PIETRO DELLA VECCHIA (1603-78).

Once out of the church, you will see the **Casa Rossa**, a small palazzo (ca. 1520) with a portal and Lombardesque windows, under the jurisdiction of the Council of Ten and reserved for the Superintendents of the Lido and their representatives. On the little island opposite, Le Vignole, you can see the **Forte di Sant'Andrea** (1543-47, renovated in 1570-73), built mostly by the architect MICHELE SANMICHELI with the collaboration of General F. MARIA I DELLA ROVERE, Duke of Urbino, and Colonel A. DA CASTELLO. Proceeding along the Riviera, turn right onto Via Doge S. Valier until you reach the former Guglielmo Pepe barracks, whose original nucleus consisted of the so-called **Serraglio**, a quarter for 2,000 soldiers, one of the first courtyard structures used for military purposes in Europe, built in 1591-95 (not open to the public). In the vicinity is the Austrian **Forte Ridotto** (1846-50), which can be visited by reservation. Retracing your steps, go into the square facing the San Nicolò monastery. Keeping to

your left, after Via G.A. Selva, you arrive at Piazzale Ravà and go past the secondary entrance of the Ospedale al Mare. In the right-hand sector of the hospital area there is the Neo-Gothic **Santa Maria Nascente Church**, built in 1932 to a design by the engineer A. SPANDRI. The fourteen Stations of the Cross are painted on wood panels and signed by G. CHERUBINI. The same artist also did the frescoes on the inside façade (*The Crucifixion*), on the wall connected to the chancel (*Annunciation, Madonna and Child, The Immaculate Madonna*), and on the side walls of the chancel (*The Young Mary Adored by Angels* and *Our Lady of the Assumption with Angels*). After you visit this church, walk along the main avenue toward the exit of the hospital area. At left, the ground floor of the tallest pavilion houses the small **Teatro "Mario Marinoni."** Once out of the hospital, take a bus to Piazzale Santa Maria Elisabetta and from here walk (to the right) along the

Gran Viale Santa Maria Elisabetta. At no. 1C Via Lepanto is **Villa Mon Plaisir** (1906), an example of Liberty style architecture designed by GUIDO CONSTANTE SULLAM. On the other side of the Gran Viale is a building with a Neo-Renaissance façade (nos. 43-47) and, farther along, **Villa Eva** (no. 49) in "Neo-Codussian" style. Proceeding on the right-hand side of the avenue, after Via Ascalona you will come to the **Hotel Hungaria**; after Piazzale Bucintoro, is the **Blu Moon** complex (2002). From this point you can see the breakwaters of the two port entrances, which had been planned by C. SABBADINO far back in the 1500s: to the left, the San Nicolò breakwater (1872-early 20th century) and, at right, the Alberoni breakwater (1840-72). Returning to the Piazzale, at right, on Lungomare G. d'Annunzio, you will arrive at the Venice Planetarium (2003), while to your left proceeding along Lungomare G. Marconi, you will come to the **Grand Hotel des Bains**. This building, designed by F.

MARSICH and opened in 1900, was the setting for Thomas Mann's famous short novel, *Death in Venice*. Take a public bus to get to the former **Casinò Municipale** (City Casino; 1936-38), designed by E. MIOZZI, and the **Palazzo della Mostra di Cinema** designed by L. QUAGLIATA and inaugurated in 1937. Lungomare G. Marconi is also lined by another famous hotel, the **Albergo Excelsior** (1908), a Neo-Moorish-Byzantine building designed by G. SARDI. Take the bus again to go to **Malamocco**. This ancient port (5th and 6th century) of call was the home of the doges before their residence was moved to Venice; it disappeared because of the tidal wave of 1106-07. When you arrive in Piazzale Malamocco and look at the urban center, which is bordered on three sides by a canal, at left you can recognize the **Palazzetto del Podestà** (no; 2), a 15th-century structure. The proud Lion of St. Mark in Istrian stone above the door dates from the 16th century. By skirting the Palazzetto you

enter the Campo de la Chiesa, a square with two wellheads: the hexagonal one at right (1589) was restored in 1783, while the other one, with large thick leaves on the four corners, dates from the second half of the 15th century. On the left side of the square, after an oratory there is a Gothic house (no. 3) that was altered in later periods. On the opposite side of the Palazzetto del Podestà is **Santa Maria Assunta Church**, founded in the 15th century and later rebuilt. Inside the church are 17th- and 18th-century works by G. FORABOSCO, G. LAMA and F. PITTONI. The right side of the church overlooks Piazza Maggiore, in the middle of which is a hexagonal wellhead dating from 1537. After the church, at no. 2 of the Merceria, is the former **Canonica Arcipretale**, with a plaque dated 1800. At the end of Piazza delle Erbe, at left, is a 17th-century house (no. 8), after which is an arch and the Ponte di Borge, an arcuate bridge leading to the: **Forte di Malamocco**

(early 19th century). The fort stands near the **Murazzi**, the huge, stepped sea wall that was built to protect the shore from high waves. Now retrace your steps and go to Piazzale Malamocco, where you can see, at left, the two **Ottagoni** (1570-73) or small platform forts on the water (at Alberoni and San Pietro) built to protect this part of the Lido from Turkish landings. Take the bus and go to the southern tip of the Lido, to the town of Alberoni. By following the Strada del Fiore, you will reach the Venice golf club which has a canal and traces of the **Forte Alberoni**, built at the same time as the Ottagoni and altered in 1646-50. This fortress, together with the one on the opposite shore of San Pietro in Volta, defended the water accessway to the Porto di Malamocco.

GLOSSARY

Acroterion: Ornament located above a tympanum, consisting of a small plinth; in a wider sense, the sculpture standing on it.

Aedicule: A small construction much like a tabernacle framed by four columns and surmounted by a > guglia.

Agnus Dei: Lamb of God. The symbol of Christ's sacrifice represented by a lamb with a cross or chalice and a cross-shaped halo. This image, which derives from *The Revelation*, may also be an attribute of St. John the Baptist.

Agony in the Garden: An episode in the Passion of Christ that took place after the Last Supper. In paintings, Jesus is shown praying at the Mount of Olives, or Gethsemane. In front of him are one or more angels with the Eucharist chalice, while three Apostles are sleeping near him. In the distance one can see the soldiers arriving, led by Judas.

Albergo: A hospice. The hall of a > scuola used to accommodate the poor and pilgrims and, in a later period, used for the meetings of the > ospedale.

Ambo: An architectural element of different shapes in a church, much like a stand or terrace, used for reading the Bible to worshippers.

Anastasis: Resurrection. A Byzantine iconographic motif depicting Christ's descent into Limbo and the liberation or resurrection of his ancestors and the patriarchs.

Apotheosis: Assumption, glorification, the ascent to Heaven of a saint.

Archivolt: The outer surface of an arch. Also, the > intrados.

Arte: Craft, > corporation or trade guild.

Attica: A region in Greece.

Attic: The crowning storey of a building situated above the cornice. It is a typical element of the triumphal arch and may include statues and/or inscriptions.

Barbacane: The supporting element or corbel of the protuberant sections of a building.

Bay: The dividing space situated between two supporting elements or under a vault.

Biscuit: A type of ceramic or porcelain left unglazed after being fired, often used for miniature statuary.

Blind: Referring to a walled window or dome with a > lantern.

Bucintoro: A bucentaur. The luxurious ceremonial galley used by the > doge and the > Signoria on solemn occasions such as the > Sensa festivities.

Ca': Abbreviation for *casa* or house. A Venetian palazzo usually owned by an aristocratic family.

Calle: Street. Dim.: *calletta*. From the Lat. *callis* or "path."

Camerlengo: Treasurer. Venetian syn.: *camerario*. The former Palazzo dei Camerlenghi is in the Rialto.

Campo: Square. The open space lined with public and private buildings that originally had no pavement and was occupied by a field or grass. Dim.: *campielo*.

Candelabra: A Renaissance decorative motif sculpted on a pier and depicting an elaborate candlestick on which are hanging pagan allegories or Christological symbols such as pairs of dolphins, birds or flowers.

Capitano da Mar: The admiral of the Venetian fleet.

Capitano da Terra: The general of the Venetian army.

Cartoon: A preparatory drawing or painting for a mosaic or fresco.

Casino: A place originally used for meetings and discussions and that was later used for festivities, banquets, gambling and amorous trysts. > *Ridotto*.

Caulicole: The branch or stalk rising up from the leaves in the upper part of a Corinthian column capital.

Cavana: A roofed canal garage for boats, either outside in a canal or inside a building or palazzo.

Chancel: The area around the high altar reserved for the clergy and dignitaries, separated from the nave by a balustrade or an > iconostasis.

Chapter: An assembly of friars, nuns, canons or confreres who are members of a > scuola. The meeting place in monasteries or *scuole* is known as a chapter house.

Chiovere: A plot of land used for grazing, as a sort of playing area, and where woolen cloth was hung to dry.

Ciborium: A small tabernacle placed on the altar, or a baldachin supported by four columns that is raised over, and highlights, the high altar.

Clipeus: A round decorative architectural element or relief.

Cloisonné: Partitioned cell enamalling in which the liquid glaze is poured into cloisons separated by metal and is then polished.

Collegio: An organ of the Republic of Venice in which the matters to be dealt with in the > Senato and the > Maggior Consiglio were prepared, legislative and political activities were promoted, foreign ambassadors were received, and the end-of-term reports of Venetian ambassadors or rectors and > provveditori who had governed other cities and territories were read.

Compagnia: > Scuola.

Conch: A semicircular architectural element above a niche or apse.

Confraternita: Confraternity. A brotherhood of persons united for some purpose, usually of a charitable, religious, professional or mutual aid nature. > Scuola.

Consiglio dei Dieci: Founded in 1310, after the abortive Querini-Tiepolo conspiracy, the Council of Ten consisted of 17 members – including the > doge and the six > dogal councillors – with vast powers which ranged from the security of the state to the discipline of the patricians, monasteries, the > scuole and the > corporations, often coming into conflict with the > Senato. Every month, the Consiglio itself elected its three *Capi* or chiefs, who had executive and celebrative duties.

Corporation: An association of citizens who practised the same trade whose aim was to protect their common professional interests and carry out charitable and religious services. Syn.: *arte*, trade guild.

Corte: Small courtyard or square surrounded by houses and often with a well. If it is part of a house it may have an outside stairway.

Counterfacade: A facade or wall over and beside the entrance in the interior of a church.

Cristus Passus: Representation of the dead Christ, who is standing and is sometimes held up by angels or other figures.

Cuba: Cube. A Byzantine building technique, consisting of a dome on large arches and barrel vaults and supported by piers. In a wider sense, the distributional pattern of a central dome and four minor domes. The most famous examples of this are in St. Mark's Basilica di San Marco and San Giacomo Church, at the Rialto.

Cuori d'oro: Leather sheets with painted, gilded or printed floral motifs used to cover the walls of a room or to ornate an altar frontal. From the Lat. *corium*: hide or leather.

Decime: A ten percent tax on property income collected by the office of the Dieci Savi alle Decime at the Rialto.

Deesis: Intercession. A Byzantine iconographic motif depicting Christ at the Last Judgment with the Virgin Mary and St. John the Baptist at his side, who are imploring him to be merciful in his judgment of souls. Syn.: deisis.

Dogal councillor: An assistant of the > doge who headed the magistratures of the Republic. There were six councillors – one for each > *sestiere* – who made up the **Minor Consiglio**, the body responsible for the administration of the city.

Dogaressa: The wife of the > doge in power. In works of art she was often portrayed as the representation of Venice.

Doge: The highest office of the Venetian Republic, the doge was elected by the members of the > Maggior Consiglio and flanked by the > dogal councillors, who offered him advice and also controlled his every move. The dogate as a hereditary office was abolished in 1032.

Dormition: Byzantine iconographic motif illustrating the death of the Virgin Mary surrounded by the Apostles.

Ecce Homo: "Behold the Man". Words uttered by Pontius Pilate when Jesus was presented to the people. In artistic representations of the Ecce Homo, Christ is shown before the crowd with signs of the flagellation, wearing a crown of thorns and a purple cloak and holding a cane.

Encarpus: Festoon. A composition of branches, flowers, fruit and ribbons hanging from the two ends used as an ornamental motif, especially on friezes.

Etymasia: Preparation of the throne before the Last Judgment. A Byzantine iconographic motif depicting the empty divine throne surmounted by a cross and with the Book of Life.

Ex-voto: An object or artwork offered as thanks and to fulfill a vow.

Foil: A round or semicircular Gothic ornament with tracery generally situated in rose windows or under the arch of a window. The lobes are separated from one another by smooth grooves.

Fondaco: A merchant's warehouse and trading post. Syn.: *fontego*. From the Arabic word *funduq*.

Fondamenta: Street along a canal, lined with buildings.

Fontego: > Fondaco; warehouse, trading post.

Galera: A fast galley ship with one or more banks of oars rowed by condemned criminals. Syn.: *galia* (in Venetian dialect).

Gastaldo: A steward. In Venice, the *gastaldo* governed a trade guild. > Guardian.

Guardian: The head of a convent or governor of a > scuola or confraternity.

Guardian grande: The president of one of the Scuole Grandi in Venice.

Guglia: A cusp or pinnacle. An architectural element with a pyramidal shape that crowns a building or an > aedicule. In Venice it is also a small pyramid or obelisk used as an acroterium that is a sign reserved for families one of whose members was a > capitano da mar.

Holy Family: A representation in art works featuring the Virgin Mary, the Child and St. Joseph, sometimes flanked by the infant St. John the Baptists, other saints, or donors.

Iconostasis: A tall screen or grille decorated with statues and paintings situated between the chancel and nave of a church.

Immanuel: "God with us". In the Old Testament this figure is a sign of God as protector of the chosen people and is depicted as a beardless young man, the prefiguration of Christ.

Inquisitori di Stato: The magistrature – connected to the Consiglio dei Dieci and founded in 1539 – which, besides being responsible for the security of the state, was the supreme political court.

Intrados: The inner surface of an arch.

Jesse: The father of David. > Stump of Jesse.

Lantern: The terminal part of a dome or of the dome cladding in the shape of an > aedicule with windows.

Lion of St. Mark: The symbol of the Republic of Venice. There are two types of lion. The most common one is the *leone andante*, the lion depicted either standing or walking, which is almost always accompanied by the *Gospel According to St. Mark*. The other type of lion is the so-called *moleca* or crab. This is a particular and ancient representation of the lion of St. Mark, used as the seal of the Republic, in which the front of the animal is covered with wings. The paws facing downward and the upward facing wings call to mind the chela of a crab, hence the name.

Liagò: Viewpoint. A covered veranda or loggia on the upper floor of a Venetian palazzo that is surrounded by pillars, columns or glass windows.

Lista: Area of a street in front of or next to a palazzo used by a foreign ambassador, where the right of asylum or immunity is respected.

Lunette: A flat, semicircular surface above a lintel, on a dome, etc.

Maggior Consiglio: The assembly of Venetian patricians founded around the end of the 12th century and reorganized in 1297. In 1319 membership became hereditary and was reserved for nobles over 25 years old. The Maggior Consiglio was considered the sovereign legislative body and highest expression of the Venetian aristocrats, which guaranteed equality among its members and was the vanguard of republican liberty as opposed to the many attempts the > Consiglio dei Dieci made to establish an oligarchic form of government. Depending on the period, it consisted of 1,200-2,000 members, had far-reaching legislative powers, nominated the members of the various councils and offices, and elected the > doge and the members of the > Senato, to whom it delegated most of its duties.

Marciano: Concerning St. Mark and St. Mark's Basilica. More in general, everything regarding the Republic of Venice.

Mariegola: From the Italian *madre regola*, or mother rule. The statute of a > scuola or a > confraternita.

Martyrium: A tomb or church where a saint is buried.

Mezzanine: In the Venetian palazzo, the low storey above the warehouses that housed offices; also, the attic used as the servants' lodging.

Minor Consiglio: > Dogal councillor.

Modillion: An S-shaped console or bracket used to support the cornice of an

entablature, a small statue or a window ledge.

Morea: The former name for the Peloponnesus in Greece.

Noli me tangere: "Touch me not." The words uttered by Christ to Mary Magdalen when she met Him after His Resurrection. In paintings and sculpture, the Magdalen is shown kneeling, stretching out her hands to Christ who, sometimes in the guise of a gardener, dissuades her from touching Him.

Oculus: A round opening in a wall or the top of a dome. In Gothic architecture it is a quatrefoil.

Odighitria: A type of Byzantine representation of the Virgin Mary recognizable by her hand indicating the Christ Child as the way to salvation.

Order: In architecture, one of the five modes used for columns, comprising the base, shaft, and capital (Doric, Ionic, Corinthian, Composite and Tuscan).

Ospedale: The Venetian equivalent of a hospice, orphanage or refuge.

Paliotto: The frontal or antependium of an altar. that is movable and may consist of a cloth or a covering made of wood, silver or other material.

Panoply: A composition of pieces of armor, weapons and flags used as a trophy or ornament.

Pantocrator: The Almighty, used for Christ as "lord of the world," depicted seated on a throne, in the act of benediction and, sometimes, holding the globe of the universe.

Parousia: The Second Coming of Christ at the end of the world. An iconographic motif connected to the Revelation and Last Judgment.

Pastiglia: A paste similar to stucco used for relief decoration.

Patera: A round relief ornament usually with zoomorphic motifs.

Patriarch: A prestigious ecclesiastic office that in Venice, in 1451, was merged with that of the bishop of the city, whose headquarters were in the cathedral, San Pietro di Castello.

Pendentive: The triangular spherical section between two large arches that support a dome, usually containing portraits of the Evangelists or Doctors of the Church.

Pietà: The scene after the Deposition, in which one or more persons are grieving over the body of the dead Christ. The most common type depicts the Virgin Mary with the body of her Son on her knees. This subject has Eucharistic meanings. If Christ is held up by angels, the scene is also known as an *Imago pietatis*.

Pinakes: Images made of mosaic tessarae.

Pluteus: A slab that is either smooth or in relief and is part of a balustrade or parapet.

Portego: The entrance and central hall of a patrician palazzo that is usually perpendicular to the façade and extends for the entire length of the building. Also, the rooms above this – that is, the piano noble or main storey – which have a similar shape and can be recognized on the facade by their multi-lancet windows.

Predella: The base of a polyptych or altarpiece; also a painting decorating this base.

Primicerio: The head prelate of St. Mark's Basilica, appointed by the > doge and having authority over the churches and convents under dogal jurisdiction.

Procuratore: The office of procurator of St. Mark, reserved for the wealthiest and most influential patricians, was second only to that of the > doge. Each > sestiere had the right to have its own procuratore, who was elected by the > Maggior Consiglio. Among his main duties were the tutelage of orphans and the execution of last wills and testaments. From 1443 on, the Procuratori "de Citra" dealt with the *sestieri* on the west side of the Grand Canal (Castello, S. Marco and Cannaregio), while the Procuratori "de Ultra" were responsible for the *sestieri* on the other side of the canal (S. Croce, S. Polo and Dorsoduro). The Procuratori "de Supra", instituted in the 14th century, were responsible for the tutelage and administration of St. Mark's Basilica, St. Mark's Square, and the campanile in the square.

Pronaos: A vestibule or porch that precedes the cella of a Greek temple or the interior of an Early Christian church.

Proto: The superintendent of a shipyard or construction yard and, in a wider sense, the head of a team of artisans. Syn.: master-builder, architect. In Venice the *proto* was not always the person who designed the work under construction. From the Gr. *protos* or "first."

Protome: A high relief or bust of a human or animal head that is generally situated on a keystone.

Provveditore: A public supervisor responsible for a particular sector or construction site in the state apparatus.

Psychostasia: The weighing of souls. A Byzantine iconographic motif linked to the Last Judgment depicting the Archangel Michael with scales and, sometimes, one or more devils who are trying the tip one of the plates of the scale to their side.

Pulvin: An architectural element in the shape of an overturned truncate pyramid situated over a column capital. Syn.: dosseret.

Quarantia: The Consiglio di Quaranta, established sometime between the 12th and 13th century and made up of senators. Its original wide-ranging power, especially in financial matters, was later limited to jurisdictional affairs. Later on, because of the growing number of appeal cases, the Quarantia Civil Vecchia (later called the Quarantia Criminal) and the Quarantia Civil Nuova were founded in 1441 and 1492 respectively.

Ramo: A small > *calle*.

Ridotto: A gambling house. > Casino.

Rio: A small inner canal.

Rio Terà: A covered or filled-in canal.:

Riva: The paved banks of canals with steps where boats could unload their cargo. Also, the steps situated in front of palazzi used for the same purpose.

Ruga: Street with houses and shops. From the French word *rue*.

Salizada: A paved street. From *salizar*: to pave.

Scapular: Part of monks' dress. If it consisted of two small rectangles of cloth fastened together by two ribbons, it was one of the distinguishing signs of the devotees of the cult of the Madonna del Carmelo. Those who wore the scapular had the privilege of being liberated from the flames of Purgatory on the Saturday after their death.

Scuola: An association or confraternity of lay persons, citizens or patricians with charitable, devotional or mutual aid aims. Depending on the number of members and type of statute, the Scuole were divided into *Grandi* or large – called *disciplinarie* or *dei battuti* (disciplinary, of the whipped) because originally their members carried out the expiatory practice of self-flagellation – and *Piccole* or small. Syn.: > confraternita, > sovvegno. The headquarters of a Scuola usually consisted of a hall on the ground floor and some rooms on the first floor such as the chapter house and > albergo. In the 16th century the members of the Scuole Grandi were divided into two categories: the *fratelli di banca*, who paid a high membership fee and were eligible to be elected as members of the governing organs of the Scuola, and the *fratelli di disciplina*, who paid only a symbolic membership fee and had no voting rights. The Venetian word *scola* is also a synonmy for the choir of a church or synagogue.

Sectile: Wall or pavement decoration consisting of stone tesserae.

Senato: A major organ of the Venetian Republic that may have been instituted in 1229, the Senate was the legislative body that governed the city and the state, deliberating political, administrative, legislative, economic and financial questions. In the field of foreign policy, the Senate coordinated the activities of the diplomatic centers, including the major cities in Italy and Europe, as well as Constantinople and St. Petersburg.

Sensa: The Ascension Day festivities during which the > doge, in his > Bucintoro, went to the San Nicolò di Lido harbor and celebrated Venice's marriage with the sea.

Serliana: A type of window, door or archway made popular by the Bolognese architect Sebastiano Serlio. It has three openings: the central one is surmounted by a round arch and the side ones by a rectangular window that may at times be an imitation.

Sestiere: Each of the six districts into which Venice is divided. This division was introduced in 1171 to facilitate tax collection. I *sestieri* on the St. Mark's side of the Canal Grande (S. Marco, Castello and Cannaregio) were called "de Citra," while those on the other side (S. Croce, S. Polo and Dorsoduro) were known as "de Ultra." Each *sestiere* had the right to elect a > procuratore of St. Mark, a > dogal councillor, and a person who would be responsible for public order in the district.

Signoria: The corporate organ of the Venetian Republic consisting of the > doge, the > Minor Consiglio and the three heads of the > Quarantia.

Signori di Notte al Criminal: Magistrature founded to see to public order in the city of Venice.

Signum Christi: The sign of Christ. > Trigram of Christ.

Sotoportego: A public arcade or covered street that passes under a private building or house. > Portego.

Sovvegno: A confraternity aiming at both material and spiritual mutual aid. > Scuola.

Squero: A construction yard where small and medium-size boats such as gondolas were built.

Stylite: A hermit who lives on the top of a column.

Stump of Jesse: The genealogical tree of the Virgin Mary, in which Christ's ancestors are depicted. The allegory stems from a passage in Isaiah: "A shoot shall spring forth from the stump of > Jesse."

Tambour: Supporting element of a dome with a cylindrical or octagonal shape.

Terà: Venetian term indicating a filled-in or covered > rio.

Thermal window: A semicircular, three-light window divided by two mullions. A typical feature of Palladian religious architecture used, from the second half of the 16th century on, to afford light to churches.

Trigram of Christ: The three letters IHS, initials of *Jesus Hominum Salvator*, Jesus the Savior of Humanity. The letters can be placed in a disc, the image of Christ the Sun or of the Eucharist, and they often refer to the > Signum Christi displayed during the sermons of San Bernardino da Siena.

Trefoil: Tracery ornament formed by three > foils usually situated under the pointed or flamboyant arch of a Gothic window.

Via Crucis: The Way of the Cross. The course followed by Jesus from the gate of Jerusalem to Calvary. It is part of the Passion and in general consists of fourteen distinct episodes known as the Stations of the Cross.

Vicario: Vice-president of a > Scuola or other institution.

ESSENTIAL BIBLIOGRAPHY

For reasons of limited space, it has not been possible to cite the very many publications consulted, in particular, collections of documents, guides to the city and its museums, exhibition catalogues, articles and monographs dedicated to palaces, churches, schools, theaters and artists. The author apologises profusely to the authors.

AIKEMA B., MEIJERS D., *Nel regno dei poveri. Arte e storia dei grandi ospedali veneziani in età moderna, 1474-1797*, Venice 1989.

ARSLAN E., *Venezia gotica. L'architettura civile*, Milan 1986.

BASSI E., *Architettura del Sei e Settecento a Venezia*, Venice 1980.

BELLAVITIS G., *Venezia*, Rome-Bari 1985.

CORNER F., *Notizie storiche delle chiese e monasteri di Venezia e di Torcello*, Padua 1758 (anastatic reprint: Bologna 1990).

COZZI G. – KNAPTON M., *La Repubblica di Venezia nell'età moderna*, Turin 1986 and 1992, 2 vols.

FRANZOI U., DI STEFANO D., *Le chiese di Venezia*, Venice 1976.

FRANZOI U. et al., *Il Palazzo Ducale di Venezia*, Treviso 1990.

Itinerari veneziani, publ. by SERVIZI EDUCATIVI del Comune di Venezia, Venice 1983-88, 11 installments of itineraries, in particular those by G. GULLINO.

LANE F., *Storia di Venezia*, Turin 1978.

MANNO A., *I mestieri di Venezia. Storia, arte e devozione delle corporazioni dal XIII al XVIII secolo*, Cittadella (Padua) 1995.

MIOZZI E., *Venezia nei secoli*, Venice 1957 and 1968, 4 vols.

PAOLETTI P., *L'architettura e la scultura del rinascimento in Venezia*, Venice 1893-97, 2 vols.

PEROCCO G., SALVADORI A., *Civiltà di Venezia*, Venice 1979, 3 vols.

POLACCO R., *San Marco. La basilica d'oro*, Milan 1991.

RIZZI A., *Scultura esterna a Venezia*, Venice 1987.

ROMANIN S., *Storia documentata di Venezia*, Venice 1853-61, 10 vols.

SALERNI L., *Repertorio delle opere d'arte e dell'arredo delle chiese e delle scuole di Venezia*, I, Vicenza 1994.

San Marco. I mosaici, la storia, l'illuminazione, with articles by O. DEMUS et al., Milan 1990-91, 2 vols.

SEMENZATO C., *La scultura veneta del Seicento e del Settecento*, Venice 1966.

Storia di Venezia, Istituto dell'Enciclopedia Italiana, Roma 1992-2002, 12 voll. vols. In particular, *Temi: L'arte*, ed. by R. PALLUCCHINI, Rome 1994 and 1995.

ZORZI A., *Venezia scomparsa*, Milan 1984.

WOLTERS W., *La scultura veneziana gotica, 1300-1460*, Venice 1976, 2 vols.

PLACE INDEX

P

Pala d'Oro, 90, 90c
Palazzetti Foscari-Contarini, 33
Palazzetto Barbarigo, 38
Palazzetto Contarini-Pisani, 38, 38c
Palazzetto Dandolo, 42
Palazzetto del Podestà
 (Malamocco), 578, 609
Palazzetto Tron-Memmo, 44
Palazzo (*see also* Ca')
 Amadi, 269, 297
 Archivio, dell' (Torcello), 578,
 596, 597
 Ariani-Cicogna, 528, 537,
 Badoer, 449
 Balbi, 14m, 16c, 19, 24c, 25
 Barbarigo della Terrazza, 27, 27c
 Barbaro, 15m, 20c, 21, 34,
 50, 51c
 Barbo-Molin, 206
 Barzizza, 29, 29c
 Basadonna-Giustinian, 465, 484
 Bellavite-Terzi, 163, 189, 189c
 Belloni-Battagia, 15m, 19, 32, 32c
 Bembo, 40c, 41
 Bernardo, 28, 29c
 Bollani, 465, 484
 Bragadin-Carabba, 269, 297
 Businello, 29c
 Camerlenghi, 15m, 19, 30,
 151, 384, 388-389, 388c, 389
 Cappello, 245, 255
 Cappello-Trevisan, 245, 246,
 246c
 Cavalli-Franchetti, 15m, 34,
 44, 48c, 49, 188
 Centani, 432
 Chiurlotto, 29, 29c
 Cini, 465, 510
 Civran-Grimani, 25
 Coccina-Tiepolo-Papadopoli,
 29, 29c
 Coletti-Duodo, 38, 38c, 326c,
 327
 Comunità, della (Burano),
 578, 594
 Consiglio, del (Torcello), 578,
 596
 Contarini dagli Scrigni e
 Corfù, 14m, 19, 22, 23c, 25
 Contarini dal Zaffo, 14m, 19,
 22, 23c, 355, 368
 Contarini del Bovolo, 163,
 170, 170c
 Contarini delle Figure, 14m,
 34, 45, 45c
 Contarini-Fasan, 52, 53c
 Corner (Ca' Grande), 15m,
 34, 50-51, 51c, 189
 Corner-Contarini dei Cavalli, 44
 Corner-Mocenigo, 421, 432,
 432c

Corner-Spinelli, 37, 52
Correr, 320, 338, 339c
da Mula, 20
Dandolo, 42, 43c, 201, 202,
 202c, 203c
Dandolo-Farsetti, 43, 43c
Dieci Savi, dei, 30, 384, 388c,
 389
Diedo, 320, 339
Diedo-Emo, 33
Donà (in Cannaregio), 13d,
 269, 311
Donà, 320, 340, 341, 355, 362
Donà-Balbi, 33
Donà-Giovannelli, 320, 338
Ducale (Doge's Palace), 11m,
 16, 24, 26, 38, 53, 54, 54c,
 55, 97, 98, 100, 100c, 102c,
 103, 105c, **108-133**, 182,
 202, 212, 566
Duodo, 32c, 163, 179
Erizzo, 36c, 37
Falier-Canossa, 48, 49c
Farsetti, 15m, 34, 44
Ferro-Fini, 15m, 34, 52, 53c
Flangini, 14m, 34, 34c, 35
Fontana-Rezzonico, 38, 38c
Foscarini, 528
Fortuny, *see* Pesaro degli Orfei
Gabrielli, 210, 211c
Gambara, 465, 484
Garzoni, 45
Genovese, 19
Giustinian-Lolin, 48
Giustinian-Morosini, 53
Giustinian-Pesaro, 38c
Giustiniani (Murano), 578, 588
Giustiniani-Faccanon, 161
Gradenigo, 384, 418
Grassi, 14m, 34, 46c, 47
Grimani, 15m, 34, 44, 45c,
 245, 254c, 255
Grimani-Marcello, 15m, 19, 28
Gritti, 36, 36c
Gritti-Badoer, 201, 206
Gritti-Morosini, 163, 179
Gussoni, 269, 300
Gussoni-Grimani della Vida, 38
I.N.A.I.L., 384, 418
Labia, 14m, 34, 35, 320, 344,
 345, 345c
Lando-Corner-Spinelli, 44, 45c
Lanfranchi, 29c
Lezze, 355, 364c, 365
Loredan, 163, 187, 187c
Loredan-Corner, 15m, 34, 42-
 43, 43d
Loredan dell'Ambasciatore,
 14m, 22m, 23
Loredan-Vendramin-Calergi,
 15m, 34, 36-37, 36c, 44, 51
Maffetti, 555

Malipiero-Cappello, 48, 49c
Mangilli-Valmarana, 38c, 39, 40c
Manin, 150
Manin-Dolfin, 15m, 34, 40c,
 41, 44
Manin-Sceriman, 35, 320, 347
Manolesso-Ferro, 52, 53c
Marcello, 37
Marcello dei Leoni, 25
Mastelli, 355, 368
Memmo-Martinengo, 36, 36c
Michiel dalle Colonne, 38c, 39
Minelli, 555, 566
Minelli-Spada, 355, 368
Mocenigo, 555, 568
Mocenigo "Casa Nuova", 45, 45c
Mocenigo "Casa Vecchia", 45,
 45c
Molin-Balbi-Valier della
 Trezza, 22
Moro, 23, 269, 300
Moro, 384, 400
Moro-Lin, 45
Morosini, 163, 188, 189c
Morosini-Brandolin, 31
Morosini-Erizzo, 268
Morosini-Sagredo, 15m, 34,
 38c, 39
Mostra del Cinema (Lido),
 578, 609, 609c
Morosini-Tassis, 268
Muti-Baglioni, 384, 400
Nani, 378
Nani-Dandolo, 555, 568
Navagero, 201, 206
Nunziatura, della, 220, 236,
 236c
Patriarcale, ex, 54, 156, 156c,
 220, 224, 246
Pesaro degli Orfei (Fortuny),
 162, 173, 173c
Pisani, 163, 188, 189c
Pisani-Moretta, 15m, 19, 26,
 27c, 49
Pisani-Trevisan, 163, 179
Podestà, del (Burano), 578, 594
Prigioni, delle, 53, 202, 248
Priuli, 245, 254, 254c
Priuli-Bon, 32, 32c
Querini Stampalia (*see also*
 Museums, Querini) **312**
Riva del Vin, on the, 30
Ruzzini, 269, 310, 310c
Sagredo, 236
Salvioni-Cappello, 245, 260
San Sebastiano Venier, House
 of, *see* House
Savorgnan, 355, 382c, 383
Seminario, del, 18, 465, 526, 527c
Soranzo, 384, 418, 418c,
Soranzo, 421, 426d, 427
Soranzo-Calbo-Crotta, 34, 34c

MUSEUMS AND OTHER CULTURAL
INSTITUTIONS: Information

Old Jewish Cemetery (Museo Ebraico, Comunità Israelitica di Venezia), tel. 041 715359 – *Vaporetto* (water bus) stop: Lido, Santa Maria Elisabetta – Entrance: Riviera S. Nicolò, corner of Via Cipro.

Arsenale (Ufficio Presidio Difesa), tel. 041 2709439 – *Vaporetto* (water bus) stop: Arsenale – Entrance: Campo de l'Arsenal, no. 2407 (Castello). Visits by appointment only for groups.

St. Mark's Basilica (Procuratoria di S. Marco), tel. 041 5225205 – *Vaporetto* (water bus) stop: S. Marco-Vallaresso; S. Zaccaria – (S. Marco). The following museums or monuments are also part of the Procuratoria di S. Marco circuit:
– Museo di San Marco and Loggia dei Cavalli (Basilica)
– Tesoro (Basilica)
– Pala d'Oro (Basilica)
– Campanile of St. Mark's Square
– San Basso Church (Piazzetta dei Leoni)

Casa di Carlo Goldoni e **Centro di Studi Teatrali – Palazzo Centani** (Musei Civici Veneziani), Tel. 041 2440317 – *Vaporetto* (water bus) stop: S. Tomà – Entrance: Calle dei Nomboli, no. 2794 (S. Polo).

Churches
For information, make inquiries at the Curia Patriarcale of Venice, tel. 041 2702411 (operator). There are also three series of churches connected to the following associations or institutions:
– Chorus, Associazione Chiese Venezia: Tel. 041 2750462.
– I.R.E. (Istituto di Ricovero e di Educazione di Venezia): Tel. 041 5217411.
– Sant'Apollonia: Tel. 041 2702464. Basilica di Santa Maria Assunta -Torcello: Tel. 041 730119.

Forts in the Lagoon
For information regarding visits by reservation:
– Lido: Forte Alberoni: Circolo Golf Venezia, Tel. 041 731333; Forte Malamocco: Hotel Golf & Residence, Tel. 041 2700111; Forte Ridotto (San Nicolò di Lido): Cooperativa Sociale La Città del Sole, Tel. 041 5387751.
– Mazzorbo: Ridotto: Associazione Guide e Scouts Cattolici Italiani, Tel. 041 5289515.
– Sant'Erasmo: Ridotto Nuovo e Torre Massimiliana: Associazione culturale Il Lato Azzurro, Tel. 041 5230642.
– Vignole: Forte Sant'Andrea: Comitato Certosa e S. Andrea – Venezia, Tel. 338 5779434.

Palazzo Cini Art Gallery (Fondazione G. Cini). Visits by appointment, Tel. 041 5210755 – *Vaporetto* (water bus) stop: Accademia – Entrance: Piscina del Forner, n. 864 (Dorsoduro).

Galleria Giorgio Franchetti – Ca' d'Oro (Soprintendenza Speciale per il Polo Museale Veneziano), Tel. 041 5222349 – *Vaporetto* (water bus) stop: Ca' d'Oro – Entrance: Calle Ca' d'Oro, next to no. 3932 (Cannaregio).

Galleria Internazionale d'Arte Moderna – Ca' Pesaro (Musei Civici Veneziani), Tel. 041 5240695 – *Vaporetto* (water bus) stop: S. Stae – Entrance: Fondamenta de Ca' Pesaro, no. 2076 (S. Croce).

Gallerie dell'Accademia – Ex Scuola and Chiesa della Carità (Soprintendenza Speciale per il Polo Museale Veneziano) Tel. 041 5212709 – *Vaporetto* (water bus) stop: Accademia – Entrance: Campo della Carità, no. 1050 (Dorsoduro).

Biennale di Venezia – Gardens and pavilions, Tel. 041 5218711 – *Vaporetto* (water bus) stop: Giardini – Entrance: Riva dei Partigiani (Castello). Open during the Biennale Arte e Architettura exhibit.

Islands
– **Lazzaretto Nuovo** (Archeoclub d'Italia), Tel. 041 2444011.
– **San Francesco del Deserto** (Francisan Minorites), Tel. 041 5286863 – Islet can be reached only by private boat.
– **San Lazzaro degli armeni** (Armenian Mechitarite Congregation), Tel. 041 5260104.

Libreria Vecchia or Sansoviniana (Biblioteca Nazionale Marciana), Tel. 041 2407223 – *Vaporetto* (water bus) stop: S. Marco-Vallaresso; S. Zaccaria – Entrance: Piazzetta S. Marco, n. 13 A (S. Marco). Now part of the Musei di Piazza S. Marco circuit. Visitors' entrance: see the Museo Correr.

Museo Archeologico – Procuratie Nuove (Soprintendenza Speciale per il Polo Museale Veneziano), tel. 041 5225978 – *Vaporetto* (water bus) stop: S. Marco-Vallaresso; S. Zaccaria – Entrance: Piazzetta S. Marco, no. 17 (S. Marco). Now part of the Musei di Piazza S. Marco circuit. Visitors' entrance: see Museo Correr.

Armenian Museum (Mechitarite Congregation, San Lazzaro degli Armeni island), Tel. 041 5260104 – *Vaporetto* (water bus) stop: Isola di San Lazzaro degli Armeni.

Museo Civico di Storia Naturale – Fontego dei Turchi (Musei Civici Veneziani), Tel. 041 2750206 – *Vaporetto* (water bus) stop: Riva di Biasio – Entrance: Salizada del Fontego dei Turchi, no. 1730.

Museo Correr – Ala Napoleonica e Procuratie Nuove (Musei Civici Veneziani), Tel. 041 2405211 – *Vaporetto* (water bus) stop: S. Marco-Vallaresso – Entrance: Piazza S. Marco, Ala Napoleonica, monumentale staircase (S. Marco). Part of the Musei di Piazza S. Marco circuit.

Museo d'Arte Orientale – Ca' Pesaro (Soprintendenza Speciale per il Polo Museale Veneziano) Tel. 041 5241173 – *Vaporetto* (water bus) stop: S. Stae – Entrance: Fondamenta de Ca' Pesaro, no. 2076 (S. Croce).

Museo del Merletto (Burano) – Palazzo del podestà (Musei Civici Veneziani), Tel. 041 730034 – *Vaporetto* (water bus) stop: Burano – Entrance: Piazza B. Galuppi, no. 187.

Museo del Settecento Veneziano – Ca' Rezzonico (Musei Civici Veneziani), Tel. 041 2410100 – *Vaporetto* (water bus) stop: Ca' Rezzonico – Entrance: Fondamenta Rezzonico, no. 3136 (Dorsoduro).

Museo di Icone – Istituto Ellenico di Studi Bizantini e Postbizantini di Venezia, Tel. 041 5226581 – *Vaporetto* (water bus) stop: S. Zaccaria – Entrance: Campo dei Greci, no. 3412 (Castello).

Museo Diocesano d'Arte Sacra – Chiostro di Sant'Apollonia, Tel. 041 5229166 – *Vaporetto* (water bus) stop: S. Zaccaria – Entrance: Fondamenta S. Apollonia, no. 4312 (Castello).

Museo di Palazzo Mocenigo – Centro Studi di Storia del Tessuto e del Costume (Musei Civici Veneziani), Tel. 041 721798 – *Vaporetto* (water bus) stop: S. Stae – Entrance: Salizada S. Stae, no. 1992 (S. Croce).

Torcello Museum – Palazzo del Consiglio and **Palazzo dell'Archivio** (Amministrazione Provinciale di Venezia), Tel. 041 730761 – *Vaporetto* (water bus) stop: Torcello – Entrance: Palazzo del Consiglio, no. 20. For the basilica, see the entry "Churches."

Museo Ebraico (Comunità Israelitica di Venezia), Tel. 041 715359 – *Vaporetto* (water bus) stop: Ferrovia, San Marcuola, Ponte delle Guglie-Ghetto – Entrance: Campo de Gheto Novo, no. 2902/B.

Museo Querini – Palazzo Querini Stampalia (Fondazione Querini Stampalia), Tel. 041 2711411 – *Vaporetto* (water bus) stop: S. Zaccaria or Rialto Entrance: Campo S. Maria Formosa, no. 5252 (Castello).

Museo Fortuny – Palazzo Pesaro degli Orfei (Musei Civici Veneziani), Tel. 041 5200995 – *Vaporetto* (water bus) stop: S. Angelo – Entrance: Ramo Orfei, no. 3780 (S. Marco).

Museo Storico Navale (Marina Militare Italiana), Tel. 041 5200276 – *Vaporetto* (water bus) stop: Arsenale – Entrance: Campo S. Biagio, no. 2148 (Castello).

Museo Vetrario di Murano – Palazzo Giustiniani (Musei Civici Veneziani), Tel. 041 739586 – *Vaporetto* (water bus) stop: Navagero – Entrance: Fondamenta Marco Giustinian, no. 8.

Crociferi Oratory (Istituto di Ricovero e di Educazione di Venezia) – *Vaporetto* (water bus) stop: Ca' d'Oro; Fondamente Nuove – Entrance: Campo dei Gesuiti, no. 4903 (Cannaregio).

Doges' Palace (Musei Civici Veneziani), Tel. 041 5224951 – *Vaporetto* (water bus) stop: San Zaccaria – Visitors' entrance: Molo S. Marco, Porta del Frumento, no. 2 (S. Marco); reserved entrance: Piazzetta S. Marco, Porta della Carta, no. 1. Part of the Musei di Piazza S. Marco circuit, comprising:
– Museo dell'Opera
– Armeria
– Prigioni Nuove
– Secret Itineraries: visit by reservation, Tel. 041 5209070.

Peggy Guggenheim Collection - Ca' Venier dei Leoni (Solomon R. Guggenheim Foundation, New York), Tel. 041 2405411 – *Vaporetto* (water bus) stop: Salute – Entrance: Fondamenta Venier dei Leoni, no. 708 and Calle S. Cristoforo, no. 701 (Dorsoduro).

Pinacoteca Manfrediniana and Raccolta Lapidaria – Palazzo del Seminario Patriarcale Visit by appointment, Tel. 041 5225558 – *Vaporetto* (water bus) stop: Salute – Entrance: Campo de la Salute, no. 1 (Dorsoduro).

Venice Planetarium (Musei Civici Veneziani), Tel. 041 5224951 – *Vaporetto* (water bus) stop: S. M. Elisabetta (Lido) – Visitors' entrance: Lungomare D'Annunzio, formerly Luna Park area (Lido).

Ospedaletto Concert Hall, (Istituto di Ricovero e di Educazione di Venezia) – *Vaporetto* (water bus) stop: Rialto or Ospedale Civile – Entrance: Barbaria de le Tole, near Santa Maria dei Derelitti Church (Castello).

Scala del "Bovolo" – Palazzo Contarini (Istituto di Ricovero e di Educazione di Venezia) – *Vaporetto* (water bus) stop: Rialto – Entrance: Corte Contarini del Bovolo, no. 4299 (S. Marco).

Scuole, Scuole Grandi and Arciconfraternite – Dalmata dei Santi Giorgio e Trifone detta degli Schiavoni, Tel. 041 5208446 – *Vaporetto* (water bus) stop: Riva degli Schiavoni – Entrance: Fondamenta dei Furlani, no. 3297 (Castello).

– **San Giovanni Evangelista**, Tel. 041 718234 – *Vaporetto* (water bus) stop: San Tomà or Piazzale Roma – Entrance: Campiello de la Scuola, no. 2454 (S. Polo).

– **San Rocco**, Tel. 041 5234864 – *Vaporetto* (water bus) stop: San Tomà or Piazzale Roma; S. Tomà – Entrance: Campo S. Rocco, no. 3054 (S. Polo).

– **Santa Maria del Carmelo**, Tel. 041 2413557 – *Vaporetto* (water bus) stop: S. Barnaba or S. Basilio – Entrance: Calle de la Scuola, no. 2617 (Dorsoduro).

– **San Teodoro**, Tel. 041 5287227 – *Vaporetto* (water bus) stop: Rialto – Entrance: Campo S. Salvador, no. 4810 (S. Marco).

Torre dell'Orologio (Musei Civici Veneziani), Tel. 041 5225625 – *Vaporetto* (water bus) stop: S. Marco-Vallaresso; S. Zaccaria – Entrance: Marzaria de l'Orologio, no. 147 (S. Marco).

PHOTOGRAPHIC CREDITS

THE AUTHOR

Antonio Manno was born in Urbino and lives in Venice. He is a lecturer, essayist, author for publishers and newspapers, and curator of exhibitions of Venetian art. He has undertaken specialized research on art history and the history of architecture and town planning, mostly concerning the Medieval and Renaissance periods, and his studies primarily focus on iconology and religious art. Currently, Mr. Manno teaches the History of Visual Art at the Istituto Statale d'Arte, Venice. He is a consultant on Internet- and computer-based education and he created and manages the ARTs website (http://members.tripod.com/artsnet). His most important publications deal with English town-planning, military architecture and engineering, the Palmanova fortress, Jacopo Tintoretto, St. Mark the Evangelist, the trades in Venice (for which he received the Gambrinus Prize), and the column capitals of the Doge's Palace in Venice.

The author wishes to express his gratitude to Chicca for the invaluable suggestions and help she afforded during the preparation of this volume.

Museo d'Arte Orientale – Ca' Pesaro (Soprintendenza Speciale per il Polo Museale Veneziano) Tel. 041 5241173 – *Vaporetto* (water bus) stop: S. Stae – Entrance: Fondamenta de Ca' Pesaro, no. 2076 (S. Croce).

Museo del Merletto (Burano) – Palazzo del podestà (Musei Civici Veneziani), Tel. 041 730034 – *Vaporetto* (water bus) stop: Burano – Entrance: Piazza B. Galuppi, no. 187.

Museo del Settecento Veneziano – Ca' Rezzonico (Musei Civici Veneziani), Tel. 041 2410100 – *Vaporetto* (water bus) stop: Ca' Rezzonico – Entrance: Fondamenta Rezzonico, no. 3136 (Dorsoduro).

Museo di Icone – Istituto Ellenico di Studi Bizantini e Postbizantini di Venezia, Tel. 041 5226581 – *Vaporetto* (water bus) stop: S. Zaccaria – Entrance: Campo dei Greci, no. 3412 (Castello).

Museo Diocesano d'Arte Sacra – Chiostro di Sant'Apollonia, Tel. 041 5229166 – *Vaporetto* (water bus) stop: S. Zaccaria – Entrance: Fondamenta S. Apollonia, no. 4312 (Castello).

Museo di Palazzo Mocenigo – Centro Studi di Storia del Tessuto e del Costume (Musei Civici Veneziani), Tel. 041 721798 – *Vaporetto* (water bus) stop: S. Stae – Entrance: Salizada S. Stae, no. 1992 (S. Croce).

Torcello Museum – Palazzo del Consiglio and **Palazzo dell'Archivio** (Amministrazione Provinciale di Venezia), Tel. 041 730761 – *Vaporetto* (water bus) stop: Torcello – Entrance: Palazzo del Consiglio, no. 20. For the basilica, see the entry "Churches."

Museo Ebraico (Comunità Israelitica di Venezia), Tel. 041 715359 – *Vaporetto* (water bus) stop: Ferrovia, San Marcuola, Ponte delle Guglie-Ghetto – Entrance: Campo de Gheto Novo, no. 2902/B.

Museo Querini – Palazzo Querini Stampalia (Fondazione Querini Stampalia), Tel. 041 2711411 – *Vaporetto* (water bus) stop: S. Zaccaria or Rialto Entrance: Campo S. Maria Formosa, no. 5252 (Castello).

Museo Fortuny – Palazzo Pesaro degli Orfei (Musei Civici Veneziani), Tel. 041 5200995 – *Vaporetto* (water bus) stop: S. Angelo – Entrance: Ramo Orfei, no. 3780 (S. Marco).

Museo Storico Navale (Marina Militare Italiana), Tel. 041 5200276 – *Vaporetto* (water bus) stop: Arsenale – Entrance: Campo S. Biagio, no. 2148 (Castello).

Museo Vetrario di Murano – Palazzo Giustiniani (Musei Civici Veneziani), Tel. 041 739586 – *Vaporetto* (water bus) stop: Navagero – Entrance: Fondamenta Marco Giustinian, no. 8.

Crociferi Oratory (Istituto di Ricovero e di Educazione di Venezia) – *Vaporetto* (water bus) stop: Ca' d'Oro; Fondamente Nuove – Entrance: Campo dei Gesuiti, no. 4903 (Cannaregio).

Doges' Palace (Musei Civici Veneziani), Tel. 041 5224951 – *Vaporetto* (water bus) stop: San Zaccaria – Visitors' entrance: Molo S. Marco, Porta del Frumento, no. 2 (S. Marco); reserved entrance: Piazzetta S. Marco, Porta della Carta, no. 1. Part of the Musei di Piazza S. Marco circuit, comprising:
– Museo dell'Opera
– Armeria
– Prigioni Nuove
– Secret Itineraries: visit by reservation, Tel. 041 5209070.

Peggy Guggenheim Collection – Ca' Venier dei Leoni (Solomon R. Guggenheim Foundation, New York), Tel. 041 2405411 – *Vaporetto* (water bus) stop: Salute – Entrance: Fondamenta Venier dei Leoni, no. 708 and Calle S. Cristoforo, no. 701 (Dorsoduro).

Pinacoteca Manfrediniana and Raccolta Lapidaria – Palazzo del Seminario Patriarcale Visit by appointment, Tel. 041 5225558 – *Vaporetto* (water bus) stop: Salute – Entrance: Campo de la Salute, no. 1 (Dorsoduro).

Venice Planetarium (Musei Civici Veneziani), Tel. 041 5224951 – *Vaporetto* (water bus) stop: S. M. Elisabetta (Lido) – Visitors' entrance: Lungomare D'Annunzio, formerly Luna Park area (Lido).

Ospedaletto Concert Hall, (Istituto di Ricovero e di Educazione di Venezia) – *Vaporetto* (water bus) stop: Rialto or Ospedale Civile – Entrance: Barbaria de le Tole, near Santa Maria dei Derelitti Church (Castello).

Scala del "Bovolo" – Palazzo Contarini (Istituto di Ricovero e di Educazione di Venezia) – *Vaporetto* (water bus) stop: Rialto – Entrance: Corte Contarini del Bovolo, no. 4299 (S. Marco).

Scuole, Scuole Grandi and Arciconfraternite – Dalmata dei Santi Giorgio e Trifone detta degli Schiavoni, Tel. 041 5208446 – *Vaporetto* (water bus) stop: Riva degli Schiavoni – Entrance: Fondamenta dei Furlani, no. 3297 (Castello).

– **San Giovanni Evangelista**, Tel. 041 718234 – *Vaporetto* (water bus) stop: San Tomà or Piazzale Roma – Entrance: Campiello de la Scuola, no. 2454 (S. Polo).

– **San Rocco**, Tel. 041 5234864 – *Vaporetto* (water bus) stop: San Tomà or Piazzale Roma; S. Tomà – Entrance: Campo S. Rocco, no. 3054 (S. Polo).

– **Santa Maria del Carmelo**, Tel. 041 2413557 – *Vaporetto* (water bus) stop: S. Barnaba or S. Basilio – Entrance: Calle de la Scuola, no. 2617 (Dorsoduro).

– **San Teodoro**, Tel. 041 5287227 – *Vaporetto* (water bus) stop: Rialto – Entrance: Campo S. Salvador, no. 4810 (S. Marco).

Torre dell'Orologio (Musei Civici Veneziani), Tel. 041 5225625 – *Vaporetto* (water bus) stop: S. Marco-Vallaresso; S. Zaccaria – Entrance: Marzaria de l'Orologio, no. 147 (S. Marco).

PHOTOGRAPHIC CREDITS

THE AUTHOR

Antonio Manno was born in Urbino and lives in Venice. He is a lecturer, essayist, author for publishers and newspapers, and curator of exhibitions of Venetian art. He has undertaken specialized research on art history and the history of architecture and town planning, mostly concerning the Medieval and Renaissance periods, and his studies primarily focus on iconology and religious art. Currently, Mr. Manno teaches the History of Visual Art at the Istituto Statale d'Arte, Venice. He is a consultant on Internet- and computer-based education and he created and manages the ARTs website (http://members.tripod.com/artsnet). His most important publications deal with English town-planning, military architecture and engineering, the Palmanova fortress, Jacopo Tintoretto, St. Mark the Evangelist, the trades in Venice (for which he received the Gambrinus Prize), and the column capitals of the Doge's Palace in Venice.

The author wishes to express his gratitude to Chicca for the invaluable suggestions and help she afforded during the preparation of this volume.